Signed!

The Pursuit of Spiritual Wisdom

THE THOUGHT AND ART OF

Vincent van Gogh

AND

Paul Gauguin

Naomi Margolis Maurer

For my dear friends Barbara + Earl
with love,
naomi
12/98

Madison • Teaneck
Fairleigh Dickinson University Press
London
Associated University Presses
in association with The Minneapolis Institute of Arts

Associated University Presses
440 Forsgate Drive
Cranbury
NJ 08512

Associated University Presses
16 Barter Street
London WC1A 2AH
United Kingdom

Associated University Presses
P.O. Box 338, Port Credit
Mississauga
Ontario
Canada
L5G 4L8

The paper used in this publication meets the requirements
of the American National Standard for Permanence of Paper
for printed Library Materials z39.48-1984.

LIBRARY OF CONGRESS CATALOGING–IN–PUBLICATION DATA

Maurer, Naomi E.
 The pursuit of spiritual wisdom : the thought and art of Vincent van Gogh and Paul Gauguin / by Naomi Margolis Maurer.
 p. cm.
 Revision of thesis (Ph.D.—University of Chicago, 1985) under title: The pursuit of spiritual knowledge.
 Includes bibliographical references and index.
 ISBN 0-8386-3749-3 (alk. paper)
 1. Symbolism (Art movement)—France. 2. Gogh, Vincent van, 1853–1890—Criticism and interpretation. 3. Gauguin, Paul, 1848–1903—Criticism and interpretation. I. Gogh, Vincent van, 1853–1890. II. Gauguin, Paul, 1848–1903. III. Maurer, Naomi E. Pursuit of spiritual knowledge. IV. Title.
 N6847.5.N3M39 1998
 759.9492—dc21

 98-16272
 CIP

Printed and bound in Kranj, Slovenia, by Gorenjski Tisk

For Evan, Noah, and Aaron

Contents

List of Illustrations

VINCENT VAN GOGH

(unless otherwise noted)

Catalogue numbers refer to Jan Hulsker, *The Complete van Gogh* (New York: Harry N. Abrams, Inc., 1980).

Holland

Paris

canvas, H1311. Van Gogh Museum (Vincent van Gogh Foundation), Amsterdam.

87. *Interior of restaurant*, June–July, 1887, oil on canvas, H1256. Kröller-Müller Museum, Otterlo, Netherlands.

88. *Vegetable gardens in Montmartre*, June–July, 1887, oil on canvas, H1245. Stedelijk Museum, Amsterdam.

89. *The Hüth factories at Clichy*, summer 1887, oil on canvas, H1287. The St. Louis Art Museum.

90. *Wheat field with lark*, May–June, 1887, oil on canvas, H1274. Van Gogh Museum (Vincent van Gogh Foundation), Amsterdam.

91. *The Bridge at Asnières*, summer, 1887, oil on canvas, H1327. The Foundation E. G. Bührle Collection, Zurich.

92. *Path in the woods*, summer, 1887, oil on canvas, H1315. Van Gogh Museum (Vincent van Gogh Foundation), Amsterdam.

93. *Trees and undergrowth*, summer, 1887, oil on canvas, H1312. Van Gogh Museum (Vincent van Gogh Foundation), Amsterdam.

94. *Self-portrait*, spring 1887, oil on artist's board mounted on cradled panel, H1249. The Art Institute of Chicago.

95. *Self-portrait with straw hat*, summer 1887, oil on canvas, H1310. Van Gogh Museum (Vincent van Gogh Foundation), Amsterdam.

96. *Still-life: basket of apples*, autumn 1887, oil on canvas, H1341. The St. Louis Art Museum.

97. *Still-life with apples, pears, lemons and grapes*, autumn 1887, oil on canvas, H1337. The Art Institute of Chicago.

98. *Flowering plum tree (after Hiroshige)*, autumn 1887, oil on canvas, H1296. Van Gogh Museum (Vincent van Gogh Foundation), Amsterdam.

99. *Oiran (after Kesaï Yeisen)*, autumn 1887, oil on canvas, H1298. Van Gogh Museum (Vincent van Gogh Foundation), Amsterdam.

100. *Two cut sunflowers*, autumn 1887, oil on canvas, H1331. Kunstmuseum, Bern, Switzerland.

101. *Four cut sunflowers*, autumn 1887, oil on canvas, H1330. Kröller-Müller Museum, Otterlo, Netherlands.

102. *Skull*, winter 1887, oil on canvas, H1347. Van Gogh Museum (Vincent van Gogh Foundation), Amsterdam.

103. *Still-life with plaster cast, rose and two novels*, winter 1887–1888, oil on canvas, H1349. Kröller-Müller Museum, Otterlo, Netherlands.

104. *Still-life with French novels and rose*, December 1887, oil on canvas, H1332. Private Collection.

Arles

105. *Blossoming apricot trees*, March, 1888, oil on canvas, H1380. Van Gogh Museum (Vincent van Gogh Foundation), Amsterdam.

106. *Orchard in blossom*, April, 1888, oil on canvas, H1399. Harmon Fine Arts, Ltd.

107. *Pink peach trees. Souvenir de Mauve*, March, 1888, oil on canvas, H1379. Kröller-Müller Museum, Otterlo, Netherlands.

108. *Bridge of Langlois*, March 1888, oil on canvas, H1368. Kröller-Müller Museum, Otterlo, Netherlands.

109. *View of Arles with irises*, April–May 1888, oil on canvas, H1416. Van Gogh Museum (Vincent van Gogh Foundation), Amsterdam.

110. *Harvest landscape at La Crau, towards Montmajeur*, June 1888,

oil on canvas, H1440. Van Gogh Museum (Vincent van Gogh Foundation), Amsterdam.

111. *Fishing boats on the sea at Saintes-Maries-de-la-mer*, June 1888, oil on canvas, H1453. Pushkin State Museum of Fine Arts, Moscow.

112. *Fishing boats on the beach at Saintes-Maries-de-la-mer*, June 1888, oil on canvas, H1460. Van Gogh Museum (Vincent van Gogh Foundation), Amsterdam.

113. *The Sower*, June 1888, oil on canvas, H1470. Kröller-Müller Museum, Otterlo, Netherlands.

114. *Harvest in Provence*, June 1888, oil on canvas, H1481. The Israel Museum, Jerusalem.

115. *Wheat fields with reaper*, June 1888, oil on canvas, H1479. The Toledo Museum of Art, Toledo, Ohio.

116. *Sunset: wheat fields near Arles*, June 1888, oil on canvas, H1473. Künstmuseum Winterthur, Switzerland.

117. *Arles: view from the wheat fields*, June 1888, oil on canvas, H1477. Musée Rodin, Paris.

118. *Seated Zouave*, June–July 1888, oil on canvas, H1488. Private collection, Argentina.

119. *Postman Joseph Roulin*, July–August 1888, oil on canvas, H1522. Museum of Fine Arts, Boston.

120. *Portrait of Patience Escalier*, August 1888, oil on canvas, H1563. Private Collection.

121. Henri de Toulouse-Lautrec, *Young woman at a table, 'Rice Powder'*, 1887, oil on canvas, Van Gogh Museum (Vincent van Gogh Foundation), Amsterdam.

122. *Self-portrait with straw hat and pipe*, August 1888, oil on canvas on paste-board, H1565. Van Gogh Museum (Vincent van Gogh Foundation), Amsterdam.

123. *Vase with sunflowers*, August 1888, oil on canvas, H1561. Bayerischen Staatsgemäldesammlungen, Munich.

124. *The Night café*, September 1888, oil on canvas, H1575. Yale University Art Gallery, New Haven, Connecticut.

125. *Café terrace at night*, September 1888, oil on canvas, H1580. Kröller-Müller Museum, Otterlo, Netherlands.

126. *Starry night over the Rhone*, September 1888, oil on canvas, H1592. Musée d'Orsay, Paris.

127. *Portrait of Eugène Boch*, August 1888, oil on canvas, H1574. Musée d'Orsay, Paris.

128. *The Garden of the Poets*, September 1888, oil on canvas, H1578. The Art Institute of Chicago.

129. *Vase with oleanders and books*, August 1888, oil on canvas, H1566. The Metropolitan Museum of Art, New York.

130. *Public park with couple and blue fir tree: The Poet's Garden III*, October 1888, oil on canvas, H1601. Private Collection.

131. *Self-portrait as bonze, dedicated to Paul Gauguin*, September 1888, oil on canvas, H1581. Fogg Art Museum, Harvard University, Cambridge, Massachusetts.

132. *Vincent's bedroom at Arles*, October 1888, oil on canvas, H1608. Van Gogh Museum (Vincent van Gogh Foundation), Amsterdam.

133. *The Sower*, November 1888, oil on canvas, H1629. Van Gogh Museum (Vincent van Gogh Foundation), Amsterdam.

134. *Memory of the garden at Etten*, November 1888, oil on canvas, H1630. The State Hermitage Museum, St. Petersburg.

PAUL GAUGUIN
(unless otherwise noted)

Note: 'w' numbers refer to Georges Wildenstein and Raymond Cogniat, *Gauguin. Catalogue* (Paris: Édition Les Beaux-Arts, 1964); 'G' numbers to Christopher Gray, *The Sculpture and Ceramics of Paul Gauguin* (Baltimore: The Johns Hopkins Press, 1963); 'GU' numbers to Marcel Guérin, *L'Oeuvre gravé de Gauguin*, 2 vols. (Paris: H. Floury, 1927).

Tahiti

281. *Faaturuma* (*Melancholy*), 1891, oil on canvas, w424. Nelson-Atkins Museum of Art, Kansas City, Missouri.

282. *Vahine no te tiare* (*Woman with a flower*), 1891, oil on canvas, w420. Ny Carlsberg Glyptothek, Copenhagen, Denmark.

283. *Te fare hymenee* (*The House of song*), 1892, oil on canvas, w477. Private Collection.

284. *Upaupa* (*Dance of joy*), 1891, oil on canvas, w433. The Israel Museum, Jerusalem.

285. *The Man with the axe*, 1891, oil on canvas, w430. Galerie Beyeler, Basel, Switzerland.

286. *Standing figure*, west frieze of the Parthenon, Athens, Greece, 447–33 BC

287. *Matamoe* (*Sleeping*), early 1892, oil on canvas, w484. Pushkin State Museum of Fine Arts, Moscow.

288. *I raro te oviri* (*Under the pandanus palms*), 1891, oil on canvas, w432. The Minneapolis Institute of Arts.

289. *A banquet scene*, fresco from the Tomb of Nebamun, Thebes, Egypt, 18th dynasty, ca. 1400 BC, The British Museum, London.

290. *Ta Matete* (*The Market*), 1892, oil on canvas, w476. Oeffentliche Kunstsammlung Basel, Kunstmuseum.

291. *Seated deities*, frieze from the Treasury of the Siphnians, Delphi, Greece, ca. 6th century BC

292. *The Meal*, 1891, oil on canvas, w427. Musée d'Orsay, Paris.

293. *Ia Orana Maria* (*We greet you, Mary*), 1891, oil on canvas, w428. The Metropolitan Museum of Art, New York.

294. *Two Tahitians on the seashore*, 1891 or 92, oil on canvas, w456. Honolulu Academy of Arts.

295. *Tahitians on the seashore*, 1891 or 92, oil on canvas, w462. The Metropolitan Museum of Art, New York.

296. Pierre Puvis de Chavannes, *Bathers*, 1890, oil on canvas. Art Gallery of Ontario, Toronto.

297. *Aha oe feii?* (*What, are you jealous?*), 1892, oil on canvas, w461. Pushkin State Museum of Fine Arts, Moscow.

298. *Two women on the seashore*, 1891, oil on canvas, w434. Musée d'Orsay, Paris.

299. *Te Faaturuma* (*The Brooding woman* or *The Silence*), 1891, oil on canvas, w440. Worcester Art Museum, Massachusetts.

300. *Idol with a pearl*, 1891 or 92, stained and gilded tamanu wood with inlaid pearl, G94. Musée d'Orsay, Paris.

301. *Street in Tahiti*, 1891, oil on canvas, w441. The Toledo Museum of Art, Ohio.

302. *Parau parau* (*Words words*), 1891, oil on canvas, w435. The State Hermitage Museum, St. Petersburg.

303. *Parau parau* (*Words words*), 1892, oil on canvas, w472. Yale University Art Gallery, New Haven, Connecticut.

304. *Ea haere ia oe?* (*Where are you going?*), 1893, oil on canvas, w501. The State Hermitage Museum, St. Petersburg.

305. *Nafea faa ipoipo* (*When will you marry?*), 1892, oil on canvas, w454. Oeffentliche Kunstsammlung Basel, Kunstmuseum.

306. Photograph of Tehamana, ca. 1894.

307. *Vahine no te vi* (*Woman with a mango*), 1892, oil on canvas, w449. The Baltimore Museum of Art.

308. *Te nave nave fenua* (*The Land of sensuous pleasure*), 1892, oil on canvas, w455. Ohara Museum of Art, Kurashiki, Japan.

309. Odilon Redon, "There was perhaps a first vision attempted in the flower," #2 of *The Origins*, 1883, lithograph. M 46. The Art Institute of Chicago.

310. *Manao tupapau* (*The Spirit of the dead is watching*), 1892, oil on canvas, w457. Albright-Knox Art Gallery, Buffalo, New York.

311. *Tiki* (detail), stone, Marquesas islands. Musée de l'Homme, Paris.

312. *Idol with a shell*, 1893, ironwood with mother-of-pearl and bone, G99. Musée d'Orsay, Paris.

313. *Barbaric tales*, oil on canvas, w459. Private collection.

314. *Parau hanohano* (*Terrifying words*), 1892, oil on canvas, w460. Private collection.

315. *Hina and two attendants*, 1892, carved tamanu wood cylinder, G95. Hirshhorn Museum and Sculpture Garden, Smithsonian Institution, Washington D.C.

316. *Parau na te varua ino* (*Talk about the evil spirit*), 1892, oil on canvas, w458. The National Gallery of Art, Washington, D.C.

317. *Eve*, doorjamb sculpture from the church at Guimiliau, Brittany, France.

318. *Parau na te varua ino* (*Talk about the evil spirit*), 1892, pastel, Oeffentliche Kunstsammlung, Basel, Kupferstichkabinett.

319. *Fatata te miti* (*By the sea*), 1892, oil on canvas, w463. The National Gallery of Art, Washington D.C.

320. *Te aa no areois* (*The Seed of the Areois*), 1892, oil on canvas, w451. The Museum of Modern Art, New York.

321. *Vairumati tei oa* (*Her name is Vairumati*), 1892, oil on canvas, w450. Pushkin State Museum of Fine Arts, Moscow.

322. Pierre Puvis de Chavannes, *Hope*, 1872, black chalk on paper. The Walters Art Gallery, Baltimore.

323. *Parahi te marae* (*There is the temple*), 1892, oil on canvas, w483. The Philadelphia Museum of Art.

324. The Taputapuatea *marae* at Opoa on Ra'iatea.

325. Top of a Marquesan oar, carved wood. The British Museum, London.

326. *Matamua* (*In former times*), 1892, oil on canvas, w467. Carmen Thyssen-Bornemisza Collection.

327. *Arearea* (*Joyousness*), 1892, oil on canvas, w468. Musée d'Orsay, Paris.

328. *Tahitian pastorale*, end of December 1892, oil on canvas, w470. The State Hermitage Museum, St. Petersburg.

329. *Pape moe* (*Mysterious water*), 1893, oil on canvas, w498. Private Collection, Switzerland.

330. *Hina Tefatou* (*The Moon and the earth*), 1893, oil on canvas, w499. The Museum of Modern Art, New York.

331. Vegetation in the South Seas (Native drinking from waterfall).

332. Jean-Auguste-Dominique Ingres, *Jupiter and Thetis*, 1811, oil on canvas. Musée Granet, Aix-en-Provence, France.

333. *Arii matamoe* (*The Sleeping King* or *The Royal end*), 1892, oil on canvas, w453. Private collection.

334. *Merahi metua no Tehamana* (*The Many parents of Tehamana*), 1893, oil on canvas, w497. The Art Institute of Chicago.

France

335. Gauguin's studio at 6 rue Vercingétorix, with Annah the

Javanese in the back row between Paul Sérusier (left) and Georges Lacombe, 1894. Musée Gauguin, Papeari, Tahiti.

336. *Self-portrait with palette*, c. 1894, oil on canvas, w410. Private Collection.

337. Photograph of Gauguin with palette, ca. 1888. Musée d'Orsay, Paris.

338. *Aita tamari vahine Judith te parari* (*The Child-woman Judith is not yet breached*), late 1893–94, oil on canvas, w508. Private Collection.

339. *Self-portrait with hat*, winter 1893–94, oil on canvas, w506. Musée d'Orsay, Paris.

340. *Mahna no varua ino* (*Day of the evil spirit*), 1894–95, woodcut, GU34. The Art Institute of Chicago.

341. *Auti te pape* (*Fresh water is in motion*), 1894–95, woodcut, GU35. The Art Institute of Chicago.

342. *Te Atua* (*The Gods*), 1894–95, woodcut, GU31. The Art Institute of Chicago.

343. *Nave nave moe* (*Delicious repose*), 1894, oil on canvas, w512. The State Hermitage Museum, St. Petersburg.

344. *Arearea no varua ino* (*Joyousness of the evil spirit*), 1894, oil on canvas, w514. Ny Carlsberg Glyptotek, Copenhagen.

345. *Mahana no atua* (*Day of the God*), 1894, oil on canvas, w513. The Art Institute of Chicago.

346. *The Assault of Mara*, relief carving from Borobodur Temple, 8th century, Java.

347. *Oviri* (*Savage*), late 1894, glazed stoneware, G113. Musée d'Orsay, Paris.

348. Female deity from Ra'ivavae, Marquesas, stone. Musée Gauguin, Papeari, Tahiti.

349. *Ea haere oe i hia?* (*Where are you going?*), 1892, oil on canvas, w478. Staatsgalerie, Stuttgart, Germany.

350. *Self-portrait, Oviri*, 1894–95, bronze, G109. Folkwang Museum, Essen.

Tahiti

351. *Te Arii vahine* (*The Royal woman*), 1896, oil on canvas, w542. Pushkin State Museum of Fine Arts, Moscow.

352. *Self-portrait. Near Golgotha*, 1896, oil on canvas, w534. Museu de Arte de São Paulo Assis Chateaubriand, Brazil.

353. *Te Vaa* (*The Canoe*), 1896, oil on canvas, w544. The State Hermitage Museum, St. Petersburg.

354. *Eiaha ohipa* (*Don't work*), 1896, oil on canvas, w538. The State Hermitage Museum, St. Petersburg.

355. *Nave nave mahana* (*Delightful day*), 1896, oil on canvas, w548. Musée des Beaux-Arts de Lyon, France.

356. *Te Tamari no atua* (*The Child of God*), 1896, oil on canvas, w541. Bayerischen Staatsgemäldesammlungen, Munich.

357. *Bébé* (*Baby*), 1896, oil on canvas, w540. The State Hermitage Museum, St. Petersburg.

358. *Nevermore O Taiti*, 1897, oil on canvas, w558. Courtauld Institute Galleries, London.

359. *Vairumati*, 1897, oil on canvas, w559. Musée d'Orsay, Paris.

360. *Te Rerioa* (*The Dream*), 1897, oil on canvas, w557. Courtauld Institute Galleries, London.

361. *The Little dreamer*, 1881, oil on canvas, w52. The Ordrupgaard Museum, Copenhagen.

362. Marquesan kumete, wood. Auckland Art Gallery, New Zealand.

363. *Te Faruru* (*Making love*, or *The Embrace*), 1894–95, woodcut, GU22. The Art Institute of Chicago

364. *Where do we come from? What are we? Where are we going?*, 1897, oil on canvas, w561. Museum of Fine Arts, Boston.

365. *The Source*, 1894–95, pen and ink drawing on p. 92 of Gauguin's final *Noa Noa* manuscript (R. F. 7259), Cabinet des dessins, Louvre, Paris.

366. *Bonjour Monsieur Gauguin*, 1897, pen and ink drawing on p. 167 of Gauguin's manuscript *Avant et après*.

367. *Rave te hiti ramu* (*The Monster-glutton seizes*), 1898, oil on canvas, w570. The State Hermitage Museum, St. Petersburg.

368. *The White horse*, 1898, oil on canvas, w571. Musée d'Orsay, Paris.

369. *Faa Iheihe* (*To Glorify*), 1898, oil on canvas, w569. Tate Gallery, London.

370. Albrecht Dürer, *The Knight, Death, and the Devil*, 1513, engraving. The Art Institute of Chicago.

371. *Rupe rupe* (*Luxuriance*), 1899, oil on canvas, w585. Pushkin State Museum of Fine Arts, Moscow.

372. *Te Avae no Maria* (*The Month of Mary*), 1899, oil on canvas, w586. The State Hermitage Museum, St. Petersburg.

373. *Maternity*, 1899, oil on canvas, w582. Private Collection.

374. *Maternity*, 1899, oil on canvas, w581. The State Hermitage Museum, St. Petersburg.

375. *The Great Buddha*, 1899, oil on canvas, w579. Pushkin State Museum of Fine Arts, Moscow.

376. *Still-life with sunflowers on an armchair*, 1901, oil on canvas, w603. The State Hermitage Museum, St. Petersburg.

377. *Still-life with sunflowers and Puvis' "Hope,"* 1901, oil on canvas, w604. Private collection.

378. *The Flight*, or *The Ford*, 1901, oil on canvas, w597. Pushkin State Museum of Fine Arts, Moscow.

379. *The Flight*, or *The Ford*, c. 1900, watercolor. Location unknown.

Marquesas

380. *The Fall* or *Adam and Eve*, 1902, oil on canvas, w628. The Ordupgaard Museum, Copenhagen.

381. *The Call*, 1902, oil on canvas, w612. The Cleveland Museum of Art.

382. *Marquesan in a red cape*, (*The Magician of Hivaoa*), 1902, oil on canvas, w616. Musée d'Art moderne et d'Art contemporaine de la Ville de Liège, Belgium.

383. *Barbaric tales*, 1902, oil on canvas, w625. Museum Folkwang, Essen.

384. *Portrait of Tohotua*, 1902, oil on canvas, w609. Museum Folkwang, Essen.

385. *The Invocation*, 1903, oil on canvas, w635. National Gallery of Art, Washington, D.C.

386. *Women and white horse*, 1903, oil on canvas, w636. Museum of Fine Arts, Boston.

387. *Change of residence*, 1899, woodcut, GU66. The Art Institute of Chicago.

Acknowledgments

THIS BOOK HAD ITS GENESIS IN TWO GRADUATE SEMINARS given by Professor Richard Shiff at the University of Chicago in 1975. In the first, dealing with the intellectual undercurrents of nineteenth-century Europe, I was assigned to research the period's religious beliefs—a topic in which I thought I had little interest but which proved to relate in many unexpected ways to the development of the modern era's avant-garde art movements. In the second seminar we were given a list of terms which critics and artists of the late nineteenth and early twentieth centuries had used to describe the work of Paul Cézanne, and invited to choose the one or two whose meaning we wished to investigate. I selected "primitive" and "naive" partly because these adjectives had surfaced frequently in my reading about the century's religious views, and partly because of the interest I'd already developed in tribal art and culture as a result of the scholarly work done in this area by my husband, Dr. Evan Maurer. As I explored the significance these terms had for Cézanne's contemporaries, it emerged that they denoted not backwardness and ignorance, but spirituality, insight, and an intuitive ability to grasp the essence of things and convey it abstractly and symbolically. It also became apparent that the three turn-of-the-century artists who were most often praised by their avant-garde contemporaries for conveying primitive aesthetic power and religious meaning in their work were Odilon Redon, Vincent van Gogh, and Paul Gauguin.

The discoveries of these seminars led me to write my doctoral dissertation on the relationships that existed between these three men's spiritual views and the intellectual climate that nurtured them, their relevance to the Symbolist art theory all three espoused, and the specific ways in which their religious ideas and values are encoded in their very different-looking works of art. Over the years I reworked this material in a variety of ways for university courses and museum or private lectures, culminating in a series of public lectures given at the Minneapolis Institute of Arts in 1990 and 1991. This book is the outcome of these revisions, although considerations of size caused me to eliminate Redon from the present study.

My principal debt of gratitude is still to my teacher, Richard Shiff, who currently holds the Effie Marie Cain Regents Chair in Art at the University of Texas in Austin. His unconventional and provocative approach to the study of modern art opened my eyes onto unexpected vistas, and his rigorous but always good-humored intellectual acuity helped me to learn the critical and analytical methods of exploring them. One of his greatest lessons was to examine works of art as much as possible from the perspective of their creators' values and intentions and in terms of their own terminology. This was relatively easy in the cases of van Gogh and Gauguin because they both wrote so much about their ideas, feelings, and sources. It is their view of themselves and their work that I focus on in this text.

I was fortunate to be able to do the majority of my original research in two superb facilities: the University of Chicago's Regenstein Library and the Art Institute of Chicago's Ryerson Library, whose staff were always helpful. While working on the present publication I received additional assistance in obtaining source materials from Harold Peterson and other members of his department in the Minneapolis Institute of Arts Library, who generously solved whatever problems I gave them. Others at the Institute who deserve appreciative recognition are Michele Callahan, who kindly helped with administrative chores and the assembling of photo request files, former curator Michael Conforti, now director of the Francine and Sterling Clark Institute in Williamstown, Massachusetts, who suggested that I send my manuscript to Associated University Presses, and Tim Fiske, who oversaw the museum's arrangements with them as co-publishers.

Regarding publication, I owe a special thanks to Thomas Yoseloff at Associated University Presses for his willingness to collaborate in producing a long and expensive book whose subject and approach are at odds with the deconstructionist bent of much of the last two decades' art historical literature. I am also deeply indebted to Albert Kostenevitch, curator of Modern European Painting at the Hermitage, for supplying us with hard-to-acquire transparencies of the St. Petersburg paintings and facilitating our contact with the Pushkin Museum in Moscow. Gratitude is also due to Martin Summers of the Reid and Lefevre Gallery in London, Mary Anne Stevens of the London Royal Academy, the Daniel Malingue Gallery in Paris, Richard L. Feigen in New York, and the staffs of Christie's and Sotheby's in New York and London for their efforts on our behalf in acquiring permission to reproduce certain crucial images in private collections.

My most heartfelt appreciation for technical assistance goes to Denise May, Assistant to the Director at the Minneapolis Institute of Arts, who spent ten months dealing with the unexpectedly complicated and frustrating task of obtaining reproduction rights and photographic materials for the 387 very diverse illustrations that accompany the text. Without her matchless organizational skills, her patient perseverance in the face of endless delays and problems, and her selfless sacrifice of personal time, including too many weekends, this project would never have come

to fruition. I am also grateful to copy editor Chris Owen for a meticulous review of the text, and most especially to Andrew Lindesay for his sensitive lay-out of the book and his always amiable oversight of the many details of production. A final thanks for technical help goes to Keith Kepler at Microsoft Corporation, who cheerfully took on the challenge of upgrading my currently unusable Microsoft Word I disks to a Windows format, and whose unexpected success saved me weeks of re-typing.

On the personal level, I am profoundly indebted to several people whose contribution to this book cannot be measured. The first are my parents, Vera and Asher Margolis, who from my earliest years shared with me their passion for all the arts and their deep respect for intellectual pursuits. My mother in particular inspired me with her love of literature and her unquenchable interest in human psychology, both areas which played a significant role in the development of my ideas about van Gogh and Gauguin.

Next, my husband Evan Maurer became a model and inspiration for me, not only because of his intense appreciation for art and culture and his meticulous approach to research, but because he has always unhesitatingly taken on difficult challenges and spared no effort to bring them to fulfillment. Over the years he has unreservedly encouraged me to follow my interests wherever they led, and supported me uncomplainingly in their pursuit even when I became obsessively distracted.

Finally, I thank Bruce B. Dayton with all my heart for his enthusiastic response years ago to my lectures, and for his extraordinary generosity in making it possible for the Minneapolis Institute of Arts to publish this material in its present form. Without his vision and commitment to my work, this book would have been neither written nor produced. I will always cherish his regard and friendship, and always remember his role in enabling me to share my ideas with so many others.

Van Gogh and Gauguin in the Context of Symbolist Thought

The Symbolist Revolt against Modern Life

Modern Malaise and Symbolist Aspirations

TODAY THE WORKS OF VINCENT VAN GOGH AND PAUL Gauguin are among the most revered and highly priced of the modern age, but in their own lifetimes both men were viewed contemptuously as unconventional rebels and their art was ridiculed as the crude, inept productions of a madman and a charlatan. During the intervening century, the developments of expressionism, abstraction, pop, and conceptualism have so challenged popular perceptions of artistic beauty and significance that to the contemporary public eye, the once-despised work of van Gogh and Gauguin appears traditional, comprehensible, and superbly decorative. But although their recognizable subject matter and sensuous treatment of conventional media have enabled most people now to appreciate their art, there is still very little general understanding of the deep philosophical meaning that these two artists attached to their imagery, and to the once unaccepted manner in which they depicted it.

Van Gogh and Gauguin were friends, albeit with reservations on Gauguin's part, and although their subjects and stylistic characteristics seem superficially unrelated, their work exhibits a multitude of thematic and aesthetic parallels that transcend the differences in their personal modes of expression. Similarly, while van Gogh's intense piety and selfless humanitarianism seem far removed from Gauguin's arrogant self-assertiveness and egoism, in reality the two men shared so many attitudes and values that their views of life, morality, religion, and the function of art are virtually identical. Despite the personality conflicts they experienced during the brief time they lived together, and despite their differing opinions about the way in which nature and imagination should be balanced in art, their most cherished beliefs and their life stories have so much in common that by examining them in relation to one another we can gain a more profound understanding of

their times, their goals, their achievements, and the underlying meaning of their work. Although both were perceived as independent artists of a unique and original kind, it is no coincidence that the avant-garde critics and theorists of their own milieu consistently linked them together as exemplars of the new Symbolist movement that developed in France around 1885.[1]

Symbolism evolved as a reaction not only against the warring trends of Academicism and Naturalism in art, but against the whole direction of contemporary culture. All the poets, writers, and artists connected with Symbolism, which has been described not as a style or a school but as a state of mind,[2] believed that the fundamental nature of art is religious, that its spiritual character and significance had been lost in the modern age, and that the goal of all contemporary artistic endeavor must be to recover its original quality in ways meaningful for the times. The Symbolists not only identified art with religion, they characterized the principal problem of modern civilization as our inability to understand or appreciate either of these fundamental human activities. It was on the basis of this correlation that van Gogh complained to his sister that "art—the officially recognized art—and its training, its management, its organization, are stagnant-minded and moldering, like the religion we see crashing."[3]

Aware that art and the conduct of daily life are related expressions of a society's spiritual and moral values, both van Gogh's and Gauguin's writings are filled with diatribes against most of the standards and practices of European culture and its governing institutions. Van Gogh blamed the absence of genuine spiritual values in modern life not only for the debasement of art and religion but for "the diseases which we civilized people labor under most . . . melancholy and pessimism."[4] Convinced that the social fabric of Western civilization was rotten to the point of disintegration, he

predicted gloomily: "We are living in the last quarter of a century that will end in a tremendous revolution. We certainly shall not live to see the better times of pure air and the rejuvenation of all society after those big storms."[5] Gauguin, who described himself similarly as suffering from "the vices of civilization: from lost illusions,"[6] and who exclaimed bitterly, "What a beastly existence European life is!",[7] shared van Gogh's pessimism about their times. "The future for our children is indeed black . . . in this rotten and evil Europe,"[8] he told their young painter friend Émile Bernard, and to another artist he prophesied: "A terrible epoch is being prepared for the coming generation in Europe: the reign of gold. Everything is rotten, both men and the arts. We must be ceaselessly rent apart."[9]

Both van Gogh and Gauguin were passionate, strong-willed men whose deep convictions about the depravity of modern European civilization and the debased role of art incited them to reject the social and aesthetic conventions of their time and embark on paths of self-fulfillment which led to public condemnation, impoverishment, and personal despair. Along with other Romantic intellectuals of the late eighteenth and nineteenth centuries, they believed Western culture had been sapped of its spiritual force and integrity by the excessive glorification of rationalism, materialism, and utilitarianism that accompanied the development of modern science and technology. When the world began to be viewed not as the mysterious and sacred creation of deity, but as a mechanical system of purely physical forces susceptible to human domination, sensual and pragmatic concerns came to supercede the religious awe and ethical impulses that exist when people believe they are ruled by an omnipotent deity inspiring reverence and demanding adherence to certain moral codes. While Romantic thinkers recognized that the decline of religious awe and the rise of an industrialized middle-class society permitted greater intellectual freedom, individual growth, and material advantages, they also felt that the disintegration of traditional values had resulted in unchecked greed and selfishness, the obliteration of communal spirit, and what van Gogh called "the triumph of mediocrity"[10] and a deplorable upsurge of "cynicism and scepticism and humbug"[11] in all areas of daily living. With his predilection for conceiving ideas in terms of visual imagery, he wrote to his brother Theo that "when today's deteriorating society is seen against the light of renewal, it stands out as a large, gloomy silhouette."[12]

Both van Gogh and Gauguin believed that every aspect of contemporary Western culture required reformation and renewal, and their writings are filled with impassioned condemnations of the inhumane attitudes and behavior that dominated the legal system, the military, the established churches, the schools, and the relationships between classes and sexes. Summing up his contempt in one of his journals, Gauguin concluded:

Like inundations, morality crushes us, stifles liberty in hatred of fraternity—morality of the backside, religious morality, patriotic morality, morality of the soldier, of the policeman. . . . Duty in the exercise of its functions, . . . the morality of public instruction, of censure. Aesthetic morality, of criticism assuredly. . . . My recitation will change nothing, but . . . it soothes me.[13]

Van Gogh observed similarly that "now, as in all periods when civilization is in a decline, the corruption of society has turned all the relations of good and evil upside down,"[14] and that, given the complex realities of life, "it is impossible always to know what is good and what is bad, what is moral and what is immoral."[15] He concluded that conventional modern values "do not hold true and often are hopelessly, fatally wrong . . . this life is such a mystery that the system of 'conventionality' is certainly too narrow. So that it has lost credit with me."[16]

Van Gogh, whose father was a pastor and whose own religious inclinations were so strong that he studied for the ministry and worked as an evangelical preacher prior to finding his vocation as an artist, turned away from organized religion entirely because of its rigid conventions and perversions of the principles of the Gospel. "For me that God of the clergymen is as dead as a doornail," he admitted, "but am I an atheist for all that?"[17] On the contrary, according to an elderly pastor from the Borinage region of Belgium where van Gogh had ministered to the coal miners, "his religious sentiments were very lively and he wanted to obey the words of Jesus Christ in the most absolute way. . . . He felt compelled to imitate the first Christians."[18] Gauguin attested to the same quality in van Gogh, remarking in his journal that his friend had "the great tenderness and altruism of an evangelist."[19] Although Gauguin lacked this self-denying, Christlike sympathy, he also castigated establishment religion for fostering repressive, artificial beliefs and standards of behavior instead of teaching people compassion, and reverence for truth and for the mystery and beauty of creation. In two essays on Catholicism and modern times, as well as in his journals and newspaper articles, he condemned the Church for its harsh opposition to what he called "the sacred needs of the flesh"[20] and for its practice of self-enrichment and self-aggrandizement at the expense of the poor and the powerless. He also excoriated it for insisting on the observance of petty rites and ceremonies instead of the performance of charitable actions, and for rejecting all scientific and philosophical ideas that contradicted established orthodoxy.[21] Because of these spiritual failures, he declared, "religiously, the Catholic Church no longer exists."[22] "Sage actions are

the only prayers," he argued. "*The God* of your temples, he to whom you pray. *It is necessary to kill him.* The only God from now on resides in wisdom, in virtue."[23]

Both Gauguin and van Gogh blamed institutionalized Christianity for actively contributing to the intolerance with which Europeans encountered people of other persuasions. "By what right," demanded Gauguin angrily, "has the Church been authorized to administer from childhood on a poison as dangerous as that of the superstitious belief in the absurd, the deceitful faith with all its consequences: the hatred of sect for sect?"[24] He was particularly enraged by missionaries, whom he claimed "would willingly march . . . the Gospel in one hand, the rifle in the other: the Gospel for their God, the rifle in the name of Western civilization whose representatives they believe themselves to be."[25] Gauguin criticized the missionaries not only for trying to eliminate other forms of worship, but for wiping out superb native artistic traditions because of the "idiotic prejudice" that heathen art was offensive to a Christian God.[26] His distress at the ravages made by Western society on foreign peoples in the name of religion was shared by van Gogh, who expressed horror at the habit of white men, "very Christian and all that," to exterminate or debase native populations with their vices: "Those tattooed races, Negroes, Indians, all of them, all, all are disappearing or degenerating. And the horrible white man with his bottle of alcohol, his money and his syphilis—when shall we see the end of him? The horrible white man with his hypocrisy, his greediness and his sterility."[27]

Both van Gogh and Gauguin shared the general Romantic conviction that the salvation of Western culture depended on the regeneration of our religious sensibility in accordance with more humanistic principles. One of the nineteenth century's foremost writers on religion, Ernest Renan, claimed in 1848 that "the religion of the future will be pure *humanism*, that is, the cult of everything which appertains to man, the whole of life sanctified and raised to a moral value."[28] For Romantic intellectuals the specific nature of various beliefs was far less important than the underlying spiritual attitudes they conveyed, and the acquaintance with different cultural practices which accompanied the worldwide explorations of the modern age fueled the perception that all religions contain, in the words of the eighteenth-century philosopher Jean-Jacques Rousseau, "eternal truths which have been accepted at all times and by all wise men, recognized by all nations, and indelibly engraved on the human heart."[29] This idea of eclectic tolerance was popularized internationally in the second half of the nineteenth century by Renan's bestseller *L'Avenir de la science* (*The Future of Science*), a book well respected by the avant-garde of the 1880s. In it, Renan builds a bridge between the discarded traditions of the past

and the needs of the modern age by drawing parallels between the religious and the scientific pursuits of knowledge. Dissociating religion from adherence to dogma and ritual and comparing it instead with the scientific quest to understand the world, Renan claimed that "one's attitude and spirit and intellectual standpoint can constitute a religion and be a foundation for morality."[30]

This new spiritual attitude was disseminated throughout the Romantic period particularly by the movement of theosophy, an approach to human culture first popularized by the eighteenth-century scientist and mystic philosopher Emmanuel Swedenborg, and quickly incorporated into the thinking of countless writers and artists throughout the Western world. Theosophy examined both the outward forms and the intrinsic spiritual meaning of all the world's major religions, comparing them not only to one another but to a universal heritage of legends and folktales and to the ideas generated by modern science about the nature of the cosmos and human evolution. The central contention of theosophy is that religions consist of "the same truth under various vestments,"[31] and that it is therefore possible to "reconcile all religions, sects, and nations under a common system of ethics, based on eternal verities."[32] These beliefs informed not only the majority of the Romantic period's writings on religion, but the spiritual philosophy of the nineteenth century's greatest novelists. Gauguin and especially van Gogh were avid readers of literature, and in the books of Rousseau, Honoré de Balzac, Victor Hugo, Émile Zola, Jules and Edmond de Goncourt, Guy de Maupassant, Thomas Carlyle, Charles Dickens, George Eliot, Walt Whitman and Leo Tolstoy, they found similar indictments of the modern age and an identical commitment to a religion of humanistic sympathies and mystical appreciation for the world. The theosophical approach to religion satisfied the great hunger felt by European intellectuals not only for a sense of connectedness with the past and a direction for the future, but for a spirituality in harmony with modern scientific truth: a religion which, instead of confining one within a system of dogma, fulfilled the longing of all the artists associated with the Symbolist movement to expand their understanding and broaden their points of view. Reminiscing about the group's ideals, Symbolist writer André Fontainas concluded: "In summary, our generation avidly instructed itself from the most fertile and diverse sources. We wanted to know, in order to feel ourselves free. . . . We wanted to receive and choose, compare and class, assimilate and enlarge ourselves to the degree of our temperaments and aspirations."[33]

Like all others connected with Symbolism, van Gogh and Gauguin subscribed wholeheartedly to the theosophical point of view. In arguing the case for broadening our

concept of religion, van Gogh quoted to his brother the similar maxims of Victor Hugo and artist Charles Gavarni that "religions pass, but God remains," and that "one must seize what doesn't pass away in what does."[34] He loved Carlyle's philosophical novel, *Sartor Resartus*, whose subject is our need to discard the tatters of our old religious forms and weave new "vestments" to clothe our eternal spiritual impulses. After reading about Tolstoy's views on religion, Vincent commented that the Russian author had also identified the "eternal verities in all religious thought,"[35] and, like himself, contended that we must abandon our narrow and outworn conventions in favor of a more meaningful spiritual outlook. "Tolstoi implies," he wrote, "that . . . there will also be a private and secret revolution in men, from which a new religion will be born, or rather something altogether new, which will have no name, but which will have the same effect of comforting, of making life possible, which the Christian religion used to have."[36] Gauguin shared van Gogh's longing for an alternative to institutionalized Christianity, and he too was intrigued by the philosophical relationships between many systems of ancient thought. In his critique of a book on the history of the Catholic Church lent to him by a bishop in the South Seas, he noted the similarities between certain fundamental teachings of Plato, the Buddha, Confucius, and Christ, and commented that for all Christianity's boasts of superiority to other creeds, it represented only a continuation of ideas already established in other cultures' beliefs.[37] It gave him a deep sense of satisfaction to realize that despite the degeneration of the Church, its most essential and valuable teachings had come from and still existed in the alternative forms of other religions: "The word remains. Nothing of this word is dead. The Vedas, Brahma, Buddha, Moses, Israel, Greek philosophy, Confucius, the Gospel—all is alive."[38]

What both van Gogh and Gauguin sought in religion was the humanistic spirit of tolerance and compassion which is crucial to social harmony and individual well-being. In a notebook containing some advice addressed to his daughter Aline, Gauguin quoted the Christian maxim "Do to others that which you would want them to do to you,"[39] and in a later journal noted that Confucius in his *Tchoung-Youngou* preached the same lesson.[40] In his fictive account of his first Tahitian experience, a manuscript called *Noa Noa*, he relates that he tried to restrain his anger at a lie his young native mistress told him by reminding himself of the Buddha's admonition: "It is by gentleness that one must conquer anger; by goodness that one must conquer evil; by the truth, the lie."[41] He wrote ardently throughout his life of his desire for a socialist sharing of wealth and for equal rights and privileges for all members of society, and he bitterly attacked the nationalist impulses responsible for

the pillaging of the weak by the powerful.[42] These themes preoccupied him particularly during his last years in Tahiti, when he addressed a multitude of related issues in a series of articles for a local paper aptly called *Les Guêpes* (*The Wasps*). Continually questioning the West's conventional definition of progress, he repudiated our easy assumption that technological advances are the principal criteria of superior cultural stature:

The Eiffel Tower, for example, does that really represent progress, when compared with the Temple of Jerusalem? . . . And in philosophy there were Buddha, the Greeks, divine Plato, and finally Jesus. Do Luther and Calvin constitute progress?

But we are civilized beings! Yes, yesterday slings and arrows were used, and today we have guns and cannons. And the barbaric hordes who in the past would have traveled on foot or on horseback now take the train or a steamer, where then are the changes?

Only when society lives in blissful peace, when it benefits from the work of intellectuals, and when there is fair distribution for the workman and for the talented, then only can it be called a civilized society.[43]

Van Gogh held identical views. Writing to Theo of his distress at the sufferings he witnessed daily all around him, he observed: "Because I see so many weak ones trodden down, I greatly doubt the sincerity of much that is called progress and civilization. I do believe in civilization . . . but only in the kind that is founded on real humanity."[44] Like Gauguin, van Gogh's sympathies were with society's underdogs: the poor peasants and laborers, independent and unrecognized artists, and the downtrodden prostitutes whom he saw as victims of unnatural moral laws. Our true moral responsibility, he felt, lies in valuing and protecting other living beings: "We are called on to preserve life, to respect life; this is our duty. . . ."[45] A constant theme in Vincent's letters is his yearning for a sense of community and union with others based on reciprocal sympathy, a need so strong that he told a friend: "the existence or non-existence of mutual respect is of such importance to me that little else can be compared to it; nothing else is essential in the way that this spiritual unity is."[46]

The Symbolists' distress with their times grew from their recognition that modern European civilization respected nature, people, and the fruits of human endeavor only in so far as they contributed to sensual or sentimental gratification or material utility. Like many other Romantics they believed that this devaluation of humanistic and spiritual values was responsible not only for the general deterioration of morals and religion in contemporary society, but for the public's inability to understand or honor genuine art. Science had broken free from its earlier limitations and had changed the West's vision of the world, but

the spheres of art and religion lagged behind, hampered not only by the inertia of tradition from developing new ways of expressing society's altered ideas and attitudes, but by the public's mistaken belief that in an age of technological advances and scientific rationalism, art and religion were themselves unnecessary. Seen as outmoded vestiges of earlier superstitions, both these crucial human activities were now reduced to the role of decorative but trivial accessories to the real business of life.

All the Symbolists lamented this devaluation of art and its consequences for themselves in the same manner that they mourned the dwindling of religion. Albert Aurier, a young critic who in 1890 was one of the first champions of van Gogh's and Gauguin's work, quoted in an early article the German philosopher Friedrich Schiller's views on the plight of art in modern times: "Utility is the great idol of the epoch, all forces are employed in its service, all talents render it homage. In this gross balance, the spiritual merit of art is of no weight, and, deprived of all encouragement, it is disappearing in the noisy march of the century."[47] This belief was advanced also by van Gogh's and Gauguin's young artist friend Émile Bernard, who in an essay on the relationship between workers and artists wrote: "Industry is the natural enemy of Poetry, of Painting, of Music, of Happiness, . . . industry is the idol of the 19th century."[48] In such an atmosphere, Bernard claimed, "the engineer replaces the architect, the worker replaces the artist . . . the artist becomes *useless*."[49] Bernard's words are the echo of van Gogh's complaint to his brother in 1882 that "Snobs, nobodies, take the place of workers, thinkers, artists; and it isn't even noticed,"[50] and his lament in 1888 regarding avant-garde artists in particular that "the new painters [are] isolated, poor, treated like madmen."[51] The public's lack of comprehension and sympathy was so extreme, he wrote, that he and Gauguin and others like them "shall be forced to submit deliberately to poverty and social isolation . . . We must live almost like monks or hermits, with work for our master passion, and surrendering our ease."[52]

Although they believed in egalitarian ideals, the Symbolists found the public's contempt for artists and insensitivity to ideas and beauty deeply demoralizing. It was for this reason that Gauguin could write: "The great lords alone patronized art, from instinct, from duty (by pride, perhaps)—no matter, they had great and beautiful things made. The Kings and the Popes dealt with an artist, so to speak, as equal to equal . . . and you want an artist to be a Republican!"[53] Gauguin felt that art had not only a spiritual utility, but a practical value which the modern public ought to take into greater consideration: "I believe that in a society every man has the right to live and live well according to his work. If the artist can't live then the society is criminal and badly organized—Some say: The artist makes a useless thing! The worker, the craftsman, in short, every man who supplies the nation with a work that can command payment enriches the nation."[54] The letters of both van Gogh and Gauguin, with their constant pleas for money to buy paints, canvas, and the bare necessities of life, bear witness to their claims that Western society stifled true artists of genius and inhibited their creativity. Writing to Bernard in 1890 about the younger man's plans for the future, Gauguin warned him of the artist's plight: "I don't want to give you any advice—but from a full heart I address myself to the man who suffers, to the artist who is unable to work at his art here in Europe."[55] In another letter two months later, he added bitterly: "One must make a sacrifice in art. . . . Yes, we are destined (we searching and thinking artists) to perish under the blows of the world. . . ."[56]

The Defects of Modern Art: The Rebellion against Mediocrity

Gauguin's reference to "searching and thinking artists" expresses the distinction made by all the Symbolists between their own work and the kind of art that was perpetuated by establishment institutions and appreciated by the public. Just as religious practice was dictated by Church doctrine, so the practice of art in Europe was controlled and legislated by academies established during the seventeenth and eighteenth centuries to standardize artistic production in accordance with the idealized forms of classical antiquity and the Italian Renaissance. It has been observed that much of the art of the nineteenth century reflects a search for truth and that the thematic and stylistic differences associated with the period's principal movements are the result of the various assumptions made by these groups about the nature of truth and how it can best be communicated.[57] Although theoretically the French Académie des Beaux-Arts wanted painting and sculpture to express significant truth, it believed that only "higher" truths considered ennobling by the governing classes were appropriate to art.[58] Because the Academy's fundamental premise was that spiritual and aesthetic elevation could not be derived from an exploration of the "vulgar" or disturbing aspects of real life, only forms and subjects meeting preconceived standards of beauty and morality were permitted. Students learned not so much by studying and drawing from nature as by copying plaster casts of ancient sculpture and paintings from the late Renaissance (figs. 1 and 2), while the themes dictated to them were selected primarily from the

obscurer events of classical mythology (fig. 3) and biblical or Roman history (fig. 4). Although these were once potent subjects, they had little or no relevance for a modern, secularized public which combined skepticism about religious stories with ignorance of classical allusions, and was seldom aware of the symbolic meanings conveyed by either. For the public, the appeal of Academic imagery lay in its seductive combination of idealized prettiness, exotic costume drama and easy sentiment.

In addition to maintaining explicit hierarchies of acceptable subject matter and insisting that all representation exhibit conventionalized sentiments and graceful charm, the Academy also taught that there is a systematic process of creating beauty which depends on logic and obedience to rigid rules rather than on any special receptivity of the artist's heart and mind. The innumerable dicta of Academic technique resulted in a slick, impersonal, highly refined surface on which motifs were depicted in a profusely detailed and dryly illusionistic style. It was believed that the elimination of the artist's subjective vision and evidence of his "inferior" manual labor endowed the work with aesthetic universality and an aura of "purified" spirituality, while the emphasis on the details of material forms gave it the fictitious appearance of reality and proved the painter's imitative skills. The small number of artists who rebelled against the Academy during the nineteenth century, however, claimed that its methodology reflected the rationalist and materialist biases of Enlightenment thinking, and that these values debased art's role as an expression of meaningful truth capable of enlarging the viewer's understanding of life. These independent Romantics criticized the Academy for perpetuating trivial, worthless ideals, for the falseness and trickery of portraying these ideals as physical actualities, and for suppressing the genuine emotions and expressive technical processes which could result in original, moving works of art. For creative artists with modern values, the Academy's identification of aesthetic excellence with bloodless purity and outmoded subject matter seemed the equivalent of organized religion's association of spirituality with sensual repression and a literal acceptance of unbelievable myths and dogmas. Because it controlled all art instruction and state commissions, legislating artistic worth by committee with prizes awarded at its seasonal Salon exhibitions, the Academy had a stranglehold on nineteenth-century aesthetics. By refusing to allow art to become relevant to modern life, by pandering to the public's preference for minutely detailed surfaces, refined decorative effects, sentimentality, and the titillation of erotic or exotic subjects, the Academy had contributed to the degradation of art just as surely as the churches' failures to alter their concept of spirituality had resulted in the degeneration of religion.

Along with all members of the avant-garde, van Gogh and Gauguin execrated everything about the Academic system. In an 1889 article deploring the triviality and stifling conservatism of Academic painting, Gauguin concluded: "Happy were the ancient painters who had no academy."[59] He complained that the powerful commissioners of the École des Beaux-Arts were "always imbecilic and ignorant,"[60] and he decorated the margin of a 1902 diatribe against Academic councils and critics with a drawing of a pig.[61] His accusation that the successful, much admired painter Adolphe-William Bouguereau (fig. 5) "stinks from platitudes and impotence"[62] suggests that the Academician's work is so artificial and anemic that it breathes decay instead of vitality—that it conveys no forceful, living truth capable of moving the spectator's heart or igniting fertile ideas in his mind. Even van Gogh, who seldom descended to name-calling, dismissed Bouguereau as "swine"[63] because he made "only easy, pretty things,"[64] and he rejected the popular Academic painter Jean-Léon Gérôme (fig. 6) for being cold and sterile.[65] "I feel very little sympathy for this figure by Gérôme," he told his brother; "I can find no sign of spirituality in it, and a pair of hands which show they have worked are more beautiful than those of this figure."[66]

For van Gogh, the preoccupation of Academic artists with elegant forms and refined surfaces was the equivalent of false and superficial values in religion. Early in his career he observed to his artist friend Anton van Rappard: "Art, although produced by men's hands, is something not made only by hands, but of a deeper source. It springs from the soul, and in the adroitness and technical knowledge of the artist I find something that reminds me of what, in religion, is called self-righteousness."[67] He made a similar association of Academic painting with degenerate spirituality when, describing to Theo a drawing he had come across of two clergymen, one a pompous, imposing, fashionably dressed city cleric and the other a shabby village curate, he concluded that for him these types symbolized the differences between the sincere, impoverished artists of the avant-garde and smug, establishment practitioners "like Bouguereau and Makart."[68]

Assessing the state of contemporary art in a letter to Theo, Vincent quoted in support of his own views a passage from Zola, one of his favorite authors: "Observe that what pleases the *public* is always what is most banal, what they have been accustomed to see each year; they are used to such insipidities, to such lies, so pretty, that they refuse strong truths with all their power."[69] Van Gogh believed fiercely that strong truths had always been crucial to great art and that they could only derive from nature and reality. "Every day I am more convinced that people who do not first wrestle with nature never succeed," he wrote to Theo;

". . . the most touching things the great masters have painted still originate in life and reality itself."[70] It was because Academic instruction substituted literary subjects and the copying of other art for working directly from the living world that at the very commencement of his artistic endeavors van Gogh warned van Rappard: "The Academy is a kind of mistress who will prevent a more serious and fruitful love from awakening in you. Leave her alone, and fall head over heels in love with the real lady—love Dame Nature, or call her Reality."[71] Well aware that the task of wresting beauty and meaning from the complexities of the modern world was far more difficult than concocting pretty fantasies in the studio, van Gogh nevertheless insisted that it must be attempted. Comparing life to the turbulent, dangerous sea, he told van Rappard that to achieve genuine knowledge and self-fulfillment "we must become FISHERMEN IN THE OCEAN OF REALITIES."[72] For van Gogh, this principle applied to both living and making art. Years later he wrote to Bernard: "I persist in believing that you will discover that in studios one not only does not learn much about painting, but not even much good about the art of living; and that one finds oneself forced to learn how to live in the same way one must learn to paint, without having recourse to the old tricks and eye-deceiving devices of intriguers."[73]

The Symbolists leveled the same kind of criticisms against a branch of their own movement which they repudiated as decadent. Gustave Kahn, a writer who formulated one of the first definitions and defenses of Symbolism in 1886, claimed that he and his associates always distinguished themselves and the small number of independent artists they admired from a larger group of painters whom they considered inferior and decadent despite the fact that they conceived of themselves as Symbolists. Artists like Armand Point and Jean Delville (figs. 7 and 8) exhibited principally with the Belgian group Les XX and the French Rose+Croix, organizations with a decidely mystic, occult orientation. Kahn, who noted in his book *Symbolistes et décadents* that "in 1885 there were . . . many decadents and few symbolists,"[74] observed that the genuine Symbolists found the public's inability to differentiate between them very irritating.[75]

Although the decadents too were appalled by the quality of modern life, they sought to counteract it either by ignoring the realities of existence or by placing an exaggerated emphasis on certain grotesque aspects. Some immersed themselves in the subjects and forms of bygone centuries; others evolved deeply personal, artificial imagery which was too esoteric to be relevant to most people. Thematically and stylistically they remained tied to the conventions of traditional Academic art; spiritually they maintained an elitist distaste for the earthy aspects of

physical existence, and their religious and moral outlook was sentimental and abstract. Consisting of cloying renditions of medieval themes rendered almost surreal by the new predilection for photographic illusionism, or macabre fantasies tinged with disconcertingly sexual, occult, or morbid overtones, decadent art tended toward excess and imbalance. The mainstream Symbolist artists and critics consistently condemned decadent art as eccentric and unhealthy, incapable of evoking any sensation of the fundamental, meaningful actualities of nature or human experience. Camille Mauclair, in his history of modern French painting written at the end of the nineteenth century, dismissed these artists as "a crowd of sentimental allegorists of wearisome preciosity," who being "born for Academicism, degenerated into oddity by inventing ridiculous symbols."[76]

The avant-garde proponents of Symbolism were aware that they were not the first artists of the century to rebel against Academicism, and their sense of kinship with their independent precursors was strong. Both van Gogh and Gauguin revered a number of earlier nineteenth-century painters and emulated aspects of their technical and stylistic innovations, but both were also dissatisfied with the direction taken by some avant-garde elements. Each adored the work of Eugène Delacroix (figs. 9 and 10), whose moody color harmonies, loose, painterly brushwork and expressively distorted forms created great furor in the neoclassical Academic world during the 1830s, '40s and '50s. Contemporaneously with him, other independents such as Jean-Baptiste-Camille Corot, Charles Daubigny and Théodore Rousseau began to paint in the Barbizon forest and its surrounding countryside, substituting unprepossessing local landscapes for the grandiose, melodramatic subjects and contrived settings of Salon art (figs. 11, 12, and 13). Painted predominantly in low-key, muted tones, their silent copses and meadows evoke a poetic mood tinged with melancholy, a dreamy and introspective reaction against the exaggerated sentiments and artificial themes demanded by Academicians. The same gently poetic, poignant air invests the peasant pictures of Jean-François Millet (fig. 14), a favorite of van Gogh who, beginning in the 1850s, rendered the laboring poor at their menial toil in simplified, expressive images. Mingling quiet pathos and dignity, Millet's stolid, broadly-treated figures are a stark contrast to the false, picturesque charm of the Salon's rosy-cheeked, smiling peasants.

This current of romanticized naturalism was countered during the 1850s and '60s by artists whose realism was of a more robust and prosaic variety. Gustave Courbet's landscape paintings transmute the Barbizon mood of poetic mystery into an earthier effect, but it was his large-scale, unidealized depictions of lower-class work and pleasure

which most horrified the establishment (fig. 15). Not only did these pictures of stone breakers, dozing shop girls, and peasant funerals portray rudely dressed, physically unattractive, and often doltish-looking subjects in drably colored, unadorned settings, but their huge size imitated and therefore travestied the format reserved by the Academy for its most heroic subjects. Courbet's unappealing imagery and bold palette-knife technique were correctly perceived to be an aggressive socio-political as well as aesthetic assault on conventional standards and values. During the 1860s and '70s the rebellion intensified as Edouard Manet and then the Impressionists broke the rules of Academic technique and acceptable subject matter even more ruthlessly. Manet scandalized public and critics not only because he painted ordinary, "vulgar" aspects of contemporary life like soubrettes and people drinking in crowded cafés (fig. 16), but because his vigorous brushwork and his simplified, strongly outlined, and flatly painted forms violated all canons of Academic style. By eliminating the Academy's rigidly orchestrated gradations of colors and conventional compositions, by abandoning the dark shadows and other pictorial devices used to create the illusion of perspective space, Manet gave his canvases a flat, crude, abstracting look and a suggestion of unplanned informality which aroused the fury of all traditionalists.

The lead of these Naturalists was followed from the 1860s to the mid-1880s by "Impressionists" Edgar Degas, Claude Monet, Pierre Renoir, and Camille Pissarro (figs. 17 and 18). Such artists, while sharing the Realists' concern with the characteristic appearance of ordinary scenes, had an additional interest in capturing the shifting and fragmented impressions of the environment which their eyes perceived and which they recorded with increasing technical freedom. For these artists, conveying relevant truth in art involved not only the freedom to paint idiosyncratically, but an almost scientific concern for recreating the experience of optical perception, with all its imprecision and blurring of detail. Although the Naturalists were refused participation in the Salon exhibitions, some of their innovations were picked up by Academic painters during these decades. By blending aspects of realism into their own idealized imagery, artists like Gérôme and Bouguereau and Bastien-Lepage created strange hybrids in which imaginary subjects were rendered with a photographic wealth of mundane detail. When the Symbolists complained about naturalism, their remarks refer as much to these academic Naturalists as to Courbet, Manet, and the Impressionists.

Symbolism originated in the mid-1880s when a group of avant-garde poets and writers crystallized the yearnings of many contemporary artists to explore the realms of the spirit which the positivist preoccupation with material reality and objective perception had deemed inappropriate to a modern vision of the world. All the visual artists connected to Symbolism at first admired and learned from the Naturalists' radical stylistic methods, but they later came to feel that to have any real or lasting meaning, art must deal with the human feelings and ideas which make up the most significant aspects of our experience. The realism of Naturalist artists was confined to a description of appearances and seldom revealed much about their subjects' inner life or the larger aspects of existence which affected them. Courbet, in fact, stated plainly that painting is "an essentially concrete art which can consist only of the representations of real and existing things; it is a totally physical language which is composed for me of all visible objects. An abstract object, not visible, is not in the domain of painting."[77] The Symbolists' objection to this theory of art lay in its assumption that only concrete phenomena can be considered to exist and that they alone can be adequately portrayed in a picture. They were equally dissatisfied with Zola's definition of art as "a corner of nature seen through a temperament."[78] While this concept at least took into account the necessary component of the artist's subjective personality, the Symbolists felt that the notion of "temperament" was far too limited to account for the complex amalgam of emotions and knowledge conveyed in great works of art, and they believed that insisting on the primacy of some specific corner of nature in the artistic equation neglected the processes of stylistic abstraction by which reality is transformed into art.

For the Symbolists, both these theories of art were crippled by the materialist biases of positivist science and by the assumption that fidelity to the model and the development of an original style automatically endowed subjects with significance. They believed that great art is not merely an individual's unique recreation of things perceived, but the sum of his feelings and ideas about them: his poetic understanding of the most universal aspects of human experience. As a result, everyone connected with Symbolism fought against the imitative tendency referred to by Bernard as "this sad photographic catastrophe,"[79] a tendency which the movement's young spokesman Maurice Denis attributed to "this foolish preconception . . . that it is enough for the painter to copy what he sees, stupidly, as he sees it; that a picture is a window open on nature, and finally, that art is exactitude of rendering."[80] It was because naturalism preferred the "facts" of surfaces to the deeper realities of thoughts and feelings that Denis called it "a theory false and evil in itself—one of these errors that one meets again . . . in hours of decadence and sterility."[81] When the Symbolist poet Charles Morice described their age as "this time of interminable naturalist agony" in which "it is negative art that reigns, and dissolute art,"[82] he

was expressing the conviction of the group that the art of their period reflected the flaws of society's entire approach to life. A generation earlier the same distress with Naturalism's descriptive tendencies had been discussed by Delacroix and his champion Baudelaire, who lamented in 1859: "Each day art further diminishes its self-respect by bowing down before external reality; each day the painter becomes more and more given to painting not what he dreams but what he sees."[83]

When van Gogh tried to analyze his dislike for the art of the latter nineteenth century, he claimed that the works of academic Naturalist artists aroused in him "terrible boredom" because they "give me neither food for the heart nor for the mind, because they have obviously been made without a certain passion."[84] Believing that modernism requires art to reflect the individual's experience of life in an original and expressive way, he claimed: "Romance and romanticism are of our time, and painters must have imagination and sentiment."[85] Gauguin similarly perceived the lack of feeling and creativity in art to be the result of the century's preoccupation with material considerations, concluding in a 1903 letter to Morice:

We have just undergone in art a very great period of aberration caused by physics, by mechanical chemistry, and the study of nature. Artists, having lost all their savagery, no longer having instinct, one could say imagination, have strayed in all directions in order to find productive elements which they haven't the power to create.[86]

But Baudelaire's advocacy of dreams and van Gogh's and Gauguin's regret at the loss of imagination and emotion in art did not preclude their devotion to nature or their certainty that it must be the ultimate foundation of visual arts. Baudelaire had praised the fidelity with which Delacroix captured the essential quality of life in his work, claiming that "nature . . . is a vast dictionary whose leaves he turns and consults with a sure and searching eye,"[87] and the Symbolists shared his conviction that every great artist must study nature assiduously.

Van Gogh, whose letters are filled with paeans to nature and minute descriptions of its visual effects, told van Rappard when warning him against Academicism that in rendering any motif, "I usually draw it in three or more variations . . . only I always refer to Nature for every one of them."[88] His statement to Theo, however, that "it is the painter's duty to be entirely absorbed by nature and to use all his intelligence to express sentiment in his work so that it becomes intelligible to other people"[89] reveals that for him the individual's emotional reaction to nature was as important as the physical details of appearances in the creation of art. He told Theo: "In my opinion, two things which remain eternally true and which complement each other are, Do not quench your inspiration and imagination, do not become the slave of your model; and, Take the model and study it."[90] Although van Gogh appreciated certain kinds of Naturalist-inspired art more than the other Symbolists did, he was equally adamant that art is not meant to be an exact reproduction of visual appearances. "The real thing," he wrote to his brother, "is not an absolute copy of nature, but to know nature so well that what one makes is fresh and true."[91]

Gauguin too, despite his passionate advocacy of imagination in art, never questioned the fundamental importance of using the material world as a starting point, and although van Gogh felt that his friend sometimes deviated too far from his models in the real world, he nevertheless accorded him "the highest respect for the way he loves nature."[92] Gauguin himself claimed that he could never begin painting in a new locale until he had thoroughly assimilated it physically: "In each country, I need a period of incubation, to grasp each time the essence of plants, of trees, in short, of all nature: so varied and so capricious, never wanting to be divined and to yield itself up."[93] For Gauguin, however, as for the other Symbolists, it was the impossibility of either capturing this complex, elusive physical world adequately or separating its material impressions from the mind and spirit apprehending them which made naturalism such a limited and barren approach to art. Arguing the falsity of the Naturalists' premise that an "objective" depiction of physical appearances would yield a universally relevant art, he observed sardonically:

The truth is before your eyes, Nature guarantees it: would she fool you by chance? Would she be quite naked or disguised? In default of reason would your eyes have the requisite perfection to discover it? . . . And in front of this little canvas which has the pretentious intention of imitating real nature one is tempted to say: O man, how small you are.[94]

In one of Gauguin's earliest essays on art he wrote: "The vaguest, the most indefinable, the most varied, that is really matter. Thought is the slave of the sensations."[95] When he and van Gogh expressed their belief that the only meaningful reality consists in the interaction between constantly shifting things in the material world and the equally fluctuating and impalpable thoughts and emotions of the individual experiencing them, they reflected the ideas of innumerable Romantic intellectuals with which they were familiar from their reading. From Swedenborg and Rousseau to German Idealist philosophers like Kant, Hegel, Schopenhauer and Schelling, from Carlyle and Renan to the theosophical writers and the great novelists of the nineteenth century, Neoplatonic thinkers propounded the view of ancient Buddhism, Hinduism, and

Greek philosophy that the world has no objective and definitive character, that all reality is subjective and relative. It was because physical reality is in constant flux and strikes each of us so differently that the Symbolists abjured the assumptions of Naturalism and felt that the Impressionist goal of rendering nature's fleeting details was insufficient to the creation of truly meaningful art.

The Symbolists appreciated the decorative qualities and stylistic innovations of Impressionism, but they also criticized it for being too rigorously circumscribed by the desire for scientific exactitude and too insistent on following predetermined rules of color usage. When van Gogh found himself deviating increasingly from Naturalist descriptive tendencies he wrote to Theo wryly: "I should not be surprised if the Impressionists soon find fault with my way of working, for it has been fertilized by Delacroix's ideas rather than by theirs. Because instead of trying to reproduce exactly what I have before my eyes, I use color more arbitrarily, in order to express myself more forcibly." [96] Arguing early in his career that the point of art is not to imitate nature but to create its analogue in decorative and compelling images, van Gogh maintained that "a painter had better start from the colors on his palette than from the colors in nature;" that he should concentrate on paralleling rather than copying nature's effects. "Of nature I retain a certain sequence and a certain correctness in placing the tones," he wrote; "I study nature, so as not to do foolish things, to remain reasonable; however, I don't care so much whether my color is exactly the same, as long as it looks beautiful on my canvas, as beautiful as it looks in nature. . . ." [97] Gauguin complained similarly that Impressionism laid such stress on the exactitude with which the fleeting appearances of nature were to be rendered that it became as much "a school" and "a dogma" as Academicism, [98] a criticism he leveled also at Neo-Impressionism, whose rigid stylistic theories originated at the same time as Symbolism. Like all the Symbolists, however, Gauguin's principal quarrel with the Impressionists was that "they see harmoniously, but without any purpose: their edifice was constructed on no serious base, founded on the correctness of sensations perceived by means of color. They search around the eye and not at the mysterious center of thought." [99]

Aurier, in an essay on Gauguin and symbolic art, described realist artists and the Western public as so deluded by the transient appearances of things that they are blind to the deeper truths of causal realities, and he invoked Plato's metaphor of prisoners in a fire-lit cave who assume that the shadows flickering on their walls constitute the real world. What we need, Aurier claimed, is to learn to scrutinize the underlying nature of things with what Swedenborg described as "the clairvoyance of man's inner eye" and theosophists call "the eye of the spirit." [100] Because Gauguin, like van Gogh, believed that all the significant truths of reality can never be perceived by the eyes alone, and that art must have a spiritual premise and a spiritual impact as well as a material one, he too contended that "the imitation of nature, however exact it may be, authorizes no one to assume the sacred title of artist." [101] What Gauguin advocated instead was "an art without end . . . rich in techniques of all sorts, capable of translating all the emotions of nature and of man, adapting itself to each individuality, to each epoch, in joys and in sufferings." [102]

Both Gauguin and van Gogh believed that this spiritually powerful kind of art could be generated only when the artist developed his inner eye by cultivating his own emotional and imaginative responses to the world around him. Like all the other Symbolists, both men were convinced that these crucial human faculties were being ruthlessly undermined by our culture's disproportionate reverence for logic and sensory perception. Émile Bernard expressed the feelings of all connected with the movement when he wrote to artist Odilon Redon: "Is there no longer then in France either brain or imagination, do they have neither spirit nor soul? Does not materialism, having preyed on the French for 25 years, want to release its hold, to make room finally for the advent of an *artistic* art, a mystical, idealist, or thinking art?" [103] Elaborating on this belief that there was a profound social need for works capable of igniting meaningful ideas and emotions in the spectator, Aurier, in an essay praising the Symbolists' efforts to restore spiritual qualities to art, declared:

It is mysticism that is necessary today, and it is mysticism alone which can save our society from brutalization, from sensualism, and from utilitarianism. The noblest faculties of our soul are in process of atrophying. In a hundred years . . . we shall be brought back, by positive science, to pure and simple animalism. We must again cultivate in ourselves the superior qualities of the soul. We must become mystics again. We must again learn love, source of all comprehension. [104]

Mysticism and Primitivism: The Return to Tradition

The Symbolists' call for mysticism did not mean that they wanted to supplant the modern scientific investigation of the physical world with far-fetched metaphysical theories.

It was not the activity or fruits of legitimate science they rejected, but the "positivist" assumption that science is objective and factual and therefore offers a more legitimate

and meaningful truth than art. The Symbolists believed that science and art are not mutually exclusive ways of approaching and interpreting the world, but are rather related, mutually supportive, and capable of being synthesized into a larger understanding of reality. They upheld Schelling's view that art and science are merely different routes to the solution of the same problem;[105] that in the early ages of man, philosophy and science were born from and nurtured by poetry, and that as both have come in their maturity to resemble art more and more closely, ultimately "they will return as just so many individual streams to the universal ocean of poetry from which they started out."[106] Refuting the notion that the Symbolists' advocacy of mysticism was anti-scientific, André Fontainas maintained that "art no longer ignores scientific work: new source of inspiration, nourishment offered to the most robust . . . The century belongs to science, how could the poet not be interested in it?"[107]

It was important to the Symbolists that contemporary scientific research into the nature of perception validated their belief that the way we see things and what we learn from our perception results as much from how we assimilate the objects of vision as from the physical aspects of optical experience. In his treatise "The Phenomena of Vision," published in French in 1880, experimentalist David Sutter came to the theosophical conclusion that "it is necessary to see nature with the eyes of the spirit and not solely with the eyes of the body, like a being deprived of reason . . ."[108] The idea that perception and scientific investigation are far more complicated and subjective processes than positivists would concede was a central tenet of most Romantic philosophers' and artists' theories of how we acquire knowledge, and their contentions were supported by numerous scientists of the Romantic period as well. Among others, the eighteenth-century mathematician and biologist Swedenborg and the late-nineteenth-century physicist Jules Poincaré agreed that the practice of science is actually subjective, imaginative and symbolic, and that its truths not only are relative, but often verify the knowledge available to us through our intuitional and emotional insights. Renan, explaining the relationship between art and science in *The Future of Science*, also noted that instead of utilizing pure logic and fixed, objective procedures to arrive at unassailable truths, science consists, like art, of "delicate perceptions, undefinable and fugitive glimpses, ways of framing one's idea rather than positive data, ways of looking upon things absolutely undefinable."[109] In assessing what we might dismiss as "romantic" notions, it is important to realize that such observations have been supported and amplified by many respected members of the twentieth-century scientific community, from mathematician Jacob Bronowski and physicist Wolfgang Pauli to physi-

cian-biologist Lewis Thomas and geologist-naturalist Stephen J. Gould.

Aurier's call for mysticism and love as a bases for understanding the world again reflected the larger context of Romantic thought. Philosophers, writers, and creative artists throughout the eighteenth and nineteenth centuries had argued that profound knowledge of things can only be acquired when we lose ourselves in them, a process accomplished not through dispassionate observation and rational analysis, but through the spiritual faculties of imagination and emotion. Both van Gogh and Gauguin agreed that the ability to respond to nature and to other human beings emotionally and imaginatively is crucial in developing the understanding of life and the mystical love for the world which artists must possess if their work is to convey meaningful spiritual ideas. The crux of all the Symbolists' criticisms of Western civilization was that our way of life incapacitates us to either achieve this kind of knowledge ourselves or appreciate its expression by other more sensitive souls in unconventional religious ideas or artistic creations.

This regret had motivated the work of a number of other independent artists between the 1860s and the 1880s, each of whom influenced the development of Symbolism by evolving original ways of communicating significant spiritual realities neglected by both Academics and Naturalists. Visionaries Gustave Moreau and Odilon Redon (figs. 19 and 20) created powerfully evocative imagery by abstracting essential themes or characters from the art and literature of earlier civilizations and transforming them in poetic and highly individual ways to convey moods and ideas of a serious, universal import. Their forms and settings are so palpably imaginary and dreamlike that they could never be confused with the Academy's eye-deceiving fantasies, and both artists worked with a stylistic freedom that tied them to the avant-garde. Pierre Puvis de Chavannes and Georges Seurat (figs. 21 and 22) pursued a very different method to infuse a sense of eternity and decorative order into art. Despite the fact that Puvis' chastely robed figures and reduced, generalized landscapes suggest the remote world of ancient Roman frescoes, while Seurat's modern-life subjects inhabit the prosaic contemporary settings of park or circus or boudoir, both artists used similarly simplified, immobile forms and geometrically structured environments to create a sensation of stability, serenity, and permanence. But although van Gogh and Gauguin respected these attempts to move beyond the strictures of Naturalism, they found each lacking in some fundamental way. Moreau was too literary and ornate, Redon too surreal, Puvis too bloodless and old-fashioned, and Seurat too obsessively committed to the techniques of divisionism and pointilism he created to rid his and other Neo-Impressionists' canvases of unwanted subjectivity.

Finding little in the modern urban world to stimulate their spiritual and aesthetic sensibilities, the Symbolists turned principally to the cultural traditions of the past and of non-Western societies in order to find models of inspiration for the regeneration of European life and art. Their purpose was not to copy the art or revive the specific religious beliefs of other civilizations, but to identify the principles on which these were founded and use them as a basis for the creation of new forms meaningful for their own time. It was for this reason that in his seminal essay on Symbolism Maurice Denis coined the term "neo-traditionist" to describe the new movement, later observing that because of its humanistic reverence for ancient traditions "our generation never ceased to seek a discipline, a method from all its echoes, to invoke the experience of the Masters, to interrogate the Past."[110] When the Symbolists wrote of their "revolution" they meant not a rejection of traditional values, but literally a turning around, a return to the sound and meaningful ideals which the modern age and the Academy had abandoned. As Gauguin exclaimed in response to the popular misconception that the Symbolists' revolt implied the overthrow of all respected values: "What, I! a revolutionary; I who adore and respect Raphael. What is a revolutionary art? what period is without its revolution?"[111]

The goal of linking themselves with the past and hopefully the future was very important to the Symbolists, because they believed that essential ideas and feelings constitute an ongoing universal wisdom which transcends individual culture. Gauguin wrote: "I feel that the thought which has guided my work or a part of my work is very mysteriously connected to a thousand others, be they my own or learned from others."[112] Bernard also articulated this idea when he remarked that geniuses in both the present and the past "are the result of other geniuses . . . this is tradition. Rembrandt, Rubens, Michaelangelo, da Vinci are perpetual schools without professor and without controller; their work is a language, it speaks to whoever is attentive to them."[113] We find the identical perception in van Gogh's observation to his brother that "there is something of Rembrandt in Shakespeare, and of Correggio in Michelet, and of Delacroix in Victor Hugo, and then there is something of Rembrandt in the Gospel, or something of the Gospel in Rembrandt, as you like it—it comes to the same."[114] It was because they understood the relationships binding together great works of art from all civilizations that van Gogh claimed that "we are nothing but links in a chain,"[115] and Gauguin protested: "No, a thousand times no, the artist isn't born all of a piece. That he adds a new link to the chain already begun is still a lot."[116]

Both these men found consolation for the hardships and disappointments of their lives in a belief that their work would ultimately be recognized and appreciated as part of the continuous tradition of human wisdom. Van Gogh, who told his brother that "painters, to take them alone, dead and buried speak to . . . succeeding generations through their work,"[117] wrote that his creation of art compensated him for not fathering children and helped him to feel a part of the ongoing life of humanity.[118] "If what one is doing looks out on the infinite," he claimed, "and if one sees that one's work has its raison d'être and continuance in the future, then one works with more serenity."[119] In the face of public rejection both men could comfort themselves only by their assurance that their efforts would further the noble cause of sustaining this unbroken chain. Vincent told Theo: "I feel I am working to provide for the future, so that after me another painter will find a going concern."[120] Gauguin wrote similarly to his wife: "I work at my art which is nothing (in terms of money) for the present (times are difficult), which is designed for the future."[121]

The Symbolists' desire to learn from the works of other civilizations led them not only to European art museums which housed the treasures of ancient Egypt, Greece, Rome and Europe, but to the Museum of Ethnography in Paris and the foreign pavilions of the 1889 Universal Exposition, where they saw examples of art from the more exotic cultures of the Orient, the South Seas, Africa and ancient America. They also perused newly available collections of photographic reproductions of works of art from all over the world, and frequented galleries in Paris such as Bings and Père Tanguy's where, since the 1870s, recently imported Japanese prints had been increasingly on display. From their own perceptions of all these objects, and from the numerous articles in avant-garde periodicals about the civilizations which produced them, the Symbolists came to feel that what they called "primitive" cultures (by which they meant traditional, pre-industrial cultures shaped and governed by religious beliefs) shared a common mode of experiencing life and a common attitude toward making art which seemed to hold an antidote to the mediocrity and soullessness of modern society. Whatever the disadvantages suffered by peoples with limited technology and small scope for individual development, these traditional societies enjoyed a unity of life in which all the practical concerns of daily existence were permeated with spiritual and aesthetic considerations, and each person felt himself to be a harmoniously integrated element within a divine and resplendent order.[122] In such cultures, where the creation of every utilitarian object was invested with spiritual significance, artistic beauty and power were deeply valued and artists were as indispensable as priests or medicine men.

Van Gogh and Gauguin praised "primitive" societies

such as the Egyptians, Japanese, and Tahitians for their appreciation and cultivation of art in the details of their ordinary life, and both of them attributed this concern for aesthetics to these cultures' profoundly religious attitude toward existence. If all nature is felt to be magical and sacred, each aspect of human "making" is seen as sanctified, and care is taken to imbue each act or object with the grace and vitality and forceful truth of creation. When van Gogh called the Symbolists "these primitive painters"[123] and Gauguin described himself as "a naïve and brutal savage,"[124] they were referring as much to their cultivation of primitive attitudes toward life as to their appropriation of the elements of primitive style. All the Symbolists agreed with Delacroix's contention that to be "primitive" had to do with the development of natural religious sensibility through imagination and emotion, and that therefore "the real primitives are men of original talent."[125] It was because they felt primitive aesthetics are valid only when they convey genuine spirituality that van Gogh remarked of the Impressionists: "If they dare call themselves primitives, certainly they would do well to learn a little to be primitives as men before pronouncing the word primitive as a title."[126]

The Symbolists could view the arts of such seemingly disparate cultures as ancient Egypt, Mexico, Greece, Japan, India, and medieval Europe (figs. 23–28) as comprising what Denis called "a living Tradition . . . denuded of all academicism,"[127] because they recognized in each a similar tendency to subordinate illusionistic concerns to expressive ones. "Primitive" art, they claimed, was not sullied by what Aurier referred to as "the sacriligious desire" for optical realism,[128] but was instead perceived as an abstract symbol in which forms distilled from nature were modified in order to convey significant ideas and feelings about reality. They were transformations of reality into metaphoric expressions of spiritually meaningful truths, or what Denis called "the translation of vulgar sensations—of natural objects—into sacred, hermetic, imposing icons."[129] Believing that this kind of art constitutes the only means by which human beings can convey their most important knowledge of the world, van Gogh told Gauguin: "You will not be long in discovering at the heart of all modernity the antique and the renaissance sleeping. Now . . . it is up to you to resuscitate them."[130] Gauguin gave his daughter the same advice, warning her: "you will always find

nourishing milk in the primitive Arts. In the Arts of high civilization—I doubt it!"[131] All the Symbolists recognized that the work of Delacroix, Redon, Puvis, and in certain respects Seurat and Cézanne shared the abstracting tendencies and expressive purposes of primitive arts and represented different ways of reviving its traditions. Their conviction that this universal primitive tradition was the necessary foundation on which to build was summed up best by Denis when he wrote in a retrospective essay: "Our art was an art of savages, of primitives. The movement of 1890 derived at the same time from extreme decadence and from a fermentation of renewal. It was the moment when the swimmer touches the solid bottom and reascends."[132]

Since the work of art for the Symbolists, as for all Romantic thinkers, was the expression of spiritual wisdom and a means of actualizing spiritual experience in a time when for many, traditional religion had lost its power, they deemed the artist a priest and prophet of greater importance than the dignitaries of the established churches. It was therefore truly in the spirit of a religious crusade that the Symbolists rebelled against the art and culture of their times. This was why Bernard stigmatized Naturalist painters as "false priests . . . worthy Cerberuses of triumphant mediocrity,"[133] and Denis declared that "we need a man called by God, a monk, an ascetic, a mystic, a saint who [will] raise before the century's eyes the standard of revolt against the impiety and impurity which debase art, against the followers of mediocrity and decadence."[134] Symbolist theorists contended that all great primitive works of art, whether ancient or contemporary, share certain qualities and fulfill certain requirements in order to communicate the large spiritual truths of philosophy, religion, and science. Aurier defined these characteristics in his essay on Gauguin and symbolism in painting when he declared that art must be simultaneously *ideist, symbolist, synthetist, subjective, and decorative*,[135] requirements which reflect the Neoplatonic concepts of all Romantic thinkers about the nature of reality and its recreation in art.

In the next chapter we shall explore the meaning of these terms in relation to van Gogh's and Gauguin's many remarks about the role and effect of art and their working processes as artists. As we do, we shall begin to understand the profound spiritual significance not only of their ideas, but of their subjects, forms, and stylistic innovations.

The Symbolist Requirements of Art

Art as Idea: The Revelation of the Infinite through the Dream

AURIER'S CONTENTION THAT THE FIRST REQUIREMENT OF A work of art is that it must be "ideist" had a long tradition in the history of human culture. From the earliest beginnings of image making, the forms people created have been meant to express their makers' most crucial perceptions and understanding of their world for the purposes of either propitiating and controlling the forces of nature or communicating their special knowledge of reality to others. In the late eighteenth and early nineteenth centuries, the German Idealist philosophers wrote at length about these original purposes of art, relating it to the spiritual goal of bringing the deepest resources of our souls and minds to bear on our interactions with the world. Hegel summarized these views when he claimed that "it is in works of art that nations have deposited the richest intuitions and ideas they possess; and not infrequently fine art supplies a key of interpretation to the wisdom and religion of peoples."[1] Philosophers since Plato have recognized that the ideas conveyed in great works of art are not simple concepts capable of being articulated or understood through verbal logic alone; they are large and multidimensional, and their expression is the fruit of the artist's life experience, of his entire spiritual, emotional, and perceptual grasp of reality.

The Symbolists followed the lead of many earlier philosophers in sometimes using a capital letter to differentiate the simple conceptual idea from the kind of Idea that Plato wrote of in characterizing creation. Platonic Ideas are generalized blueprints for things which exist materially in an infinite variety of specific ways. The term "tree" refers to a broad category of physical phenomena whose innumerable unique manifestations have certain fundamental aspects in common: essential similarities of structure and function which relate them and set them apart from other things. Art communicates Idea when it suggests widely

relevant, basic truths about some aspect of reality which it requires a great experience of particulars to recognize and understand. The artist perceives the underlying laws or patterns which govern all form and experience and then utilizes them to create a new form which conveys his subjective internalization of these principles. Like all Romantic thinkers, the Symbolists contended that this most meaningful kind of knowledge had been replaced in the art of modern Western society by ideas of a much more limited and irrelevant kind. Academic and decadent art were based on fictitious, artificial ideas and Naturalism on superficial ones: neither communicated wisdom about the most important aspects of reality in the way that the great art of other cultures or of Romantic independents like Delacroix did.

Both van Gogh and Gauguin insisted that art must express the significant, all-embracing kinds of Ideas which arise from the artist's personal experience of life and his reflections about the world around him. Writing to van Rappard in 1882 about the relationship between making art and becoming a thinking and sensitive person, van Gogh declared:

I will not accept it . . . that a painter should do nothing but paint. I mean, there are many who think, for example, that reading books is wasting time, while to me it seems just the contrary. If we educate ourselves in some other type of thinking, one that is, however, directly and forcibly connected with our own, we shall do more and better work. For my part it is of great importance and influence on my work to look at things from different angles, and to learn various interpretations of life.[2]

Van Gogh's desire for self-expansion was crucial to both his religious and artistic goals. In a sermon he preached in 1877 during his evangelical ministry with the coal miners of the

Borinage region, he prayed "may we grow better as we go on in life,"[3] an effort he associated with learning more about the sufferings and strivings of others. Trying to explain to his brother the intimate relationship he perceived between art, religion, and his unconventional lifestyle, he claimed that it was his longing to be of use and serve some purpose in the world which underlay his desire for firsthand knowledge of peoples' real lives. In the quest to understand the world, he wrote, "the love of books is as sacred as the love of Rembrandt," and therefore "one must learn to read just as one must learn to see and learn to live."[4]

Van Gogh believed that a person can acquire a spiritual view of existence by studying history, literature, painting, and the biographies of great men, and it can also be acquired if one "takes a free course at the great university of misery, and pays attention to the things he sees with his eyes and hears with his ears, and thinks them over."[5] He felt that "books and reality and art are all alike"[6] because he recognized that they convey the same truths or Ideas about nature and human experience; it was for this reason that he revered them as equivalent sources of spiritual wisdom and stressed the need for painting to reflect the artist's knowledge of life:

To try to understand the real significance of what the great artists, the serious masters, tell us in their masterpieces, that leads to God; one man wrote or told it in a book; another in a picture. Then simply read the Gospel and the Bible: it makes you think, and think much, and think all the time. Well, think much and think all the time, it raises your thoughts above the ordinary level without your knowing it.[7]

Although van Gogh seldom painted conventional biblical subjects, his own goals as an artist were always deeply religious. Unlike the detached Naturalist, he saw nature as a divine and sentient creation whose forms and processes possessed a spiritually meaningful, associative character rather than a factual, objective one. Despite his reliance on the physical model, therefore, he always sought ways of conveying his religious vision of nature in his art. He told Theo: "It seems to me it's a painter's duty to try to put an idea into his work," and the idea he said he wanted to communicate in his own was "the existence of God and eternity."[8] Assuredly no Naturalist could have confessed to such a spiritual, mystical purpose. Although van Gogh insisted on working from his observations of the real world and refused to paint scenes wholly from imagination, he nevertheless admitted that he dreamed for a long time over a motif before attempting to paint it.[9] Only through this process of emotional and spiritual internalization, he claimed, could he discover the best way of rendering his sense of the mysterious sanctity and continuity which

underlay his mundane subjects. It was because he believed art must offer us a visionary experience of nature rather than a replication of it that he wrote: "The imagination is certainly a faculty which we must develop, one which alone can lead us to the creation of a more exalting and consoling nature than the single brief glance at reality—which in our sight is ever changing, passing like a flash of lightning—can let us perceive."[10]

Gauguin's writings express the same conviction that great art must convey powerful ideas and feelings about life instead of simply depicting the details of the physical world. It was because he recognized that the public no longer understood the relationship between aesthetics and the mystical perceptions of the spirit that he felt obliged to spend so much of his time committing his views on these subjects to paper. "Alongside art, very pure art," he stated at the close of one of his journals, "there are all the particulars of the richness of the human intelligence, and it is necessary to talk about them."[11] Like van Gogh, he felt that the expansion of the intellect was a crucial religious task for the creative artist, and that the worst aspect of poverty and isolation was that they became "an impediment to work, to the development of the intellectual faculties."[12] While Zola had defined art as "a corner of nature seen through a temperament," implying that the artist is merely an eye and sensibility uniquely molded by the automatic, unconscious effects of personality, Gauguin called art "the reproduction of what the senses perceive in nature through the veil of the soul."[13] As a Symbolist, he believed that a work of art recreates not an observed piece of the world, but something of what the artist has learned about nature through all the emotional and intellectual faculties which make up his being.

Although Gauguin felt as strongly as van Gogh about the importance of experiencing and communicating feeling, he stressed that the artist's emotions, like his perceptions or technical ingenuity, must be subservient to his spiritual development. Remarking on a report that Courbet, when asked what he was thinking about while painting a landscape, had replied: "'I am not thinking, Madame, I am moved,'" Gauguin repudiated the notion that great art can be achieved without much reflection:

Yes, the painter in action ought to be moved, but before that he thinks. Who can assure me that such and such a thought, such a reading experience or pleasure hasn't influenced one of my works several years later? Forge your minds, young artists, constantly give them healthy nourishment, be great, strong, and noble; I tell you in truth, your work will be in your image.[14]

Like van Gogh, Gauguin felt that art is great in relation to the quality of the ideas which inform it. "For me," he

wrote to a friend, "the great artist is the formulation of the greatest intelligence; it is he who attains the most delicate and therefore the most invisible feelings and translations of the brain."[15] Claiming that his own work was "the achievement of profound reflection,"[16] he argued that pure aesthetics are of less value than art's spiritual and ethical impact, and that "considered as an immediate pictorial result, my work has little importance when compared to its definitive moral result."[17] Shortly before his death in 1903, he wrote to his friend Charles Morice: "The work of a man is the explanation of this man."[18]

Gauguin was well aware that the ambition to become a great artist has its component of egoism, but like van Gogh he viewed it as a God-given drive to bring to fruition the gifts with which nature had endowed him. "In great intelligences," he claimed, "ambition is only negative. It struggles, works, creates, not because it is desirable to surpass others, but because it is insupportable to be surpassed when one feels oneself capable of not being."[19] This quest for self-fulfillment and for the development of one's inner resources, he felt, was not entirely a selfish personal affair, but the necessary mainspring of progress in the expansion of humanity's collective intelligence. Claiming that his own work was founded on the achievements of others, he wrote: "On an intelligence which is my own, I wanted to build a superior intelligence which will become that of my neighbor if he wishes it."[20] For Gauguin, as for van Gogh, the great spiritual goal for all humankind was to behave wisely and virtuously. Observing caustically that "if man is free to be a fool, his duty is to be one no longer,"[21] he proclaimed that the soul consists of "moral, intellectual, wise, divine perfections,"[22] and that it is therefore possible that "all men by their wisdom, their virtues, can become Buddhas."[23] It was his profound conviction that the artist contributes to the progressive spiritual development of humanity by creating works capable of communicating the kinds of ideas and ideals which stimulate our own sensations of reverence, compassion, and unity with the world. Just as van Gogh claimed that the idea he tried to express in his art was the "existence of God and eternity," Gauguin wrote that what he sought to evoke was a sense "of the beyond, of a heart that beats."[24]

As the Symbolists indicated in their call for a mystical art based on love and able to express all the thoughts and feelings that make up life, the Ideas they felt art should convey are inseparable from emotional experience. Both van Gogh and Gauguin upheld the Romantic conviction that knowledge and spiritual growth depend on the insights of the heart as well as on the perceptions of the eye and the reasoning of the logical faculty; both believed that the capacity to feel sympathetic emotions is a divine gift that is crucial for moral and spiritual virtue and the creation of

meaningful art. "There is no better nor surer way to follow through life than Love,"[25] van Gogh claimed; "Our duty in life is to love God and our neighbors as ourselves."[26] Trying to justify to his family his break with organized religion and his supposed atheism, he protested: "The clergymen consider me so—so be it—but I love, and how could I feel love if I did not live and others did not live; and then if we live, there is something mysterious in that—that is God, or as good as God."[27] Just as he rejected the stultifying rules and cool artificiality of Academic art, he refused to accept a theoretical concept of God as the supreme arbiter of a cold and inflexible moral code, and his ideas about the nature of deity relate to his insistence that art communicate passionate feeling. "To me," he exclaimed, "to believe in God is to feel that there is a God, not dead or stuffed but alive, urging us toward *aimer encore* [loving again] with irresistible force."[28]

For van Gogh, love implied something far more profound than mere sexual desire or sentimental attachment: he saw it as the force within us that allows us to penetrate the world external to ourselves, to comprehend it and unify ourselves with it. "But one must love with a lofty and serious and intimate sympathy, with strength, with intelligence," he wrote to Theo; "and one must always try to know deeper, better, and more. That leads to God, that leads to unwavering faith."[29] Because he believed that "God wants us in these days to reform the world by reforming morals, by renewing the light and fire of eternal love,"[30] the attitude of institutionalized Christianity toward love filled him with horror. "The clergymen call us sinners," he wrote bitterly, "conceived and born in sin, bah! What dreadful nonsense that is. Is it a *sin* to love, to need love, not to be able to live without love? I think a life without love a sinful and immoral condition."[31]

Van Gogh's highest praise for works of art extolled their capacity to express feelings and arouse them in others. He claimed that "for me, Millet and Lhermitte are the real artists for the very reason that they do not paint things as they are, traced in a dry, analytical way, but as *they* . . . feel them."[32] He idolized Shakespeare because his language and style are "quivering with fever and emotion;"[33] he revered Dickens, Whitman, Eliot, Zola, and Harriet Beecher Stowe for the way in which their books communicated the spiritual value of love, compassion, friendship, and tender sympathy, particularly toward the oppressed and the suffering. His entire conception of life was colored by his awareness that love and suffering are inextricably linked and that both are necessary for the individual's spiritual growth. In the sermon he preached in 1877 he repeated three times St. Paul's maxim that one must be "sorrowful yet always rejoicing,"[34] a phrase he used often throughout his life. To suffer and struggle willingly, to accept the emotional and physical

burdens of life with an uplifted spirit still capable of adoring and empathizing with creation, seemed to him the epitome of a spiritual approach to existence and a profoundly meaningful Idea to convey in art. Writing to Theo that "our life is a pilgrim's progress," he told him how moved he was by a painting he once saw in which a tired pilgrim encounters a figure in black on the road at evening: a scene he described as representing an "Angel of God" who encourages the traveler to continue on, "sorrowful yet always rejoicing" although the road is "uphill . . . all the way" and the journey lasts "from morn till night."[35]

Van Gogh embraced his own emotional susceptibility as an essential aspect of his creative spirit, quoting to his brother Jean-François Millet's observation that "I never want to suppress suffering, because often it is what makes artists express themselves most energetically."[36] He told Theo that "an artist needn't be a clergyman or a church-warden, but he certainly must have a warm heart for his fellow men,"[37] and he advised van Rappard: "We must sympathize with everyone and continue to do so, otherwise our work will be cold and weak."[38] Although he suffered terribly from the emptiness and loneliness of his life, his poverty and degrading dependence on his brother, his own severe health problems and his sensitivity to the miseries of others, he was fortified by the belief that his pain was enriching him spiritually and enhancing his artistic powers. "The more I am spent, ill, a broken pitcher," he wrote to Theo, "by so much more am I an artist—a creative artist."[39] It consoled him to find in the biographies and journals of past artists, as well as in the Romantic literature he loved, ample proof that his experiences were not only common to men of genius, but were considered the very hallmark of their special status.[40] Before he even became a painter he had compared the trials of unaccepted artists with those of the saints and martyrs who had suffered for their religious calling, claiming that both rebelled against authority and conventions out of a need to bring truth to humanity.[41] In later years, when he began experiencing not only depression but the seizures and hallucinations which accompanied the onset of an epileptic condition, he related these aspects of "madness" to his spiritual and artistic drives as well. On the wall of his room in Arles he inscribed the motto "*Je suis Saint-Esprit. Je suis Sain d'Esprit*" [I am Saint Spirit. I am Sane of Spirit],[42] and he wrote to Bernard: "It is possible that . . . great geniuses are only madmen, and that one must be mad oneself to have a boundless faith in them and a boundless admiration for them. If this is true, I should prefer my insanity to the sanity of others."[43]

Beyond the consolation of knowing that he suffered in good company, van Gogh was also comforted by his belief that to convey emotion in his work was to achieve a bond with others and bring them the same relief he felt himself from art. If an artist can charge his work with enough feeling to "lift up your heart to heaven," he wrote, then he experiences the grace of sympathetic communion, "because one thinks, it's true I'm sitting here alone, but while I am sitting here silently, my work perhaps speaks to my friend, and whoever sees it will not suspect me of being heartless."[44] To grasp the message and meaning of great art, he believed, required not any intellectual or theoretical knowledge of ideas and aesthetics, but simply the emotional receptivity to be attentive to nature and experience and to ponder them. The significance of art as well as of life, he claimed, is available to "everyone who has eyes and ears and a heart to understand."[45] It was because establishment art criticism seldom took the emotional effect of a work into account that van Gogh applauded Zola's attack on the Academic critic Hippolyte Taine, telling van Rappard: "I am glad he lands Taine one in the eye; Taine deserves it, for at times he is irritating with his mathematical analysis."[46]

Gauguin's views about the spiritual importance of emotional involvement were identical to van Gogh's, and like his friend he wrote extensively about the sacred nature of love. His journals are filled with reflections on the differences between European and Tahitian attitudes toward love and sexuality: he denigrated the Western approach as artificial, repressive, inhumane, and interwoven with material considerations; the "primitive" he praised as natural, permissive, nurturing, and joyous. Believing that a woman attains the fulfillment of her nature and discovers her soul through the emotional and physical experiences of love,[47] convinced that sex can't be considered a sin because it is essential to "the most beautiful act in the world, Creation, a divine act in the sense that it is the continuation of the creator's work,"[48] Gauguin also decried the West's easy acceptance of loveless marriages and its condemnation of love and sex outside of marriage.[49] He shared van Gogh's perception of sensual love as an aspect of the driving spiritual force of nature, and was pleased to point out that this view was supported by the precepts of Christ:

Jesus Christ in his words: Increase and multiply, seems to speak also as a carnal voice: increase, that is to say keep the body healthy, perfect it by all the exercises which are necessary to its vitality; multiply, that is to say copulate, ★ *a law which is as applicable to man as to the animals and the plants. As spiritual word, the same law exists; the perfecting of the soul and creation by means of the intelligence coupled with feeling, beautiful, wise.*

★*And he [Christ] indicates no legal form of coupling.* [50]

Like van Gogh, Gauguin found support for these views in Romantic literature as well as in the Bible, and he discovered in Balzac's theosophical novel *Séraphita* an image of the mystical power of sexual and spiritual union which so

perfectly expressed the relationship between love, knowledge, and creativity in the functioning of the universe that he referred to it in his own journals. Conjuring up from Balzac's story the Blakean vision of a creator figure sheltering the alter egos of man and woman beneath its cloak, he wrote: "The colossus reascends to the pole, the pivot of the world; his great mantle reanimates and shelters two seeds, Séraphitus, Séraphita, fertile souls in ceaseless union who leave their boreal vapors to go out over all the universe in order to learn, to love, and to create."[51]

Gauguin was as aware as van Gogh that suffering serves a role similar to love's in contributing to spiritual growth and creativity. His letters and journals are similarly filled with references to the miserable, solitary condition of his life as an unaccepted avant-garde artist, the loss of his family's love and respect, the contempt of the public and the art establishment, and the undermining of his health and productivity by poverty with its far-reaching ramifications. He too compared the artist dedicated to the pursuit of spiritual truth with those who suffered for their religious convictions through the ages, remarking bitterly to his painter friend Émile Schuffenecker: "One must confess that we are the martyrs of painting."[52] In both his writings and his art he likened himself at various times to Christ, to an Indian undergoing torture at the hands of his enemies, and to the victimized but great-spirited Jean Valjean, protagonist of Victor Hugo's novel *Les Misérables*. Like van Gogh, he found comfort in Romantic literature, consoling himself with Carlyle's views on the relationship between sorrow and blessedness in his book *Sartor Resartus*, or with Morice's exploration in his study of contemporary ideas, *La Littérature de toute à l'heure*, of the necessary relationship between public rejection and an artist's ability to achieve work of genuine spiritual elevation. Gauguin also shared van Gogh's conviction that there is virtue in accepting suffering willingly and reverencing life by continuing to work even under the harshest circumstances. In one of his journals he wrote: "You spend yourself, you spend yourself again; things only have value if you suffer You climb your calvary laughing—legs shaking under the weight of the cross:—having arrived you grit your teeth and then smiling again you avenge yourself—you spend again."[53] Invoking yet another model for this principle of bearing one's trials with stoic resignation, he added: "With the Indian under torture, the pride of knowing how to smile in the face of the anguish greatly relieves the suffering."[54]

It was to Gauguin's emotional sensitivity that one of his early biographers ascribed his ability "to proceed as far as possible into the penetration of things, to not stop at their appearances."[55] Gauguin himself felt that insight was crucial to his ability to charge his art with the truth that constitutes meaningful Idea. He wrote to his wife from Brittany that he had finally "penetrated the character of the people and of the country. An essential thing for doing good painting,"[56] and in his *Noa Noa* manuscript he hazarded that a prospective Tahitian model had been frightened off by his searching gaze: "I realized that in my painter's scrutiny there was a sort of tacit demand for surrender, surrender forever without any chance to withdraw, a perspicacious probing of what was within."[57] Prior to his departure from Tahiti he announced: "I am fairly content with my last pictures and I feel that I am beginning to get a grip on the Oceanian character. I am immersed in work, now that I know the soil, its odor, and the Tahitians whom I am making in a very enigmatic manner."[58] These paintings, he claimed, were not the result of servile imitation, but were rather "the product of profound reflection, of logical deduction drawn up from within myself and not from materialist theories made by the Parisian bourgeoisie."[59]

Like van Gogh, Gauguin felt that the modern tendency to define things in concrete or quantifiable terms and apply analytical logic to every situation stifles our instinctive ability to feel and to imagine, and this hampers both our spiritual and moral growth and our ability to either create or appreciate meaningful art. He too believed that we no longer possess the clairvoyance of the inner eye, that "our modern spirit, lost in the details of analysis, cannot see that which is too simple and too visible."[60] His criticisms of society's approach to religion and to art, like those of van Gogh, reflect identical spiritual values. In one of his essays on the defects of Catholicism, he admonished:

Before the immense mystery, which you cannot resolve to let remain unfathomable, you proudly and lazily exclaim: I have found it! And you have replaced the unfathomable, so sweet to poets and to sensitive minds, with a determinate being, entirely small and mean in your image. . . . To define him, to pray to him, is to deny him.[61]

When Gauguin himself studied the Gospel "seeking to penetrate its sense," he wrote, "not only its unfathomable mystery but its fabulous, supernatural forms pleased my artist's imagination. . . . I loved God without knowing, without defining him, without understanding."[62] For the same reason he resisted the public's insistence that art be conceptually assimilable, complaining to a friend: "They sometimes reproach me for being incomprehensible just because they are looking in my pictures for an explanatory side when there is none there . . . [they are] a pack of imbeciles who want to analyze our pleasures. . . ."[63]

Such a remark reveals that although Gauguin was committed to communicating ideas in art, they were not the kind of ideas that could be easily or rationally dissected any more than could those of religion. Just as he argued that one could be moved by the spiritual ideas in the Gospel

without understanding them logically, so he contended that we must engage ourselves emotionally with a work of art in order to get some insight into its meaning. Observing that most people lose patience with art if they can't isolate and analyze its message quickly, he remarked to Morice that when the viewer closes himself to a work he loses all possibility of comprehending it: "Not finding what he believes ought to be there, he no longer understands and is not moved. Emotion first! Then comprehension."[64] The true aesthetic value and inner significance of any unfamiliar work of art, he claimed, will be obvious "to the eyes of those who have an instinct and a love for these primordial qualities."[65] Like van Gogh, Gauguin felt that love rather than reason underlies genuine insight, because only strong feelings trigger our willingness to be attentive and receptive to things outside ourselves and to explore our own reactions to them. Comparing art to the phenomena of nature, he wrote: "The plastic arts don't allow themselves to be easily divined; in order to make them speak one must interrogate them at all times while interrogating one's own self. . . . It is especially necessary to love them considerably."[66]

Gauguin often described his pictures as poems or dreams because their forms and organization were not subject to rational analysis, and because their meaning could only be intuited from their total visual and psychological effect on the viewer in accordance with his sensitivity to mood and to the suggestive implications of material phenomena. Describing his own art, he quoted to a friend Mallarmé's observation regarding his poetry, that "my dream does not allow itself to be seized, comprises no allegory; a musical poem, it dispenses with a libretto."[67] The poetic Idea, the dream Gauguin sought to convey in his art, was the sensation of the inexplicable mystery and continuity of universal life: that sense "of the beyond, of a heart that beats"[68] which paralleled van Gogh's Idea of "the existence of God and eternity." Trying in one of his journals to explain the feelings about life which compelled him to be an artist, Gauguin wrote:

If I look before me into space, I have something like a vague consciousness of infinity and yet I am the starting point—I would understand then that there would be a beginning and that there would not be an end—In that I don't have the explanation of a mystery but simply the mysterious sensation of this mystery . . . And this sensation is intimately linked to the belief in an eternal life promised by Jesus—or then, if we are not the beginning in coming into the world one must believe like the Buddhists that we have always existed changing our skins.[69]

Gauguin claimed that his first sight of Tahiti from the boat also triggered this sensation of timelessness and of merging with the infinite, which eluded rational comprehension but had the force of truth so often connected with dreams. He recalled this moving experience years later in very similar terms:

My eyes see the space before me without understanding, and I have the sensation of an endlessness of which I am the starting point— Mooréa on the horizon; the sun approaches it. I follow its doleful progress; without comprehending, I have the sensation of a henceforth perpetual movement: a general life that will never be extinguished . . . my eyes close so as to see without understanding the dream in the infinite space which flees before me.[70]

Gauguin's image of closing his eyes in order to see the dream without understanding it is particularly revealing. His intensely meaningful experience of reality here was a visionary one, intuitive and emotional rather than perceptual, and he grasped it not with his rational consciousness, but with his clairvoyant inner eye. It is significant that in the same letter in which he wrote of his art as a dream and a musical poem, he described his feelings about the atmosphere of Tahiti in identical language. His evocative, elusive terminology so perfectly captures the mysterious mood and imagery of his paintings that it is obvious they derived from precisely this sort of creative dreaming before nature:

Here, near my hut, in total silence, I dream about violent harmonies in natural perfumes which intoxicate me. Pungent delight in I know not what sacred horror which I divine about things immemorial. The past, odor of joy which I breathe in the present. Animal figures of a statuesque rigidity: I know not what it is of the ancient, of the august, of the religious that there is in their rare immobility. In eyes that dream, the surface troubled by an unfathomable enigma.

And here is the night. Everything rests. My eyes close so as to see without understanding the dream in infinite space which flees before me.[71]

Throughout his career Gauguin invoked the idea of the dream in relation to his artistic activity. In 1885, when he first committed himself to art as his sole occupation, he advised Schuffenecker that the only way to paint was to abandon himself to his inner experience of nature and lose his self-awareness in an intuitive identification with his subject: "Work freely and madly . . . a great feeling can be translated instantaneously, dream on it and seek the simplest form."[72] Toward the end of his life, in 1901, he explained that he had moved from Tahiti to the more remote and undeveloped Marquesas because there "I have everything that a humble artist can dream of."[73] What he had sought and found there was an atmosphere of such mystery and beauty that it induced a dream state powerful enough to enable the painting to come of its own accord: to flow

directly from the universe to his canvas as if he were no more than a medium in a trance. "Here," he declared, "the poesy emerges all by itself and it suffices to let oneself go into a dream while painting in order to suggest it."[74]

It is significant that we find the same kind of statements in van Gogh's letters. Writing about the emotions he experienced in contact with nature, he described identical sensations of self-abandonment, loss of individual consciousness, and merging with the infinite—the same sense of religious exaltation as Gauguin felt. Comparing the contemplation of both nature and art to the blissful experience of timelessness and union inherent in the act of making love, van Gogh claimed: "A complete thing, a perfection, renders the infinite tangible to us; and the enjoyment of a beautiful thing is like coitus, a moment of infinity."[75] Because he recognized that the distillation of nature's inherent beauty and infinity into a work of art requires the elimination of much peripheral information which the more "objective" Naturalist would include, he remarked regarding his working methods: "I do my best not to put in any detail, as the dream quality would then be lost."[76] His perception of this dream quality did not spring from fantasizing, however. When, in telling Aurier about the powerful visionary state he fell into vis-à-vis the natural world, he confided that "the emotions that grip me in front of nature can cause me to lose consciousness,"[77] he was implying a condition not of insensibility, but of heightened perception. "I have a terrible lucidity at moments, these days when nature is so beautiful," he wrote to Theo; "I am not conscious of myself anymore, and the picture comes to me as in a dream."[78] It was because van Gogh recognized that the mystical state of awareness triggered by his ecstatic appreciation of nature was in reality a profound religious revelation of truth—truth directly experienced rather than intellectualized—that he could confess: "There are moments when I am twisted by enthusiasm or madness or prophecy, like a Greek oracle on the tripod."[79]

For the Symbolists, as for innumerable philosophers and religious thinkers from antiquity to the present, the state of mystical consciousness is a spiritual revelation in which the individual, immersed in an intuitive, emotional contemplation of the world, sees directly into the essence of reality, senses the consoling truth of nature's unity and eternity, and feels himself to be part of the flow of universal life. Because it is a direct experience of certain fundamental truths which are inaccessible to our rational state of awareness and ordinary mental processes, it is a state of knowledge as well as of feeling.[80] Romantic intellectuals viewed this kind of wakeful "dreaming" not as idle fantasizing, but as a mode of constructive comprehension in which the imagination and emotions join forces with the faculties of observation and reason, enabling the mind to creatively penetrate the essential nature of phenomena. But while Romantic thinkers defined this capacity for mystical consciousness as an aspect of human nature which is available to all spiritually sensitive people, they attributed only to great religious leaders and artists the rare ability to communicate the experience of this revelatory awareness in words or images capable of arousing similar sensations in others. In deeply spiritual cultures people have access to the experience of mystical consciousness through the daily, comprehensive practice of their religion; in the modern Western world, philosophers believed, it could best be stimulated by works of art: those acts of imagination in conjunction with nature which Schelling called "products of intuition." It was from this conviction that Baudelaire praised the creative artistic imagination as a mechanism for acquiring knowledge of the most profound and eternal kind:

How mysterious is Imagination, that Queen of the Faculties! It touches all others; it rouses them and sends them into combat. . . .

It is both analysis and synthesis. . . . It is sensitivity. . . . It is Imagination that first taught man the moral meaning of color, of contour, of sound and scent. In the beginning of the world it created analogy and metaphor. It decomposes all creation, and with the raw materials accumulated and disposed in accordance with rules whose origins one cannot find save in the furthest depths of the soul, it creates a new world, it produces the sensation of newness. . . . Imagination is the queen of truth. . . . It has a positive relationship with the infinite.[81]

It was because they shared such convictions that van Gogh wrote of our need to develop the faculty of imagination "which alone can lead us to the creation of a more exalting and consoling nature than the single brief glance at reality . . . can let us perceive,"[82] and Gauguin claimed that "the domain of the imagination is limitless. It comprehends the whole universe."[83] Because the Symbolists believed that art can and should convey the experience of mystical consciousness, Odilon Redon described it as "a little door open on the mystery"[84] and Morice asserted that "by its very nature, the essence of Art is religious . . . Art is not only the revealer of the Infinite: it is . . . a means of penetrating it."[85] Bernard, explaining the ability of art to help us transcend the confines of our own existences and egos by putting us in touch with the essential elements and laws of universal life, wrote:

The Dream, which has been sung by the poets, what is it but this violent desire to escape to the outer boundary of our limits, which sometimes precipitates us into the profound forgetfulness of our habits, which projects us into impalpable and unknown spheres, which causes us to escape from time, from the limited. . . . [It is] a

legitimate and . . . supernatural revolt against that which 'binds us into the finite' and prevents us from opening the wings of our soul towards its unchanging and perfect model.[86]

It is particularly revealing that in summarizing his thoughts about the dream state, Bernard concluded: "God is love. The dream of divine love is thus the true dream."[87] The Symbolists believed that it is the love for things implicit in this experience of cosmic consciousness which accounts for the individual's sensation of mysterious alliance with the spiritual underpinnings of the universe. In all their remarks about the dream state we see the high value they placed on the feeling it engendered of bonding with the world by sensing the relationships inherent in nature, by grasping the continuity of its forms and processes, and by recognizing the analogies that connect all phenomena. Like all Romantic thinkers, the Symbolists believed that in humanity's more deeply spiritual past this intuitive knowledge and the feelings of unity with the cosmos it fostered were enjoyed by all peoples, but that in our sterile modern society it had been undermined by the worship of logic, materialism, and utilitarianism. In pleading for a revival of mystical consciousness they were not advocating an abandonment of the rational faculties and a return to primitive supernaturalism, but rather a regeneration of the equally human mechanisms of intuition, imagination, and emotion which had been allowed to atrophy but which are crucial for the growth of knowledge and spiritual fulfillment.

Romantic thinkers and Symbolist artists encouraged the development of mystical consciousness, and of works of art which communicate it, because they recognized that the intuitions or Ideas of this dream state link the knowledge conveyed in the great spiritual traditions of the past with the findings of science in our own times. As Fontainas claimed of the poetic artist when defending the Symbolists against the charge of being antiscientific: "He absorbs all the other arts in his art; how, without science, would he even in his own art make this synthesis a symbol of the ultimate synthesis?"[88] Fontainas' reference here to the work of art as a scientifically valid symbol of synthesis brings us to an examination of Aurier's contention that in addition to being ideist, art must be synthetist and symbolist. Even a hundred years ago, the experimental research of various branches of science had revealed a truth that modern studies in physics, chemistry, astronomy, and biology have corroborated and expanded: that the fundamental principles of nature involve a law of correspondences or analogies which link all forms and processes to one another, as well as a law of synthesis by which a constantly shifting equilibrium, a harmonious unity, is created from the interactions of innumerable opposing forces. Romantic and Symbolist thinkers in many different disciplines maintained that these principles of nature, which are intuited by the mystical consciousness, must be the basis of all our moral, spiritual, and aesthetic ideals, and that the beauty created in works of art is in actuality a demonstration or symbol of the lawful structural patterns of the universe. It was because they viewed the "dream" embedded in the work of art as a metaphor for the most insightful experience of reality that they could refer to it as the equivalent of thought, or "the only reality."[89] When Gustave Kahn in an early defense of Symbolist ideas wrote of "the dream being indistinguishable from life,"[90] he didn't mean that the creative dreamer is unable to distinguish fact from illusion, but that the experience of mystical awareness is an illumination of the essence of reality and therefore inseparable from it.

Art as a Symbol of Synthesis: The Revelation of Harmonious Union through Correspondences

The concept that art recreates the world by symbolizing the law of synthesis also goes back to antiquity. Egyptian theology, Hinduism, Buddhism, and many Greek philosophers envisioned nature as a reconciliation or harmonizing of opposites, and conceived of art as a demonstration of this synthesis: a mirror not of reality's infinite details, but of its underlying order. The Hellenistic philosopher Plotinus summarized this viewpoint when he described the work of art as a creation which in combining many aspects of reality "has rallied confusion into cooperation: it has made the sum one harmonious coherence." Beauty, he claimed, lies in order, while ugliness is "something that has not been mastered by pattern."[91] Ancient thinkers were also aware that all phenomena are related through mysterious and subtle connections which enable the physical, formal elements of the material world to trigger specific associations and emotional responses in human beings, and that artists can use these relationships to elicit various reactions from their audiences. Plato wrote that because of these underlying analogies, different kinds of harmonies express such varying mental states as sorrow, resolve, passion, and moderation, and he advised musicians in particular to suppress certain "negative" rhythms that have a harmful moral influence.[92] Aristotle supported this belief, claiming that proportions and rhythms, forms and colors have the universal power to stimulate different moral and emotional effects so forcefully that experiencing them induces changes in our very souls.[93] It was because of these "corre-

spondences" that people in antiquity perceived art as a symbol of moral and spiritual realities.

The belief that reality results from a principle of synthesis and that art can convey meaning by manipulating the connective correspondences inherent in physical phenomena became the basis of Romantic theories of knowledge and art. Swedenborg and Rousseau, Pascal and the German Idealist philosophers, Carlyle and Renan, Baudelaire and Delacroix all echoed ancient thought when they wrote of the universe as a unified totality, an equilibrium in which a myriad conflicting elements are inter-woven, and when they described religion, morality, and aesthetics as related symbolic activities through which human beings actualize their understanding and appreciation of this natural law. According to Romantic theory, religion instills this principle through the experiences of mystical consciousness that it fosters as well as through the metaphorical teachings of myth, while ethical systems encourage individuals to achieve harmony in their social interactions, to fuse their diverse and often opposing interests into some kind of collective unity for the benefit of all. Art, however, Romantic intellectuals agreed, acts as a sensory symbol or demonstration of harmony which, unlike religion or ethics, can engender these beneficial spiritual and moral impressions while simultaneously engaging all of our cognitive, imaginative, emotional, and sensory faculties in what Kant called "a free relational play."[94]

Romantic philosophers concur that art is the single activity capable of fully actualizing this synthesis of all our faculties for apprehending the world, that art alone can give us the exalting and consoling sensation of utilizing our entire inner being and uniting it with the external world, and that every work of art must achieve its effect of synthesis in an original way which reflects nature's own boundless creativity and diversity. Writers and artists throughout the nineteenth century described man as a union of matter and spirit whose existence lies in the myriad interactions between the finite self and the infinite universe, and whose greatest fulfillment can be to realize and reconcile all the dualities inherent in our nature: our sensuous and intellectual impulses, our conscious and unconscious modes of awareness, and our sense of ourselves in relation to the world. Romantic thinkers claimed that the creation of beauty, or art, represents the supreme achievement of human endeavor because it synthesizes perception, emotion, and reflection; because it displays all the forces of our nature in balanced equilibrium and in conformity to the requirements of natural law. Schelling wrote that in its merging of forms and ideas, matter and spirit, art recreates and reveals the universe; that because it springs from an infinity of relatedness and can therefore reconcile an infinity of feelings, ideas, and interpretations, its moral

effect lies not in its representation of any specific ethical concept, but in its capacity to enlarge the viewer through an unlimited suggestiveness. In its creation of a complete synthesis, he concluded, art is the model for science as well as the organon and document of philosophy.[95] Hegel concurred, claiming that by expressing God as a "moving to and fro between opposites," by conveying so supremely the paradoxical unity of nature, art joins religion and philosophy by becoming "one mode and form through which the Divine, the profoundest interests of mankind, and spiritual truths of the widest range, are brought home to consciousness and expressed."[96] Because Schopenhauer, like other Romantic thinkers, recognized that the completeness and complexity of art defy analysis and that its meaning is as inexhaustible as that of life, he concluded that art "resembles a living organism, developing itself and possessed of the power of reproduction, which brings forth what was not put into it."[97]

Romantic theorists beginning with Swedenborg revived the Platonic idea that art can summarize and symbolize life because all matter and spirit are linked through correspondences and because human beings have an innate ability to acquire knowledge through analogy and association. In a unified universe whose parts are generated from a single set of formative principles, all phenomena have the power to suggest other phenomena. Carlyle wrote that because all aspects of reality work together in perpetual metamorphosis, "all visible things are emblems:" the embodiment of some idea or pattern of organization with the capacity to evoke not only other forms, but intangible experiences.[98] It was particularly through Carlyle, Baudelaire, Delacroix, theosophical writings, and contemporary perceptual and aesthetic theory that the Symbolists became familiar with the ancient Greeks' ideas about the effects on the psyche of forms and colors through the agency of the correspondences which bind the universe together. Correspondences make symbolism possible, and in exploring the nature of symbolism, it is pertinent to note that the word "symbol" derives from the Greek roots *syn*, meaning together, and *ballein*, to throw. *Symbolon* was the name given to a bone broken by friends into two parts that were kept as tokens of their emotional union, and "symbol" has therefore always signified both the physical and spiritual aspects of joining together separated parts to form a unified whole.[99] Because the symbol restores something incomplete to its original state of integration by reconnecting the individual to the world and by synthesizing matter and spirit, form and idea, every culture has perceived symbols as having religious implications. In fact, the original English meaning of symbol was "a formal summary or synopsis of religious belief," but by the sixteenth century it had come to signify

something that stands for, represents, or denotes something else (not by exact resemblance, but by vague suggestion, or by some . . . conventional relation); especially a material object representing or taken to represent something immaterial or abstract, as a being, idea, quality, or condition; a representative or typical figure, sign, or token.[100]

Romantic thinkers wrote of symbols as suggestive modes of communication whose power lies in their veiled and allusive nature. Carlyle built on the views of Swedenborg when he extolled symbols for being infinitely evocative of multiple and relational truths by virtue of their indirectness, and he similarly concluded that everything in nature and life can ultimately be perceived as a symbol:

In a Symbol there is concealment and yet revelation . . . For it is here that Fantasy with her mystic wonderland plays into the small prose domain of Sense, and becomes incorporated therewith. In the Symbol proper there is ever . . . some embodiment and revelation of the Infinite; the Infinite is made to blend itself with the Finite, to stand visible . . . Man everywhere finds himself encompassed with Symbols, recognised as such or not recognised: the Universe is but one vast symbol of God . . . What is man himself but a Symbol of God; is not all that he does Symbolical?[101]

This same vision of the spiritual and symbolic nature of the world was expressed by Baudelaire in his aptly entitled poem "Correspondences":

> *Nature is a temple where from living pillars*
> *Confused voices sometimes emerge;*
> *Man passes there through forests of symbols*
> *Which watch him with familiar glances.*
> *Like long echoes that from afar merge*
> *Into a shadowy and profound unity,*
> *Vast as the night and as the light,*
> *The perfumes, the colors, and the sounds correspond.*[102]

In his theoretical writings Baudelaire amplified his belief that all our sensory experiences are unified responses to stimuli whose nature we can only begin to divine when we synthesize our faculties and perceive the material world as symbolic of indirect meaning. The universe, he claimed, is a storehouse of interreactive images and signs which stimulate and in turn are ordered by the human imagination.[103] In art, the inevitable physical and spiritual relationships which link us to the other phenomena of nature allow the artist to communicate emotions and ideas through the arrangement of material elements alone. Baudelaire praised Delacroix for having such sensitivity to correspondences that he could "*translate* those fine days of the soul" on which we discern the hidden significance of nature for our

own inner life, "when colors speak and scents tell of whole worlds of ideas."[104] It was because Delacroix created moving symbols not from explicitly meaningful subject matter but from his manipulation of purely aesthetic elements that Baudelaire credited him with being "the most *suggestive* of all painters; he is the painter whose works . . . set one thinking the most and summon to memory the greatest number of poetic thoughts and sentiments."[105] Because Baudelaire insisted that the symbolic meaning of a work of art is always indirect, ineffable, and inaccessible to conceptual analysis or total assimilation, he referred to Delacroix's art as "veiled," as a "phantasmagoria distilled from nature,"[106] "an evocation, a magical operation,"[107] and something possessing "the quality of a dream."[108]

In the Symbolists' own generation these ideas were pursued particularly by Mallarmé, who wrote of the relationship of art to the symbol and the dream in terminology similar to van Gogh's and Gauguin's:

To name an object, is to suppress three-quarters of the pleasure of the poem which is made to be penetrated bit by bit; to suggest it, there is the dream. It is the perfect use of this mystery which constitutes the symbol: to evoke an object little by little in order to demonstrate a state of mind, or inversely to choose an object and disengage a state of soul from it by a series of decipherings.[109]

Neoplatonic descriptions of art as a suggestive symbol of nature's synthesis were also employed by researchers in the field of perception and by theosophical writers throughout the latter half of the nineteenth century. Among the many theorists who tried to relate art to science, the aesthetic concepts of Charles Blanc and Charles Henry were particularly important for both the Neo-Impressionists and the Symbolists. Their treatises summarized the findings of many preceding experimentalists and theorists as well as their own research into the realm of what was called "psychophysics:" the "science" which disclosed the laws according to which forms, colors, and directional movements automatically trigger distinct emotional and associational reactions in human beings. This belief that physical phenomena have universal psychological repercussions was advocated by theosophists as well, who pointed out that the practice of magic had always involved translating a sophisticated knowledge of nature's physical and spiritual interactions into compelling and mystifying acts, and that the "Mysteries" into which ancient priests inducted their initiates were similar symbolic demonstrations of the laws of synthesis, metamorphosis, and correspondences. The theosophists held that magic, the religious rituals of the Mysteries, myths, and works of art are all related emblematic representations of the principles of union and analogy from which the universe is constructed, and they warned

that all such vehicles must be interpreted as suggestive metaphors rather than accepted literally if their meaning is to be comprehended.[110]

Associated with these ideas in the minds of Romantic thinkers was the belief that this capacity to grasp truth through symbolic association was particularly developed in "primitive" cultures, whose members habitually experienced phenomena in an instinctively synthesizing way and were adept at encoding their knowledge into powerful symbolic forms. What drew the Symbolists so strongly toward primitive life and art was their conviction that these two abilities went hand in hand, that in both mundane activities and the creation of art primitive peoples achieve what Denis called "an instinctive conciliation between nature and the Idea."[111] Romantic theorists from Swedenborg and Rousseau to Hegel, Renan, Carlyle, and Baudelaire wrote of primitives as sharing with children and with artists the special, productive kind of insight that fails to distinguish between physical and spiritual aspects of reality, that recognizes the power of perceptions acquired through imagination, dreams, and visions, and that not only regards matter as symbolic, but experiences symbolic representations as embodying and exerting the spiritual power of the things they signify. Primitives, claimed Romantic thinkers, delight in looking at and learning from everything without preconceived judgments about value, quality, or utility; their sense of wonder at the world and their curiosity over all its manifestations endow them with a perspicacity and an ability to synthesize experience into the symbolic hieroglyphs of myth and art which few in our own culture possess. It was for these reasons that Romantic intellectuals repeatedly urged the urban males who dominate modern Western civilization to learn wisdom from children, from "savages," from uneducated peasants, from women (who were similarly viewed as motivated more by their instincts and emotions than by practical reason), and, finally, from those geniuses and artists who alone in our society unite these desirable primitive spiritual faculties with the mature ability to transform their insights into scientific or aesthetic communication appropriate for our times.

The Symbolists were very aware of the Romantic ideas concerning primitives and the relationship between magic and art, and they too viewed the regeneration of symbols throughout the ages as the passing of a torch from the earliest shamans to those geniuses of the modern period who are able to transcend the normal perception of nature.[112] All the Symbolists' theories about the symbolic and synthesizing nature of the universe, of art, and of artistic vision reveal the influence of Romantic Neoplatonic thought. When Aurier wrote his first essays on Symbolist painting and Gauguin, he described the universe as a cosmic totality in which all things exist in fluctuating union, all matter is imbued with spirit, and all knowledge must be of the relationships that constitute nature's harmonious fabric.[113] He contended that every genuine work of art must be achieved through a synthesizing process and must convey this principle to the viewer, thus becoming "the supreme mode of expression," the most complete synthesis of the self and the world,[114] or, in his anthropomorphic terminology, "*a new being* . . . alive, because it is animated by a soul, which is itself the synthesis of two souls, the soul of the artist and the soul of nature . . . the paternal soul and the maternal soul."[115] The material attributes of nature, Aurier claimed, are really "the letters of an immense alphabet which the man of genius alone knows how to spell out" because he alone grasps the symbolic nature of phenomena.[116] The artist is therefore "a genial savant" whose work is "a page of ideographic writing recalling the hieroglyphic texts of the obelisks of ancient Egypt."[117]

Aurier argued that all true art is by definition ideist, symbolist, and synthetist because all nature is, and just as the aesthetic and spiritual principles of great works of contemporary art are identical to those of primitive art, so the Symbolists' complex theories are only the verbal explanations of wisdom which was intuited by all peoples since the earliest ages of culture.[118] The problem with Academic art, the Symbolists believed, was that instead of distilling an original aesthetic Idea from his own subjective experience of the world, the Academic artist simply copied the outward manifestations of earlier art and lost the understanding of how meaning is engendered and conveyed. While the genuine artist "idealizes" nature by stripping away whatever is extraneous to essential form or experience and synthesizing the most significant elements into a new suggestive emblem, the Academic idealizes by suppressing displeasing aspects of reality and "improving" others according to preconceived, artificial notions of beauty, propriety, or desirability. In other words, Academic art synthesizes and recomposes nature not to reveal its underlying truths, but to cleanse it of unpleasant ones, and it therefore conveys none of the vital power, ambiguity, or mystery that we sense when confronted with raw nature or real art.

Denis, Bernard, and Paul Sérusier, all of whom formulated the details of Symbolist theory under the influence of Gauguin, wrote in similar terms about the synthesizing, symbolizing, spiritual nature of the universe, of art, and of the role of the artist. Although both Aurier and Denis wrote their initial detailed explanations of Symbolism in 1890, Denis was the first to codify the ideas of van Gogh and Gauguin, and of their equally independent but related contemporaries Odilon Redon and Puvis de Chavannes, into a coherent and comprehensive body of theory. In an essay on van Gogh and Gauguin, Denis wrote of synthesis as the law of nature, and of art as "a creation of our spirit of

which nature is only the occasion. . . . [It is] the expressive synthesis, the symbol of a sensation" "the language of man, sign of the Idea."[119]

In another essay, Denis also identified nature's unifying principles as the basis of Symbolist art, claiming:

It is not to be doubted that there are in some sense inevitable correspondences between forms, the harmonies of lines and of colors, and on the other hand, our emotions. "For all clear ideas," said Puvis de Chavannes, "a plastic thought exists which translates them." Admirable affirmation of symbolism! To disengage this plastic thought, to discover these correspondences, there is all the work of art, it is the secret of style.[120]

What separated the Symbolists from the Naturalists, Denis contended, was their conviction that by using the medium of correspondences, the artist could find unlimited ways of expressing spiritual conditions and ideas through the material forms of the world, and could therefore combine objective and subjective realities. He complimented the Symbolists for having had

the good fortune to resolve the dual aesthetic and psychological problem of art. For the idea of 'nature seen through a temperament' we have substituted the theory of equivalence or of the symbol: we have affirmed that the emotions or states of mind provoked by some kind of spectacle arouse in the artist's imagination signs or plastic equivalents capable of reproducing these emotions or states of mind without it being necessary to furnish a copy of the original spectacle; that for each state of our sensibility there must be an objective harmony capable of translating it.[121]

In this way, art demonstrates the spiritual nature of the physical world, Denis concluded; through symbolism "matter becomes expressive, and the flesh is made the Word."[122]

Like Denis and Aurier, Bernard also claimed that true reality lies in the interactions between all the seemingly opposed extremes of nature; that the law of the universe is "this original harmony for whose vital expansion death is a condition of eternal youth and eternal return."[123] He too wrote of art as "this powerful accord from which harmony results, this resplendent synthesis which revealed unity to me,"[124] and as "a great all, a human and divine cosmos, a double world, material and celestial."[125] In an essay on van Gogh written after the latter's death, using terminology which is strongly reminiscent of both his deceased friend and Baudelaire, Bernard declared: "Behold the sublime in art: to point out one of the truths hidden in the mystery . . . The sublime is to ally sound, color, scent to form this unison; harmony is the gift of analogy, of affinity, of penetration; it is, in a word, the gift of vision."[126] Bernard main-

tained that art, far from depicting the "concrete" realities advocated by Courbet or the fleeting appearances pursued by the Impressionists, is a "divine language . . . not therefore the representation of what is, but of the eternal truth concealed under the changing form of objects and beings, of worlds and gods."[127] Echoing both van Gogh and Gauguin, he claimed that this eternal truth, this deeper reality (van Gogh's "existence of God and eternity" and Gauguin's "sense of the beyond, of a heart that beats") can be revealed only "by this rare faculty of extracting, while dreaming, the essential and the profound from the complication of facts and of forms."[128] Regarding Gauguin's conception of symbolism he wrote:

All art that tends to represent more than appearances is symbolist; but one could better say that all art which does not suggest more than appearances is not art; in effect, all art rests on poesy, and this Greek word means creation. Now, all creation contains a mind, and the mind is what lies beyond appearance. In nature, not a form exists that is not a sign for the spirit; the entirety of nature is therefore itself a symbol. Thus we live, thus we breathe in the symbol. The goal of art being more divine than human, being . . . this disengagement of the latent meaning of nature, it follows that it is by symbolism that art attains its end.[129]

Explaining the mechanism of art's metaphorical process, Bernard claimed that the artist, through his grasp of nature's correspondences, "seizes the invisible line that secures things as if they were attached to one another, and gives them this perfect unity which is the symbol of superior harmonies."[130]

It is significant that all the early advocates of Symbolist art wrote about van Gogh as frequently as about Gauguin, for although Vincent died in 1890 when the movement was only a few years old, both his art and his ideas on all these crucial issues were clearly Symbolist. Van Gogh too thought of the universe as a coherent creation in which all phenomena flowed from a uniform set of laws, and he too felt that the ability to grasp these relationships separated the artist from the rest of modern Western society. "We are still far from the time when people will understand the curious relation between one fragment of nature and another, which all the same explain each other and enhance each other,"[131] he wrote to Theo, but the reward of being an artist is that "a painter is happy because he is in harmony with nature as soon as he can express a little of what he sees."[132] Everything in nature conveyed the principle of synthesis or the equilibrium of complementary forces to van Gogh, as is evident in his observation that "there is no blue without yellow,"[133] or in his question, so similar to Bernard's definition of the cosmos: "Is the whole of life visible to us, or isn't it rather that this side of death we see

only one hemisphere?"[134] He wrote regarding sorrow that "that eternal negative is balanced by the positive work which is thereby achieved after all,"[135] and noted that in ethics "right and wrong do not exist separately, any more than black and white do in nature."[136]

Van Gogh's writings stress his belief that morality and art are spiritually valid only when they conform to natural principles. "My opinion," he avowed, "is that a man who regulates his life in harmony with the eternal laws of nature as well as of morality contributes his share toward the reform and progress and amelioration of things which have become disoriented in present day society."[137] Accordingly, when he tried to justify his emotional and financial commitment to a "fallen woman" with whom he had become involved, he argued that permanent relationships and accepting the consequences of one's interactions are in harmony with nature,[138] and when he expressed to his brother his regret at the disillusioning fractiousness of the avant-garde's independent painters, he concluded: "I cannot believe so much coolness and disharmony is natural."[139] Recognizing that harmony is the ultimate operative principle of nature, he insisted that one could arrive at a deep understanding of natural laws only by synthesizing the intellect and the feelings, instinct and reason, observation and imagination.[140] Regarding art, he claimed that considerations of harmony and synthesis were among his foremost concerns in working out the technical and formal aspects of his pictures, and he accordingly devoted much time and concentrated thought to studying and then applying Delacroix's and Charles Blanc's ideas about the perceptual and associational impact of colors and the interactions of color complementaries.[141] After becoming friendly with Neo-Impressionist Paul Signac in Paris in 1886, van Gogh augmented his knowledge of the principles of aesthetic harmony from Signac's wealth of information about the theories of Seurat and of Charles Henry.[142]

Van Gogh wrote often of his desire to convey the relationships and connections between things, which are the essence of synthesis. He described his effort to achieve "a drawing style which tries to express the interlocking of the masses"[143] rather than the details of separate forms, and he rebelled against the Academic convention that treated form and color as separable elements in the work of art and accorded precedence of value to linear drawing. Subscribing to Baudelaire's observation that "with Nature, form and color are one,"[144] he argued that "in color seeking life the true drawing is modelling with color."[145] Whenever any artist created form through color, he felt, it reflected the synthesizing vision of nature that the artist had achieved, for, as he told Theo: "Now that I let myself go a little, and look more through the eyelashes, instead of staring at the joints and analyzing the structure of things, it leads me more directly to seeing things . . . like patches of color in mutual contrast."[146] When he scrutinized the paintings of artists like Rembrandt and Velasquez, he found support for this belief that form and color must be synthesized in order to create the impression of reality. Noting that the old masters achieved this fusion by suggesting form through color juxtapositions, he wrote that the best pictures "are but patches of color side by side, and only make their effect at a certain distance,"[147] and the best painters understand that "color expresses form if well applied and in harmony."[148]

Van Gogh insisted that color usage could not be arbitrary; an artist must grasp the perceptual and ideational effects of different colors and learn how these correspondences can be manipulated to create expressive harmonies. "The laws of the colors are unutterably beautiful, just because they are not accidental,"[149] he told Theo, and the essence of their lawfulness lies in their innate capacity to convey mood and to create a harmonious accord from the interactions of opposites. To illustrate his point he described to Theo a hypothetical plan for a series of paintings illustrating the seasons according to this principle of symbolic synthesis:

Spring is tender, green young corn and pink apple blossoms. Autumn is the contrast of the yellow leaves with violet tones. Winter is the snow with the black silhouettes. But now, if summer is the contrast of blues with an element of orange in the golden bronze of the corn, one could paint a picture which expressed the mood of the seasons in each of the contrasts of the complementary colors (red and green, blue and orange, yellow and violet, white and black).[150]

Because harmony results only from lawful syntheses and not just aimless combinations, van Gogh claimed, "one really ought to study each color separately in connection with its contrast before one can be positively sure of being harmonious."[151] Only through such oppositions, he felt, can the artist suggest the unified nature of the world and, by extension, the goal of our spiritual and moral lives. Recognizing that art and religion are related symbolic expressions of the same perceptions and pursuit of harmony, van Gogh told Bernard that Christ had been the ultimate formulator of truth in symbolic form, a "matchless artist" whose medium was the parable. Through his verbal metaphors, van Gogh declared, Christ reached "the very highest summit" of art and thereby endowed it with "a pure creative power," considerations which he assured Bernard "are connected with painting" and account for the fact that the patron saint of artists is "St. Luke, physician, painter, evangelist."[152]

Like all the Symbolists, van Gogh disparaged the Academic use of conventional symbols to convey specific,

limited conceptual meanings. Instead, he espoused an organic, expansive symbolism based on the intuitive recognition that natural phenomena can be perceived as analogues of aspects of human experience and can therefore suggest ideas relevant for human life. All things in nature, he held, contain the same energies, are worked on and motivated by the same forces, and have the same capacity to teach us the lessons of existence. In his letters he repeatedly revealed the extent to which his choice of subjects and his method of portraying them were governed by this belief. He told Theo:

In all nature . . . I see expression and soul, so to speak. A row of pollard willows sometimes resembles a procession of almshouse men. Young corn has something inexpressibly pure and tender about it, which awakens the same emotion as the expression of a sleeping baby, for instance.

The trodden grass at the roadside looks tired and dusty like the people of the slums. A few days ago, when it had been snowing, I saw a group of Savoy cabbages standing frozen and benumbed, and it reminded me of a group of women in their thin petticoats and old shawls whom I had seen standing in a little hot-water-and-coal shop early in the morning.[153]

Because he was so sensitive to the metaphorical nature of reality, and because he felt that people could be comforted and uplifted by viewing their own experiences as part of the larger workings of the natural world, van Gogh always tried to convey these associations in his art. Writing to Theo about two drawings he had been working on in relation to one another, a study of tree roots and a figure entitled *Sorrow* depicting a nude, grieving woman, he claimed: "Now I tried to put the same sentiment into the landscape as I put into the figure: the convulsive, passionate clinging to the earth, and yet being half torn up by the storm. I wanted to express something of the struggle for life in that pale, slender woman's figure as well as in the black, gnarled roots."[154]

As with Baudelaire and Delacroix, not only forms but colors conveyed meaning to van Gogh, and he believed that by manipulating color relationships he could create a natural, universal symbolism to supplant the conventionalized images of bygone times which no longer seemed honest or relevant. He wrote, for example, that he wished "to paint men and women with that something of the eternal which the halo used to symbolize, and which we seek to convey by the actual radiance and vibration of our coloring."[155] His goal, he claimed, was

to express the love of two lovers by a wedding of two complementary colors, their mingling and their opposition, the mysterious vibrations of their kindred tones. To express the thought of a brow by the radi-

ance of a light tone against a somber background. To express hope by some star, the eagerness of a soul by a sunset radiance. Certainly there is no delusive realism in that, but isn't it something that actually exists?[156]

Van Gogh's descriptions of his pictures in his letters go into considerable detail about his choice of colors and the significance they had for him, and the color combinations of his paintings often tell us much about his own emotional state. Writing to Bernard about a picture he was working on during an agonizing period of incarceration in an asylum for the mentally ill, he concluded: "You will realize that this combination of red-ocher, of green gloomed over by gray, the black streaks surrounding the contours, produces something of the sensation of anguish, called 'noir-rouge,' [black-red] from which certain of my companions in misfortune frequently suffer."[157]

Like other Romantic thinkers and Symbolist artists and writers, van Gogh believed that the ability to grasp the ideational and emotional significance of forms and colors and to experience reality in a synthesizing way was especially the province of the primitive and the child. The critic Octave Mirbeau, writing about van Gogh's distress that the public was unable to comprehend or appreciate the "new language" of his expressive style, quoted him as complaining that "their brain is rigidified by too many earlier habits . . . by too much misery. . . . I can do nothing with them. . . . It is to the little children that I should go. . . . It is in these completely new and flexible organisms that I should deposit the seed. . . . It is into these souls, in process of formation and continually being born, that I should speak the word of life."[158] Van Gogh praised the young not only for their receptivity, but for their susceptibility to the voices of conscience and feeling and for their ability to lose themselves in thought.[159] His recognition that there is a relationship between the ways in which children and artists experience the world, is evident in his remark that he would like to live "without mental reservation—as naïve as a child, no, not as a child, as an artist . . ."[160] It was the naturalness, openness and freedom from artificial constraints which youth enjoyed that led him to tell Theo: "Gauguin and Bernard talk now of 'painting like children'—I would rather have that than 'painting like decadents.'"[161] Like the other Symbolists, he believed that the admirable childlike qualities of curiosity, spiritual susceptibility, and simplicity were responsible for the aesthetic and emotional power of primitive arts. Praising Egyptian art for conveying a sense of calm, simplicity, and truth,[162] he claimed that "the Egyptian artists, having a faith, working by feeling and instinct, express all these intangible things—kindness, infinite patience, wisdom, serenity—by a few knowing curves and by their marvelous proportions."[163] He extolled the Japanese

similarly for a love of nature and a reverent interest in all its manifestations which resulted in their extraordinary powers of penetration, their unerring precision in extracting essential forms from nature and rendering them in terms of broad, simplified color contrasts.[164] It was this wonder-inspired capacity to synthesize and symbolize the general Ideas of nature that he was referring to when he, like so many others connected with the Symbolist movement, wrote of a longing to become "naïve" and "primitive."[165]

We find the same ideas about the related issues of symbolism and synthetism when we turn to the writings of Gauguin. He too perceived nature as a harmonious system in which life and death mingle and alternate and all things are modified by their opposites. When departing Europe for Tahiti, where he felt these universal rhythms and relationships would be more apparent than in the artificial culture of the West, he wrote to Odilon Redon: "I will not dream, I promise you, of death, but on the contrary of eternal life, not death in life, but life in death. In Europe, this death with its serpent tail [a reference to the symbolic imagery of Redon's lithographs] is plausible, but in Tahiti, one must envision it with roots from which flowers shoot up once more."[166] In true Neoplatonic fashion he viewed heaven as a state of ultimate harmony in which all the senses were synthesized, quoting to Redon Richard Wagner's "credo" regarding the reward in store for artists who are sensitive to nature's laws: "I believe in a last judgment. . . . I believe that in the second coming the faithful disciples of great art will be glorified, and that, enveloped in a celestial fabric of light rays, perfumes, and melodious accords, they will return to lose themselves for eternity in the bosom of the divine source of all harmony."[167]

For Gauguin as for van Gogh and other Romantic thinkers, harmony was the great goal of existence on both the individual and social levels. He valued sexuality not only for the sensual pleasure it gives but for the feelings of union it engenders, claiming that one of the most revealing differences between Tahitian and Western life was that "in Oceania a woman says 'I can't know if I love him because I haven't been to bed with him yet,'" while "in Europe the woman says 'I loved him: since I went to bed with him, I love him no longer.'"[168] His regret that in the Christian world, sex was seldom viewed as a means toward spiritual unity led him to feel that the "unnatural" chastity of monks and nuns and their condemnation of other peoples' sexuality was out of harmony with the principles of God's creation.[169] He was drawn to ancient mythology because it described the universe as resulting from the union of male and female forces in nature, and he wrote admiringly of the concept of androgyny as an ideal state of being in which male and female characteristics would be synthesized and harmonized. He perceived human beings as mortal spirits

who are "always in conflict with matter,"[170] always struggling to reconcile their sensual and spiritual natures,[171] their good and evil impulses, their strengths and weaknesses,[172] and he conceived similarly of existence as a constant balancing act between the extremes of hope and fear, desire and apathy, exaltation and despair, benevolent intentions and disastrous results. Summing up the duality of life with his habitual irony, he wrote: "As you see, everything is serious, ridiculous as well."[173]

Like all the Symbolists, Gauguin also viewed art as the product and exemplar of synthesis, and as had happened with van Gogh, his search for the artistic means of conveying nature's unity led him to repudiate the Academic idea that form and color can be treated separately in the work. In his essay of 1886 entitled "Notes synthétiques," he declared that each helps to create the other and that the success of their overall effect depends on their interaction. "Can you really make me believe," he asked rhetorically, "that drawing does not derive from color, and vice-versa? . . . Then try to draw in the same exact proportions a Rembrandt head and put in the coloring of Rubens—you will see what a shapeless thing you will have and at the same time the color will have become disharmonious."[174] His own objective, he told Schuffenecker two years later, was to create a "synthesis of form and color in which neither is considered dominant."[175]

Taken by itself this might be construed as no more complex a goal than the Impressionists pursued, but like van Gogh, Gauguin believed that the purpose of unifying form and color in art was not simply to create an aesthetically satisfying harmony, but to convey through material equivalents that synthesizing sensation of nature's harmonious essence which they called "the dream." Never averse to appropriating other peoples' explanations of ideas which were important to him, he incorporated into his own notes a phrase about painting which he abstracted from an essay written about him by the critic Achille Delaroche. In a statement redolent of Schelling and Hegel, Delaroche had claimed that "among all others, painting is the art which will prepare the way by resolving the antimony of the perceptible and intellectual worlds."[176] Gauguin sought to achieve this symbolic synthesis "by taking the elements of nature and creating a new element:"[177] by using the vocabulary of physical phenomena to write his own subjective language.

Gauguin often referred to his work in terms of language, just as Aurier described Symbolist art as a "page of ideographic writing recalling the hieroglyphic texts . . . of ancient Egypt." Calling color "this language so profound, so mysterious, language of the dream,"[178] Gauguin claimed of his art that "in stammering a language that I have pleased myself by creating, I have tried to portray

in forms and colors what my Dreams have seen and understood."[179] Like van Gogh, he rejected conventionalized symbols associated with literary meanings as being too limited and inadequate for this purpose, telling his friend Fontainas: "I have tried through a suggestive decor to translate my dream without any recourse to literary means, with all possible simplicity of craft, a difficult labor."[180] He was able to do this because he too looked at the world with his clairvoyant inner eye and was therefore sensitive to the spiritual and associative meaning inherent in natural phenomena. He told van Gogh that he wasn't trying to suggest specifically "poetic" ideas because "I find *everything* poetic and it is in the sometimes mysterious recesses of my heart that I glimpse poesy. Forms and colors brought into harmony produce a poesy by themselves."[181]

Like other Neoplatonic thinkers, Gauguin believed that our sense of the latent significance in things, the sense which is responsible for their poetic effect on us, is the result of the correspondences which link us to them, and like van Gogh he was convinced that the physical attributes of nature could therefore be used to express our impalpable thoughts and feelings. He wrote to Schuffenecker:

To make something known in painting is not the same thing as describing it. This is why I prefer a color suggestive of forms, and a parable in the composition rather than a painted novel. . . . why should we not create diverse harmonies corresponding to the state of our soul? Too bad for those who are unable to read them; we shouldn't have to explain to them.[182]

Swedenborg had claimed that "allegorical correspondences" supply us with "interpretive principles for dreams, parables, and ancient myths,"[183] an idea with which Gauguin probably became familiar not only via Delacroix, Blanc, and psychophysical theory, but from reading Balzac's Swedenborgian novel *Séraphita,* in which the author wrote of the spirit's ability to "penetrate the sense of numbers . . . sounds . . . colors" and the directional movements of all material phenomena.[184] Gauguin gave Schuffenecker a typically fragmented description of his ideas about correspondences in an 1885 letter:

Observe in the immense creation of nature and you will see if there are not laws for creating, with aspects that are completely different and yet similar in their effect, all the human feelings. . . . All our five senses arrive directly at the brain affected by an infinity of things and no education can destroy this. I conclude from this that there are noble lines, false ones, etc. The line should denote infinity, the curve limits creation, without counting the fatality in numbers. Have the numbers 3 and 7 been sufficiently discussed? The colors are even more expressive although less multiple than lines, by virtue of their power over the eye. There are noble tones, others that are common,

tranquil harmonies, consoling ones, others which excite you by their boldness. . . . In pure truth sideways does not exist; it is in our feeling that right-slanting lines advance and left-slanting ones recede . . . : why are willows whose branches hang down called weepers? And is the sycamore sad because they put it in cemeteries, no, it is the color that is sad.[185]

Gauguin's writings contain many references to the particular moods attaching to specific colors or color combinations, a good example of which is his description of his attempt to suggest the fear of death in a painting by creating a "general harmony, somber, sad, frightening, tolling in the eye like a funeral knell. Violet, somber blue and orange-yellow."[186]

Like van Gogh, Gauguin felt that works of art which convey a profound understanding of life symbolically are comparable to the teachings of religion. In an 1888 letter to Schuffenecker he too compared Christ's genius in shaping peoples' moral sense through powerfully associative verbal images with the artist's mission of creating visual symbols, concluding: "What an artist, this Jesus, who has molded all human nature."[187] Claiming that art speaks "in a kind of parabolic language which, translated by the critic literally, is in effect absurd, yet translated rationally becomes a noble language,"[188] Gauguin responded to the common criticism that his paintings were mad and unrealistic by quoting the Gospel: "Let them meditate these words: 'The wise man, he alone, will seek to penetrate into the mystery of parables.'"[189] He argued repeatedly that all religious texts are symbols which must be interpreted rationally according to their intrinsic and metaphorical spiritual meaning, because to take them literally results in misconstruction and the substitution of absurd dogmas for wisdom.[190] Applying this argument about biblical allegory to the explanation of his own pictorial imagery, he told Fontainas:

I work a little like the Bible whose doctrine (especially concerning Christ) is enunciated under a symbolic form presenting a double aspect; a form which first of all materializes the pure Idea so as to render it more perceptible . . . this is the literal, superficial, figurative, mysterious sense of a parable; and then the second aspect, giving the Spirit of the first."[191]

Gauguin also subscribed to the general Romantic and Symbolist belief that the facility for seeing metaphorically and synthesizing nature into evocative symbols was shared by the artist with primitives and children. According to Sérusier, Gauguin once defended himself from the charge of disseminating absurd doctrines and making ridiculous art by declaring: "I cannot be ridiculous, because I am two things which cannot be ridiculous: a child and a savage."[192] His letters and journals repeatedly refer to artists as children

and to himself as a primitive or "savage," and the fact that he perceived this identity as a necessary aspect of creativity is evident from his assertion to a journalist that "to make something new, one must go back again to sources, to humanity in infancy."[193]

Observing that ancient artistic traditions understood the principles of symbolism and synthesis, he credited the Japanese for using color to create diverse harmonies capable of giving the impression of heat or other impalpable aspects of reality,[194] and cited the advice of "the great professor Vehbi-Zunbul-Zadi," an artist in the time of Tamerlane, regarding the need to deviate from the model in order to express "your sensations, your intelligence and your soul" as well as to achieve harmonious color juxtapositions.[195]

According to Morice, Gauguin differentiated primitive from "refined" art on the basis of how this grasp of symbolism affects the artist's use of natural forms:

Primitive art originates from the spirit and employs nature. So-called refined art originates from sensuality and serves nature. Nature is the servant of the first and the mistress of the second. But the servant [mistress] cannot forget her origin, she debases the artist by allowing herself to be adored by him. It is thus that we have fallen into the abominable error of naturalism. . . . Truth is pure cerebral art, it is primitive art—the wisest of all. . . . In our present misery, there is no remedy possible but by the reasoned and frank return to the beginning. And this return involves the necessary action of symbolism in poesy and in art.[196]

Art as Subjective and Decorative:
The Revelation of the Soul and the World through Distortion

When the Symbolists scrutinized the works of "primitive" artists from ancient Egypt to modern Japan and from Leonardo da Vinci to Delacroix in order to identify the techniques by which symbols can be created from nature, they found, as had Romantic independents of the previous generation, that the key to this process lay in the abstracting principles of distortion and reduction. Baudelaire, in describing the art of primitive peoples and symbolists as syntheses of reality rather than imitations of objects, had claimed that the distortions of color and form their works exhibit are not the result of ineptitude. Instead, he argued, they are the "childlike" generalizations and stylizations of minds that see things in their broadest and most relational aspects, and he concluded that "all those painters whose vision is synthesizing and abbreviative have been accused of barbarousness . . ."[197] Delacroix, whose deviations from realism Baudelaire was defending, maintained that distortion is necessary in art because "showing only what it is shown in nature will always make the painter colder than the nature which he thinks he is imitating."[198] Claiming that what allows a work of art to become "the essential expression of the idea" is the artist's ability to dominate his subject through suppression and accentuation,[199] Delacroix accordingly recommended "certain exaggerations . . . [to] increase the power of expression," "disproportionate or unfinished parts which augment the importance of the parts which are complete," and the continual need "to prune, to condense, to summarize and bring order into things."[200]

The Symbolists subscribed to the belief that art can function as a dual symbol of the artist's interior synthesis and of his union with the external world only when it alters the appearances of things. Among the Symbolist theorists, Denis offered the most complete and illuminating account of how these deviations from appearances function in art, and his analysis leads us to the consideration of Aurier's final two requirements for the work: that it be subjective and decorative. In his first essay on "neo-traditionist" art Denis differentiated between two equally necessary aspects of aesthetic distortion, claiming that all great artists utilize "*subjective Deformation* . . . with a view to more sincerity,— and *objective Deformation* to conform their imagination to the eternal laws of decor."[201] Although both kinds of deformation function together in the work of art, their meaning will be clearer if we define the first and trace its significance for van Gogh and Gauguin before returning to explore the second.

SUBJECTIVE DISTORTION:
STYLE AS THE REVELATION OF INNER BEING

Subjective distortion, Denis tells us, is the result of the artist having recreated the world according to his own personal feelings about and vision of things, and if his forms seem to us "gauche" or exaggerated or simplistic, it is because he has spontaneously and sincerely rendered essential qualities of phenomena without concern for either superficial realism or for conventional, preconceived notions of beauty.[202] In Denis' view, these "gaucheries," or personally contrived distortions, are the only means by which an artist can manifest his intuitive, penetrating, spiritual vision of nature in a work of art,[203] and he therefore praised the Symbolists for technical and formal qualities which Academic critics and public perceived as "barbarisms"—evidence of an inability to make things look real.

Throughout van Gogh's and Gauguin's writings we find similar explanations of why their forms and colors deviated from an illusionistic duplication of appearances. In justifying his tendency to simplify and generalize forms, van Gogh told his brother:

What I want to make is a drawing which will not be exactly understood by everyone: the figure essentially simplified with intentional neglect of those details which do not belong to the real character, and are only accidental. For it must not be a portrait of Father, but rather the type of a poor village clergyman on his way to visit the sick. In the same way the couple arm in arm . . . must be the types of a man and woman who have grown old together in love and faith.[204]

Attempting to explain his even more flagrant deviations from objective accuracy, he insisted that strict fidelity to surface appearances prevents the revelation of those deeper experiential realities which are so meaningful in human life. The most important kind of truth, he claimed, required distortion:

I should be desperate if my figures were correct, . . . I do not want them to be academically correct, . . . I adore the figures by Michelangelo though the legs are undoubtedly too long, the hips and backsides too large. . . . for me Millet and Lhermitte are the real artists for the very reason that they do not paint things as they are, traced in a dry, analytical way, but as they . . . feel them. . . . my great longing is to learn to make those very incorrectnesses, those deviations, remodelings, changes in reality, so that they may become, yes, lies if you like—but truer than the literal truth.[205]

When van Gogh compared figures by establishment artists, conventionally rendered to be "correct in proportion and anatomy," with those of painters like Delacroix and his own independent contemporaries, he concluded that with the latter "the shape of the figure will be *felt* much more, and yet . . . the proportions will sometimes be almost *arbitrary*, the anatomy and structure often quite wrong 'in the eyes of the academician.' But it will *live*."[206] Because he understood that this sensation of organic life comes not from scrupulously imitated surface details but from finding ways of translating subtle internal realities into visible forms, he insisted that "what I try to acquire is not to draw *a hand* but the *gesture*, not a mathematically correct head, but the general *expression*. . . . In short, *life*."[207] Realizing that the same principles applied to landscape, he wrote later regarding his paintings of the trees and fields of Arles: "I am trying now to exaggerate the essential, and purposely leave the obvious things vague."[208] The merit of this expressive, summarizing style, he felt, is that it evolves naturally from the way in which the individual artist experiences reality. Whatever the shortcomings of his transcriptions, he claimed:

I find in my work an echo of what struck me after all. I see that nature has told me something, has spoken to me, and that I have put it down in shorthand. In my shorthand there may be words that cannot be deciphered, there may be mistakes or gaps; but there is something of what wood or beach or figure has told me in it, and it is not the tame or conventional language derived from a studied manner or a system rather than from nature itself.[209]

Van Gogh's manipulation of color was governed by the same desire to reveal the ideas and emotional significance of nature's underlying laws, and he therefore confessed to having "played hell somewhat with the truthfulness of colors" in order to make what he called "naïve pictures" "in a wholly primitive manner."[210] Relating the freedom of primitive style to its practitioners' intelligence and sincerity, he remarked regarding its differences from the Academic approach: "I prefer to see a simple brush stroke and a less far-fetched, difficult color. More simplicity, in short that intelligent simplicity which is not afraid of frank technique."[211] In the museum in Antwerp he noted that the same stylistic boldness was the hallmark of other great painters like Velasquez, Rubens, Rembrandt, Hals, and Chardin, and he quoted to Theo the Goncourt brothers' written description of their surprise that a mouth painted with seemingly infinite delicacy by Chardin was on a closer perusal observed to "'have been made only of a few streaks of *yellow* and a few swipes of *blue*!'"[212] That he perceived this as proof of extreme sophistication and technical ability rather than of ineptitude is evident from his concluding to Theo: "I hope not to forget the lessons which I am thus learning these days; *in one stroke*—but with absolutely complete exertion of one's whole spirit and attention."[213] Arguing that this natural technique was far superior to the tight, slick virtuosity of the Academy's artificial style, he told van Rappard: "We must try to get so far beyond the secrets of technique that the public gets past that matter entirely and swears by all that is holy that we have no technique. Let our work be so *savant* that it seems naïve and does not reek of our cleverness."[214]

Gauguin also had insisted from the beginning of his artistic career that the exact rendering of detailed appearances according to rational criteria was inimical to great art. He warned his friend Schuffenecker: "A word of advice, don't paint too closely after nature. Art is an abstraction; draw it out of nature while dreaming in front of it and think more about the creation which will result; it is the only means of ascending towards God by doing as our Divine Master does, by creating."[215] Several of his later journals cite similar maxims from the medieval master Vehbi-Zunbul-Zadi, who cautioned that "it is good for young men to have a model, as long as they draw the curtain over it while they are painting it,"[216] and that it is better not to finish your

work too precisely lest it freeze the lava of inspired creativity.[217] Gauguin too followed Delacroix and Baudelaire in advocating deviations from correct form and color as a means of achieving a more profound kind of truth in art than uninflected physical realism can convey. Strict accuracy in depicting color, he wrote, creates an effect that is

lifeless, frozen; impudently and stupidly, it deceives. . . . in order to create the equivalent (your canvas being smaller than nature) it is necessary to put a greener green than that of nature. There you have the truth of the lie. In this fashion your picture, illuminated by a subterfuge, a deception, will be true because you will give the sensation of a real thing.[218]

Gauguin also agreed with van Gogh's observation that distortion is a hallmark of great art and could be found in all the revered traditional masters: ". . . all the great painters have never done otherwise! Raphael, Rembrandt, Velasquez, Botticelli, Cranach have deformed nature. Go to the Louvre, look at their works, not one resembles another; if one of them is in the right, all the others are wrong according to your theory. . . ."[219] Comparing the stylistic distortions of artists as disparate as the Japanese and the medieval Italian painter Giotto, Gauguin declared that "to draw honestly is not to affirm a thing true to nature . . . but to use pictorial forms of speech which don't disguise the thought."[220] Like van Gogh, he felt that the individual's comprehension of reality was the essential ingredient in any work and that its expression justified whatever deviations from appearances the artist found necessary. "If a painter wished tomorrow to see rose or violet shadows," he told an interviewer, "one could not call him to account as long as his work was harmonious and thought-provoking."[221] Justifying his own simplifications of form, he argued just as van Gogh had done that these generalizations were vital to the expression of poetic meaning: "The forms are rudimentary? It is necessary. The execution is too simple? It is necessary. Many people say that I don't know how to draw because I make unusual forms. When will they understand that the execution, the drawing and the color (the Style) have to be in accord with the poem?"[222] With this statement that the distortions of style are necessary to the expression of the poem, we arrive at the last of the Symbolists' requirements of art: that it be decorative.

OBJECTIVE DISTORTION:
BEAUTY AS THE RHYTHM OF LIFE

We recall that the "poem" has a dual significance in Symbolist thought, referring not only to the artist's subjective, emotional internalization of experience, but to his insight into the laws of nature. This brings us to the consideration of the second aspect of aesthetic distortion, characterized by Denis as "objective Deformation." While "subjective Deformation" encompasses the alterations of form and color artists contrive to manifest their own sincere feelings about the world, it is the purpose of *"objective Deformation* to conform their imagination to the eternal laws of decor."[223] The Symbolists believed that although the manifestations of beauty are infinitely varied, all share certain fundamental properties because all derive from universal principles which underlie the fabric of nature. All art must be decorative as well as subjective, they claimed, because what makes it decorative is its application of the harmonic laws of the physical world. As we examine the Symbolists' elaborations of their ideas about beauty, this complex notion that decorativeness relates to the laws governing physical structure will become clearer.

Denis expressed a central point of Symbolist theory when he wrote in an essay on van Gogh and Gauguin that genuinely spiritual works of art are not necessarily ones which represent traditional religious subject matter, but those which reveal "the order of the universe, the divine Order that the human intelligence manifests, [which] appears the same in them throughout the variety of individual formulas."[224] He noted that Gauguin, "who put so much disorder and incoherence into his life, didn't tolerate it in his painting. He loved clarity, sign of intelligence," and "by returning to the sources of art" he was seeking "the original principles that he called the eternal laws of the Beautiful."[225] Denis elaborated on this idea in an essay on religious painting, claiming that artists distort appearances not only to convey their own subjective vision, but because "they have wished to submit themselves to the laws of harmony which rule the relationships of colors and the arrangements of lines."[226]

The Symbolists maintained that the basis of these harmonic laws is mathematics, for it is mathematics which governs the development of all forms in nature. This concept goes back to the ancient Greek mystic philosopher and mathematician Pythagoras, who, according to Aristotle, ascribed all the movements and harmony of the universe to the order of numbers. "Discerning in numbers the conditions and reasons of harmonies also," Aristotle wrote, "[the Pythagoreans] assumed that the elements of numbers were the elements of all things, and that the whole heavens were harmony and number."[227] Sharing Pythagoras' belief, the Symbolists therefore characterized spiritual art as art which, in Denis' words, "recaptures the intimate secret of nature, the number. From the mathematical relationships between lines and colors arises a supernatural Beauty. . . . Admirable relationships signify truth from above; proportions express concepts; there is an equivalence between the harmony of forms and the logic of Dogma."[228]

Whereas the artist's emotions, imagination, and intu-

ition bring insight into the inner nature of things, it is reason that perceives the structural correspondences and patterns in nature through which subjective vision can be fashioned into a universally relevant artistic style. When the artist fails to submit his subjective fantasies to the overriding rational faculty which recognizes nature's formative laws, Denis claimed, his work becomes both aesthetically weak and morally trivial. "Style," he asserted, "most decidedly seems to be a system of subordination . . . an effort of the spirit against the facility of the imagination, the tyranny of the senses." [229] Through this effort of subordination, Denis insisted, "the decorative, aesthetic and rational composition . . . becomes . . . the necessary corrective to the theory of equivalents. . . . *objective deformation* in its turn obliges the artist to transpose everything into Beauty."[230] By this principle, when the artist achieves decorative beauty he also makes art the equivalent of science: a symbol of the most fundamental ways in which the material world is ordered. It is for this reason that Aurier called the artist "a supreme formulator who knows how to write Ideas in the manner of a mathematician . . . an algebraist of Ideas . . . whose work . . . is a marvellous equation."[231]

Sérusier stated a fundamental tenet of Symbolist thought when he claimed that "Immutable principles exist in art. There is a science called aesthetics which teaches them. . . . One can deduce these principles from laws that are innate in us, from ideas of harmony common to all unspoiled men."[232] The Symbolists agreed that artists from the earliest cultures had recognized that the mathematical relationships which underlie the universe must be the basis of aesthetics if the work of art is to symbolize nature convincingly and share its powerful charge of organic vitality. Maintaining that insight into the mathematical underpinnings of nature and their translation into decorative beauty is the work of the governing intelligence, the aspect of our being which partakes of the same divine ordering properties as nature's forms, Denis explained that

. . . from this subordination of nature to sensibility and to human reason devolved all the rules: the proper proportions, the measures from which can be found . . . the numerical relationships of the Japanese as well as for the Egyptians—proportions which in effect coincide with our instinctive need of symmetry, of equilibrium, of geometry; the laws of composition, whose principle is to order the details in the ensemble as a function of the directing thought of the work.[233]

Because artists throughout time have created their aesthetics from the structuring laws of nature, Denis argued, we find that "the same principles of color that make the richness of a Gauguin or a van Gogh were applied by Tintoretto and Titian. The beauty of the curves, the style of the lines of a Degas or a Puvis de Chavannes are found on the side of Greek vases and in the frescoes of the [Italian] Primitives."[234]

At the beginning of his first essay on Symbolist art Denis stated that the purpose of art lies not in illusionistic representation, but in the formulation of a harmonious, decorative image through the abstraction and simplification of visual aspects of nature. "A picture," he wrote, "—before being a battle-horse, a nude woman, or some sort of anecdote—is essentially a flat surface covered with colors arranged in a certain order."[235] Through the reduction of forms and spatial relationships to a surface pattern of harmoniously balanced and rhythmically integrated colored shapes, the artist not only creates an aesthetic effect which symbolizes the world, he does so without violating or falsifying the two-dimensional nature of his medium. In every possible way, therefore, the Symbolist work of art manifests truth, and its truth goes to the very heart of reality because it incorporates the principle which ties us to the universe. In a passage that both sums up Romantic philosophy and anticipates the advent of the purely abstract art of the twentieth century, Denis claimed:

The subject of the painter is in him. Nature is an inexhaustible repertoire of motifs for one who knows how to see. Whoever has been granted the marvelous faculty of creating beauty with colors and forms can have no other subjects than the harmonies of colors and forms that he conceives or observes. All spectacles, all emotions, all dreams are summarized for him in combinations of spots, in relationships of tone and hue, in lines. What he expresses is never some sort of anonymous fact, a pure accident; it is the interior rhythm of his being, his aesthetic effort, his necessary Beauty.[236]

Denis' reference here to "the interior rhythm of his being" touches on one last and very important aspect of Symbolist aesthetics: the relationship that all the Symbolist artists claimed exists between visual art and music as exemplars or metaphors of nature. This idea also originated with Pythagoras, who believed that "the universe produces melody and is put together with harmony"[237] because "the qualities of numbers exist in a musical scale (*harmonia*) in the heavens and in many other things."[238] Plato claimed that because of this law, truth to nature in art results from using numerical proportions which reflect the Ideas or essential patterns on which reality is built, proportions which are also embodied in musical harmonies. "Strains of music are our laws," he wrote, noting that "law" was the name given by the ancients to lyric song.[239] Because music expresses the structure of the universe, he maintained, it has a powerful spiritual effect on our inner being by bringing it into harmony with creation, and for this reason "musical training is a more potent instrument than any other, because rhythm and harmony find their way into the

inward places of the soul, on which they mightily fasten, imparting grace . . ."[240] The Greeks were aware that since all forms in art are embodiments of the same principles of harmony and rhythm, the same structuring elements of measure and proportion, all partake of the qualities and effects of music, a perception Aristotle expanded when he noted that art also relates to science since both deal with these fundamental relationships.[241]

These ideas formed a significant part of the theories of the Symbolists' favorite Romantic authors, poets, and artists. Among these, one of the most interesting statements comes from Thomas Carlyle's *On Heroes, Hero-Worship, and the Heroic in History*, a book which was familiar to the Symbolist avant-garde and which van Gogh in particular admired. Claiming that poetry must be musical, Carlyle concluded:

Musical: how much lies in that! A musical thought is one spoken by a mind that has penetrated into the inmost heart of a thing; detected the inmost mystery of it, namely the melody which lies hidden in it; the inward harmony of coherence which is its soul, whereby it exists, and has a right to be, here in this world. All inmost things, we may say, are melodious; naturally utter themselves in Song. The meaning of Song goes deep. Who is there that, in logical words, can express the effect music has on us? A kind of inarticulate unfathomable speech, which leads us to the edge of the Infinite, and lets us for a moment gaze into that! . . . All deep things are Song. It seems somehow the very central essence of us; and of all things. . . . See deep enough, and you see musically; the heart of Nature being everywhere music, if you can only reach it.[242]

While Carlyle's statements might seem overly romantic and far-fetched to our rational, practical minds, contemporary scientists have expressed the same idea in a variety of ways. Biologist and physician Lewis Thomas, for example, in an essay entitled "The Music of *This* Sphere," writes that the fundamental natural law of thermodynamics by which the flow of energy from the sun arranges matter into a constantly changing order, or rhythm, is repeated and reflected in all living things. "Somewhere," he states, "underlying all the other signals, is a continuous music,"[243] and it is echoed by all organisms in the pulse and beat of their biorhythms, which "make music" as an essential expression or "celebration" of energy and life. Music, Thomas tells us, is an embodiment of the model of thermodynamics, and the phrase scientists use to describe the fluid, rhythmical patterns of "rearrangement and molecular ornamentation" permeating the cosmos is, aptly enough, a "grand canonical ensemble."[244]

Innumerable Romantic thinkers related music to deity and the experience of musical harmonies to a spiritual sense of union with creation. Authors as diverse as Goethe,

Balzac, Sand, Eliot, and Dickens endowed their most sensitive characters with musical ability and stressed the religious nature of the feelings that flowed from it: feelings which twentieth-century soprano Montserrat Caballer has described as a sense of ineffable, mystical detachment and rapport with the cosmos.[245] Renan described God as "reason . . . the laws of aesthetic and eurythmy; he is the number, weight, measure which makes the world harmonious and eternal,"[246] and the theosophists noted that the concept of "the music of the spheres" and of the divine origin of geometric and mathematical relationships is not only found in all religions, but is upheld by the modern scientific understanding of the ways in which matter structures itself on the most primal level.[247]

In the French artistic world these ideas were echoed and applied to the visual arts especially by Delacroix, Baudelaire, Blanc, Henry, and Seurat, all of whom wrote of aesthetics as the equivalent of music and a similar source of religious sensations. For all of them, the arrangement of forms and colors in a painting created what Delacroix described as "the music of the picture," and it was this which was responsible for the emotional effect of a work before its subject matter was even recognized. Baudelaire characterized Delacroix's truth to nature as "musical seductiveness,"[248] and wrote repeatedly of color relationships as "melodious marriages," as symphonies, variations, cadences, counterpoints, and successions of melody.[249] Psychophysical and perceptual theorists claimed that "the laws of the aesthetic harmony of colors are learned as one learns the rules of musical harmony,"[250] and that aesthetics is "the seeking out and implementation of those rhythms which will enhance life and expand consciousness, . . . a necessary psychological function which furthers the evolution of the organism" by allowing it to become "completely integrated with the rhythms of life."[251]

The Symbolist poets and artists, including van Gogh and Gauguin, wrote similarly of decorative beauty in art as arising from universal, structuring laws of a mathematical and musical nature, and believed that the apprehension of beauty induces a powerful spiritual experience. Van Gogh observed to his brother that "the laws of the colors are unutterably beautiful, just because they are not accidental,"[252] and he insisted that the painter could not make these laws manifest simply by copying the way colors appeared in nature. In explaining how he achieved a decorative effect in his work, his terminology reveals his awareness of the relationship between color, music, and mathematical proportions as expressions of natural law:

Of nature I retain a certain sequence and a certain correctness in placing the tones, I study nature so as not to do foolish things, to remain reasonable; however, I don't care so much whether my color

is exactly the same, as long as it looks beautiful on my canvas, as beautiful as it looks in nature. . . . One loses that general harmony of tones in nature by painfully exact imitation; one keeps it by recreating in a parallel color scale which may be not exactly, or even far from exactly, like the model.

Always intelligently make use of the beautiful tones which the colors form of their own accord when one breaks them on the palette, . . . starting from one's palette, from one's knowledge of the harmony of colors is quite different from following nature mechanically and servilely.[253]

According to the reminiscences of his artist friend Anton Kerssemakers, van Gogh was often even more explicit about the relationship of painting to mathematics and music. Kerssemakers claimed that van Gogh advised him to study the angles and spatial arrangements and tonal relationships of forms more closely so as to be able to contrive a more truthful equivalent of nature in his work, and in doing so he reminded him that "'painting is like algebra: something is to this as that is to the other.'"[254] Moreover, Kerssemakers noted:

He was always drawing comparisons between the art of painting and music, and in order to get an even better understanding of the values and various nuances of the tones, he started taking piano lessons with an old music teacher who was at the same time an organist in Eindhoven. This, however, did not last long, for seeing that during the lessons Van Gogh was continually comparing the notes of the piano with Prussian blue and dark green and dark ocher, and so on, all the way to bright cadmium-yellow, the good man thought he had to do with a madman, in consequence of which he became so afraid of him that he discontinued the lessons.[255]

The music teacher's inability to see beyond the conventional compartmentalization of phenomena and grasp the essential unity of nature's manifestations in sound and color was typical of the blindness and insensitivity which the Symbolists felt characterized the West's entire approach to life. In a letter to Theo written from Arles in the south of France, van Gogh pursued a train of thought which, through a series of what at first seem to be nonsequential, fragmented passages, reveals the relationship he perceived between art, music, spirituality, and the law of natural harmony. He first commented that although Arles was no longer as beautiful as it had been in the past, he was nevertheless content to remain there and contemplate it patiently because with long observation its old charm became perceptible. He went on to remark that he had read an article on Wagner entitled "Love in Music," and that he believed one needed "the same thing in painting:" in other words, attentive emotional involvement is required to appreciate the essential aesthetic qualities of both visual and

musical arrangements. Moving next to Tolstoy's views on religion and the possibility he held out of a new spirituality (something van Gogh didn't define here but which the reader familiar with Tolstoy's work knows was to be based on a loving respect for and sense of affinity with others), he declared that "in the end we shall have had enough of cynicism and skepticism and humbug, and we shall want to live more musically. How will that come about, and what will we really find?" Dismissing the idea that the future holds only war or cultural bankruptcy, he offered as an example of "living musically" the Japanese artist who spends his time studying "a single blade of grass:" an occupation which next "leads him to draw every plant and then the seasons, the wide aspects of the countryside, then animals, then the human figure." Living musically meant to van Gogh grasping the unifying harmonious relationships of all aspects of nature through loving attentiveness to its details and their interactions. Relating this "musical" approach to life to the essence of natural spirituality, he concluded: "Come now, isn't it almost a true religion which these simple Japanese teach us, who live in nature as though they themselves were flowers?"[256]

Gauguin wrote at even greater length than van Gogh on these issues, and evidenced more awareness that his ideas had been influenced by a great deal of Romantic thought. In one of his journals he cited Swedenborg's view that harmonic principles are divinely ordained and artists are the transmitters of religious wisdom about the nature of the cosmos:

There is in the firmament a book in which is written the law of harmony and of beauty. The men who know how to read this book are the favorites of God, says Swedenborg. He adds that since the artist is the true chosen one, because he alone has the ability to write this message, one should regard him as a Divine messenger.

And Swedenborg was a wise man! [257]

Like other Symbolists, Gauguin's conception of the laws of harmony was linked to his understanding of the principle of universal correspondences and his belief that their expression in aesthetic style required the distortion of appearances. In his "Synthetic notes" he countered the conventional Academic criticism that the avant-garde deviated from physical reality by arguing that the only inadmissible exaggeration is one which creates an imbalanced effect that is not consonant with the scientific laws of harmony in nature: "Ah!" he exclaimed, "if you mean by exaggerated every badly balanced work, then in this sense you are right; your work . . . will be accused of exaggeration when there will be a fault of harmony. Is there then a science of harmony? Yes. In this regard the sense of the colorist is precisely natural harmony."[258] The laws of harmony relate

to mathematics and aren't easy to understand, Gauguin maintained, but they enable one to penetrate more deeply into nature's secrets. Regarding the artist's task, he wrote: "What an accumulation of numbers, a veritable Chinese conundrum, and it is not surprising that the science of the colorist is so little investigated by painters and so little understood by the public. But also what a wealth of means for entering into an intimate relation with nature."[259]

In a newspaper interview, Gauguin expanded on the relationship between intelligent artistic distortions and the revelation of essential realities through the creation of musical harmonies that have the power to enlarge the mind by provoking associative thought. His own distortions, he claimed,

are absolutely willful! They are necessary and everything in my work is calculated, meditated a long time. It is music, if you like. By the arrangement of lines and colors, with the pretext of some subject borrowed from life or from nature, I obtain symphonies, harmonies representing nothing absolutely real in the vulgar sense of the word, expressing no idea directly, but which should make one think just as music makes one think, without the help of ideas or images, simply by the mysterious affinities that exist between our brains and certain arrangements of colors and lines.[260]

Gauguin, who played several musical instruments and wrote often of the ecstatic feelings music aroused in him, made frequent references to the similarity between painting and music. In some early notes linking the creation of beauty to the expression of a religious sentiment, he claimed that decorative art is like polyphony, a symphony, akin to the orderly auditory arrangement of thought we like to hear in a cathedral.[261] This idea persisted throughout his career, emerging in his last journal as a defining characteristic of the "poetry" inherent in all symbolizing painting:

I will affirm however that in regard to colors, the poem should be more musical than literary. . . . Quite a while ago, what did Delacroix want to say when he spoke of the music of the picture?

Make no mistake about it, Bonnard, Vuillard, Sérusier, to cite several young ones, are musicians, and be persuaded that color painting is entering into a musical phase.

Cézanne, to cite an old-timer, seems to be a student of César Franck; he plays constantly on a great organ, which made me say that he was polyphonous.[262]

As the first line of this passage makes clear, Gauguin associated the musical quality of painting with the mysterious, evocative poetry of nature and art. Viewing reality as ambiguous, nuanced, multirelational and full of subtle associative meaning, he felt that art had to be the same in order to convey life's essential quality and impact. It was for this

reason that he told his friend Daniel Monfreid that "there is, in short, more point to looking for suggestion than description in painting, as is also the case with music."[263] Pursuing this point in some notes in which he again paraphrased the ideas of Achille Delaroche, he called color "the language of the listening eye" and declared: "Color being in itself enigmatic in the sensations that it gives us, one can logically only employ it enigmatically, every time one uses it not for drawing, but for giving the musical sensations that flow from it, from its own nature, from its interior, mysterious, enigmatic force."[264] Justifying the inexplicable aspect of his work in a letter to his friend Fontainas, he again related its associative and evocative qualities to the experience of the mystical consciousness when he quoted Mallarmé's description of his poetry as a dream sharing the necessarily vague and suggestive nature of music: "a musical poem" without a libretto.[265] Trying to pinpoint precisely how painting achieves this musical effect, Gauguin concluded once more that it is its ability to recreate nature's interior force that makes music, whether auditory or visual, such an important mode of expression:

. . . these repetitions of tones, of monotonous accords, in the musical sense of color, wouldn't they be analogous to these oriental monotonous intonations chanted in a shrill voice, accompanied by vibrant notes which lie in contiguity to them, enriching them by opposition. . . . Delacroix with his repetitious harmonies of chestnuts and dull violets, a somber cloak suggesting the drama to you. . . . look attentively at Cimabue. Think also about the musical role that color will take from now on in modern painting. Color which is vibration just as is music, can similarly attain what is most general and therefore most vague in nature: its interior force.[266]

In these statements we have the parallel of Carlyle's and Lewis Thomas' contention that musicality is the fundamental expression of nature's primal force; that in the vibrations or rhythms of music we find the echo of the lawful patterns of energy that shape the universe. Gauguin repeated this observation in a variety of ways, noting for example that "a green next to a red doesn't yield some reddish brown as a mixture, but two vibrant notes,"[267] or remarking that the rhythmic patterns of moonlit bamboos outside his Tahitian hut created the visual effect of a stringed instrument whose music put him to sleep.[268] Like Pythagoras and many Neoplatonists, Gauguin understood that the ordered rhythmic intervals which constitute music are also the basis of mathematics, and as such reflect the nature of the unity that informs creation.

In his "Synthetic notes" he observed that "instrumental music has, like numbers, a unity for its basis. The entire musical system devolves from this principle."[269] Because music possesses the ability to impress us directly and sensually

with the rhythmic and harmonic patterns of nature, Gauguin called it his "great consolation,"[270] and because painting has a similar capacity to transport us to the heart of creation, he credited it with being the "sister of music."[271] Ultimately, however, he felt that painting is superior to music as an experience of synthesis, for it condenses not only emotion and idea but vision into a single harmonious accord which is spatially and temporally unified and therefore more intense, immediate, and synthesizing in its impact. In the "Synthetic notes" he paraphrased the argument of Delacroix when he wrote:

Painting is the most beautiful of all the arts; in it all sensations are summarized. . . . A complete art which incorporates all others and completes them. Like music, it works on the soul through the intermediary of the senses, the harmonious tones corresponding to the harmonies of sound; but in painting one obtains a unity impossible in music where the accords come one after another and one's judgment therefore feels an incessant fatigue if it wishes to reunite the end to the beginning. . . . Sight alone produces an instantaneous impulse.[272]

Gauguin claimed that "by means of expert harmonies the symbol is created,"[273] an idea which his friend Morice expanded when he wrote that "we seek the Truth in the harmonious laws of Beauty, deducing from them a whole metaphysic—because the harmony of nuances and of sounds symbolizes the harmony of souls and of worlds— and all morality."[274] In this concept we see that the Symbolists' five requirements of art (that it be ideist, symbolist, synthetist, subjective, and decorative) are themselves seamlessly unified into one circular theory. Art is the expression of Idea, a recreation of eternal truths of nature grasped by the artist through the vehicle of the Dream, an experience of mystical consciousness achieved by engaging all one's faculties in contemplation of the world. This artistic recreation takes the form of a plastic symbol, equivalent to a metaphor or parable, which, through the agency of the correspondences or underlying similarities that bind all things together, signifies in a suggestive and expansive way information about both the world and the artist's responses to it. Because this symbol synthesizes many aspects of being, it has the capacity to evoke in the spectator an infinite variety of sensations and associations. It effects its expressive synthesis through the distortion of physical forms: the exaggeration, deformation, abstraction, simplification, and condensation of material elements into a new organic unity manifesting both the individual's subjective vision and the structural laws of nature. This decorative unity called Beauty is also the Idea: a visual reflection of the mysterious ordering principle which balances all nature's

diverse forces in an interactional harmony that we call the rhythm of life. As such, the work of art is a revelation of universal religious truth, the expression of humanity's deepest comprehension of all the related physical and spiritual aspects of nature, a symbol of our own complete union with the world and with God, and the only means of providing others with an unbounded sense of spiritual enlargement and exaltation. It was on the basis of these concepts that the Symbolist writer André Barre offered the following summation of the movement's ideology:

Mystery, philosophic truth and the symbol are affairs of religion and of art, the one, moreover, being only the second form of the other. Artists are, in effect, creators of religious symbols and by that they are superior to priests. Direct emanations of the Divinity, they reproduce his word, they translate his thoughts. They are the prophets of this always hidden truth. . . . Art is not separate from religion, because art derives from a superior morality and is itself a religion.[275]

As we turn from this exploration of Symbolist theory to an examination of the art of van Gogh and Gauguin, we shall see how deeply these ideas influenced their work. Both men strove to find personally meaningful ways of embodying their vision of life in aesthetic forms which could convey their wisdom to others. Both created symbolic repertoires of significant, evocative images which through expressive formal and coloristic relationships communicate spiritual truths about nature and human existence. The art of each illuminates the principle of synthesis by symbolizing the interactive relationship between life and death, change and renewal, love and suffering, and exaltation and resignation. The art of each is also about the insatiable human desire for knowledge and experience, and the combination of despair and consolation we derive from them. Ignored or ridiculed in their lifetimes, van Gogh and Gauguin have ultimately achieved fame because their work, in uniquely beautiful and powerfully moving ways, reveals the meaning of life and suggests a philosophy of how to live that is universally and eternally applicable. The final issue to be addressed here, then, is a paradox which seems to flaw the concept of art as a communication of spiritual wisdom. If great works of art are by necessity so subtle and complex, if their meaning is so veiled and indirect and difficult for the ordinary spectator to penetrate, how can they be considered universally accessible expressions of a kind of knowledge that is vital for the well-being of humanity? Why was the public of the 1890s incapable of perceiving and appreciating the beauty and the significance of van Gogh's and Gauguin's art, and why do people in most cultures find unfamiliar kinds of imagery unpalatable?

The Paradox of Art: Elite or Universal Wisdom?

Philosophers since antiquity have grappled with the question of art's accessibility, and most have concluded that in complex societies art is an elite activity whose products are comprehensible and meaningful only to the sensitive and enlightened few. Plato declared that aesthetic judgment is relative and variable in accordance with the spectator's "virtue and education,"[276] and Plotinus held that "to any vision must be brought an eye adapted to what is to be seen, and having some likeness to it."[277] These convictions underlie most Romantic theories of art and are admirably summed up in the English Lord Shaftesbury's exclamation:

What difficulty there be in any degree knowing! How long ere a true taste is gained! How many things shocking, how many offensive at first, which afterwards are known and acknowledged the highest beauties! For 'tis not instantly we acquire the sense by which these beauties are discoverable. Labor and pains are required, and time. . . .[278]

Shaftesbury's contention that the understanding and appreciation of art require careful examination, contemplation, and a cultivated judgment[279] was upheld by European philosophers and artists throughout the Romantic period. From Swedenborg's mystical notion that although "the speech of the spirits is universal" it is comprehensible only to those who are blessed with "the inner eye of the soul,"[280] to Kant's rationalist argument that the beauty and significance of art are available only to those select few who are practiced in the free relational play of the cognitive faculties of imagination and understanding,[281] Romantic intellectuals agreed that art is not an open book to all. Schopenhauer was particularly insistent that although in art "the wisdom of the nature of things itself speaks, everyone . . . must certainly contribute out of his own means to bring that wisdom to light; accordingly he comprehends only so much of it as his capacity and culture admit of."[282] The expanded Platonic Idea which is the subject of great art, Schopenhauer wrote,

is only attainable by the man of genius, and by him who, for the most part through the assistance of the works of genius, has reached an exalted frame of mind, by increasing his power of pure knowing. It is therefore not absolutely but only conditionally communicable, because the Idea, comprehended and repeated in the work of art, appeals to everyone only according to the measure of his own intellectual worth. So that just the most excellent works of every art, the noblest productions of genius, must always remain sealed books to the dull majority of men, inaccessible to them. . . .[283]

Schopenhauer went on to explain why it is that great art is so often unappreciated in its own time, and how it eventually comes to be accepted and revered. Innovative works are "coldly received by their own age" and "slowly and unwillingly recognized," he claimed, because so few people in any given period are receptive enough to grasp them. Those sufficiently sensitive and perceptive come along "singly and rarely," but their votes, accumulated gradually over the years, constitute the authority "which alone is the judgment-seat we mean when we appeal to posterity . . . for the mass of posterity will always be and remain just as perverse and dull as the mass of contemporaries always was and always is"[284] It is because the slowly acquired weight of the opinions of an ongoing elite eventually influences the public to open its eyes and be receptive to an unconventional work of art that the once-despised object comes to be considered a masterpiece and taste has been changed.

Schopenhauer's opinion of the perversity and unperceptiveness of the general public was shared by Carlyle, who exclaimed in *Sartor Resartus*:

Strange enough how creatures of the human-kind shut their eyes to plainest facts; and by the mere inertia of Oblivion and Stupidity, live at ease in the midst of Wonders and Terrors. But indeed, man is, and was always, a block-head and dullard; much readier to feel and digest than to think and consider. Prejudice, which he pretends to hate, is his absolute law-giver; mere use-and-wont everywhere leads him by the nose.[285]

It was from this conviction that Carlyle developed his theory of the social import of the hero, the artist or poet, priest or prophet who raises the standard of high ideals and opens peoples' minds to significant truths. It is the acts and creations of rare, insightful geniuses, Carlyle held, which inspire others and elevate us from our normal state of lethargic and complacent mediocrity, which maintain civilization and ensure that the symbols of religious wisdom which are our most precious heritage will continue to be transmitted and renewed.[286]

Renan espoused the same view in *The Future of Science*, maintaining that while most people never enjoy the "rich delights" that unfold from the cultivation of the faculties, the indirect and subtle influence of those in positions of respect and authority, whom Renan mistakenly assumed would always be persons of humanistic education and culture, would have an impact in moving others toward high moral, spiritual, and aesthetic values.[287] In a volume of philosophical musings of 1871, in a section entitled "Dreams," Renan claimed that although democracy has many benefits, its current ideology and practice rest on a

false premise because people are not and never can be completely equal in their aptitudes and accomplishments, and to accord equal weight to their opinions on all subjects is ultimately damaging to society. Nature's way, he held, "is not that all men see the truth, but that the truth is seen by some, and its tradition conserved." It is unrealistic to imagine that all people can be brought to an ideal state of wisdom; instead, "the essential thing is that great culture be established and make itself mistress of the world, by making its beneficent influence be felt by less cultivated parties."[288] The maintenance of great culture, Renan believed, doesn't depend on its being upheld by everyone, but because the tendency of democracy is to pull the level of society's values down to a superficial and vulgar median, the existence of an enlightened elite is nature's way of sustaining an equilibrium between humanity's brute impulses and most exalted spiritual aspirations.[289]

Innumerable artists of the Romantic period expressed similar ideas. Stendhal and Flaubert, Baudelaire and Delacroix, Renoir and Cézanne lamented that the perceptual and intellectual inadequacies of the majority made them blind to the beauty and meaning of great art. The Symbolists laid the blame for this situation on the failure of modern society to educate the general public properly in matters of aesthetic appreciation. As Signac put it, "Why complain about the lack of taste when nothing is done to educate the eye? To learn the piano one exercises the fingers. . . . They have eyes and they don't see."[290] The Symbolists addressed this problem repeatedly in their articles and reviews, and the critic Gustave Geffroy expressed the general tenor of their ideas when he wrote that people have so much difficulty in their encounters with art because "too many prejudices, artifices, and habits interpose themselves between the person who looks and the work that is regarded."[291] Because people are indifferent to real power and originality and are contemptuous of the unfamiliar, he claimed, they refuse to participate in the active collaboration necessary for appreciation by making the effort to investigate a work attentively and openly.[292] But although a result of democracy has been the participation in art patronage of a class whose values and education make it hard for them to appreciate either the unusual forms or the intellectual and spiritual implications of serious and original works, Geffroy and the Symbolist artists optimistically hoped that with time, exposure, and education the public would regain the respect for art and the capacity to comprehend it that people in "primitive" or traditional societies have always enjoyed. The value of art for human culture, they felt, is not only that it brings "comfort and exaltation,"[293] but that it can help us evolve a more harmonious, fruitful and fulfilling life. Geffroy wrote regarding art's potential:

I believe art is a powerful factor in this evolution. I believe artists [are] destined to exercise, more than ever, an influence on the destinies of the crowd. Art is a demonstrator of life. It penetrates it, it summarizes it, it makes it comprehensible, it will play a more important role than one supposes in the societal transformation of tomorrow. I mean, of course, art in its entirety, art mingled in existence, in manual labor as well as in cerebral labor, in the individual's relaxation and in manifestations of national existence, the art of books and of music, the art of painting and of theater, of architecture, of sculpture, and of the object. It is made to replace, by placing value on life, the so vaunted productions of religions, the pomps of processions where the crowd is a spectator, the military occasions where it is the victim. It can give to all, simultaneously with the joy of the spectacle, the joy of creation.[294]

Bernard, who agreed that in the present state of affairs "the more an artist is original and spiritual, the less chance he has of being spontaneously admired by all,"[295] hoped to encourage people to change their attitude toward great art by enlarging on its role as a positive force in modern life. The value of preserving and interpreting art, he claimed, is that it is the supreme vehicle for and impetus to our spiritual development, and as such provides a necessary balance to the utilitarian concerns that necessarily dominate so much of our time and mental energy. Bernard contended that without the mitigating force of art, civilization in the broad humanistic sense of the word would be impossible. Echoing the Buddhist idea that "to meditate a form is to meditate the world," he argued that the contemplation of art broadens our understanding of nature and of life, and by spiriting us outside our normal embroilment in "the degeneracy of the actual, it offers us a salutary oasis."[296] As the religious beliefs which once provided this outlet and refuge weaken even more, as religion ceases to be a practical force in our daily lives, he concluded, art will become increasingly necessary as the remaining form of religious faith. Bernard's explanation of the way in which art becomes an expression of spiritual belief relates to the reasons that religions have so often used art to convey their wisdom, and in considering his ideas it is important to remember that the Symbolists shared Poe's and Baudelaire's conviction that "the beautiful is always strange," and often has nothing to do with prettiness:

The work of God, nature, is the only thing that makes us live, that is to say, to think continually. The work of man can make us think, but for that it must be beautiful, that is to say poetic, that is to say inspired by nature, source of all poesy. Spiritual activity requires the beautiful work. In our ugly cities, beings end up by ceasing to think. . . . Nothing is more useful, morally, than a beautiful public garden, than a noble building. The day when these last vestiges of beauty will be refused to the inhabitants of our cities, souls will be irremediably

debased. Noble feelings only exist in hearts which glimpse God; now to look at beauty is already to see God a little; for God being the very activity of thinking, all spiritual activity ceases without the essential stimulus of the Beautiful.[297]

We have already encountered many of van Gogh's and Gauguin's views on the public's unthinking conventionality and preference for whatever is banal and easy in both moral and aesthetic affairs. Van Gogh told van Rappard regarding his deviations from Academic style that the power of his paintings would "out-thunder all mistakes—given a public with character enough to look at the things *with a reflective mind*,"[298] but the fact that he wasn't overly sanguine about his chances of encountering such an enlightened public is evident from a remark he made to Theo on this subject:

Years ago I read something . . . in Renan, which I have always remembered, and shall continue to believe, namely that he who wants to accomplish something really good or useful must neither count on nor want the approval or appreciation of the general public, but, on the contrary, can expect that only a very few hearts will sympathize with him and take part in it.[299]

Despite this intellectual recognition, van Gogh's evangelical spirit was so strong that for years he struggled in the teeth of all resistance to share his vision with the public. The critic Octave Mirbeau wrote of him:

The vocation of art sometimes has this apostolic character. . . . van Gogh wants to be useful. . . . to devote himself to others. What always wounded him, what pains him . . . what he would like to cure, . . . is ugliness . . . is men's ignorance, the predominance of bestiality over the spirit, grown dull from gross appetites, from servile preconceptions, from grievous follies. Then an ardent need for proselytizing pushes him towards people. . . . He seeks out the masses . . . speaks to them. . . . He would like to elevate them towards something higher, purer. . . . He tries to explain to them what moral beauty is . . . what beauty is. But the masses understand nothing of his new language.[300]

It was van Gogh's eventual resignation to the unlikelihood of ever gaining "converts" within his own lifetime that caused him to transfer his hopes to the accumulated judgment of posterity and content himself with his conviction that his work had "its raison d'être and continuance in the future."[301] Succeeding generations, he felt, would derive from his art the same peace, exaltation, and assuagement of loneliness and despair that he experienced from nature and from the books and art which illuminate life for us. Both the creation and delectation of art were for him a source of renewal, "a force of resurrection stronger than any act,"[302] and believing as he did in the far-reaching repercussions of

all experience, he was sure that the fruits of any personal renewal, whether tangible or psychological, involved a creation of spiritual beauty which would work to the general benefit of humanity. It was from this conviction that he wrote to Theo that

the man . . . who finally produces something poignant as the blossom of a hard, difficult life, is a wonder, like the black hawthorne, or better still, the gnarled old apple tree which at a certain moment bears blossoms which are among the most delicate and most virginal things under the sun. . . . The artist's life, and what an artist is, it is all very curious—how deep it is, how infinitely deep.[303]

For Gauguin too, the artist's life and vocation were a mystery and an anomaly in the modern world. Observing that "the public wants to understand and acquire in a single day, a minute, what the artist has spent years in learning,"[304] he claimed that to judge a work of art in any meaningful way "one must have—besides intelligence and [an understanding of] artistic science—special sensations before nature, one must be, in a word, born an artist, and few are chosen among all those called."[305] Gauguin didn't mean by this that only artists can appreciate art, but that one must share the artist's sensitivity to and fascination with phenomena in order to grasp his parables and read the pages of the book which is sealed to those who have eyes but cannot see.[306] Suffering as he did from habitual ridicule, he mused: "Ah! if this good public would finally want to understand a little, how I would love it!"[307] Meeting their rejection with his own stubborn pride, however, he, like van Gogh and so many other artists of the period, put his faith in the future. In 1888 he wrote to Schuffenecker: "I well know that they will understand me less and less. What does it matter if I distance myself from others, for the mass I will be a puzzle, for a few I will be a poet, and sooner or later the good takes its place."[308] During subsequent years, Gauguin increasingly relied for moral support on the judgment of those few kindred spirits who recognized that he was a poet, for as he told Daniel de Monfreid in 1893: "My Tahitian works have had a moral success with some artists, but with the general public, the result: *not a cent*."[309]

Gauguin's letters to his wife are filled with attempts to defend his calling and his hopes for eventual triumph, and he cited the opinions of "others who count" that "my business is art, it is my capital, the future of my children, the honor of the name I have given them, all things that will one day serve them. . . . Consequently, I work at my art which is nothing (in money) for the present (times are difficult), which is designed for the future."[310] It is significant that when he tried to justify to his daughter his "abandonment" of the family when it became impossible to both support them and pursue his artistic vocation, he pleaded

the overriding value of his work to the progress of civiliza-tion. "Isn't it a false calculation to sacrifice everything to the children," he argued, "and doesn't it deprive the nation of the genius of its most active members? You sacrifice yourself for your child who, becoming a man in his turn, will sacrifice himself, thus one after the other. . . . And the stupidity will go on for a long time."[311] Writing to his wife about the spiritual sensations he derived from the landscape and culture of Tahiti and the impact they were having on his art, he added: "Do not think for that that I am egotisti-cal and that I am abandoning you. But leave me some time to live this way. Those who reproach me don't know every-thing that is in an artist's nature, and why should they want to impose on us duties similar to their own? We don't impose ours on them."[312]

Gauguin's writings ring with his conviction that by devoting himself to his art he was fulfilling a sacred obliga-tion. He told his wife: "I believe that I am doing my duty and strong in that, I accept no advice, no reproach;"[313] he insisted to Monfreid that "I feel that in art *I am right* . . . in any case I will have done my duty and if my works don't remain there will always remain the memory of an artist who liberated painting from many of its former academic mistakes."[314] Van Gogh once told Aurier: "Gauguin . . . likes to make you feel that a good picture is equivalent to a good deed; not that he says so, but it is difficult to be on intimate terms with him without being aware of a certain moral responsibility."[315] It was from this inner sense that Gauguin derived the courage to continue on his thorny path. He wrote to his wife from Tahiti: "Every day I say to myself, there, another day won. Have I done my duty? Fine, let us go to bed now, tomorrow I shall perhaps be dead."[316] Passionately convinced that his highest moral obligation was to bring his God-given gifts to fruition for the welfare of others, he told her:

It is necessary that I continue the struggle always, always. And the fault again rebounds on Society. You have no confidence in the future; but as for me, I have confidence because I want to have it. Without that I would have blown my brains out a long time ago. To hope is almost to live. I must live in order to do my duty up to the

end and I can do it only by forcing my illusions, by creating hopes in the dream.[317]

In his journal *Before and after*, Gauguin related a curious dream which illustrates his belief that both the spiritual development of humanity and his own artistic struggle were divinely ordained. In the dream he found himself back in primordial times, surrounded by primitive, monkeylike humans, when suddenly a smiling angel followed by an old man with an hourglass appeared before him and explained to him God's plan of continuous human spiritual evolution:

Be informed that these beings are men like you were in the past when God began to create you—Ask the old man to lead you later to infinity and you will see what he wishes to make of you and you will find that today you are singularly unfinished—What would the work of the creator be if it was of one day? God never rests—The old man disappeared and awakened, lifting my eyes to the sky, I caught sight of the angel with white wings who mounted towards the stars. Its long blond tresses passed into the firmament like a train of light.[318]

It is each person's responsibility, Gauguin felt, to parti-cipate to the utmost of his ability in this divine elevation of the species. He expressed the philosophy of all serious artists, and particularly of those who like himself and van Gogh persisted in the face of great hardship and personal sacrifice, when he wrote toward the end of his journal: "On an intelligence that is my own I have wanted to build a superior intelligence which will become that of my neigh-bor if it suits him. The effort is cruel but it is not vain. It is from pride and not from vanity."[319]

In the following chapters we shall see how the specific events of van Gogh's and Gauguin's lives and the ideas they had developed about the world and their role as artists shaped the form and the content of their art. Although today our eyes have been opened to the beauty of their work, our appreciation of its profound meaning can only be enhanced by a greater knowledge of their experiences and the manner in which they encoded their spiritual wisdom.

PART TWO

"The Existence of God and Eternity:"
Van Gogh's Search for Spiritual Salvation

Out of Darkness

B Y THE EVIDENCE OF HIS OWN LETTERS AND BY THE description of everyone who knew him, Vincent van Gogh was a deeply spiritual man. Born the eldest of six children in Zundert, Holland on March 30, 1853, the son of a pastor and the nephew of three art dealers, he grew up in a family in which religious and artistic interests were mingled.[1] Although he enjoyed drawing during his youth Vincent never envisioned becoming an artist, and in 1869, at the age of sixteen, he went happily to work as a junior apprentice in The Hague office of Goupil & Co., an international art firm in which his uncle "Cent" (Vincent) was a partner. Specializing in the publication of graphic reproductions of works of art, Goupil was a large, successful business with other branches in London, Brussels, and Paris, and during Vincent's first successful years in The Hague a comfortable and secure future must have seemed assured to him. When, at the age of twenty, his achievements were rewarded with an appointment to the London office, his supervisor wrote him a glowing testimonial and told his parents how well-liked he was by everyone.[2]

Finding lodging in the home of a curate's widow who ran a school for little children with her daughter, he spent an exuberantly happy year in the company of two women whose goodness and loving relationship seemed to him exceptional, and it was perhaps unavoidable that he fell in love with the daughter, Ursula. When he revealed his feelings to her, however, he learned that she was already engaged to their other boarder. She persistently refused Vincent's advances, and from the moment of her rejection, personality changes began to disturb the course of his career. He grew despondent and silent, thin and withdrawn, and as loneliness began to overwhelm him he dwelt more and more on religious issues, becoming increasingly restless and dissatisfied with his life, increasingly moody and argumentative. He spent much of his time alone, read-

ing literature and philosophy, and gradually he developed a longing to discover and fulfill his inner potential, to elevate himself and sacrifice himself in some great cause that would benefit humanity. As these obsessions deepened, so did his problems with relationships. Although during subsequent years his warmth and broad intellectual interests attracted friends, most were eventually alienated by his impassioned, stubborn opinions, his tendency to sermonize about all his ideas and feelings, his extreme emotional neediness, and his impossibly high standards of friendship. During the years of his early manhood his only real friend was his younger brother Theo, with whom he began to correspond in 1872 when Theo was fifteen, and with whom he maintained a close but often stormy relationship until his death eighteen years later. Vincent's junior by four years, Theo went to work for the Brussels branch of Goupil & Co. in 1873, and with this additional bond became his brother's principal confidant and connection to the family circle from which Vincent felt increasingly estranged.

Vincent's growing spiritual yearnings and distaste for his bourgeois employment and the entire comfortable world of social values it represented intensified when he was posted to Paris against his will. Brooding and depressed, he isolated himself even more from social intercourse and spent his free time poring over the Bible. When in 1876 it became clear that his antisocial manner and reluctance to pursue his employer's material advantage were losing sales, he left his job with Goupil, now a part of Boussod & Valadon. Returning to England, he taught for a while at a boarding school in Ramsgate and occasionally preached in the poor neighborhood of Isleworth outside London. Eventually deciding to try to actualize his religious leanings in an acceptable way, he began to prepare for entrance into a theological seminary. As he studied the

Latin and Greek necessary to read the texts which formed the basis of the curriculum, however, he realized that the rigid emphasis on dogma and doctrine which was so central to academic, institutionalized theology seemed to him the antithesis of what people really needed from religion. Abandoning this plan in 1878, therefore, he joined an evangelical ministry working with coal miners in a depressed region of Belgium called the Borinage. Although he threw himself unreservedly and selflessly into his work, his appointment was not renewed after the first year because it was felt that he was too zealous and unconventional in his attempts to follow the original precepts of Christ. By giving away all his possessions to the impoverished miners and living as the most destitute among them did, by going into their cottages to bring the comfort of the Gospel directly to them instead of waiting for them to come to church, he must have seemed to the authorities both an undignified role model and a dangerous influence on the lower class's expectations of the clergy.

It was following this rejection that in August of 1880 Vincent decided to become an artist, a vocation he inaugurated by copying some of Jean-François Millet's images of field labor (figs. 29 and 30). He found that the drawings he made of the toiling and ravaged peasants gave him a

religious satisfaction, and he came to believe that if he could depict the most salient aspects of their difficult lives with dignity and empathy, he would open the public's eyes and hearts to the plight of the poor and possibly even bring the common people some measure of solace for their suffering. He embraced art because he perceived it as an alternate path to religion by which he could achieve his goal of benefiting humanity through the expansion of truth and love, and it was his conscious, stated purpose to produce a cumulative body of visual images whose collective meaning and impact as spiritual parables would be valuable to others and the proof of his own worth as a human being.[3] It was because he believed that his desire to be an artist was grounded in a high spiritual purpose that he was able to withstand his parents' practical objections and displeasure and resign himself to accepting financial support from Theo, a difficult and sensitive issue which caused much grief over the ensuing years. It was his belief in the religious nature of his artistic calling that supported him through another deeply wounding rejection, when in 1881 his older cousin Kee, a young widow with a small child, emphatically spurned his love and left town to prevent him from persisting in his unwelcome and inappropriate suit.

"Sorrowful Yet Ever Rejoicing:" The Northern Works, 1881–1885

For five years Vincent drew and painted in various cities and villages in Holland and Belgium, and from the very beginning his work revealed his anti-Academic bias and the nature of his spiritual and moral concerns. He depicted only earthy, humble scenes—the kinds of people, landscapes and objects which typified the bleak lives of the poor and aroused his own compassionate feelings for them. During 1881 and 1882 he confined himself to drawing (figs. 31 and 32), trying to find ways of rendering the most salient qualities of form with the simplest possible means. Although he occasionally took lessons, he usually worked from nature and allowed his style to develop naturally as a transcription of what he saw and felt. His peasants' bodies are misshapen and awkward because their lives had made them so: he emphasized their stumpy proportions, bent backs, and knobby limbs to reveal the results of poor nourishment and the unremitting hard labor of tilling the soil and trudging under heavy loads. He was aware that the suave elegance of Academic technique was incapable of capturing such harsh realities, that it would trivialize them by giving them a false charm, and he felt that his simplified style with its rough, angular line and bold contours was the appropriate vehicle to convey the essential crudeness of his subjects' lives and milieu. Believing that "the type distilled

from many individuals . . . is the highest thing in art, and *there* art sometimes rises above nature,"[4] he stripped his generalized figures of all that was extraneous to "the real character," reducing them to the coarse, ill-fitting clothing that defines their graceless shapes, and to the postures and expressions that best convey the physical and emotional repercussions of their existence. In keeping with his conviction that distortion is necessary for expression, he has also exaggerated their most telling features to intensify their visual and emotional impact on us. Although his first figures are often awkward and stiff and his technique seems crude, he struggled from the beginning to make each stroke strong and purposeful in its descriptive effect.

Influenced by contemporary Dutch painters Anton Mauve and Adolphe Monticelli, whose work combined a gentle Naturalism with Impressionist brushwork (figs. 33 and 34), Van Gogh applied the same principles to all his early paintings. His landscapes (figs. 35 and 36) are as minimal as his figure studies, condensed into layered divisions of earth, sea, and sky with roughly streaked-in strokes of paint to create the effects of furrows and clods, waves or clouds. Many of these northern pictures use a dark-toned palette of drab, closely related colors which conjure up the chill gloom of the climate as well as of the peasants' lives.

Even when his colors are brighter and more intense (figs. 37 and 38), his scenes often evoke a mood of mingled melancholy and mystery, of human loneliness mitigated by a transcendental sense of the poetry of nature. In comparison, most of his depictions of human dwellings (figs. 39 and 40) appear even more oppressive than their settings. Featureless farms and rude cottages painted in dark, muddy tones loom against the low Dutch skies, their squat forms more like outcroppings of earth than the homes of families. There is no hint of active life in these images: the occasional figure is reduced to a mere indication of presence, and the pervasive sensation is of silence and withdrawal. These somber, empty-looking hovels and unpeopled spaces create a poignant, almost menacing sensation of sadness, of hardship and isolation.

Although related to the genre traditions of seventeenth-century Dutch painting (figs. 41 and 42), van Gogh's images are very different in mood and technique from those visually accurate but emotionally neutral scenes of rural life. They are not only stylistically rougher and more reductive, but far more serious in psychological effect than his predecessors', for their purpose is neither to entertain, nor decorate, nor present physical data, but rather to reveal difficult aspects of human experience and kindle our emotional and imaginative responses to them. Hobbema presents us with a detailed description of a picturesquely conceived peasant landscape which seems to capture a casual moment in time but actually has a strongly romantic flavor. Van der Poel depicts a seedier, coarser aspect of peasant life, but his imagery, rendered in the factual, anecdotal style so typical of Dutch Baroque art, arouses little emotion or imaginative identification. Van Gogh, however, gives his lowly subjects spiritual significance. Typical of many of his early works, his 1884 painting *Farmers planting potatoes* (fig. 43) is a frieze-like representation of human toil in which generalized, emblematic figures are frozen into characteristic poses against a flat, evenly layered background of earth and sky. Stripped of all particulars, the image becomes a timeless, universally relevant symbol of the necessity for human beings to labor for their sustenance: a religious icon comparable to the bas-relief scenes of the Labors of the Months carved on the facades of medieval cathedrals (fig. 44) or painted in private breviaries to accompany the cycles of daily and seasonal prayers which ordered the Christian calendar and endowed basic life-supporting activities with sanctified meaning.

Van Gogh composed such icons to suggest that our fundamental need to wrest food from the soil is graced with dignity and mysterious beauty, that it reflects God's eternal order. The peasants' drab, dark clothing blends with the bare earth of which they seem a part, but where a beam of light touches a bent back with glowing color, its

beauty is all the more compelling and poignant for appearing so unexpectedly in such unprepossessing surroundings. Similarly, although the day is overcast, the clouds gleam with a rich, lemony light that burnishes the muddy ground with warm ocher tones and floods the sky with golden radiance. Like an emanation of deity, this nacreous light transforms the workers' task into a hallowed spiritual effort, an effect intensified by the ritualized quality of their poses and the silent, serious air with which they perform their labor. The restrained palette of muted colors enhances this mood of sobriety, as does the geometry of the composition. Everything in the canvas conveys the idea that nature is a divinely ordained system governed by the law of unified equilibrium. The picture plane is divided into two strictly horizontal bands of glowing sky and dark soil, against which the eternally toiling figures of the peasants are arranged in a contrapuntal rhythm of evenly placed vertical accents. An almost equally balanced number of male and female laborers, their heads all positioned along the horizontal median of the canvas, alternate between the foreground and midground to form an inward-facing, self-contained symmetrical pattern around the central opposed pair. The rigidity of this order is saved from lifeless sterility by innumerable small irregularities and variations: the single head rising above the horizon line on the right balancing one on the left which sinks below the others, the subtle differences of posture, the mottled and richly nuanced colors, the loose, fluid brushwork. Through such organic touches the vitality of life is conveyed, but the ordering principle so obviously at work here suggests that our struggle to survive is an integral part of some universal plan, some natural law. In their abstracting reductiveness and revelation of nature's geometric structure, in their flat, frieze-like composition and sense of timeless serenity, van Gogh's paintings of this period are the counterparts of Puvis de Chavannes' and Seurat's (figs. 21 and 22), but his subjects are earthier and more fundamental and his style seems more naturally appropriate to his forms than those of his avant-garde colleagues.

Vincent's still-lifes (figs. 45 and 46) also reveal how his treatment of ordinary things differed from the earlier Dutch pictures which were enjoying a renewed popularity with the nineteenth-century middle-class (fig. 47). He depicts only the meager and homely possessions of the very poor: their basic foodstuffs, their rough earthenware crockery and thick bottles of beer set out clumsily on plain tables against dark backgrounds. These early works never exploit the sensuous textural or coloristic nuances of forms; they never represent the luscious fruits and half-eaten pastries, the sparkling cut glass and gleaming tankards so scrupulously detailed for the viewer's delectation by seventeenth-century artists and currently so appealing to Academic

taste. Van Gogh presents his humble objects soberly and respectfully, not to capitalize on any superficial decorative allure, but to suggest the elemental nature of human lives in which such simple things provide the only material comforts. It was his sense of the spiritual implications of all the peasants' belongings and surroundings that opened his eyes to whatever pictorial beauty was inherent in their simple visual effects. The aesthetic qualities he wanted to capture, he told Theo, were subtle and subdued: the "splendid" look of "old oakwood against a grayish wall," the evocative "Rembrandtesque" quality of the lamplight in which a weaver worked, the mysterious juxtaposition of dark figures with colored cloth and white walls crossed with shadows.[5]

Van Gogh found plain, dun-colored vegetables and crude vessels compelling and meaningful because he felt that they evoked the essential character of peasant existence (figs. 48 and 49). Painted in dark, earthy pigments and overflowing in tumbled mounds from coarse wicker baskets or cheap pottery, his blemished onions and potatoes, his bruised apples or pears are as knobby and irregular as the bodies of the peasants for whom they are the staples of life. He explained to Theo that in these still-lifes "I tried to get the *corps*, I mean, to express the material in such a way that they become heavy, solid lumps—which would hurt you if they were thrown at you, for instance."[6] Redolent of the soil, their dirty surfaces and physical imperfections conveying the sobering truths that all growth is difficult and that hard labor was expended in their harvest, van Gogh's rude produce bears the heavy imprint of life's processes. By focusing on this suggestive aspect of physical forms and depicting their "defects" with respectful care, the artist imparts a sacramental quality to his lowly subjects.

It was Vincent's sensitivity to the latent meaning of material forms that underlay his choice of motifs. He devoted a series of paintings, for example, to the depiction of bird nests (fig. 50). These meticulously constructed nests sheltering their clutches of eggs must have had a dual attraction for him, for not only do they display the intrinsic beauty of such simple natural substances as twigs and mosses, but they also speak of the great effort expended by the birds that built them: the arduous toil which throughout nature is inseparable from life-sustaining activities. Always aware of the connections between the experiences of living organisms, he found eloquent examples of this natural law everywhere in the world of plants and animals. Stunted, ungainly trees (figs. 51 and 52), their trunks twisted into tortured, angular shapes or bulging with goiterous-looking boles, their branches like crippled or severed limbs, furnished mute reminders that all things are susceptible to the ravages of the elements and the struggle for existence. This was the metaphor he wanted to convey in the drawing of tree roots which he worked on simultaneously with the figure study he entitled "*Sorrow*" (fig. 53), images which he claimed both expressed this same idea.[7] The peasants' beasts of burden aroused similar feelings of compassion in him, and he executed a number of canvases in which knock-kneed, sway-backed horses and oxen droop between the cart shafts or wait listlessly with bowed heads (figs. 54 and 55). Describing to Theo a painting by his teacher and mentor Anton Mauve depicting horses dragging a heavy fishing boat up a dune, he concluded that the sight of these exhausted farm animals exerting all their strength to pull their load was better than any sermon on the virtue of resignation:

Those nags, those poor, ill-treated old nags, black, white and brown; they are standing there, patient, submissive, willing, resigned, and quiet. . . . They are panting, they are covered with sweat, but they do not murmur, they do not protest, they do not complain, not about anything. They got over that long ago, years and years ago. They are resigned to living and working somewhat longer, but if they have to go to the knacker tomorrow, well, so be it, they are ready. I find such a mighty, deep, practical, silent philosophy in this picture—it seems to say, "To know how to suffer without complaining, that is the only practical thing, it is the great science, the lesson to learn, the solution to the problem of life."[8]

This philosophical attitude permeates van Gogh's many interior scenes of peasants pursuing their domestic chores (figs. 56 and 57). As pared down to essentials as all his other subjects, the sparse furnishings of these hovels are not only an indication of poverty, but a means of focusing our attention on their inhabitants. In dim, low-ceilinged rooms whose gloomy shadows are intensified rather than relieved by the patches of outdoor light that gleam in the small windows or reflect fitfully off the dingy walls, men and women work ceaselessly at household tasks and cottage industries such as weaving. They are usually alone and often hemmed in by their looms or the other implements of their toil as if imprisoned by them, a visual metaphor for the harsh reality that locks the poor into their endless, repetitious labor. Yet there is a dignity and a deeply religious quality to most of these images. The people work silently, doggedly, uncomplainingly, their serious profiles illuminated by the light which scarcely penetrates their dark abodes but lends an aura of spirituality to their features. It is significant that Vincent chose not to depict the squalor and violence which so often accompany poverty. Instead, he portrays those quiet moments that reveal the courage and matter-of-fact patience with which these people accept their lives. He noted often that the Bible teaches that life is pain and travail, and he wanted his pictures not only to sensitize us to this truth, but to suggest that there is

something redemptive and holy in the perseverance with which the poor struggle to live. Years earlier he had written to Theo:

And I believe . . . that the victory achieved after a whole life of work and effort would be better than one gained sooner. Whoever lives sincerely and encounters much trouble and disappointment without being bowed down is worth more than one who has always sailed before the wind and has only known relative prosperity. For who are those that show some sign of higher life? They are the ones who merit the words, "Laborers, your life is dreary, laborers, you suffer during life, laborers, you are blessed" . . . It is good to try to become like this.[9]

Suffering and sorrow were Vincent's constant preoccupation during these years, and he captured their grim effects in his work with the same seriousness and spiritual sensitivity as Rembrandt (figs. 58 and 59). Many artists over the centuries depicted people grieving over some tragic event, but none had ever devoted themselves as he did to conveying the hopeless sadness of the poor, the deep despondency and anxiety which result from chronic want and ceaseless toil. His portraits from this period (figs. 60 and 61) evoke the tragedy of blighted lives more succinctly than any verbal description, but while they epitomize despair and desolation, there is also some mitigating element of stoic resignation, of inner strength. In his numerous drawings and paintings of people bowed down with care (figs. 62 and 63), there is no melodrama, no theatrical posturing: his figures succumb to grief or depression quietly, their slumped poses and faces buried in their hands eloquent evocations of inner collapse. Consolation in this restricted world comes only from genuine religious faith, evidenced in simple acts of prayer (figs. 64 and 65), and from love, which even when sorely taxed by the hardships of life can still give some solace to the poor (fig. 66). It is significant that Vincent's evocation of this emotion is never sweet and sentimental: while the tenderness between mother and child is apparent here, the woman's face is embittered and more expressive of depression than joy.

Van Gogh had ample experience of the problematic nature of love relationships among the lower classes. After a violent argument with his parents at Christmas in 1881— one of many involving the family's distress with his break from organized religion, his failure to settle down productively to some secure and financially remunerative work, and his increasingly unconventional ideas and manners— he moved away from home to The Hague. Having failed to elicit love from the respectable women he had earlier pursued, driven by a long-repressed, intense need for physical and emotional companionship, he entered into a liaison with a "fallen" woman named Christine (Sien) Hoornik, a substantially older unmarried mother who was already pregnant with another child and was supporting herself by prostitution. Bringing all his evangelical zeal and humanistic sympathies into this union with an uneducated, alcoholic, greedy and, as he eventually discovered, dishonest woman, Vincent convinced her to give up prostitution and rely on their joint efforts to survive together as a family. Denounced by his own relatives but still receiving money from Theo, he spent a miserable twenty months trying to make progress in his artistic work while burdened with the myriad cares he assumed when he took on the responsibility for Sien and her children. Believing as he did that God is to be found in our impulse to love[10] and that "God wants us . . . to reform the world by reforming morals, by renewing the light and fire of eternal love,"[11] he rejected his own family's condemnations of his involvement and their pleas that he reconsider the ramifications of his actions. An outraged letter from his uncle about his new living situation left him "just as cool as an ordinary sermon,"[12] and he described his reaction to this outpouring of moral and religious platitudes as "a stunned feeling," as if he "had been standing too long against a cold, hard, whitewashed Church wall."[13] Repeating to Theo some of their uncle's conventional religious arguments against his behavior, he remarked regarding the Church: "No wonder one becomes hardened there and turns to stone."[14]

It was his family's reaction to his relationship with Sien that turned Vincent even more decisively against the bourgeois establishment. Condemning his father for basing his judgments on narrow-minded, conventional prejudices instead of on Christian sympathy and charity, he defended his alliance as natural, humane, and moral in that it was beneficial for all its participants. Unfortunately, its benefits were largely a matter of wishful thinking and an idealistic impulse to create a harmonious union from two unhappy and discordant lives. Lazy and sluttish, avaricious and manipulative, Sien resisted all Vincent's attempts to educate and enlarge her views and soften her grasping nature. She continued to drink and neglect the children, and when it became evident that the money from Theo was insufficient to maintain them all and that no further help from the van Gogh family was forthcoming, she returned to prostitution. After trying for months to sustain a situation that was both financially and psychologically impossible, Vincent finally succumbed to Theo's advice and, with much regret and guilt, left Sien toward the end of 1883 and went to live in the village of Drenthe.

Despite the disillusionment of this experience, Vincent persisted in rejecting the middle-class values his family represented and in idealizing the virtues of the poor, although he now shifted his regard from the urban lower classes to the peasants of the countryside. Complaining to Theo that

their parents "are so terribly genteel (not sensitive underneath, however . . .),"[15] he associated their moral defects with the decadence of city life, claiming:

Now, when I compare the population of a city with the people here, I do not for a moment hesitate to say that the population of the heath, the peat workers here, seem to me to be better . . . in my opinion a simple farmer who works, and works intelligently, is the civilized man . . . it has always been so and always will be . . . the nearer one gets to the large cities, the further one gets into the darkness of degeneration and stupidity and wickedness.[16]

He repeated this conviction many times over the next few years, telling Theo that "I for my part often prefer to be with people who do *not even know the world*, for instance the peasants, the weavers, etc., rather than being with those of the more civilized world."[17] Equating his desire for a natural, spiritually satisfying life with his rejection of urban culture and his decision to be an artist, he wrote: "I am finished with all that is not simple; I don't want the city any longer, I want the country; I don't want an office, I want to paint."[18] With his great need to identify with the common people, Vincent perceived his own struggle to develop his artistic skills as comparable to the working poor's effort to support existence. His letters repeatedly stressed his desire to be useful, and he agonized both over his inability to earn an honest wage from his labor and the public's general assumption that a painter's activity is neither arduous nor useful.[19] Feeling that his own need to make art was a drive as strong and peremptory as the primal drives for food or procreation, he believed that the emotional anguish and physical deprivation he was undergoing in order to create meaningful works was as holy as that of all others whose labor and progeny sustained society.[20] Regarding toil not so much as a cause of suffering as an antidote to it, he had earlier written to Theo of "the rage of work" in which he was immersed as an "apparently sterile struggle [that] is no other than the labor of childbirth. First the pain, then the joy."[21]

Vincent suffered from his parents' distaste for his identification with the peasants. Contrasting their cold-hearted gentility and propriety with his own combination of compassionate feelings and uncouth physical appearance and manners, he told Theo that their mother and father viewed him as they would an uncivilized animal: "They feel the same dread of taking me in the house as they would about taking a big rough dog. He would run into the room with wet paws—and he is so rough. He will be in everybody's way. *And he barks so loud.* In short, he is a foul beast."[22] He later expanded this self-characterization into the metaphor of a shepherd dog who protects his flock, a symbol of the hard-working, faithful servant whose concern is not for superficial and hypocritical cosmetic values, but for guiding his charges along the right paths and keeping them from harm. In this identification with the dog he found an image that suggested both his spiritual mission to help others and his artistic goal to do so by penetrating and revealing reality. "I have found myself," he told Theo, "I am that dog. . . . The shaggy shepherd dog . . . is my character, and the life of that animal is my life. . . . I consciously choose *the dog's path through life*; I will remain a *dog*, I shall be *poor*, I shall be a *painter*, I want to *remain human*—going *into* nature."[23]

Vincent's vision of himself as a keeper of the flock accords with his earlier declaration to van Rappard that he wanted to be a leader of men preaching the doctrine "'People, let us give our soul to our work and let us work our heart out for our cause and—love what we love.'"[24] Perceiving his hatred of artifice and his preference for forthright, unpretentious behavior as "uncivilized" aspects of his honest "primitive" nature, Vincent cultivated the outward display of these desirable qualities as indications of his moral and spiritual ideals. He was well aware that his rebellion against the outward forms of respectability conformed to a Romantic image of the artist-genius. In the same letter in which he wrote of choosing the dog's life, he quoted Michelet's remark that "the male is very savage," and proclaimed with pride: "I look upon myself as being indeed 'a savage.'"[25] Vincent's characterization of himself as an unkempt beast, a savage, and a spiritual leader corresponded to the Romantic concept of the artist as an outcast, a madman and a prophet, paralleling, for example, Carlyle's description in *Sartor Resartus* of his protagonist Diogenes Teufelsdröckh as "our wild Seer, shaggy, unkempt . . . [of] an untiring energy,"[26] or Gustave Flaubert's advice that the artist avoid society and "live like a bear."[27]

By 1885 Vincent's hard-won skill at capturing the complex truths of peasant life resulted in his first real masterpiece, a scene called *The Potato Eaters* which exists in both a rough and a finished version (fig. 67). This was the same year that Émile Zola published his novel *Germinal*, a searing and tragic account of the brutality, frustration, misery, and fleeting compensations of coal miners' lives. Vincent was very moved by this book and realized that he was trying to capture its flavor and moral message in his own work. *The Potato Eaters*, a scene contrived from innumerable prior figural and portrait studies, sums up not only his observations of the physical and psychological trials of the poor, but his feelings about the inevitability and sanctity of toil and suffering. Seated around a crude table, the five members of the family share their minimal meal of potatoes and coffee in a somber atmosphere. As in most of his early works, the colors are earthy and drab, the technique broad, rough, and lacking in interior detail. Vincent told

Theo that his goal here was to achieve the quality a critic had once attributed to Millet when he claimed that "'His peasant seems to be painted with the very soil that he tills.'"[28] He explained his intentions to his brother at length:

I have tried to emphasize that those people, eating their potatoes in the lamp-light, have dug the earth with those very hands they put in the dish, and so it speaks of manual labor, and how they have honestly earned their food.

I have wanted to give the impression of a way of life quite different from that of us civilized people. Therefore I am not at all anxious for everyone to like it or admire it at once.

. . . it might prove to be a real peasant picture. I know it is. But he who prefers to see the peasants in their Sunday best may do as he likes. I personally am convinced I get better results by painting them in their roughness than by giving them a conventional charm.

. . . it would be wrong, I think, to give a peasant picture a certain conventional smoothness. If a peasant picture smells of bacon, smoke, potato steam—all right, that's not unhealthy; if a stable smells of dung—all right, that belongs to a stable; if the field has an odor of ripe corn or potatoes or of guano or manure—that is healthy, especially for city people. Such pictures may teach them something. But to be perfumed is not what a peasant picture needs.

. . . we must continue to give something real and honest. Painting peasant life is a serious thing, and I should reproach myself if I did not try to make pictures which will rouse serious thoughts in those who think seriously about art and about life.

. . . one must paint the peasants as being one of them, as feeling, thinking as they do.[29]

Scholars have recognized that Vincent's treatment of his motif has transformed the sharing of food into the giving and taking of a sacrament; that what we are witnessing is not just a typical moment of peasant life, but a communal event that helps to mitigate the harshness of existence.[30] As in the painting of farmers planting potatoes (fig. 43), the Naturalist genre scene has been supplanted by the Symbolist drama, a formalized ritual in this case contrived to convey Vincent's feelings about poverty and human relations. The rhythmic arrangement of the figures around the central table, the solemn silence in which they partake of the minimal attributes of food and drink, the almost ritual gestures with which these are offered, the lamp illuminating the scene—all these details recall traditional depictions of Christ's Last Supper or the Supper at Emmaus.[31] The clock and the picture of the crucifixion on the left wall, moreover, are not only plausible elements in a domestic interior, but symbolic reminders of fleeting time and the inevitability of suffering and death. The consciousness of these truths is part of every human's emotional burden, and our realization of this aspect of our common humanity adds a universal dimension to the peasant scene. But the power of the image comes also from the way in which Vincent has contrived gestures, attitudes, and facial expressions to convey the ambiguous and paradoxical nature of all human interactions. Despite the family intimacy and sharing of food, these people seem sad and isolated. The central man and woman gaze with tender, almost pleading concern at the two outer figures who are lost in melancholy thought and heedless of their attention, while in the foreground the middle figure cleaves the group with its back: a faceless dark presence splitting the scene into two separate vignettes of emotional estrangement and non communication. It is precisely because *The Potato Eaters* captures both our attempts and failures at intimacy, at assuaging the loneliness and anxiety endemic to the human condition, that it is such a great work of art.

Vincent's desire to use common objects or scenes as symbols to ignite ideas and emotions in his viewers is evident in another important work of 1885: his *Still Life with Bible* (fig. 68). He painted this picture shortly after the death of his father, an upright but severe man with whom Vincent had had nothing but conflict since he decided to become an artist. Pastor van Gogh, who had objected strongly to his son's new lifestyle and aspirations, was particularly distressed and shocked by Vincent's fraternization with the lower classes, whom the father viewed as vice-ridden and immoral. Vincent's painting depicts the elder van Gogh's Bible opened to the book of Isaiah, and set beside a snuffed-out candle and a copy of Zola's novel *La Joie de vivre* (*The Joy of living*). Scholars have assumed that Vincent meant the Bible to represent his father's old-fashioned, punitive brand of religion, the novel to signify his own modern tolerance of vice, and the extinguished candle to act simply as a traditional reminder of death.[32] But when we compare the content of the book of Isaiah and that of *La Joie de vivre* and relate their ideas to passages in Vincent's letters regarding his feelings about his father, the Bible, and modern literature, a very different and much more meaningful interpretation emerges. It is worth examining this in some detail, because in this picture Vincent communicated the philosophy of life that dominated his outlook and his symbolic imagery for the five years which remained to him.

Zola's novel contrasts two protagonists: Lazare and Pauline. Lazare is a gloomy, pessimistic, self-pitying man of impossible ideals who is peevishly dissatisfied with the realities of his life. Selfish and hard-hearted, contemptuous of all who fail to meet his exacting standards of behavior, he uses the excuse of his "sensitivity" to keep his distance from anything sordid or disturbing. But whereas Lazare casts a blight on everyone he encounters, Pauline is the incarnation of female nurturing: a cheerful, selfless, unconventionally tolerant woman who accepts life's injustices

patiently and from her own paltry resources and inexhaustible inner strength lavishes love, sympathy, and charity on all in need. Pauline embodies Vincent's most cherished moral and religious ideals, while Lazare manifests his father's detested skepticism, coldness, and harsh judgments: a spiritual dichotomy we find also in the book of Isaiah. Far from offering opposing philosophies, both the biblical text and the modern novel preach the same message. Both teach that there are two approaches to life—one positive and good, the other negative and evil—and in these divergent paths Vincent perceived the difference between his father and himself as moral and spiritual beings.

In the book of Isaiah, the prophet criticizes the people for their empty observance of rituals without practicing benevolent and humane actions such as righting injustice and relieving the distress of the oppressed (1:11, 13, 16–7; 58:1–7). Correspondingly, in *La Joie de vivre* Lazare is a punctilious churchgoer who despises and neglects his fellow man, while the tender-hearted, spontaneously generous Pauline is impatient and bored at services and lax in attending them. Isaiah levels particular condemnation against proud, inflexible men who congratulate themselves for upright conduct while perverting the spirit of genuine religion. "Woe unto them who call evil good and good evil," he charged; "who change darkness into light and light into darkness. Woe unto them who are wise in their own eyes and prudent in their own sight" (5:20–1). When Vincent described to Theo their father's violent reaction to his consorting with the lower classes, he couched his criticism in precisely the same terms as Isaiah's:

There is a certain hardness in Father like iron, an icy coldness . . . for all his outward gentleness. . . . In Father's mind there . . . is not now the faintest shadow of a doubt that what he did was the right thing. Father does not know remorse like you and me and any man who is human. Father believes in his own righteousness, whereas you and I and other human creatures are imbued with the feeling that we consist of the errors and efforts of lost souls. I commiserate with people like Father . . . because the good in them is wrongly applied, so that it acts like evil—because the light *within them is black and spreads darkness and obscurity around them.*[33]

Vincent's metaphorical equation of evil with darkness and good with light is a motif that is repeated throughout both Zola's novel and the book of Isaiah, which claims that the obscurity of wickedness blots out the joy and mirth associated with goodness (24:1–12). It is significant that each author also contends that enlightenment and goodness can only be attained through the kind of involvement with the world which enables us to learn the nature of evil. It angered Vincent that his father refused to look into the ugly, sordid lives of the poor, even from the distant perspective of reading about them in modern literature. Vincent revered the works of contemporary writers like Hugo and Zola because they depicted great human truths and spiritual values in terms of the relevant moral problems of contemporary reality. Years earlier he had written to Theo: "When Father sees me with a French book by Michelet or Victor Hugo he thinks of thieves or murderers, or of 'immorality;'. . . So often I've said to him, Then just read it, even a few pages of such a book, and you will be impressed yourself; but Father obstinately refuses."[34]

Vincent found a parallel to his frustration in the prophet Isaiah's comparison of religious insensitivity to blindness and deafness, as when he told the people that genuine moral vision has "become to you as the words of a writing that is sealed" (29:10–11), and promised them that when they heeded the true spirit of religion, "in that day shall the deaf hear the words of a book, and the eyes of the blind shall see out of obscurity and out of darkness" (29:18). Isaiah even reserved a special warning for watchmen who were designated to guard the flock but who "are all blind, without knowledge . . . and these are shepherds that cannot understand; they all turn to their own way" (56:10–11). Vincent must have seen this reprimand as particularly relevant to his father, a minister of God who felt no moral duty to go among people he considered sinners. As he wrote to Theo: "in my opinion Father is forever lapsing into narrowmindedness, instead of being bigger, more liberal, broader and more humane. It was clergyman's vanity . . . and it is still that same clergyman's vanity which will cause more disasters now and in the future."[35]

Both Isaiah and Zola contrast the unenlightened wicked to God's elect: outcasts whose unconventional good deeds and failure to conform to superficial outward forms of behavior have earned them the scornful rejection of society. Isaiah's description of the religiously pure of heart as "despised and forsaken of men, A man of pains and acquainted with disease, And as one from whom men hide their faces" (53:2–3) is paralleled in *La Joie de vivre* by the fate of Pauline, who is sneered at and ill-treated because her desire to help others has motivated her to read "improper," forbidden books on science and medicine and to go among the "depraved" and sick to bring them food and aid. Like Vincent himself, Pauline paid for her unconventional principles by inciting the contempt of her relatives, bringing herself to financial ruin, and losing all possibility of marriage and children. It is significant that Isaiah tells the unappreciated servants of God to take heart because one day their detractors will be "extinct, quenched as a wick" (43:17). In all of these references we find the components of Vincent's memorial painting: the quenched candle symbolizing his dead father who even in life was blind and shed no light or warmth; the black background

evoking the spiritual darkness of his moral and religious views; the modern novel in its identifying yellow cover, a book containing moving truths about contemporary life which Pastor van Gogh refused to read and which Vincent therefore depicted closed; the Bible, which his father professed to revere, lying open at Isaiah's stern warnings about the evil of closed-mindedness and lack of compassion.

Far from viewing the Bible as epitomizing his father's religious attitude, Vincent believed that his father didn't understand its real teachings. He wrote to Theo: "I cannot be reconciled to Father's system—it oppresses me, it would choke me. I too read the Bible occasionally, just as I read Michelet or Balzac or Eliot; but I see quite different things in the Bible than Father does, and I cannot find at all what Father draws from it in his academic [i.e. dogmatic and unfeeling] way."[36] His juxtaposition of the ancient text with the modern novel was meant not as a contrast but as a parallel: an expression of his belief that both old and new sources convey the same spiritual wisdom and that each culture must recast universal truths into a form that is relevant and accessible to its own people. Two years later, after praising contemporary literature and mentioning *La Joie de vivre* in a letter to his sister Wilhelmina, Vincent wrote:

Is the Bible enough for us?

In these days, I believe, Jesus himself would say to those who sit down in a state of melancholy, It is not here, get up and go forth. Why do you seek the living among the dead?

If the spoken or written word is to remain the light of the world, then it is our right and our duty to acknowledge that we are living in a period when it should be spoken and written in such a way that—in order to find something equally great, equally good, equally original, and equally powerful to revolutionize the whole society—we may compare it with a clear conscience to the old revolution of the Kristians [Christians].

I myself am always glad that I have read the Bible more thoroughly than many people nowadays, because it eases my mind somewhat to know that there were once such lofty ideas. But because of the very fact that I think the old things so beautiful, I must think the new things beautiful à plus forte raison [for an even stronger reason]. À plus forte raison, seeing that we can act in our own time, and the past as well as the future concern us only indirectly.[37]

Vincent wrote to Theo that the great modern authors "don't tell you that the Gospel is no longer of any value, but they show how it may be applied in our time, in this our life, by you and me, for instance."[38] Believing as he did in the continuity of human wisdom, he valued both texts for their insights into the complex issues of our moral and spiritual choices. Over the years he often referred to books that deal with essential human experiences as "a rich source of light" and "a light in the midst of darkness,"[39] and in the same spirit that Carlyle wrote of the ideas contained in literature as "the means of conquering the devil,"[40] Vincent praised the spirit of life and love in modern novels as "something to set against the dark and evil and terrible things in this world."[41] In his painting, Zola's contemporary tale with its glowing yellow cover and the old Bible whose pages are flecked with mellow colors and set off by brilliant white margins stand out like beacons against the darkness of his dead father's ignorance, prejudice, and hard-heartedness. For Vincent, they symbolized the spiritual lesson that we must fight the myriad evils of life with love and positive actions instead of slipping into pessimism, lethargy, and despair.

By 1885, Vincent knew that he needed to combat darkness not only in the outside world, but within his own depressive personality. His father's death gave him a sense of release and an impetus to begin a new phase of his life, to find new friends and develop a more serene and joyful outlook—to become, in fact, more like the elect of God in Isaiah and *La Joie de vivre*, those who fulfilled his favorite maxim of St. Paul that we should be sorrowful yet always rejoicing. In the letter to his sister in which he cited Zola's novel as an example of the kind of book that "sheds light in the darkness," he concluded: "I do not want to belong to the melancholy, or to those who turn sour or bitter or ill-tempered."[42] It was in order to grow in a more positive spiritual direction that in March of 1886 he went to live with Theo, who since 1883 had been working for Goupil & Co. in Paris. He hoped that the livelier, freer atmosphere there and the company of other avant-garde artists with similar values would enable him not only to find personal happiness, but to regenerate his art—to charge it with new vitality and positive associations so that in its turn it could bring greater light and comfort to others.

Striving for Life and Light: Paris, 1886–1887

While Vincent's experiences during his almost two years in Paris were far from being as fulfilling as he'd hoped, the initial change of environment had a positive impact on his psychological outlook. During his first summer there, he wrote to a Dutch friend: "However hard living may be here, and if it became worse and harder even—the French air clears up the brain and does good—a world of good."[43] Moreover, the impact of Impressionism and Neo-Impressionism on his subject matter and palette was powerfully transformative. Both underwent a gradual lightening and

brightening, a shift away from the sober, depressive mood of his earlier work which reflected his self-confessed struggle "for life and for progress in art."[44] This didn't happen immediately; March in Paris is often overcast and chill and Vincent's first pictures of the Montmartre rooftops and streets share the subdued coloration and cheerless emotional effect of the northern paintings (figs. 69 and 70). But although poverty and suffering existed in Paris, Vincent no longer felt compelled to seek them out. Instead, he spent most of the spring and summer painting dozens of sumptuous flower still-lifes (figs. 71 and 72), a subject which had been conspicuously absent from his northern oeuvre. As yet lacking human models and stimulated by his contact with Impressionism and his conscious desire to infuse greater vigor and gaiety into his work, he turned to flowers as a perfect vehicle for implementing his new coloristic and emotional goals. Shortly before arriving in Paris he had written to Theo that "What color is in a picture, enthusiasm is in life, therefore—it is no little thing to try to keep that enthusiasm."[45] The bouquets he painted during his first six months convey the intoxication of this spirit of renewal like a series of variations on a theme. Their vividly colored, diversely textured blossoms loom large on the canvas, filling the picture plane as celebrations of nature's profligate beauty, and while some blaze forth against the dark grounds familiar from his earlier still-lifes, an increasing number utilize backdrops of richly colored tones which relate to the hues of the flowers themselves.

Vincent's shift of attitude can be observed when we compare two self-portraits from the spring of 1886 and the spring of 1887 (figs. 73 and 74). Although both pictures reveal the seriousness and intensity of his personality, the difference of palette produces a different psychological effect. The earlier work is executed in somber, dead-leaf tones of browns and rusts offset by dull black clothing and skin of an eerily gleaming pallor: melancholy, wintry colors that accord perfectly with the artist's sober gaze. The face in his tiny portrait of 1887 is no more light-hearted than before, but instead of reinforcing the sense of his intrinsic sadness, his colors seem to be trying to counteract the disturbing effect of his troubled, driven stare. Sporting a pinkish gray suit and hat piped in vivid sky blue to match his tie, his ruddy head glowing in rich golden and salmon tones against a background dusted with paler robin's-egg blue, this new self-depiction manifests his determined effort to find beauty even in unhappiness, to lighten and enrich his vision even when rendering his own haunted features.

The same attitude informs his treatment of another potentially depressing motif in the spring of 1887: his own leather shoes (fig. 75), which one scholar called "his companions" on his long walks through Paris[46] and another

interpreted as "a symbol of Vincent's own journey through life."[47] His battered footgear speaks eloquently of their wearer's condition in life, acting as an attribute which stands in lieu of a portrait or of scenes of laboring peasants. It has been observed that these old, worn shoes "tell a story of poverty, wretchedness, and weary, endless tramping," which by extension expresses "the toil and fatigue of the whole world."[48] Like their owner, they are rough, awkward, and homely, their misshapen contours implying years of hard usage. Yet despite their suggestion of a deprived and exhausting existence, these shoes don't convey the gloom of his pre-Paris pictures. Everything about them expresses vitality, from the rippling, gaping tongue and energetically twisting laces to the casual disposition that gives us the impression they were just slipped off their wearer's feet. In accordance with his new appreciation of the positive emotional repercussions of bright color, Vincent created an effect of warm, vigorous life by painting the shoes in glowing shades of orange and salmon, modified with touches of green broken with orange and set against an intensifying complementary background of strong blues and violets. His technique by this time had also altered under the influence of Impressionist style, the solid, opaque strokes of paint that characterized his earlier work replaced now by a looser, thinner, more mottled and varied application of pigment which enlivens the surface and adds a greater charge of energy to his pictures. Even the inversion of one shoe to display the stippled pattern of glistening tacks on its sole is testimony to his cultivation of a more cheerful spirit: one that looks for beauty in the small, commonplace realities of ordinary life.

During 1886 Vincent took classes at the studio of a history painter named Cormon, where he met some of the younger members of the Symbolist avant-garde. Through Émile Bernard and Paul Signac he met Pissarro and Seurat and Gauguin as well, and after his earlier isolation he was heartened to find other rebellious and eccentric spirits with whom he hoped to establish the kind of staunch friendships that would bind them to one another in a mutually supportive brotherhood. He liked to feel that he could repay Theo in part for his ongoing financial support by introducing him to many of the still unknown members of the Symbolist artistic community, including Gauguin, and by taking him to studios and enlarging his acquaintance with and understanding of the avant-garde movement.[49] Theo was grateful for these contacts, for as an enterprising young dealer ambitious to make a name for himself, he hoped to promote the new art in the same manner that the older paintings dealer Durand-Ruel had the Impressionists.' By the spring of 1887 Vincent had digested the lessons of both Impressionism and Neo-Impressionism and was applying the stylistic and theoretical

principles which were not only manifest in their works, but were the constant topic of intense discussions in the cafés where the avant-garde artists and critics frequently met.

The changes in Vincent's style embraced all categories of subject matter. His still-lifes from the spring of 1887 (figs. 76 and 77) contrast sharply with his earlier depictions of lumpish vegetables and coarse crockery immersed in darkness. Now he chose to paint a translucent glass and bottle filled with the sunlight that pours in from the nearby window and transforms the tabletop into a flood of radiance; or a crystal decanter shimmering with the red and green reflections of the gaily patterned wallpaper behind it, and set beside a plate of golden lemons and oranges on a table vibrating with rich green strokes. His city scenes from this spring (figs. 78 and 79) are correspondingly lighter and brighter than those from the previous year with their drab tones of buff, gray, and brown. Dissolved now in delicate, gleaming washes of iridescent blue and pearl, flecked with dabs of intense red, green, violet, and turquoise, the solid Paris buildings and rain-washed boulevards scintillate like jewels in the damp air. With the advent of good weather, the rural settings of Montmartre also yielded motifs which in the North he had rendered as dark and forbidding but that he now endowed with a mood of bucolic serenity and enchantment (figs. 80 and 81). The windmill of la Galette is little more than a lightly brushed-in vertical accent in a dominant setting of fresh green flower-strewn grass and limpid blue sky; the vegetable gardens, a mass of gold flecked with red blossoms and blue shadows and divided by brilliant green verges, melt into the turquoise and yellow sheds surrounding them beneath a sky of ethereal blue veiled with opalescent haze and shot through with streaks of lemon-yellow light. The melancholy poetry of the northern landscapes has now been supplanted by an enraptured appreciation of the way in which nature's beauty transfigures even the humblest aspects of reality.

Vincent's new attitude during 1887 affected his representations of the people around him as well. In place of his deeply shadowed, tragic portraits of peasants, we now find colorful paintings of a few of the members of the petite bourgeoisie who befriended him in Paris: for example, a spring portrait of Mme Agostina Segatori (fig. 82), proprietress of one of the avant-garde's favorite cafés, and a late autumn or winter picture of Père Tanguy (fig. 83), a seller of art supplies and prints. He depicts them both as thoughtful but gently smiling, good-natured people, seated in their places of business in front of walls enlivened by Japanese prints. These inexpensive Japanese prints, which Julien Tanguy sold in his shop, were all the rage with the Impressionists, and Vincent, who with Theo bought them avidly by the hundreds, had mounted an exhibition of their

collection at Mme Segatori's café, Le Tambourin. His admiration for their stylistic qualities was so profound that he proclaimed his desire to draw in the manner of the Japanese,[50] an ambition which influenced his handling of form and color for the remainder of his life.

These portraits, like so many of his paintings from this period, reveal the impact of the Japanese aesthetic in their organization of flat, linear forms to create a decorative surface pattern. The Japanese tradition eschewed the illusion of spatial depth that Western artists achieved through the use of shadows and the continuous perspectival recession of objects into the distance. Instead, they worked on the surface of the picture plane, emphasizing its unity of design by juxtaposing big, bold areas of color without shadows or gradations of light and dark: a technique that flattens individual forms and maintains a vertical format by creating abrupt visual transitions between spatially remote objects. These canvases also embody the theories about color harmonies which Vincent had been imbibing from his Neo-Impressionist friends and from the available literature on color perception and psychophysical responses. These studies indicated that the more concentrated and exaggerated colors and forms are, the more intense an impact they have on the psyche. They also suggested that a greater intensity of effect can be achieved by juxtaposing colors with their complementaries: yellow with violet, orange with blue, red with green, black with white. Vincent put this idea into practice in both portraits, rendering Mme Segatori in a combination of cool, springlike greens and muted reds which accords well with her pensive air, and Père Tanguy in a more vivid, richly varied and fully balanced system of reds, pinks, oranges, and golds contrasted with violets, blues, and greens—a dense and stable equilibrium of color which helps to convey a sense of his sitter's solid and serene personality. According to Seurat, the juxtaposition of all the complementaries in a work of art ensures a balanced emotional effect as well as aesthetic harmony: it endows the object with the diverse unity of nature, where opposites counteract one another's effects within an overall order that is visually and psychologically satisfying.

Throughout 1887 Vincent worked on incorporating these stylistic principles into his paintings. With the advent of good weather in the spring, he turned his attention to the sunny stretches of the banks along the Seine and the parks in outlying districts (figs. 84 and 85), translating grasses, flowers and trees, water and sky into dynamic dashes and dots of strong, bright color that create the effects of glinting light and shimmering heat. While the Impressionists applied their idiosyncratic styles of brushwork to all forms indiscriminately, and the Neo-Impressionists (also known as divisionists or pointilists because of their dotlike application of unmixed pigments) similarly

subjected their motifs to the impersonal tyranny of the dot, Vincent's works reveal his desire to let each form dictate the technique which best captures its essence. Paintings like *Fishing in spring*, therefore, combine strong, streaklike strokes—used to define the tree bark and the ripples and reflections on the water or the underside of the bridge, with a mixture of dabs and spots which suggest the rustling, glistening foliage and glowing sky. Each mark is decisive, bold, and summarizing: the epitome of the "shorthand" technique he developed to transcribe what the components of nature told him. Although other pictures such as *Lane in Voyer d'Argenson Park* appear to be more purely pointilist, a closer look reveals that they too exhibit a great deal of variety in the brushwork used to depict the different forms. The greater vitality of his brushwork is paralleled by the structure his compositions, many of which now substitute highly energized systems of interlocking diagonal wedges for the more static, frontal arrangements of horizontals and verticals he had used earlier.

Whereas in the north, Vincent devoted himself to depicting the gloomy environments of the poor, in Paris he sought out milieus which seemed more conducive to gaiety and buoyant spirits. In addition to his many idyllic outdoor scenes of foliage and water, he executed a number of paintings of local cafés and restaurants (figs. 86 and 87): those convivial establishments where a great deal of social eating and drinking went on amid the conversations and intellectual arguments which were such an important part of an avant-garde artist's life in Paris. In his evocations of both the exteriors and interiors of these neighborhood restaurants, he rendered their simple architecture and decor in exaggerated shades of lemon yellow, sunny orange and brilliant green which convey a welcoming atmosphere of warmth and vitality. These pictures, with their obvious stylistic debts to Pissarro and Seurat, also reveal the impact that Vincent's feelings about such places had on his manner of representing them. Although the unpretentious cafés where he met the artists whose friendship and emotional support he wanted so badly were in reality quite plain, he flooded his painting of the facade with such a powerful golden radiance that its open door seems the gateway to a haven of happiness, while the dining room has the visionary quality of an enchanted garden. Walls and floors are flecked with petal-like dabs of warm yellows and oranges and pinks interwoven with pastel blues and greens, transforming them into screens of blossoms almost indistinguishable from the bouquets on the tables. Because Vincent saw his art as conveying his inner experience of life, the scintillating beauty of such images wasn't conceived merely as a decorative pictorial effect, but as an expression of his new appreciation of the dynamic beauty of common physical phenomena and of the fraternal cama-

raderie such meeting places suggested. A letter to his sister from this period indicates the extent to which his longing for a more positive experience of life influenced his selection and rendering of subject matter. "In order to write a book, perform an action, paint a picture in which there is life," he wrote, "one ought to live as a human being oneself. . . . so enjoy yourself as much as possible, and always remember that what is required in art nowadays is something very much alive, very strong in color, very much intensified."[51]

This attitude permeates Vincent's summer painting to the extent that even the most mundane and seemingly unpicturesque scenes are endowed with transcendental beauty. *Vegetable gardens in Montmartre* (fig. 88) presents us with a panoramic vista of a fairly desiccated area whose rough sheds and windmills, ramshackle fence and bare, dusty road are subsumed into a textured fabric of exquisitely harmonized colored strokes. The sensation of nature's vastness engendered by the breadth of the landscape is enhanced not only by the brushwork, which diminishes rapidly in size and clarity from foreground to background, but also by the rapid recession of the road. Occupying almost the entire width of the foreground, it flows like a swift river of converging streaks to an abrupt vanishing point in the midsection of the canvas—a great triangular wedge that pulls us into the heart of the countryside. Orchestrated in complementary juxtapositions of reds and greens, creamy ochers and blues, the humble farm buildings and baked earth sing a hymn to nature and to the human life that it sustains. The factories at Clichy (fig. 89) are similarly transfigured, their brilliant red roofs gleaming jewel-like above walls of jade green, violet, peach, and soft blue, their sooty chimneys and dark encircling fence contrasting dramatically with the gold and green and orange grasses rippling across the fields. Even the black smoke pouring from the great stacks dissolves gently into the upper air, tinging the sky with a pall of richly modulated celadons and pale pinks and blurring at the horizon into a vaporous chalky blue. With its mysterious green light and great, empty expanse of glowing meadow, its strong shadows and exquisitely colored buildings, this representation of a suburban wasteland has the visionary quality of a dream.

By this summer Vincent had become gravely disenchanted with Parisian life, and pictures of the countryside like these, with their elevated and far-reaching perspective, suggest his need to distance himself from the city and from all the disappointments and frustrations of his personal experiences there: a need to transcend unhappiness by viewing human existence from the perspective of its place in the larger natural world. It is a perspective that softens the ugliness of modern urban environments and subsumes

the details of individual suffering within the context of nature's vastness, its fertile loveliness, and its inexorable laws of continuity and change. Vincent's preoccupation with these ideas and his efforts to suggest them in his paintings differed considerably from the Impressionists' goals. While they were interested in the visual transformations wrought by fleeting light effects, Vincent, as we can see from pictures like *Wheat field with lark* (fig. 90), expressed the more Symbolist concern with the spiritual significance of the passage of time and the brevity of life.

Here everything is in motion: the wheat blowing in the wind, the lark winging over the bending stalks, the air streaked with currents like a choppy sea flecked with whitecaps. Because Vincent, with his religious background and sensitivity to biblical parables, perceived wheat fields as metaphors for the lifecycle of humanity,[52] his depiction is not only a celebration of growth and organic beauty, but a metaphor for existence, for the susceptibility of all things to the powerful forces of nature. During this summer he wrote to his sister about the fragility of flowers and wheat and all organic things in the face of life's stresses and inexorable processes:

You see yourself that in nature many flowers are crushed underfoot, get frozen or scorched by the sun; and further that not every grain of wheat, after ripening, returns to the earth, there to germinate and become a new plant—but that the great majority of grains of wheat do not attain their natural development, but go to the mill.[53]

This painting conveys this vulnerability to the agents of change and destruction: the wheat in the foreground has been harvested for the mill, while the growing grain which remains sways under the force of the wind just as we bend and bow to the pressures and necessities of our lives. The mowed stubble, the submissive wheat, the flickering sky, and the bird in flight at the center of the canvas speak eloquently of nature's dual principle of continual change within an ongoing continuity—a principle that is simultaneously tragic and comforting.

Although Vincent's pictures from 1887 are clearly Impressionist in technique and strive to convey a positive spirit, many of them have undertones of seriousness or a poignancy of effect which reveal his sensitivity to life's ambiguous and problematic realities. His restaurant, after all, is empty, and its atmosphere of waiting stillness, so different from the genial air of relaxed camaraderie we find in the Impressionists' renderings of contemporary social gatherings, seems to reflect instead the hopeful expectations of one who still looks on from the outside. His landscapes too are either uninhabited or minimally staffed with one or two isolated and indeterminate figures, and many of them,

such as *The Bridge at Asnières* (fig. 91), communicate a sensation that is far from light-hearted. Landscape and water here are painted in streaks of rich, jewel-like color, but blended into their sensuous beauty is a weightiness and a vague aura of melancholy. This arises in part from the conscious, Symbolist way in which van Gogh worked out his color values and relationships. Wanting to suggest life's fundamental oppositions through color contrasts, he balanced all the bright, light tones associated with sunny weather and cheerful spirits with an equivalent number of dark, moody shades of blues, purples, and deep forest greens. These heavier, somber colors complement the yellows and oranges, both intensifying them and yet counteracting their gaiety and warmth by imparting a tinge of sadness to the canvas.

The composition also contributes to our feeling that this pleasant scene harbors unsettling undercurrents. The source of disturbance is implicit not only in the distortions of space, whose angled tilt creates a sense of psychological unease and disequilibrium, but also in the relationship between the empty, sun-drenched triangle of foreground with its untenanted boats and isolated watching figure, and the right-hand triangle with its chilly-looking dark water and ponderous bridges and train, which fill the upper register with intimations of urban commerce, dirt, and noise. Before coming to Paris, Vincent had read Zola's novel *L'Oeuvre* (*The Masterpiece*), whose protagonist, a lonely and eccentric avant-garde artist, becomes obsessed with gazing at the spectacle of modern industrial power centered around the bridges of the Seine—a sight he finds threatening and demoralizing. Vincent, who hated cities and idealized country life, achieves a similar suggestion of alienation in this picture through his manipulation of all the elements of his composition. The dark train blotting out the sky as it rushes across the top of the composition trailing its plume of black smoke, the shadowy, anonymous figure crouching beneath the bridge, the isolated watcher on the bank, the vacant boats, the steeply, uncomfortably angled spaces, the deep, sonorous colors of the water and the disturbingly greenish tinge of the sky—all combine to create a feeling of tension or oppression.

Many of Vincent's summer landscapes share this evocative, ambiguous mood (figs. 92 and 93). He was drawn particularly to lonely, secluded spots, and the number of scenes he painted of dimly lit copses, bosky paths, and deeply shadowed undergrowth indicate how strongly he was attracted by the dark core of nature. Although this predilection had been shared in part by the Barbizon painters and Courbet, it was far removed from the Impressionists' plein-air concerns. By this date the Impressionists had also eliminated most earth tones from their palettes and now concentrated on obtaining brilliant color effects

by applying only the "spectral" pigments of the rainbow or prism, a method they felt filled their canvases with the intensity of real light. Although Vincent had wholeheartedly adopted this palette of the spectrum, he also retained the use of dark, blackish greens and browns, which he stippled into the bright yellows and emeralds of his foliage in order to create the effect of mysterious, earthy shadows lying at the heart of the shrubbery and permeating the woods. These pockets of blackness intensify through contrast the sun-drenched, glistening quality of the light on the vegetation, but they also add a subtle suggestion of the dark enigma of the organic world and the melancholy sensations our experiences arouse.

The depressive side of van Gogh's sensibility is nowhere more evident than in his self-portraits from this period. Despite his attempts to look on the world with a joyful spirit, he was not happy in Paris, and it is significant that although he described his pictures from the spring and summer of 1887 as having "open air in them, and good humor," he added darkly: "It is better to have a gay life of it than commit suicide."[54] A self-depiction from late spring (fig. 94) reveals the deep melancholy he struggled to contain and alleviate. Despite its obvious debts to the pointilist techniques of Neo-Impressionism, this is a powerfully Symbolist image in which the color has been contrived in order to lay bare inner emotional realities as forcefully as possible. In accordance with the principles of psychophysical theory, the profound sadness of his face is reinforced by the dark, night-sky blues of his clothing and background: an example of the psychological relationship between color and mood to which we pay tribute in our expression "having the blues." This visually overwhelming, cosmic blue is relieved only by the waxen pallor of his combined yellow, pink and green skin tones and the bloody red-orange of his hair and beard, a secondary color accent which he also flecked throughout the blue in order to enrich and intensify it. This intermingling of dabs of contrasting complementaries sets up optical vibrations which fill the picture with energy, creating a shimmering aura of charged particles around him that suggest his passionate, volatile personality while simultaneously embracing him with that "vibration of the infinite" to which he was so attuned and which he found so comforting. It is interesting that although a self-portrait from later in the summer (fig. 95) substitutes golden ocher tonalities for blue, the effect in relation to his fiercely intense face is smoldering rather than cheerful. With its glaring eyes and compressed mouth emerging from the matrix of fiery red strokes which define his features, beard, hat, and lapels, and with its central slash of black shadow outlining his nose, his face conveys the impression of banked-down flames, of barely contained combustible forces which threaten to ignite with explosive power. This effect is reinforced by the brushwork, which, freed from the restraint of the dot technique that imparted a suggestion of control and order to the earlier self-portrait, now crackles behind his head like an electrical discharge of random, dancing strokes.

Vincent's disappointment with his life in Paris grew as the year progressed. He had failed to establish the companionable and mutually supportive friendships he'd hoped to have with other avant-garde artists, most of whom seemed to him cold, ambitious, and given to petty rivalries with their fellow painters. His relationship with Theo had also been subjected to severe strain, for his brother, who had supported him for years and had now been sharing his small apartment with him as well, found Vincent's slovenly personal habits and irrational shifts of mood from tender generosity to argumentative peevishness increasingly difficult to tolerate. A friend of Theo's wrote to his parents in 1886 regarding Vincent: "The man hasn't the slightest notion of social conditions. He is always quarreling with everybody. Consequently Theo has a lot of trouble getting along with him."[55] During the autumn Vincent seems to have tried to cheer himself by painting still-lifes of fall fruits, which he endowed with an almost hallucinatory quality of supernatural vitality and beauty (figs 96 and 97). His richly colored apples, grapes, and lemons palpitate with life force, fleetingly potent manifestations of energy and sensuous form which blaze forth against dynamic systems of parallel strokes that surround the fruit with an aura of electrical radiance. Unlike his earlier still-lifes, these pictures eliminate all secondary props such as tables and background structural elements. Floating on flat, unspecified surfaces of shimmering color, his fruits have a concentrated power of presence that gives them the force of spiritual revelation. While in the past Vincent endowed his pictures of humble foodstuffs with a sense of his religious reverence by emphasizing their rough and homely qualities, he now found it comforting and exalting to transform his common subjects into resplendent visions that glorify God's bounty.

Vincent found another means of keeping up his spirits in painting oil versions of some of his favorite Japanese prints, ones whose bold, abstracting simplicity and lively decorative effects he found particularly compelling. It is interesting that the image of plum trees by Hiroshige which he copied (fig. 98) has much in common with his own drawings of winter trees from 1883 (fig. 51), and we shall see what an impact this style had on his manner of depicting the flowering fruit trees in the south of France the following spring. The lady by Kesaï Yeisen (fig. 99), a popular image which also appeared as a cover illustration of the contemporary magazine *Paris Illustré*, can be found as well in the lower right corner of Vincent's portrait of Père Tanguy (fig. 83). It is significant that he painted this portrait

during the winter, at a time when his depression and disillusionment with life in Paris were at a high point and the release of going out to paint the landscape was no longer possible.

Père Tanguy was a man Vincent admired: an old Communard who had gone to prison for his ideals, a kindly, benevolent soul who sympathized with the rebellious avant-garde artists, letting them purchase their paints on credit and displaying the unconventional works of the as yet unrecognized Seurat, Cézanne, Gauguin, and Vincent himself in his shop.[56] The humanistic and philosophical purveyor of art materials and prints must have seemed to the unhappy Vincent a model of the stability and serenity he so coveted. As observed earlier, he synthesized the formal and spatial aesthetic of the Japanese prints around Père Tanguy with the color theories of Neo-Impressionism in order to create a portrait which he felt expressed the essence of his sitter's character. His carefully contrived equilibrium of dense, rich colors is not only harmoniously beautiful, it also conveys an impression of depth and balance which, in conjunction with Tanguy's frontal, centralized position, solid impassivity of form, and imperturbable facial expression, gives him the iconic tranquillity of a Buddha. With Mount Fuji poised behind his head like an Oriental crown, he sits enthroned amid a nimbus of the gaily colored Japanese prints which, for Vincent, represented not only a superb and enduring visual aesthetic, but the spiritual expression of a culture whose people recognized deity in nature and whose artists lived in fraternal simplicity. Vincent portrayed the compassionate and placid Tanguy as a symbol of the religious spirit of the Japanese artists whose works he sold, gracing him with dignity and beauty by making him the hub of a burst of flowerlike works of art. He wrote to his sister during this period: "Having as much of this serenity as possible, even though one knows little —nothing—for certain, is perhaps a better remedy for all diseases than all the things that are sold in the chemists' shops."[57]

Other pictures that Vincent executed during the fall and winter of 1887 and the beginning of 1888 are more ambiguous in mood and serious in implication. Around September he painted four versions of cut and withering sunflowers (figs. 100 and 101), a motif that came to have deep associative meaning for him. Vincent developed a special fondness for these humble, unpretentious country flowers, and two years later told his sister that they symbolized gratitude for him,[58] perhaps because they continually turn their faces to follow the sun. These lopped and desiccated heads with their shriveled petals must have seemed to him a visual metaphor for the drying up of his own spirit in the inhospitable, artificial atmosphere of the big city; a symbol of deteriorating friendships and blighted hopes. Yet

with his goal of rejoicing even in sorrow, he depicted the dying blossoms with great formal beauty, rendering them in sumptuous combinations of reds, greens and golds, or orange and gold contrasted with deep violet blue and green. Perhaps it is also significant that their great heads are filled with the seeds that guarantee renewal, a principle to which he had long been sensitive and which now, in his disillusionment with Paris, he began to crave again with increased intensity.

We find the same blend of beauty and poignancy in two oil studies he did that winter of a skull (fig. 102), both of which treat the menacing death's head as if it were a piece of fruit from one of those radiant still-lifes. Like a gleaming pear of jade green mottled with pink, violet, and cream reflections, the skull drifts against the void, suspended in an aura of golden brushwork. It is the contradictory associations this image evokes as well as its aesthetic qualities that give it such power. The sensual appeal of its exquisitely modulated and harmonized color and its fruit-like form coexists with the frightening impact of its dark eye sockets and rigidly grinning jaw, and paradoxically the material beauty both relieves and intensifies the brutal fact of mortality that the skull conveys. Unlike traditional representations of skulls painted as reminders of death, Vincent's seems to be terrifyingly alive as well as putrefyingly dead, its sockets harboring green spots of paint rimmed in red that look like eyes staring malevolently at us, its colors those of decaying vegetation displayed against a smear of phosphorescent slime, or is it perhaps a halo of glittering light? His skull is a symbol of the complex duality of nature, of the truth that death and life are intimately intertwined, that beauty emerges from decay, that the most terrible things can serve as the basis of an aesthetic transformation which lends them grandeur and the power to communicate important ideas.

Another painting from the winter of 1887 which is thematically related to the dying sunflowers and the death's head is the *Still-life with plaster cast, rose and two novels* (fig. 103). Vincent executed a picture earlier in the year of a heap of books lying scattered on a tabletop with a cut rose in a glass of water (fig. 104), a work whose brilliant yellow tonalities and shimmering flecks of green and orange give it a cheerful look. The books' yellow covers identify them as contemporary French novels, literature whose subject matter was far from cheerful but which Vincent, we recall, perceived as "a great source of light." By massing them in a profusion of lemon, orange, pink, and green accents, he accorded them the beauty and freshness of the rose in water which blooms beside them, as if suggesting that they are parallel manifestations of the same life force. The painting from the winter has a very different impact. The plaster cast had been used for drawing practice in Cormon's studio

when Vincent took classes there in 1886, and he executed a number of paintings of it in various color combinations. Here, however, he has used the mutilated torso with expressive intention, juxtaposing it with other items which, when considered collectively, suggest a significant idea. The books are Guy de Maupassant's *Bel-ami* and Jules and Edmond de Goncourt's *Germinie Lacerteux*, two contemporary explorations of Parisian life which deal with the corruption of values and relationships in modern Western society and the consequent tragic wastage of women's lives. In both novels women are judged and related to solely in terms of their domestic and sexual utility; their inner spiritual qualities are ignored and their capacity for selfless love and devotion abused. For Vincent, who revered love as the supreme spiritual impulse, this callous contempt constituted the real depravity of the modern world.

These complementary yellow and blue books, one with a male and the other with a female protagonist, implicitly condemn our society not for its sexual permissiveness, but for promoting inhumane, hypocritical moral values that allow men full sexual license while punishing women for succumbing to their demands. The successful, debonair man-about-town Bel-ami ruthlessly uses women for pleasure and self-advancement, then leaves them without concern or remorse, while the servant Germinie is mistreated by her lower-class lover as well as by the heartless upper-class woman she works for, both of whom take advantage of her compliant, generous nature and abandon her pitilessly when she needs their help. Vincent has symbolized the novels' content with the headless plaster cast, an object which suggests society's view of women as brainless, insensitive sexual objects, and with the plucked and discarded rose that implies not only the conventional loss of virginity, but the careless brutality with which we enjoy and then toss aside fragile, vulnerable things. Because Vincent, as a sensitive, unappreciated artist who felt rejected not only by the public but by his avant-garde colleagues as well, identified himself with cast-off women and trampled flowers, his imagery can be understood as concerning the tragedy not just of women, but of all who are unloved and unprotected, scorned and abandoned. Although the yellow book and pale gold tablecloth create a sense of visual warmth and light, the intense, dark violet blue of the background and the green-blue shadows dominating the lower section of the picture contribute a subduing note of melancholy. Together they achieve a muted and poignant effect which is itself expressive of the novels' disturbing message.

Disillusioned with Parisian values and with the petty intrigues, selfishness and egoism of the various artistic cliques, drinking too much and suffering from a variety of physical problems during the winter, Vincent concluded that he could revitalize himself and ensure his own emo-

tional and artistic renewal only by turning, like the sunflowers, toward the sun, by moving south to the small country town of Arles. In February of 1888 he left for Provence, not only to restore his spirits and health in a place where he told his sister "there is even more color, even more sun,"[59] but also "to get away from the sight of so many painters who disgust me as men."[60] He had earlier characterized Parisians as "analytical, steely, 'knowing,'"[61] and his experiences there had revived all his previous views about the intrinsic superiority of country life and unsophisticated peasants. His disenchantment with Paris was a common Romantic phenomenon among artists and literati, who from Rousseau and George Sand to Leo Tolstoy had decried the falsity and immorality of modern urban life and contrasted it with the frank simplicity and spirituality of rural existence. A generation earlier, Balzac had claimed metaphorically that "the poor country district, for so shabby as she is, is an honest girl; but Paris is a prostitute, rapacious, deceitful, artificial"[62] and Gustave Flaubert wrote in a similar spirit to a friend: "You tell me that it is only in Paris that one breathes 'the breath of life.' In my opinion your Parisian 'breath of life' often has the odor of rotten teeth."[63] Although Paris had seemed to Vincent to at least offer an opportunity for "the exchange of ideas with somebody who knows what a picture is,"[64] even the intellectual atmosphere now seemed an insufficient compensation for what one lost there.

Vincent had always been sensitive to the power of nature to affect our moral outlook. In 1883 he had written to Theo: "I go out into the open air and paint what strikes me, breathe the fragrant air of the heath deeply, and believe that after a while I shall become fresher, newer, better."[65] This renewal was spiritual as well as physical, for, as his explanation to his brother reveals, he believed that to immerse oneself in the created world is a way of coming closer to God:

What life I think best, oh, without the least shadow of a doubt it is a life consisting of long years of intercourse with nature in the country—and Something on High—inconceivable, 'awfully unnamable'—for it is impossible to find a name for that which is higher than nature. Be a peasant . . . be a painter, and as a human being, after a number of years living in the country and of having a handicraft . . . you will . . . gradually become something better and deeper in the end.[66]

The capacity of nature to stimulate the moral and spiritual rejuvenation of a person lies, of course, in its own physically regenerative character. Nature provides a ceaselessly unfolding example of growth and decay, of birth, death and renewal; it embodies continual change within an ongoing continuity, and to the thoughtful observer it suggests not

only the process of our physical aging, but of our emotional and intellectual development as well. Vincent found nature consoling even in its tragic implications because he perceived in its laws a divine and eternal order which, if we harmonize ourselves with its principles, can both compensate us for the brevity of our lives and inspire us to grow and change. In 1885 he wrote: "And it is a good thing to be deep in the snow in winter; in autumn, deep in the yellow leaves; in summer, amid the ripe corn; in spring, in the grass; it is a good thing to always be with the mowers and the peasant girls, with a big sky overhead in summer, by the fireside in winter, and to feel that it has always been so and always will be."[67] For Vincent, who had advised his friend van Rappard to fall in love with Dame Nature if he wanted to make spiritually powerful art, becoming an artist had from the beginning been synonymous with becoming intimate with the organic world and developing into a better person by doing so. In a series of letters to Theo in 1883, he had repeatedly linked these issues, writing of becoming an artist as a "renewal of life [which] changes your whole character, changes your thoughts and opinions,"[68] reiterating his intention "to refresh, to rejuvenate myself in nature,"[69] and finally declaring: "I shall be a *painter*, I want to *remain human*—going *into* nature."[70] When he left for the south of France in February of 1888, therefore, he saw himself as purposefully embarking on another stage of his quest for spiritual regeneration and self-expansion.

Salvation in the South: The Year in Arles

Regeneration in the Provençal Japan: February – October, 1888

IN HIS FIRST BRIEF NOTE TO THEO AFTER ARRIVING IN THE south of France, Vincent revealed one of his underlying purposes in going there when he commented that, as he viewed them from the train, "the landscapes in the snow, with the summits white against a sky as luminous as the snow, were just like the winter landscapes that the Japanese have painted."[1] Predisposed to find in Arles and the surrounding countryside a natural, spiritual, "primitive" peasant environment, and observing the flat contours of the snowy fields through the eyes of a devotee of Japanese prints, his association of Provence with Japan was inevitable. A few months later he even confessed to Gauguin that his expectations of finding the Orient in Arles had been so strong that he kept peering out of the train window "to see whether it was like Japan yet!"[2] He told his sister, "I don't need Japanese pictures here, for I am always telling myself *that here I am in Japan*,"[3] and to Theo he argued that even if living there was more expensive than they had anticipated, it was worthwhile to remain because "we like Japanese painting, we have felt its influence, all the Impressionists have that in common; then why not go to Japan, that is to say to the equivalent of Japan, the South?"[4]

For Vincent the primitive virtue of Provence lay not merely in the decorative effect of its fortuitous topography and light, but in the power of its atmosphere to restore and enhance the creative faculties. "I wish you could spend some time here," he enthused to his brother; "you would feel it after a while, one's sight changes: you see things with an eye more Japanese, you feel color differently. The Japanese draw quickly . . . because their nerves are finer, their feelings simpler."[5] Merely living in the intoxicating atmosphere of the South, he felt, could turn one into the European equivalent of the astute Japanese artist. Later, when trying to convince Bernard to join him in Arles, he told him: "In the South, one's senses get keener, one's hand

becomes more agile, one's eye more alert, one's brain clearer. . . . I venture to believe most firmly that anyone who loves artistic work will find his productive faculties develop in the South."[6] Vincent was in sore need of both physical and psychological regeneration when he arrived in Provence, as he reminded his brother several months later in referring to his condition "when I left you at the station to go South, very miserable, almost an invalid and almost a drunkard."[7]

It was especially meaningful to Vincent in his quest for renewal that he arrived in Provence at the beginning of spring. Within two weeks the first fruit trees had burst into blossom (figs. 105 and 106), and the budding branches of almond and pear seen against the remnants of snow in the clear southern light seemed to him a symbol of his own longing to rejuvenate himself, to bloom and grow. He must have found the visual juxtaposition of flowering trees and snow to be an especially evocative and poignant contrast: an embodiment of that moment of transition, that cusp between the seasons which is so demonstrative of the law of change. Long accustomed to perceive the reawakened trees as a metaphor for the process of spiritual rebirth, he had written to Theo five years earlier that artistic endeavor was like a flowering tree, and that the "man who finally produces something poignant as the blossom of a hard, difficult life, is a wonder, like the black hawthorne, or better still the gnarled old apple tree which at a certain moment bears blossoms which are among the most delicate and virginal things under the sun."[8] It is significant that one of the first studies he produced in Arles of a flowering almond twig (H1362) depicts it in a glass of water next to a book, another equivalent source of spiritual regeneration. Thinking in terms of these correspondences and moved by profound respect for what he later described as "a human soul vigorous enough to mold itself anew,"[9]

he wrote enthusiastically to Theo: "I'm up to my ears in work, for the trees are in blossom and I want to paint a Provençal orchard of astounding gaiety."[10]

For Vincent, however, gaiety was never completely divorced from the darker side of life, and a passage in one of his letters to Theo reveals what complex spiritual implications the spring trees had for him. Returning to his lodgings after a day's work, he found a Dutch notice from his sister concerning the death of Anton Mauve, the landscape artist who had been his teacher and his friend. Deeply moved, he inscribed "Souvenir de Mauve" on an already completed painting of a flowering pink peach tree (fig. 107) and wrote to Theo that he wished to send it to the widow as a memorial. "It seemed to me that everything in memory of Mauve must be at once tender and very gay," he told Theo, adding:

> O never think the dead are dead,
> So long as there are men alive,
> The dead will live, the dead will live.[11]

His fertile tree, its branches red with sap like veins filled with blood, embodied for him the ongoing, creative life force and reverence for nature which he felt had passed from Mauve to himself via the influence of the older artist's work. Mauve's spirit and vision had helped Vincent revitalize his own soul and art, enabling him in turn to pass this spirit of renewal on to others. The peach trees mingle exquisite beauty with intimations of the brevity of life, and he felt that the poignant joy they inspired was therefore not inappropriate as an expression of his sorrow at Mauve's death and his gratitude for his artistic legacy. "Mauve's death was a terrible blow to me," he told Theo in a subsequent letter; "You will see that the pink peach trees were painted with a sort of passion."[12]

Explaining to Bernard the relationship he perceived between his feelings for his subject, his grasp of its essential nature, his use of "savage," unconventional techniques in rendering his motif, and his decorative aesthetic concerns, he wrote a few weeks later:

At the moment I am absorbed in the blooming fruit trees, pink peach trees, yellow-white pear trees. My brush stroke has no system at all. I hit the canvas with irregular touches of the brush, which I leave as they are. Patches of thickly laid-on color, spots of canvas left uncovered, here and there portions that are left absolutely unfinished, repetitions, savageries; in short, I am inclined to think that the result is so disquieting and irritating as to be a godsend to those people who have fixed preconceived ideas about technique. . . .

Working directly on the spot all the time, I try to grasp what is essential in the drawing—later I fill in the spaces which are bounded by contours—either expressed or not, but in any case

felt—with tones which are also simplified, by which I mean that all that is going to be soil will share the same violet-like tone, that the whole sky will have a blue tint, that the green vegetation will be either green-blue or green-yellow, purposefully exaggerating the yellows and the blues in this case.

In short, my dear comrade, in no case an eye-deceiving job.[13]

Throughout the spring Vincent worked at incorporating the principles of Japanese aesthetics into his Provençal pictures. Two paintings which he referred to specifically as Japanese in conception are the *Bridge of Langlois* (fig. 108) and *View of Arles with irises* (fig. 109), and when we consider them in detail and in relation to his remarks about Japanese art and artists, we realize that the associations implied for him by the characterization "Japanese" went beyond the stylistic qualities of spatial flatness and bright color to include a certain spiritual view of life. In the letter to Bernard in which Vincent mentioned his picture of the bridge of Langlois, he prefaced his reference with the remark that "if the Japanese are not making any progress in their own country, still it cannot be doubted that their art is being continued in France."[14] He felt that his most recent works exhibited what he later described as "the simplification of color in the Japanese manner," whereby the artist "ignores reflected colors, and puts the flat tones side by side with characteristic lines marking off the movements and forms."[15] In comparison with his Paris landscapes, for example his 1887 *Bridge at Asnières* (fig. 91), the *Bridge of Langlois* is pictorially a more simplified and harmoniously unified image—the product, he believed, of his acquisition of a simpler yet more refined "Japanese" sensibility. The grasses on the riverbank and the reflective surface of the water are defined by a minimal number of boldly juxtaposed strokes of color, while a few expressive, curving lines capture the womens' characteristic postures or suggest the rippling movement of water as they wash their clothes. There is far less blending of colors and strokes than in the earlier picture, the dash-like streaks of paint are longer and stand out more forcefully, and the palette is reduced to only two or three shades of a color instead of multiple subtle variations. The result is a powerful intensification of values: a clearer, brighter, and more visually abstract image which Vincent felt conveyed the "naïve" and "primitive" quality of the Provençal countryside and lifestyle.

In addition to creating the air of bold naïveté and vivid gaiety which Vincent associated with the South, these stylistic reductions also help to achieve the impression of aesthetic and, by extension, spiritual harmony which was so crucial for him. Substituting these vigorous and rapidly executed simplifications for the closely worked over and blended surfaces of his previous paintings seemed to him

proof of his own more intuitive penetration of nature's essential patterns. His increased sensitivity to the unity of phenomena is manifested pictorially in his construction of an ordered network of strong color and directional contrasts throughout the canvas. Alternating strokes of red orange and green grasses balance the yellow and blue complementaries of the bridge, sky, and river, each of which is flecked with its opposite to produce a vibrant and coloristically unified whole. Compositionally, the vertical and horizontal geometry of the bridge and its reflection in the water create a great central cross which imparts a classical symmetry and equilibrium to the canvas. This central geometric framework, which is echoed and enclosed by the bands of sky above and bank below, is relieved and enlivened by the great undulating sweep of the hill and shore, the round knot of washerwomen amid the circular ripples of the water, and the flexible, slightly curved grasses at the right. Both formally and chromatically, the *Bridge of Langlois* demonstrates Vincent's abstraction of nature to its essential coloristic and formal elements, and his creation from these components of a harmoniously interwoven unity in which humanity and its works are perfectly integrated.

Southern France seemed to Vincent to be the Western equivalent of Japan not only because of its light and color, but because he felt that in its unpretentious atmosphere, his own life would "become more and more like a Japanese painter's, living close to nature. . . ."[16] His "Japanese" craving for a simpler existence in harmony with the organic world is evident in his May painting *View of Arles with irises* (fig. 109) as well. It is meaningful that when he wrote to Bernard about this picture of what is essentially a landscape, he described it first as "a view of Arles." "Of the town itself," he went on,

one sees only some red roofs and a tower, the rest is hidden by the green foliage of fig trees, far away in the background, and a narrow strip of blue sky above it. The town is surrounded by immense meadows all abloom with countless buttercups—a sea of yellow— in the foreground these meadows are divided by a ditch full of violet irises.[17]

To Theo he wrote of the painting as depicting "a little town surrounded by fields all covered with yellow and purple flowers, exactly like a Japanese dream,"[18] a reference not only to the predominant color contrast, but to his recognition that the view of Arles he was depicting was suggestive of the Japanese people's vision of human life as an integral part of nature's totality. Vincent was aware that this perspective was not common in the West, for he later remarked to Theo that "we are still far from the time when people will understand the curious relation between one fragment of nature and another, which all the same explain and enhance each other."[19]

The "Japanese dream" for him had to do with the Oriental's spiritual perception of our subordinate and interactive place in the overall fabric of creation. It was for this reason that he characterized the Japanese artist as

a man who is undoubtedly wise, philosophic and intelligent, who . . . studies a single blade of grass.

But this blade of grass leads him to draw every plant, and then the seasons, the wide aspects of the countryside, then animals, then the human figure. So he passes his life, and life is too short to do the whole.

Come now, isn't it almost a true religion which these simple Japanese teach us, who live in nature as though they themselves were flowers?[20]

Although there are no animals or human figures in the picture, the red roofs clustered around the central church tower indicate man's physical and spiritual presence. Balanced by the green foliage and juxtaposed with the alternate complementaries of yellow and purple flowers, embedded in and dominated by the seasonal plants, the larger aspects of the countryside, Arles and by extension its inhabitants are presented here as a tiny fragment within a resplendent whole.

This religious vision of the Provençal landscape dominated many of the motifs Vincent painted during his first summer in Arles. Describing a picture of fields viewed from the vantage point of a nearby hill (fig. 110), he wrote to Bernard in July that he had depicted

an immense stretch of flat country, a bird's eye view of it seen from the top of a hill—vineyards and fields of newly reaped wheat. All this multiplied in endless repetitions, stretching away towards the horizon like the surface of a sea, bordered by the little hills of Crau.

It does not have a Japanese look, and yet it is really the most Japanese thing I have done; a microscopic figure of a laborer, a little train running across the wheat field—this is all the animation there is in it.

Listen, one of the first days after I came to this spot I talked to a painter friend of mine, who said, 'How boring it would be to do this.' . . . And I am still going there, over and over again. . . . that flat landscape, where there was nothing but . . . infinity—eternity.[21]

These insights into the nature of the physical world constituted a mystical experience for van Gogh, an intuitive revelation of truth which he associated with becoming more "primitive." It was infinity and eternity that he sensed so overwhelmingly when his emotions before nature's beauty caused him "to lose consciousness," to fall into a state of

"terrible lucidity" in which the picture came to him "as in a dream."[22] The Japanese quality, which he claimed had little to do with any aesthetic resemblance to Japanese art, involved here, as in the *View of Arles with irises,* the creation of a vision in which the world is experienced as it is by the meditating Buddhist: a dream-like manifestation of God's infinitude, a totality where humanity is no more than a minute component in the vastness of space and the endlessness of time.

Vincent found reality so naturally expressive of suggestive truths that he saw symbolic meaning in many of the seemingly ordinary scenes around him. On a week's visit in June to the nearby Mediterranean fishing village of Saintes-Maries-de-la-Mer, for example, he did a series of drawings and several paintings of fishing boats. All the works in this group depict only two basic motifs: small, one-man fishing smacks either sailing on the sea or drawn up on the beach (figs. 111 and 112). Although the letters which mention these pictures offer no comments on their meaning, Vincent's earlier correspondence is filled with references that shed light on the appeal these two motifs had for him beyond the affinity any Dutchman feels for nautical imagery. In his letters to van Rappard between 1881 and 1883 he often used the sea and boats as metaphors for life. Man, he told his friend, is like a sailor on the sea of life, and "if we are never thrown against the rocks or buffeted by breakers, we'll not become real sailors. And there is no mercy for us; everyone has to go through a period of worry and struggle if he wants to go into real deep water." His own goal as a leader of men, he added, was to "show the open sea"[23]—to reveal the hazards and beauty of real life and encourage others to venture forth and grapple with it. He again compared existence to the sea and himself to a sailor when he later confessed that "when my worries become too great, I feel as if I were on a ship during a hurricane. But you see, although I well know that the sea has its dangers, and that one can drown in it, still I love the sea; and notwithstanding all the perils that the future may hold, I have a certain serenity."[24] He reiterated this metaphor to Theo later that year when trying to persuade him to become an artist and join him in the village of Drenthe, writing of resolving to "push off to the open sea" and of "the secret of the depth, the intimate, serious charm of the Ocean of an artist's life."[25]

Although at the time that Vincent depicted the sailboats tossing on the waves at Saintes-Maries he did not repeat these ideas in his letters, the strength of such associations must have accounted for his obvious preoccupation with the motif. In the versions he executed of the boats out fishing, the sea brims high and choppy in the composition, creating an impression of great depth and powerful currents which make the little boats skimming over the

dark water seem even more fragile. In writing to Bernard of these pictures, Vincent noted that because the boats were so small and crewed by a single man they never ventured out in rough weather or risked getting too far from shore.[26] But the high level of water in his paintings, the swelling, turbulent surface, and the sails straining in the wind, create a sufficient impression of the sea's potential menace and the boats' vulnerability to arouse our sense of the sailors' courage in pursuing their calling.

Additional marine references in Vincent's letters are relevant to the other series of works representing boats pulled up on the beach. Two days after writing to van Rappard of his desire to sail on deep water and show men the open sea, he admitted:

In the long run a man cannot stay out on the open sea continuously; he has to have a little hut on the shore, with a little fire in the chimney—and a wife and children around it . . . We must become FISHERMEN IN THE OCEAN OF REALITIES, *but there must be 'the little hut' for myself as well as for those whose path I cross . . . the sea and the resting place.*[27]

In later years he told Theo that his financial dependency on him was like a little boat being towed by a ship, and he couched his plea for more money in terms of the expediency of "keep[ing] the little boat trim and sea-worthy." "I, who am the skipper of my tiny vessel," he went on, "ask...that my little boat be kept trim and well-provisioned, in order that I may do better service in times of need." He elaborated on this idea in the next paragraphs, reiterating that Theo's aid would be "in both our interests" because "in case of a tempest *I shall be willing and perhaps able* to be of some use and service to you."[28] Despite the fact that these remarks preceded it by years, all have relevance to the images of beached boats at Saintes-Maries. All contain the idea that in order to prepare for and sustain themselves during the dangerous voyage on the sea of life, people must have recourse to the support of others, a safe harbor to which they can periodically return to warm themselves and refurbish their vessels.

Although by 1888 Vincent had abandoned the hope of ever having a real home or a wife and children from whom he could derive comfort, he still clung to his belief in the power of friendship to alleviate loneliness and provide mutual emotional and material benefits. During this very May and June his letters are filled with references to his cherished project of persuading Gauguin to join him in Arles, and to his conviction that by banding together in communal artistic enterprises as the Japanese artists did, the avant-garde European painters could defeat both their poverty and their isolation. He hoped that in the humanizing South he could finally actualize that longing for frater-

nal companionship which had been frustrated in Paris and which he perceived as a truly religious craving. "Nothing else is essential in the way that this spiritual unity is,"[29] he had told van Rappard years before; now he wrote to Bernard of his ideal that magnificent works of art be "created by groups of men combining to execute an idea held in common," and he mourned the loss of such potential masterpieces as another "reason to regret the lack of corporate spirit among the artists."[30] The same month, immediately before leaving for Saintes-Maries, he wrote to Theo about a letter he had received from Gauguin in which the latter, who had spent years in the merchant marine and navy, likened the need for heartfelt cooperation among the avant-garde painters to the situation of sailors laboring at sea. "He says," Vincent reported, "that when sailors have to move a heavy load, or weigh anchor, so as to be able to lift a very heavy weight, and to make a huge effort, they all sing together to keep them up to the mark and give them vim. That is just what artists lack!"[31] Shortly after, he wrote again to Theo, applauding a scheme of Gauguin's for creating a society of independent painters backed by sympathetic bankers: "I am inclined to think that the artists would guarantee each other a livelihood . . . and that the profits as well as the losses should be had in common. I do not think that this society would last indefinitely, but I think that while it lasted we should live courageously, and produce."[32]

Surely it is no coincidence that at the very time Vincent was meditating these plans, which represented his last hope of acquiring real spiritual and intellectual companionship and easing the burden on Theo of maintaining him, he should have become fascinated by the motif of the group of little one-man boats clustered in close proximity on the beach. From their overlapping shapes and contrasting complementary colors of red and green, yellow and blue, black and white, he constructed an interlocking unity of forms that seems to symbolize the singleness of purpose with which the boats will together take to the sea again from their resting place on the shore. That Vincent intended this meaning seems evident from his bold inclusion of the word "Amitié" (Friendship), printed clearly on the white prow at the center of the canvas. A passage in a letter to Bernard from the following month confirms the relationship between these images and ideas. "Furthermore," he wrote,

the material difficulties of a painter's life make collaboration, the uniting of painters, desirable (as much so as in the days of the Guild of St. Luke). By safeguarding their material existence, by loving each other like comrades-at-arms instead of cutting each other's throats, painters would be happier, and in any case less ridiculous, less foolish and culpable.

But for all that I won't labor the point. For I know that life drags us along so fast that we haven't time both to argue and to act. For which reason . . . we are at present sailing the high seas in our wretched little boats, all alone on the great waves of our time.[33]

On his return to Arles, Vincent set to work again painting the principal seasonal activities in process in the countryside: the harvesting of the first crop and the sowing of the next. A picture from this June to which he attached a great deal of importance and for which he executed many drawings was *The Sower* (fig. 113). It is noteworthy that when he wrote to Theo and Bernard about this painting he made it clear that it held religious meaning for him; it is also significant that most of his comments about it have to do with its color. He first told Theo that "it's a composition in which color plays a very important part,"[34] and in a later letter claimed that it embodied his first conscious attempt to use color symbolically. "It is color not locally true from the point of view of the delusive realist," he stated, "but color suggesting some emotion of an ardent temperament."[35] It is particularly relevant that in explaining his intentions to Theo, he likened his image of the sower not to the figure by Millet (fig. 14) which he had first copied in 1881 (fig. 29) and whose pose he had once again borrowed here (a figure he described as "a colorless gray"), but rather to two unrelated religious paintings by Delacroix: works he praised for communicating a spiritual message of consolation and redemption through an evocative rather than a realistic use of color—for speaking "a symbolic language through color alone."[36] These comments reveal that the unusual color harmonies of *The Sower*'s golden sky and purplish earth were not the result of some abstract aesthetic experiment, but the manifestation of van Gogh's desire to convey a spiritual idea through the material attributes which psychophysical theory deemed most suggestive for the purpose. He touched on the relationship between his philosophical intention and his distortion of color in a letter to Bernard when he wrote:

I have played hell with the truthfulness of the colors. I would much rather make naive pictures out of old almanacs, those old 'farmer's almanacs' in which hail, snow, rain, fair weather are depicted in a wholly primitive manner . . . I am still charmed by the magic of hosts of memories of the past, of a longing for the infinite, of which the sower, the sheaf are the symbols . . .[37]

For Vincent, the planting of seeds and the ripening of the crops were natural metaphors for all the cyclical, eternal processes by which life is regenerated and comes to maturity. It is significant, therefore, that behind the figure scattering the seeds of new life in the freshly turned, violet earth we find a field of ripe wheat, the intermediate stage

in the ongoing cycle of insemination and harvesting, and that the huge yellow sun rises like the eye of God at the center of the composition, flooding the earth with its quickening warmth and energy. In the interaction between sun and earth new life is created, and the colors of the painting function symbolically to suggest this relational process. The purple, blue, and lilac strokes of the soil evoke the cool, moist quality of the earth, deeply shadowed and mysterious. Interlaced across its surface, the contrasting dashes and flecks of apricot, peach, and orange set up a shimmering effect of sunlight warming and fertilizing the dark clods. The sun itself is a disk of vibrant yellow, radiating its life-giving force in staccato pulses of paint which are the physical expression of the artist's own vitality as well of the energy of nature. Even the pose of the sower suggests the religious meaning this motif had for him: unlike the bent and toiling potato planters of Vincent's northern paintings, this figure strides upright across the field, head erect, face illuminated with golden light, his arm swinging rhythmically in counterpoint to his step as he performs his sacred ritual like an acolyte swinging a censer.

Vincent believed that in the fields we can observe laws at work which help us acquire perspective on our own life problems. The following summer he asked his sister:

What else can one do, when we think of all the things we do not know the reason for, than go look at a field of wheat? The history of those plants is our own; for aren't we, who live on bread, to a considerable extent like wheat, at least aren't we forced to submit to growing like a plant without the power to move, by which I mean in whatever way our imagination impels us, and to being reaped, when we are ripe, like the same wheat?[38]

Because he saw in the wheat fields a metaphor for human existence, its imagery had additional implications on the spiritual and moral levels to which he had long been sensitive. In 1877 he wrote to Theo about a sermon he had heard during which he was especially moved by the parable of the sower as it applied to the mysterious development of moral repercussions from human actions. The minister, he wrote,

spoke about 'Jesus walked in the newly sown field.' He made a deep impression on me. In that sermon he spoke about the parable of the sower, and about 'the man who should cast seed into the ground and should sleep and rise night and day, and the seed should spring up and he knoweth not how.' He also mentioned the 'Funeral Procession through the Cornfields' by van der Maaten.[39]

It is revealing of Vincent's vision of life that he was particularly receptive to ideas linking growth or spiritual renewal to death. The inevitable connection he perceived

between birth and mortality must have stemmed not only from his observation of their relationship in nature, but from his recognition that it is knowledge of this ultimate fate which often spurs us to self-improvement. That his own thinking tended this way is evident from another letter of 1877, in which he quoted at length from a sermon he had heard on Ecclesiastes' teaching that wisdom and the impetus to moral behavior arise when we remember death and sorrow even in the midst of joy, when we dwell on the insubstantiality of life even when beholding the sun. After recording a long passage from this text, he added by way of his own commentary: "For whatsoever a man soweth, that shall he also reap . . . he that soweth to the Spirit shall of the Spirit reap life everlasting."[40] This was a popular metaphor in Romantic literature, one which Vincent found also in Carlyle's *Sartor Resartus*. Extrapolating from Goethe's phrase "Time is my seedfield,"[41] Carlyle compared life to a seed field in which people sow actions and ideas. "Wouldst thou plant for Eternity," advised Carlyle in a passage to which Vincent must have particularly responded, "then plant into the deep, infinite faculties of man, his Fantasy and Heart."[42] It was van Gogh's most passionate desire to create works of art which for all time would speak to us through our imaginations and emotions about the great mysteries and laws, the sorrows and consolations of life. The sower was therefore also a symbol of his own artistic creativity, and he saw his pictures as seeds of life-giving ideas and feelings which he hoped would be reaped by future generations.

Given such associations and his desire to record the fundamental activities of each season in the manner of farmers' almanacs and medieval breviaries, Vincent devoted much of June to painting harvest scenes as well (figs. 114 and 115). These depictions of reapers working among the sheaves in the fields are all executed in the summer color complementaries of golden orange and blue, with relieving accents of red and green enriching and balancing the dominant contrast. The jade-green tonalities of the skies, which shift gradually into dark, rich shades of violet blue in the upper registers of the canvases, endow the heavens with a mysterious glow and an enamel-like density and intensity that makes the air a counterweight to the dazzling yellows of the wheat. As in all these works from 1888, the forms are reduced to a few defining strokes and the effects of stubble, sheaves, wind-blown wheat, figures, and distant buildings are achieved by roughly but deftly drawing their characteristic outlines in color. Generalized, faceless, minimally indicated, the harvesters take on the same angular or undulating contours as their surroundings, demonstrating through the repetition of these formal patterns their unity with the natural world in which they perform the tasks of subsistence. In some of

these pictures (figs. 116 and 117), our sense of the peasants' immersion in the infinity and eternity of the landscape is overwhelming. Like the little boats at Saintes-Maries, they labor in the sea of wheat, and as in the spring painting of the town glimpsed across the field of irises, the houses and factories of Arles are again presented as no more than a distant backdrop to the ongoing drama of nature's reproductive cycles.

Working compulsively on these scenes of reaping, with all their intimations of mortality, Vincent confessed to Bernard that he felt "utterly exhausted" not only by the heat, but by the obsessive speed with which he felt driven to render his subjects. "How tired you get in the sun here!" he wrote; ". . . The landscapes yellow—old gold—done quickly, quickly, quickly and in a hurry, just like the harvester who is silent under the blazing sun, intent only on his reaping."[43] The haste with which Vincent worked had both artistic and psychological motivations. He had already come to believe that the sureness and speed of an artist's execution were hallmarks of acute sensibility as well as of technical proficiency: we recall his claim that "the Japanese draw quickly, very quickly, like a lightning flash, because their nerves are finer, their feeling simpler,"[44] and he similarly praised the Barbizon artists and other admired contemporaries for painting "with very great rapidity."[45] He was careful to point out to Theo that this did not mean his pictures were unplanned or haphazard in their effects, but to the contrary required such intense mental effort that he used cerebral strain as the justification for his excessive use of alcohol and tobacco during this period: "Don't think that I would maintain a feverish condition artificially," he told his brother, "but understand that I am in the midst of a complicated calculation which results in a quick succession of canvases quickly executed but calculated long *beforehand*. So now, when anyone says that such and such is done too quickly, you can reply that they have looked at it too quickly."[46]

In addition to the stress of planning and executing his canvases, however, the urgency he experienced in painting these pictures came even more from the emotional pressure he felt to produce, not only in order to fulfill his calling and justify Theo's long-term financial support ("my ambition is to be less of a burden to you"[47]), but to combat fleeting time by capturing every telling moment of eternity. His consoling idea of insuring against his own end by creating as many immortal images as he could was certainly stimulated by the suggestive nature of the countryside, for he often expressed his awareness of the inexorability of death in terms of harvest metaphors. The previous year, we recall, he had observed to his sister "that not every grain of wheat, after ripening, returns to the earth, there to germinate and become a new plant—but that the great majority

of grains of wheat do not attain their natural development, but go to the mill—isn't this true?"[48] Such thoughts helped him bear his own disappointment at not fathering children or finding a permanent relationship with a woman, and frustrated in attaining that aspect of natural development, he was determined to fulfill his artistic potential by bringing forth from his inner being as many comforting visions of natural law as possible before being reaped himself.

Because the wheat, like the sea, suggested to him not just death but the totality of existence, the rhythmic ebb and flow of destructive and regenerative forces functioning harmoniously, serenely, in relation to one another, he went on to compare the reproductive capacities of the plants to the human experience of spiritual renewal through the vitalizing action of love. "In every man who is healthy and natural," he told his sister, "there is a germinating force as in a grain of wheat. And so natural life is germination. What the germinating force is in a grain of wheat, love is in us."[49] Just as the generative light and heat of the southern sun revives physical life, he believed, by the same divine law God also ensures humanity's spiritual reformation by inspiring us to rekindle what Vincent described as "the light and fire of eternal love."[50] Perhaps it was this association of the wheat with the idea of nurturing and consoling love that led him to paint these pictures of little couples in the midst of the grain, their closely joined figures forming a focal point in the fields like emblems of male and female union. Whether reaping back to back or strolling along the edge of the rippling golden tide under the setting sun, the tiny couples surrounded by the harvest landscape remind us that companionship and physical love compensate us for the difficulty and brevity of life, sustaining and nurturing our spirits as the wheat does our bodies. Vincent believed that if one were deprived of this natural human relationship, one could still find emotional fulfillment and a sense of harmony with the world by extending one's loving feelings to the entirety of nature and, through an intimate rapport with God's creation, one could produce works of art as spiritual progeny to bequeath to the future. As he expressed it to Theo in September: "And if, frustrated in the physical power, a man tries to create thoughts instead of children, he is still part of humanity."[51]

In addition to painting the fields and gardens around Arles, Vincent, who had written to his sister in April that "people here are picturesque too,"[52] began during the summer months to execute portraits of some of the local inhabitants with whom he had struck up acquaintance and who seemed to him typical representatives of Provence's vigorous rural society. In June he made several pictures of Zouaves, the traditionally costumed North African regiment whose colorful presence in southern France lent the sleepy provinces a touch of romance and must have

reminded him of Delacroix's Moroccan imagery. His full-length depiction of one of these exotic soldiers (fig. 118) emphasizes the quality of primitive, animal naturalness which he felt characterized the archetypal military male. With his tasseled cap sliding rakishly down over one ear, the swarthy, non-European looking Zouave sprawls at ease in his chair, knees agape, feet planted solidly on the simple tile floor, rough hand resting matter-of-factly on the center of his flamboyant red skirts as if protecting or calling attention to his genitals. That Vincent meant this provocative posture and gesture to express his subject's primal, animal nature seems apparent from his comments about his model to Theo and Bernard. He described him to his brother as having "a little head, a bull neck, and the eye of a tiger," and characterized his first study of him as "a savage combination of incongruous tones, not easy to manage . . . very harsh, but all the same I'd like always to be working on vulgar, even loud portraits like this."[53]

The Zouave's animal vitality and coarse sensuality were attractive features to Vincent, who had for years been trying to distance himself from the cold gentilities and repressiveness of his Dutch Protestant upbringing, and who, being often sickly and by circumstance sexually unfulfilled himself, deeply admired the powerful life force in all its natural manifestations. It is significant that in response to receiving a sketch of a brothel from Bernard, he told him that he would save one of his pictures of the Zouave to exchange with him. "If we two did a picture of a brothel," he added, always thinking with pleasure of the possibility of joint projects, "I feel sure that we would take my study of the Zouave for a character."[54] Vincent's connection of the Zouave with the brothel reveals how he perceived him and what he wanted his picture to symbolize. His own sole sexual outlet since Christine had been with prostitutes, and although he believed fervently that sexuality is healthy, desirable, even sacred, he also had come to feel that modern artists were too debilitated by the physical and moral unhealthiness of the times to be able to indulge in very much sexual activity. He warned Bernard:

Painting and fucking a lot are not compatible; it weakens the brain. Which is a bloody nuisance.

As you know, the symbol of St. Luke, the patron saint of the painters, is an ox. So one must be patient as an ox if one wants to labor in the artistic field. But the bulls are lucky enough not to have to work at that filthy painting.[55]

The bull-like Zouave, fortunate not to suffer from the modern artist's undermined constitution and refined sensibilities, suggested the rude health and potency Vincent had come South to acquire. The strength of these associations is evident from the number of times he revived the subject

in subsequent correspondence. In his next letter, after mentioning the Zouaves in reference to Bernard's prospective military service and plans to visit Africa, he advised him "to try to cultivate a temperament which can stand a lot of wear and tear, a temperament which enables you to live to a great age; you ought to live like a monk who goes to a brothel once every two weeks—that's what I do myself; it's not very poetic, but I feel it is my duty to subordinate my life to my painting."[56] In a later letter he expanded further on his views about the relationship between sex and making art in the present as opposed to the more natural and vigorous past. Responding to Bernard's denunciation of Edgar Degas as "impotently flabby," Vincent told his friend:

Degas lives like a small lawyer and does not like women, for he knows that if he loved them and fucked them often he, intellectually diseased, would become insipid as a painter.

Degas's painting is virile and impersonal for the very reason that he has resigned himself to be nothing personally but a small lawyer with a horror of going on a spree. He looks on while the human animals, stronger than himself, get excited and fuck, and he paints them well, exactly because he doesn't have the pretension to get excited himself.

Rubens! Ah, that one! he was a handsome man and a good fucker, Courbet too. Their health permitted them to drink, eat, fuck. . . . As for you, my poor dear comrade Bernard, I already told you in the spring: eat a lot, do your military exercises well, don't fuck too much; when you do this your painting will be all the more spermatic.

Ah! Balzac, that great and powerful artist, has rightly told us that relative chastity fortifies the modern artist. The Dutchmen [seventeenth-century artists like Hals and Rembrandt] were married men and begot children, *a fine, very fine craftsmanship, and deeply rooted in nature.*[57]

Going on to assess Bernard's recent drawings, he told him "I have vague misgivings that your new studies will not have the same vigor, exactly in point of virility," and he continued: "If we want to be really potent males in our work, we must sometimes resign ourselves to not fuck much, and for the rest be monks or soldiers, according to the needs of our temperament. The Dutch, once more, had peaceful habits and a peaceful life, calm, well-regulated." After noting that Delacroix too "did not fuck much, and only had easy love affairs, so as not to curtail the time devoted to his work," he concluded:

I know that the study of the Dutch painters can only do you good, for their works are so virile, so full of male potency, so healthy. Personally I feel that continence is good for me, that it is enough for our weak, impressionable artists' brains to give their essence to the

creation of our pictures. For when we reflect, calculate, exhaust our-selves, we spend cerebral energy.

Why exert ourselves to pour out all our creative sap where the well-fed professional pimps and ordinary fools do better in the matter of satisfying the genital organs of the whore, who is in this case more submissive than we are ourselves?[58]

In his painting of the Zouave, Vincent epitomized the primitive male potency he so respected and envied but believed he had sacrificed to his spiritual artistic goals. In addition to the self-confident swagger of the pose, all the elements of his style function purposefully to suggest the earthy simplicity of the soldier's sensual, unintellectual nature. The powerful, dominant scarlet tones set off by vivid green accents convey boldness and passion, the rough plaster wall in dirty white impasto and the heavy, unadorned wooden door frame reinforce the impression of elemental simplicity or crudity, and the steep slant of the earthy tiled floor echoes and intensifies the bravado effect of the Zouave's precariously tilted fez and wide-spreading, angular skirts. Vincent was aware that nothing could be further from the genteel conventions of Academic European portraiture. When writing to Bernard about his pictures of this sitter, he called them "very ugly" and remarked: "The figures I do are nearly all detestable in my own eyes, and all the more so in the eyes of others."[59]

Vincent had difficulty finding people who were willing to pose for him, but he was pleased to acquire a model whom he felt typified the unpretentious decency of the working classes in this southern rural town. When he became friendly with the postman Joseph Roulin (fig. 119) who lived next door with his wife and family, Vincent wrote to Theo that he found him more than usually interesting because he was "a violent Republican" with a face "very like Socrates."[60] He was so struck by Roulin's physical and psychological character that he repeated this description both in a subsequent letter to Theo and in a later letter to Bernard, where he referred to him as "a Socratic type, none the less Socratic for being somewhat addicted to liquor," and "a terrible republican, like old Tanguy."[61] To the liberal and democratic van Gogh, the postman suggested the virtues of the earthy philosopher of antiquity: a straightforward man of the people, simple but with great practical wisdom, a realistic but uncompromising champion of the same humanistic values Vincent himself espoused. These were the qualities he sought to convey in two portraits he executed of Roulin in July and August, both of which portray his neighbor sitting stiffly in his postal uniform with a somewhat dour expression.

Although Vincent commented to Bernard that he had to paint a second version of Roulin because he "kept himself too stiff while posing,"[62] this awkwardness actually

helped to evoke the character he wanted to express. With his rigidly held arms, large, clumsily disposed hands, and gracelessly spread knees Roulin epitomizes the plebian provincial, and Vincent emphasized his personal lack of pretension by presenting him seated upright on a plain chair at a plain table in an unadorned setting. Yet there is dignity in his self-conscious bearing, in the slightly aggressive, defiant tilt of his chin, and in the pensive, somewhat acerbic and skeptical expression of his face. He is decidedly a man of experience, a man who holds opinions. Everything about this image conveys the mingled simplicity and authority of the spartan republican: the basic furniture, the bare room, and the stolid, matter-of-fact presentation of the figure with its coarse, bushy beard and boxy blue uniform. The decision to paint Roulin in uniform must have been purposeful as well, for Vincent saw him not just as a neighbor, but as the representative of a type: the common workingman as natural philosopher, virtuous, intelligent in an uncomplicated way, uncorrupted by urban artifice. He must have seemed to the romantic van Gogh the incarnation of the perfect citizen for that utopian republic he had envisioned encountering in the South.

With his idealized convictions about the inherent morality and vitality of peasant existence, Vincent was on the lookout during the summer for more models whose portraits would convey the healthy, natural life of the South. In a letter of midsummer he told Theo: "You are shortly to make the acquaintance of Master Patience Escalier (fig. 120), a sort of 'man with a hoe,' formerly cowherd of the Camargue, now gardener at a house in the Crau."[63] The "man with a hoe" refers to a peasant figure of Millet's, but as was the case with Vincent's *Sower*, the old gardener creates a very different effect than did either Millet's drably colored and brutish-looking laborer or van Gogh's own earlier peasant paintings. As he went on to remark to Theo: "The coloring of this peasant portrait is not so black as in the "Potato Eaters" of Nuenen, but our highly civilized Parisian *Portier*—probably so called because he chucks pictures out—will be bothered by the same old problem."[64] What he meant was that although this picture was coloristically more appealing than his earlier work, it had the same unconventional roughness and simplicity of technique which was such anathema to the decadent tastes of Parisians. He went on to suggest that it would make a salutary contrast to a painting by his friend Henri de Toulouse-Lautrec of a young woman in a café—a pale, listless habituée of the demimonde whom he felt epitomized urban depravity and artificiality (fig. 121):

I do not think that my peasant would do any harm to the de Lautrec in your possession if they were hung side by side, and I am even bold enough to hope that the de Lautrec would appear even

more distinguished by the mutual contrast, and that . . . my picture would gain by the odd juxtaposition, because that sun-steeped, sunburned quality, tanned and air-swept, would show up still more effectively beside all that face powder and elegance.

What a mistake Parisians make in not having a palate for crude things. . . . I imagine the man I have to paint, terrible in the furnace of the height of harvest time, as surrounded by the whole Midi. Hence the orange colors flashing like lightning, vivid as red-hot iron, and hence the luminous tones of old gold in the shadows.

Oh, my dear boy . . . and nice people will see only the exaggeration as a caricature.[65]

Unlike the dark Northern portraits with their suffering, brooding faces, the Provençal gardener's vivid coloration and quietly dignified expression reflect Vincent's conviction that in the regenerative atmosphere of the South, health and serenity are the reward for an unpretentious outdoor life of hard work and limited expectations. With the sunburned olive, ocher, and orange tones of his sitter's skin and the glowing golden-orange background evoking all the heat and light of the southern summer, with the intensifying complementary richness of the blues, reds, and greens of the clothing, and also with the look of patient resignation on the gardener's face, he sought to capture the healthy beauty of body and soul which he believed the simple existence of a laborer in Provence entailed. When writing to his sister toward the end of the summer about the relationship between the exaggerated brilliance of his palette and the sense of energetic life he felt was achieved by modern authors in their literary treatment of such mundane motifs as Parisian streets and cafés, he stressed his conviction that it was morally and emotionally therapeutic to impart an intense, glowing beauty to even the most plebian subjects:

It is my belief that it is actually one's duty to paint the rich and magnificent aspects of nature. We are in need of gaiety and happiness, of hope and love.

The more ugly, old, vicious, ill, poor I get, the more I want to take my revenge by producing a brilliant color, well-arranged, resplendent. Jewelers too get old and ugly before they learn how to arrange precious stones well. And arranging the colors in a picture in order to make them vibrate and to enhance their value by their contrasts is something like arranging jewels properly or—designing costumes.[66]

The reverential attitude toward the simple worker which he conveyed through the jewel-like color contrasts of Escalier's portrait paralleled the feelings of many Romantic authors toward the peasantry. Perhaps in formulating this image Vincent had in the back of his mind a passage from Carlyle's *Sartor Resartus* in which praise and

honor are invoked for "the toilworn Craftsman" with his hard hands and stained clothing—a passage concluding: "Venerable too is the rugged face, as weather-tanned, besoiled, with its rude intelligence; for it is the face of a man living man-like. O, but the more venerable for thy rudeness, and even because we must pity as well as love thee!"[67] Vincent felt a strong sense of identification with the workers he encountered, and, convinced that his recovery of physical and emotional health in the South was attributable to sharing their simple life of hard work outside in "the blessed warmth," he wrote to Theo in August:

I am as well as other men now . . . and it is rather pleasant. By other men I mean something like the navvies, old Tanguy, old Millet, the peasants. When you are well, you must be able to live on a piece of bread while you are working all day, and have enough strength to smoke and to drink your glass in the evening, that's necessary under the circumstances. And all the same to feel the stars and the infinite high and clear above you. Then life is almost enchanted after all.[68]

It is significant that in one of his few self-portraits from this period (fig. 122), Vincent painted himself with a minimal number of quick, rough strokes as a peasant with a big straw hat and a crude, smocklike jacket similar to the gardener's. Unlike the vast majority of his other self-portraits with their melancholy or tormented expressions, his face in this picture appears serene and contemplative, which is perhaps why it is a comparatively unconvincing likeness. It is equally relevant that during the late summer he undertook a series of paintings of sunflowers (fig. 123), which he intended to hang as decoration in the studio of his house: the room in which Theo would stay when he visited and in which he fervently hoped Gauguin would soon be installed. Reminding Theo a few months later that Gauguin, on seeing them, had particularly admired these pictures, he revealed how strongly he associated himself with them when he remarked that while other artists specialized in peonies or hollyhocks, "the sunflower is mine in a way."[69] Homely and unpretentious, turning always toward the light and heat in a way that made it a metaphor for a positive, life-seeking spirit, the sunflower seemed to Vincent so evocative of everything he valued in the South that he determined to paint a dozen canvases to create "a symphony in blue and yellow."[70] He went on to note that depicting these motifs necessitated painting them quickly and "in one rush" because "the flowers fade so soon," an observation which indicates that the sunflower was symbolic on yet another deeply meaningful level. So redolent of the healthy vitality of the fields, yet withering so soon, it suggested simultaneously the radiant beauty and the poignant brevity of life. It is not a coincidence that each of

the sunflower paintings he produced represents various stages in the life cycle of the plants, from unopened buds to dying blossoms whose petals have dropped but whose heads are filled with seeds. It was his reverence for these flowers as symbols of religious meaning that led him to describe the anticipated effects of their chrome yellows "blaz[ing] forth on various backgrounds—blue, from the palest malachite green to *royal blue*, framed in thin strips of wood painted with orange lead" as being "like those of stained-glass windows in a Gothic church."[71] The same spiritual impulse moved him to paint one version "on royal blue ground" with what he described as "'a halo,' that is to say each object is surrounded by a glow of the complementary color of the background against which it stands out."[72]

Vincent's obsession with painting the sunny outdoors was balanced by an equal fascination with the night, which he claimed he often thought "is more alive and more richly colored than the day."[73] His first nighttime picture, *The Night Café* (fig. 124), however, presents a dramatic contrast to the healthy vision of nature his daylight motifs convey. In early September he stayed up all night and slept during the day for three days running in order to paint the interior of a local café, paying the landlord for the privilege by giving him his picture when it was finished. He didn't mind losing it for potential sale purposes, he told Theo, because

the picture is one of the ugliest I have done. It is the equivalent, though different, of the 'Potato Eaters.'

I have tried to express the terrible passions of humanity by means of red and green.

The room is blood red and dark yellow with a green billiard table in the middle; there are four citron-yellow lamps with a glow of orange and green. Everywhere there is a clash and contrast of the most disparate reds and greens in the figures of little sleeping hooligans, in the empty, dreary room, in violet and blue. The blood-red and the yellow-green of the billiard table, for instance, contrast with the soft tender Louis XV green of the counter, on which there is a pink nosegay. The white coat of the landlord, awake in a corner of that furnace, turns citron-yellow, or pale luminous green.[74]

In his next letter to Theo he enlarged on this explanation:

In my picture of the 'Night Café' I have tried to express the idea that the café is a place where one can ruin oneself, go mad or commit a crime. So I have tried to express, as it were, the powers of darkness in a low public house, by soft Louis XV green and malachite, contrasting with yellow-green and harsh blue-greens, and all this in an atmosphere like a devil's furnace, of pale sulphur.

And all with an appearance of Japanese gaiety, and the good nature of Tartarin.[75]

Finally, from a reference to this picture in a letter to Bernard, we learn that the café was also "a free-love hotel, where from time to time you may see a whore sitting at a table with her fellow. . . ."[76]

It is evident from Vincent's remarks about this canvas that he conceived it as epitomizing all the evils of Western life from which he was trying to escape, a reality that seemed to him antithetical to the joyful, productive world of nature and outdoor labor. In the brothels, dance halls, and dives of Arles he witnessed how the seamy aspects of urban culture corrupted the wholesome simplicity of rural society, and his picture seeks to convey all the violent passions and despair of the lonely, unfulfilled people who were its casualties. It was not so much sexual license that was responsible for the depravity of such places in Vincent's mind, but the evils of lovelessness, frustration, mental imbalance, and alcoholism: evils to which he was particularly sensitive because he had to struggle so hard against them himself. All the details of his painting join to evoke the complicated sensations that the café at night aroused in him, and he told his brother, regarding its effect, that if Tersteeg, his former boss at Goupil & Co., could see it, "he would say that it was delirium tremens in full swing."[77]

Although the canvas is dominated by yellows, the color usually so evocative of the vital warmth of the sun in Vincent's paintings, his remarks reveal that the strident, unhealthy quality they take on here has to do with his creation of discordant combinations of carefully contrived tones. By his unnatural application of these glaring yellows to people and objects indoors, he obtained the diabolical effect of the artificial gaslights which pulsate above the room, a tangible and ghastly expression of modern technology. By juxtaposing them with acid green and blood red, he was able to produce a harsh, clashing jangle of color which communicates all the intense emotion, the stress and desolation of night life in Arles. The menacing effect of the colors is reinforced by the gaping, tilted floor with its lurching perspective, the disarranged chairs, the slumped, isolated figures, and the looming central shadow of the billiard table—a symbolic expression of the darkness and emptiness lying at the heart of this hellish place. The overall sensation of disharmony and instability that these forms and colors produce make this picture disturbing and depressing beneath its surface impression of "Japanese gaiety" or the good-natured buffoonery he associated with Tartarin, a Provençal character in the novels of Daudet.

But for Vincent, the drunken dissolution of the café was a mockery of the essential spirit of the night, a divine spirit that he sensed from the deeply religious feelings he experienced at the sight of the starry sky. His belief that this sensation was crucial to regaining his spiritual and physical health in the South is evident from his remark that

to feel as well as the peasants meant being able to work all day, and yet at night have enough emotional energy left "to feel the stars and the infinite high and clear above you. Then life is almost enchanted after all."[78] Like the sun-drenched fields, the stars spoke to Vincent of infinity and eternity, and it was for this reason that he had told Bernard in April that the starry sky was the kind of image that "can lead us to the creation of a more exalting and consoling nature than the single brief glance at reality—which in our sight is ever changing, passing like a flash of lightning—can let us perceive."[79] Like the spiritual heroine Pauline in Zola's *La Joie de vivre*, the sight of the night sky didn't oppress him with feelings of isolation or personal insignificance—it conveyed to him the possibility of life beyond death. "Is the whole of life visible to us, or isn't it rather that this side of death we see only one hemisphere?" he mused that June;

. . . looking at the stars always makes me dream, as simply as I dream over the black dots representing towns and villages on a map. Why, I ask myself, shouldn't the shining dots of the sky be as accessible as the black dots on the map of France? Just as we take the train to get to Tarascon or Rouen, we take death to reach a star.[80]

The stars suggested to him a vital, life-filled universe and the possibility of a continuing existence for mankind, an idea he speculated on with a mixture of playfulness and seriousness in another letter to Theo:

But don't let's forget that this earth is a planet too, and consequently a star, or celestial orb. And if all other stars were the same!!!! That would not be much fun; nothing for it but to begin all over again. But in art, for which one needs time, it would not be so bad to live more than one life. And it is rather attractive to think of the Greeks, the old Dutch masters, and the Japanese continuing their glorious school on other orbs.[81]

That this idea of cosmic metamorphosis was not an entirely frivolous notion in van Gogh's mind is evident from the fact that he expressed it also to Bernard, claiming that as destitute artists they should derive serenity from the thought that there was a possibility of "painting under superior and changed conditions of existence, an existence changed by a phenomenon no queerer and no more surprising than the transformation of the caterpillar into a butterfly, or of the white grub into a cockchafer."[82] It has been pointed out by contemporary scholars that these ideas about a life-filled, expansive universe were popularized also by the scientific articles of the period, particularly those of the world-famous astronomer Camille Flammarion, whose illustrated essays described a cosmos of cataclysmic forces in perpetual movement and metamorphosis.[83] Flammarion, a humanistic social reformer who, like Vincent, had even visited the Belgian coal mines out of sympathy with the plight of the miners, also postulated human reincarnation on other celestial bodies, and he suggested that the enlargement of people's perspective to connect our own existences with the life of the heavens would result in a new sense of universal brotherhood and the decline of social injustice.[84]

In September Vincent incorporated the motif of the starry sky into several pictures. *Café terrace at night* (fig. 125) is the first mentioned in a letter to Theo, where he refers to "the terrace lit up by a big gas lamp in the blue night, and a corner of a starry blue sky."[85] The receding lines of the pavement and buildings create a geometric funnel which focuses our attention on the loose knot of human conviviality at the center of the canvas. With its warm orange carpet and luminous awning, this little gathering place glows like a jewel in the yellow incandescence of the gas light, its lemon and gold surfaces tinted with lime-green shadows, its brilliance intensified by the complementary dark blues and violets framing it. In the background, the dwindling buildings are subsumed in purple and black shadow, lit fitfully and sporadically by narrow windows: they hint at the dark mystery of our private lives, the enigma of what transpires outside our spheres of social intercourse. Above, the richly modulated violet sky blazes with huge, radiant stars, the celestial equivalent of the terrestrial lights which mark our human habitation. In fact, the intensity of van Gogh's blue pigments gives the whole triangle of sky the same visual weight and tonal value as the triangle of the café, a formal equivalence which suggests the philosophical idea of parallel worlds that he wanted to convey. The effect of the whole is one of magical transformation, the commonplace transfigured by that sense of enchantment which he claimed the sight of the stars ignited in him.

The next of these pictures was *Starry night over the Rhone* (fig. 126), a night scene depicting a couple van Gogh described as lovers, walking along a harbor embankment sheltering a central group of boats at anchor. In the background the buildings of the town cast long, glittering reflections of their artificial lights on the dark water, while above, in Vincent's words, "on the blue-green expanse of sky the Great Bear sparkles green and pink, its discreet pallor contrasts with the harsh gold of the gas."[86] In the same letter he indicated the spiritual meaning such a motif had for him when he confessed to his brother that he felt "a terrible need of—shall I say the word?—of religion. Then I go out at night to paint the stars. . . ."[87] Thinking perhaps of the contrast this picture made to *The Night café* (fig. 124), he later opined that Theo would like it because it

conveyed "a greater quiet" than some of the others he had recently finished.[88] It is significant that towards the end of this letter, after mentioning that he still wanted to paint the starry sky, he next referred to Tolstoy's *My Religion*, a book he had read about in an article. Vincent noted that although Tolstoy didn't believe in resurrection in the Christian sense, or in heaven either, he "seems to believe in the equivalent—the continuance of life—the progress of humanity—the man and his work almost infallibly continued by humanity in the next generation. . . ." "He believes," Vincent continued, ". . . in a peaceful revolution, caused by the need of love and religion which must appear among men as a reaction to skepticism, and to that desperate suffering that makes one despair."[89]

Starry night over the Rhone conveys not only van Gogh's similar belief in the transcendent power of love to solace us, but his conviction that our longing for love relates to our yearning for the eternal. The dark, melancholy expanses of water and night sky, with their haunting intimations of a vast, impersonal universe, are relieved and mitigated by the linked figures of the lovers, by the closely clustering boats with their implications of shared human enterprise, by the warmly gleaming lights that suggest the intimacy of home life, and, finally, by the constellation of the Great Bear itself. The infinitely distant fires of the pinkish stars, each radiating a complementary green glow against the mysterious, resonant cosmos, were for him not only a manifestation of the same divine energies that governed life on earth, but the signs of potential abodes for the continuance of artistic lives governed by love and reverence for creation. It is meaningful that as Vincent described it, the picture's color scheme consists of a dominant contrast of deep, vibrating blue greens and russet oranges with a secondary chord of violet and yellow. Two months earlier, he had revealed what symbolic meaning such interactions of harmonious complementaries had for him when he told his sister that "there are colors which cause each other to shine brilliantly, which form a *couple*, which complete each other like man and woman."[90] He repeated this significant metaphor when he wrote Theo that his goal was "to express the love of two lovers by a wedding of two complementary colors, their mingling and their opposition, the mysterious vibrations of kindred tones."[91] It was because of all these spiritual implications of universal unity that Vincent conceived of *Starry night over the Rhone* as what he called "a poetic subject" which "will do some peoples' hearts good."[92]

Vincent also used a starry sky as a backdrop for a portrait he executed in September (fig. 127). Just as he had appropriated the Zouave, the postman, and the gardener as representatives of the South's unaffected manners and healthy constitutions, so he had been seeking a model for another "type" he felt would be crucial to the utopian community he envisioned himself becoming part of. He wrote to Theo that he had spent time with a visiting Belgian artist named Eugène Boch whose interest in painting the lower classes was similar to his own, a fellow devotee of Delacroix's religious pictures whom he described as a "young man with the look of Dante." He went on: "Well, thanks to him I at last have a first sketch of that picture which I have dreamed of for so long—the poet. He posed for me. His fine head with that keen gaze stands out in my portrait against a starry sky of deep ultramarine; for clothes, a short yellow coat, a collar of unbleached linen, and a spotted tie."[93] Further into the letter he added: "And in a picture I want to say something comforting, as music is comforting. I want to paint men and women with that something of the eternal which the halo used to symbolize, and which we seek to convey by the actual radiance and vibration of our coloring."[94] He returned to this desire at the close of the letter, telling Theo that in his use of color, his goal was "To express the thought of a brow by the radiance of a light tone against a somber background. To express hope by some star, the eagerness of a soul by a sunset radiance."[95]

Vincent had been planning these poetic effects even before Boch became his model, for in August he had written to Theo: "I should like to paint the portrait of an artist friend, a man who dreams great dreams, who works as the nightingale sings, because it is his nature." Envisioning a blond subject, he went on to describe how he would exaggerate the fair tones of the hair, concluding: "Behind the head, instead of painting the ordinary wall of the mean room, I paint infinity, a plain background of the richest, intensest blue that I can contrive, and by this simple combination of the bright head against the rich blue background, I get a mysterious effect, like a star in the depths of an azure sky."[96] Eugène Boch was not blond, but Vincent used his pallid face to achieve the contrast he wanted. Through its background of the infinite night sky and its sonorous color complementaries of deep golden ochers and midnight blues, this portrait conveys his sense of the eternal. The bony, ascetic-looking artist's brow glows with light against the dark blue of the heavens, a luminous temple from which his intelligent, thoughtful glance shines forth, and in both the thin golden line surrounding his head and the loose circlet of stars hanging above it we see the remnants of the halo, the ancient symbol Vincent retained in modified form to mark the "poet's" sacred nature.

Vincent's reference to the medieval poet Dante in his description of Boch was particularly significant, for during this period he was thinking often about ancient poets and artists. In September he remarked to Theo:

Some time ago I read an article on Dante, Petrarch, Boccaccio, Giotto and Botticelli. Good Lord! it did make an impression on me reading the letters of those men.

And Petrarch lived quite near here in Avignon, and I am seeing the same cypresses and oleanders.

I have tried to put something of that into one of the pictures painted in a very thick impasto, citron yellow and lime green.[97]

He was referring to a recently executed painting of a motif he had described a few days earlier as "a weeping tree, round clipped cedar shrubs and an oleander bush"[98] (fig. 128), one of a series of pictures he had been working on in the public gardens near his house. He came to call this park the "Poets' garden" because it reminded him of the medieval Italian writers who had worked in Provence, and in the letter in which he mentioned the article about them, he indicated that it was the poetic beauty of the spot which was inciting him to put in extraordinarily long hours and paint at top speed:

Because I have never had such a chance, nature here being so extraordinarily beautiful. Everywhere and all over the vault of heaven is a marvelous blue, and the sun sheds a radiance of pale sulphur, and it is soft and as lovely as the combination of heavenly blues and yellows in a Van der Meer of Delft. I cannot paint it as beautifully as that, but it absorbs me so much that I let myself go, never thinking of a single rule.[99]

Going on to describe the location he had just been painting in the gardens as being "quite close to the street of the kind girls," a euphemism for prostitutes, he remarked: "But you realize, it is just this that gives a touch of Boccaccio to the place." As his next comment reveals, however, it was not just the proximity of the brothels and the sight of the strolling lovers in the park that reminded him of a poet famous for his frank treatment of the sensual and emotional passions. Both Boccaccio's and Petrarch's themes were love, grief, and mortality, and van Gogh felt that even the shrubbery in the gardens provoked these associations. He went on to note that "This side of the garden is also, for the same reason of chastity or morality, destitute of any flowering bushes such as oleanders. There are ordinary plane trees, pines in stiff clumps, a weeping tree, and the green grass." A letter of a few days later describes yet another canvas from the series in similar symbolic terms:

The row of bushes in the background are all oleanders, raving mad; the blasted things are flowering so riotously they may well catch locomotor ataxia. They are loaded with fresh flowers, and quantities of faded flowers as well, and their green is continually renewing itself in fresh, strong shoots, apparently inexhaustibly.

A funereal cypress is standing over them. . . .[100]

It is evident that for Vincent the poetic atmosphere of these gardens derived in part from the suggestive nature of the flora, which stirred him not only by their beauty but by the eloquent oppositions they offered between joyful potency on the one hand and grief and death on the other. It is no coincidence that when painting a vase full of extravagantly blossoming oleanders the previous month (fig. 129), he chose to juxtapose it with a copy of Zola's *La Joie de vivre*, a novel which deals with the power of a positive, loving, nurturing spirit to transcend the sorrows of all injustice, pain and mortality.

In his first version of the park, *The Garden of the Poets (I)* (fig. 128), Vincent juxtaposed a central clump of flowering oleander bushes with a weeping ash, a tree whose long, flowing fronds seemed like coursing tears, and pruned cedars, whose dense, dark foliage aroused mournful or morbid associations. That he purposefully manipulated the components of the park's vistas in order to establish vivid contrasts between these symbols of fertile productivity and funerary suffering is clear from his admission to Theo regarding one of these images that "it is true that I have left out some trees" because the landscape "has been overcrowded with shrubs which are not in character."[101] A letter to Gauguin of the same period again acknowledges that Vincent had condensed and rearranged the details of reality so as to reveal what he felt was the fundamental quality of nature and existence in Provence:

The ordinary public garden contains plants and shrubs that make one dream of landscapes in which one likes to imagine the presence of Botticelli, Giotto, Petrarch, Dante, and Boccaccio. In the decoration I have tried to disentangle the essential from what constitutes the immutable character of the country.[102]

The essential character of the South seemed to van Gogh to be ancient, vigorous, and redolent of complex poetic emotions. He told Theo that "when you have seen the cypresses and oleanders here, and the sun . . . then you will think even more often of the beautiful 'Doux Pays' [Pleasant land] by Puvis de Chavannes and many other pictures of his."[103] The picture he cited (fig. 21) is an idyllic yet vaguely melancholy scene of seminude women resting silently by the sea, and Puvis' paintings in general possess a mythic and poignant quality deriving from the pensive gravity and tranquil immobility of his figures, the timeless simplicity and serenity of his settings, and the intimation we receive from these restrained visions that such ideal states are forever beyond our grasp. It is indicative of Vincent's sensation of Provence as a place of strong, rejuvenating mythic underpinnings that after making this comparison he immediately added: "There is still a great deal of Greece all through the Tartarin and Daumier part

of this queer country . . . there is a Venus of Arles just as there is a Venus of Lesbos, and one still feels the youth of it in spite of all."[104] The following spring he reiterated to Theo this association between the fertile, flowering native foliage and some ideal essence of love and happiness which he felt pervaded the region: "The oleander—Ah! that speaks of love and is beautiful like the Lesbos of Puvis de Chavannes, with women on the seashore."[105]

It was the regenerative quality of the landscape and life of the South that impressed Vincent so forcibly and led him to regard it as an ideal locus for the revitalization of Western art. His letters are filled with references to the healthy vitality of the sun, the earth, and the natural manners there, and to his belief that in such an atmosphere, the work of avant-garde painters would flourish and blossom into a new Renaissance built on the great traditions of the past. When he wrote to Gauguin about his enthusiastic preparations for the latter's intended sojourn with him in Arles—preparations which included hanging his sunflower and "Poets' garden" pictures in the room Gauguin would occupy, he offered Provence as an antidote to the miseries of their mutual poverty and ill health, a spur to matchless artistic creativity:

The part of the country where I live has already seen the cult of Venus—in Greece essentially artistic—and after that the poets and artists of the Renaissance. Where such things could flourish, impressionism will too.

I have expressly made a decoration for the room you will be staying in, a poet's garden . . . And what I have wanted was to paint the garden in such a way that one would think of the old poet from here (or rather from Avignon), Petrarch, and at the same time of the new poet living here—Paul Gauguin. . . .

However clumsy this attempt may be, yet it is possible you will see in it that I was thinking of you with a very strong emotion while preparing your studio.[106]

Another canvas from the "Poets' garden" series (fig. 130), one which deals with the intertwined themes of love, death and continuity in a different way, depicts a couple walking down a long path under what Vincent described as "an immense pine tree of greenish-blue, spreading its branches horizontally over a bright green lawn, and gravel splashed with light and shade." The somewhat gloomy scene is "brightened," as he put it, by "beds of geraniums, orange in the distance under the black branches."[107] The pine, an evergreen, is a traditional emblem of immortality to whose associations Vincent had long been sensitive. Years earlier he had written of "an evergreen life" as an eternal life achieved through hope and love, a spiritual existence which although still subject to sorrow, enabled one to be simultaneously "ever-rejoicing."[108] During this

period he had also developed the metaphor of life as a journey on a long road.[109] The pine tree, whose foliage doesn't die in the winter and retains the power to renew itself in fresh growth, is a symbol of our spiritual capacity to refresh and restore ourselves, to keep our lives *ever green*. Yet its dense shade and dark color create a sensation of melancholy, and its massive, towering presence intensifies our recognition of how vulnerable and transient the dab-like flowers in the background and the little humans walking beneath its overhanging limbs are. Looming over the lovers and their path, it dapples them with a flickering combination of sun and shadow suggestive of the mingled and alternating sorrows and joys which all life experience entails. The flowers also seem dual in their implications, for while they brighten the scene with color, lending it the touch of beauty and gladness which occasionally relieve us, they also remind us of the impermanence of all such reprieves. The man and woman dominated by the majestic and mysterious evergreen function as a metaphor for Vincent's belief in the power of love to keep one eternally hopeful and vital on the path through life, and spiritually alive in the hearts of others after death. It was because he associated this philosophical attitude toward life with the medieval poets and artists whose presence he sensed in these gardens, that after telling Theo how he had tried to infuse one of his paintings with this spirit, he added: "Giotto moved me most—*always in pain*, and always full of kindness and enthusiasm."[110]

Vincent's musings on the continuity of life and death and the equivalence of joy and suffering during the months that he worked on the sunny fields, the starry sky and the poetic garden coincided with his growing interest in Buddhism. Like the theosophists, he was sensitive to the relationships between the fundamental insights of ancient religions, and he realized that a similar vision of life and the cosmos linked Buddhism to Christianity. In June he had written to Bernard regarding the possibility of life after death, pointing out that although modern science had dispelled the old belief that the earth was flat, people

persist nowadays in believing that life is flat and runs from birth to death. However life too is probably round, and very superior in extent and capacity to the hemisphere we know at present. . . . maybe Science itself will arrive . . . at conclusions more or less parallel to the sayings of Christ with reference to the other half of our existence.[111]

The following spring he mused to Theo regarding the idea of life after death: "Under the name of optimism we are falling back once more into a religion which looks to me like the tail end of a kind of Buddhism. No harm in that; on the contrary, if you like."[112] Vincent's interest in

Buddhism developed out of his obsession with Japanese culture, references to which are sprinkled liberally throughout his autumn correspondence, and it is revealing of the depth of his identification that while waiting for Gauguin's arrival, he painted a self-portrait "in which," he told his sister, "I look like a Japanese."[113] The implications of this characterization go far beyond the mere fact of his having "made the eyes *slightly* slanting like the Japanese."[114]

Vincent later dedicated his *Self-portrait as bonze* (fig. 131) "to my friend Paul G.," and in writing about it to Gauguin he stated:

I have a portrait of myself, all ash-colored. . . . But as I also exaggerate my personality, I have in the first place aimed at the character of a simple bonze worshiping the Eternal Buddha. It has cost me a lot of trouble, yet I shall have to do it all over again if I want to succeed in expressing what I mean. It will even be necessary for me to recover somewhat from the stultifying influence of our so-called civilization in order to have a better model for a better picture.[115]

It has been noted that Vincent's knowledge of the "bonze" came from the book *Madame Chrysanthème*,[116] a novel about Japan by the contemporary French author Pierre Loti, which he had already recommended to Theo.[117] It has also been observed that a bonze is not simply a worshiper of the Buddha, but a priest who shows others the Way,[118] who elects to remain within the world in order to help others achieve enlightenment. It is clear that Vincent the evangelist was attracted by Buddhism's ethical concern for the welfare of others and goal of universal harmony, religious values which he believed were practiced by Japanese artists living in monklike communities.

After receiving Gauguin's self-portrait entitled "Les Misérables" (fig. 226), a work Vincent felt he had spurred Gauguin to execute, he wrote revealingly to him: "I am in fact a great advocate of the system of exchanges among artists, because I see that it used to be of considerable importance in the lives of the Japanese painters."[119] Neither *Madame Chrysanthème* nor an article he had recently read on Japanese artistic practice mentions this custom,[120] but wherever he had come across the idea, it obviously related to his own passionate desire for comradeship and intellectual exchange with other independent, non-Academic artists. He wrote to Bernard the same month:

For a long time I have thought it touching that the Japanese artists used to exchange works among themselves very often. It certainly proves that they liked and upheld each other, and that there reigned a certain harmony among them; and that they were really living in some sort of fraternal community, quite naturally and not in intrigues. The more we are like them in this respect, the better it

will be for us. It also appears that the Japanese earned very little money, and lived like simple workmen.[121]

For Vincent, the life of an artist was ideally that of a Buddhist monk dwelling austerely and serenely within a community of his fellows, devoting his existence equally to the worshipful contemplation of reality, the creation of spiritually evocative works of art based on a consummate grasp of nature, and the establishment of harmonious feeling among those with whom he lives. It was in order to actualize this Buddhist approach to life and therefore become "a better model for a better picture" that he felt he had to recover from the pernicious individualism and materialism of Western civilization, a process he felt was underway in the healthy "Japanese" atmosphere of the South to which he was trying to entice Gauguin, Bernard, and several other interested independents. That he envisioned the "studio of the South" as a religious collective was the logical extension of his conviction that the practice of art is essentially spiritual and beneficial for others. It is significant that in speculating on the actual working out of their arrangements, he characterized the prospective establishment as a monastery, telling Theo: "When it is a question of several painters living a community life, I stipulate at the outset that there must be an abbot to keep order, and that would naturally be Gauguin." It is equally revealing that later in the same letter he concluded dramatically: ". . . you have committed yourself to Gauguin body and soul. So you will be one of the first, or the first dealer-apostle."[122]

The ultimate result of his efforts to become increasingly spiritual, increasingly the persona of the Buddhist monk, he felt, would be the eternal life he would gain through his paintings. As these became more powerfully religious, conveying great truths in the form of beautiful and expressive metaphors drawn from nature, they would join the exalted traditions of primitive arts which speak to humanity through the ages. "Those who are able to paint, to paint the best," he told his sister, "are the beginnings of something that will last a long time to come; they will go on existing as long as there are eyes capable of enjoying something that is specifically beautiful."[123]

Vincent painted the exterior of his house buttercup yellow to convey the healthy vitality and positive spirit he felt his new center for the renaissance in the tropics possessed. Within the haven of this sunny house, the sanctuary he was preparing for his fraternal life with Gauguin, his bedroom seemed to him to most fully epitomize the serenity he craved (fig. 132). While awaiting Gauguin's arrival, he therefore soothed his exacerbated eyes and nerves and replenished his spiritual strength by painting this room—a pleasant respite after his months of intense labor on technically demanding and emotionally draining subjects pursued

in the blinding sun or the difficult artificial light of the gas lamps. Given his remarks about this picture, it is clear that depicting his bedroom was a release from the strain of dealing with the themes of life and death, love and grief that had been preoccupying him for so long, and he invested its representation with great symbolic meaning. He had given the decorating of the yellow house careful thought, wanting to achieve the spare, simple look of a Japanese artist-monk's abode, and had earlier described to Theo the simple red tiles, the white walls, the "rustic chairs, white deal table," and other items "not precious . . . but . . . having character." "About the beds," he wrote, "I have bought country beds, big double ones instead of iron ones. That gives an appearance of solidity, durability and quiet, and if it takes a little more bedding, so much the worse, but it must have character."[124]

Vincent's initial remarks to Theo about his picture of his bedroom reveal that he meant his entire motif to express the same quiet character, to convey rest both physical and psychological:

This time it's simply my bedroom, only here color is to do everything, and giving by its simplification a grander style to things, is to be suggestive here of rest or sleep in general. In a word, looking at the picture ought to rest the brain, or rather the imagination.

The walls are of pale violet. The floor is of red tiles.

The wood of the bed and chairs is the yellow of fresh butter, the sheets and pillows very light greenish-citron.

The coverlet is scarlet. The window green.

The toilet table orange, the basin blue.

The doors lilac.

And that is all—there is nothing in this room with its closed shutters.

The broad lines of the furniture again must express inviolable rest. . . .

The frame—as there is no white in the picture—will be white.

. . . The shadows and the cast shadows are suppressed; it is painted in free, flat tints like the Japanese prints. It is going to be a contrast to, for instance . . . the night café.[125]

In a letter to Gauguin the next day, Vincent repeated this description in abbreviated form, noting now that the interior was "of a Seurat-like simplicity."[126] This reference to Seurat is important, because it enables us to understand the aesthetic principles according to which van Gogh sought to make his picture symbolically meaningful. His description to Theo lists the components of the motif in sets of color complementaries: violet and pinkish red contrast with yellow and citron green, scarlet with strong green, orange with blue, lilac presumably with the unmentioned yellow and orangish picture frames on the walls. After

describing his color system to Gauguin, he concluded: "By means of all these very diverse tones I have wanted to express an *absolute restfulness*, you see, and there is no white in it except the note produced by the mirror with its black frame (in order to get the fourth pair of complementaries into it.)"[127]

It is significant that between writing to Theo of his initial conception and to Gauguin of this later adjustment, he decided to include the originally absent elements of white and black within the picture itself. This addition related to his desire to adhere fully to the Neo-Impressionists' psychophysical concepts, as his reference to Seurat implies: it was necessary for the proper implementation of his scheme to effect a sensation of rest from all these strong, seemingly unharmonious colors. According to Charles Henry, whose color theories paralleled and influenced the Neo-Impressionists, the sum of the eight basic pigmentary colors is black and the sum of the six spectral colors is white, the two sets complementing and completing each other.[128] Moreover, Henry claimed, the experience of color synesthesia, of perceiving a unified image made up of all the primary color contrasts, results in a state of total sensory synthesis and mental equilibrium which he described as "physiological white" and compared to the mystical, liberating tranquillity achieved by whirling dervishes and meditating yogis.[129] Van Gogh himself expressed a similar idea of the psychological effect of synesthesia in a letter to his sister the previous spring. Stressing the importance of using strong, brilliant color contrasts, he declared that "by intensifying *all* the colors one arrives at quietude and harmony. There occurs in nature something similar to what happens in Wagner's music, which, though played by a big orchestra, is nonetheless intimate."[130]

Van Gogh's depiction of his bedroom thus attempts to achieve a mood of soothing serenity primarily through a complicated orchestration of all the basic colors into a whole so balanced and unified that it paradoxically yields an effect of extreme simplicity—an effect reinforced by the broad, generalized treatment of the furniture and accoutrements he had characterized as solid, durable, and quiet. He enlarged on this intention in a letter to his sister written a year later when he was comforting himself during a distressing period by reworking this image of his bedroom in Arles. His remarks here indicate that the quality he wanted to capture related to the tranquil spiritual condition he associated with the proletarian hero in George Eliot's novel *Felix Holt* and similarly attributed to the Oriental artists he wished to emulate:

I wanted to achieve an effect of simplicity of the sort one finds described in Felix Holt. . . . *Doing a simple thing with bright colors is not at all easy, and I for my part think it is perhaps useful to*

show that it is possible to be simple by using something other than gray, white, black, or brown.

. . . I certainly wish that other artists had a taste and a longing for simplicity as I do. But the idea of simplicity renders life more difficult in modern society—and whoever has this ideal will not be able to do what he wants to in the end, as is the case with me. . . .

The Japanese have always lived in very simple interiors, and what great artists have not lived in that country?[131]

When Vincent wrote of his painting of the bedroom as a contrast to the night café, then, he meant it in the psychological sense of projecting an antithetical mood. While the blazing inferno of the café epitomizes the extreme disharmony and mental anguish wrought by modern European civilization, the bedroom evokes an optical and emotional sensation of the unity and tranquillity which he felt emerged from the Buddhist approach to life.

The Crisis with Gauguin and its Aftermath: October 1888 – April 1889

When Gauguin arrived in Arles at the end of October, Vincent's initial enthusiasm for mutual influence and collaborative artistic enterprises led him to submit briefly to Gauguin's encouragement to work more from imagination. Perhaps it was his sense of embarking on a new period of even more intense regeneration that led him in November to celebrate the autumn planting by painting a new version of *The Sower* (fig. 133). Now, in a sky of citron yellow and green, hazed with pink clouds hanging over the violet earth, an immense golden sun throbs directly above the sower's head like a halo, an even more explicit indication of the sanctified nature of our participation in the renewal of life. The figure is more compacted and reduced than the June sower, more closed in on itself, and its effect is one of an iconic absorption in the scattering of seed. Immediately beside this roughly generalized, archetypal form rises a gnarled tree whose scanty russet foliage proclaims the season of ebbing life, but whose trunk is streaked with the rich green of organic growth. This tree, its branches freshly lopped off to ensure vigorous new growth in the coming year, serves as a parallel symbol of the principle of rebirth and enhances the meaning of the sower. Its severely pruned limbs recall Vincent's advice years earlier to his brother regarding the regenerative results of giving up one's previous pursuits in order to become an artist. Describing Theo's artistic sensibility as a "new shoot [which] will sprout and it will sprout quickly," he concluded: " I am afraid the old trunk is split up too much, and I say, sprout in an entirely new direction, otherwise I am afraid the trunk will prove to lack the necessary vitality."[132]

By creating a formal and coloristic equivalence between the angular, precariously leaning tree and the similarly thick, slanting, and darkly green figure of the sower, Vincent suggests that the procreative, productive man, the man who labors for renewal, is at one with nature. Man and tree are similar manifestations of a divine creative principle and both are susceptible to the workings of natural law. When we note that he signed his name directly on the trunk, the combined motif of sower and tree become an even more potent symbol of his own hopeful aspiration for

regeneration. Shortly after finishing this canvas, he made another study of a sower from a more distant perspective (H1617), and then, always sensitive to the inherent symbolism of contrasts in the landscape, "a study of a plowed field with the stump of an old yew tree."[133] Telling Theo this fall that remaining in Arles to continue painting the same landscape scenes was valuable because the contemplation of these ordinary, universal motifs of cyclical change and rebirth brought him comfort and serenity, he concluded: "Will my work really be worse because, by staying in the same place, I shall see the seasons pass and repass over the same subjects, seeing again the same orchards in the spring, the same fields of wheat in the summer? . . . if I keep some studies here to make a coherent whole, it will mean work of a deeper calm at the end of a certain time."[134]

Despite his hopes that his artistic work would be fertilized by Gauguin and influenced to sprout in a new and more robust direction, Vincent harbored very ambivalent feelings about the prospect of submitting himself to someone else's ideas. Days before Gauguin's arrival he confessed to his brother that he was pushing his own work "as far as I could in my great desire to be able to show him something new, and not to be subjected to his influence (for he will certainly influence me, I hope) before I can show him indubitably my own individuality."[135] His resistance continued, for the pictures he produced under the stimulus of their short-lived and tempestuous communal arrangement seldom deviated much from the kinds of imagery he had been producing before his friend joined him. In *Avant et après (Before and after)*, a journal begun eight years later, Gauguin claimed that it was under his advice and example that Vincent shifted from his Neo-Impressionist influenced, "incomplete and monotonous" work in complementaries to tonal harmonies derived from subtle variations on a single color.[136] Although we have no way of ascertaining whether the credit for this aesthetic innovation was actually due to Gauguin, it is clear that under his encouragement Vincent made a brief foray into painting from imagination instead of from the scenes around him. His *Memory of the garden at Etten* (fig. 134), however, while

richly colored and decorative with its dotlike technique, lacks the force and the convincing effect of truth that his pictures usually have. Now that the cold November weather had set in, he had told Theo regarding another picture of this type that although he didn't dislike trying to work from imagination, since it allowed him to stay in, he had nevertheless "spoiled that thing that I did of the garden in Nuenen and I think that you also need practice for work from the imagination."[137] The following year, admonishing Bernard for his lapses from expressive realism, he admitted: "As you know, once or twice, while Gauguin was in Arles, I gave myself free rein with abstractions . . . and at the time abstraction seemed to me a charming path. But it is enchanted ground, old man, and one soon finds oneself up against a stone wall."[138] When he painted his picture of the garden at Etten, a second attempt to paint from memory, he told Theo that "Gauguin gives me the courage to imagine things, and certainly things from the imagination take on a more mysterious character."[139] But while his painting has the dreamlike and bejeweled quality of a vision, it has neither the vigor nor the rough poetry of the pictures he conceived from motifs which lay beneath his gaze.

It is significant that after spoiling his first garden picture he turned with relief to painting a series of unadorned portraits in simple color contrasts of the Roulin family: man, wife, and children ranging from a sixteen-year-old to a baby. This accomplishment filled him with exhilaration, for he felt they were "all characters and very French,"[140] thus desirable additions to the collection he was building of quintessential southern types. He had also just found and painted a typical local woman, the proprietress of the night café, whom Gauguin also painted and whom both men referred to as the "Arlésienne." Struggling between his natural inclination to work from the model and his desire for collaborative growth with Gauguin, he tried to convince himself that painting from the imagination would improve his pictures, writing to Theo at the end of the month that "I am going to set myself to work from memory often, and the canvases from memory are always less awkward, and have a more artistic look than studies from nature, especially when one works in mistral weather."[141] Unfortunately, the mistral raged for weeks, and their enforced enclosure in the restricted space of the yellow house led to increasing friction between these two highly opinionated, idiosyncratic men, each of whom had his own agenda and needs in this trial arrangement. Although Vincent praised Gauguin's cooking and assured Theo that it was doing him "a tremendous amount of good to have such intelligent company as Gauguin's, and to see him work," so much so that the eloquent Gauguin had "more or less proved to me that it is time I was varying my work a little,"[142] he referred in the same letter to a project he had just completed which

suggests that the relationship between them was more contentious than he cared to admit.

Once again turning to furniture to express an idea or feeling which was important to him, he painted studies of his own and Gauguin's empty chairs which were fraught with implicit meaning (figs. 135 and 136). His first mention of this project to Theo stresses the symbolic nature of his intention: he described his own seat as "a wooden rush-bottomed chair all yellow on red tiles against a wall (daytime). Then Gauguin's armchair, red and green night effect, walls and floor red and green again, on the seat two novels and a candle. . . ."[143] With his tendency to think of life in terms of contrasting or opposing forces, he perceived in these two chairs an expression of the essential, distressing conflict of personalities which was undermining his dream of fraternal companionship. His own chair is the epitome of simplicity, homely and unadorned, holding only the pipe and twist of tobacco which was his principle means of obtaining relief from his work, of soothing and calming himself. The image is painted in daytime complementaries, the sunny yellow chair balanced by a sky-blue door dominating a secondary complementary chord of muted terracottas and greens in the earthen tiles. Together, these forms and colors suggest Vincent's preference for the simple outdoor life of the natural world, an impression reinforced by the bin of onions in the corner. The onions must have had a particular significance for him, for not only did he include them in this very stripped-down expression of his own identity, but he signed his name on the bin directly beneath them. The clue to their meaning lies in the fact that he painted them all with large, prominent sprouts tipped with vivid green. Like the oleanders and the evergreens, they embodied for him that unquenchable life force he so revered: the vitality which manifests itself in continuous growth and the sending forth of new, regenerative shoots. The lowly onions under which he wrote his name must have seemed to him an excellent symbol of his own humble unpretentiousness and desire for growth and productivity.

Gauguin's chair contrasts strongly with this earthy simplicity and daytime color. In describing *The Night café* Vincent had written that he had "tried to express the terrible passions of humanity by means of red and green,"[144] and he seems to have repeated this color combination in Gauguin's chair to convey a sense of his guest's volatile nature and the emotional conflicts his impassioned convictions engendered. Vincent wrote to Theo regarding their conversations about art: "Our arguments are terribly *electric*, sometimes we come out of them with our heads as exhausted as a used electric battery."[145] A month and a half later, when Gauguin was no longer living with him, he told his brother that Gauguin's "passions must be stronger

than ours," and described him as "a welter of incompatible desires and needs."[146] The decor of the painting conveys this complexity, for the richly patterned Oriental carpet and the striped cushion on the curving, comfortable armchair suggest that Gauguin had a taste for material comforts and opulent decorative effects which Vincent didn't share and which seemed to him incompatible with Gauguin's professed desire for a simple, primitive life. The lit candle and books imply not only Gauguin's creative vitality and love of literary ideas, but also his preoccupation with things of the imagination, with a nocturnal world of dreams and fantasies rather than the healthy outdoor world of sun and earthy fundamentals. Vincent characterized Gauguin to Theo as "very powerful, strongly creative,"[147] but he also claimed that Gauguin's "conception of the South" was "absolutely imaginary."[148] Vincent's own conception, he felt, was based on clear, daytime vision; he took pride in deriving it directly from the landscape and the people, the humble objects and scenes surrounding him which his spiritual sensibilities rendered expressive and inspiring. Gauguin formulated his imagery from memories, from motifs in art and literature, and from his own brightly burning imagination. Van Gogh drew strength and a sense of renewal from the sunlit, simple life of the laborer and the opiate of his smoking habit; Gauguin depended for comfort more on his own inner visionary life. For the ardent, sensitive Vincent, these differences must have seemed as polar as day and night.

The clash of the two men's modes of working and the friction of their irreconcilable temperaments and expectations exacerbated Vincent's psychological and physical problems. Since living in Paris he had suffered from anemia and circulatory difficulties as well as digestive disorders. His eating habits were unhealthy due to poverty and irregular hours, and the stress of his financial and artistic anxieties was such that he was often in pain and couldn't keep food down. He was prey to bouts of debilitating melancholy and weakness, and increasingly during these months found himself gripped by a persecution mania. Every physical and emotional resource had been poured into making art: between August and October he produced thirty superb paintings and several dozen drawings, and there is no doubt that the process seriously undermined his health.[149] In October he began experiencing fits of vertigo as well, so by the time Gauguin arrived, he was already in a fragile and vulnerable state.

In November and December, while he and Gauguin argued vehemently into the night and Vincent became increasingly aware of his companion's sense of superiority, he also began to experience sporadic auditory and visual hallucinations—symptoms he later learned were indications of an epileptic condition. By 23 December, after two weeks of rain which had kept them too much indoors together, Vincent wrote with seemingly offhand understatement to Theo that "Gauguin was a little out of sorts with the good town of Arles, the little yellow house where we work, and especially with me,"[150] information which must have come as no surprise to Theo, since he had recently received a letter from Gauguin informing him that he and Vincent "absolutely cannot live side by side without trouble because of incompatibility of temper."[151] In his later journal, Gauguin described Vincent as "volcanic" and wrote of the shock he experienced at the extreme physical and financial disorder in which he lived and the irrational disparities between his avant-garde ideas about art and his taste for some pictures which Gauguin and the other independent painters dismissed as sentimental rubbish.[152] In addition to their doctrinal differences and the tension created by Gauguin's dictatorial advice, Gauguin asserted that Vincent's manner began to alternate between brusqueness, loudness, and silence, and that several evenings he awoke to find him approaching his bed—a behavior stemming perhaps not from sexual intentions but from Vincent's fear that Gauguin was going to depart without warning during the night.

The situation came to a crisis when Vincent, according to Gauguin's later account, hurled a glass of absinthe in his face at a café and returned home to fall into a heavy sleep. Accepting his apology the next day, Gauguin informed Vincent that if he ever struck him again he would lose his self-control and strangle him, and that he therefore intended to write to Theo announcing his return to Paris—the incident which propelled Vincent to confess to Theo that Gauguin "was a little out of sorts" with their situation. That evening after dinner, wanting to be by himself for a while, Gauguin left the house for a walk without informing Vincent. Suspiciously convinced that his disenchanted companion was about to leave him in the lurch, he followed Gauguin, who later claimed that the distraught van Gogh flung himself at him with an open razor in his hand but rushed off when Gauguin turned to confront him.[153] Although it has been suggested that Gauguin fabricated this account of an attack in order to justify his subsequent conduct, it seems clear that he had ample cause to fear for his safety. Justifiably unnerved by van Gogh's increasing evidence of mental disturbance, he went off to sleep at a hotel, ignorant until the following day that Vincent had subsequently used the razor to slice off part of his own ear and had delivered it to a prostitute in the nearby brothel as "a souvenir of me,"[154] a gesture reminiscent of the matador who awards the ear of the bull he has killed to a favored lady.

The postman Roulin brought Vincent home and got him to bed, but the police, alerted by the prostitutes, and,

in the morning, finding him unconscious and bleeding from a severed artery, took him to the hospital and then interrogated Gauguin. Theo was summoned to Arles by telegram and stayed a few days, long enough to see his brother on the road to recovery, but Vincent remained in the hospital for two weeks, suffering initially from fever, loss of blood, and intermittent attacks of delirium during which he agonized over philosophical and religious issues.[155] Gauguin departed for Paris as soon as the immediate danger was past, obviously relieved to escape what had become a disastrous situation. Vincent emerged from the hospital at the end of the first week of January 1889, having recovered his health and spirits but remaining subject to intermittent seizures which were brought on by fatigue or distress. He harbored no overt ill will toward Gauguin, to whom he in fact wrote on 1 January offering "words of very deep and sincere friendship"[156] and whom he mentioned frequently to Theo, fluctuating between cordiality and sarcastic resentment over Gauguin's swift departure and scrupulously self-interested working out of their practical affairs. A few more letters were exchanged, but the two men never met again.

The pictures Vincent painted in January, when he began to work again, reveal his profound need for solace and regeneration on both the physical and emotional levels. His *Still-life on the drawing board* (fig. 137) is particularly meaningful in this respect. Spread out on and around the cheerful yellow surface of his drawing board, the locus of his creative activity, are a profusion of ordinary items: a plate of onions, a pipe and portion of tobacco, a book, a letter, a pot and bottle, a lit candle with matches, and a stick of sealing wax. The book, clearly titled *Annuaire de la Santé* by F. V. Raspail, was a home-health manual detailing household remedies for the masses—a symbol of Vincent's belief that he could combat his own sickness and heal himself through ordinary means. This book provides the key to the significance of the other objects, all of which represent aspects of his daily life by which he sought to sustain and console himself. The focal point of the composition is the central white plate of onions, all of which have long, vigorously growing green shoots, and one of which lies suggestively on the cover of the restorative manual. Around these symbols of his determination to renew himself, to continue to grow, he arranged the items which were crucial to his program of self-help: the physical and emotional supports he needed to replenish his strength and enable him to pursue his spiritual artistic task.

On the left are the opiates and stimulants he depended on for comfort and relief: his smoking materials, the bottle of wine, and the pot of strong coffee—all substances he was tempted to overindulge. During the previous summer, when suffering from the cerebral and emotional stress of his hectic outdoor painting, he had written to Theo that he found "the only thing to bring ease and distraction . . . is to stun oneself with a lot of drinking or heavy smoking,"[157] and he told his sister that when he was depressed he was "in the habit of taking large quantities of bad coffee" because it had an "exhilarating influence."[158] After his breakdown he confessed to his doctor that he had kept himself "going on coffee and alcohol" because "to attain the high yellow note that I attained last summer, I really had to be pretty well keyed up,"[159] and he confided to his sister that he daily took "the remedy which the incomparable Dickens prescribes against suicide," which included "a glass of wine . . . and a pipe of tobacco."[160] Such statements indicate the extent to which these substances were necessary for his physical and emotional well-being.

The remaining items, arrayed on the right side of the drawing board, are all closely associated with his spiritual welfare. The letter, which is addressed to Vincent, symbolizes the precious communications he relied on from the few friends and family members with whom he corresponded: those whose interest meant so much to him in his isolated life. The sealing wax and matches represent his own letter writing, his sole outlet besides his art for pouring out his thoughts and feelings to others and establishing that contact of mind and heart which for him was the essence of religion. The lit candle signifies, as it did in the painting of Gauguin's chair, the artist's imaginative and creative powers, his vital spirit and love of life still burning brightly to ward off darkness and despair. This assemblage of all that was essential in his existence is not treated as a normal still life, but as an emblem of salvation. Optimistic that what he had gone through was not evidence of permanent dementia but "simply an artist's fit," insisting that he was making good physical progress and "in the same way serenity returns to my brain day by day,"[161] he made this picture a symbol of his own hopeful outlook. Painted in cheerful, vivid shades of yellow and green with cerulean shadows and touches of pink and orange, set against a sky-blue wall shimmering with flecks of gold, the entire arrangement radiates the positive spirit with which he was trying to meet his crisis. All the items are placed separately, given a visual emphasis which reveals each one's importance for him, and in their regular spacing and careful geometric balancing we see Vincent's effort to create order and stability, to prove to himself, as he wrote in a January letter to a friend, that "I haven't wholly lost my equilibrium as a painter."[162]

The same concerns are evident in two self-portraits he executed during this recovery period. In *Self-portrait with bandaged ear and easel* (fig. 138), he depicted himself closely backed up, indeed almost buttressed and held in place, by his easel (like the drawing board a reference to his identity

as an artist), and by a Japanese print on the wall, a symbol of that entire system of spiritual values and Buddhist philosophy of life which he associated with Japanese artists and now more than ever needed to foster in himself. Like the items in the still-life, these were components in his program of self-help. The second picture, his *Self-portrait with bandaged ear and pipe* (fig. 139), however, eliminates all supplementary symbols and communicates its message through purely formal elements. In this image, driven by his pressing need to reassure himself that despite his illness he retained control of his métier and his powers of reasoning, he constructed a meticulous demonstration of harmonious order. The canvas is organized into interlocking geometric shapes and simplified sets of strong color complementaries, the upper register playing his violet and blue cap off against an orange and yellow ground, the lower setting the green jacket against a vivid red. The two sections are linked by the artist's pale, citron-yellow face set off by the white bandage and collar, which in turn are balanced by the heavy black outlines of jacket and pipe. Lying at the center of these systematically opposed complementaries, Vincent's face conveys the meditative quiet associated, as it was in the picture of his bedroom, with the experience of color synesthesia. The eyes, placed precisely on the horizontal dividing line of the background, regard the spectator with dispassionate calm, and the thin eddies of smoke from his pipe ascend in evenly spaced strokes which suggest the regular rhythm of his breathing under the tranquilizing action of smoking. In his serious, unflinching gaze and the studied order of the composition and the evenly balanced colors we discern Vincent's determination to combat his mental agitation and regain the stability necessary to live and work.

Vincent also tried his hand at some still-lifes of ordinary kitchen items, but while a few are cheerful motifs, others create a sense of unease. Was it a coincidence that he chose to paint canvases of dead herring and bloaters stretched out on crumpled paper, or a crab (fig. 140) lying helplessly on its back, its powerful pincers rendered useless as it struggles to regain its equilibrium? The disabled creature's red shell against a vivid green ground reminds us that for Vincent this color combination suggested the tormented passions of humanity. Turning quickly from such uncomfortable imagery, he spent the remainder of the winter working on motifs that raised his spirits and consoled him for his many problems—subjects that spoke to him of love, of health, and of physical and spiritual renewal. In his first letter to Theo after the latter had returned to Paris at the end of December, written while Vincent was still in the hospital, he revealed his desire to fortify his spirit with the delectation of nature. Although it was only the beginning of January, far too early for the

trees to flower, he told his brother that "soon the fine weather will be coming and I shall again start on the orchards in bloom."[163] Feeling that the spectacle of nature's reawakening would speed his recovery, he anticipated spring by painting more versions of his sunflower pictures from the preceding August, radiant combinations of golds and citron, sky blue and bright greens which evoke the fruitful vitality of the summer and recall his faith in the healing powers of the Provençal sun. But his longing for emotional contact and a reassuring sense of being not wholly isolated from the rest of humanity made him turn chiefly to portraits as a source of consolation. In a sense, these portraits, like the sunflowers, symbolized gratitude, for he painted the people who had helped him during his illness and offered him some measure of sincere, cordial friendship.

The first of these, painted "on leaving the hospital,"[164] was of the surgeon who tended him there, Dr Félix Rey (fig. 141), a man to whom Vincent was attracted not only on account of his medical aid, but because he had an interest in art and seemed "uncommonly quick at understanding at least what complementaries are."[165] He rendered the doctor in complementary interminglings of green with red touches, and blue and violet with orange and yellow touches, using the collar, hair, and jacket outlines to provide the white and black necessary to complete the synthesis. The preponderance of deep greens and blues in the color equation creates an effect of mystery or seriousness, of rich density, against which the benevolent doctor's citron-yellow face glows like a lamp. But in addition to using shades suggestive of a personality at once thoughtful and benevolent, Vincent added another symbolic indication of his model's strong, positive, revitalizing role for him in the fantastical wallpaper which surrounds his head with a nimbus of huge, energetically twisting gold and orange designs. Many Provençal houses used wallpaper patterned with large flowers, but van Gogh exaggerated and distorted and transformed their ordinary designs into a demonstration of psychophysical theory. Charles Henry had written that the spiral is the perfect example of a dynamogenic form: a form which conveys the dynamic energy of the universe, a manifestation of coiled and springing life. These vigorously twisting stems with their curling tendrils are played off against a screen of petal-like dabs which enrich and enliven the surface even more. Together, they make the background an aesthetic expression of what Dr Rey's help had given Vincent—a promise of renewed strength and creative energy. It is also interesting to note the treatment of the doctor's ear, which stands out in blood red against the green: a recreation on the physician of the wound Vincent had inflicted on himself. Apparently, Vincent deluded himself when he claimed that Rey understood what comple-

mentaries were all about, for the doctor confessed years later that although van Gogh talked to him about them, "for the life of me I could not understand that red should not be red, and green not green!"[166] Vincent gave him his portrait in gratitude for his help, but the municipal librarian of Arles told an interviewer long afterward that "the doctor thought it so lacking in beauty that he put it in the garret. It is said that there it took the place of a broken windowpane, serving the purpose of keeping out the drafts."[167]

An even more meaningful portrait for van Gogh was the first in a series of five similar pictures of Mme Augustine Roulin, the postman's wife (fig. 142). He had begun painting her before his illness and resumed the project now that she had kindly agreed to sit for him while her husband was away on a trip.[168] Her picture was so important to him that he created four more versions of it during the winter and spring months, and as we examine his comments about the painting and his model, the reasons for his emotional involvement with her portrait become clear. A letter of January to his Dutch friend A. H. Koning reveals that his intention regarding this image was to create a vision of maternity comparable to a literary description he had admired in a book by the Dutch author Frederik van Eeden. He told Koning: "I call it 'La Berceuse,' . . . or in van Eeden's Dutch, quite simply 'our lullaby or the woman rocking the cradle.'" After describing the colors and decor of the canvas, including "the hands holding the rope of the cradle," he added that van Eeden's writing seemed to him the literary analogue of his own color style, and that he tried to parallel this prose style so as to sing "a lullaby in colors."[169] He communicated the same idea but gave a different source for the image when he told Theo that a conversation he had had with Gauguin in December had triggered his conception for Mme Roulin's portrait. They had apparently been discussing a novel they had read by Pierre Loti, entitled *Les Pêcheurs d'Islande (Icelandic Fishermen)*,[170] in which the sea rocks the sailors like a mother and the men are watched over and protected by an icon of the Madonna which they have hung in the cabin. Vincent's remarks to Theo indicate the relevance of this theme and of his portrait of Mme Roulin for his own immediate situation:

I have just said to Gauguin about this picture that when he and I were talking about the fishermen of Iceland and of their mournful isolation, exposed to all dangers, alone on the sad sea—I have just said to Gauguin that following those intimate talks of ours the idea came to me to paint a picture in such a way that sailors, who are at once children and martyrs, seeing it in the cabin of their Icelandic fishing boat, would feel the old sense of being rocked come over them and remember their own lullabies.[171]

The similarity between Loti's and van Eeden's books must certainly have struck Vincent, and the immediate attraction of the consoling maternal theme that they suggested must have related in part to his long-standing tendency to think of our experience of life's vicissitudes in the metaphoric terms of little boats on the high seas, and sailors in need of some resting place on the shore with a wife and children waiting. His association of the sailors' loneliness and fear with his own life as an artist is apparent not only in his many references to himself and other independent painters as captains of little one-man vessels on deep and dangerous waters, but in his comparison of sailors to "children and martyrs," both of whom he also identified with artists. He had already told Theo that while in the hospital he had remembered every detail of his childhood home with great clarity,[172] memories which brought comfort to him in his martyred condition, a victim of his artistic obsession and society's blindness to his genius.

It is apparent from a number of Vincent's remarks about Mme Roulin that he regarded her not only as a very nurturing mother, but as a loving wife. The sailors looking at such a picture would, he believed, think not only of the comfort of being rocked by their mothers, but of the love and consolation they received from their wives. "But after all," he wrote to Theo at the end of March when he began his fifth version of this portrait, "I want to make a picture such as a sailor at sea who could not paint would imagine to himself when he thinks of his wife ashore."[173] Vincent's own situation at this time made him particularly susceptible to such thoughts. Suffering from extreme depression and the shattering effects of a second seizure, he solaced himself by recreating in his art his ideal of a loving, supportive partner, a mate. The power of Mme Roulin to suggest this kind of comfort, to be the model for an image he reworked with obsessive devotion, lay in what he knew of her marital relationship, which he told Theo was as exemplary as that of their own parents.[174] It is also no coincidence that during the period when he was working on these pictures and feeling his own loveless condition so deeply, his letters are filled with references to Theo's approaching marriage to Johanna Bonger. In fact, in several instances his comments about *La Berceuse* are followed almost immediately by remarks about his brother's wedding plans or expressions of hope for his and his fiancée's happiness.[175] His good wishes for his brother have a poignant ring when one realizes how much they reflected his own longings for married life and children: "And with your wife you will not be lonely any more. . . . When you are married, perhaps there will be others in the family, and in any case you will see your way clear and the house will not be empty any more."[176]

Vincent saw *La Berceuse* as a religious image of a spiri-

tually uplifting kind, one that would be as consoling as he said the music of Berlioz and Wagner is.[177] He made several musical comparisons in describing the portrait, not only ascribing to it the effect of a lullaby, but characterizing its color relationships as "discordant sharps of crude pink, crude orange, and crude green . . . softened by flats of red and green,"[178] and describing his attempt "to get all the *music* of the color here into 'La Berceuse.'"[179] He gave additional proof of perceiving these pictures as hymnlike devotional images, communicating an essentially Christian message about the sanctity and immortality of human love, when he wrote to Theo regarding their display: "I picture to myself these same canvases between those of the sunflowers, which would thus form torches or candelabra beside them."[180] He obviously conceived this juxtaposition of motifs as forming an altarpiece, for he later reminded his brother that "if you arrange them in this way, say 'La Berceuse' in the middle and the two canvases of sunflowers to the right and left, it makes a sort of triptych."[181] That he saw Mme Roulin as an archetype of the regenerative power of Christian love is also apparent from a statement he made to Theo six months later, in the autumn of 1889:

And I must tell you, and you will see it in 'La Berceuse'. . . . if I had the strength to continue, I should have made portraits of saints and holy women from life who would have seemed to belong to another age, and they would be middle-class women of the present day, and yet they would have had something in common with the very primitive Christians.[182]

Vincent's portraits of Mme Roulin are indeed iconic. Her breasts and spreading lap and hips are exaggerated like those of ancient fertility figures, her whole body is rounded and made as soft and embracing as a comfortable chair, her colors are heightened and intensified so that the glowing olive golds of her skin and the flaming orange of her hair make her a fire at which man and child can warm themselves. Her hands on the cradle cord, she sits impassively like a medieval Madonna enthroned, enshrined against a flat background whose designs are even more spiritually suggestive than those behind Dr Rey. Here the dahlia-printed, dot-flecked Provençal wallpaper has been exaggerated to evoke the magical beauty and reassuring power of the eternally blooming flowers and the star-dusted sky, a mundane reality transformed by van Gogh into an imaginatively expressive adjunct to his holy image. In this guise, the woman rocking the cradle epitomizes everything Vincent sought in the South; she is, as the admiring critic Albert Aurier described her, "this gigantic and genial image of Épinal,"[183] a reference to a popular type of crude regional folk art and the equivalent of Vincent's own description of her as resembling "a chromolith-

ograph from a cheap shop."[184] If one imagines her between the flanking wings of his sunflowers, with all their intimations of health, warmth, gratitude for life, and the promise of eternal regeneration, one understands how these pictures illustrate his entire religious conception of life.

Vincent's grateful and affectionate feelings extended to Joseph Roulin as well, and after the postman returned from his trip, Vincent painted three new and very similar portraits of him (fig. 143). He had liked and respected Roulin ever since they met, and we recall that he painted him in July in a manner that conveyed his model's Socratic appearance and spartan republican values (fig. 119). Since then he had become familiar with the postman's family life and had come to admire his love for his children and wife, a feeling reinforced by Roulin's tender treatment of him during his crisis. It was Roulin who found Vincent and brought him home from the brothel, bandaged him and got him to bed, cleaned up the blood, visited him in the hospital, and was attentively concerned for him after his release. He had proved to be a supportive and faithful friend, a man of warmth as well as inner strength and practical wisdom, and in an April letter to Theo, Vincent described him in a way that reveals how altered his perception of his neighbor now was. "Roulin," he told his brother, ". . . has a silent gravity and a tenderness for me such as an old soldier might have for a young one . . . [he is] a man who is neither embittered, nor sad, nor perfect, nor happy, nor always irreproachably just. But such a good soul and so wise and so full of feeling and so trustful."[185]

Vincent's new pictures of Roulin are very different from the earlier ones: they present the postman iconically to the spectator, not as a man of the people sitting casually at his rough table, but as an embodiment of compassion and wisdom. The slightly dour, skeptical look of the summer portraits has been replaced by a faintly smiling expression of calm and knowing benevolence: the Socratic republican has become an imperturbable Buddha. Roulin's previously angular face with its broad peasant cheekbones has softened in appearance just as the brusque, plain-speaking man had softened into a loyal and sympathetic friend. In fact, Roulin has lost some of his idiosyncratic physical individuality and taken on the character of a religious symbol, like his wife. It is significant that shortly before Roulin went away, Vincent wrote to Theo about him in a way that reveals his awareness of this dual or metamorphic character: "I have rarely seen a man of Roulin's temperament, there is something in him tremendously like Socrates, ugly as a satyr, as Michelet called him, 'until on the last day a god appeared in him that illumined the Parthenon.'"[186]

Vincent created this spiritual impression through his manipulation of the picture's details. The naturalistic skin coloring of the earlier portraits has been intensified so that

Roulin's face now glows with a rich golden light, the physical expression of his inner warmth and enlightened approach to existence. His beard, in the summer represented as a shapeless growth of bristling straight hair, is now a mass of thick, shining curls springing with life. Since it is doubtful that the unpretentious postman had begun to curl his beard artificially, we must assume that Vincent's transformation of this feature related to his desire to infuse Roulin's image with those dynamogenic rhythms of healthy vitality operative in his portrait of Dr Rey. The spiral ringlets of Roulin's beard suggest the powerful, positive life force which Vincent associated with the moral virtues of compassion, good faith, and patient resignation, all qualities he had observed in the postman during the winter months. Like his wife, Roulin is presented against a tapestry of starry dots and extravagantly blooming flowers with writhing stems: emblems of beauty, love, and renewal which demonstrate the existence of God and eternity.

Working on these images helped van Gogh to cope with his many problems during the winter and spring. Unfortunately, these did not abate with his recovery from fever and the healing of his wound, for he continued to suffer occasional debilitating and terrifying seizures with accompanying perceptual and auditory hallucinations, delusions that people were poisoning him, that voices were reproaching him. All of this was exacerbated by trouble with his neighbors. Although at the end of January he told Theo that "Everyone here is kind to me, the neighbors, etc., kind and attentive as if I were at home,"[187] this was only true with regard to his small circle of local friends. By the rest of the neighborhood, after the public scandal surrounding the incident with his ear, he was generally considered suspect.[188] A bohemian artist living alone or with another disreputable character, unemployed and often seen loitering about the brothel, keeping irregular hours and painting purposefully crude, ugly-looking pictures was enough of an anomaly in this working class community, but self-mutilation and scenes with prostitutes made Vincent seem no longer an affable eccentric but a dangerous lunatic. On his return from the hospital he heard that his landlord was arranging to turn him out and rent his house to someone else,[189] and he found himself suddenly the butt of the children's curiosity and taunting and the focus of their parents' fears and resentments. One of these children reminisced years later: "Along with other young people I used to poke fun at this queer painter. . . . His appearance made a highly comical impression on us. His long smock, his gigantic hat, the man himself continually stopping and peering at things, excited our ridicule."[190] Vincent's odd manner now elicited complaints from the neighbors and because of these he was forcibly hospitalized for a while in February, choosing after his release to continue eating and

sleeping at the hospital while going out to work during the day. This arrangement seemed good because it relieved him of trying to care for himself while he recovered his strength and health, but it came to an abrupt end when, after the children's baiting had goaded him to turn on them in anger, the neighbors signed a petition to the mayor to have him locked up. At the end of February he found himself in an isolation cell, forbidden his pipe, books, or paints, stripped of everything that made life possible for him. The incident precipitated another epileptic seizure, and he remained shut up until the end of March, once again continuing to eat and sleep at the hospital after his release because the police had closed his house.[191]

Although he seemed to regain normality during the spring, it must have been a period of enormous emotional stress. He had now begun to fear that he was going mad and would never get well, but at first he tried to minimize the horror of such a thought. He told Theo that people were in sympathy with him because "everyone here is suffering either from fever, or hallucinations, or madness," and that even the prostitute to whom he had given his ear had reassured him "that in this country things like that are not out of the ordinary."[192] He tried to shrug off the potential ramifications of his situation, writing to Theo that "the best we can do perhaps is to make fun of our petty griefs and, in a way, of the great griefs of human life too. Take it like a man, go straight to your goal. In present day society we artists are only the broken pitchers."[193] But he was aware that he couldn't return to his previous independent life. "I am myself rather afraid," he confessed to his brother, "that, if I were at liberty outside, I should not always keep control of myself if I were provoked or insulted. . . ."[194] He was periodically overwhelmed with lassitude and fatigue and loss of will, with feelings of utter hopelessness and wrenching anxiety about the future. He remained a prey to nightmares and paralyzing fear that the violent, unpredictable symptoms of his illness would suddenly return and devastate him again.

Steps had to be taken to provide a new living arrangement, but although the Reverend M. Salles, a local cleric who helped Vincent during this period, found an apartment for him, Vincent recognized before moving in that he was truly not capable of managing on his own again. Salles told Theo that there was no need for Vincent to be in an asylum now that he had regained his equilibrium, an assessment echoed by the painter Signac who visited him in Arles,[195] but Vincent suddenly decided otherwise and wrote abruptly and emotionally to Theo on 21 April, several days after Theo's wedding, that he wanted at the end of the month to go as a "resident boarder" to a hospital for mental patients at St. Rémy.[196] This decision seemed to him the only feasible solution to his current problem. He

had already rejected Theo's proposal that he could come live with him in Paris, on the grounds that "the excitement of a big town would never do for me,"[197] especially since he recognized that "I may easily relapse into a state of overexcitement on account of fresh mental emotion."[198] Theo must have been deeply relieved to hear this, for not only was he on the eve of marriage when he made his offer, he was also well aware of how extremely difficult it was for people to relate to his brother. He wrote to his fiancée regarding Vincent that in addition to dressing and behaving unconventionally,

there is something in his way of speaking that makes people either like or dislike him strongly. He always has people around him who sympathize with him, but also many enemies. . . . It is difficult even for those who are his best friends to remain on good terms with him, as he spares nobody's feelings. If I had time, I would go to him and, for instance, go on a walking tour with him. That is the only thing, I imagine, that would do him good. If I can find somebody among the painters who would like to do it, I will send him. But those with whom he would like to go are somewhat afraid of him, a circumstance which Gauguin's visit did nothing to change.

Then there is another thing which makes me afraid to have him come here. In Paris he saw so many things which he liked to paint, but again and again it was made impossible for him to do so. Models would not pose for him and he was forbidden to paint in the streets; with his irascible temper this caused many unpleasant scenes which excited him so much that he became completely unapproachable and at last he developed a great aversion for Paris. If he himself wanted to come back here, I would not hesitate for a moment . . . but again I think I can do no better than to let him follow his own inclinations. A quiet life is impossible for him, except alone with nature or with very simple people like the Roulins; for wherever he goes he leaves the trace of his passing. Whatever he sees that is wrong he must criticize, and that often occasions strife.[199]

Although Vincent had assured Theo that "as far as I can judge, I am not properly speaking a madman,"[200] he had begun during March and April to accept the reality of his psychological fragility. He agreed with Theo's warning that "one must not let oneself have any illusions about life," that one must "put up with the real facts of your destiny," and he understood that "If they should continue, these repeated and unexpected agitations may change a passing and momentary mental disturbance into a chronic disease."[201] He couldn't bear the thought of remaining in Arles "if I had to endure my work and my private life being interfered with every day by gendarmes and poisonous idlers of municipal electors. . . ."[202] He began to tell himself that the possibility of going into an asylum was tolerable because it was the common fate of genius:

Am I to suffer imprisonment or the madhouse? Why not? Didn't Rochefort and Hugo, Quinet and others give an eternal example by submitting to exile, and the first even to a convict prison? . . .

. . . I am thinking of frankly accepting my role of madman, the way Degas acted the part of a notary. But there it is, I do not feel that altogether I have strength for such a part.[203]

While he vacillated, unwilling to take definitive steps, he soothed himself by painting his fifth version of Mme Roulin, two pictures of the newly blossoming peach trees with all their heartening implications of rebirth, and two canvases of butterflies hovering among the spring flowers, symbols not only of the fragility, brevity, and metamorphic nature of existence, but of its beauty and joy. It is significant that his paintings of the flowering trees (figs. 144 and 145), both executed in exquisite combinations of intense, richly exaggerated color, represent vistas in which human habitation forms only a distant backdrop to the powerful dramatic beauty of nature. Like the *View of Arles with irises* that he painted after arriving in Provence the previous year (fig. 109), these canvases convey his attempt to deal with his problems by viewing human life from a larger perspective: one that obliterates the personal affairs of individuals within the spectacle of infinity and eternity. Despite the consolation of such motifs, however, he had come to feel that he was unfit to remain in this beautiful place, that he had failed to live up to the challenge of its potent atmosphere. He told Theo with self-deprecating bitterness that he could never go to "the real South" because that was an undertaking better left "to men who have a more well-balanced mind, more integrity than I. I am only good for something intermediate, and second rate, and self-effaced."[204]

While struggling with these feelings and trying to resolve the problem of what to do next, he chose to reread Harriet Beecher Stowe's novel *Uncle Tom's Cabin* and Dickens' *Christmas Stories*, all tales involving suffering people who meet their trials with patient resignation. In the same letter in which he mentioned these books to Theo, he related that he had been thinking often of an article he had recently read about an epitaph on an ancient tomb discovered in the area: "'Thebe, daughter of Thelhui, priestess of Osiris, who never complained of anyone.'" This, we recall, was the same trait he admired so much in Mauve's image of the patient horses struggling up the dune, or in the medieval painter Giotto, whom he claimed "moved me most—*always in pain*, and always full of kindness and enthusiasm."[205] After discussing the funerary epitaph briefly, he reiterated his conviction that he wasn't mentally fit for "the real South," concluding:

isn't it rather there that you would find reasonableness, patience,

serenity enough to make you like that good 'Thebe, daughter of Thelhui, priestess of Osiris, who never complained of anyone.'

Compared with this I feel utterly ungrateful.

That is the happiness, the serenity, I am invoking for you and your wife on the occasion of your marriage, so that you may have this 'real South' within your soul.[206]

Vincent had finally realized that the physical and spiritual salvation he had hoped to find in Provence was an illusion, accessible perhaps to others but not to him. He wrote to Signac:

But at times it is not easy for me to take up living again, for there remain inner seizures of despair of a pretty large caliber.

My God, those anxieties—who can live in the modern world without catching his share of them? The best consolation, if not the best remedy, is to be found in deep friendships, even though they have the disadvantage of anchoring us more firmly in life than would seem desirable in the days of our great sufferings.[207]

When he made the decision to enter St. Rémy, he did so from the bleak recognition that such friendships were of no avail to him in his present straits, that there was no one so attached to him as to provide him with a refuge. Theo's marriage must have been the catalytic event that led him to accept the inevitable, for he believed that his brother's new emotional and financial commitments would rightfully deprive him in some measure of his psychological and financial support. Urging Theo selflessly "to transfer this affection to your wife as much as possible,"[208] he chose the secure, regimented, and communal life of an institution as the only alternative to returning "to that painter's life I have been living, isolated in the studio so often, and without any other means of distraction than going to a café or a restaurant with all the neighbors criticizing, etc. *I can't face it.*"[209] Entering the asylum was his only means of acquiring the protection and sympathetic care others received from spouses, parents, and children, the only way he could remove himself from the perpetual temptations of alcohol and his own self-destructive neglect of his health. As he told Theo, "I have been 'in a hole' all my life, and my mental condition is not only vague *now*, but *has always been so*, so that whatever is done for me, I *cannot* think things out so as to balance my life. Where I *have* to follow a rule, as here in the hospital, I feel at peace."[210]

Vincent tried to reconcile himself to his act of self-incarceration by claiming that it would free him from the ordinary demands of fending for himself and allow him to devote his energies entirely to his work,[211] the sole advantage it seemed to offer over joining the Foreign Legion, which was an alternative he actually considered.[212] Although aware that there were "50,000 epileptics in France, only 4000 of whom are confined,"[213] he freely recognized that his artistic drives made his case more complicated. It is a touching indication of his longing for the company of other artists and his ongoing need to identify his emotional and physical problems with the plight of other contemporary creative spirits that he remarked wistfully to Theo: "They have lots of room here in the hospital, there would be enough to make studios for a score or so of painters." Still debating the necessity of entering the asylum, he concluded: "I really must make up my mind, it is only too true that lots of painters go mad, it is a life that makes you, to say the least, very absent-minded. If I throw myself fully into my work again, very good, but I shall always be cracked."[214] Despite this realization, it seemed to him that given the chance of regaining sufficient stability to continue painting, it was worth committing himself to the confines of an institution. Theo assured him, and he willingly believed, that his stay in St. Rémy would be temporary and custodial, a means of enabling him to recover some degree of health while continuing with his work. "By staying here a good long time," he wrote to Theo after his arrival there, "I shall have learned regular habits and in the long run the result will be more order in my life and less susceptibility."[215]

"Through a looking glass, by a dark reason"
The Final Struggle for Life and Art

"Ground between the millstones:" St. Rémy, May 1889–May 1890

VINCENT ENTERED THE ASYLUM AT ST. RÉMY, FORMERLY the monastery of Saint-Paul-de-Mausole, in May, and his first pictures reflect his desire to lift his own spirits through a delectation of natural beauty. Painting the lilacs and irises in the asylum garden (fig. 146), he wrote to his sister-in-law: "I have never been so peaceful as here and in the hospital in Arles."[1] It is revealing of his tendency to always mingle hopes for renewal with thoughts of death, however, that at the same time he was working on the spring flowers, he also made several studies of "a very big, rather rare night moth, called the death's head" (fig. 147) which, appropriately enough, he had to kill in order to paint.[2] As always, his choice of motifs reflected a mind that conceptualized in terms of contrasts and oppositions: the sunlit, daytime vision of irises executed in carefully balanced, vivid complementaries of violet and yellow flowers against the terra-cotta earth and jade-green leaves, followed by the subdued canvas of the short-lived nocturnal creature with its morbid associations, depicted in olives and grays, cool green blues, and black with a few touches of dark red. Although he assured Theo and Jo that he was glad to be in the asylum and was adjusting to the other inmates and the way of life, although he claimed that the fear of madness was leaving him "to some extent" and that he anticipated with pleasure working on the "lovely scenery" outside the hospital,[3] his descriptions of the other patients' ravings and of his own weakness and psychological state leave no doubt that his situation remained traumatic. As was true in Arles, many of the motifs he now chose to paint and the manner in which he composed and rendered them reveal the workings of his mind and his emotions, but now in St. Rémy, under severe mental and physical stress, his symbolic imagery took on an even more expressive character.

An early example of this can be seen in a painting he wrote to Theo about on 9 June, a landscape visible from his barred window (fig. 148): "In the foreground, a field of wheat ruined and hurled to the ground by a storm. A boundary wall and beyond the gray foliage of a few olive trees, some huts and the hills. Then at the top of the canvas a great white and gray cloud floating in the azure."[4] This scene must have appealed to him as an evocative example of the way in which the larger realities of nature paralleled his own experience with violent illness. The prostrate, damaged wheat felled by the storm, and the lingering threat of another onslaught that is implicit in the huge, rolling gray cloud that nearly obliterates the blue sky, together create a metaphor not only for his condition after his last seizure, but for his fear of another recurrence. The painting's colors reinforce the suggestiveness of the motif: the fresh green of the ruined young wheat is modified by white and yellow accents which give the field a blanched and sickly look, and although a pale blue sky reappears at the right in the wake of the great chalky cloud drifting through the upper register, the left-hand corner remains an ominous blue-black. Formally, the steep tilt of the fields and the mountains beyond convey a sense of precariousness, of skewed balance, while the broken lines of the storm-tossed grain and the undulating contours of the cloud reveal the turbulence of the mistral, the legendary wind which was such a powerful force in Provence and which must have seemed to van Gogh to be the equivalent of the destructive paroxysms that swept through his own body and brain. Perhaps it is significant that when his next attack hit the following month, it "came on me in the fields, on a windy day, when I was busy painting."[5]

It is typical of Vincent's continual attempts to struggle against the negative forces which beseiged him and undermined his spirit, however, that during the same period in which he produced the picture of the ruined wheat, he

made a series of strange drawings of an Egyptian head wearing an expression that is at once melancholy and smiling (fig. 149). In the letter in which he described the painting of the wheat to Theo, he went on to remark idealistically: "Now what makes Egyptian art, for instance, extraordinary—isn't it that these serene, calm kings, wise and gentle, patient and kind, look as though they could never be other than what they are, eternal tillers of the soil, worshipers of the sun?"[6] When we recall that in April he had been dwelling on the example of "Thebe . . . priestess of Osiris, who never complained of anyone," as a model for a genuinely religious approach to life, this adulation of the Egyptians provides the key to understanding his odd drawings of the pharaoh's head. Our example's peculiarly mournful smile conveys the idea of being "sorrowful yet ever rejoicing," that description of St. Paul's to which Vincent had so long been attached and which defined spirituality as a positive, accepting reverence for the pain of experience. In these drawings, whose varying features indicate his attempts to find the facial expression best able to suggest his meaning, he seems to have been trying to live up to the tradition of Egyptian artists, who, he told Theo in the same letter, "having a faith, working by feeling and by instinct, express all these intangible things—kindness, infinite patience, wisdom, serenity—by a few knowing curves and by the marvelous proportions."[7]

At first confined to depicting the hospital grounds and the enclosed field he could see from his room, by the second week of June Vincent was feeling physically stronger and was allowed to go out during the day to paint the surrounding countryside. These forays outside the asylum were crucial not only as proof of his returning vitality, but as an escape from the spectacle of the other patients' dementia and from his own sense of confinement. When describing the anguish of his epileptic attacks and the symptoms accompanying them, he admitted that even after the abatement of the seizures and the optical and auditory derangements he experienced, he was subject to a "*horror of life,*" a pervasive melancholy and loss of will which persisted, diminishing only gradually.[8] Going out among the fields and trees was for him a means of restoring and strengthening his will to live, and just as he was occasionally comforted by observing the similar or worse situations of his fellow patients, he also derived consolation from the spectacle of suffering and striving exhibited in many aspects of nature.

He was immediately attracted to the groves of olive trees, for they seemed to him not only typical of the region, but deeply evocative of the same kind of meaning as the broken wheat. During June he painted a number of versions of the olive trees, writing to Theo about the first (fig. 150) that he believed it to be "parallel in feeling" to the as yet unseen religious pictures of Christ in the Garden of Olives which Gauguin and Bernard had told him they were working on.[9] It was because he perceived the olive as a religious symbol that instead of copying the groves slavishly, he manipulated and altered the details of the landscape in order to obtain an approximation of the deeper spiritual truth the trees implied. In a brief description of his picture to Theo he remarked that he had exaggerated the arrangement of the landscape in order to emphasize the character of the olives, creating an effect in which "their lines are warped as in old wood."[10] The gnarled, writhing shapes of the trees conveyed to him the tortuous process of weathering and aging which had given them their characteristic form, and he felt that the ravages of extreme heat and fierce wind which their stunted shapes suggest corresponded to the physical and emotional trials that mold and stamp the human body and psyche.

Although this sensitivity to the moral implications of natural form was not valued as a spiritual virtue in Christianity, it was deemed crucial by the theosophists, who taught that in grasping and assessing reality one must always keep in mind that "the great energies of nature are known to us only by their effects."[11] It is possible that the olive tree's bent and crippled look, its dusty gray and dull green coloring, and even the associative significance of its fruit being crushed and discarded after pressing, made it seem to Vincent a powerful symbol of the suffering of a living thing convulsed by forces beyond its control. In this first painting of June, he impregnated the entire landscape with the sensation derived from the olives of the violent upheaval caused by trauma. Through the rippling, contorted lines of earth, trees, mountains, and clouds, and a palette dominated by deep, darkly shadowed blues and greens offset by heavy black contours, he gave a universal form to the cataclysmic forces of nature which had just warped his own body and psyche. But the true expressive power of these trees as religious symbols, comparable in feeling to a scene of Christ's anguish in Gethsemane, derives from the complexity of ideas they convey, and for Vincent their tragic implications were balanced by the simultaneous lesson of endurance they communicated. Twisted and distorted as they are, they stand firmly rooted in the soil and withstand the turbulence that buffets the earth. Still growing, still productive, they lift their bent limbs toward the blue sky and the warmth of a sun which, though hidden from view, lights the heavy cloud with a reflective creamy glow and turns the parched soil into a burnished sheet of white gold. For van Gogh, the essence of spirituality was the strength of will and reverence for life which enable us to withstand our trials and continue bravely on our chosen path.

Other paintings of the olives (fig. 151, for example)

also reveal his desire to mitigate the poignant connotations of the trees' forms by endowing them with a shimmering beauty of color and light that dazzles the eye and lifts the spirit. With their violet and blue-green shadows rippling in lacy patterns across the contrasting gold-tinged sandy soil, the pale cream and yellow highlights amid the silvery green tones capturing the glint of the hot Provençal sun as it reflects off leaves and ground, the olive groves clinging to their dusty slopes suggest the same fortitude and positive spirit that Vincent meant to convey in the twisted smile of the Egyptian king. We find a similar mingling of menacing or melancholy elements with effects of ravishing beauty in other pictures from early June, such as *Field with poppies* (fig. 152), with its patchwork vista of crops and meadows rolling down the steep hills in a perspective that gives us the sensation of the ground dropping dizzily away beneath our feet. Perhaps such a motif appealed to him precisely because it did suggest the vertigo he periodically experienced, but he has made it an eloquent symbol not only of the precarious instability of his health and future, but of his rapturous appreciation of beauty and vitality. As in his paintings of the olives, he again sets up strong contrasts between the dark and the light aspects of nature. Barricading us from the flower-strewn and richly colored fields, big clumps of blackish-green shrubs fill the foreground with a weighty mass of dense shade, while in the background a line of equally dark and ominous cypresses intrudes from the right to bracket the view. Although the bright yellow greens and light blues, the pinks and oranges and scarlets of the fields create a sensation of sun-drenched, light-hearted gaiety, the preponderance of very dark greens in the foliage and the large areas of black shadow at their core add a powerful note of mystery and nocturnal emotion to the scene.

Another painting of early June, which Vincent mentioned along with his first picture of the olive trees as conveying religious feeling comparable to Gauguin's *Christ in the Garden of Olives*, was a new version of *Starry night* (fig. 153). In discussing *Starry night over the Rhone* from Arles (fig. 126), we noted Vincent's association of the stars with eternal life and love. These themes are also the subject of this picture, but they are now intensified and the references to death are more explicit and emphatic. In explaining the imagery of his Poets' garden pictures from the preceding autumn, Vincent had characterized the cypress as "funereal," and his remarks about it this June indicate that he continued to perceive it as a powerful natural symbol of mortality and melancholy. In this painting we find no strolling couple: only a little town overlooked and dominated by the immense, flamelike dark cypress and by an apocalyptic night sky coruscating with huge celestial bodies. But, as one perceptive analysis of *Starry night* has indicated, although no human lovers are present, the lights in the little houses attest to the warmth of family life,[12] while at the center of the sky, surrounded by the stars which Vincent perceived as fiery emblems of divine love and energy, the swirling clouds fuse in a great yin-yang form: the Oriental symbol signifying the union of opposites in the cosmos. Together, the landscape and heavens weave an organic whole from complementary elements: the phallic, male forms of tree and church spire balance the circular female shapes of the stars and moon, dark vies with light, and the mountains and cypress surge up into sky so dynamically that their flowing, energized forms suggest vitality and striving. As Graetz observed, this is indeed an image of God and eternity,[13] perhaps the most powerful van Gogh had yet created. In his vision, the cypress shooting up into the resplendent heavens suggests that death is not a somber ending, but a path into the infinite life of the universe.

Like so many of van Gogh's paintings, *Starry night* presents us with a reality rearranged and distorted to convey feelings and ideas. John Rewald established that this view of the town, the mountains, and the western night sky was an impossible confluence from the room where Vincent was locked in for the night; it represents a composite subject painted from his memory of separately observed phenomena.[14] It seems likely, however—given his tendency to perceive art, books, and nature as equal manifestations of reality and to identify particularly moving and expressive literary images with motifs and color effects in paintings—that in fashioning this religious vision, he was also stirred by memories of certain poetic images from Thomas Carlyle's *Sartor Resartus*. Carlyle, in rhapsodizing about the majestic and spiritual nature of creation, described man as a spirit who

sees and fashions for himself a universe, with azure starry spaces, and long thousands of years . . . Stands he not thereby in the center of immensities, in the conflux of eternities? He feels; power has been given him to know, to believe; nay, does not the spirit of love, free in its celestial primitive brightness, even here look through?[15]

Carlyle's hero, whose characterization as "a Pilgrim, and a traveler from a far country"[16] Vincent had the previous autumn appropriated and applied to himself and Gauguin in his letters,[17] comes upon a little town in a scene that corresponds closely to this painting both visually and philosophically:

A peculiar feeling it is that will rise in the Traveler, when turning some hill range . . . he descries lying far below, embosomed among its groves and green natural bulwarks, and all diminished to a toy-box, the fair Town, where so many souls, as it were seen and yet unseen, are driving their multifarious traffic. Its white steeple is

then truly a starward-pointing finger; the canopy of blue smoke seems a sort of Life-breath: for always, of its own unity, the soul gives unity to whatsoever it looks on with love; thus does the little Dwelling place of men, in itself a congeries of houses and huts, become for us an individual, almost a person.[18]

The sensations of Carlyle's protagonist at the onset of night also exactly parallel those Vincent described in his letters and embodied in this painting: "a murmur of Eternity and Immensity, of Death and of Life, stole thru his soul; and he felt as if death and life were one, as if the earth were not dead, as if the spirit of the earth had its throne in that splendor, and his own spirit were therewith holding communion."[19] These images, bound up as they are with ideas about humanity's unity with nature and the relationship between love, death, and eternity, must have left a deep impression on van Gogh's artistic imagination, and his own depiction of the "little Dwelling place of men" echoes both the author's vision and his meaning. Vincent's town too is centered around its starward-pointing church steeple and nestled into the surrounding bulwarks of its green groves. Lying between the huge, dark cypress symbolizing death and the "azure starry spaces" aflame with symbols of love, eternal life, and, in the crescent moon, cyclical regeneration, the town of St. Rémy has become a symbol of humanity's religious aspirations and of the artist's grasp of the principles of cosmic unity.

Many of Vincent's summer pictures from St. Rémy focus on the towering, blackish-green cypresses which he associated with death, but as in *Starry Night* they are usually balanced by some contrasting element (fig. 154). In this next example, the tree's dark bulk rises out of a lacy collar of sunlit flowers and grasses and is set against a sky flushed with delicate mother-of-pearl tones. Above a luminous apricot-pink cloud, the golden new moon hangs beside the cypress, a reminder that death is followed closely by rebirth and renewal. Formally, the vigorous brush-work and wavering patterns of wind-blown foliage and clouds unify these complementary manifestations of natural forces. In a letter of 25 June in which he made a sketch of the cypress with new moon, he told Theo: "The cypresses are always occupying my thoughts; I should like to make something of them like the canvases of the sunflowers. . . . It is as beautiful of line and proportion as an Egyptian obelisk."[20] It is very revealing that in characterizing the tree's appearance he compared it to an ancient monument which usually served a funerary or commemorative purpose, but his meaning in relating the cypress to sunflowers is a bit more obscure. The following February he wrote regarding his work of this period: "When I had done these sunflowers, I looked for the contrast and yet the equivalent, and I said—it is the cypress."[21] The sunflowers symbolized

daytime and sunshine, gratitude for light and life, while the cypress stood for night, mystery, and death, yet they are equivalent because both are part of the overall unity and harmony of nature, where opposites balance each other in a divinely ordained totality. It was typical of Vincent's attitude toward death that he always envisioned it within the context of life, as a poignant contrast to the golden, growing fields. After comparing the cypress to an obelisk in June, he continued: "It is a splash of black in a sunny landscape . . . you must see them against the blue, *in* the blue rather."[22]

We find the same kind of effect in *Wheat field with cypresses* (fig. 155), in which he synthesized a number of motifs that had symbolic significance for him: the field of mature, ready-to-harvest grain bending in the wind, the writhing olive trees, the blackened cypresses shooting up to link the earth with the heavens, the eternal blue mountains rippling along the horizon, and the mistral-whipped, clouded sky like a sea of pale jade filled with churning white caps.

When, in responding to Albert Aurier's laudatory article about him early in 1890, he wrote to the critic that he intended to send him this canvas, he stressed that the cypress had an explicit charge of somber menace which typified the southern landscape but needed to be set off by contrasting vivid tones in order to achieve the full intensity of its visual and psychological effect. "The cypress is so characteristic of the scenery of Provence," he told Aurier, "you will feel it and say: 'Even the color is black. . . . it is a note of a certain nameless black in the restless, gusty blue of the wide sky, and the vermilion of the poppies contrasting with this dark note."[23]

This was the same ambiguous or paradoxical mood he sought to convey in a harvest painting he began at the end of the month of a wheat field "in which there is a little reaper and a big sun. The canvas is all yellow except for the wall and the background of violet-tinted hills"[24] (fig. 156). His work on this picture was interrupted by a seizure suffered early in July, but when he was again able to resume "struggling" with the motif he told Theo:

For I see in this reaper—a vague figure fighting like a devil in the midst of the heat to get to the end of his task—I see in him the image of death, in the sense that humanity might be the wheat he is reaping. So it is—if you like—the opposite of that sower I tried to do before. But there's nothing sad in this death, it goes its way in broad daylight with a sun flooding everything with a light of pure gold.[25]

It is indicative of van Gogh's philosphical attempt to include death within his all-encompassing love of life that in the paragraph immediately preceding his description of

this picture he mentioned an incident he had read about in the preface to Henri Conscience's book *Le Conscrit* (*The Conscript*). The writer, he told Theo, during a long illness which weakened his sympathetic affection for other people, found "that on long walks in the open fields his feeling of love returned. This fatality in suffering and despair—there, I am wound up again for another spell—I thank him for it."[26]

Inevitably, Vincent applied his perceptions of the inseparability of life and death or of joy and suffering to his personal condition, and it is meaningful that when he did so he often invoked the metaphor of the wheat field. He wrote to Theo shortly before his July seizure:

It is just in learning to suffer without complaint, in learning to look on pain without repugnance, that you risk vertigo, and yet it is possible, yet you may even catch a glimpse of a vague likelihood that on the other side of life we shall see a good reason for the existence of pain, which seen from here sometimes so fills the whole horizon that it takes on the proportions of a hopeless deluge. We know very little about this, about its proportions, and it is better to look at a wheat field, even in the form of a picture.[27]

By painting the black cypress amid the sunny wheat and under the blue sky, the reaper harvesting the grain in a flood of radiance, he reassured himself and ultimately the spectator that our suffering, our labor, and even our deaths are but a necessary part of a larger, more meaningful and consoling whole. Soon after, he wrote to Theo:

Do you know what I think about pretty often, what I already said to you some time ago—that even if I did not succeed, all the same I thought that what I have worked at will be carried on. Not directly, but one isn't alone in believing in things that are true. And what does it matter personally then? I feel so strongly that it is the same with people as it is with wheat, if you are not sown in the earth to germinate there, what does it matter?—in the end you are ground between the millstones to become bread.

The difference between happiness and unhappiness! Both are necessary and useful, as well as death or disappearance . . . it is so relative—and life is the same.[28]

At the beginning of July Vincent received word from Theo's wife Jo that she was pregnant. Given his financial and emotional dependence on his brother and his fears that the commitments of marriage and family life would necessarily interfere with their relationship and financial arrangements, this news must have caused Vincent a great deal of anxiety. While he expressed only joy at the tidings, his emotions were surely conflicted as he compared Theo's conjugal happiness and incipient paternity with his own isolated and besieged state. In the letter in which he

responded to their announcement of the impending birth and their own poor health, he warned them that it would be at least a year before he could consider himself cured and that "the least little thing might bring on another attack."[29] It seems probable that the stress of their information triggered the seizure which devastated him a week later. It must also be pertinent that Jo and Theo had told him she expected a boy whom they intended to name Vincent and wanted to be his godchild. This gesture, which likely struck Vincent as a symbol, however unintentional, of the way in which the baby would displace him in his brother's life, must have been particularly unsettling for him because exactly one year before Vincent's own birth his parents had had a stillborn first son whom they had named Vincent and buried in the parish cemetery beside their house. The daily sight of the dead baby's grave inscribed with his own name and birth date had given the second Vincent a strange sense of alienation and loss of identity as he was growing up, and some remnant of these feelings must have resurfaced on hearing of Theo's and Jo's well-meant decision.

It is also revealing of his low spirits that in the letter in which he replied to the news of Jo's pregnancy, after mentioning how soberly he was living, now that he no longer drank, he announced shortly: "I am going to paint more in gray, in fact."[30] He left the asylum the next day in the company of two attendants to make a brief trip back to Arles in order to retrieve some of the paintings he had left there, and on his return he pursued this plan to work in a subdued and cheerless palette. The pictures he painted during the following week are gloomy and bleak—forceful symbols, it would seem, of his feelings about his own situation and his barren life in St. Rémy. In his dark depictions of the bases of tree trunks smothered in coils of ivy against deeply shadowed grounds, or of barren mountains whose convulsed heaps of blanched stone threaten to crush a tiny, dark hut lying nearly obliterated by the foliage at their base (fig. 157), we sense the overwhelming depression against which he was struggling. His *Entrance to a quarry* (fig. 158) is even more forbidding. Densely enframed by dark, twisting vegetation which fills the foreground and creates a peep-hole into the picture, a steep slope of denuded rock lies at the center of the canvas, its flank gouged with an ambiguous, blood-red gash that forms the focal point of the composition. It was while working on this picture in a strong mistral that his next seizure overcame him on 16 July, and as Vincent described the painting to Theo when recovering from the attack, its color as well as its threatening forms conveyed a darkness of outlook to which he hadn't succumbed since coming to France. "Truly it was a more sober attempt," he wrote, "mat in color without showing it, in broken greens, and reds and rusty yellow

ocher, just as I told you that sometimes I felt a great desire to begin again with the same palette as in the north."[31] The dulled and darkened colors in their unpleasant tonal combinations and the harsh, menacing nature of the motifs are a clear indication of both Vincent's despondency and his sense of vulnerability. A remark in a later letter, however, reveals that he paradoxically found something essentially sound and comforting in confronting the depressing feelings that such a motif elicited; as he put it to Theo, he liked the painting because he felt that "the somber greens go well with the ocher tones; there is something sad in it which is healthy. . . ."[32]

The mental and physical repercussions of this attack, a dementia during which he ate his paints, were so severe that he was unable to work much or even go outside for six weeks. Two self-portraits from the end of the summer, when he was finally able to paint again, reveal much about his state of mind and his physical condition. He began the first of these (fig. 159) the day he got out of bed in late August, when "I was thin and pale as a ghost,"[33] and finished it in early September. Gazing out at us with furrowed brows, his hollow-cheeked, bony face is no longer melancholy and pensive, but ravaged and intense. Shadowed by sickly green tones and framed by the crude yellow orange of his hair and beard, his waxen yellow skin stands out harshly against the rough, dark purple strokes of the background like a beacon of illness in a dark and moody ambience. But it is not an image of despair, for his eyes are fixed on ours with stern purpose and in his hand he holds the palette and brushes which he believed would be his salvation. Like the self-portrait he painted after his first seizure in Arles (fig. 138), this image attests to his conviction that by fulfilling his spiritual goals as an artist, he could recover his psychic and bodily health. "It is to be hoped," he had written to Theo a few days earlier, "that if sooner or later I get a certain amount better, it will be because I have recovered through working, for it is a thing which strengthens the will and consequently leaves these mental weaknesses less hold."[34] He repeated this hope in the letter in which he mentioned the latest portrait, telling his brother: "I am struggling with all my energy to master my work, thinking that if I succeed, that will be the best lightning-conductor for my illness."[35]

In the next of these self-portraits, his artistic attributes are absent (fig. 160), but the image has taken on a more aggressive, defiant tone. His haggard face is fiercer, the more tightly compressed mouth and scowling brow now emphasized with dark lines, the eyes glaringly intense. The morbid, spectral pallor of his skin is reinforced by the cold, ashen tones of whitened gray green and gray blue in his jacket and background: chalky, drained colors rendered even bleaker by contrast with the fiery, angry red orange of

his beard. Throughout the painting his brushstrokes swirl in great undulating and circular sweeps to create the same patterns of turbulence that churned through the skies and wheat fields of his recent landscapes—the visual manifestation of the uncontrollable forces which both engender and disrupt life. It is a more forceful image than the first self-portrait, and although to our eyes the artist looks far from healthy, it is significant that in describing this canvas he claimed that if Theo compared it to the self-portraits he had done in Paris, he would see that "I look saner *now* than I did then, even much more so."[36]

Throughout the autumn, Vincent found it difficult to go out: "I tried in vain to force myself to go downstairs," he wrote in early September. "And it is nearly two months since I have been in the open air."[37] In this mood, he again turned to making copies, or "translations" as he called them, of other works of art. Some were versions of earlier paintings of his own which he found comforting to rework, such as his *Bedroom at Arles,* the *Wheat field with cypresses,* or his latest picture of the reaper who represented death going "its way in broad daylight with the sun flooding everything with a light of pure gold." Most, however, were copies of images by other artists which particularly moved and consoled him. Theo sent him large numbers of prints and photo reproductions of famous works, and of these he chose to make a painting from a Rembrandt etching of an angel (fig. 161), concentrating on its troubled, compassionate Dutch face floating over an ethereal body in a haze of celestial blue. He also executed two versions of Delacroix's *Pietà* (fig. 162), a theme which, since it represents the yearning love of a mother grieving for her suffering, dying son, spoke similarly to his own spiritual needs. His description of this picture to his sister Wil reveals what emotions and associations he wanted to convey:

The exhausted corpse lies on the ground in the entrance of a cave. . . . It is the evening after a thunderstorm, and that forlorn figure in blue clothes—the loose clothes are agitated by the wind—is sharply outlined against a sky in which violet clouds with golden edges are floating. She too stretches out her empty arms before her in a large gesture of despair, and one sees the good sturdy hands of a working woman. . . . And the face of the dead man is in shadow—but the pale head of the woman stands out clearly against a cloud—a contrast which causes those two heads to seem like one somber-hued flower and one pale flower, arranged in such a way as mutually to intensify their effect.[38]

The extent to which he identified with this motif is evident when we observe that he gave Christ his own red hair and beard, creating a dramatically bloody focal point against the dark cosmic blue of the Virgin's robe and the hopeful radiance of the gold-streaked sky after the storm.

He embarked next on a complete set of renditions of Millet's series of ten paintings entitled *Labors of the field*, pictures of peasants engaged in a variety of basic outdoor tasks which he reworked from a set of wood engravings (figs. 163 and 164). His use of these motifs was not merely a convenience stemming from his inability to go out after his own subjects; instead, his letters indicate that he found solace in recognizing his own formal and spiritual relationships to other great painters and in reworking what for him were their most meaningful themes. He wrote to Theo: "When I realize the worth and originality and superiority of Delacroix and Millet . . . then I am bold enough to say—yes, I am something, I can do something. But I must have a foundation in these artists, and then produce the little I am capable of in the same direction."[39] Looking at their pictures was not enough; it was the act of recreating them through expressive, symbolic color and thereby making them his own which gave him comfort. He told his brother:

Because I am ill at present, I am trying to console myself, for my own pleasure. I let the black and white by Delacroix or Millet . . . pose for me as a subject. And then I improvise color in it, not, you understand, altogether myself, but searching for memories of their pictures—but the memory, the vague consonance of colors which are at least right in feeling—that is my own interpretation. Many people do not copy, many others do—I started on it accidentally, and I find that it teaches me things, and above all sometimes gives me consolation.[40]

The consolation van Gogh received from copying derived not only from the feeling of kinship with other painters which he experienced in the process, but from his perception of the reverence for nature and the sympathy for the human condition with which his favorite artists imbued their works—a love of life and a compassion which paralleled his own. Unable to go out into the fields, the source of his greatest inspiration and pleasure, he sought out art which captured the essential power and beauty of natural life. He perceived Millet's peasants no less than Delacroix's *Pietà* and Rembrandt's angel as religious images: figures sharing the iconic simplicity of the rustic workers who, in medieval art, symbolized the sanctified, cyclical labors of the months. In copying them, Vincent was returning to motifs which had occupied him when he first became an artist, but while his northern peasant pictures were gloomy and stark, his renditions of Millet reflect his current desire to look for the compensatory joy or beauty in harsh realities. He translated Millet's monochromatic laborers into sumptuous combinations of blue and gold, colors which were so often used in the religious paintings of the Middle Ages and Renaissance, and which

for Vincent evoked the healthy beauty of the outdoor world that compensated him for his pain. Revealingly, he wrote to Theo: "Well, do you know what I hope for, once I let myself begin to hope? It is that a family will be for you what nature, the clods of earth, the grass, the yellow wheat, the peasant, are for me; that is to say, that you may find in your love for people something not only to work for, but to comfort and restore you when there is a need for it."[41] Yet despite the continual good wishes and concern for their welfare which Vincent expressed to Theo and Jo during this period, his letters are studded with remarks that reveal the underlying bitterness he felt when he compared their lot in life with his own. He complained not only that he wasted precious energy trying to interact with the deranged patients, but that the hospital administration allowed them to vegetate and fed them "stale and spoiled food" which he was afraid to eat.[42] "Indeed," he concluded with acid humor in one letter, after a long passage about conflicted emotions, sympathetic bonds, Theo's approaching paternity, and the need to remember their former carefree times, "I am so glad that if there are sometimes cockroaches in the food here, you have your wife and child at home."[43]

In October and November, despite the continuation of occasional spells of dizziness and depression, and despite running out of canvas twice for a period of weeks, Vincent was again able to go out to work. In most of his pictures of the trees, fields, and hills around Saint-Paul's during October, the reappearance of rich color reveals the restoration of a positive spirit as he felt his physical health and psychological equilibrium return. A picture of the asylum garden, for example (fig. 165), creates a lively and exalting impression not only with color, but through the majestic proportions of the trees, whose vital, twisted forms energize the air and seem to be dancing in front of the cheerful yellow facade of the hospital. Dwarfing the building and the little strolling figures in the garden and thereby reminding us of our relative insignificance in the scheme of things, they rise out of a band of dark red earth and emerald foliage to tower airily against a sky shading upward from jade and cerulean to the deep, intense blue violet of heaven's vault. His description of this picture to Theo reveals how much of this effect is due to his own creative transformation of the actual scene. Remarking that he had chosen views "where this place looked very pleasing," he added: "I tried to reconstruct the thing as it might have been, simplifying and accentuating the haughty, unchanging character of the pines and cedar clumps against the blue."[44] His study of a flaming orange and gold mulberry tree set against a backdrop of lemon-yellow, stony soil and a vivid blue sky (fig. 166) achieves the same effect of radiant vitality, the essence of what he referred to when he exclaimed in the same letter: "From

time to time there are moments when nature is superb, autumn effects glorious in color, green skies contrasting with foliage in yellows, oranges, greens. . . ."[45] His canvases from this autumnal period include one of a farmer plowing a dark swath of earth through a tide of rippling grain (H1794). Always sensitive to natural metaphors, and viewing his artistic work as equivalent to the common peoples' difficult struggle to sustain life through ceaseless toil, he wrote to his mother that although "I consider myself certainly below the peasants . . . I am plowing on my canvases as they do on their fields."[46]

Other paintings from October depict more problematic motifs, one of which was another *Entrance to a quarry* (fig. 167). Although unquestionably an untamed and dangerous site, this version not only lacks the threatening character of the scene he was working on at the time of his attack, but even has a decorative quality which Vincent compared to "something Japanese; you remember there are Japanese drawings of rocks with grass growing on them here and there and little trees."[47] A related picture is *Les Peiroulets ravine* (fig. 168), a scene of wild rock formations and rushing stream through which two figures climb laboriously on an uphill path. It is a composition of oppressive confinement: the steep walls of the ravine converge to block our path into the picture and to impede the rush of the stream flowing tortuously through the gorge, while in the background another mountain rises to close off the distant perspective. Painted in a somber combination of violet grays, chalky blues, and gray greens with strong black outlines to convey what Vincent described to Bernard as "a fine melancholy,"[48] the savage ravine in which the little figures slog determinedly along their way seems a metaphor for his own dogged struggle to make progress in his work despite the gloom and confinement of his environment. Both of these pictures, in fact, seem to seek to relieve the menacing aspect of a fundamentally hostile environment by portraying it as capable of supporting life and aesthetic effects. In both images the forbidding walls of mutilated gray rock are softened and vivified by touches of pink, lavender, and pale blue in the stone, while accents of vivid red orange, golden ocher, and bright yellow enliven the straggling clumps of vegetation that have taken root in their crevices. And while the path that the figures must follow is arduous, it is nevertheless a way through and out of the wilderness. The impression left by these scenes is a hopeful intimation that even in the bleakest setting, life can renew itself and growth and progress can occur; even in dismal surroundings the willing spirit can discern beauty and vitality.

It is another example of Vincent's tendency to alternate between contrasting subjects and sensations in his choice of motifs that at the same time that he painted the

desolate and frightening Peiroulets ravine, he made two translations of works whose mood and theme are tender and consoling. The first is a poignantly violet-toned copy of a picture by Mme Dumont Breton representing a woman resting peacefully by the fire with a sleeping baby on her lap; the other is a re-creation of Millet's *The Family at night* (fig. 169), depicting a mother and father working at their nocturnal tasks of sewing and basketweaving by the family hearth. Between them, a hanging lamp floods the humble cottage with radiance and illuminates the baby sleeping in its cradle directly beneath it. The centrality of the cradle flanked symmetrically by the parents and positioned under the brilliant light with its halo-like glow endows this image of cozy domesticity with the quality of a religious scene, calling to mind traditional representations of Christ's nativity in the stable. It is revealing that Vincent expressed to Theo his wish that Jo could see this picture, which he described as "a color scheme of violets and tender lilacs with the light of the lamp pale lemon, then the orange glow of the fire and the man in red ocher."[49] Clearly, as he was recovering from his September attack, his thoughts were often on the married happiness of his brother and the child his wife was expecting, a family life from whose intimate and loving circle he felt forever barred.

It was in a spirit of hopeful self-renewal that during late October and November Vincent turned again to the olive groves (figs. 170 and 171), which he now rendered in an autumnal palette very different in effect from his pictures of the previous June. The earth, once light ocher, cream, and pale green, is now a dark orange with accents in brown and rust; the tree trunks are no longer silvery gray but russet and roan. It is significant that Vincent embarked on his new series of pictures of the olive trees when he received a sketch from Gauguin of the painting he had described to him early in June, his *Christ in the Garden of Olives* (fig. 250), and then photos from Bernard of his paintings of similar subjects. All of their imagery depressed and irritated him considerably. Chiding Bernard for trying to achieve a spiritual effect by reviving outmoded biblical motifs instead of harnessing the natural expressiveness of material reality to convey meaning, he claimed:

Personally, if I am capable of spiritual ecstasy, I adore Truth, the possible, and therefore I bow down before that study . . . of peasants carrying home to the farm a calf which has been born in the fields. Now this, my friend, all people have felt from France to America, and after that are you going to revive medieval tapestries for us? Now honestly, is this a sincere conviction?[50]

To Theo, he attributed his distaste for these pictures to the fact that when Bernard and Gauguin took up such themes

as Christ's emotional ordeal in the Garden of Olives, they didn't trouble to look at real olive trees and were therefore "avoiding getting the least idea of the possible, or of the reality of things, and that is not the way to synthetize—no, I have never taken any stock in their biblical interpretations."[51]

Vincent's antipathy was not to biblical subjects per se, for he followed his condemnation of Bernard's and Gauguin's work with praise of Rembrandt's, Delacroix's, Puvis', and even the pre-Raphaelites' handling of such themes. Believing, however, that the olive trees themselves suggested the essence of the biblical story's message, he felt his friends had missed the opportunity of communicating truth in a more modern and universal way by applying the law of correspondences and utilizing an obvious natural metaphor. "If I stay here," he told his brother, "I shall not try to paint 'Christ in the Garden of Olives,' but the glowing of the olives as you still see it, giving nonetheless the exact proportions of the human figure in it, perhaps that would make people think."[52] A subsequent letter reveals that his own efforts along this line were in direct reaction to Gauguin's and Bernard's canvases:

The thing is that this month I have been working in the olive groves, because their Christs in the Garden, with nothing really observed, have gotten on my nerves. Of course with me there is no question of doing anything from the Bible [had he forgotten his recent "translations" of Rembrandt's angel and Delacroix's Pietà, *or didn't they count because they were based on other artists' imagery?]—and I have written to Bernard and Gauguin too that I considered that our duty is thinking, not dreaming, so that when looking at their work I was astonished at their letting themselves go like that . . . The trouble with them is that they are a sort of dream or nightmare—that they are erudite enough—you can see that it is someone who is gone on the primitives . . . but it gives me a painful feeling of collapse instead of progress. Well, to shake that off, morning and evening these bright cold days, but with a very fine, clear sun, I have been knocking about in the orchards. . . . The olive is as variable as our willow or pollard willow in the North. . . . Now the olive and the cypress have exactly the significance here as the willow has at home. What I have done is a rather hard and coarse reality beside their abstractions, but it will have a rustic quality, and will smell of the earth.*[53]

Part of the "coarse" and "rustic" effect Vincent was trying to achieve derived from his brushwork. In a previous letter he had told Theo that he was searching for a more "virile, deliberate" drawing style,[54] and in these pictures he simplified his strokes into strong, minimal hatchings which unify all parts of the canvas. His descriptions of these paintings focus on the exquisite beauty of nature's color effects which he observed in the olive groves:

Then, as the bronzed leaves are getting riper in tone, the sky is brilliant and radiant with green and orange, or, more often even, in autumn, when the leaves acquire something of the violet tinges of the ripe fig, the violet effect will manifest itself vividly through the contrasts, with the large sun taking on a white tint within a halo of clear and pale citron yellow. At times, after a shower, I have also seen the whole sky colored pink and bright orange, which gave an exquisite value and coloring to the silvery gray-green.[55]

In both our examples, the rich coloring of the sky acts as a foil to the green foliage of the trees, their vivid contrasts intensifying the vital effect of the dash-like brushwork. These incandescent skies crown the olive groves with a palpable aura, a revelation of God which sanctifies the suffering and the striving in the groves below. Vincent's dislike of Bernard's and Gauguin's images spurred him to prove that spirituality can be conveyed by emphasizing the forms and colors of the created world; that in the contrast of orange earth and deep violet-blue shadows, the dazzling intermingling of yellows and reds with cerulean and jade green in the sunset, or the spectacle of a palpitating sun hanging like a halo in a shimmering golden sky, a motif as ordinary and typical as the olives can become an eloquent symbol of deity. When Vincent likened the olive tree to the cypress and the weeping willow, he meant that its form alone conjures up the impression of suffering or grief. When he depicted his olive groves beneath skies of supernatural beauty, as he had set the cypresses against the golden wheat and deep blue heavens, he glorified this suffering as a necessary and meaningful part of life. Perhaps this is what he meant when he claimed that his paintings of the glowing, humanly proportioned olive trees would make people think.

In the letter of early December in which van Gogh chastised Bernard for his biblical abstractions, he offered two examples of pictures he had recently completed which he felt demonstrated his contention that spiritual feelings and ideas can be conveyed without recourse to ancient literary texts. The first of these, an oblique view of the asylum's garden (fig. 172), he described at length in very revealing terms:

on the right a gray terrace and a side wall of the house. Some deflowered rose bushes, on the left a stretch of the park—red-ocher— the soil scorched by the sun, covered with fallen pine needles. This edge of the park is planted with large pine trees, whose trunks and branches are red-ocher, the foliage green gloomed over by an admixture of black. These high trees stand out against an evening sky with violet stripes on a yellow ground, which higher up turns into pink, into green. A wall—also red-ocher—shuts off the view, and is topped only by a violet and yellow-ocher hill. Now the nearest tree is an enormous trunk, struck by lightning and sawed off. But

one side branch shoots up very high and lets fall an avalanche of dark green pine needles. This somber giant—like a defeated proud man—contrasts, when considered in the nature of a living creature, with the pale smile of a last rose on the fading bush in front of him. Underneath the trees, empty stone benches, sullen box trees; the sky is mirrored—yellow—in a puddle left by the rain. A sunbeam, the last ray of daylight, raises the somber ocher almost to orange. Here and there small black figures wander around among the tree trunks.

You will realize that this combination of red-ocher, of green gloomed over by gray, the black streaks surrounding the contours, produces something of the sensation of anguish, called "black-red," from which certain of my companions in misfortune suffer. Moreover the motif of the great tree struck by lightning, the sickly green-pink smile of the last flower of autumn serve to confirm this impression.[56]

Although it is clear that Vincent's expressive motifs and colors work together to achieve the desired effect of anguish, when we compare this painting with another version of the identical scene (fig. 173), we find that the dark and troubling mood of the first picture derives far more from its colors than from the tragic elements of the blasted tree, the dying roses, the isolated, aimlessly wandering figures, the empty benches, and the high wall which shuts in the patients and shuts out the view. We find all these components in the alternate version, and the general descriptive areas of color are also the same, but the subtle differences of tone and value in the second picture create a very different psychological effect. The foliage of its trees and fallen pine needles are a combination of fresh yellow green and clear emerald instead of brown and dull green "gloomed over" with black and gray; the path interweaves citron, jade, and golden orange instead of drab olive and chalky blue with glaring yellow puddles; the red ocher of the trunks is clearer and more vivid and their original heavy black outlines are almost completely eliminated; the severed trunk glows pistachio green and lemon instead of dark mustard; the hills in the background are bright blue and soft ocher instead of dark gray violet and muddy ocher; the clouds are pink instead of dark purple; the blue streaks in the yellow sky are softer in both color and contour and not outlined in violet; and the little figures wear bright, cheerful blue in place of black. The resulting effect of this more richly colored and lighter-toned palette is that the desolate autumnal motif acquires a note of gaiety or at least of exquisite optical appeal.

The second picture which Vincent cited to Bernard for its naturally expressive motif was *Enclosed field with rising sun* (fig. 174):

Another canvas shows the sun rising over a field of young wheat;

lines fleeting away, furrows rising high into the picture toward a wall and a row of lilac hills. The field is violet and yellow-green. The white sun is surrounded by a great yellow halo. Here, in contrast to the other canvas, I have tried to express calmness, a great peace.[57]

It is very revealing that in order to produce an effect of calm, Vincent painted a picture whose power of radiant, triumphant beauty and energy is almost hallucinatory. Shimmering under an incandescent sky, the field of newly emerged wheat rushes toward us like a mighty river; majestic, awe-inspiring, resplendent, it is the very image of God and eternity that Vincent found so spiritually regenerative and comforting. The serenity that he felt it induced results not only from the heartening spectacle of the miracle of rebirth taking place at the dawn of a new day in a jewel-like landscape, but from a new technique he initiated around this time, which he associated with a more tranquil mental state. He told Theo: "I think that probably I shall hardly do any more things in impasto; it is the result of the quiet, secluded life that I am leading, and I am all the better for it. Fundamentally I am not so violent as all that, and at last I *myself* feel calmer. Perhaps you will see it in the canvas . . . which I sent off yesterday; the field of wheat at sunrise."[58] Instead of continuing to load the canvas with pigment, he now chose to "prepare the thing with a sort of wash of essence, and proceed with strokes or hatchings in color with spaces between them,"[59] a less impassioned, more controlled process which he felt reflected the peace of mind toward which he was striving and which he associated with the renewal of his own health. After describing these paintings of the asylum garden with its stricken tree "like a defeated proud man" and of the peaceful wheat field surging with new life, he observed to Bernard: "I am telling you about these two canvases, especially about the first one, to remind you that one can try to give an impression of anguish without aiming straight at the historic Garden of Gethsemane; that it is not necessary to portray the characters of the Sermon on the Mount in order to produce a consoling and gentle motif."[60] Relentlessly reiterating that Bernard's "Biblical pictures are a failure," he concluded: "Sometimes by erring one finds the right road. Go make up for it by painting your garden just as it is."[61]

In addition to continuing his work on the grounds and landscape around St. Rémy, and particularly the olive groves where he executed a number of bucolic, pastel-colored pictures of women on ladders harvesting the fruit, Vincent also pursued his project of "translating" favorite works of art. In November and December he made new versions of Millet's diggers, sower, and other peasant imagery, as well as a copy of his own deeply metaphorical painting of the threatening ravine with the rushing stream

and the two figures toiling up their rocky road. Shortly before Christmas, exactly a year after his first attack in Arles, he suffered another seizure whose worst symptoms lasted only a week but must have dealt a severe blow to his optimistic hopes of recovery. It seems significant that during January and February he painted a number of copies of pictures by other artists whose subjects he found particularly relevant to his own situation and emotional needs.

In October, when working on his copies of the woman and baby by the fire and *The Family at night,* in a letter which opens with his thanks to Theo for a new package of Millet reproductions, he mentioned his long, solitary walks in the countryside and remarked: "Ah, now certainly you are yourself deep in nature, since you say that Jo already feels her child move—it is much more interesting even than landscapes, and I am very glad that things should have changed so for you." He then continued, referring to one of the prints Theo had sent: "How beautiful that Millet is, 'A Child's First Steps!'"[62] It is meaningful that in January, waiting for the imminent birth of Jo's baby and feeling "overcome with discouragement" after his recent seizure, yet convinced that "my work at least lets me retain a little of my clarity of mind, and makes possible my getting rid of this someday,"[63] he embarked on a translation of *A Child's first steps* (fig. 175). Executed in soft shades of creamy, pale yellow and fresh, light greens and blues, this sentimental scene breathes the tender spirit of family love and generational continuity. In a modest garden beside a tree-embowered cottage, a father has put down his spade and holds out his arms to the toddler whose mother leans down protectively to guide its first steps. The springlike colors, the warm light playing over the walls of the cottage, and the engrossment of the parents in their child's attempt speak to Vincent's yearning for the simple consolations of family ties, for a life in which one's efforts are rewarded by the birth and growth of children instead of by the barren and draining production of unsalable pictures.

Vincent's preoccupation with this theme of family unity and the continuity between generations also seems evident in his decision to paint a copy of Daumier's *The Drinkers* (fig. 176) in February after the birth of Theo's and Jo's baby. Despite its fresh, light, outdoor color, this picture, which seems to represent the stages of life, has much in common with *The Potato eaters* (fig. 67). Standing around a table set out in the open fields, a tiny child in white baby clothes and bonnet, a youth, a father, and an older, white-haired man with a cane thirstily drink a liquid which from its ruby color in the adults' glasses appears to be wine. Like *The Potato eaters*, the scene has a sacramental quality: a single pitcher stands on the rough table at the center of the foreground, creating the impression of a ritual communion around the altar of family sustenance. These representatives of the different ages of humankind are refreshing themselves both physically and spiritually through the sharing of a fundamental, invigorating drink in the midst of a healthy natural setting. Since communion, the act of drinking wine that symbolizes the blood of Christ, is a metaphor for partaking of the Christian spirit of love, this image conveys the same message as so many of Vincent's own works. The colors in which he chose to depict Daumier's black and white print contrast the predominantly cool, liquid tones of greens and blues in the figures, table and pitcher with the hot, parched yellow field behind the figures, intensifying our impression that a revivifying sacrament is being enacted.

Again revealing his inclination to alternate consoling and despairing motifs, Vincent executed a copy of Gustave Doré's *Prisoners' round* (fig. 177) at the same time as the Daumier drinkers. Perhaps he was attracted by the contrasting effects achieved through their similar compositions: the energetic family circle drinking eagerly from the cup of life in the open fields, and the depressed circle of prisoners cut off from life in the dark gloom of an institution. The image of the dispirited inmates shuffling endlessly and mechanically along their round, hemmed in by high walls and paving which bar them not only from freedom but from nature, must have seemed to him a perfect visualization of his feelings of hopeless imprisonment within the stifling routine, the vegetative lethargy, and the strict rules of the asylum. He complained often of these aspects of life at St. Rémy and, despite his hope that his residence there would ultimately be beneficial for him, he chafed increasingly at his incarceration as he felt the contrast between his own and his brother's situation more bitterly. Two months later he put his feelings into concrete terms when he told Theo: "Yes, I must try to get out of here, but where to go? I do not think I could be more shut up and more of a prisoner in the homes where they do not pretend to leave you free, such as Charenton or Montevergues."[64] Neither Doré's print nor van Gogh's painting convey a spirit of rebellion. Instead, the bent heads and defeated postures of the prisoners communicate a mood of slogging despair, of resignation to the inevitable, while the bleak combination of chilly blues highlighted with glaring white and rusty red that Vincent invented to augment the image intensifies the impression of debilitating melancholy.

The appeal of this image for van Gogh must have related to even deeper issues than his voluntary confinement in the asylum, however, for in many ways it epitomized the crucial problem of his adult life: his sense of being trapped in isolation and personal unhappiness. In reality, he was held captive by the exigencies of his own unfulfilled needs, his personality, his very difficult path as an unaccepted, penniless, and dependent artist, and ultimately

the uncontrollable physical condition which was at least in part the outgrowth of all these factors. Ten years earlier, in 1879 and 1880, he was already familiar with these feelings and communicated them to Theo in a series of letters. Writing of his gratitude to his brother for a visit he had made him after a long period of separation in 1879, he admitted:

When I saw you again and walked with you, I had the same feeling which I used to have more than I do now—as if life were something good and precious which one must value; and I felt more cheerful and alive than I have for a long time. . . . When one lives with others and is united by a feeling of affection, one is aware of a reason for living and perceives that one is not quite worthless and superfluous, but perhaps good for something. . . .

A prisoner who is condemned to loneliness . . . would in the long run, especially if it lasted too long, suffer from the consequences, as certainly as a man who fasted too long. Like everyone else, I feel the need of family and friendship, of affection, of friendly intercourse; I am not made of stone or iron, like a hydrant, or a lamp post, so I cannot miss these things without being conscious of a void and feeling a lack of something, like any other intelligent and decent man. I tell you this to let you know how much good your visit has done me.[65]

The following year, after a nine-month interval during which he and Theo had again had no contact, he wrote again "with reluctance" but because he felt he was "up against a stone wall."[66] In this long and impassioned letter in which he sought to reestablish relations with his estranged family, and in which he wrote about his love of literature and art and the moral and spiritual lessons they taught about love, he dwelled repeatedly on his need to liberate himself from the imprisonment of his unfulfillment through meaningful work and human intimacy:

How can I be of use in the world? Can't I serve some purpose and be of any good? How can I learn more and study certain subjects profoundly? You see, that is what preoccupies me constantly; and then I feel imprisoned by poverty, excluded from participating in certain work, and certain necessities are beyond my reach. That is one reason for being somewhat melancholy. And then one feels an emptiness where there might be friendship and strong and serious affections, and one feels a terrible discouragement gnawing at one's very moral energy, and fate seems to put a barrier to the instincts of affection, and a choking flood of disgust envelops one. And one exclaims, "How long, my God!"[67]

Trying to explain his difficulty in settling down to a normal career, a failure which had angered his parents and uncles, he wrote of himself as "the idle man who is idle in spite of himself, who is inwardly consumed by a great

longing for action but does nothing, because it is impossible for him to do anything, because he seems to be imprisoned in some cage, because he does not possess what he needs to become productive, because circumstances bring him inevitably to that point."[68] He went on to develop this metaphor at greater length:

A caged bird in spring knows quite well that he might serve some end; he is well aware that there is something for him to do, but he cannot do it. What is it? He does not quite remember. Then some vague ideas occur to him, and he says to himself, "The others build their nests and lay their eggs and bring up their little ones;" and he knocks his head against the bars of the cage. But the cage remains, and the bird is maddened by anguish.

"Look at that lazy animal," says another bird in passing, "he seems to be living at ease."

Yes, the prisoner lives, he does not die; there are no outward signs of what passes within him. . . . But then the season of migration comes, and attacks of melancholia—"But he has everything he wants," say the children that tend him in his cage. He looks through the bars at the overcast sky where a thunderstorm is gathering, and inwardly rebels against his fate. "I am caged, I am caged, and you tell me I do not want anything, fools! You think I have everything I need! Oh! I beseech you liberty, that I may be a bird like other birds!"

A certain idle man resembles this idle bird.

And circumstances often prevent men from doing things, prisoners in I do not know what horrible, horrible, most horrible cage. There is also—I know it—the deliverance, the tardy deliverance. A justly or unjustly ruined reputation, poverty, unavoidable circumstances, adversity—that is what makes men prisoners.

One cannot always tell what it is that keeps us shut in, confines us, seems to bury us; nevertheless, one feels certain barriers, certain gates, certain walls. Is all this imagination, fantasy? I don't think so. And one asks, "My God! is it for long, is it forever, is it for all eternity?"

Do you know what frees one from this captivity? It is every deep, serious affection. Being friends, being brothers, love, that is what opens the prison by some supreme power, by some magic force. Without this, one remains in prison. Where sympathy is renewed, life is restored.[69]

Although written so many years before, these passages are unquestionably relevant to Vincent's feelings in February of 1890. In December he had expressed his sense of his situation to Theo in similar terms, telling him that his preoccupation with color and drawing was so overwhelming that his thoughts were always "going around in a rather small circle. So I want only to live by the day—trying to get on from one day to the other. And besides, my painter-friends also often complain that the profession makes one so powerless, or that it is the powerless who follow it."[70]

Now physically confined with iron bars on his window, rendered unproductive by his bouts of dementia, even more hindered emotionally from fulfillment than he had been ten years earlier, and having before him now in Theo's marriage and child an even more trenchant reminder of his own miserable condition, it is no surprise that at this moment he chose to make Doré's prison image his own.

Vincent tried to fight against despair by the same means he had avowed in 1880: by recalling the bonds of "deep, serious affection" and sympathy that linked him with others. It was as a manifestation or evocation of friendship's power to console that in January and February he painted four versions of a portrait representing a woman he had known in Arles: Mme Ginoux, the proprietress of the café whom he and Gauguin had painted together in November of 1888 and referred to as the Arlésienne. At that time he had made two similar portraits of her; one with gloves and an umbrella on the table before her, the other with a pile of untitled books (fig. 178). Exactly a year later, in the November just past, he had visited the Ginoux family during a brief trip back to Arles and had returned to St. Rémy heartened by his renewal of friendships there and determined to boost his spirits with another visit in February. In a letter he wrote to them in late December or early January after his first visit, he began by recalling that Mme Ginoux had been taken ill the previous year at the very time he underwent his first attack in Arles. Mentioning his latest pre-Christmas seizure from which he was now recovering, he went on to offer the encouragement and advice of a fellow sufferer to Mme Ginoux, who was similarly experiencing a relapse of her disease. This letter, the first of several he wrote to the Ginoux during January and February while he was working on his new portraits of the Arlésienne (fig. 179), expresses thoughts and feelings which explain the relevance these revised pictures had for him.

After noting the coincidence of their illnesses, he observed: "So, my dear friends, as now and then we suffer together, this makes me think of what Mme Ginoux said—'When you are friends, you are friends for a long time.'"[71] He went on to proffer hopeful ideas about the ultimate benefits of adversity, the impetus it can give us after recovery to take up life again with renewed enthusiasm and a revived longing for growth and love, and yet the simultaneous difficulty of overcoming the dispiriting weakness and fear of recurring pain and death which sickness entails. "Ah well—" he concluded, "it would seem that we are not the masters of this—of our existence—it seems that what matters is that one would learn to want to go on living, even when suffering." Offering his ardent hopes that Mme Ginoux would soon return to health and would find, as he had, that her experience of disease had helped her, he went on to reiterate how crucial friendship and support are in enabling one to combat illness. "But if I had not been so well cared for," he claimed, "if people had not been so good to me as they have been, I am convinced I should have dropped dead or lost my reason completely." He concluded:

So I write this letter, my dear friends, in order to try and distract our dear patient for a moment, so that she may once again show us her habitual smile and give pleasure to all who know her. . . .

Diseases exist to remind us that we are not made of wood, and it seems to me this is the bright side of it all.

And after that one dreams of taking up one's daily work again, being less afraid of obstacles, with a new stock of serenity; and even at parting one will tell oneself, "And when you are friends, you are friends for a long time"—for this is the way to leave each other.[72]

Vincent's portraits of Mme Ginoux are dual in their implications, however, for they suggest the consolation he derived from thinking not just about her and their shared experience of illness, but also about his friendship with Gauguin, whose companionship in Arles had meant so much to him even when they were in conflict. This is evident from the fact that instead of basing his new versions of Mme Ginoux on his own previous image, he chose to model his revised portraits on a drawing of her by Gauguin which was in his possession (fig. 180). One reason for this could have been his realization that Gauguin's depiction was a better and more revealing likeness: certainly the way in which it confronts our gaze is more intimate and direct than Vincent's own dreamily abstracted image with averted eyes, and it is therefore a more appropriate expression of the personal bonds he now wanted to emphasize. But an unfinished letter to Gauguin, which Vincent wrote the following June after sending his friend one of these paintings as a gift, reveals that his new pictures were also an expression of his feelings about Gauguin and his gratitude for the latter's friendship and appreciation of his work:

And it gives me enormous pleasure when you say the Arlésienne's portrait, which was based so strictly on your drawing, is to your liking. I tried to be religiously faithful to your drawing, while nevertheless taking the liberty of interpreting through the medium of color the sober character and the style of the drawing in question. It is a synthesis of the Arlésiennes, if you like [i.e., of Gauguin's image and his own idea]; as syntheses of the Arlésiennes are rare, take this as a work belonging to you and me as a summary of our work together. For my part I paid for doing it with another month of illness, but I also know that it is a canvas which will be understood by you, and by a very few others, as we would wish it to be understood.[73]

The new portraits of Mme Ginoux represented a tribute to

Vincent's friendships with both the sitter and Gauguin, and an embodiment of that process of artistic collaboration which he had always viewed as spiritually meaningful and comforting. Several other alterations of his own devising, however, add to these initial intentions a level of significance which is relevant to his state of mind in St. Rémy. By changing the color scheme of his original portraits, altering the facial expression of his own and Gauguin's earlier renditions, and adding titles to the books on the table, he enlarged the portrait's symbolic meaning to suggest his feelings about suffering with equanimity—beliefs long held but intensified during his year of recurrent illness.

In his own first representations of Mme Ginoux, the intense citron tones of the background produce a cheerful, light-hearted effect which outweighs the complementary sobriety of both the figure in its blackish, raw Prussian blue clothing and the dark green table with its deep-red books. Interested at the time in creating an effect of calm through the synthesis of all the primary and secondary colors, an effort he had initiated the previous month in his picture of his bedroom, he rounded out his scheme here by contrasting the orangish chair back with his model's violet-blue headgear, and the white touches in her fichu and books with black outlines around the forms. Mme Ginoux's healthily tanned face is correspondingly neutral and serene, her pensive expression lightened by good humor. In all four of his 1890 portraits, however, he reduced his palette to the much more subdued complementaries of bleached pink and soft blue greens balanced by the dark gray and broken white of his sitter's dress. Since the contrast of red and green was for him a means of conveying anguished or passionate emotion, the paler, duller harmonies of the later portraits express a restrained sense of pain overcome, of anguish chastened and subdued.

The slightly altered cast of Mme Ginoux's now pallid face also contributes to this suggestion of patient suffering. In Vincent's earlier pictures she is reflective, but the only visible corner of her mouth quirks upward slightly to give her a pleasant look that is not at all melancholy. Gauguin's depiction of her has the same quality of thoughtful good humor, with eyes that slant up at the corners and a faint but distinct smile curving her lips. When copying Gauguin's drawing in 1890, however, van Gogh gave the left side of her mouth and the outer corner of her left eye a definite downward emphasis, while simultaneously arching her eyebrows into the more angular form expressive of anxiety. The resulting look is more complex and ambiguous than those of his own and Gauguin's 1888 versions, more strained and rueful. Mme Ginoux has lost a certain sweetness and gained in character: she looks not only more aware but older and more worn, an effect enhanced by the shadows which now mottle her face and hand.

By creating an equilibrium of upward and downward slanting lines in Mme Ginoux's mouth and brows in accordance with the psychophysical theories of the day, Vincent evoked a sensation of the spirit he cherished and wished to encourage in both himself and his friend—the ability to remain cheerful even in the midst of pain and sorrow. When writing that February to his sister Wil about his revised image of the Arlésienne, the woman who epitomized the spiritual and physical health of the South, he stated that in it he was "after another expression than that of the Parisiennes," that he was thinking of Millet's ability to paint humanity with "that Something on High," and of Delacroix's moving faces, "so full of grief and feeling . . . *nearly* smiling."[74] This was precisely the quality he had praised in Giotto and in "Thebe . . . priestess of Osiris, who never complained of anyone," and it is interesting that his experimentation with subtle alterations of facial expression in his four versions of Mme Ginoux (fig. 181) parallels his search for the same effect of mingled sadness and smiling resignation in his drawings of the Egyptian pharaoh (fig. 149).

In two of these new versions of the Arlésienne van Gogh reinforced the philosophical effect of his sitter's facial expression by placing titles and names of authors on the books. They are Harriet Beecher Stowe's *Uncle Tom's Cabin* and Charles Dickens' *Christmas Tales*, all stories which deal with human suffering, injustice, loneliness, fear of death, and the redemptive power of Christian love and sympathetic feeling to strengthen us in our struggle against evil and despair. Since it is highly unlikely that the uneducated, provincial Mme Ginoux had ever read this foreign literature, Vincent must have included these faintly drawn titles as a further indication to the well-read spectator of the moral and spiritual ideas he wished to communicate. The message of all these tales is that humanity should fear neither pain nor death, for suffering can nurture compensatory, holy virtues of compassion, resignation, and enhanced appreciation for life which glorify the sufferer, while death is not an end, but the gateway to a superior and eternal existence. It is also significant that in all these stories, well-educated and advantaged adults are taught how to live nobly and courageously by the innocent, the poor, and the downtrodden. Certainly Vincent believed that he had learned profound religious philosophy from his life among the disadvantaged and the peasants, and he sought to materialize it in his portrait of this Provençal woman of the people whose continued friendship renewed his own incentive to pursue the same attitude he was recommending to her.

Around the middle of February Vincent mentioned in letters to his mother and sister that he had been thinking of Theo's and Jo's new son and had "started right away to

make a picture for him, to hang in their bedroom, big branches of white almond blossom against a blue sky."[75] He left this image of newly flowering beauty (fig. 182) unfinished when he went back to Arles a few days later to visit the Ginoux and bring them one of his portraits of the Arlésienne, a trip he also viewed "as a kind of trial, in order to see if I can stand the strain of traveling and of ordinary life without a return of the attacks."[76] It must have seemed like some fateful, inescapable decree when after a day in Arles he was devastated by a particularly severe seizure from which he didn't begin to recover until April. In a letter of that month to Theo, the first he'd been able to write since the February attack, he observed sadly: "My work was going well, the last canvas of branches in blossom—you will see that it was perhaps the best, the most patiently worked thing I had done, painted with calm and with a greater firmness of touch. And the next day, down like a brute."[77] In his next letter he added revealingly that he had felt ill at the time he was working on the almond blossoms,[78] a confession which leads us to wonder whether it was the very struggle he made in the teeth of his own misery to feel and express joy at his nephew's birth and his family's happiness, which caused his body to overwhelm him with a fresh revelation of his sickness. When he returned to work on the picture it must have struck him even more forcibly as a symbol of his own longing for renewal. After describing to Theo the attack which had interrupted it, he added hopefully that "after a time of affliction perhaps peaceful days will come again for me too."[79]

During March and April, while his head remained "altogether stupefied" much of the time[80] and he continued to feel "sadder and more wretched than I can say,"[81] he painted a series of very strange, disturbing pictures which he described to Theo as "memories of the North"[82] (figs. 183 and 184). He wrote to his mother and sister: "I continued painting even when my illness was at its height, among other things a memory of Brabant, hovels with moss-covered roofs and beech hedges on an autumn evening with a stormy sky, the sun setting amid ruddy clouds. Also a turnip field with women gathering green stuff in the snow."[83] The motifs of bleak cottages and Millet-influenced toiling peasants are revivals from his early work, and it seems apparent that at this period of low emotional ebb his thoughts were dwelling for comfort on the region of his childhood and his beginnings as an artist, just as they had when he was recovering from his first attack the year before. His sudden desire to summon up and recapture his earlier peasant subjects must have related in part to the absence of such possibilities in St. Rémy, not only because of his illness and the restrictions on how far abroad he could wander even when well, but because, as he had

observed long before, one seldom saw laborers out in the fields in this part of Provence.

But it is likely too that this impulse to revive memories of Brabant was a manifestation of his deep need to regain the vanished sense of high purpose and exaltation with which he had begun his artistic career. He asked both Theo and his mother to send him any of his old peasant sketches which they might have kept, intending to use them as subjects for new paintings[84] and feeling perhaps that by referring to them he would regain the strength of will and emotional commitment he had brought to their creation. But while these motifs recall his pictures of the early 1880s, the imagery now has the surreal, hallucinatory quality of things seen through a distorting glass. Figures, cottages, landscapes, and skies shimmer mirage-like before our eyes, their wavering contours suggesting the dissolving, shifting sensation of reality he experienced for so many weeks after the last seizure. His colors too have the exaggerated intensity of a dream. The spare hovels and agitated whorls of foliage bathed in the eerie light of the churning green clouds loom like an underwater landscape glimpsed through eddies of seaweed, while the snowy field and gusty sky of his turnip pickers reflect the low orange sun in rainbow-hued streamers and splashes of color that lend a transcendental beauty to the bleak winter scene.

After executing many sketches and a few canvases from his earlier motifs, Vincent singled out one other particular image to rework as a painting: an 1882 drawing of an old man with his face buried in his hands (fig. 62). It was a pose he had found particularly expressive and utilized in a number of his early pictures, and he had been so moved by this particular drawing when he first produced it that he had quickly repeated it in a lithograph which he called *On the threshold of Eternity*. It is revealing that when he had described the image to Theo in 1882, he had not stressed its evocation of grief or despair, but had claimed that "In this print I have tried to express . . . what seems to me one of the strongest proofs of the existence of 'quelque-chose là-haut' [something on high] . . . namely the existence of God and eternity."[85] When he decided to revive this motif as a painted copy (fig. 185), it was because it suggested to him not only his anguish over his broken health and prospects, and his fear that he would be unable to complete all the pictures that filled his imagination before death overtook him, but also his compensatory belief in an eternal life beyond this all too brief and sorrowful one. In January, several months before returning to this image, he had written to his sister:

I often think of Holland, of our youth in the past. . . . And yet I am aging, you know, and it seems to me that life is passing by more rapidly, and that the responsibilities are more serious, and that

the question of how to make up for lost time is more critical, and that it is harder to do the day's work, and that the future is more mysterious and, dear me, a little more gloomy.[86]

At the end of April, still reeling from the attack in February, he was more than ever convinced that his disease would increasingly interfere with his creative powers and that he was unlikely to live into old age. Although he was only thirty-seven, his physical and mental deterioration made death seem an imminent prospect, one he could face with equanimity only by thinking of it as a gateway to eternal life. Besieged by waves of loneliness and anxiety, his consolation lay in reaffirming the sanctity of the human spirit and the immortality of the soul. It is a tribute to his belief in the power of natural, expressive postures to convey complex and ambiguous states of feeling, however, that he did not attempt to convey the idea of the old man thinking of eternity by depicting him glancing piously and melodramatically toward heaven. Instead, he let the grieving figure speak for itself, stripping the scene of all extraneous detail and concentrating our full attention on the sorrowing and worn-out old man alone in his bare and cheerless room. His body turned away from the warmth of the fire, his face hidden by clenched fists, he seems to have withdrawn into the solitary darkness of his own melancholy. But while with the original black and white image the sensation of "something on high" depends almost entirely on the subjective religious associations of the spectator, in the painted version van Gogh utilized color to suggest the spiritual nature of suffering and the eternal context in which it is eventually subsumed. Using the same fundamental complementary contrast of sky blue and warm ocher in which he had rendered his painted translations of Millet's peasants toiling at their hallowed cyclical labors, he endowed the scene with the subdued radiance of a religious icon. Bathed in clear, pale light and set against the warm apricot and orange tones of floor and chair, his bowed, balding head glowing like a golden crown, the grieving figure in celestial blue garb is himself an intimation of heaven. But Vincent was not yet ready to die. Just before going off to visit Arles in February he had told his sister that he still felt "the desire to renew myself, and to try to apologize for the fact that my pictures are after all almost a cry of anguish. . . ."[87]

As always, he turned to nature for solace and strength as soon as his energy returned, once again seeking motifs which would reinforce the positive, life-enhancing spirit he had lost. Having missed the flowering trees while he was ill, he set to work on pictures of "a lawn in the blazing sun with yellow dandelions" and "fresh grass in the park," but it was clear to him by now that he was getting worse instead of better in St. Rémy. At the beginning of May he

wrote to Theo: "Now you propose, and I accept, a return to the North instead. I have led too hard a life to die of it or to lose the power to work."[88] Telling his brother that he was filled with longing to see him, Jo and the baby, and his own friends again, and that moreover it was "almost impossible for me to endure my lot here," he added with an optimism born of desperation: "I am almost certain that in the North I shall get well quickly, at least for a fairly long time. . . . I dare think that I shall find my balance in the North, once delivered from surroundings and circumstances which I do not understand or wish to understand."[89] Having made this decision, every day's delay was fresh cause for distress, and his next letter communicates an increased urgency in his desire and resolve to leave not only St. Rémy, but Provence, which he had come to feel was too potent, too raw for his weak constitution. When Theo urged the necessity of waiting till arrangements to have him accompanied could be made, he wrote back frantically:

My surroundings here begin to weigh on me more than I can say—my word, I have been patient for more than a year—I need air, I feel overwhelmed with boredom and grief.

Then work is urgent, I should waste my time here. . . .

I have tried to be patient, up till now I have done no one any harm; is it fair to have me accompanied like a dangerous beast? . . .

But I dare to believe that my mental balance will not fail me. I am so distressed to leave like this that my distress will be stronger than my madness, so I shall have, I think, the necessary poise. . . .

As for me, I can't go on, I am at the end of my patience, my dear brother, I can't stand any more—I must make a change, even a desperate one.[90]

It seems significant that during this period he painted a picture of white butterflies hovering among red poppies (fig. 186), a study in complementary contrasts of green and red and white and black against bronze. We recall that in Arles he had associated the butterfly's metamorphosis with the possibility of human and particularly artists' rebirth, suggesting that after death "the existence of the painter-butterfly would have for its field of action one of the innumerable heavenly bodies. . . ."[91] The butterflies in this picture, as was the case with his earlier paintings of the same subject in Arles, seem to be charged with complex meaning, for while they symbolize change and liberation, they also, like the spring flowers, epitomize the brevity and fragility of life. Depicted here at the center of a darkly menacing tangle of blackish green stems against a dull gold ground, surrounded by flowers whose opiate properties made them a traditional symbol of stupefaction, forgetfulness, and death, the delicate white butterflies amid the poppies seem to be a metaphor for the exalted ability of the human spirit to transcend the dark forces which threaten it,

to live the moment in beauty and freedom, and to face oblivion without fear. It is a motif which suggests not only van Gogh's hope for release from the asylum and the revitalization of body and psyche which he felt sure would follow a move north, but his simultaneous recognition that beyond this liberation lay another of an even more profound kind.

It was agreed that Vincent would leave St. Rémy around the middle of May, stop in Paris for a few days, and go on to the village of Auvers-sur-Oise in the outlying countryside, where arrangements had been made for him to be cared for by a doctor who specialized in depression. During the two weeks which preceded his departure, he worked with renewed enthusiasm on pictures that convey his fervent hopes for renewal and his gratitude to his family for rescuing him. After refreshing his spirit with the canvases of fresh grasses studded with spring flowers, he quickly painted translations of two prints which had just arrived in a shipment from Theo and immediately struck him as powerful symbols of his own feelings and situation. The first of his paintings (fig. 187) was not so much a copy as an enlargement of a detail in Rembrandt's etching *The Resurrection of Lazarus*, a work whose theme of the return to life of a dead man surrounded by his family moved him immeasurably. Significantly, he excerpted only the figures of Lazarus and his sisters, focusing on the explosive drama of the women's emotional reaction to the raising of their brother from the grave. He described his attempt to Theo in terms of its color:

The cave and corpse are white-yellow-violet. The woman who takes the handkerchief away from the face of the resurrected man has a green dress and orange hair, the other has black hair and a gown of striped green and pink. In the background a countryside of hills, a yellow sunrise.

Thus the combination of colors would itself suggest the same thing which the chiaroscuro of the etching expresses.[92]

The chiaroscuro of the etching—its contrast between light and shadow—suggests the mingling of joy and grief, illumination and darkness, life and death which comprises the totality of existence, and it was this complex unity of experience so evident in the very subject of Lazarus which Vincent wanted to convey in his color scheme. The central sister's impassioned reaction of amazement, fear, and hope is manifested not only in her posture and facial expression, but by the vibrant intensity of her colors, her orange hair and bright green dress washed in the brilliant, lemon yellow light that floods sky and earth. This golden radiance warms and transfigures with its positive overtones all that is sinister or fearful here: the corpse in its white shroud, the violet-shadowed mouth of the burial cave, even the more reserved, faceless sister with her heavy black outlines and

hair. It is proof of Vincent's spiritual purpose and creative use of color in adapting another artist's motif that although there is only a diffused light in the background of Rembrandt's etching, in his own version he included the great orb of the rising sun as an alternative for the figure of Christ. Despite his claim of producing the effect of chiaroscuro, his addition of the sun in his composition shifted the emphasis of his color harmony to the sacred, life-giving yellow tones which dominate the canvas, a symbol of the regenerative warmth and power of Christian love which resurrected Lazarus from the tomb.

This theme of salvation was also the subject of Delacroix's *The Good Samaritan*, the second print Vincent copied (fig. 188). It illustrates the story in the gospel of St. Luke of the traveler beset by robbers and left injured by the roadside. Ignored by the priest and the other pillar of the community who pass him by and continue on their own way, he is finally rescued and aided by a compassionate Samaritan, one of a people who were themselves despised by the Jewish establishment at the time. All the elements of Delacroix's motif must have moved van Gogh: the steep and rocky terrain, the suffering face of the wounded man, the struggle of the Samaritan to lift him to the horse's back, the patient steed who bears the load, the wraithlike forms of the unconcerned travelers disappearing in the distance, the empty chest tossed aside on the ground telling its tale of violence and loss. The color effects he created to convey the significance of all this intermingled good and evil are more subdued than those of the *Lazarus*, evoking a more poignant and sober mood, but the pale violets and gray blues, the rich ochers and soft malachite greens are equally touched by a golden glow. It is the predominance of this warm tonality throughout the canvas which conveys the uplifting, revivifying spiritual effect that human sympathy and succor have on those in need. It is revealing of the associations Vincent sensed between these religious images and his own condition that in the letter in which he thanked Theo for sending these prints, he told him that the letters sent to him by members of his family had "done me an enormous amount of good in giving back a little energy, or rather a little desire to climb again out of the present state of prostration I am in."[93]

Immediately after finishing these translations, filled with relief and renewed hope at the prospect of leaving the asylum and returning north, Vincent wrote to Theo: "At present all goes well, the whole horrible attack has disappeared like a thunderstorm and I am working to give a last stroke of the brush here with a calm and steady enthusiasm."[94] After producing a rapid series of studies of roses and irises in a variety of color harmonies, he painted two final canvases which reveal that on the eve of his departure from Provence, his thoughts were still on the intermingled

subjects of life, death, and eternity. A small, summarily executed picture of a couple out walking through a hilly, olive-studded landscape beneath an ethereal crescent moon (fig. 189) seems a metaphor for humanity's journey through this vale of tears. The way is steep, the scattered olive trees stunted and bent, and in the background the funereal cypresses rise like dark flames to frame the deeply shadowed blue mountains. But the jade green sky is flushed with the lingering gold and orange light of sunset, its warm glow illuminating the lovers and casting a refreshing tinge of complementary green over the arid soil and the dusty foliage. Crowning the sunset radiance, the shimmering, enhaloed new moon hovers as a symbol of renewal over the couple who, dressed in complementary yellow and blue, make their way together through the twilight. Like the figure of Christ from his copy of Delacroix's *Pietà*, the man in this painting has the red hair and beard of Vincent himself. Perhaps this little scene symbolized what he had hoped his own life could be: a journey lightened and sanctified by companionship and love.

His last picture from St. Rémy, *Road with cypress and star* (fig. 190), conveys a similar spiritual theme. When writing to Gauguin the following month from Auvers-sur-Oise, Vincent brought up this picture as an example of how he too was working towards expressing the anguished yet resigned effect which Gauguin had sought in his painting *Christ in the Garden of Olives*:

I still have a cypress with a star from down there, a last attempt—a night sky with a moon without radiance, the slender crescent barely emerging from the opaque shadow cast by the earth—one star with an exaggerated brilliance of pink and green in the ultramarine sky, across which some clouds are hurrying. Below, a road bordered with tall yellow canes, behind these the blue Basses-Alpes, an old inn with yellow lighted windows, and a very tall cypress, very straight, very somber. On the road, a yellow cart with a white horse in harness, and two late wayfarers. Very romantic, if you like, but also Provence, *I think.*[95]

Like the painting *Starry night*, this "last attempt" from Provence depicts human life in the context of infinity and eternity. The wayfarers on their winding road, the patient horse plodding between the traces, the little inn providing sustenance and cheer for the traveler—all are dominated by the awesome cypress that cleaves the center of the composition. On either side of this symbol of grief and death, the evening star and the new moon fill the darkening sky with expanding circles of radiant energy. Suggesting a sentient universe filled with love and the eternal possibility of rebirth and renewal, they add a cosmic perspective to the earthly scene which gives us spiritual consolation on our journey. It seems significant that both of van Gogh's last pictures from Provence depict twilight, for it was at the end of this year in St. Rémy that he began to feel he had reached the evening of his life.

"Taking Death to Reach a Star:" Auvers-sur-Oise, May–July 1890

Auvers-sur-Oise seemed an ideal place for Vincent, for not only had it been an artists' colony ever since it was discovered back in the 1840s by Barbizon painters Daubigny and Corot, but it also was the home of the well-known Dr Paul Gachet, a specialist in melancholia and a devotee of modern art who owned works by Pissarro and Cézanne. After meeting Gachet, with whom he immediately felt such rapport that he wanted to paint his portrait,[96] and after settling into a small inn where he felt he would be able to work well, he threw himself with eager enthusiasm into painting the picturesque village and its environs at prodigious speed. His sister-in-law, who had been surprised when he arrived in Paris to find that he looked healthier and stronger than Theo, tells us that he left them after only three days because he was impatient to get back to work in the countryside,[97] a desire he had anticipated when he wrote from St. Rémy regarding this move: "I shall be in the open air there—I am sure that the longing for work will devour me and make me insensible to everything else, and cheerful. And I shall let things slide, not thoughtlessly, but without lapsing into regret for things that might have been."[98]

His initial letters return to this idea repeatedly. In the first of these, he told Theo and Jo that Dr Gachet "said that I must work boldly on, and not think at all of what went wrong with me,"[99] while his next declares: "Auvers is decidedly very beautiful. So much so that I think it will pay better to work than not to work, *in spite of all the bad luck with the pictures that may be expected*." He went on to request canvas and paper immediately "so as not to waste time," and reiterated that working was not only "the natural road" to success, but the best way of meeting people and regaining serenity, which "will come as my work gets on a bit."[100] During his first weeks he painted with feverish optimism, often producing a picture a day, hoping not only to make up for all the time lost during his year of illness, but to prove to himself and his family that "it is mostly a disease of the South that I have caught and that returning here will be enough to dissipate the whole thing."[101]

After the harshness of the southern climate and landscape Vincent found Auvers lushly green and sumptuously colored, and his first paintings of its cottages and trees (figs. 191 and 192) share a rich intensity of color saturation and a

bold abbreviation of form which came to characterize all his work there. The increased simplification of his forms and speed of his execution were obviously the result of his obsessive desire to produce, but they must have seemed desirable on stylistic grounds as well: proof of the increased "Japanese" sensitivity and technical superiority he had acquired in Provence. Now that he was no longer imprisoned down there, he regained his original conviction of its value for his perceptual development, telling Theo and Jo that "I already feel that it did me good to go south, the better to see the north. It is as I thought, I see more violet hues wherever they are."[102] These purples are particularly evident in the shadowed areas of his pictures, where they add a moving resonance to the landscapes and enhance the brilliance of the greens, yellows, and blues. But in many of the Auvers paintings we find them increasingly in the upper registers of the skies, where they capture the sensation of profound optical intensity and spiritual mystery that we experience when we perceive the gradual darkening of the heavens from light, transparent blue at the horizon to heavily saturated, opaque violet blue in the vault above. It seems significant that such a large proportion of van Gogh's works from this last period of his life have skies of such achingly dark purple blue that they simultaneously threaten and exalt us.

Although many of the pictures Vincent executed during late May and June convey a cheerful and lively mood, many others evoke a powerful sense of perceptual or psychological disturbance. In his painting of Dr Gachet's garden (fig. 193), for example, a study in the impassioned complementaries of green and red with black contours, a menacing array of spiky plants bristle in front of an undulating blackish green cypress beneath a sky so darkly blue as to look nocturnal. There is an aggressive violence in the way the plants seem to brandish their razor-sharp, knifelike leaves, and an unhealthy look about the isolated bare stem which thrusts up in the foreground to display a single sparse tuft of yellow foliage against the blood red wall. With its intense, exaggerated color and steeply shooting perspective, the wall behind this unpleasant vegetation adds a further jarring and dislocating note to the whole. Even the delicate patches of lavender-pink earth create a sickly effect in the jangling color harmony of this picture. In similar fashion, a canvas representing a village street with steps (fig. 194) produces a sensation of distorted perception or emotional upheaval, its warped and wavering lines creating the effect of an earthquake in progress, its rapidly receding perspective, like that of the Peiroulets ravine (fig. 168), ending abruptly in the center of the canvas at a point where movement is blocked, progress impeded. All this seismic activity and dissolution of solid form into a few extremely simplified, abstracted lines and contours, how-

ever, is kept under firm control by the meticulous geometric order the artist imposed on his motif. In his structuring of the composition into interlocking quadrants and in his careful alternations of contrasting color areas we see his continuing impulse to achieve a balance and serenity that could hold chaos at bay.

This same combination of intense expression and reasoned equilibrium is evident in his painting of the local church (fig. 195), which he rendered in cold tones of grayish white, the ribs of its roof looking like bleached bones, the windows of its central tower like black holes. It seems significant that he chose to depict not the front of the church, the welcoming entrance of its main portal, but rather the closed, impenetrable back of the building surrounded by a ring of shadow. The tall windows of the apse are dark and uninviting, the road splits before the vacant-looking structure to circumvent it, and the great expanse of dark cobalt-blue sky invests the scene with a note of intense melancholy. Vincent's imagery seems to suggest that for him, the institutionalized church was empty, a whited sepulchre, a place of no hope, no consolation. Yet he counters the sense of despair he has conjured up by locking the church into a symmetrically ordered setting, and by offsetting the desolate colors of sky and building with the yellows and golden greens of the sunny grass, the warm ochers and browns of the sandy path "with the pink glow of sunshine one it,"[103] and the bright touches of red in the roofs. Again the creation of an aesthetic order and balance enabled him to control and communicate sensations which were perhaps too painful to endure otherwise.

Pictures such as these hint at the disruptive anxieties which so often undermined his resolution to strive for tranquillity and resignation. A letter to his mother from mid June reveals the extent to which he perceived his art as a remedy, a means of life, a necessity which, because it enabled him to endure his deep personal unhappiness, he would expend himself to the limit to pursue, believing that it would bring not merely momentary consolation, but the only immortality he could ever have. Responding to his mother's news that she had revisited a place where she had once been happy and had found herself able to feel thankful for all she had in the past and ready "to leave them to others with a peaceful mind," he wrote:

As through a looking-glass, by a dark reason—so it has remained; life and the why of saying goodbye and going away and the continuance of unrest, one does not understand more of it than that.

For me, life might well continue to be isolated. Those whom I have been most attached to—I never descried them otherwise than through a looking-glass, by a dark reason. And yet there is a reason for there occasionally being more harmony in my work now. Painting is something in itself. Last year I read in some book or other

that writing a book or painting a picture was like having a child. This I will not accept as applicable to me—I have always thought that the latter was more natural, and best—so I say, only if it were so, only if it were the same.

This is the very reason why at times I exert myself to the utmost, though it happens to be this very work that is least understood, and for me it is the only link between the past and the present.[104]

Shortly before writing this letter, and at the same time that he painted the Auvers church, Vincent executed a picture which was particularly meaningful for him: a portrait of Dr Gachet (fig. 196). When he met the doctor on his arrival in the village, he had quickly perceived him not merely as a physician, but as a potential friend. Part of this initial attraction must have lain in his recognition that while they shared similar looks and temperament, the doctor had his own melancholy under control—something Vincent must have found deeply heartening. His first letter to Theo and Jo from Auvers described Gachet's face as "grief-hardened," and commented that he "gives me the impression of being rather eccentric, but his experience as a doctor must keep him balanced enough to combat the nervous trouble from which he certainly seems to be suffering at least as seriously as I."[105] By the time he started his portrait of Gachet two or three weeks later he had become strongly attached to him, for the doctor showed him great sympathy, let him come to his house to see him as often as he wished, and as a bonus had "a good knowledge of what is being done these days among the painters."[106] The extent to which Vincent identified with Gachet, and looked on him as an exemplar of that resignation under suffering which he tried so hard to cultivate in himself, is evident in all his remarks about both the doctor's personality and his own portrait of him. He wrote to his sister that he felt Gachet was already "a true friend . . . something like another brother, so much do we resemble each other physically and also mentally. . . . He lost his wife some years ago, which greatly contributed to his becoming a broken man."[107] In describing his portrait to Gauguin, Vincent claimed that it embodied "the heart-broken expression of our time. *If you like*, something like what you said of your 'Christ in the Garden of Olives. . . .'"[108]

Gauguin felt that his self-portrait as Christ in Gethsemane (fig. 250) represented "the obliteration of an ideal, a grief as divine as it is human, Jesus abandoned by all . . ."[109] and when we compare his picture with van Gogh's portrait of Dr Gachet, we find that both artists went about communicating this suffering in ways learned from psychophysical theory. In addition to using color schemes in which the melancholy effect of deep, sonorous blues is simultaneously relieved and intensified by contrasting red-

orange accents, both also gave their figures a diagonal inclination toward the left, the negative side traditionally associated with evil or depressed spirits, and downward-drooping features which express desolation. But as Gauguin's many writings reveal, his identification with Christ also involved his reverence for the ability to follow serenely on the path of inner truth and accept any resulting suffering with dignity. Van Gogh's reference to Gauguin's ideas about his picture of Jesus on the Mount of Olives indicates that it was not merely agony he wanted to convey in Gachet's portrait, but also the heroic spirit of calm resignation through which we can defeat bitterness and despair. This was the expression he had sought to convey in a portrait he had painted the previous September of the head attendant at the asylum in St. Rémy (fig. 197), whom he described to Theo as "a man who has seen an enormous amount of suffering and death, and there is a sort of contemplative calm in his face. . . ."[110] It was the same look he had tried to achieve in his pictures of Mme Ginoux (figs. 179 and 181), and in explaining to Theo his hunger to find more models for such portraits of modern-day saints, he confessed that their "personalities are the characters of my dreams."[111]

In Dr Gachet Vincent found a new model through whose image he could embody this crucial spiritual response to life, and it is revealing that in describing the doctor's reaction to his portrait he told Theo:

M. Gachet is absolutely fanatical *about this portrait, and wants me to do one for him, if I can, exactly like it. . . . He has now got so far as to understand the last portrait of the Arlésienne; . . . he always comes back to these two portraits when he comes to see the studies, and he understands them exactly, exactly, I tell you, as they are.*[112]

Perhaps it was this association that Vincent perceived between Dr Gachet's and Mme Ginoux's inner character that led him in this first version of his portrait to include two books on the table along with the sprig of foxglove—the plant from which physicians derived the digitalis they used at that time to treat melancholia, and which Vincent painted "a somber purple hue" in contrast to the yellow novels. The titles on the books' spines reveal them to be *Manette Salomon* and *Germinie Lacerteux* by Jules and Edmond de Goncourt—works which deal respectively with impoverished artists and lower-class working people undergoing the emotional and physical hardships of cruel Parisian life. Like the *Christmas Tales* and *Uncle Tom's Cabin* in the portrait of Mme Ginoux, they examine the struggles of men and women to remain moral and courageous in the face of injustice, cruelty, and indifference—to continue their work despite the pain which undermines our ability to live cheerfully.

The profound significance Vincent attached to both this portrait and the other version completed later for the doctor is evident from remarks in his two last letters to his sister. In the first, he prefaced his description of Dr Gachet's portrait with the following confession:

What impassions me most—much, much more than all the rest of my métier—is the portrait, the modern portrait. . . . I should like to paint portraits which would appear after a century to the people living then as apparitions. By which I mean that I do not endeavor to achieve this by a photographic resemblance, but by means of our impassioned expressions—that is to say, using our knowledge of and our modern taste for color as a means of arriving at the expression and the intensification of the character.[113]

Vincent's desire to manipulate color and form to communicate the state of his subject's soul was so important to him that he returned to this longing in his last letter to Wil:

I painted a portrait of Dr Gachet with an expression of melancholy, which would seem like a grimace to many who saw the canvas. And yet it is necessary to paint it like this, for otherwise one could not get an idea of the extent to which, in comparison with the calmness of the old portraits, there is expression in our modern heads, and passion—like a waiting for things as well as a growth. Sad and yet gentle, but clear and intelligent—this is how one ought to paint many portraits.

At times this might make a certain impression on people. There are modern heads which people will go on looking at for a long time to come, and which perhaps they will mourn over after a hundred years.[114]

The moral message conveyed in the Goncourts' novels was particularly relevant because it paralleled the advice Dr Gachet repeatedly gave Vincent about working in spite of adversity. In fact, many of Vincent's letters from Auvers refer to his art as if it constituted the basis of his cure, and he continually quoted his physician's assurances that "in my case work is the best thing to keep my balance,"[115] and that "I ought to throw myself into my work with all my strength, and so distract my mind."[116] It is revealing that the previous September in St. Rémy, when working on his picture of the reaper intent on his harvesting like Death going its way in a light of pure gold (fig. 156), he had written to Theo: "I am working like one possessed, more than ever I am in a dumb fury of work. And I think that this will help cure me."[117] He repeated this conviction throughout his letter, referring to his art as "the best lightning conductor for my illness" and asking: "What's to be done? There is no cure, or if there is one, it is working zealously." A few paragraphs later he mentioned the novel *Manette Salomon*; several more beyond that, he declared

that "the desire I have to make portraits just now is terribly intense;" further on he returned to the subject of his *Reaper*, claiming that "it is an image of death as the great book of nature speaks of it—but what I have sought is the 'almost smiling.'"[118] Written nine months before he met Dr Gachet, this letter suggests that Vincent had already in an unconscious, associative way prepared the ideological elements of his portrait: the image of a melancholy man broken by his experience of death but attempting through hard work to achieve the "almost smiling" state of calm resignation, a copy of the Goncourts' novel at his elbow. It is meaningful that a few weeks later, when circumstances had led to a resurgence of his terrible anxiety about his future, Vincent painted the second version of this portrait which Dr Gachet had requested for himself (fig. 198). In it, the books teaching the moral beauty of asserting a positive spirit against adversity have disappeared, the doctor's face is far more anguished than resigned, and the color scheme has shifted to a simpler, more powerful contrast between darker complementaries unrelieved by the lighter tones which break up and therefore moderate the mournful effect of the blues and greens in the earlier portrait .

Since for Vincent making art was a spiritual activity, he felt that the very act of painting would bring in its wake a surge of revitalizing religious exaltation, a charge of creative energy which he hoped would galvanize his weakened body and spirit into a healthier and even more productive state. For a while in Auvers this seemed to be the case: his nightmares disappeared, he felt well and was pleased with much of his work, and the doctor seemed optimistic about his prospects. He continued to paint with obsessive speed, trying in his last letter to his sister to rationalize his immoderate haste as an outgrowth of the rapid tempo of contemporary existence: "I am working a great deal and quickly these days; by doing this I seek to find an expression for the desperately swift passing away of things in modern life."[119] But the intensity of his pace really related to his fear that time was running out for him; he increased his production to counteract the symptoms of despair much as one would increase the dosage of a life-prolonging drug under the threat of a virulent disease. A large number of the still-lifes, landscapes, and portraits of the villagers that he executed during June share stylistic qualities which resulted from his impassioned haste and had already appeared in his work at previous periods of stress: a reduction of nuance and detail in both form and color, a broadening of line and simplification of effect, a more scumbled and gestural brushwork. In the most successful of these late pictures, the abbreviation of process and form results in a blunt, crude expressiveness which seems at once primitive in feeling yet proof of a masterful grasp of subject and medium.

Throughout June and July Vincent continued to try to heal himself by painting all the beauties of nature he found around him: the elegant, abstract linear patterns and exquisite pastel modulations of young wheat (fig. 199); the stark visual power of pear trees standing in black silhouette against a shimmering sunset sky of citron and orange (fig. 200); the mysterious, haunting vision of a couple standing silently amid a grove of violet tree trunks, a carpet of brilliant yellow and white flowers spread in the sun-dappled grasses at their feet, a canopy of black shadow suspended like darkest night above their heads (fig. 201). A young village girl seated in the midst of the early wheat and poppies (fig. 202) has the serious, tranquil dignity of a religious icon, a symbol of the sanctity and healthy beauty of youth ensconced in nature and in harmony with its seasons. Executed in carefully balanced sets of color complementaries, she projects the same sober serenity as his portrait of Mme Roulin (fig. 142).

Despite Vincent's enthusiasm for Auvers and his relief that he had suffered no recurrence of his attacks there, he was never free from the fear that his illness could at any time overwhelm him, nor from his awareness that the problem of his continuing dependence on his brother remained unresolved. Since St. Rémy he had often mentioned his anxieties about Theo's and Jo's poor health and financial difficulties, and since his arrival in Auvers he had urged them to join him there, ostensibly so they could benefit from the healthier atmosphere, but also because it would mean money saved and company for him. At the end of June he received news from Theo that the baby was ill, Jo worn out, and money problems so severe that he was meditating leaving his job with Boussod & Valadon in order to strike out on his own as an independent dealer. He included hopes that Vincent would one day have a wife and family of his own.[120] Vincent's response to this barrage of unsettling, potentially threatening news reveals his deep concern for both his brother's family's welfare and his own, for it mingles arguments in favor of their coming to the country to recover with a reminder that his own health was precarious and his prospect of ever having someone else to care for him was dim:

The people at the inn here used to live in Paris, where they were constantly unwell, parents and children; here they never have anything wrong with them at all, especially the youngest one, who came here when he was two months old, and then the mother had difficulty nursing him, whereas here everything came right almost at once. . . .

I myself am also trying to do as well as I can, but I will not conceal from you that I hardly dare count on always being in good health. And if my disease returns, you would forgive me. I still love art and life very much, but as for ever having a wife of my own, I

have no great faith in that. I rather fear that toward forty—or rather say nothing—I declare I know nothing, absolutely nothing as to what turn this may take. But I am writing to you at once because I think that you must not be unreasonably worried about the little one; . . . it would perhaps be possible to distract him more here where there are children, and animals, and flowers, and fresh air . . .[121]

A week later he went for the day to Paris to visit Jo and Theo, and from the letters he wrote to them immediately after his return to Auvers, it is evident that a distressing confrontation had taken place on the subject of Theo's financial problems and prospective difficulty in continuing to support his brother. His first hurt note observes that "it matters comparatively little to insist on having any very clear definition of the position in which we are. You rather surprise me by seeming to wish to force the situation. Can I do anything about it, at least can I do anything that you would like me to do?"[122] This is the first intimation that he was beginning to contemplate suicide as a solution to his problems, and that he could now view it not as a weak and negative act of escape from his own pain, but as a strong and positive deed by which he would enable his beloved brother and his family to survive. His next long letter is a poignant combination of solicitude for all of them, anxiety about being a burden on them, fear that having no money to continue painting would result in the loss of his creative powers, and a paranoid, self-pitying certainty that he was being deserted by everyone, including Dr Gachet. Reminding them of his concern for the baby, and adding that "since you were good enough to call him after me, I should like him to have a soul less unquiet than mine, which is foundering," he went on to suggest ways of salvaging their situation by economizing so that he could continue painting:

I can get a lodging, three small rooms at 150 fr. a year. . . . I should find a shelter for myself and could retouch the canvases that need it. So that the pictures will be less ruined, and by keeping them in good condition, there will be a greater chance of getting some profit out of them. . . .

But I will still do what I can so that all will go well.

It is certain, I think, that we are all of us thinking of the little one. . . . For myself, I can only say at the moment that I think we all need rest—I feel exhausted. So much for me—I feel that this is the lot which I accept and which will not change.

But one more reason, putting aside all ambition, *we can live together for years without ruining each other. . . . I am trying not to lose my skill. It is the absolute truth, however, that it is difficult to acquire a certain facility in production, and by ceasing to work, I shall lose it more quickly and more easily than the pains it has cost to acquire it. And the prospect grows darker, I see no happy future in it.*[123]

Jo immediately wrote him a reassuring and loving reply, which in his answering letter he said was "like a gospel to me, a deliverance from the agony which had been caused by the hours I had shared with you, which were a bit too difficult and trying for us all." He then went on to relate this crisis to three canvases which he had produced in response to the visit:

Back here, I still felt very sad and continued to feel the storm which threatens you weighing on me too. What was to be done— you see, I generally try to be fairly cheerful, but my life is threatened at the very root, and my steps are also wavering.

I feared . . . that being a burden to you, you felt me to be rather a thing to be dreaded, but Jo's letter proves to me clearly that you understand that for my part I am as much in toil and trouble as you are.

There—once back here I set to work again—though the brush almost slipped from my fingers, but knowing exactly what I wanted, I have painted three more big canvases since.

They are vast fields of wheat under troubled skies, and I did not need to go out of my way to try to express sadness and extreme loneliness. . . . I almost think that these canvases will tell you what I cannot say in words, the health and restorative forces that I see in the country. Now the third canvas is Daubigny's garden, *a picture I have been thinking about since I came here.*[124]

These three landscapes seem to portray three stages in the passage of the storm which had just shaken van Gogh's personal life and which he felt threatened his very existence. The first, *Wheat field under stormy sky* (fig. 203), depicts an immense expanse of peaceful fields in fresh green and yellow stretched out under scudding banks of gray cloud and a deep blue sky which darkens menacingly at the horizon. We recall Vincent's association of wheat with humanity, and his vision of the endlessly rolling landscape as a manifestation of infinity and eternity. For him, these vast fields of grain represented the vulnerable existence of all mankind, and the approaching storm epitomized those fateful, uncontrollable, but passing catastrophes which sweep through people's lives leaving destruction in their wake. In the second painting, *Crows over the wheat field* (fig. 204), the tempest is even more imminent. Now the sky has darkened to a Prussian blue that is almost black, and the sudden lifting of the crows from the wind-whipped, flattening wheat in their last-minute flight for cover indicates that the violence of the storm is about to unleash itself. One scholar who analyzed this powerful picture noted that the rushing perspective creates a sense of compulsion and pathos, that the rapid enlargement of the crows toward the foreground makes them objects of approaching menace and anxiety whose swift advance signifies the fleeting passage of time and the inexorability of

death, and that the solid, unified, geometric masses of the formal structure and the balanced synthesis of color complementaries indicate the artist's attempt to counteract the forces of destruction with his own creation of order and discipline.[125] We should also note that the sense of impending cataclysm is intensified by the violence of the brushwork, each stroke standing out in a ridge of paint which testifies to the force and staccato rhythm of its application. The colors too are fraught with meaning: the sky and wheat are the dark blue and golden yellow of cosmos and earth, while the divergent paths rushing blindly out from our feet are the red and green Vincent associated with impassioned emotion. These three paths are themselves symbolic of van Gogh's recognition that he must now choose a course of action to follow at this crossroads of his life, under the threat of the approaching disaster. Perhaps he was reminded of the options considered by Carlyle's hero in *Sartor Resartus*, who under similar conditions of crisis meditated giving himself up to art, to madness, or to suicide. Two of these roads Vincent had already trod, and the fact that in his painting two paths immediately branch out of the picture, leaving the central one to bury itself in the heart of the wheat, suggests that in some sense his decision was already prepared.

In grasping the implications of this picture, it is useful to note that over the years Vincent had continually associated storms with the inevitable pain and grief of human life. In addition to making remarks about the vulnerability of little one-man boats during storms at sea, he also linked the tempest to the wheat field. A year before, shortly after painting the field of ruined grain in St. Rémy (fig. 148), he had written to Theo that it was necessary to "look on pain without repugnance," and that when suffering "sometimes so fills the whole horizon that it takes on the proportions of a hopeless deluge . . . it is better to look at a wheat field, even in the form of a picture."[126] For all its susceptibility to the ravages of storm and sickle, the wheat field comforted him because it embodied the ongoing process of life, the irrelevance of the individual's fate in the overall beauty and harmony of the divine order. It is particularly revealing to note here a passage from a letter of 1882 in which he communicated to Theo his feelings about the image of the sorrowing old man he had depicted in *On the threshold of eternity*:

In Uncle Tom's Cabin, *the most beautiful passage is perhaps the one where the poor slave, sitting with his wife for the last time, and knowing he must die, remembers the words,*
"Let cares like a wild deluge come,
And storms of sorrow fall,
May I but reach my home,
My God, my Heaven, my all."

This is far from theology, simply the fact that the poorest . . . [person] can have moments of emotion and inspiration which give him a feeling of an eternal home, and of being close to it.[127]

It was because of these beliefs that Vincent could claim that these storm-ridden canvases express not only despair, but also "the health and restorative forces that I see in the country."

The last of the three paintings Vincent grouped together as his response to the crisis with Theo and Jo was *Daubigny's garden* (fig. 205). To understand the relationship of this very different image to the others we have to consider not only the picture itself, but Vincent's feelings about Daubigny, one of the Barbizon artists who "discovered" Auvers and whose widow still lived in their house there. Before Vincent ever became an artist himself, Daubigny always figured in his lists of modern painters whom he most admired. When he heard of Daubigny's death back in 1878, he wrote to Theo:

It must be good to die, conscious of having performed some real good, and knowing that one will live through this work, at least in the memory of some, and will leave a good example to those who come after. A work that is good may not be eternal, but the thought expressed in it is; the work itself will certainly remain in existence for a long, long time. Later, others . . . can do no better than to follow in the footsteps of such predecessors and do their work in the same way.[128]

Interestingly, Vincent referred again to Daubigny in 1882 at the time he was reworking his drawing of the sorrowing old man thinking of eternity, claiming that he was one of that body of enlightened Romantic artists whose unwavering spiritual goals gave their art force.[129] In his next letter, after describing his drawing of the old man facing eternity and quoting the passage from *Uncle Tom's Cabin* about the deluge of sorrow being mitigated by the hope of heaven, he had gone on to cite Daubigny as one of the artists who tried to evoke the same ideas in his work, and whose pictures "lift up your heart to heaven" and console loneliness through their communicative power.[130] Years later, in St. Rémy, he wrote to Theo: "I have gradually come to believe more than ever in the eternal youth of the school of Delacroix, Millet . . . and Daubigny,"[131] and when in a later letter he quoted from the novel *Manette Salomon* the conviction that "what will last is the landscape painters," he immediately cited Daubigny as a representative.[132]

We realize from all these references that for Vincent Daubigny represented both an artistic and a spiritual ideal—a proof that the work of a great painter, and particularly a sensitive landscape painter, enables him to transcend death and achieve immortality. His painting of Daubigny's garden depicts the unquenchable fertility of nature which survives all storms and continually renews life. Lushly green and flowering, it is a haven of peace and beauty, a sanctum for the delectation of sunshine and growing things which restores serenity to our souls. Rising centrally behind the trees is the artist's house, in Vincent's mind the dwelling place of love and the spiritual work of aesthetic creation. The cat stalking across the grass and the little black-clad figure of Daubigny's widow walking toward a convivial group of garden chairs on the left testifies to the ongoing presence of life in the artist's garden even after his own death. For Vincent, Daubigny's garden symbolized Daubigny's landscape painting, and by extension and self-identification, the legacy of work with which Vincent too hoped to endow posterity. By conveying his appreciation for a dead artist and therefore his hopes for his own future, this picture completes on a note of reverent acceptance the series which encompassed the threat of the deluge. To the very last, he hoped to continue finding, in his love of nature and art, the inner courage to live, and it is for this reason that he described this work as "one of my most purposeful canvases."[133]

During the following two weeks Vincent continued to pour his soul into his work, completing another version of Daubigny's garden and many other pictures of wheat fields. In his last letter to his mother, after concurring that "for one's health, as you say, it is very necessary to work in the garden and to see the flowers growing," he described a painting of wheat fields he was working on, "boundless as a sea," with delicate soft shades of yellow and green and violet under a vaporous blue and pink sky, and concluded: "I am in a mood of almost too much calmness."[134] In his last letter to Theo, written on 23 July, he included sketches of "vast fields of wheat after the rain" (fig. 206) and observed: "As far as I'm concerned, I apply myself to my canvases with all my mind, I am trying to do as well as certain painters whom I have greatly loved and admired."[135] On the evening of 27 July, he went out into the fields and shot himself in the chest, missing his heart but inflicting a wound that killed him two days later. Theo arrived the following morning and sat with him until he died the next day, and according to him and to Dr Gachet, who made a crude drawing of his patient on his deathbed (fig. 207), Vincent remained calm and stoical to the end. He was thirty-seven years old.

Many authors have written of van Gogh's suicide as an act of great despair committed by an unbalanced man who saw his life as useless. While it is obviously true that he suffered enormously both physically and emotionally, it seems evident that there were positive elements in his decision to take his life which in some sense made this final act an affirmation rather than a negation of his inner

being. He killed himself as much to relieve Theo and Jo of the burden of his support as to end his own misery, and he did so seemingly in the conviction that when he departed this world he would embark on an eternal life, leaving behind a gift of himself which would comfort future generations and ensure his own immortality. It is most revealing that in an unfinished letter to Theo which was found in his pocket, he did not thank his brother for the emotional and financial support he had so generously given him over the years, but instead with simple pride offered him a compensatory share in the glory of creation he had sponsored. Referring to an ongoing controversy about whether dealers should be selling only the safe works of dead artists or taking the risk of backing living painters, he observed:

Well, the truth is, we can only make our pictures speak. But yet, my dear brother, there is this that I have always told you, and I repeat it once more with all the earnestness that can be expressed by the effort of a mind diligently fixed on trying to do as well as possible—I tell you again that I shall always consider you something more than a simple dealer in Corots, that through my mediation you have had your part in the actual production of some canvases, which will retain their calm even in the catastrophe.

For this is what we have got to, and this is all or at least the main thing that I can have to tell you at a moment of comparative crisis. At a moment when things are very strained between dealers in pictures of dead artists, and living artists.

Well, my own work, I am risking my life for it and my reason has half foundered because of it—that's all right. . . .[136]

Perhaps when Vincent made the decision to kill himself he entertained the thought that his death would increase the value to his brother of his legacy of hitherto unsalable pictures, which were just beginning to attract some favorable attention from a handful of artists and critics. If so, there is an especially cruel irony in the fact that Theo, crushed by Vincent's death and never very strong himself, fell ill just two months later, lapsed into delirium,

and died six months after his brother and a scant two years before Vincent's genius began to be universally recognized. But his suicide was hardly undertaken for such purely financial, if generous, motives. A passage from a letter of two years before, in which Vincent speculated on the possibility of an afterlife on some star, suggests that in many ways his choice of death was an act of hope for himself as well as for his brother. He had written:

It certainly is a strange phenomenon that all artists, poets, musicians, painters, are unfortunate in material things. . . . That brings up the eternal question: Is the whole of life visible to us, or isn't it rather that this side of death we see only one hemisphere?

Painters—to take them alone—dead and buried speak to the next generation or to succeeding generations through their work.

Is that all, or is there more to come? Perhaps death is not the hardest thing in a painter's life.

. . . Just as we take the train to get to Tarascon or Rouen, we take death to reach a star. One thing undoubtedly true in this reasoning is that we cannot get to a star while we are alive, any more than we can take the train when we are dead.

So to me it seems possible that cholera, gravel, tuberculosis and cancer are the celestial means of locomotion, just as steamboats, buses and railways are the terrestrial means. To die quietly of old age would be to go there on foot.[137]

Vincent dealt himself the coup de grâce which he was sure his illness would soon deliver, hoping perhaps that by doing so he would speed his arrival in some happier place. His colleague Gauguin well understood that for van Gogh death seemed to offer this compensation. On hearing of their difficult friend's suicide, he wrote to Emile Bernard:

To die at this moment is a great happiness for him, it is the end of his sufferings, and if he finds himself in another life he will reap the fruit of his beautiful conduct in this world (according to the law of the Buddha). He has taken with him the consolation of not having been abandoned by his brother, and of having been understood by several artists.[138]

From Here to Eternity:
Gauguin's Journey Towards Nirvana

Decadence and Disillusionment in the West

Rebellious Beginnings: 1873–1884

THE COMMON IMAGE OF GAUGUIN THAT HAS COME DOWN to us through the years is the image of the irresponsible bohemian artist: an unconventional rebel who suddenly quit his job as a Parisian stockbroker and abandoned his wife and five children in order to live a carefree, sexually promiscuous life as an avant-garde painter; a hedonist, who moved to Tahiti to bask in the sun and in the arms of a series of juvenile native mistresses. But while it is true that Gauguin rebelled against the restrictions of a complacent bourgeois existence, we have seen that he was motivated in part by deep-seated moral and spiritual convictions. In his search for alternatives to the decadent values of European society he turned not only to the consolations of nature as van Gogh had, but also to the realms of mythology and ancient thought. Whereas van Gogh drew his subject matter exclusively from his observations of the natural world, Gauguin formulated his as much from his imagination and from the artistic imagery of many other cultures, which he synthesized in an eclectic, evocative way. Over the years he, like van Gogh, used his symbolic forms in different combinations and variations in order to express the fruits of his reflections about the nature of the world and the great dilemmas of human existence.

Despite his desire to communicate meaningful truths, however, Gauguin differed from van Gogh in that he also consciously sought to make his art mysterious and enigmatic. He saw no conflict in this dual purpose because, as we have already discovered, he believed that indirect, suggestive art more closely emulates life itself, with all its ambiguities and complexities and subjective associations. He was irritated by attempts to pin neat conceptual explanations to his imagery because he believed that by its very mysteriousness and apparent indecipherability his art would offer us unlimited opportunities to expand our con-

sciousness, to ponder and question and dream. Yet because this renegade paradoxically craved the understanding and approval of the society he scorned, he went to great pains to provide the public as well as his intimates with written explanations of his views and intentions. The ideas and feelings about life and art that he expressed in his numerous letters, journals, essays, and interviews reveal a great deal about him and offer us many clues to the meaning of his often cryptic imagery, but the clues can also be misleading. Gauguin was a bold and unconventional man who, finding himself unaccepted and impoverished, had an axe to grind and a reputation to carve out for himself. Valuing imagination over facts as an approach to life, he had no scruples about dramatizing, embellishing, and even fictionalizing the particulars of his experience in order to create a poetic, romantic image of himself that would justify his actions and help an uncomprehending world approach his art. As we investigate both his imagery and his writings, we have to unravel their intertwined elements of truth and fantasy in order to arrive at some apprehension of the real Gauguin: a man of flawed character but genuine convictions, who set out to re-create himself as a mythic hero.

Gauguin was born 7 June 1848 to a French father, Clovis, and a mother, Aline, whose maternal roots were Peruvian.[1] On both sides of the family there was a deep commitment to liberal politics, and in 1849 Clovis Gauguin found that his role as a journalist during the 1848 revolution made it expedient for them to leave France for a while. On board the ship that was carrying them to join his wife's family in Peru, Clovis died suddenly of an aneurism. Aline continued on to Lima with the infant Paul and his three-year-old sister, and for the next six years they lived there with her wealthy uncle. At the beginning of 1855 Aline returned to France with the children in order to receive an inheritance from her father-in-law and begin

Paul's education. They moved in with Gauguin's uncle Isidore in Orléans, and Paul, now seven, was enrolled in a school which he later accused of trying to stifle all his best natural instincts.[2]

After his early years of freedom in an exotic and permissive environment, the strict regimentation of bourgeois life in urban France must have seemed like prison to the rebellious boy, and his youth was apparently not an easy one. At the end of 1865, when his mother drew up her will, she suggested that Paul "get on with his career, since he has made himself so unliked by all my friends that he will one day find himself alone."[3] A month later he enlisted in the merchant marine for two years, then served three more years as a seaman in the French navy. In 1872, following his release from military service, he went to live in Paris where he came under the influence of the man his now deceased mother had made his guardian: an art enthusiast and collector named Gustave Arosa. It was with Arosa's encouragement that the twenty-four-year-old Gauguin began to sketch and paint and become acquainted with a great variety of art, including Impressionism, and it was also due to Arosa's recommendation that he acquired a good position in a firm of stockbrokers. In the autumn of 1872 he met a young Danish woman, Mette Gad, who was visiting Paris from her native Copenhagen, and by January of 1873 he

had proposed. They married that November, and the following August the first of their five children was born.

During the next decade, while continuing to work as a broker for a series of investment and insurance firms, Gauguin also embarked on the artistic pursuits that gradually came to dominate his life. In 1876 he exhibited a painting for the first time at the annual Salon—a landscape in the Naturalist style—and in 1877 he began to learn sculpture techniques. He deeply admired the art of Degas and Pissarro (figs. 17 and 18), whose influence on his own early work was profound (figs. 208 and 209), and in 1879 the two artists signified their recognition of his talent by inviting him to join the fourth Impressionist exhibition. By 1881 the Impressionists' dealer, Durand-Ruel, had purchased three of Gauguin's paintings, one of which he sold a month later. When the stock market plummeted at the beginning of 1882, undermining Gauguin's financial career and devastating his assets, it was therefore not entirely without reason that he began to think seriously of trying to establish a new life for himself as an artist. He mulled over the prospect until the autumn of 1883, when he finally felt ready to embark on a career as a full-time painter. Enthusiastic and unduly optimistic about his ability to earn a modest living with his art, he moved Mette and their five children to Rouen to join Pissarro at the beginning of 1884.

Escaping Civilization and Pursuing the Primitive: 1884–1887

When, at the age of thirty-five, Gauguin gave up a lucrative job to devote all his time to art, it naturally created serious problems in his personal life. It was soon evident that as an unconventional, non-Academic artist he could no longer support his family in the accustomed comfortable style. Life in urban France was expensive even in a provincial city like Rouen, and by the summer of 1884 it was clear that their situation was untenable. Mette returned to Denmark to explore the possibility of their relocating there, and by the end of the year Gauguin had taken a position as a sales representative for a firm of French canvas manufacturers and moved with their children to Copenhagen to live near Mette's family. The next six months were bitter ones for him. Mette's relations were conservative, conventional people who found Gauguin's unexpected artistic vocation incomprehensible and reprehensible. He was soon demoralized by their antagonism and endless criticisms, and although he struggled to combine his obligation to support his family with his strong need to make art, he was unsuccessful in his sales job and frustrated because of the time it took away from painting. When, in May, an exhibition of his work at a Copenhagen gallery closed ignominiously after only three days, he felt he could no

longer remain in the uncongenial atmosphere of his wife's native country. Despising everything about Danish life, Gauguin decided to return to France, but Mette was unwilling to undertake an impoverished existence with him and chose to remain with the children in the protective shelter of her family. Having little appreciation for his work and no genuine sympathy with his compulsion to follow this path, Mette was bitterly resentful that her husband's decision to devote all his time to art had destroyed their comfortable way of life. He, on the other hand, was deeply aggrieved that her materialistic desire for bourgeois comforts was stronger than her love for him. As a result, when in 1885 he left for France with their young son Clovis but without Mette, both of them felt abandoned by the other. It is interesting that the Degas-like interiors Gauguin produced from 1881 (fig. 209) to 1885 (fig. 210) convey a strong sense of his own feelings of isolation and psychological bleakness in a respectable middle-class environment. The pervasive quality of silence, the faceless or abruptly cut-off forms viewed at a distance through empty rooms, the sober colors and dark, weighty furniture create an oppressive mood of emotional estrangement.

It is probably no coincidence that a concern for

expressing meaningful ideas symbolically began to emerge in Gauguin's art around the time that his disgust with modern Western life crystallized and his need to give himself up to art disrupted his comfortable existence. Around 1884[4] he carved a wooden box for Mette that clearly reveals his attitude toward the values of urban European society (fig. 211). On one side of the little chest a group of Degas-like ballet dancers posture and primp, while on the lid other dancers are ogled by a huge male head with a bulbous nose and a flowing mustache.[5] Rising behind this lascivious head like an embodiment of his desire is a woman whose low-cut bodice exposes her breasts. In the nineteenth century, dancers were often courtesans, and were generally viewed as loose women who used the illusions and enchantments of the theater as well the sexual lure of their bodies to ensnare men for financial advantage. The exterior of this box therefore presents an eloquent indictment of the vanities, lusts, and artifices that Gauguin felt dominated the relations between the sexes in civilized Western life. His message is intensified when we look inside the box and find a naked figure lying like a corpse in a sarcophagus: a sudden vivid reminder of the brevity of existence and the meaninglessness of those petty, superficial concerns which motivate us to pursue sensual pleasure and material gain. Gauguin's box rebels against European aesthetic values as well as Europe's spiritual decadence, for stylistically it breaks with every Academic convention of pretty decoration and graceful composition. Crude and rough according to Salon standards, its figures are distorted and sketchily indicated, its organization fragmented and composite rather than fluid. In this object Gauguin has begun to turn the lessons of Degas and the Impressionists toward a new, non-Naturalist purpose: the expression of meaningful spiritual ideas through the abstraction and distortion of realistic form.

After returning to Paris in 1885, Gauguin soon found that even by moving in with friends and taking on a menial job as a bill poster he was unable to manage financially, and in his poverty he found the inequalities and artifices of city life increasingly demoralizing. An oil sketch for a fan that he did in 1885 (fig. 212) indicates the direction of his inclinations: it depicts his pensive son Clovis flanked by a mandolin and a large vase of flowers, gazing off into a background of beach, sea, and sky. All the elements of this composition had previously been used by Gauguin as separate subjects in conventional landscape or still-life pictures. Now, by condensing these disparate motifs into a nonperspectival scene that is clearly imaginary rather than observed, he created an expressive symbol of his own longings during a period of wrenching change in his middle age. The contemplative child seems sensitive to the transient beauty of the flowers and the ebb and flow of the waves, suggesting a dreamy awareness of the law of tempo-

rality which governs the natural world. It is this fundamental and continuous rhythm of cyclical change that creates the music of life, a concept for which the large, centrally positioned mandolin acts as a conspicuous symbol. This compact little image evokes the simple beauties of nature and the reveries of youth, tinged by a melancholy hint of their susceptibility to the ongoing passage of time. Images of dreamy or sleeping children reappear often in Gauguin's work over the subsequent years. Perhaps as his own adult life brought increased hardship and disillusionment, he found the spectacle of childhood's innocent dreams ever more significant and appealing.

In 1886 Gauguin put Clovis into boarding school and moved for the summer to Brittany on the northwest coast of France. Here he could not only live more cheaply, but could enjoy the kind of natural and spiritual atmosphere that he believed would help him make great art. Brittany, a region of rugged seacoast, hilly fields, and harsh climate, was at that time still characterized by a highly traditional society practicing the same customs and life style as in the Middle Ages. Remote from modern life, rural and primitive, its activities were the basic ones of farming and fishing, and its inhabitants were permeated with the superstitions and religious convictions that had long since dropped away from so-called civilized city dwellers. Numerous artists came to Brittany to paint during the nineteenth century because it offered an escape from modern civilization and an environment that nurtured the poetic imagination. Gauguin wrote of it: "I like Brittany, it is savage and primitive. The flat sound of my wooden clogs on the cobblestones, deep, hollow, and powerful, is the note I seek in my painting."[6] Here, working at first in the Impressionist style he had learned from Pissarro, and then in a more deliberately naïve and distinctive style, Gauguin began to paint figures of silent, meditative women and children in landscape or seascape settings (figs. 213 and 214). We have already noted that it was common for nineteenth-century Romantics to regard women, children, and peasants as being more in harmony with the natural world—more sensitive and intuitive and emotional—than urban males, and Gauguin depicts his Breton subjects here not as individuals, but as embodiments of primitive simplicity. Dressed in traditional clothing and engaged in such timeless, fundamental activities as watching the flocks and attending to their domestic chores, they participate in nature's eternal processes with quiet dignity.

It was during the period of 1884–1886 that Gauguin began to be influenced by Symbolist theories of form and color. His own writings from this time include his rendition of a manuscript describing the aesthetic principles of the fourteenth-century Turkish artist Mani-Vehbi-Zunbul-Zadi, and an essay entitled "Synthetic Notes" which deals

with the relationship of painting to literature, music, and mathematics. Both of these texts advocate using color and form expressively rather than descriptively, and both emphasize the crucial role of the artist's imagination, feelings, and soul in creating poetic evocations of reality. Gauguin's early Breton pictures convey his vision of peasant life as tranquil and soothing, and he adopted from artists like Delacroix, Degas, and Pissarro a muted, minor-key palette whose subdued tones enhance his figures' air of sober serenity. But it was in his work with ceramics as much as in his painting of this period that he began to experiment with the principles of abstraction and simplification which gradually transformed his art from its early Naturalist and Impressionist style to a Synthetist style influenced by various "primitive" traditions.

Gauguin had been interested in ceramics since the beginning of his artistic career and had already done some experimental work in the medium which was undergoing an extensive revival during the second half of the century.[7] In 1886, however, under the influence of the master potter Ernest Chaplet, Gauguin devoted a good deal of the year to making ceramics which he conceived of as sculpture rather than pottery.[8] The imagery of these rough and unusually shaped vessels was unconventional for French ceramics, and ranged from Degas-like dancers or Breton women and children engaged in unromantic activities such as fishing or tending geese (fig. 215), to somewhat surreal depictions of figures peering around the contours and over the rims of the pots (fig. 216). Working in clay seemed to enable Gauguin to liberate himself even more thoroughly from Academic stylistic constraints. His figures are purposefully crude and basic, and while the forms of some vessels are the product of his own inventiveness, others reveal the direct influence of the styles and techniques of sixteenth- or seventeenth-century Japanese ceramics and ancient Peruvian pottery (figs. 217 and 218). Gauguin was familiar with pre-Columbian objects because his mother's uncle in Lima had had a large collection and Aline had

brought some back to France, while Gustave Arosa owned many types of foreign as well as domestic ceramics. Gauguin's adaptation of Japanese and pre-Columbian aesthetics at this point reflects his growing desire to utilize authentic "primitive" artistic styles to represent the rustic, simple imagery that seemed so much more valid and meaningful to him than civilized urban motifs.

These experimental ceramics had even less success than his paintings, and in April of 1887, after writing to Mette that he was forced "to flee from Paris which is a desert for the poor man,"[9] the penniless Gauguin and a fellow artist named Charles Laval set sail from France for the Caribbean island of Martinique. There they hoped to find not only a better climate than chilly, foggy Brittany could offer, but even cheaper living conditions and a more intensely primitive, unrestrictive atmosphere. Although he and Laval were beset with illness and found life in Martinique neither as inexpensive nor as idyllic as they'd imagined, it did provide the stimulus of a more exotic and lush environment. While he was there, Gauguin continued to dwell on images of women pursuing their simple daily activities in nature (figs. 219 and 220), but his depictions were now more richly and imaginatively colored under the double influence of the brilliant tropical light and the natives' predilection for strong colors and patterns. His forms are also more sinuous and rhythmic, conjuring up the women's sensuous grace and the languor of the atmosphere, while his compositions reveal debts to Japanese prints (fig. 221). These scenes evoke the impression of a harmonious, universal way of life in which the natives' intermittent labors of tending the herds and picking fruit alternate with periods of dreamy relaxation lounging by the sea or under the trees. Gauguin's preoccupation with these subjects stemmed from his conviction that this sort of relaxed and unchanging existence was physically and spiritually healthier than bourgeois urban life. He maintained this belief despite his own continual disappointments, and it must have added to the bitterness of his wife's refusal to share it with him.

The Development of Synthetism and Symbolism: Brittany and Arles, 1888

Malaria, dysentery, and the unexpected difficulty of supporting himself in Martinique brought Gauguin back to Brittany in February 1888. Here, his powerful, compelling personality and passionate aesthetic convictions made him an influential figure in a coterie of younger painters who, although attracted by Impressionism, also shared strong spiritual interests and a desire to make art that was more in keeping with the condensed decorative style and sacred purposes of past traditions. Gauguin brought to his new Breton landscapes the brilliant, fanciful color and the sim-

plified, rhythmic form he had developed in Martinique (fig. 222), and as his experience with the arts of such "primitive" cultures as Japan and medieval Europe grew, his representations of the peasants became increasingly reduced and flattened.

When Gauguin produced his painting *Young Bretons wrestling* (fig. 223), he wrote to his friend Émile Schuffenecker in Paris that the impression he had sought to create was of something "totally Japanese but seen through the eyes of a Peruvian savage."[10] As his reference suggests, his

figures were influenced by illustrations of wrestlers he had seen in the mangwa albums of the popular Japanese artist Hokusai (fig. 224), but his manner of representing them has a bluntness and naïveté that he felt added to their primitive effect. It has been observed that Gauguin's figures were also based on the wrestling boys at the center of Puvis de Chavannes' painting *Pleasant land* (fig. 225),[11] an example of his appropriating imagery from a contemporary whom he only grudgingly admitted admiring but from whom he often borrowed. Not only in the highly simplified figures of the boys, but in the extreme reduction of background detail and the two-dimensional effect of the high horizon line and steeply angled perspective, we see Gauguin working toward the type of nonillusionistic, generalized form and abstract design that he admired in all kinds of "primitive" art. Working closely with his young colleague Bernard (who later claimed the major credit for their mutual achievement), he adapted the aesthetics of medieval sculpture and stained glass as well as Japanese prints to his renditions of Breton life, and began to strive increasingly for poetic effects achieved solely through distortions of form and color. By September of 1888 his efforts crystallized in two genuinely synthetizing and symbolizing pictures.

The first of these is his *Self-portrait called "Les Misérables,"* (fig. 226), a work he painted for van Gogh, whom he had first met in Paris in November of 1886 and with whom he had been corresponding since his return from Martinique. Vincent had moved to the south of France in February of 1888 and, lonely and impoverished, had invited Gauguin to come live with him there so they could cut their expenses and provide intellectual and artistic stimulation and companionship for each other.[12] What persuaded the penniless Gauguin to make the move was an offer from Vincent's brother Theo, who had recently begun exhibiting Gauguin's work at the art gallery in Paris where he was a dealer. In June, Vincent wrote to Gauguin that if he would join him in Arles, Theo would pay him a monthly sum of 250 francs in exchange for one painting a month.[13] Gauguin acquiesced, and in September, Vincent wrote to him and to Bernard to suggest that they should all exchange self-portraits in the fraternal tradition practiced by Japanese artists. It was in response to his request that Gauguin painted the picture which he entitled "Les Misérables" on the canvas and which includes a portrait of Bernard hanging on the wall at the right.

In a letter to Schuffenecker in which Gauguin described this self-portrait, he emphasized that his goal was to express emotions and ideas solely by means of form and color:

I think it's one of my best things: absolutely incomprehensible

(upon my word) it's so abstract. A bandit's head, at first glance, a Jean Valjean (Les Misérables), personifying also an Impressionist painter, discredited and always bearing the chains of the world. The design is quite special, complete abstraction. The eyes, the mouth, the nose are like flowers on Persian carpets which also embody the symbolic side. The color is a color far removed from nature: imagine a vague memory of pottery distorted by the great heat of the kiln! All the reds, the violets, streaked by fiery bursts like a furnace radiating from the eyes, the seat of the painter's intellectual struggles. Everything on a pure chrome background sprinkled with childlike bouquets. The room of a pure young girl. The impressionist is pure, not yet sullied by the putrid kiss of the Beaux-Arts (School).[14]

The character Jean Valjean with whom Gauguin identified himself here is the protagonist of Victor Hugo's famous novel *Les Misérables*. First a galley slave and then a hunted escaped convict whose crime had been to steal bread for his starving family, Valjean spent the rest of his life striving for moral self-improvement. His sacrifice of himself to help others, the religion of love that he taught through his actions, and the cruel injustice of his treatment at society's hands made him a modern Christ figure whose sufferings Gauguin also associated with the plight of avant-garde artists. When he compared Valjean to the discredited Impressionist who bears the chains of the world, he was referring to the martyred condition of all unconventional painters who reject false artistic ideals in order to live and depict reality honestly and who are therefore dragged down by the shackles of society's suspicion and contempt.

On a more personal level, however, Gauguin was well aware that his decision to make art at the expense of his family's financial stability seemed in the eyes of his wife and the world the equivalent of a serious crime. Over the years he frequently tried to justify his decision to Mette, writing to her: "Unless I pursue my path I will consider myself a brigand. . . . Well, what does it matter. . . . I believe I am doing my duty and strong in that, I accept no advice, no reproach."[15] Jean Valjean embodied many of the personal qualities common to the Romantic heroes with whom Gauguin identified: he was an independent, passionate man with a strong will, a profound concern for moral issues, and the courage to violate the dictates of convention and practical self-interest for a high spiritual purpose. In casting himself as Valjean, Gauguin consoled himself for his difficult plight and society's contempt by raising his struggle to an epic level that he felt graced it with heroic nobility.

In the painting, the artist's personal and vocational sufferings are conveyed both directly in his face and by subtle implication in his environment. He described the face as a mélange of burning reds and violets intensified by green and blue shadows, a fiery effect of pottery contorted in the furnace. This analogy reveals the extent to which his

choice of artistic materials related to his feelings about life: his work with ceramics obviously satisfied him in part because what happened to the medium in the kiln suggested truths about human experience. In an article he wrote the following year, he remarked metaphorically regarding ceramics that the substance that has been in the fire takes on the character of the kiln, and becomes graver and more serious the longer it has remained in hell.[16] The blazing colors of Gauguin's sardonic face, his eyes deeply shadowed with melancholy blues and acid greens, seemed to him to express the diabolical ravages of life as clearly as the transmuted forms and colors of his pottery revealed the effects of the firing process.

The contribution of the background to Gauguin's self-conception has to do with its evocation of innocent beauty. Its clear, warm yellow color and sprinkling of delicate pink and blue blossoms suggest the room of the "pure young girl" to whom he referred—a maiden whose sexual chastity paralleled in his mind the moral integrity of the painter who refuses to succumb to the financial and social temptations of decadent Academic values. A decade later these metaphors still had validity for him. In a series of notes called "Diverse things," he compared artists to children and to fragile blooms, claiming that "Like flowers they open themselves to the least ray of sun, exhaling their perfumes, but they wither at the impure contact of the hand that defiles them."[17] Of the public he wrote: "When I see them examining and turning over one of my works, I always fear that they are handling it roughly as they would grope a girl's body, and that the work, thus deflowered, would always bear the ignoble traces."[18]

In this self-portrait, then, Gauguin seems to be depicting two different but related aspects of his own personality: what he had described to Mette earlier that year as "the Indian and the sensitive,"[19] or the masculine and feminine sides of his nature. The strong, dark, mature male face, ironic and as stoic as an Indian's under life's fiery torture, is surrounded by the complementary pastel and flowering ambience of a girlish sensibility that shrinks from the desecration of its chastity and high ideals. It is interesting that when van Gogh received the portrait he perceived it as disturbingly negative, and he wrote to Theo that it "gave me absolutely the impression of its representing a prisoner. Not a shadow of gaiety. Absolutely nothing of the flesh, but one can confidently put that down to his determination to make a melancholy effect, the flesh in the shadows has gone a dismal blue." Comparing Gauguin's picture with the self-portrait he himself had recently executed (fig. 131), Vincent concluded that "mine is as grave, but less despairing."[20] Yet when we consider what Gauguin meant when he characterized himself as "an Indian and a sensitive," and when he compared himself simultaneously to

Jean Valjean and an innocent maiden, we realize that this is actually a portrait of moral courage. The tough, experienced, "primitive" male, capable of enduring suffering without sacrificing his dignity or honor, and the vulnerable virgin, whose innate goodness is a bulwark against the blandishments of those who would deflower her, together exemplify Gauguin's determination to resist attacks on the integrity of his art and his personal sense of duty. And while there is "not a shadow of gaiety" in his face, his appreciation for the beauties of life is evident not only in the sunny, blossom-sprinkled backdrop, but in the unhappy features which he has depicted, in his own words, as exquisitely colored abstract designs equivalent to the flowers in a Persian rug.

The second of Gauguin's new symbolizing and synthetizing images was *The Vision after the sermon (Jacob wrestling the angel)* (fig. 227). This is a picture which expresses not only Gauguin's appreciation for the deeply religious nature of Breton society, but, more covertly, his feelings about his personal struggles as a modern artist to fulfill himself and maintain his integrity. The source of the image seems to have been the Breton Festival of Pardons,[21] a religious event which involved the blessing of the fields and animals to ensure their continued fertility. At this traditional festival the cow, which we see in the background left, was paraded as a symbol of sacrifice and redemption. The biblical text for the accompanying church service was the story of Jacob and the angel, and the Sunday afternoon celebration in the village centered on wrestling matches. Gauguin has synthesized these factual elements to present us with a vision of the primitive way of life. In a letter to van Gogh he described the figures of the peasant women as having "a great rustic and superstitious simplicity," and he claimed that "For me, in the picture the landscape and the struggle exist only in the imagination of the people praying, as a result of the sermon. That is why there is a contrast between the real people and the contest in its unnatural and disproportionate landscape."[22]

Gauguin admired the fact that in traditional societies, religion and daily life were not artificially divided: that religion provided the framework which gave all activities moral and spiritual meaning. He conveys the imaginary nature of the vision in several ways: by his violent disruption of realistic, continuous space (the diagonal juxtaposition of the very near with the very far) by his shift into blatantly unrealistic color in the background, and finally, by the closed eyes and reverent expressions which signify a state of inner communion with spiritual rather than perceptual realities. Gauguin felt that it was fitting to represent the religious fervor and harmony of primitive life through the aesthetics of primitive art: the two-dimensional, vertical spatial environment, the simple, generalized forms, and

the bold, flat colors and dark outlines of medieval stained glass windows and Japanese prints (figs. 224, 228, and 229).

This is not merely a depiction of credulous primitive faith, however. The theme of Jacob wrestling the angel must have attracted Gauguin because it suggested an important aspect of his own experience. His letters from these years are filled with references to his incessant, debilitating struggle not only with the artistic problems of his painting, but with extreme poverty, hunger, illness, isolation from his family, hurt at his wife's callousness and neglect, and the bitterness of his failure to win acceptance and earn a living as an artist. In the biblical text, Jacob's wrestling match represented a struggle between the demands of conscience and desire. The angel didn't defeat Jacob, and it ultimately blessed him for striving and standing firm, but it also crippled him for life. Gauguin, who claimed that all religious texts should be interpreted symbolically, must have perceived Jacob's spiritual combat as a metaphor for his own conflict with questions of his moral duty to his family and his art, an activity which he himself perceived as profoundly religious and ultimately beneficial for humanity. His decision to brave poverty and contempt in order to pursue what he felt was the higher goal of art seemed to him the equivalent of Jacob's spiritual valor, and he must also have realized that even if he eventually triumphed, he too would always sustain the wounds which the process was inflicting on him.

One other philosophical aspect of this painting is suggested by Gauguin's mention to van Gogh of "an apple tree traversing the canvas."[23] Given his consciously symbolizing intentions, this specific identification associates it with the biblical Tree of Knowledge, here separating not only the realms of reality and imagination, but the traditional world of the passive, innately devout women and priest from the more difficult world of the active, morally questioning and struggling man. The use of the apple tree suggests to the biblically aware that there has been a fall from grace here, that the intuitive, unquestioning faith of the primitive women is being contrasted to an intellectual wrestling with decisions about how to live and what to believe—a discriminating awareness which destroys that sense of harmony with life and that comfortable acceptance of our role in the world which characterized life in Eden. This duality, this tension between opposing approaches to existence, is expressed not only through the contrasts Gauguin has set up between struggle and serenity or dream and reality, but through his use of color complementaries as well: his careful interactions of red and green, blue and orange, black and white, which counterbalance each other across the surface of the canvas. As was true with van Gogh, Gauguin's use of complementaries was influenced by contemporary perceptual and psychophysical theories which maintained that colors are intensified and made more emotionally expressive and aesthetically harmonious when they're juxtaposed with their opposites.

While Gauguin deplored the lack of fantasy in Naturalist painting, he also wanted to find ways of communicating symbolically through ordinary subjects rather than esoteric ones. He often painted the rocky shoreline of Brittany with its precipitous cliffs and broken water foaming up around the great boulders scattered along the coast, and one of these pictures, *Above the whirlpool* (fig. 230), is a particularly good example of his ability to construct visual metaphors from the components of the real world. At the edge of a cliff that drops dizzyingly down to the sea below, a cow grazes quietly with its back turned to the threatening brink. Squeezed into a narrow gorge between the powerful outcroppings of rock that flank the scene, the sea boils up furiously along the same central axis as the oblivious cow, while at the top of the canvas a little boat hovers just at the outer limit of the violent current. The cow and the boat, representatives of vulnerable animal and human life which are linked to one another by the funnel of pounding surf, are depicted here as engaging in their normal daily pursuits in extreme proximity to a dangerous force. The suggestion implicit in this carefully contrived image is that all living things, whether conscious or unconscious, are forever hovering at the edge of death or disaster.

That Gauguin intended this seemingly ordinary motif to convey a significant idea about life is apparent when we consider his title, *Above the whirlpool*, and the relationship this image has to some of his favorite literature.[24] During this same year he produced a zincograph illustration for Edgar Allan Poe's short story "A Descent into the Maelstrom," which he inscribed "Dramas of the sea." Poe's tale is set on the forbidding Norwegian coast, and the story begins with the narrator climbing a precipitous cliff with a local sailor to view the site of the latter's near-fatal encounter with a mighty whirlpool. As the two men hang at the edge of the precipice, hemmed in on both sides by dark cliffs and looking down on the ocean where a tiny ship lies offshore, the sailor tells of his brush with death when his boat was sucked down into a whirlpool during a storm at sea. Poe's emphasis throughout is on the awesome power of the elements which both terrify and fascinate us, and whose beauty we feel even when we are at their mercy. When we consider their exact correspondences of setting and philosophical idea, it seems evident that Gauguin had Poe's story in mind again when he contrived *Above the whirlpool*. He might also have been under the conceptual influence of another recently read and loved book, Balzac's novel *Séraphîta*, which opens similarly with two characters climbing a steep and dangerous mountain on the coast of Norway to look down on the sea and muse

about life and death. Certainly, *Above the whirlpool* reveals Gauguin's ability to adapt local realities to express a Romantic vision of nature and human experience that he acquired in part from literature. It was precisely in order to be in an environment which could furnish him with such evocative landscape imagery that he had come to Brittany.

Gauguin's preoccupation with the ways in which our lives are shaped by elemental forces of nature emerged in another type of subject as well. During the same period in 1888, he painted a still-life incorporating the face of a young girl with slanting eyes who, chin in hand, gazes with speculative pleasure at a tantalizing assortment of ripe fruits (fig. 231). Since the early nineteenth century, artists had used images of Oriental females to suggest the seductive eroticism of women in an atmosphere of mystery and desire. Some scholars have interpreted this girl's slanting eyes and dreamy smile as diabolical and lascivious, the embodiment of forbidden sexual longings, but although this negative view of sensuality was preached by society, it is out of keeping with the opinions Gauguin expressed often about the naturalness and beauty of sexuality. It seems more likely that the seductive array symbolizes all the temptations over which inexperienced youth daydreams, and while the girl is obviously meant to epitomize desire, her pensive, ambiguous expression suggests that mingled with her longing to sample life's fruits is some incipient awareness of their danger or transience. In his writings, Gauguin often expressed his conviction that it is natural and right for people to pursue experiences which they believe will be fulfilling, and he blamed the West for perverting our instinctual longings for sexual experience and love by teaching that they are degraded and improper. In his depictions of desire he purposely avoids representing women as temptresses or femmes fatales, treating them instead as susceptible to a powerfully seductive natural force which is responsible for great fulfillment as well as great anguish. A very similar portrait of his friend Charles Laval (fig. 232) reveals that he applied a similar principle to men.

In late October Gauguin finally went to Arles to live for a while with van Gogh. There, in addition to relatively straightforward depictions of the local landscape and inhabitants, he painted several more symbolic scenes which he believed conveyed the sensation and values of primitive life. One of these, *Woman in the hay* (fig. 233), was executed in December and was therefore obviously done from imagination. Gauguin originally exhibited this picture under the title *En plein chaleur* (*In full heat*), a phrase which refers not only to the summer season, but to female fertility and sexual receptivity as well. It represents a strong-bodied peasant woman stripped to the waist, laboring amid the bales of hay and the almost identically shaped bodies of

large pigs with little curly tails that press in on her from all sides. By making her the central element in an interlocked system of similar animal and vegetable forms, Gauguin has given pictorial expression to his belief that primitive woman is locked into the harmonious unity of the natural world, that she instinctively abandons herself to the cycles of fecundity and mortality suggested by the harvested grain and the pigs. In making this juxtaposition Gauguin was in no way implying the debasement or inferiority of natural woman, because for him sexuality and maternity were sacred aspects of the laws of nature. He even wrote approvingly of pigs, claiming that they're less ridiculous than civilized men because their behavior is instinctive and therefore healthy and dignified, while people make themselves absurd by cloaking their God-given instincts under the hypocrisy of artificial respectability.[25]

Another canvas from Arles also conveys this idea of women's special relationship to natural forces. In *Vintage at Arles: "Human misery"* (fig. 234), he portrays a young girl very similar to the one in his *Still-life with fruits*, but whose face is now distinctly melancholy as she sits brooding against a backdrop of women gathering in the grape harvest. Her flaming red hair, a device Gauguin used repeatedly for symbolic purposes because of its psychophysical association with strong emotion, seems to embody all the impassioned frustrations and yearnings of adolescence, and Gauguin sets her in contrast to the working women whose dark clothing and covered heads mark them as sober matrons. This painting is about the stages in a woman's life, about the passage from youth's emotional upheavals and freedom from labor to the responsibilities and resignation of maturity. It is, in fact, about the passage from innocence to knowledge. This knowledge comes not only from recognizing the necessity for hard work, but from abandoning oneself to the rhythms and laws of life's seasons and cycles. Gauguin felt strongly that this included the experiences of marriage and childbearing, and, as one scholar observed, he suggested this idea by the pinned-up aprons hanging pouchlike from the women's stomachs to hold the harvested fruit, which is itself a symbol of the fruits of the womb.[26] Gauguin also implies here that the knowledge of life experience includes death, for the woman at the left, with her closely hooded, deeply shadowed face, and black robe which he described to Schuffenecker as the color of mourning,[27] stands waiting in the wings like a reminder of mortality.

All these details suggest that the disconsolate expression on the girl's face indicates her growing realization that adulthood brings with it hard labor and the relentless passage of time. For Gauguin, this melancholy figure embodied the emotional vulnerability which is an unavoidable aspect of the human condition, yet is not an image of

despair. In his letter to Schuffenecker, he wrote that the girl "feels the consolation of the earth" and that the woman in black who stands beside her "looks at her like a sister."[28] It seems likely that he adapted this description from a remark Vincent made to him when they were in the museum in Montpellier looking at a Delacroix portrait of a red-haired man named Brias, which Vincent said reminded him "of that poem by de Musset—'Wherever I touched the earth—an unfortunate fellow clothed in black

came and sat beside us, and looked at us like a brother.'"[29] Gauguin's iconography as well as his use of this literary idea imply that the unhappiness and frustrations which immobilize us can be soothed when we sense our harmony with nature and our bonds with our fellows; that the very toil and life processes which seem to oppress the doleful maiden's thoughts will also be her salvation, because it is through them that she will eventually acquire the calm acceptance of her sister on the left.

Issues of Life and Death: The Mummy-Eve and the Woman in the Waves, 1889

Gauguin's stay with van Gogh in Arles lasted only two months. Both men had strong personalities and held impassioned opinions, and despite their mutual respect, each found it hard to tolerate the other's needs and idiosyncrasies. Vincent wrote to Theo that they argued exhaustively at night, especially about art,[30] which Gauguin believed should be based more on imagination than on the details of nature. Gauguin complained to Bernard not only that they disagreed on which painters they admired and how to apply color, but that Vincent constantly criticized the details of his pictures and was "romantic" while Gauguin felt more "primitive."[31] When recalling this period in his later journal *Before and After*, he claimed also that he found Vincent's disordered environment and messy personal habits irritating, and his emotional demands and expectations of companionship intrusive.[32] After van Gogh's threatening behavior and seizure at Christmastime, Gauguin summoned Theo to help and quickly returned to Paris. By mid-February of 1889 he had gone back to Brittany, but in mid April he was again in Paris to make arrangements for his part in an exhibition of Impressionist and Synthetist work to be held at the Café des Arts during the Universal Exposition. Among the seventeen works he contributed to what is now called the Volpini exhibition were a number of new images which held such powerful associative significance for him that they became staples of his growing symbolic repertoire.

The first of these is a small pastel and watercolor entitled *Breton Eve* (fig. 235), under which Gauguin inscribed in pidgin French, picked up perhaps in Martinique: "Don't listen him, he liar."[33] In front of a tree around which a menacing snake peers, a naked Eve with blue hair sits in a pose similar to that of the melancholy maiden in *Vintage at Arles*. Her frightened expression and contracted posture, however, have transformed the pensiveness of the earlier figure into what is here an anguished effort to shut out the snake's tempting offer of knowledge and experience. It has been demonstrated that Gauguin's source for this figure was a Peruvian mummy (fig. 236) on display at the Museum of

Ethnography in Paris,[34] an object to which he must have been attracted not only because he found its posture extraordinarily evocative, but because its Peruvian origins linked it to what he felt was his own primitive identity. Gauguin's association of this fearful, reluctant Eve with the idea of death is further confirmed by his use of the same figure in another work of this spring which he exhibited in 1893 under the title *Life and death* (fig. 237). Here, the huddled mummy figure with blue hair is painted greenish gray, cold colors associated by psychophysical theory with sorrow and death, while the figure of life, who towels herself freely and openly after her swim, has the red hair and peachy skin tones suggestive of warmth and vitality. In the opposition of these two figures, one protecting herself from contact with the world and the other opening herself unselfconsciously to it, we find the key to Gauguin's symbolic intentions in depicting Eve as a mummy closing her ears to the temptation.

In the first section of this study, we explored Gauguin's insistence that myths and religious texts must be interpreted metaphorically rather than taken literally if they are to have any meaning for us. He deplored the fact that, although the Bible makes no mention of a loss of virginity in the story of the temptation, the Catholic Church had placed a sexual interpretation on the parable of the Fall and for centuries had taught that sexual desires are sinful and that their original indulgence was responsible for bringing death into the world. Gauguin was aware that in the Bible both sex and death were a part of natural law from the very beginning. God created male and female of all creatures, and decreed that Adam and Eve "shall be one flesh," that man and woman should cleave to one another and live as husband and wife (Genesis 2:24–25). In the text of Genesis, it is not Eve's sexual longings which tempt her to eat the forbidden fruit of the Tree of Knowledge and share it with Adam—it is her desire for full experience, her desire to acquire the understanding of the Creator (3:4–6).

When God first tells Adam and Eve the conditions of life in Eden under his paternal protection, he warns them

that if they eat from the Tree of Knowledge of good and evil, they will die (2:17). That this threat was metaphorical rather than literal is evident from the fact that after they ate the fruit they were not struck dead—they merely became aware of their nakedness, their vulnerability (3:10), and then were forcibly ejected from their blissful paradise of ignorance and dependence into a harsh outside world of increased pain, hard labor, and the unhappy consciousness of life's difficulties and brevity (3:16–18). When God expelled the pair after they had acquired moral understanding, he did so specifically to prevent them from usurping the other privilege of deity and becoming immortal by eating next from the Tree of Life (3:22–24)). The death with which God punished humanity for acquiring a discriminating intelligence was therefore the irrevocable loss of tranquil ignorance as our life experience broadens and our awareness deepens. Had Adam and Eve not acquired knowledge, the ability to differentiate between good and evil, they would have remained, like children and animals, contentedly absorbed in the moment, as oblivious of the passage of time and the inevitability of pain and death as they were of their differences from one another and the other inhabitants of the Garden.

What then did Gauguin mean by his unusual depiction of the figure of Eve and his strange inscription? Like the girl in *Vintage at Arles* whom she somewhat resembles, this Eve is still immature; she is not yet the biblical archetype, ready to reach out for experience at the cost of losing her secure paradise of unconscious ease and freedom from care. The mummy pose is also a fetal position, and this connection implies that the fear of leaving the womb to taste reality with its mingled joys and sorrows is both infantile and life destroying. Given Gauguin's personal situation at the time he created this image, it is difficult to avoid the conclusion that the Breton Eve symbolized his wife. After returning to Paris from Arles he had once again tried to convince Mette to bring their children and join him in France: to leave the comfort and security of her parental home for the thorny life he had embarked on when he defied the godlike dictates of social convention, succumbed to the temptation of satisfying his creative potential, and was expelled from the Eden of bourgeois plenty and respectability. Again she had refused, closing her ears to her husband's offer of a difficult but loving life together, choosing a death-in-life that cut both of them off from the consolations of married love and companionship.

But if Gauguin saw himself as having committed a courageous and necessary act of spiritual self-liberation, and if he blamed his wife for refusing to share its consequences with him, how are we meant to understand the warning he inscribed below the fearful Eve: "Don't listen him, he liar?" Gauguin was a man strongly given to irony

in his thinking and his manner of self-expression, and this message contributes a note of irony to the idea he meant to convey. Its voice is not so much his own as that of nineteenth-century European morality, which taught girls to fear the temptations and demands of men, and encouraged them to value conformity and material security over either love or adventurous self-expansion. It is the voice of Christian society, which Gauguin felt perverted our natural loving instincts and instilled in people a repressive spirit of death instead of a receptivity to life. According to the Romantic writer Stendhal, the modern concept of the heroic involves a willingness to take risks, to be bold and unconventional, to be passionate, to hold exalted ideals, and to fling oneself into their pursuit.[35] For Gauguin, who subscribed to these beliefs, Mette's lack of faith in the validity of his choice and her refusal to accompany him into exile were marks of her spiritual failure.

Several of the other works Gauguin exhibited with *Breton Eve* enlarge on this theme. The first is *Woman in the Waves* (fig. 238), which Gauguin is reputed to have retitled *Undine*, and it expresses a very different approach to life. It depicts a naked woman hurling herself into a cold green sea, one hand raised to her mouth as if to stifle an instinctive cry of fear, her other arm lifted to brace herself against the impact of the stylized Japanese waves. As in his symbolic figure of Life, he used blood-red hair to suggest the inherent vitality and life-enhancing passion of her act. If Gauguin did associate the legendary character Undine with this woman throwing herself into the rough current of life, his idea becomes even clearer. In Breton folklore, Undine was an immortal water spirit who gained a human soul by relinquishing her own invulnerability to pain and death in order to marry a mortal man and bear his children. The opposite of the rejecting Eve, she embodied the devotion and courage which risk all for love: a fervor Gauguin felt was healthy and sacred. Odilon Redon found this figure so expressive of the emotional tension related to crossing a spiritual threshold that he borrowed it for an etching entitled *The Passage of a soul* (fig. 239).

The fact that Gauguin conceived of the woman in the waves as the antithesis of the mummy Eve is evident from his juxtaposition of the two figures in a woodcut entitled *At the Black Rocks* (fig. 240), a work he produced as the cover illustration for the Volpini exhibition catalogue. These black rocks were ancient menhirs, huge stones covered with black-looking seaweed on the Breton coast, which according to local lore were used by women in a fertility ritual.[36] To throw oneself into the sea from these rocks was believed to ensure sexual productivity and happiness in marriage, for the sea is a life-engendering as well as a potentially destructive medium. Gauguin draws a sharp visual contrast between the woman willing to risk the

plunge in order to secure these blessings, and her fearful counterpart who turns her back on the rocks and opts for the barren safety of the shore. This duality must have reflected Gauguin's perception of his and Mette's choices, and it is interesting that this feeling was shared not only by his friends, but later by one of his own sons, Pola. In a biography of the father he had scarcely known, Pola vindicated Gauguin's decision and blamed his mother for abandoning her husband.[37] In her bitterness, Mette punished Gauguin even more by refusing to send him news of the children or allowing them to communicate with him. The loss of these contacts and the realization that his wife was turning their children against him caused him great grief, yet he continued to assume that he would be reunited with his family in the not-too-distant future, and he maintained a correspondence with Mette for many years.

The Artist as Christ: Images of Suffering and Resignation, 1889

Many of Gauguin's other works from 1889 reveal his growing preoccupation with human suffering and his continuing need to dignify and universalize his own painful experiences by relating them to mythical or biblical events. Early in the year, shortly after fleeing from the distressing incident with van Gogh in Arles, he produced a ceramic portrait jug (fig. 241) depicting himself as a martyred Christ, a motif which was influenced by the many images of Christ as the Man of Sorrows that decorated French medieval cathedrals (fig. 242).[38] This self-portrait creates a very different impression than his representation of himself as the heroic brigand from *Les Misérables* (fig. 226). There his face contained an element of brooding defiance—a smoldering resentment against the society that rejected him and forced him to sacrifice everything else in life in order to fulfill his calling as a creative artist. The portrait jug, however, with its uplifted face and closed eyes, is more spiritual in feeling; it communicates an internalized anguish rather than an outward-directed bitterness.

Many Romantic writers and artists believed that in our utilitarian and skeptical modern world, creative geniuses were doomed to share the tragic fates of ancient prophets and saints. Artists and writers had become victims of social persecution and often perceived themselves as misunderstood visionaries and idealists who were scorned and harried by philistines. The theosophical literature read by the Symbolist group around Gauguin taught that there are philosophical and spiritual relationships between the sacred figures of the world's major religions, and that in contemporary European culture it was the artists and scientists who had inherited their ancient role as purveyors of truth and wisdom. These ideas were elaborated by many influential writers of the mid to late nineteenth century and were common currency in the avant-garde milieu. Gustave Moreau, one of Gauguin's non-Academic contemporaries, often used the heads of Christ, St. John the Baptist, and Orpheus as evocations of poetic suffering (figs. 243 and 244), and images of deeply spiritual heads with closed eyes were also among Gauguin's friend Redon's most common symbolic motifs (figs. 245 and 246).

But while Gauguin's use of this motif and idea had many precedents in Romantic thought and art, it was still extremely unusual and daring for an artist to represent *himself* so unabashedly in this guise, and to do so in such an unconventional medium and style. With his penchant for combining different artistic traditions in an original way, Gauguin has here adapted the religious imagery of Christianity to the shape and style of the ancient Peruvian portrait pots he admired (fig. 247). The resulting synthesis is yet another pictorial expression of his dual heritage and his self-description as both a sensitive European and savage Incan enduring torture with stoic courage. In his typically eclectic way, however, he has created a visual reference to yet another primitive culture here by emulating the rich, somber colors and the dripping glazes of fifteenth-century Japanese ceramics (fig. 248). In a still-life that he painted soon after (fig. 249), we find this portrait jug juxtaposed with a vase of flowers and a Japanese print of an actor: the savage from Peru overlooked by the savage from Japan, equal manifestations of the mysterious life force which produces blossoms in nature, and artistic sensibility and creativity in the human spirit. It has been plausibly suggested that Gauguin's use of the earless, bloody head motif for this ceramic was influenced by van Gogh's severing of his ear the previous month in Arles, an act of madness which both men felt resulted from the unhappy, martyred condition of avant-garde painters in modern society.[39] Gauguin associated Vincent's sufferings as an unaccepted and destitute artist with his own, so when he portrayed himself as similarly wounded, it must have given him the consolation of claiming kinship not only with his friend, but with all the martyrs throughout history who had been rejected and tortured for pursuing an exalted ideal.

Back in Brittany in the summer of 1889 Gauguin depicted himself even more directly as the suffering Christ. The works he had contributed to the Volpini exhibition in May had been unexpectedly coldly received by the avant-garde critics and dealers as well as by many of the Impressionist painters, and their failure to appreciate his new synthesizing and symbolizing style led him to

break permanently from them. Gauguin now felt himself abandoned not only by Mette and the general public, but by his Parisian comrades and even by some of his younger disciples in Brittany, where a rebellion against his domineering and self-aggrandizing personality had been fomented by Émile Bernard. Nursing these bitter feelings, he painted himself next as *Christ in the Garden of Olives* (fig. 250). This is the scene in the Garden of Gethsemane when Jesus confronts the fact of his betrayal, his isolation, and his impending doom: an experience which for Gauguin seemed all too relevant to the events of his own life. In assessing his self-identification with Christ here it is important to realize that this association was not merely the product of his own vanity. When a young artist on the fringes of the Pont-Aven group described the atmosphere of religious fervor which surrounded the Symbolist enterprise, he called Gauguin "a Christ whose disciples we were . . . a man who consents to die for an idea."[40] In an interview with a sympathetic critic a year and a half later, Gauguin posed himself in front of this picture and explained: "There I have painted my own portrait. . . . But it also represents the crushing of an ideal, and a pain that is both divine and human. Jesus is totally abandoned; his disciples are leaving him, in a setting as sad as his soul."[41] To van Gogh he acknowledged that although the picture was the result of "unheard of efforts in work and in reflection," he recognized that "this canvas is fated to be misunderstood."[42]

What the critics, dealers, and other artists still more tied to Naturalism failed to appreciate was Gauguin's continuing move away from visual reality toward increasingly fanciful and abstract images: images whose colors and forms were contrived to express emotions and ideas rather than to describe nature. *Christ in the Garden of Olives* not only represented a wholly imaginative scene in an impossible landscape, it was also the fruit of Gauguin's conscious application of contemporary psychophysical theory to the new synthesizing style he had adapted from the condensed, expressive forms of ancient and primitive cultures. His abbreviated setting and simplified, wavering figures are executed in melancholy blues, blue greens, and purples intermingled with harmonizing touches of somber ochers and rusts: sad, subdued tones which are intensified by the violent contrast of his vermilion hair and beard. He described this false feature to critic Albert Aurier as being a "supernatural red"[43]—a slash of bloody color acting as a dramatic spotlight to focus our attention on his brooding face. Like the bleeding streaks on his self-portrait jug, the red hair and beard conjure up the martyr's pain and passion,[44] and again give Gauguin a strong fictitious resemblance to the suffering van Gogh. Vincent's unadmitted influence seems evident as well in Gauguin's duplication of

the color scheme his friend had created for several melancholy self-portraits of 1887 (see fig. 94). The memory of these canvases must have made its contribution to Gauguin's conception here.

The tree which divides the composition in half separates Gauguin physically from the fleeing disciples who disappear in the distance, isolating him on the left side of the canvas, the side occupied by the figures of the damned in traditional scenes of the Last Judgment. In many cultures the left hand is shunned, and psychophysical theory also maintained that leftward-slanting lines produce a negative or unsettling emotional effect. Gauguin not only inclined his figure and his background trees to the left, he also gave all his forms the downward droop that conveys both physical and emotional depression: the limply dangling hands in their hanging sleeves, the sagging body, the downcast eyes, the bent mass of trees. By formulating this expressive image in accordance with the theories of psychophysics, Gauguin believed he was aligning himself simultaneously with ancient symbolizing traditions of art and with modern scientific insight into the psychological repercussions of our perceptual experience.

The theme of the suffering Christ preoccupied Gauguin throughout the summer and fall of 1889. In his painting *Breton Calvary: The Green Christ* (fig. 251), a pensive Breton woman holds a black lamb in front of a roadside sculpture of the Pietà in which Christ's dead body is supported by the three Marys. The setting is the hilly Breton fields through which a distant laborer wends his way, and a little black-shrouded peasant woman with averted face in the center of the landscape adds a note of menace or mystery—perhaps a reminder of ever-present death. These outdoor sculptures depicting the events of Christ's Passion were common in the Breton countryside, and Gauguin took his imagery from the base of an actual sandstone group in the vicinity of his village (fig. 252).[45] The peasants could worship at these shrines on their way to and from the fields and sea, and for Gauguin this spontaneous form of daily prayer seemed proof that the Breton people's spirituality was genuine and deeply embedded in their lives. He wrote to Theo van Gogh that in this picture depicting "Brittany, simple superstition and desolation . . . everything breathes belief, passive suffering, primitive religious style."[46] The emotional effect of the stone figural group is quiet and contained, and although its cool green tonalities create a suggestion of subdued melancholy, this is offset on the left side of the canvas by the warm pinks and yellows of the fields. Because of this balance, the mood of the picture is not one of unrelieved anguish, but, as Gauguin pointed out, of faith and resignation. Its message, like that of his earlier painting *Vintage at Arles: "Human misery"* (fig. 234), seems to be that the universal sadness of the

human condition can be stoically endured and even mitigated by the fertile beauties of nature and the consolations of religion.

Gauguin felt that when the solitary individual contemplated both the holy figures' suffering and the natural passive acceptance of the domestic animals (the black sheep which perhaps symbolizes erring humanity and the cows which he described as "a cordon . . . disposed as a calvary"),[47] their example must bring the comforting realization that our own pain and eventual deaths are no more than a small and harmonious aspect of nature's eternal laws and rhythms. It was because Gauguin recognized the applicability of ancient religious symbolism to his own experiences that these shrines representing the stations of the cross were so meaningful to him. The previous September he had written to Vincent: "It is a long calvary to travel, the life of an artist. And it is perhaps this which makes us live. Passion vivifies, and we will die when it no longer has nourishment."[48] His conviction that pain is necessary for the life of the spirit motivated Gauguin to struggle toward an attitude of patient resignation. If he had to accept suffering as a vital part of his role as an artist, a prophet, then his pride in this role helped to compensate him for its torments. He wrote to Mette several years later: "I am a great artist and I know it. It is because I am that I have been able to endure so much suffering."[49]

Gauguin executed a painting during this period which, although not a part of the Christ series, also deals with the idea of the artist's journey toward death and utilizes a figure shrouded in black similar to the one in the middle ground of the *Breton Calvary. Bonjour M Gauguin* (fig. 253) seems to have been conceived as a Symbolist response to the 1854 Naturalist painting by Courbet entitled *Bonjour Monsieur Courbet* (fig. 15), which depicts the artist greeting a local patron encountered on a walk. Gauguin's version must also have been inspired in part by van Gogh's characterization of him in Arles as a traveler, a pilgrim, and "a man from afar,"[50] a description which Gauguin mentioned to Schuffenecker.[51] These phrases came from Carlyle's *Sartor Resartus*,[52] but related as well to a poem by Christina Rossetti which van Gogh loved and had discussed with Gauguin—a poem he associated with a painting he had seen entitled *Pilgrim's progress*.[53] In the poem, a tired traveler making his way uphill meets an old woman dressed in black whose name is "Sorrowful yet always Rejoicing" and who assures the traveler that the road goes uphill to the end and that the journey will take from morn till night.[54] The poem leaves no doubt that the incident is a metaphor for life and that the woman in black is the spirit of death. Gauguin's painting seems to be a pictorial recasting of this poem with himself as the pilgrim, the "man from afar," coming up over the rise of a steep ascent to be confronted by the

black-garbed, faceless figure on the other side of the gate. As observed in discussing the similar figure of the woman on the left of *Vintage at Arles*, Gauguin apparently found the somber appearance of the black-clad and hooded crones and widows very evocative of thoughts of mortality, and he used variants on this image repeatedly in his later works as a symbol of death.[55]

Around September of 1889 Gauguin painted another picture on the theme of the calvary called *Yellow Christ* (fig. 254), and again he used the peasant women, the medieval art, and the landscape of Brittany as the pictorial ingredients in a philosophical and spiritual metaphor. He based his figure of the crucified Christ on a seventeenth-century polychromed wood sculpture from the Trémalo Chapel at Pont-Aven where he was living at the time, but the background scene here depicts the view of the hill of Sainte-Marguerite which was visible from his studio.[56] By resituating the crucifixion outdoors in the Breton fields and surrounding it with a group of worshipping women, he creates an effect of simple, natural reverence similar to that in his *Vision after the sermon* or *Breton Calvary*. Again, neither the peasants nor the Christ here convey anguish or suffering: their rudimentary features are tranquil, their poses are quiet and contained. Gauguin has further eliminated any dismal aspect of his subject by flooding his canvas with the tonalities that psychophysics associated with solar heat and energy. Like van Gogh's all-yellow paintings of sunflowers, which Gauguin later claimed he had influenced,[57] the yellow Christ set in the golden autumnal landscape sheds a beneficent radiance and warmth on the silent women below, who, like the peasants in *Vision after the sermon*, close their eyes to contemplate the spiritual import of the crucifixion. The glowing color links the dying savior visually with the fruitful but also dying fields, implying that the fundamental events of human existence reflect those of the larger world of nature. Like van Gogh, Gauguin believed that in the cycles of the seasons, with their related activities of sowing and reaping and their ceaselessly unfolding processes of birth, death, and renewal, we can observe lawful patterns which help us place our own life experiences in a more universal and meaningful perspective. Gauguin's imagery, like that of Vincent's reaper (fig. 156), conveys his conviction that in the healthy physical and spiritual environment of a simple and pious society, suffering can be assuaged through faith and resignation, and that in the context of nature, even death can be viewed consolingly as the source of eternal life.

It is significant that Gauguin chose to incorporate a reference to this painting into another of his self-portraits from the end of 1889 or the beginning of 1890. *Self-portrait with Yellow Christ* (fig. 255) depicts the artist's brooding face against a background evenly divided between two of his

own works of art that cleave a central line behind his head. One of these is a slightly inexact mirror image of the Yellow Christ; the other is a rough ceramic tobacco jar (fig. 256) that he had executed at the beginning of 1889. Like his self-portrait jug, this object was influenced by traditional Peruvian portrait pots, and in the autumn of 1889 he offered it to Bernard's seventeen-year-old sister Madeleine as a momento of himself because he felt it resembled "Gauguin the savage."[58] He wrote to Bernard regarding this piece: "The character of the stoneware is the feeling of a great fire, and this figure which has been scorched in hell is, I think, a strong expression of that character. Like an artist glimpsed by Dante on his tour of the Inferno. A poor devil all clenched up to endure his suffering."[59] It is generally recognized that Gauguin used these two works of art here as symbols of his dual nature as a "sensitive" and an "Indian," but it is important to remember that these were not contradictory aspects of his personality. Although they suggest the dichotomy of his tender vulnerability and his tough will as well as the oppositions of his European and Peruvian heritages, the fact that both Christ and the "savage" signify the ability to bear suffering with stoic endurance makes them mutually reinforcing symbols of his spiritual purpose.

A portrait Gauguin painted in August of a local Pont-Aven beauty named Marie-Angélique Satre communicates a similar message about the relationship between spiritual attitudes in different cultures. Entitled *La Belle Angèle (Beautiful Angel)* (fig. 257), it isolates the traditionally costumed woman within an outlined circle against a flat, decorative ground. It has been observed that Gauguin's device of separating his subject from its setting by a bubble was common in Japanese woodcuts as well as in contemporary magazine and book illustrations,[60] but as another scholar has noted, the most immediate influence on Gauguin's choice of this motif was probably the letterhead of the stationery used by the hotel next door to his inn, which depicted the bust of a Breton woman in just such a medallion.[61] The attraction of this emblematic convention for Gauguin must have lain in the suggestion of sanctity it conveyed. Stolid Mme Satre, her face rapt and inscrutable, is enshrined in the same kind of encompassing halo or mandorla as the little statue of the Buddha which he included so improbably beside her, its curled legs duplicating the curve of her arms, and both are backed by the dark, moody blue of the infinite and eternal sky. Through the formal parallels of their juxtaposed images as well as through his title, Gauguin implies a fundamental theosophical message: that the serene, patient peasant woman, the Christian angel, possesses the same spiritual wisdom as the Buddha. It was unfortunate that this portrait represented only Gauguin's philosophical ideal and not Mme Satre's actual personality, for when he triumphantly brought his picture to show to her, she exclaimed "What a horror!" and informed him he could take it straight home with him because she wouldn't have it in her house. "Imagine!" she told one of Gauguin's early biographers, many years later: "At that time and in a little place like this! Especially since I knew next to nothing about painting. Gauguin was very sad and said with great disappointment that he had never succeeded in painting a portrait as well as this."[62]

Primitive Paradise versus the Corrupt Babylon: Themes of Cultural Contrast, 1889

Gauguin had been equally distressed and offended when both the church at Pont-Aven and the nearby church at Nizon flatly rejected his offer to give them his painting *The Vision after the sermon.*[63] His disillusionment with Brittany stemmed not only from its increasing popularity with artists and tourists and his inability to succeed financially with the work he did there, but from his realization that even though, as he wrote to Vincent, "the peasants have an air of the middle ages [sic] and don't have the air of thinking for an instant that Paris exists and that one is in 1889,"[64] these simple people who lacked Parisian artifices and refinement were also unable to appreciate his unconventional style. A series of sculptures and carved reliefs on Martiniquan themes which he executed during the summer and early fall of 1889 reveal that his mind was now straying nostalgically back to the non-Western primitive world he had glimpsed in the Caribbean in 1887. Like *La Belle Angèle*, however, many of these new pieces deviate increasingly from descriptive realism by synthesizing forms from different cultures in order to convey ideas emblematically. For example, a wax figure of a black woman wearing the characteristic madras head scarf of the Martiniquans sits in a yoga-like pose reminiscent of Buddhist art (fig. 258). These repeated references to Buddhism were not coincidental. Gauguin's early ceramics reveal the influence of Buddhist imagery with which he was already familiar from Arosa's collection and other sources, but in Paris in June of 1889, after the failure of the Volpini exhibition, he had visited the Universal Exposition and been intoxicated by the non-Western cultural manifestations he found there. He was particularly impressed in the Javanese pavillion by demonstrations of traditional dancing and by the display of plaster casts of relief sculptures from the famous eighth-century Buddhist temple at Borobodur, two types of Oriental art forms which combined sensuality and hieratic dignity. Not only did he acquire a set of photographs of the

Borobodur carvings[65] which he used for the rest of his life as models for his own work, but he also found and treasured a wooden fragment of a dancer from the frieze that had decorated the pavillion. When he moved to the village of Le Poudu in the fall of 1889 he kept this carving on the mantlepiece of his inn's dining room, close to his statuette of the Martiniquan woman.[66] In its precise, ritual hand gesture as well as in its twisted yoga posture and nudity, Gauguin's figure reveals debts to Oriental aesthetics rather than to contemporary Caribbean realities.

Another sculpture from this period that demonstrates the same kind of eclectic synthesis of forms is a ceramic called *The Black woman* (fig. 259). While the woman's body and features seem Martiniquan, her pose and accoutrements combine both Christian and Buddhist references. The figure's statuesque posture and deeply serious face give her the dignity and pathos of a religious sculpture, and the male head with closed eyes which lies rooted in her lap by its hair enhances this impression. Resembling the ceramic cup on which Gauguin represented himself as a wounded Christ (fig. 241), this spiritual head turns the hieratic native into a primitive madonna: a symbol of women's universal grief for their children's pain and mortality. This is no simple black Pietà, however, for the severed head she cradles grows out of the fleshy stem of a lotus plant which also links a frieze of animals and flowers around the statue's base. In Hindu and Buddhist iconography the lotus is a symbol of the regenerative process which unifies life and death, for in autumn its blossoms are cut back to their underwater roots so the plant can renew itself more lavishly in the spring. In Buddhist philosophy this flower signifies not only self-creation, but "the purity of the spirit rising from the misery of material existence, symbolized by the muddy waters in which the lotus has its roots."[67] Gauguin's enigmatic imagery suggests the idea that just as all organic life arises from death and dissolution, so in human existence all growth is the result of suffering and change. The maternal female nude, who personifies the physical and emotional productivity of sexuality and love, and the male head that seems to symbolize the artist's spiritual creativity are here inseparably linked, the faces of each revealing the sad repercussions of life experience. Both, however, also emerge seamlessly from a foundation of connected organic forms, suggesting that they participate in the same natural law which governs and binds together the world of plants and animals. The lotus reminds us that if we are all subject to suffering and death, this is the unavoidable price we pay for life with all its beauty and for genius with all its talent.

Gauguin continued to use Martiniquan themes to convey spiritual ideas in a number of carved wood reliefs from this period. In *Martiniquan women* (fig. 260), a baby's head hovers near the pensive figures like, as one scholar put it,

an emblem of their thoughts:[68] a fruit of nature's ceaseless fertility which arises as naturally as the flowering vine from which it seems to emerge. Calm and Buddha-like, the women suggest the matter-of-fact acceptance with which Gauguin believed primitives contemplate sexuality and maternity, a frame of mind that seemed to him far healthier than the repressive anxieties of Europeans. Another relief on the same subject, entitled *Martinique* (fig. 261) portrays a seminude woman with a vaguely Egyptian coiffure and jewelry lolling under a tree hung with large fruits and entwined with serpentine vines. Monkeys lurking in the vines pluck the fruit smilingly while the woman reaches up with casual negligence to grasp the one nearest her. A goat browses at her feet, and in the branches above float two disembodied heads which watch the scene with avid interest. The fruit-picking woman seems an obvious reference to the biblical tale of Eve, but with his surrounding imagery Gauguin has altered the message of the original text. This Eve, whose appearance suggests a sensual as well as a pantheistic civilization, reclines at her ease, enshrined in a natural world with which she is in perfect harmony. Like the animals, she tranquilly and effortlessly fulfills her instincts by partaking of the fruits nature offers, while the deities who preside over her actions from above seem vigilant and participatory rather than punitive.

Gauguin used the same figure in *Reclining woman with a fan* (fig. 262), another allegory of the primitive paradise in which human nature is viewed as part of a sacred totality. Here too his imagery synthesizes several different traditions. His woman bears a resemblance to the soubrette in Manet's *Olympia* (fig. 263), a picture that he saw at the Universal Exposition and liked so much that he copied it in 1891. But perhaps he admired Olympia in part because her superbly calm and dignified pose recalled not only traditional Renaissance images of Venuses and nymphs with which he was familiar (fig. 264),[69] but also sacred figures from the Buddhist temple at Borobodur (fig. 265).[70] Moreover, by giving his figure of universal woman a halo through the device of her circular fan, Gauguin also identified her with the Virgin Mary and other Christian saints. Through his composite iconography, Gauguin implies that woman in her ancient pagan role as a goddess of love and fertility also possesses the sanctity of Christian virtue.

This interpretation seems borne out by the bizarre appearance of the ram in the sky. Some scholars have identified this as the Lamb of God and related it to the Christian idea that sexuality leads to death and sacrifice. Given Gauguin's ideas about the sanctity of sexuality, however, it seems more likely that it refers to the beliefs of the ancient druids, the priest cult of western Europe before the advent of Christianity. Gauguin and his friends were familiar with

a theosophical text by Edouard Schuré entitled *Les Grands Initiés* (*The Great Initiates*), which devoted a long section to druidical philosophy. According to this account, the ram is the symbol of the original druid who established religious rituals to celebrate the ordered cycles of the seasons and the constellations, rituals which relate human existence to sacred cosmic patterns and which glorify fruitfulness and harmony. For the druids, the signs of the zodiac were the "secret emblems of progressive initiation,"[71] and the sign of the ram signified the equality of all people, respect for women, ancestor worship, and the abolition of human sacrifice and slavery.[72] Gauguin's own writings testify that he also subscribed enthusiastically to these values, and his delight in synthesizing symbolic motifs from early traditions makes the ram a valid choice of presiding deity over this scene of peaceful unity. This is not the Christian Paradise in which carnal experience leads to shame, expulsion, and death, but a theosophical primitive Eden in which humanity still believed that love and sexuality are part of the gods' universal bounty.

Gauguin became increasingly preoccupied with the differences he perceived between modern European attitudes toward love, sex, maternity, fidelity, and marriage, and the attitudes that he thought were held by ancient or non-Western societies. His bitter feelings on this subject crystallized in one of the most complex and enigmatic works he ever produced: a carved and painted wood-relief sculpture executed around September of 1889 and entitled in the relief *Soyez amoureuse, vous serez heureuse* (*Be loving, you will be happy*) (fig. 266). Gauguin was always torn between his desire to be provocatively mysterious and his equally strong desire to have his imagery understood and appreciated. He wrote to Bernard in September that he counted on becoming even more incomprehensible, and therefore felt that *Be loving, you will be happy* was the best and strangest thing he had yet accomplished. He went on to describe the work somewhat cryptically as depicting "Gauguin (as a monster) taking the hand of a woman who defends herself, saying to her: Be loving, you will be happy. The fox, Indian symbol of perversity, then in the interstices some little figures."[73] To Theo van Gogh, who complained that he couldn't understand this image, he reluctantly gave a more elaborate explanation after noting that his goal was "to express a general state more than a single thought, to arouse in the eye of another an indefinite infinite impression," but that "since you want literature I am going to give it to you (for you alone)."[74] He went on:

On top the rotten city of Babylon. Below as if through a window, the view of fields, nature with its flowers. A simple woman whom a demon takes by the hand and who defends herself despite the good tempting advice of the inscription. A fox (Indian symbol of perver-

sity). More figures throughout the whole which express the contrary of the advice (you will be happy) in order to indicate that it is a lie. For those who want literature there it is. But this is not for examination.[75]

Although some of the motifs in this relief remain ambiguous and no single meaning seems to explain all its fragments completely, Gauguin's remarks indicate that this work, like so many others he'd done since returning from Martinique, deals with the topic that was always consuming him: the failure of his marriage and his belief that Mette's abandonment of him was symptomatic of the overall degeneracy of Western civilization. Gauguin set his marital drama within a structural framework whose resemblance to human internal anatomy[76] implies that the subject portrayed is fundamental and universal. In the upper region that he identified as the rotten city of Babylon, we find at the left a contorted figure with swollen features who seems to bite savagely through the barrier separating him from the woman below. Gauguin borrowed this powerful image of despair from the left-hand drowning swimmer in Eugene Delacroix's famous painting of 1827, *The Barque of Dante*,[77] which depicts the ancient poet Virgil accompanying the medieval poet Dante on a boat tour through Hell to observe the sufferings of the damned (fig. 267). There, the tormented swimmer is attacking the poets' craft as if trying vengefully to pull them down into the water to share his fate. Gauguin was bitterly aware that this was exactly how he appeared to Mette and to the public in general: a damned soul whose decision to become an artist had plunged him into hell and who was ruthless enough to try to drag his wife down with him.

The idea that he used the figure of the damned swimmer to symbolize himself seems reinforced by the little rat which perches above it at the top of the panel. Not only was "rat" the popular slang term for an art student during this period, but when, a few months after completing this relief, Gauguin wrote to Schuffenecker of his terrible discouragement and poverty, he concluded: "I am stripped of everything. What's to be done about it? Nothing, unless it is to wait like a rat, on a cask in the middle of the water."[78] Other references in Gauguin's letters also indicate that his adaptation of this figure from Delacroix's picture was thematic as well as formal, and that the subject of the artist trapped in hell by a perverted and inhumane society was one of the principal ideas he wanted to portray here. Each cryptic motif in the relief contributes to the overall symbolic message he has constructed about the depravity and tragedy of Western life.

Opposite the savage swimmer, in the upper right corner, the figure that Gauguin described as the "demon-monster Gauguin" also reaches its hand across to grasp that

of the resisting woman. This strange and haunting self-portrait with closed eyes and thumb at mouth is a version of that ceramic tobacco jar (fig. 256) he had executed at the beginning of 1889—the pot which this same autumn he offered to Bernard's sister as a memento of "Gauguin the savage" and which he described to Bernard as having been "scorched in the ovens of hell. . . . Like an artist glimpsed by Dante on his tour of the Inferno. A poor devil all clenched up to endure his suffering."[79] In another letter to Bernard he again referred to this pot and to the metaphor of the furnace when he described his sufferings from poverty and from the loss of his wife and family:

In the end, especially when all the principal joys of existence are beyond my reach and intimate satisfaction is lacking, my isolation and my concentration on myself cry with a kind of hunger, like an empty stomach; and in the end this isolation is an inducement to [find] happiness, unless one is ice-cold and absolutely without feeling. Despite all my efforts to become so, I simply am not; my fundamental nature keeps welling up, like the Gauguin of the pot, the hand shriveling in the furnace, the cry that longs to escape.[80]

Both of these flanking figures, then, represent the damned and suffering undergoing the torture of hell: dual personifications of Gauguin trying to reach and hold onto the woman from whom the barriers erected by a corrupt society divide him, a woman whose ringed finger reveals that she is married. Around these principal actors we find some rudimentary little forms: a naked female rising behind the swimmer, a ballet dancer bending in the center flanked by an odd little head with a long nose which seems to peer curiously over a wall, and an intently watchful, primitive-looking face hovering behind the monster Gauguin's shoulder. Gauguin claimed that these peripheral figures contradicted the title's promise that love brings happiness. The ballerina and the naked woman looming up behind the swimmer recall the imagery of the box he had carved for Mette years before (fig. 211), and here too they can be understood as symbols of the vanity, artifice, and material values which degrade the relationships between men and women in the corrupt Babylon. The face peeking surreptitiously at the drama over a wall suggests the intrusive interest of nosy neighbors and public, that curious and judgmental scrutiny to which Gauguin felt the details of his personal life were subjected, but the primitive-looking observant head rising behind Gauguin's own seems an emanation of his aware inner self, always observing his own sufferings with detached stoicism.[81]

The figures in the lower section of the relief also prove the irony of the title's promise. In the area Gauguin referred to as nature with its fields and flowers, the married but implacably rejecting woman is flanked by the familiar figure of the anguished mummy-Eve hovering over a malevolent-looking fox that Gauguin characterized as the Indian symbol of perversity. It has been observed that Gauguin's imagery here suggests the Greek myth of Persephone, the maiden daughter of the fertility goddess Demeter, who while picking flowers in the meadow was abducted by Hades, god of the dead, and carried off to the underworld to be his bride.[82] Another metaphor for the adversarial nature of marital relations in Europe, Gauguin's motif with its mythic overtones implies that our perverted culture casts men as evil seducers and women as fearful victims in marriage instead of loyal companions. In the European Babylon, built on the foundation of ancient Greek and then Christian culture, terrified girls are carried off by the evil, perverse forces of social custom as well as by the perverse, tempting lies of men, and delivered into a state of marital bondage where they stoically defend themselves against their partners' needs. In such unions, both men and women must struggle to break down the barriers which socially enforced slavery and material considerations have intruded into love relationships.

It is impossible to avoid the conclusion that the mature married woman in this relief is Mette, who, despite what Gauguin called "the *good* tempting advice" he offered in his inscription, continues to ignore the tormented swimmer and resist her husband's pull on her ringed hand. Over the years Gauguin reproached Mette often for her cold, practical attitude, her insistence that without money he was a failure and deserved whatever suffering his folly had inflicted on him, her refusal to admit that his isolated and destitute situation was more painful than her own relatively comfortable circumstances. Perhaps by depicting this figure naked and with non-Western features Gauguin was not only universalizing his image, but implying an appeal to the natural, instinctively loving primitive woman buried inside his civilized and angry wife. His self-depiction is particularly poignant, for his odd gesture of biting his thumb was a common expression of both defiance and regret.[83] Although he characterized himself from society's viewpoint as a demon and a monster, and from his own as a savage artist burning in the inferno, he actually looks like a troubled child reaching out in his sleep for the comfort and loyalty he felt his wife denied him. Ironically, these are the very virtues we value in the dog, which Gauguin included here sitting conspicuously beneath the word "happy," its collar a sign of its domestic status. In later years Gauguin often used the dog as a symbol of himself; perhaps here it referred to his own or their mutual bondage within a state of marriage that no longer gave them consolation but kept them irrevocably tied.

The ambiguity of Gauguin's imagery expresses the complexity and ambiguity of the ideas and feelings he was

trying to convey. While he obviously pities his own plight, he seems to be just as aware of the difficulty of Mette's position: equally imprisoned by their marriage in an era when religious constraints and societal condemnation made divorce an impossibility, she was a slave to her maternal role, forced to contend with demands for which she had no sympathy, and influenced by strong social and material considerations to reject a once loved husband whose quixotic artistic needs deprived her of a normal and secure life. The tragedy here is hers as well as his, and the irony of the title is not that fulfillment in love is categorically impossible, but that in a decadent and perverted civilization where neither art nor emotional commitment is valued and where marriage is a prison of unnatural laws, the artist who asks a woman to depend on love alone for happiness is rightly perceived as a monster and a liar.[84]

The Pursuit of Enlightenment, 1889–1890

At the beginning of October Gauguin moved from Pont-Aven to the less frequented village of Le Pouldu, where he settled at an inn owned by a local beauty named Marie Henry. He was accompanied by a pupil sent to him by Pissarro: an aspiring artist named Jacob Meyer de Haan. De Haan was a Dutch Jew who had sold out his interest in a family business in order to obtain an income sufficient to live as a painter—an income now used to support Gauguin as well.[85] Soon after their arrival in Le Pouldu, Gauguin executed pendant portraits of himself and his companion which they hung in the dining room of the inn. While there is certainly an element of caricature and satire in these portraits, they are also a clear expression of the artists' interests, values, and recognition of the way they appeared to the eyes of the bourgeois world.

Gauguin's *Portrait of Meyer de Haan* (fig. 268) depicts his friend in the same pensive, chin-in-hand pose as the girl in his *Still-life with fruit* (fig. 231) and the melancholy maiden in *Vintage at Arles: "Human misery"* (fig. 234), both of whom he somewhat resembles with his red hair and slanting, Oriental-looking eyes. Beside him on the table lie a bowl of apples, a lamp, and two books: the French translation of John Milton's epic poem *Paradise Lost* and Carlyle's theosophical novel *Sartor Resartus*, a work which, as we have already seen, was highly popular with the Symbolist avant-garde. Both of these books, which begin with the story of Adam and Eve and deal with the heritage of the Fall, are about humanity's craving for knowledge, about our troubled questioning of God's purposes, and our need to derive meaning and moral values from personal experience and inner conviction rather than from blind obedience to established dogmas. Both books also treat this quest for true knowledge as a painful process, one that is fraught with danger and anguish and yet is necessary for the maturation of consciousness and the achievement of spiritual fulfillment. In both books we learn that good has no meaning without evil—that we must experience evil in order to identify the good and actively strive for it. Both also dramatize the truth that it is only through loving and suffering that we develop the ability to recognize and judge between good and evil: an ability that brings us closer to deity and helps to compensate us for the loss of tranquillity and innocence. In conjunction with the bowl of apples, the symbol of the Fall, these literary references suggest that the brooding de Haan represents the universal burden of adult consciousness: the painful recognition that when we satisfy our craving for the fruits of knowledge, when we choose the path of larger experience, we also lose Eden. The glowing lamp in the foreground, however, implies that whatever price we pay in mental anguish, the search for truth and meaning is a spiritual attempt to illuminate the darkness, to facilitate clear sight and an understanding of reality which is in itself a religious goal.

Why, then, does Gauguin impart such a foxlike, devilish cast to de Haan's features and such a clawlike form to his hand? De Haan actually had reddish hair and slanting eyes which Gauguin has exaggerated in order to create a demonic effect, but he was described not only as a quiet and scholarly man, but also as small and sickly—"almost an invalid."[86] Despite his unprepossessing appearance he managed to attract their landlady, the beautiful Marie Henry, who rejected Gauguin's advances but later had a child by de Haan. Gauguin was well aware that his friend was a man of the flesh as well as a seeker after truth, and it is no coincidence that both *Paradise Lost* and *Sartor Resartus* describe man as a fallen angel, a paradoxical mixture of godlike and demonic qualities which must be reckoned with and kept in balance. Gauguin, who believed that both sexuality and the independent exercise of a skeptical mind are healthy and sacred rather than evil, could not have created the satanic overtones of this portrait as his own commentary on de Haan's character. Instead, they seem to constitute his ironical perception of the way in which society viewed a man whose search for meaning led him to relinquish a lucrative family business, become the disciple and supporter of a notorious and irresponsible bohemian, and finally enter into an illicit relationship with an unsuitable woman. Since Gauguin liked to use the fox as a symbol of perversity, it seems probable that the foxy emphasis he gave to de Haan's features was meant to suggest the devilish perversity

of human make-up that incites us to rebel against what is safe, comfortable, and socially acceptable. De Haan's demonic appearance presents him as the public must have judged him: as a man whose disregard for ordinary social or aesthetic conventions and whose curiosity about esoteric religious practices marked him as diabolical and dangerous to the status quo. But while his tormented face reflects the books' message that once the fruit of the tree has been tasted, the happiness of Eden can never be regained, Gauguin's imagery also suggests that the suffering engendered from life experience is the vehicle of enlightenment, the crucible in which wisdom and moral virtue are forged.

The self-portrait which Gauguin painted as a pendant to de Haan's (fig. 269) displays a similar combination of caricature, irony, and philosophical seriousness. By the descriptions of all who knew him, Gauguin was a proud, opinionated man who dominated conversation and exerted a powerful influence over others. A rebel who never completed his education and who detested pretensions and decorum, he often expressed his ideas in pungent language and his sense of humor tended toward sarcasm. Charles Morice, the Symbolist writer who later collaborated with Gauguin, wrote of "the incisive intuition of his gaze, the savory impropriety of his speech, in which the slang of the sailor and that of the studio strangely cloaked ideas of purity, of an absolute nobility. . . ."[87] Gauguin's image was very important to him, and he carefully crafted his speech, his dress, his manner, and his surroundings in order to make forcible statements about his unconventional values and beliefs. In this painting, now known as *Self-portrait with halo and snake*, he fashioned an image which corresponds to the identity he contrived for de Haan.

While many scholars have interpreted this self-depiction as diabolical and some have viewed it as a joke, it seems probable that Gauguin's intention was to convey a serious idea in the sardonic terms which best expressed his vision and attitude. It has been perceptively observed that if his brooding face suggests Satan, it is in the heroic mode conceived by the Romantic authors whom Gauguin admired: daring, proud, a martyred leader, an angel fallen because he craved the satisfaction of exercising his innate powers.[88] Gauguin presents himself here as a modern Adam: a thoughtful and purposeful man whose decision to pursue the path of self-discovery and self-fulfillment was made in full consciousness of its potentially bitter implications. The apples of the temptation, one of them an unpalatable-looking poison green, dangle directly next to his eye and brow, the seat of his intellect and vision, and he presses the abstract, stylized snake firmly against his heart as if pledging himself to his chosen road as an imaginative Synthetist artist.

All too aware that his life choices were considered sel-

fish and wicked by Western conventions, Gauguin thought often about the nature of virtue and responsibility. In his *Cahier pour Aline* (*Notebook for Aline*) he defended the right of all reasonable people to arrive at their own conceptions of morality in accordance with the exigencies of their own lives and personalities. He contended that each of us has a moral obligation to bring our innate capabilities to fruition, and he claimed that the pride which had led him to go against the herd was also what impelled him to strive for exalted ideals. Convinced that his duty to his family and to society as well as to himself was to make great art, he wrote to his wife:

I determined, despite the certitude which my conscience gave me, to consult others (men who also count) to ascertain if I was doing my duty. All are of my opinion, that art is my business, my capital, the future of my children, the honor of the name I have given them— all things which will be useful to them one day. When they have to make their way in the world, a famous father may prove a valuable asset. . . . You will retort that this will be a long time ahead, but what do you want me to do about it? Is it my fault? I am the first to suffer from it. I can assure you that if those who know about such things had said that I have no talent and that I am wasting my time, I would have abandoned the attempt long ago.[89]

This portrait, therefore, seems meant as a symbol of the Promethean spirit of individualism: the decision to defy the dictates of the gods in order to bring benefit to humanity, combined with the awareness of such a choice's repercussions. In his later journal *Before and After* Gauguin wrote: "I think that life only has meaning when it is practiced willfully. . . . Virtue, good, evil are only words if one doesn't break them up in order to construct an edifice; they only have their true sense if one knows how to apply them—To submit oneself into the hands of one's creator is to annul oneself and die."[90]

Gauguin used the halo and the snake here to lend philosophical depth to his self-characterization. The halo, an ironic symbol to add to the imagery of the temptation, suggests that however diabolical he might seem to others, in his own eyes his submission to the temptation of artistic creativity was virtuous and would lead him toward God: a sentiment he expressed often in his writings. Together, the halo and snake also signify the duality of human impulses which was so much the subject of *Paradise Lost* and *Sartor Resartus,* whose protagonist's name, Diogenes Teufels-dröckh (god-seeking devil's dung), is itself a symbol of this duality. As a realist about human nature Gauguin recognized that in every pesonality, good and evil are unavoidably mingled, a conviction expressed frequently in the Romantic literature and theosophical writings with which he was familiar. He agreed with writers like Rousseau and

Baudelaire that since it is impossible to purge all evil from the world or the self, our task must be to strive for equilibrium among our warring impulses, to find a balance that allows for both fruitful activity and inner serenity. In *Before and After* years later, he wrote: "No one is good, no one is evil; everyone is both the one and the other. One drags along one's double, and yet the two somehow rub along together."[91] This rueful awareness of life's moral ambiguities was the heritage of the Fall, and Gauguin has conveyed its complex truth through his simple symbols and the pensive, sardonic expression of his face. It is the face of a man whom the Symbolist critic Octave Mirbeau wrote of as seeking "to know himself better and to listen more closely to the inner voices, . . ." a man "of a restless and infinitely tormented nature" who "must also have known the irony of sorrow which is the threshold of mystery."[92]

Gauguin pursued these ideas in another portrait of de Haan which he executed soon after in 1890 and entitled *Nirvana* on the canvas (fig. 270). De Haan, who now has the glazed and hypnotized look of someone in a trance, presses the stylized snake of the temptation to his own bosom, while behind him, against a backdrop of the eternal sea with its pounding surf, loom Gauguin's figures of the mummy-Eve and the woman in the waves (fig. 240). The fearful Eve who rejects temptation and the receptive, risk-taking woman who flings herself into the sea were Gauguin's symbols for the negative and positive ways in which humans approach life experience, particularly experiences relating to love. In conjunction with the painting's title, this imagery provides the key to deciphering this very strange portrait. Nirvana is a state of supraconscious awareness and release from the emotional burdens and limitations of one's own individuality. Nirvana was achieved by the Buddha not through withdrawal from the world's complex realities, but by opening himself up to all the mingled joys and sorrows of existence in order to acquire complete knowledge of life and death. The figures which suggest these alternative responses seem to emanate from de Haan's head as personifications of his own moral conflict, symbols of the ambivalent and contradictory longings which are the heritage of all conscious and choice-making humanity. By clasping the snake to his breast, however, de Haan indicates that he chooses experience and knowledge: the way of the biblical Adam and Eve, the way of the woman in the waves, the way of the adept seeking Nirvana.

This portrait tells us not only something about de Haan's conflicted psyche, however, but something about Gauguin as well. When he formed the snake into the G of his own signature and wrote his name boldly across de Haan's hand, he acknowledged his role as the agent of his friend's temptation. Gauguin, who in a letter to Theo van Gogh referred to "the disciple de Haan,"[93] needed to feel that his personality had a powerful impact on his associates, and his self-identification with the snake here reveals his conviction that it was his own non-conformist views about art and about the value of sexual and emotional experience which prompted de Haan to take the plunge into risky, unconventional, but life-enhancing behavior. How then do we interpret the extraordinary treatment of de Haan's face? His features have become an unmistakably foxlike and satanic mask, yet his rapt, intensely concentrated expression also suggests a mystical experience which has been called "theosophical recognition,"[94] a state of profound realization which the two artists had read about in Edouard Schuré's theosophical text *The Great Initiates*. Schuré described this first step on the path of knowledge which culminates in Nirvana as a moment of lucent awareness, a flash of insight into the relative nature of good and evil, of life and death, that is both entrancing and terrifying to the adept.[95] When Gauguin gave this complex expression to the diabolical face of a fox, an animal which in Breton folklore was a symbol of lust and devilish cunning,[96] he created yet another of his ironic statements about the moral ambiguities of human behavior and values. De Haan, who conjures up both the desire for and the fear of enlightenment, is simultaneously an initiate into life's sacred mysteries and an evil seducer, a heroic rebel against society's perversely restrictive moral values and a perverse perpetrator of potential suffering for himself and others. By this mingling of images which evoke such paradoxical ideas and associations in the spectator's mind, Gauguin implies that the life experience embraced by the eager initiate must result in evil as well as exaltation, and that in our Christian culture, whoever chooses this kind of knowledge is perceived not as a follower of the Buddha, but as an agent of Satan.

In February of 1890 Gauguin went to Paris once again to try to drum up support for his work and to find some way of leaving Europe to establish a studio in the tropics. At first he thought of Tonkin, but when the Colonial Department rejected his request for an official foreign appointment there, he took up the suggestion of Odilon Redon's wife to try her birthplace, Madagascar. With his usual optimism he began urging Bernard, de Haan, Schuffenecker, and van Gogh to go there with him to create a center for the regeneration of Western art, writing to Bernard enthusiastically in April that in Madagascar "You will find existence assured without money in a better world."[97] He elaborated on this idealistic vision to Vincent in a letter of May:

I'll go then to Madagascar, with a gentle populace without money who live from the soil. From a little hut of earth and wood I will make a comfortable house with my ten fingers; I'll plant there

myself everything necessary for food, chickens, cows etc. . . . And in a little while I'll have an assured material life there. Those who want to come later will find there the materials to work at very little cost. And the studio of the tropics will perhaps shape the St. John the Baptist of the painting of the future, reestablished there by a more natural, more primitive and especially less rotten life. I'm even offering all my canvases at 100 francs in order to realize my dream. I am sure to have in Madagascar the calm necessary for good work.[98]

In July, he reiterated these ideas to Bernard, adding that "Madagascar offers more resources, such as types, religion, mysticism, symbolism. . . . There lies the future of painting."[99] His plans for funding this move came to nothing, however, for despite a few exhibition opportunities and a sprinkling of sales, his work remained a failure both commercially and critically.

He returned to Brittany in late June, where he continued to produce landscapes and peasant scenes in a variety of media while still hoping for the big sale which would enable him to sail for a new world. During the summer he learned of Van Gogh's suicide, and he also received a letter from Bernard enthusing about a novel he had just read by their contemporary Pierre Loti, entitled *The Marriage of Loti*. Purporting to be autobiographical, this book recreated the author's experiences of life and love in Tahiti in a way that mingled facts with romantic fantasy and poetic metaphor. It was at Bernard's suggestion and as a result of his own subsequent reading of Loti that Gauguin now began to think of Tahiti as an even better primitive paradise than Madagascar in which to locate the studio of the tropics. Deep in debt and increasingly bitter about his prospects in Europe, he produced a number of works in 1890 which reveal his continuing preoccupation with the spiritual values of non-Western cultures and his tendency to view primitive life idealistically as an antidote to our social ills.

Soyez mystérieuse (Be mysterious) (fig. 271) is a carved and painted wood relief which was conceived as a pendant to *Be loving, you will be happy*. In November of 1889, when Gauguin had explained *Be loving* in a letter to Theo van Gogh, he had concluded: "You know that by birth I am fundamentally Indian, Incan, and everything I do is affected by this. It is the basis of my personality. To rotten civilization, I seek to oppose something more natural, partaking of savagery."[100] This impulse grew during the first half of 1890 as he planned his escape to the tropics, and in July he wrote again to Theo:

The more I think about it the more I am decided to go to work seriously in the savage mode. Everything pushes me in that direction. Solitude, the Orient which I have glimpsed and which has not yet had its direct interpretation in Europe. Today when so

many do Impressionism, it is necessary to distinguish oneself by a specialty of different motifs.[101]

In *Be mysterious* Gauguin presents a "primitive" or "savage" alternative to the Western Babylon by surrounding his symbolic figure of the woman in the waves with images that suggest various aspects of Eastern philosophy. The woman, whose profiled features are now distinctly non-European, hurls herself into water which is carved in a series of branching, curling undulations that resemble the stylilzed waves of Hokusai and other Japanese artists (fig. 272). Out of their writhing, serpentine forms at the far right grows a long-stemmed lotus, and immediately beside it a profiled, disembodied Oriental head with its hair curved in a lunar crescent floats over the waves. On the left, another large female head with slanting, half-closed eyes faces us, her hand raised in a ritual gesture, and hovering over her under the carved title is a flower surmounted by a little peacock.

As was noted in reference to Gauguin's *The Black woman* (fig. 259), in Hindu and Buddhist iconography the lotus is a symbol of the eternal process of cyclical regeneration which creates new life from death. For the Hindus, the fact that the lotus grows out of water is particularly significant; their symbol for water is "the serpent, called Ananta or 'Endless,'" which supports in its coils the Lord of Maya, or life-energy."[102] Gauguin's lotus, a manifestation of nature's infinite life force, emerges here from waves of an unmistakably serpentine vitality. The impassive head at the upper right suggests a lunar deity, a goddess of the moon who presides over a scene in which a woman gives herself up to the currents of life. This association of woman, sea, and moon was common to many ancient and primitive peoples, who perceived the connections between the lunar rhythms of waxing and waning, the periods of the tides, and the monthly cycles of female fertility. On the left, the other watching figure raises its hand in a gesture which in traditional Indian art conveys the message "Do not fear"— a gesture of protection and reassurance by which Hindu and Buddhist holy figures indicate that humanity need fear neither life nor death.[103] The partially closed eyes and inscrutable expression of this head also link it with Eastern philosophy, for throughout centuries of Buddhist art these physical attributes were used to denote the meditative state leading to enlightenment. The last two motifs in the relief seem to recapitulate the ideas suggested by these images. The cut flower traditionally signifies the loss of virginity, with its simultaneous implications of the death of innocence and the inception of reproductive renewal, while the peacock with its many-eyed tail was associated both with all-seeing wisdom and the triumph of the soul. What these eclectic images express in their allusive way is an Oriental

revelation of the laws of nature, with the suggestion that we need not fear submitting ourselves to them since to do so is to harmonize ourselves with the universal principles of existence. As the title indicates, woman is here enjoined by primitive deities to celebrate her special relationship with nature's creative forces by participating in its mysteries: a meaning consonant with his very similar earlier carving *Martinique* (fig. 261).

Gauguin's growing misery in Europe and his desire to distance himself from it by stressing his own non-Western roots moved him to paint two pictures in 1890 which focus on his mother, Aline. The first is a portrait (fig. 273) which he based on her photograph (fig. 274), but in which he has thickened her lips and nose and exaggerated the slant of her eyes in order to more convincingly suggest her "primitive" Peruvian origins. He and others recalled Aline as a sweet, tender woman,[104] the embodiment of that comforting maternal solicitude which he no longer received from his wife and so sorely missed in his isolated state. Painting his mother now as she had been as a young woman in his childhood must have given him the bitter-sweet consolation of dwelling on the love and happiness he had enjoyed in the distant world of his youth. The second image of Aline is a gouache entitled *Exotic Eve* (fig. 275), another of Gauguin's startling but evocative syntheses of motifs from different sources. Here he has given his mother's face to a figure of the Buddha from one of the ancient Borobodur reliefs[105] (fig. 276), and placed her in a setting which echoes the scenery of Martinique. The opposite of the Breton mummy-Eve, this sexless being reaches out deliberately to pluck the fruit from the snake-entwined tree, her eyes fixed on the spectator's in a look of serious awareness, her left hand raised like the Buddha's in a traditional Indian gesture called "varada," which denotes munificence, the conferring of a boon or grace.[106] Beside her in this primitive paradise two birds copulate conspicuously, a pictorial suggestion that sexuality existed in Eden even before Eve tasted the fruit of the Tree of Knowledge. Gauguin's iconography reveals his hunger for a world in which sex and love were viewed as a natural part of God's order, and where people were free to partake of experience without the fear and guilt and artificial constraints imposed on us in the West. By depicting Eve in the guise of the Buddha, he expressed his conviction that the urge to taste life is what leads us toward enlightenment. By appending his mother's face to the sacred figure he implied that by virtue of his maternal heritage, he too belonged in some such exotic paradise where the pursuit of truth and sanctity were not mutually exclusive.

In November of 1890 Gauguin returned to Paris, where he met more of the artists and critics connected with the emerging Symbolist movement, and where he continued to try to arrange for a sale of enough work to earn his passage to Tahiti. During this autumn he was introduced to a young seamstress named Juliette Huet, who became both his model and his mistress and soon found herself pregnant with his child. Sometime that winter Gauguin painted a picture entitled *The Loss of virginity* (fig. 277), a work which synthesizes both Christian and pagan symbolism to suggest his complex ideas about Western sexuality. He depicted Juliette[107] here laid out like a corpse against a background of a harvest landscape, with a plucked flower in her hand and a fox clasped to her breast. Her ritualized pose in this work was influenced by a number of interestingly related sources.[108] One of these was certainly Bernard's portrait of his teenage sister Madeleine, to whom Gauguin had earlier been attracted. Entitled *Madeleine in the woods* (fig. 278), it represents the girl lying dreamily on a carpet of grass in a pose which Bernard had adopted from the recumbent figure of the Virgin Mary on Chartres cathedral (fig. 279). As was the case with Gauguin's earlier wood carving of a haloed Eve lying serenely in a fertile landscape, the implication of this pictorial reference is that when a girl embarks on an adult life of sexual experience, she assumes the hallowed role of Mary, a necessary and willing participant in the deity's plan to reproduce. But Gauguin's figure duplicates even more closely Bernard's 1890 painting *The Deposition of Christ* (fig. 280), which in turn echoed many medieval images of the crucified savior. By associating the loss of virginity not only with Mary's maternal function but also with Christ's sacrifice of himself for the benefit of the world, Gauguin intimates even more strongly that a girl's submission to the forces of nature has a sacramental aspect.

It is for this reason that there is no hint of seduction or sensuality in this picture. The girl lays herself out in voluntary sacrifice, embracing the fox which in Breton tradition symbolized a lascivious seducer, but which for Gauguin symbolized perversity. The perversity here can be dual, relating both to our stubborn, innate desire for experiences which we know will bring us suffering, and to the folly of society for forbidding something which is natural and unavoidable. Like her sacred forerunners, the maiden acquiesces in the loss of her self-contained independence and safety, opening herself up to the risk of physical and emotional pain and possible death in order to fulfill her God-given instinct for love, holding the symbolic plucked flower like an attribute. The harvest imagery of the rest of the painting reinforces this philosophical message. It has been pointed out that in the harvest traditions of Brittany the grain was equated with Christ, and a last bundle of it, which we see in the right foreground, was "sacrificed" to ensure its regeneration in the spring: a custom which involved the fox as an additional symbol of fertility, "an

agent of cosmic renewal."[109] The themes and imagery of this picture are also linked to the myth of the fertility goddess's daughter Persephone, as was the wood carving *Be loving, you will be happy*. By going lightly out into the dangerous world to frolic, by thoughtlessly plucking nature's seductive flowers, the virgin Persephone laid herself open to the assault of sexual experience with all its repercussions, and her myth indicates that naïveté and innocence are no deterrents to the forces of nature. In fact, both her abduction and the subsequent compromise that allowed her to return to earth for a portion of each year to ensure her mother's renewal of the crops, were events dictated solely by the actions of the gods. As Schuré observed in *The Great Initiates*, Persephone, like Christ and the Buddha, was merely an agent of the divine will which established the laws of nature and imbued humanity with a driving hunger for the sensual and emotional pleasures which lead unavoidably to experience and knowledge. The maiden in Gauguin's picture, whose chalky white body lies amid the blood-red fields along with the sacrificed bundle of grain, represents the offering up of the self on the altar of life, the consecration of pain and death as a necessary part of God's order.

Like so many of Gauguin's images, *The Loss of virginity* has the power to suggest multiple ideas. On one level this depiction of the Fall represents the way our Christian society would view it: as a well-deserved death-in-life brought about by a girl's perverse and sinful desire for her seducer. But to those capable of deciphering his layers of meaning, Gauguin implies that if Juliette Huet suffered from her seduction by him, it was biologically the fault of nature itself, and culturally the fault of a censorious European morality which unjustly inflicted social death on unmarried women for what he regarded as not only natural but sanctified behavior. Unfortunately, Juliette was unable to share his philosophical view of sexual freedom; some years later, in a fit of jealous anger over his involvement with another woman, she burned all the letters and souvenirs that he sent her and their daughter from the South Seas and ended their relationship permanently.[110] It was in part Gauguin's yearning to live in a society which accepted the needs of the heart and the impulses of the body regardless of legal marriage that impelled him to seek his future in Tahiti, which from Loti's idealistic description seemed the opposite of all that was artificial and evil in the Western world.

In February of 1891, after much effort, he organized a sale of his work in Paris that brought him 9,635 francs for thirty paintings.[111] At the beginning of March he traveled to Copenhagen to see his family for the first time in many years, and after a loving reunion he again pleaded with Mette to resume their life together. Although agreeing to an eventual reconciliation she refused to go to the South Seas,[112] and a month later, after requesting and receiving a commission from the Ministry of Public Education and Fine Arts to study and paint Tahitian customs and landscape, Gauguin set sail alone for his primitive paradise. The poet Charles Morice, who saw him shortly before he left, testifies that his departure was far from carefree. On the eve of his new life he wept for the ruin of the old: for the loss of his wife and children, for his failure to feed them, for, in his words, "the horror of the sacrifice that I have made, which is irreparable."[113]

Death and Rebirth in the Garden:

Tahiti, 1891–1893

Paradise Despoiled and Paradise Recreated

WHEN GAUGUIN LEFT EUROPE FOR TAHITI IN APRIL OF 1891 he hoped not only to acquire a better climate and cheaper living conditions, but to escape from the cold repressiveness of modern Western life into a natural and spiritual environment capable of nurturing his art. With his Peruvian family ties and childhood memories, he also had begun conceiving of his voyage to a comparably hot and exotic country as an exodus from an alien world to discover his true psychological roots. He defended this latest step in his artistic life against the inevitable accusations of selfishness by aggrandizing his purposes, and his first references to his long-planned departure accordingly cast his decision to go to the tropics in mythic terms. In an 1888 letter to Schuffenecker he likened himself to a primordial Indian and characterized a journey to the south as a quest for his cosmic sources. "According to legend," he explained, "the Inca came straight from the sun, and I am going to return to it."[1] In June of 1890, decrying to Bernard the philistinism which prevented "seeking and thinking artists" from surviving in modern society, he claimed that salvation lay in the East. Comparing his struggle to revitalize Western life through the creation of meaningful art to a legendary combat of the Greek hero Hercules, he wrote:

We're in a deep mess but we're not dead yet. . . . The whole Orient, great thought written in golden letters in all their art, all that is worth the trouble of studying and it seems to me that I will be strengthened down there. The West is rotten at this moment and all that is Herculean can, like Anteus [Hercules' opponent], acquire new force by touching the earth down there. And one would come back a year or two later, solid.[2]

Gauguin abandoned his earlier intention to go to Madagascar when Pierre Loti's book about Tahiti convinced him that in Oceania he would find an even more untouched and primitive refuge—a simple paradise in which carefree people lived off the land and sea without needing to work. With his usual unrealistic optimism, he enthused to a Danish artist friend about the impact this circumstance would have on his work: "My material life for once well organized, I can, down there, open myself up to great works of art, removed from all artistic jealousies, without the need for vile trafficking. In art, one's state of mind counts for three quarters; one must therefore look after it if one wants to make something great and lasting."[3] He wrote in similar terms to Odilon Redon: "Madagascar is still too close to the civilized world; I am going to Tahiti and I hope to finish my life there. I believe that my art, which you love, is only a seed and I hope that down there I can cultivate it for myself to a primitive and savage state."[4] In an interview with a journalist before his departure, Gauguin emphasized his conviction that he needed an unspoiled physical and spiritual atmosphere in order to make powerful "primitive" art:

I am leaving to be tranquil, to be relieved from the influence of civilization. I want to make only simple art, very simple; for that I need to be strengthened in virgin nature, to see only savages, to live their life, without any other preoccupation than to render, as a child would, the conceptions of my mind with the sole aid of the primitive means of art, the only good ones, the only true ones.[5]

Gauguin knew that in addition to its pecuniary advantages, what he was seeking in the South Seas related to what he had experienced in diluted form in Brittany and he even noted that "From Oceania to Brittany is not far."[6] But Brittany was still Europe, and too expensive for him, since the work he had done there had brought only critical contempt and commercial failure. Accepting this meant recognizing that he could continue functioning as an artist

only in a totally different culture. Assuming erroneously from his reading that life in Tahiti was still a traditional one governed by natural values, and perhaps also trying to convince himself that paradise was still possible for him, he wrote to Bernard: "You know that Tahiti is the sanest country that exists. . . . Tahitians, . . . happy inhabitants of the unknown paradise of Oceania, know only the sweetness of life. For them, to live is to sing and to love."[7] He first told Mette of his plan to go to the South Seas immediately after reproaching her bitterly for abandoning him, for continuing to disparage and ignore him because he couldn't earn money, and for having recently written coldly to him that their lives were sundered. The bravado with which he announced his anticipated happiness has a large component of revenge, but his image of what he hoped to find there also reveals his profound and legitimate longing to at last regain a life of love and harmony. In Tahiti's simple, spiritual, and humanly nurturing society, he felt, he would find not only love unrestricted by material considerations, but that sense of unity with nature and that harmony between his emotional and artistic needs and his daily life which he believed to be the essence of religion:

I am going to flee into the woods on an island in Oceania, to live there in ecstasy, in calm, and in art. Surrounded by a new family, far from this European struggle for money. There in Tahiti I shall be able, in the silence of the beautiful tropical nights, to hear the sweet murmuring music of the movements of my heart in loving harmony with the mysterious beings who surround me. Free at last, without cares about money, I'll be able to love, to sing, and to die. Our two lives are ruptured, you say? Wrong, yours is freed of every impediment, surrounded by your family and your children, your days slip by not without painful labor but free from marital authority, adulated, respected and loved. Your genius is remunerated.[8]

Gauguin's evocation to Mette of a Tahiti in which he would experience a blissful and musical sense of unity with the world is very revealing. Suffering from the disintegration of his life and the feelings of alienation his experiences in Western culture had produced, he assumed he would find inner harmony in a land where great sensual beauty mingled with a morally and spiritually uplifting atmosphere. His description to Mette of what he anticipated in Tahiti is reminiscent of Richard Wagner's description of the ultimate reward true artists would reap in the hereafter—a passage Gauguin quoted in his farewell letter to Redon: "I think that the disciples of great art will be glorified, and, enveloped in a celestial fabric of rays of light, of sweet aromas, of melodious music . . . [will] return to lose themselves in eternity, in the bosom of the divine source of all harmony."[9] Although his romantic ideals were never realized in a Tahiti which had been dramatically altered by a century of European contact, and although his years there were filled with difficulties and unhappiness, Gauguin continually struggled to achieve this state of rapturous harmony in his life and to evoke it in his art. His paintings and his writings show us a Tahiti colored by his own poetic yearnings—his nostalgia for a primitive Eden which no longer existed, if indeed it ever had, but which acted nevertheless as a potent inspiration for his creative imagination. We recall that Gauguin had once told van Gogh he found everything poetic,[10] and the many landscapes and genre scenes, figural carvings and portraits which he produced in Oceania share a general aura of supernatural beauty and mystery. In a significant number of these works, however, he utilized the imagery of Tahiti, as he had that of Brittany, to mythicize his own experiences and to crystallize his philosophical and religious ideas into symbolic messages of particular import.

Our information about Gauguin's first two-year stay in Tahiti comes principally from his letters and from his supposed journal *Noa Noa*, actually a highly fictionalized account of his experiences which he drafted in rudimentary form after returning to Paris in 1893 and then altered and expanded in collaboration with his poet friend, Charles Morice. The final version of the manuscript intersperses this text with an eclectic combination of his own watercolors and prints, photographs, reproductions of favorite images by other artists, and drawings of Maori designs. *Noa Noa's* purpose was largely publicity: Gauguin wanted to create interest in his exotic adventures and supply a hostile public and skeptical critics with a poetically suggestive document which he felt would make his paintings more accessible and meaningful.[11] His frontispiece illustration for the manuscript is a bouquet of dreamlike flowers looming mysteriously out of dark shadows, for *Noa Noa* is Tahitian for "fragrant," and Gauguin intended these visual and linguistic references to Tahiti's natural perfumes to symbolize the heady, haunting sweetness of experience there.

It has been recognized by scholars that Gauguin created much of *Noa Noa* in order to explain the ideas and emotions he attached to particular paintings: works which he had sent back to France for exhibition and hopefully sale but which had met a contemptuous and uncomprehending audience. He also seems to have fabricated much of his text as a defense of his journey: a substantiation of his claim that his sojourn in this primitive paradise had indeed been deeply regenerative. He relates in the manuscript that he arrived in Tahiti "almost an old man, in body and soul, from the vices of civilization: from lost illusions,"[12] but that during his stay he "became each day a little more savage"[13] until at last "I went away two years older, rejuvenated by twenty years; more of a barbarian too, and yet knowing

more."[14] But while *Noa Noa* recounts Gauguin's gradual induction into a primitive world of mystery, spirituality, sensual beauty, and heightened emotion, his own appendix to his first draft of the document tells a very different story. Opening with his sardonic observation "After the work of art—The truth, the dirty truth,"[15] it chronicles the sordid details of his problems and disappointments in this flawed paradise. Much of his embittered account deals, in fact, with his efforts to leave Tahiti long before he finally succeeded in convincing the authorities to repatriate him as a pauper. Describing the trials of his boat trip back to France, this rebel who had boasted of his re-creation as a Maori concluded regarding his return: "I am here at last, among my own people and my friends."[16]

The appendix and numerous passages in his letters make it clear that *Noa Noa* is not a chronicle of real events, but an evocation of primitive experience as Gauguin wished it had been and wanted the public to think of it. Not only does it describe a Tahiti seen through the distorting lens of his own romantic desires and need to mythicize and aggrandize his life, but it was also influenced by a number of literary sources. Some sections duplicate poetic scenes from Loti's equally fictional account in his Tahitian novel, while other incidents parallel descriptions in Schuré's theosophical text *The Great Initiates* of the rites by which adepts were initiated into the mysteries of ancient religions. Parts of the manuscript also reflect the impact of a book about Polynesia which Gauguin read during his first year in Tahiti: Jacques Moerenhout's 1837 study *Voyage aux îles du grand océan* (*Voyages to the islands of the great ocean*), which described the traditional but already defunct lifestyles, customs, and spiritual beliefs of the region. Enchanted by the images this information conjured up, Gauguin wrote enthusiastically to Paul Sérusier: "What a religion that ancient Oceanian religion is! What a marvel! My brain is in an uproar and everything that it suggests to me is indeed going to alarm."[17] Gauguin's passionate interest in Moerenhout's information led him to copy out and illustrate the passages relating to Polynesian mythology in a manuscript he called *Ancien culte mahorie* (*Ancient Maori cult*), and he also incorporated references to many of these legends into his final version of *Noa Noa*. Contemporary scholars have identified these and noted the many discrepancies that exist between the purported experiences of *Noa Noa* and the more realistic evidence of the artist's letters. Although some separation of fact from fantasy is necessary if we are to understand Gauguin, it is also important that we accept his skillfully crafted presentation of his Tahitian experience as a deeply revealing expression of his ideals and ideas.

Gauguin's initial reaction on disembarking in June at the port capital of Papeete was disgust at the Europeanization which had destroyed much of the native way of life.[18]

His arrival happened to coincide with the death of King Pomaré, whose funeral he attended and described in *Noa Noa* as an event pregnant with prophetic significance. Because Pomaré had drunk himself to death, a victim of the European introduction of alcohol into the South Seas, Gauguin could interpret his demise as a symbol of the disintegration of native ways. Watching people disperse after the funeral, he concluded tragically:

That was all—everything went back to normal. There was one king less, and with him were vanishing the last vestiges of Maori customs. It was all finished: nothing but civilized people left. I was sad, to come so far for. . . . Shall I manage to recover any trace of that past, so remote and so mysterious? and the present had nothing worthwhile to say to me. To find again the ancient hearth, to revive the fire in the midst of all these ashes.[19]

This desire was the mainspring of Gauguin's purpose in the South Seas, and his longing for the Tahiti that he was too late to encounter permeated both his experience and his art. Although the landscape dazzled his eyes and kindled glowing visions of an exquisitely colored world of sensuous forms and seductive perfumes, his earliest portraits of native women convey his realization that there was a rupture in the intoxicating harmony of this remote Eden. In both *Faaturuma* (*Melancholy*) and *Vahine no te tiare* (*Woman with a flower*) (figs. 281 and 282),[20] his subjects seem lost in sad thoughts which give the lie to his earlier assumptions about the inhabitants' carefree life here. For Gauguin, the contrast between these womens' sensual features and exotic flowers and the long, plain, puritanically concealing dresses introduced by European missionaries to replace the natives' scanty *pareos* must have epitomized all the conflict he perceived between their natural eroticism and the artificial repressiveness of the West. Even with their melancholy nostalgia for a lost age, they seemed to him to embody all the primitive mystery and power of which he had dreamed. His description in *Noa Noa* of the woman with the flower reveals how much such representations reflected his own ideals and intuitive imagination. To his eyes, "veiled by [his] heart," his sitter suggested the healthy integrity of a being in whom all the ambiguous and paradoxical forces of our inner life are unified in a dignified and tranquil equilibrium. He perceived her as mingling sensuality with sadness and strength with passive resignation in a way that made her seem both primitive and classical, both physically and spiritually aware. She was, he wrote,

not pretty, by European standards: Beautiful all the same—all her features had a raphaelesque harmony in their meeting curves, her mouth, modeled by a sculptor, speaks all the tongues of language

*and of the kiss, of joy and of suffering; that melancholy of bitter-
ness mingled with pleasure, of passivity residing within domina-
tion. An entire fear of the unknown. . . . It was a portrait
resembling what my eyes veiled by my heart perceived. I believe it
was chiefly faithful to what was within. That sturdy fire from a
contained strength. She had a flower behind her ear, which was lis-
tening to her fragrance.*[21]

Gauguin's disappointment at the corruption of colonial
officials and European-influenced natives in the capital led
him to frequent the lower class fringes of society. For a few
months he indulged in the licentious round of drinking
and sex which characterized life in Papeete and which
quickly sapped both his money and his already weakened
health. When a sudden violent hemorrhage and heart
attack persuaded him to move to a rural district, he went
first to Paea and then to Mataiea on the other side of the
island where life was simpler and more traditional. Even on
the remote parts of Tahiti he found no trace of the old reli-
gion, but in paintings such as *Te fare hymenee* (*House of song*)
and *Upaupa* (*Dance of joy*) (figs. 283 and 284), he captured
the few vestiges of native customs which survived. The lat-
ter depicts a firelit scene of traditional dancing as if it were
some mysterious, primal ritual. Enveloped in deep blue
and purple shadows, embracing couples and quiet
observers merge into the ambient darkness while the
dancers are dramatically silhouetted against the leaping
flames. Gauguin must have been well aware that both the
general sexual atmosphere and the explicit imagery of the
performers' spread legs and bent knees, details which so
perfectly conjure up the throbbing rhythms of the drums
and the athletic abandon of the dance, would appear inde-
cent to a Western audience.

Because native traditions had been so thoroughly sup-
pressed by the missionaries, Gauguin had to look to the
simple activities of daily life for most of his subject matter.
As he had done in Brittany, he often rendered even ordi-
nary motifs in terms of the imagery of other cultures.
Although he had claimed that he went to Oceania to make
art based solely on his experience of virgin nature and his
own genius, he was careful to take with him a large number
of photographs, prints, and drawings of all types of ancient
and modern art which he used as models for his own: a
collection which he described to Redon before he left as "a
whole little world of friends who speak to me every day."[22]
Ranging from ancient Greek, Roman, and Indonesian
relief sculpture[23] to images by artists as seemingly disparate
as Holbein, Raphael, Dürer, Delacroix, Degas, Puvis de
Chavannes, and Manet, these "documents," as he called
them, enabled him to continually model his own work on
the great art of the ages. Because he believed that art arises
from an imaginative soul's experience of other great art as

well as of nature, he had no more compunctions about cre-
ating his Tahitian visions from the vocabularies of other
artists than he did about utilizing the elements of landscape
or still-life. The "primitive means of art" on which he
claimed he would rely referred just as much to the primi-
tive aesthetic traditions on which he based his own style as
to his artistic materials and personal experience.

The Man with the axe (fig. 285) is a good example of the
way in which he mingled reality, artistic borrowing, and
poetic meaning. He described this picture in *Noa Noa* as
originating from a common local sight which he invested
with deeper spiritual significance:

*It is morning—on the sea, by the shore, I see a canoe, and in the
canoe a woman; on the shore a nearly naked man . . . The man
lifts in his two hands, in a harmonious and supple gesture, a heavy
axe that leaves up above its blue imprint on the silvery sky, and
below, its incision on the dead tree, where, in an instant of flames,
the age-old heat treasured up each day will revive. On the purple
ground, long serpentine leaves of a metallic yellow seemed to me
the characters of some distant Oriental language,—and I thought I
read there that word of Oceanic origin: Atua, God, the Ta'ata or
Takata which, from India, radiated everywhere and can be found
in all the religions—(Religion of Buddha). In the eyes of Tatha-
gata all the fullest magnificence of Kings and of their ministers are
merely like spittle and dust; In his eyes purity and impurity are
like the dance of the six nagas. In his eyes the search for the way of
the Buddha is like flowers set before a man's eyes.*[24]

We see from this passage that the simple activities of the
natives and the harmonious grace of their bodies merged
for Gauguin with the superb colors and sinuous forms of
the landscape to summon up a sensation of deity and of
Buddhist philosophy which negated materialist values. The
figure of the woodcutter was actually based on one of the
standing horsemen from the west frieze of the Parthenon
(fig. 286)—part of Gauguin's cache of pictorial docu-
ments[25]—but for the artist, this eclectic blending of an
ancient Greek motif with a contemporary Tahitian genre
scene to suggest the essence of Buddhist religious philoso-
phy was merely a legitimate means of capturing the dignity
and sanctity of all primitive life.

Gauguin perceived his image of the woodcutter as an
archetype of Tahitian manhood, and the figure's suave,
feline grace had a particular significance for him. His writ-
ings express bitterness about the unnatural and adversarial
relationships that Western culture fostered between men
and women: the ways in which society emphasized the
separateness of the sexes physically, intellectually, emotion-
ally, and in terms of the roles they were allowed. In his final
version of *Noa Noa*, Gauguin commented that in Tahiti
there were far fewer differences between males and

females: not only did their activities and behavior have much in common, but their interactions were governed by an assumption of equality which Gauguin found heartening and exciting. The natives' physical appearance seemed to him the visual expression of this spiritual unity, because the men's smooth skin and supple grace gave them a distinctly feminine look, while the women's big shoulders, narrow hips, and heavy thighs created a masculine type of beauty which the West could not appreciate.[26] Gauguin was fascinated by the concept of androgyny, an ideal state of being which Romantic literature extolled as combining the most salient sexual and psychological aspects of male and female in a fully harmonized individual. Like Balzac, Gauguin viewed the androgyne as a symbol of divine unity: the ultimate merging of opposites, the reconciliation of human characteristics whose separation in Western culture had caused so much divisiveness and alienation.[27] For Gauguin, the woodcutter's androgynous quality was an eloquent expression of the spiritual state of wholeness and harmony which the native possessed and he himself craved.

The man with the axe had another meaning for Gauguin which related to his longing to slough off his old European self and refashion himself as a primitive. In *Noa Noa* he describes his early friendship with the handsome youth Totepha, who came daily to watch him paint or sculpt and who astonished and delighted the unappreciated Gauguin by recognizing that his artistic talent set him apart as a special and socially useful being.[28] One day Totepha took Gauguin on an expedition to a remote part of the island to obtain hardwood suitable for his carving. Dressed like the native only in a loincloth, Gauguin followed Totepha into the forest where he was suddenly overwhelmed by the young man's "sexless" animal beauty and the way in which it harmonized with the intoxicatingly lush and fragrant surroundings. He felt an unexpected, deeply embarrassing rush of attraction which was probably the result of the youth's compelling combination of feminine sensuality and masculine vigor and confidence, or what the artist described as a healthy quality of natural wholeness that he radiated. Although Gauguin must have known that homosexual love was accepted by the Tahitians, who tolerated all forms of sexuality, his lingering Western prudery made him feel that his desire was sinful. Observing Totepha's innocent eyes, he concluded ruefully: "I alone carried the burden of an evil thought, a whole civilization had been before me in evil and had educated me."[29] When they reached a thicket of rosewood and began to chop down a magnificent specimen with their axes, Gauguin perceived his assault on the tree as a fierce symbolic gesture by which he was annihilating his European persona, and as he chopped he sang: "Cut down by the foot the whole forest (of desires), Cut down in yourself the love of yourself, as a man would cut down with his hand in autumn the Lotus." It has been pointed out that in Sir James Frazer's comparative study of world myths, *The Golden Bough*, tree cutting is associated with the rejuvenation and resurrection of the chopper, the killer.[30] It is significant that Gauguin's account of his assault on the tree concludes: "Well and truly destroyed indeed, all the old remnant of civilized man in me. I returned at peace, feeling myself thenceforward a different man, a Maori."[31]

Gauguin's reference to cutting back the lotus is also meaningful, for this was the Eastern symbol he had used in earlier sculptures to signify the process whereby new life is generated from the destruction of the old. Whether or not this incident actually occurred in this manner is irrelevant to the fact that both the figure of the woodcutter and the metaphorical event of tree chopping had profound spiritual implications for Gauguin. After describing their return from the forest he remarked: "I gave not a single blow of the chisel to that piece of wood without having memories of a sweet quietude, a fragrance, a victory and a rejuvenation."[32] In a later painting entitled *Matamoe* (*Sleeping*) (fig. 287), which significantly he translated as *Dead* when it was displayed in France in 1893, the man with the axe is poised amid an exquisite, dreamlike landscape which evokes this sense of timeless serenity, eternally ready to chop the wood that will "rekindle the ancient fires" of primitive life. In the foreground stroll two peacocks—birds which were not native to Tahiti and were therefore foreign imports like Gauguin himself, birds which in ancient Oriental cultures signified the beauty of the aspiring soul. Perhaps their inclusion symbolized for Gauguin both his own longing for a new spiritual identity, and his simultaneous recognition that he too was still an oddity and an outside observer in a world whose native traditions, indefinitely suspended by foreign intrusion, were dead or sleeping.

Gauguin's desire to portray Tahiti as a truly primitive paradise led him to invest the most mundane activities with an aura of ritualized significance. His depiction of native women moving tranquilly in *I raro te oviri* (*Under the pandanus palms*) (fig. 288) has the stylized, hieratic quality of an ancient Egyptian tomb painting, and it too creates the sensation of an eternal and sacred way of life where the smallest details of secular existence are imbued with dignity and grandeur. Here again the long, sinuous shapes of the fallen leaves assume the form of a golden calligraphy, an effect that is at once decorative and evocative. Among the documents Gauguin had brought with him were photographs of Egyptian tomb murals from eighteenth-dynasty Thebes (fig. 289), and we can see their impact also in his picture *Ta Matete* (*The Market*) (fig. 290).[33] His success in recreating a generalized impression of primitive style is apparent when we realize that his women on their

bench recall not only Egyptian figures, but also the forms and disposition of gods and goddesses on early Greek friezes (fig. 291). When a scholar's research suggests that Gauguin's models were actually Papeete prostitutes waiting for customers,[34] we sense no impropriety in the artist's intent. In *Before and After* he claimed that prostitution in Tahiti had none of the negative connotations it has in the West because sex there was never considered immoral,[35] and in *Noa Noa* he romanticized regarding native prostitutes: "There is, in all of them, a love so innate that, whether mercenary or not mercenary, it is still Love."[36] By representing these women in the guise of sacred figures, he suggests visually that the age-old social function they serve is both universal and holy. It seems intentional that many lift their hands in the Buddhist gesture "fear not": the injunction of the enlightened mind unencumbered by the illusions and prejudices that cloud our Western perception of reality.

Given his preoccupation with the hypocrisy of European attitudes toward sex and the restrictiveness of our marital arrangements, Gauguin was particularly delighted to observe the freedom of male-female relationships and the natural, unselfconscious pleasure that the Tahitians took in sexuality. A painting of 1891 entitled *The Meal* (fig. 292) suggests that here, unlike in the West, the dawning of sexual awareness was not tainted by notions of perversity and guilt. This picture seems to be less a genre scene with still-life than an allegory on coming of age. The table is so prominent and raised that it takes on the appearance of an altar, while the objects so carefully and separately disposed over its surface seem emblematic rather than merely decorative in purpose. In Tahiti, fruit tables called *fatas* were customarily used as altars, and their presence identified the event in progress as having religious significance. By making the fruit table with its contents so dominant, and by lining up the young people behind it in such formal juxtaposition, Gauguin implies that there is some meaning in their relationship.

It is the faces of the trio which hint that the theme here could be the adolescents' incipient sexuality. The boys gaze sideways at the girl with expressions of vaguely troubled awareness, their attention riveted on her as a tangible, unsettling focus of their developing interest. She, however, stares pensively off into the distance as if transfixed by pleasant daydreams, a barely perceptible smile just lifting one corner of her mouth. Together these figures suggest the different ways in which awakening desires affect males and females, while the fruits and vessels spread before them seem to symbolize the eventual repercussions of their maturing feelings. The girl poised directly behind the central basin of water recalls the traditional Christian description of the Virgin Mary as a "font of living waters," a

reference to the sanctity of her reproductive role. Around this focal point, the bulging gourd container, the ripe, round fruits, the conspicuously phallic bananas, and the frieze of flowers behind the children's heads evoke an impression of fertility and sensual pleasure. By contrast, the prominent knife and the cut fruit (an allusion perhaps to the loss of virginity) contribute the subtle suggestion that this perfection is also susceptible to consumption or decay. The note of poignancy they add is intensified by the lurking presence of the faceless, black-clad crone who crouches in the open doorway at the rear: a menacing figure conjuring up forebodings of old age and death. Here she waits unheeded in the background, a distant evil ignored by the young people, whose conscious attention is focused on present and future delights.

Another painting from 1891 or early 1892 conveys a similar vision of the Tahitians' reverential appreciation for the fruits of sexual experience. Several years later, in *Before and After*, Gauguin recounted his gratification on finding that in Tahiti unmarried girls could indulge in whatever liaisons they pleased, and that their illegitimate offspring were received with joy by the entire society. Associating their attitude with the "natural" morality preached by the eighteenth-century philosopher Jean-Jacques Rousseau in his scandalous novel *Émile*, Gauguin wrote that in the liberated and healthy atmosphere of Tahiti, "the young girls, smiling, are freely able to give birth to as many Émiles as they like."[37] In *Ia Orana Maria* (*We Greet you, Mary*) (fig. 293), Gauguin's imagery and title indicate that he has transformed a traditional Christian scene of the adoration of the infant Jesus into a depiction of the Tahitians' worship of maternity and their love of children without regard for the mother's marital status. Perhaps in recasting this sacred event he recollected ironically that the Christ child also was not fathered by the original Mary's husband. In Gauguin's version of the holy scene the young woman carries her heavy child with a faint smile on her lips, her eyes fixed dreamily on the sacrificial *fata* with its offering of ripe fruits in the foreground, her and her baby's halos signifying the sanctity of all mothers and children. Behind her, two women posed like the worshipful disciples of the Buddha from one of the Borobodur reliefs (fig. 276) stand in silent devotion, while in the background, partially screened from view by the foliage, waits a Tahitian angel modeled after a Japanese print. Although its vividly colored wings give it the look of an exquisite tropical bird, the angel is holding the palm branch which in Christian iconography was presented to Mary by the Angel of Death to announce the impending crucifixion.[38]

Gauguin's inclusion here of these pictorial references to sacrifice and death reveals his recognition that even in this primitive paradise the natives are subject to grief and

mortality. The serene and smiling acceptance of the partic-ipants, however, creates a very different effect than did the stark drama of *The Loss of virginity*. Within this tranquil and harmonious environment, where the women's physical beauty seems a natural outgrowth of the richly flowering landscape, the fulfillment of human instincts is not stigma-tized as sinful. *Ia Orana Maria* pays tribute to Tahitian soci-ety for its humanistic moral values and its capacity to view the prospect of suffering and death, as well as sex, with Buddhist reverence; it presents a vision of paradise in which the sacred and the profane merge into a single evocative unity. In 1893, when Morice wrote the preface to the catalogue of Gauguin's Tahitian work to be exhib-ited at Durand-Ruel's in Paris, this was the idea that he associated with this painting: "And the sun and the foliage all around also pray, powerful, suave, fragrant (*Noa-Noa*), subtle, like the smile of the Virgin herself, a smile in which religion and pleasure are mingled, the majesty and the sauciness of the goddess and the woman, such as these nat-ural minds were able to conceive them."[39]

Preoccupied as Gauguin was with sexual liberation, one aspect of native life that he found especially delightful was outdoor bathing, although at first his embarrassment at the unselfconscious display of naked flesh prevented him from attempting to depict it. In *Noa Noa* he tells us: "In the brooks, forms of gold enchanted me—Why did I hesi-tate to pour that gold and all that rejoicing of the sunshine on to my canvas? Old habits from Europe, probably,—all this timidity of expression of our bastardized races."[40] Gau-guin felt that the freedom with which the Tahitian women bathed typified their healthy acceptance of sexuality, and he wrote of them as exhibiting the grace of animals and exuding an intoxicating fragrance.[41] When he did paint the bathers (figs. 294 and 295), he based one version on Puvis de Chavannes' recent picture of a similar subject (fig. 296), but transformed Puvis' gentle grace, pallid tones, and clas-sicizing idealism into a much bolder, stronger, more abstracting image. His intense colors, his exaggerated, sim-plified forms, and his models' plain faces and sturdy bodies unconcealed by chaste draperies create a very different kind of beauty than Puvis depicted: one that is more robust, more honest and more modern stylistically despite its dependence on a previously contrived motif.

Another aspect of Tahiti which Gauguin mentioned soon after his arrival was the pensiveness of the natives. He had always found the theme of people wrapped in thought a compelling one, and now the motif of contemplative women became even more conspicuous in his icono-graphic repertoire. Many of the Symbolists' favorite Romantic authors wrote that silent contemplation is cru-cial to sensing the most significant and eternal aspects of nature and to feeling oneself in harmony with the universe.

Jean-Jacques Rousseau, for example, claimed that his "hours of solitude and meditation are the only ones . . . when I can truly say that I am what nature meant me to be,"[42] and Carlyle in *Sartor Resartus* observed that "Speech is of Time, Silence is of Eternity."[43] Gauguin had expected to find this alluring atmosphere in Tahiti because Pierre Loti's book had described the pervasive silence of the island and had characterized the native women as having such a profound propensity for dreaming that it constituted one of their principal occupations: "The contemplative dispo-sition is extraordinarily developed among them. They are sensitive to the gay or sad aspects of nature, subject to all the reveries of the imagination. . . . The natives spend the greater part of the day squatting before their huts in sphinx-like immobility, . . . motionless and silent as idols."[44] From his reading of Loti and other Romantic texts, Gauguin was predisposed to perceive this habit of revery as symptomatic of all the mystery and spiritual sensi-tivity of the Oriental primitive. When he painted his many representations of silent, serious women on the beach or in the village (figs. 297 and 298), he meant to suggest that their capacity for profound inner communion was an essential feature of the primitive mentality and way of life.

What makes these images so compelling and provoca-tive is the aura of enigma they exude—the haunting sense they create of the complexity and obscurity of human thought. For Gauguin, this quality of impenetrable mys-tery exerted a fascination which was more appealing than conventional beauty. He wrote to Mette that "the women, in default of what is properly called beauty, have an infinitely penetrating, mysterious 'I know not what,'" and he claimed that as he became more deeply immersed in the local scene he found that he had to portray the natives increasingly enigmatically.[45] In *Aha oe feii?* (*What, are you jealous?*) (fig. 297), the form of the envious woman derives from a figure on the frieze of the ancient Athenian Theater of Dionysus,[46] but her disgruntled face creates a movingly realistic note in the idealized aesthetic harmony of beach and sea and flesh, of rippling patterns and colors. Her somber features at the center of such supernatural beauty suggest the sad truth that even in paradise human beings carry within themselves the seeds of their own unhappi-ness. Another such image is *Te Faaturuma* (fig. 299), which Gauguin translated as *The Silence* or *To be dejected* but which came to be known as *The Buddha*, perhaps because of its similarity to a wood sculpture of the Buddha that he carved during the same period (fig. 300). Chin in hand, her glance bent moodily toward a few fruits on the floor beside her, the woman here is a Tahitian version of the dis-consolate Breton girl in Gauguin's earlier picture *Vintage at Arles* (fig. 234).

This picture and others like it conjure up an atmosphere

in which the evocative power of the dreaming mind seems to be inextricably mingled with the unchanging beauty of the surroundings, the simplicity of the way of life, and the unbroken quiet of the island. Paintings like *Street in Tahiti* (fig. 301), in which the woman from *The Silence* becomes a small element within a sumptuously colored, majestic landscape, convey a powerful sensation of this essential Tahitian atmosphere; they give form to the images summoned up by Loti when he wrote:

Go out where civilization has not arrived, out where—beneath the slender coconut palms, beside the coral strands, before the immense deserted ocean—one finds the Tahitian districts, the villages with their pandanus roofs. Behold the immobile and dreamy natives; observe those silent groups, indolent and idle, at the foot of great trees, who seem to live only through the spirit of contemplation. Listen to the deep calm of nature, the monotonous and eternal soughing of the waves breaking on the coral.[47]

Shortly after his own arrival Gauguin wrote to Mette:

This night-silence on Tahiti is even stranger than the rest. It exists only there, without a bird cry to disturb the repose. Here and there, a great dry leaf falls but without giving the idea of a noise. It is rather a caress on the spirit. The natives often move around at night but with bare feet and silent. Always this silence. I understand why these individuals can remain seated for hours, for days without saying a word and regarding the sky with melancholy. I am aware of everything that is going to envelop me and I am refreshing myself extraordinarily in this moment. It seems that all this trouble of the life in Europe no longer exists and that tomorrow will be always the same thing, and so forth until the end.[48]

Gauguin claimed that the sensation of infinity and eternity he experienced from the silence of his surroundings and the meditative repose of the people played an important part in the regenerative effect Tahiti had on him. His canvases portray an idealized world, but it is not a sentimental one where people live blissfully and unconsciously. Troubled like all human beings by depressions, jealousies, daydreams, and fears, the Tahitians represented for him the honesty of a culture in which people are in touch with their emotions and in which the outer life of society allows the vagaries of one's inner life free expression.

Barbaric Tales: Themes of Love, Death, and Renewal in the Polynesian Eden

Gauguin's journals and letters tell us that when the native women were not wrapped in reverie, they spent much of their time talking in groups around their huts or under the trees. Believing as he did that women have a special sensitivity to life's essential mysteries and rhythms, he was drawn to eavesdrop on their conversations, and although their words were usually incomprehensible to him, he found the sound of them compelling and suggestive of secret knowledge. Perhaps this assumption was influenced by passages in Loti and Carlyle describing how simple villagers learned about life and death from the stories recounted by their elders under great, shady trees. Like so many Romantic authors Gauguin was also fascinated by primitive language, and although he never acquired more than a rudimentary grip on Tahitian, he, like Loti, wrote enthusiastically that it was far simpler and more direct than European languages, with many more words for the natural and spiritual and psychological phenomena to which the West was not as sensitive.[49] He painted a number of pictures of women talking, two of which are entitled *Parau parau* (*Words words*) (figs. 302 and 303). Regarding the first of these, he wrote to Mette that "this language is bizarre and offers many meanings."[50] The fact that Tahitian vocabulary was often untranslatable and referred to ambiguous and multidimensional realities must have appealed to Gauguin's Symbolist imagination and to his own desire to understand and convey ideas of an infinitely suggestive nature. It was precisely in order to summon up the evocative power of this mysterious, exotic language that he usually gave Tahitian titles to his pictures, often incorporating them directly onto the canvas. Despite his limited comprehension, he believed that the women's conversation was deeply meaningful because it concerned such fundamental issues as love, sex, death, and the activities of the evil spirits they believed shared their world. It is significant that in his second version of *Words words* he appended to the group beneath the trees the figure of one of the worshipers of the Buddha from the Borobodur reliefs, implying that this talk about elemental human experiences had a sacred import.

Many of Gauguin's pictures of Tahitian women deal in a serious, nonerotic way with the theme of love, which he claimed was their chief preoccupation. In *Ea haere ia oe* (*Where are you going?*) (fig. 304), a pensive young girl wears the white *tiare* flower behind her ear, which in Tahiti signified readiness to take a lover,[51] and she holds up like an attribute a large, breast-shaped fruit which seems to symbolize her sexual potential. Behind her, the two intently watching women convey the interest and speculation which any incipient love affair immediately aroused. In *Noa Noa* Gauguin confessed that he was at first intimidated by the "frankness" and "utterly fearless dignity" with which unattached young girls looked over prospective

partners,[52] but he soon came to feel that their subtle mingling of awareness and innocence epitomized the primitive wholeness and harmony he sought. Pictorially, he expressed his sense of their harmonious relationship to nature through the decorative patterns of leaves and flowers that bind all the elements of the canvas into an organically unified whole. *Nafea faa ipoipo* (*When will you marry?*) (fig. 305) is another example of how Gauguin reused favorite motifs, and it too treats love in terms of its larger significance. Behind a girl wearing the symbolic white flower at her ear, an older, chastely dressed woman stares seriously out at the viewer while making a ritual gesture that in Buddhist art denotes threatening or warning.[53] The artist's theme here seems to be what one scholar described as the relationship between knowledge and innocence.[54] Through her hand movement and sober expression the rear figure indicates that the experiences of love and marriage the young girl desires are more complex and dangerous than she can yet imagine.

When Gauguin first came to Papeete he took up with a half-caste woman named Titi who wanted to stay with him when he went to Mataiea, but as he tells us in *Noa Noa*: "I realized that this half-white girl, glossy from contact with all those Europeans, would not fulfill the aim I had set before me."[55] He did summon Titi twice to join him in the country after hearing rumors that the local girls suffered from venereal diseases which had been brought to Polynesia by the Europeans. This arrangement was short-lived, however, because, as Gauguin related in *Noa Noa*, "being already civilized, used to an official's luxury, she did not suit me for long. I parted from her."[56] The incidents in *Noa Noa* following Titi's dismissal chronicle Gauguin's gradual acclimatization to the tranquil, repetitive rhythm of rural life and the easy-going philosophy with which the natives encountered it: his preliminary steps in shedding his old European habits and values. At this point the manuscript becomes more blatantly the documentation of a process of initiation, one which is suspect because it contradicts other evidence that Gauguin never really fit completely into Tahitian life and spent much of his second year there trying to raise the money to return to France. In *Noa Noa*, however, he claims:

Every day gets better for me, in the end I understand the language quite well, my neighbors . . . regard me almost as one of themselves; my naked feet, from daily contact with the rock, have got used to the ground; my body, almost always naked, no longer fears the sun; civilization vanishes from me little by little and I begin to think simply, to have only a little hatred for my neighbor, and I function like an animal, freely,—with the certainty of the morrow [being] like today; every day the sun rises for me as for everyone, serene: I become carefree and tranquil and loving.[57]

Having supposedly achieved this improved mental state, Gauguin next relates the tale of his expedition with Totepha to cut wood: that incident in which he metaphorically destroyed his disillusioned and vice-ridden Western self and emerged a tranquil Maori. This crucial event is followed by an even more mysterious and supernatural journey into the heart of the forested mountains where he encounters Polynesian deities, an experience which provides mythic explanations for several important paintings to be discussed subsequently. The thread of Gauguin's narrative implies that he had now become enough of a native to take a native wife, for the next passages recount another presumably fictitious trip into the interior of the island to find a girl unpolluted by European contacts.[58] Here a Maori couple casually offer him their thirteen-year-old daughter to take back as his *vahine*. According to Gauguin, his immediate Western anxiety about the negative moral implications of such an arrangement was quickly put to rest by the girl's matter-of-fact willingness to accompany him. When he observed her natural self-possession, he tells us in *Noa Noa*, he perceived "in that tall child the independent pride of all that race . . . the serenity of a thing deserving praise. The mocking, though tender, lip indicated clearly that the danger was for me and not for her."[59] He was further reassured by the simple, humanistic nature of the arrangement, so different from the venal and tyrannical contracts of Western marriages. The girl's foster or "nursing" mother merely asked him if he was kind and would make her daughter happy, and stipulated that the girl could leave him if she was not content.[60]

This was Tehamana (fig. 306), whose name, which aptly enough means "giver of strength,"[61] Gauguin inexplicably changed in his final version of *Noa Noa* to "Tehura." According to his account Tehamana lived with him for the remainder of his two years in Tahiti,[62] and in both his paintings and his writings he treated her as a symbol of primitive being. In *Noa Noa* he immediately emphasized her role as an antidote to Western values. On their return to his hut, he tells us, the local gendarme's French wife exclaimed:

'What! are you bringing back such a trollop with you?' And with her angry eyes she undressed the young girl, who met this insulting examination with complete indifference. I looked for a moment at the symbolic spectacle that the two women offered. On the one side a fresh flowering, faith and nature; on the other the season of sterility, law and artifice. Two races were face to face, and I was ashamed of mine. It hurt me to see such pettiness and intolerance, such incomprehension. I turned quickly to feel again the warmth and joy coming from the glow of the other, from this living gold which already I loved. . . .[63]

The following August, Gauguin wrote to his friend

Daniel de Monfreid that he was soon to be a father,[64] and in *Vahine no te vi* (*Woman with a mango*) (fig. 307), he has portrayed the pregnant Tehamana as the incarnation of Tahitian sensuality and serenity. Holding the mango beside her breast as a parallel emblem of ripe perfection, her mouth curved seductively in a Mona Lisa smile, Tehamana gazes into the distance with an air of dreamy pleasure, while the fruits and blossoms hanging by her face evoke all the perfumes of nature. With its deep golden background and dress of an intensely rich violet blue, colors which recall medieval representations of the Madonna, this portrait evokes the sanctified image of their life together that Gauguin invoked in *Noa Noa* when he wrote:

I set to work again and happiness succeeded happiness. Every day at the first ray of sun the light was radiant in my room. The gold of Tehamana's face flooded all about it, and the two of us would go naturally, simply, as in Paradise, to refresh ourselves in a near-by stream. The life of every day—Tehamana yields herself daily more and more, docile and loving; the Tahitian noa noa pervades everything. As for me, I am no longer conscious of the day and the hours, of Evil and of Good—all is beautiful—all is well.[65]

Whatever the actual nature of Gauguin's relationship with his young native wife, he clearly chose to depict their life together as epitomizing all the idyllic harmony that his marriage to Mette had failed to bring him: what he described in his final version of *Noa Noa* as "Tahitian paradise, nave nave fenua. . . ."[66]

Tehamana became Gauguin's Tahitian Eve in a painting that he modeled closely after his Breton fantasy *Exotic Eve* (fig. 275), and titled on the canvas *Te nave nave fenua* (*The Land of sensuous pleasure*) (fig. 308). Scholars have observed that in *The Marriage of Loti* the author's *vahine* relates that because there are no snakes on Tahiti, missionaries explaining the temptation of Eve to the natives called the serpent "a long lizard without feet."[67] It has also been pointed out, however, that the lizard with flamboyant red wings hovering by Tehamana's ear is clearly a figment of Gauguin's Symbolist imagination,[68] a fact recognized by a contemporary critic who likened it to a chimera.[69] Posed like the Borobodur Buddha and making a gesture that denotes teaching,[70] the young girl reaches out with full consciousness to pluck an eye-like flower from a shrub which substitutes for the nonexistent apple tree in the Tahitian Eden. This eye-shaped flower must have had a dual significance for Gauguin. In Tahiti the word for eye was also used to denote profundity and mystery, and this meaning corresponded to his friend Redon's use of the same form in his art (fig. 309) to symbolize the natural aspiration of living things to "see," to enlarge their experience and awareness. These flower eyes are therefore the

equivalent of the Tree of Knowledge, and as Tehamana takes one in her hand with the calm assurance of the Buddha, her serious expression reveals that she realizes the implications of her act.

In his final version of *Noa Noa,* Gauguin wrote at length about his young *vahine* as an embodiment of Tahiti. Like Loti's descriptions of his mistress Rarahu, he characterized her as a volatile mixture of childish gaiety and ironic melancholy, a paradoxical enigma who always conveyed "tranquil certitude in the depths of her carefree laugh, in her childish frivolity."[71] Despite her irrational thought processes and primitive naïveté, he claimed, Tehamana had a serene acceptance of life and an instinctive understanding of the complexities of human nature that made him an open book for her, while she remained an impenetrable mystery to him.[72] Responding to playwright August Strindberg's contention that this painting of her opposed barbarity to civilization, Gauguin retorted: "Civilization from which you suffer. Barbary which is for me a rejuvenation." He went on to claim that this picture of his Tahitian Eve contrasted purposefully with the more conventionally beautiful images of Eve in Western art because she exemplified the frankness and earthy simplicity which the first woman ought to represent; she manifested an unselfconscious nudity and seriousness which most European artists had replaced in their own representations of Eve with wanton and seductive qualities that typified the inherent misogynism of male-female relationships in the West.[73] Gauguin's new Eve is an androgynous figure like the Buddha she emulates: a symbol of the intuitive wisdom of the East and the natural morality of primitive peoples. As he described her later in the notes he entitled *Diverse things*:

She is indeed subtle, very wise in her naïveté, the Tahitian Eve. The enigma sheltered in the depths of her childlike eyes remains incommunicable to me. This is Eve after the fall, still able to walk naked without shame, keeping all her animal beauty as on the first day. . . . Like Eve, the body has remained animal. But the head has progressed with evolution, the thought has developed subtlety, love has imprinted an ironic smile on her lips, and naively, she searches her memory for the why of times past, of times present. Enigmatically, she looks at you.[74]

In *Noa Noa* Gauguin tells us that he learned about many of the Tahitians' ancient myths and legends and customs from Tehamana while they lay in bed at night looking at the stars and talking about the gods.[75] Contemporary scholarship, however, reveals not only that all remnants of ancient beliefs had disappeared two generations before Gauguin's arrival in Tahiti as the culture became thoroughly Christianized, but also that in Polynesia, sacred stories were

passed down through the male priest cult and had always been taboo knowledge for women, much less young girls.[76] Apparently it suited Gauguin's poetic sensibility to recreate Loti's equally fictitious descriptions of his spiritual conversations with his native wife, so he attributed to Tehamana information that he actually obtained from reading Moerenhout's book about Oceania. Gauguin never pretended that the Tahitians' joy in life meant that they did not experience melancholy, and like Loti he also wrote about their supernatural fears of death and of the evil spirits which they believed existed all around them. He crystallized this aspect of primitive existence in a painting called *Manao tupapau* (*The Spirit of the dead is watching*) (fig. 310), a work he considered so important that he described and explained it in several sources.

Gauguin first became familiar with the Tahitians' fear of the spirits of the dead from Loti's novel, which described the phantom *tupapau* as fierce ghosts with blue faces, sharp teeth, and long hair.[77] When Gauguin first wrote to Mette about this picture, he told her that it was this prevalent, superstitious fear of the dead that he wanted to convey, although his pictorial conception of the ghost deviates in an interesting way from Loti's image of the *tupapau*. Gauguin also indicated, both to Mette and in his explanation of this picture in his *Notebook for Aline* under the title "The Genesis of a Painting," that this theme was actually only a secondary concern—a justification for the girl's assumption of the unselfconsciously erotic pose which had initially triggered his interest and which he felt perfectly expressed the Tahitians' natural sexuality. Knowing that a European audience would consider the posture lewd, he sought a plausible pretext for it in the natives' equally natural fear of ghosts. When he later contrived a context for his description of this picture in *Noa Noa*, he claimed, perhaps for dramatic narrative purposes, that it depicted an actual incident which occurred when he returned to their hut one night and found Tehamana huddled on the bed, terrified of the spirits of the dead. But to Mette he had written simply:

I made a nude of a young girl. In this position, a mere nothing, she is indecent. However, I want her this way, the line and the movement interest me. So I give her head a little fright. This fright, it is necessary to give it a pretext if not to explain it and that gives the character of the person, a Maori. This people has by tradition a very great fear of the spirits of the dead. A young girl with us [in Europe] would be frightened to be surprised in this position. (The woman here would not); I have to explain this fright with the least possible literary means as used to be done in the past. So I do this. General harmony, somber, sad, frightening, tolling in the eye like a funeral knell. Violet, somber blue, and orange-yellow. I make the linen greenish yellow: 1 because the linen of this savage is a different

linen than ours (beaten tree-bark); 2 because it creates, suggests artificial light (the Kanaka woman never sleeps in darkness) and yet I don't want the effect of a lamp (it is common); 3 this yellow linking the orange-yellow and the blue completes the musical harmony. There are several flowers in the background, but they should not be real, being imaginative, I make them resemble sparks. For the Kanaka, the phosphorescences of the night are from the spirit of the dead, they believe them there and fear them. Finally, to end, I make the ghost quite simply, a little old woman; because the young girl not being acquainted with scenes of French spirits cannot do other than see linked to the spirit of the dead, death itself, that is to say, a person like herself. There you have a little text which will render you knowledgeable for the critics when they bombard you with their malicious questions. To conclude, the painting had to be made very simply, the motif being savage, childlike.[78]

Gauguin's explanation of his picture indicates that it depicts several salient features of Tahitian life by mingling symbolic, expressive color with realistic, nonliterary imagery. His description of Tehamana's pose and his manipulation of color to create a somber funereal effect need no further elucidation, but his incorporation of the odd flowers and of the little old woman requires some clarification. In his writings Gauguin observed that although the nocturnal phosphorescences which were so common on the island emanated from a particular variety of luminous mushroom growing on the trees,[79] the natives believed them to be the exhalations of the spirits of the dead—material evidence that a *tupapau* was present and was preoccupied with you.[80] In his *Notebook for Aline*, Gauguin claimed that for the Tahitians the phrase "manao tupapau" meant either "she thinks of the ghost or the ghost thinks of her."[81] The sparklike blossoms drifting here between the ghost and the girl are manifestations not only of the evil spirit's physical presence, but of the potent emotions hovering between the two figures like an electrical discharge in the night air: they are the physical expression of a powerful psychological reality which Gauguin described as "the spirit of a living girl linked with the spirit of Death."[82]

Gauguin's decision to represent this ghost as a little old woman is more problematic. Since he had read Loti's description of the spirits of the dead and had also lived long enough among the natives to be aware of their visual conception of such an important aspect of their beliefs, we must question why he chose not to portray the *tupapau* correctly as a blue-faced monster with sharp fangs. Gauguin's care in supplying Mette with "a little text for the critics" and his fabrication of a more dramatic explanation of this picture's origin in *Noa Noa*, reveal that he was constantly painting with an eye to his eventual European audience. He must have realized that the black-clad crone, a Western

motif he had often utilized to symbolize death, would be far more naturally suggestive of his meaning than a bizarre monster which European viewers might misconstrue as some pagan demon, and which would disrupt the realism of the scene. Always sensitive to the ways in which ordinary things can be manipulated for expressive purposes, however, Gauguin has endowed the old woman with Oceanic character and an additional charge of supernatural menace by giving her the huge, glaring eye and masklike features of traditional Polynesian carvings of *tikis*, or spirit figures (fig. 311). In his final version of *Noa Noa* he conjured up the imagery of this picture when he wrote: "The night is loud with demons, evil spirits, and spirits of the dead; also there are the Tupapaus, with pale lips and phosphorescent eyes, who loom in nightmares over the beds of young girls."[83]

Gauguin was fascinated by the descriptions of Polynesian spirits and deities which he read in Moerenhout's volume on Oceanic culture and later attributed to Tehamana. The legends and myths recounted there seemed to embody all the savage wisdom and poetry he longed to experience first hand, and soon after reading the book in March of 1892,[84] he began to incorporate references to them into his genre scenes and landscapes. Since most traditional Tahitian art had been religious and was destroyed by the missionaries, there was very little Tahitian imagery on the island that he could use as a basis for his pictorializations. Influenced perhaps by Moerenhout's discussion of the relationships between Tahitian beliefs and the myths and deities of India, Egypt, and Greece (parallels which reinforced Gauguin's own theosophical view of religion), he felt free to formulate his images from an eclectic variety of other Polynesian, Indonesian, and even Easter Island sources. His wood sculpture *Idol with a shell* (fig. 312) is typical of this synthesizing creativity. The body seated in the lotus pose is Buddhist, but the filed teeth of inlaid bone, the pectoral necklace, the incised tattoos on the legs, and the stylized spatulate feet were all adopted from Marquesan prototypes, as were the other designs and figures on the back of the object.[85] Gauguin's inclusion of the halolike shell behind his figure's head indicates that he intended this primitive idol to represent the Polynesian creator god Taaroa, a deity whom Moerenhout described as symbolizing "brightness; he is the seed; he is the base; he is the incorruptible, the force who created the universe, the great and sacred universe which is only the shell of Taaroa."[86]

Given Gauguin's conviction that creation and death go hand in hand, it is not surprising that Taaroa's face in this sculpture has much in common with the face of the spirit of the dead from *Manao tupapau*. In another picture from this period entitled *Barbaric tales* (fig. 313), this relationship is even more apparent. Here, two women similar to those

in *Words words* (fig. 302) relate mythic stories beneath the curving branch of a tree, while nearby, like a materialization of their conversation, the black-hooded figure of the spirit of the dead sits waiting in the shadowy glade. Arching over their heads, a sprinkling of luminous, spark-like emanations confirm the *tupapau's* supernatural presence not only as the subject of the women's tales, but as an active force occupying the landscape. Gauguin enlarged the significance of the *tupapau* here by depicting the frightening spirit as he did the god Taaroa, in the meditational lotus pose associated with the Buddha's enlightenment, and by lifting the storyteller's hand in the *mudra* meaning "fear not." These details suggest the Buddhist teaching that we can conquer our natural fear of death if we accept it as a necessary aspect of life, a sacred force equivalent to creation in the overall unity of the cosmos. In Gauguin's painting, the figure of death is as real and as significant an element in the larger scene of Tahitian life as is the woman bearing fruit in the background or the dog stretched casually in the foreground—an image of animal unconsciousness that contrasts pointedly with the women's aware communication about the harsh realities lurking in the midst of their paradise.

Gauguin used the same motifs in a picture entitled *Parau hanohano* (*Terrifying words*) (fig. 314), where he appended the large figure of another deity to the group of the women and the *tupapau*. A sculpture he executed of this same figure with its name carved on the base (fig. 315) reveals that it represents another member of the Polynesian pantheon about whom he had read in Moerenhout: she is Hina, goddess of the moon and waters, the patron deity of women. According to myth, Hina pleaded with her son Fatu, the god of the sun and earth, to alter the law of death he had decreed for all living things. When he refused, she mitigated the severity of his universal principle by ensuring that everything belonging to the moon would be reborn. As was noted in discussing the imagery of *Be mysterious* (fig. 271), many cultures relate female reproductive cycles to lunar periods and to tidal ebb and flow, so Hina's act was credited with maintaining the continuity of life and allowing humanity some compensatory measure of immortality through its children. Hina's arms are raised here in a gesture used in Hindu art to signify the ongoing motion of the universe with its eternal cyclical rhythm of life and death.[87] Beside her in the painting floats a disembodied female head which duplicates Gauguin's depiction on the back of his wood cylinder of a devotee of Hina with a flower behind her ear, praying to the goddess. The subject of *Terrifying words*, then, is the intimate and reciprocal relationship the Tahitians perceived between the forces of life and death, personifications of which are here balancing each other on either side of the talking women. As in *Barbaric tales*, one of these lifts her hand in the reassuring gesture "fear not."

Gauguin pursued this idea in another related picture titled *Parau na te varua ino* (*Talk about the evil spirit*) (fig. 316). Here, a young girl who appears to be based on a sculpted figure of Eve from the doorjamb of a Breton church (fig. 317),[88] stands under the snaky tree limb which has now acquired a threatening protuberance like a leering animal face: a motif some scholars have interpreted as a phallic reference to the amorous Gauguin.[89] Behind her, the symbolic figure of the spirit of the dead waits in the meditational yoga posture called *virasana*. At the upper right, a masklike serpent face divided into red and green halves peers menacingly from the foliage, while above the girl's head hover those ghostly, sparklike flowers which reveal the malevolent presence of the *tupapau*. The girl's sideways-rolled eyes and her expression and gesture of dismay indicate her awareness of these frightening presences, but why is she covering herself with a protective cloth in the manner which in Western art is associated with Eve's sexual shame or guilt after the Fall? Polynesian girls on reaching puberty were simultaneously initiated into the arts of sexual intercourse and made to begin covering their genitals,[90] but Gauguin, like many other nineteenth-century visitors to the islands, always claimed that the Tahitians never linked sex with embarrassment or guilt. He seems to have used this traditional gesture here to indicate instead the instinct for self-protection that accompanies the dawning of consciousness.

The story of Genesis tells us that after succumbing to the temptation to acquire knowledge of good and evil, Adam and Eve covered themselves because they now realized that they were naked (Gen. 3:10). Gauguin's Eve reflects this new recognition not merely of sexual identity, but of vulnerability to the threatening forces which lurk around her in this picture: symbols of all the dangers that surround us amid the pleasures and beauties of existence, including the universal presence of death. A pastel he did this same year (fig. 318) communicates this message even more succinctly. This is not a representation of sexual guilt, but of the fear that arises when we emerge from childhood's ignorance and innocence and realize the evil potentialities residing in the familiar landscape of our daily life. These pictures communicate the same message as *Vintage at Arles* or the portraits of Meyer de Haan and of Gauguin with halo and snake: the conviction that the realities of life force every aware person to come to grips with the existence of suffering and the nature of evil.

Gauguin admired the fact that despite their powerful fears of the unknown, the natives were still willing to abandon themselves to the positive forces of life. The imagery of his painting *Fatata te miti* (*By the sea*) (fig. 319) suggests this idea subtly through its incorporation of personally symbolic forms: behind the same dark, mysteriously animistic tree, a

woman disrobes for bathing, while in the background a Tahitian version of the woman in the waves casts herself into the sea. Unlike her Breton prototype (fig. 238), this figure gives herself up to the medium of life as though prostrating herself before the water: gone are the thrown-back head and stifled cry. The similarity of her posture to that of the girl in *The Spirit of the dead is watching*[91] could also have an intentional significance, for above her head hover some of those sparklike white flowers which imply the presence of a *tupapau* while simultaneously echoing the decorative shapes of the spray on the surf. In this harmonious paradise, awareness of death and reverent participation in life coexist in a single organic whole. Gauguin again expressed this concept of interactive unity aesthetically by embedding his figures in a landscape where exquisite colors are juxtaposed with menacing shadows, where the ground is patterned like leaf-flecked waves and the foam assumes the delicate shapes of birds and fish. In this metamorphic natural world, the naked women are both formally and spiritually fused with their environment, a reflection of divine order.

Gauguin's reading about Polynesian legends in Moerenhout bolstered his belief that this primitive culture possessed an intuitive, accepting grasp of the relationship between life and death which Western civilization had lost. One of his favorite myths concerned a woman named Vairumati, regarding whom he wrote in *Noa Noa* that her legend was "one of the most important spiritual treasures that I had come to Tahiti in search of."[92] According to Moerenhout, Vairumati was a beautiful mortal who was chosen by Oro, the son of the creator god, to become his consort and bear his children. The son of her voluntary union with this deity became the founder of a priestly sect called the Arioi society, whose members comprised an intellectual elite of warrior-savants. The Arioi was responsible not only for preserving and passing on the wisdom of the gods through oral traditions, but also for regulating the social and political activities of the culture. Among the society's principal teachings were the sanctity of prostitution and the virtue of sacrificing to the gods all children except the first born of each family. Gauguin vindicated this second, seemingly bloodthirsty tradition by explaining that in the South Seas, where before the arrival of Europeans there were few natural dangers and almost no disease, this practice constituted a ritualized program of population control without which the islands would soon have become uninhabitable.[93] The myth of Vairumati and the Arioi society thus sanctifies sexuality and teaches that death is necessary for the ongoing continuity of life. Gauguin's enthusiasm for this legend must relate to its embodiment of themes which had fascinated him for years, for he included detailed descriptions of the myth in both his *Ancient Maori*

cult and *Noa Noa* manuscripts as well as devoting several works of art to the subject.

In the two paintings of Vairumati that Gauguin produced during this period (figs. 320 and 321), he depicted her like a figure from an ancient Egyptian tomb painting, very similar in form and posture to the women waiting on the bench in *The Market* (fig. 290). Here, however, she is naked, as befits primordial woman, and is wearing the white blossoms behind her ear to indicate that she is ready to take a lover. The hieratic, ritualized quality of her pose and the associations with early religious art this pose triggers in our minds suggest that she is a sacred figure, while the *fata*, the sacrificial fruit table which in Tahiti accompanied all religious rituals, informs us that her actions are sanctified. Moerenhout's redaction of Vairumati's myth relates that she set up the *fata* herself as an indication of her voluntary decision to give herself up to the god for love and procreation. In *Te aa no areois* (*The Seed of the Areois*), Vairumati's hand gesture is the Buddhist *mudra* of conferring a boon or grace which Gauguin had adopted from the Borobodur relief for his *Exotic Eve* (fig. 275), and a red sprouting seed displayed in her palm symbolizes fertility and the renewal of life. It has been observed that Gauguin must have based this figure in part on Puvis' drawing entitled *Hope*, representing a young girl holding a flowering sprig (fig. 322):[94] a pictorial "document" he had taken to Tahiti which similarly suggests the idea of regeneration offsetting the finality of death. In *Vairumati tei oa* (*Her name is Vairumati*), the serene woman holds instead an oddly anachronistic, lit cigarette. Perhaps this was an allusion to the sensual freedoms women enjoyed in Tahiti, for in *Noa Noa* Gauguin related that when, soon after his arrival in Papeete, he met the Princess Vaïtua, a niece of the deceased king Pomaré, she lay on his bed smoking a cigarette while trying casually to seduce him.[95] Behind Vairumati in this picture stands a pensive man who might represent the amorous god Oro looking her over, while in the background, a stone wall separates them from a dark, monumental sculpture.

According to tradition, the Arioi society carried out its infanticide sacrifices in a special precinct whose boundaries were marked by large stones. This was a holy enclosure called the *marae*, where the Arioi also performed sexual fertility rites.[96] Gauguin followed Moerenhout in comparing these to the rituals of phallic cults in ancient Egypt and India: ceremonies devised to symbolize the universal law that life springs from the interaction between male and female.[97] We know that Gauguin meant the wall and statue in this picture to signify the *marae* , because they duplicate the imagery of another painting of 1892 entitled *Parahi te marae* (*There is the temple*) (fig. 323), a work he described to Mette as representing the sacred precinct where the cult of the gods and human sacrifices were carried out.[98] One of

the most famous of the ancient *marae* (fig. 324) still existed in ruins on the nearby sacred island of Ra'iatea, reputed to be the original site of the worship of Oro.[99] Gauguin based the figural group in the background of this Vairumati painting on a Marquesan oar carving of a double *tiki* (fig. 325), a motif which symbolizes the law of creation as the union of male and female or of spirit and matter.[100] We know from Gauguin's many other depictions and descriptions of this motif that he used it to represent the discourse about mortality and regeneration held by Hina, goddess of the moon and waters, and Fatu, god of the sun and earth. Although Hina and Fatu were not a part of the Vairumati myth, and although no images of them existed in Tahiti, Gauguin felt free to incorporate their adapted forms into his picture because they carry the same philosophical meaning as the Vairumati story: both tales teach that the laws of creation require the union of male and female, and that death is a necessary prelude to the renewal of life.

We find similar monumental statues of Hina in many of Gauguin's Tahitian paintings, where they serve to conjure up a sensation of the spiritual way of life that existed before contact with the West. By creating pictures such as *Matamua* (*In former times*) (fig. 326), Gauguin tried to assuage his own sense of personal loss that the Tahitians no longer recounted the myths or enacted the rituals of their past traditions. In this picture he embodied what he felt must have been the essential elements of a sacred, primitive lifestyle, and it is significant that his draft manuscript of *Noa Noa* calls for a description of this painting as an example of the traditional existence he supposedly observed in the remote valleys of the interior, where he journeyed to acquire an unspoiled, primitive native wife.[101] Around the soaring central tree, the tree of life or knowledge, the Tahitian women go about their activities in what Gauguin described in *Noa Noa* as "the ancient Maori way. They are happy and calm. They dream, they love, they sleep, they sing—they pray, and I distinctly see, although they are not there, the statues of their female divinities. Statues of Hina and festivals to honor the lunar goddess."[102] It has been pointed out that the statues weren't there not because they'd fallen into disuse or been destroyed, but because they had never existed in the first place. The Tahitians didn't have large-scale sculpture or individualized figures of their various gods,[103] but since it pleased Gauguin's poetic imagination to conceive of massive figures of Hina dominating his mythic landscape, he created one which synthesizes Buddhist and Marquesan imagery with Moerenhout's description of the statues of Easter Island.

Gauguin's evocation of this imaginary way of life concludes: "Around her they dance according to the rites of time past . . . and the *vivo* varies its note clear and gay, melancholy and somber, with the passing hours."[104] The

vivo is a native reed instrument which, according to Gauguin, has a particularly haunting and plaintive sound. In the first section of this study we noted that all Romantic and theosophical literature relates music making to spirituality, holding that to make music or to respond to it emotionally is both soothing and exalting because it inspires insight into the harmonious patterns of the universe. Given his own love of music, Gauguin's inclusion of the *vivo* player here in conjunction with the lunar goddess was especially meaningful for him as an evocation of a vanished spiritual existence. In *Noa Noa* he wrote that as he lay in his hut at night, watching the reeds shift in the moonlight and listening to the music of the *vivo* as he fell asleep, he could imagine the vastness of space above his head, the celestial vault with its stars, and could feel at one with the universe.[105] For him, the *vivo*, with its gay and melancholy variations, captured the essential rhythmic pattern of nature that these worshipping women celebrated: the cyclical alternation of joy with sorrow and of life with death that the story of Hina also symbolized.

Gauguin obviously found the combination of these motifs deeply satisfying, because he used them repeatedly in other pictures. One version from 1892 entitled *Arearea (Joyousness)* (fig. 327) depicts the two women beneath the tree now more closely juxtaposed with the scene of Hina and her dancing worshippers. Gauguin has enhanced his spiritual message about the sanctity of the primitive women's way of life by placing his foreground figure in the yogic lotus posture *padmasana*, her eyes fixed on the spectator's and her hand disposed in a ritual gesture called "touching the earth" or "calling the earth to witness"[106] which signifies the Buddha's victory over the demon Mara, lord of death. Considering Gauguin's symbolizing intentions in pictures like this, we must question the significance of the dog who so conspicuously dominates the foreground here. Scholars have suggested that this and many other representations of dogs in Gauguin's Tahitian paintings symbolize the artist himself,[107] an identification which recalls van Gogh's characterization of *himself* as a rough, shaggy dog. Gauguin had a pet dog on the island which he named Pego, an anagram on the French pronunciation of his own first initial and the first syllable of his last name which was also a way he frequently signed his pictures (P. Go or Gau). Given his strong sexual drives and his delight in undermining conventional respectability, he must have also enjoyed the fact that pego is the French sailors' slang word for penis.[108] In his journal he described himself as trying to get the feel and smell of his new environment in doglike fashion by roaming around, sniffing the earth and loitering on the outskirts of the groups of women who were for him both objects of sexual desire and embodiments of spiritual wisdom. If, as seems likely, the dog with the collar in the relief *Be loving, you will be happy* (fig. 266) symbolized Gauguin the loyal spouse held captive by his European marriage, it's very possible that the free-ranging, collarless dogs in his Tahitian pictures symbolize the presence of his own liberated and "savage" or "primitive" self in his new milieu. A painting related to *Arearea* entitled *Tahitian pastorale* (fig. 328) seems to substantiate this idea, for its subject is clearly the annoyance of the woman who has noticed the presence of this eavesdropping intruder, or perhaps his nearby master, and has risen, glaring, to deal with him. It is surely no coincidence that we find another of these dogs listening to the women's talk about evil spirits in the foreground of *Barbaric tales* (fig. 313).

Gauguin continued to utilize Moerenhout's information about Polynesian mythology in his visions of ancient primitive life. In 1893 he painted two pictures which were so meaningful for him that he made them the focus of a section of *Noa Noa*. His manuscript tells us that after the woodcutting expedition with the native Totepha, in which Gauguin confronted and destroyed his old European self and emerged more a Maori, he next conceived a desire to visit the remote central plateau of the island. Apparently still proud of being perceived by the Tahitians as the bold and rational Westerner, he claimed that he was spurred on to undertake the trip by the natives' superstitious warnings that he would be "'tormented by *tupapau* at night'" and that he "'must be mad or reckless to go and disturb the spirits of the mountains.'"[109] It has been observed that this purported journey could never have occurred because the density of vegetation and the ruggedness of the mountains make the interior of the island impenetrable,[110] but Gauguin's adventure is clearly apocryphal in any case. He described his arduous ascent into the heart of Tahiti as another level of induction into the mysteries of primitive being: an initiation rite during which, after coping for two days with a series of harsh physical and psychological challenges, he was rewarded with two visionary experiences. These passages are very similar to Pierre Loti's description of a spiritual excursion made by the protagonists of his Tahitian novel, and Gauguin contrived them in order to provide explanations of the mystical ideas he associated with his paintings *Pape moe (Mysterious water)* (fig. 329) and *Hina Tefatou (The Moon and the earth)* (fig. 330).

In *Noa Noa* Gauguin tells us that after a frightening night in the pitch black forest, where he comforted himself by remembering that the supposed *tupapau* exhalations were actually luminous mushrooms,[111] he proceeded at daybreak on a path which became increasingly animistic as it led him further away from civilization. "Wilder and wilder, the river turned more and more to rapids, twisting more and more. Huge crayfish eyed me, seeming to say: 'What have you come here for? Who are you?' Age-old

eels. . . . Often I was obliged to climb, swinging from branch to branch."[112] At this point in relating how he had been reduced to some primal, apelike aspect of himself, Gauguin interrupted his draft text with a notation to describe his painting *Pape moe*. He did so in his final version of *Noa Noa*, writing: "Suddenly at an abrupt turning, I saw a naked girl standing against a rock face which she seemed to be caressing more than holding on to. She drank from a gushing spring which fell a great distance among the rocks."[113] We know that Gauguin fabricated this eyewitness experience because a scholar discovered the photograph of a Tahitian woman (fig. 331) which was his real pictorial inspiration for *Pape moe*: it was taken by a contemporary of Gauguin's who helped decorate the Tahitian pavilion at the 1889 Universal Exposition in Paris.[114] In the fictionalized *Noa Noa*, however, he continues:

I had made no sound. When she finished drinking she took water in her hands and poured it over her breasts, then, as an uneasy antelope instinctively senses a stranger, she gazed hard at the thicket where I was hidden. Violently she dived, crying out the word 'tachae' (fierce) I rushed to look down into the water—vanished —Only a huge eel writhed between the small stones of the bottom. . . .[115]

The vision described here and in Gauguin's painting is essentially a symbolic revelation of the spiritual manner in which life was experienced in a remote and primitive past. For the native viewing the world through the eyes of mythology and superstition, the mountain was the embodiment of the earth god Fatu and the waterfall an aspect of the goddess Hina. In Gauguin's design the two elements mingle with and encroach on one another, their surfaces overlaid with patterns of vegetation, reflections, and shadows to create the unified effect of a decorative screen. The "girl," whose androgynous body suggests merely a sexless primitive being, is at one with both the male and female components of her environment: she caresses the masculine stone with familiar ease while she leans out over the pool to drink the life-giving feminine water. Her close spiritual affinity to this harmonious, interactive realm is even more apparent when we realize that her gaze is fixed with calm assurance on a fish head which metamorphoses out of the rock, a pictorial suggestion related to the description in *Noa Noa* of the crayfish which eye Gauguin, as well as to the girl's own sudden, supernatural metamorphosis into an eel. Like so many women in Greek mythology, her special relationship to the forces of nature, to the gods, enabled her to avoid unwelcome contact through transformation. For years Gauguin had used the image of a woman plunging into the sea as a symbol for the human desire to plumb the depths of experience and gain knowl-

edge of life. The girl in *Pape moe*, then, must have symbolized for him the spiritually advanced state of Tahitian woman, who was already so at home in the water that she could turn herself into an eel—a water snake capable of penetrating the most inaccessible secrets of the earth.

It is significant that in another section of *Noa Noa* Gauguin described his own risky swim down into a dark, subterranean, eel-infested sacred grotto: an adventure undertaken in order to satisfy his curiosity about the mysteries concealed in its hidden depths. Here, the roots growing in the fissures of the rocks resembled serpents which regarded him ironically, and although he never succeeded in reaching the cave's innermost recesses, he experienced his return to the outer world as a rebirth.[116] For Gauguin, the native figure in *Pape moe* expressed the intuitive rapprochement with the forces of existence that he longed to actualize in himself, and in his account he spied on her as mortal men occasionally did on Greek goddesses. When Charles Morice wrote the poems which Gauguin incorporated into his final copy of *Noa Noa*, his verses on the theme of *Pape moe* also suggest that the girl's immersion in the pool signified her access to vital secrets. He wrote of the cascade:

Tahitian source! Purifying water! Sacred water!
Source of truth, your brilliance enlightens me.
Source of voluptuousness, your counsels are the true ones.
I listen to you, and your voice teaches me the Secrets.
Mysterious source, divine water, lustral water . . .
O I shall drink from your sacred stream to purify my heart . . .
And I want to wash my eyes in order to see
The ancient way of life reflected in your mirror.[117]

After the *Pape moe* incident, the next line of Gauguin's draft manuscript of *Noa Noa* notes simply: "Arrival near Arorai—Legend of Tefatou."[118] His elaboration of this in his final text provided the explanation for his painting *Hina Tefatou* (*The Moon and the earth*) (fig. 330), and it constitutes another proof that this journey was a metaphor for his own attempt to acquire primitive wisdom and spiritual harmony. He wrote: "Not without difficulty and fatigue, I at last arrived close to Arorai; the summit of the Isle, the dreaded mountain. It was evening and the moon was rising. Watching it, I was reminded of that sacred dialogue in the very place where legend tells us it was first performed."[119] Here, he quoted the passage from Moerenhout describing the conversation between Hina and Fatu about death and rebirth, a passage which he had already copied and illustrated in his manuscript *Ancient Maori cult*:

Hina said to Tefatou: Make man live again after his death. The God of the Earth replied to the Goddess of the Moon: —No I

shall not revive him. Man will die, the vegetation will die, as will those that live from it, the earth will die, the earth will be finished, finished never to be reborn. Hina replied: Do what you will. As for me, I shall revive the Moon. *And that which was Hina's continued to be, and that which was Tefatou's perished, and man must die.*[120]

At a later point in *Noa-Noa* Gauguin observed that for the Tahitians, as in many other cultures, the moon, which appears, grows, wanes, and disappears cyclically, signified life and its infinite reproductiveness—an evolutionary process they conceived of as feminine and contrasted with the masculine limitations of individual existence.[121] He went on to remark that the Hina-Fatu myth had other implications as well, such as its symbolizing the interaction between tender female sympathy and remorseless male severity, or its suggestion of the fundamental truth that death is necessary for the ongoing process of life.[122] Perhaps Gauguin was fascinated by this myth because it embodied ideas which he had already embraced and had claimed underlay his decision to come to Tahiti: his desire to unify the conflicting impulses of his personality and create a new identity from the willful destruction of his old Western self.

In this painting, he has portrayed the dialogue in terms of all its implied oppositions. The glowing goddess of the moon and waters, surmounted by a silvery white lunar crescent, leans up against the swarthy earth god, whose head is haloed by the fiery sun. Her gesture is caressing and propitiatory, while he is implacable and unyielding, and her life-giving feminine waters spill over the hard surface of the rock beneath him in the same way that her pleas trickle ineffectually in his ear. But just as water will wear away stone over a long enough period of time, modifying its seemingly impervious form, so Hina's principle of regeneration mitigates the finality of individual mortality and ultimately maintains a balance between life and death. It has been observed not only that Gauguin's image of Hina follows other nineteenth-century artists' conceptions of a common theme called *The Source*,[123] but that with his usual eclectic freedom he modeled his Polynesian version of the interaction between male and female deities on a neo-classical painting dealing with a similar subject: Jean-Auguste-Dominique Ingres' *Jupiter and Thetis* (fig. 332).[124]

Gauguin had already used this dark skinned, thick-lipped male head of a "Kanaka," or Maori, in a very cryptic work of 1892 (fig. 333) entitled *Arii Matamoe*, which literally means "Sleeping king," but which Gauguin translated as "The Royal end" when he exhibited it in France in 1893.[125] It depicts the disembodied head resting on a white pillow in a room whose darkness contrasts dramatically with the golden brilliance of the outer world

glimpsed through the door at the rear. The room's massive furniture and jewel-like Oriental carpet reinforce the title's reference to the king, since Polynesian royalty had throughout the nineteenth century enjoyed the Western trappings of European monarchies. Given the painting's title and peripheral imagery, this decapitated head seems to be a metaphor for the demise of Tahitian culture. According to traditions that Gauguin read about in Moerenhout and copied into both his *Ancient Maori cult* and *Noa Noa* manuscripts, Polynesian kingship was invested with great religious significance, and the chief was perceived not only as the head of the people, but as the personification of their social and religious power.[126] By depicting the deceased king in the manner of a sacrificial victim, a sort of martyred St. John the Baptist whose head is traditionally offered up to us on a platter, Gauguin conveys the suggestion that the West's brutal destruction of traditional Tahiti was a sacrilegious murder and an act of spiritual barbarism.

The other images in the picture seem to enlarge on this central idea. In the middle ground we find the familiar figures of the mummy-Eve and the woman in the waves, the motifs with which Gauguin symbolized the fearful rejection of experience leading to spiritual death and the courageous leap into the unknown required for meaningful life. Here, the mummy figure sits in mourning near the head in the darkened room, while the woman in the waves turns her back on the funeral chamber and rushes toward the open door, the tropical sunlight, and the daily life signified by the native figures outside. On the floor of the room rests a masklike carved head which has been identified with a drawing Gauguin made in his *Ancient Maori Cult* manuscript depicting the seventh sky of the Tahitian cosmology,[127] directly beside the door is a monumental carving seemingly of Hina and Fatu engaged in their eternal dialogue about the necessity of death and the possibility of rebirth,[128] and on the pillow beside the king's head rests the lotus which symbolizes a new flowering after the destruction of the old. Together, these motifs signifying the principle of renewal convey the idea that the challenges of change and loss can be met either by shutting oneself into grief for the past, or by throwing oneself into the life of the present. In conjunction with the title, the imagery of the painting leaves us to wonder if Tahiti is as dead as the severed head would lead us to believe, or if perhaps it is merely sleeping and will be reawakened by its inhabitants' desire to revive the values if not the rituals of their ancient traditions.

One of the last pictures Gauguin painted before returning to France in the summer of 1893 is a portrait of Tehamana entitled *Merahi metua no Tehamana* (*The many parents of Tehamana*) (fig. 334). It has been noted that this title refers to the Tahitian custom of sharing children with foster

parents,[129] a circumstance which Gauguin claimed disconcerted him at first[130] but which he soon came to feel was the ultimate proof of the natives' loving and nurturing sensibility. In his journal *Before and After* he wrote regarding the happiness with which they adopted children: "There you have the savagery of the Maoris: this I adopt. All my doubts were dissipated. I am and I will remain this savage."[131] It has also been suggested that the title of the painting relates to the natives' belief that the geneology of all Tahitians could be traced to the original union of Hina with the creator god Taaroa,[132] an idea which the imagery of the background seems to substantiate. Gauguin depicted his young native wife here with the serene dignity that he claimed characterized her even in her most childish moments, holding the plaited palm leaf fan which was traditionally the attribute of a great beauty,[133] and sitting in front of a wall on which rows of pictographs surmount an image of Hina making that Hindu gesture of ongoing life which Gauguin had already used in his painting *Terrifying words* and in a wood sculpture (figs. 314 and 315). The presence of Hina and the heads of her devotees in this frieze signify that the life-enhancing attitudes Gauguin so valued in Tahiti were part of the natives' larger religious reverence for creation: a reverence they exhibited not only in their worship of the goddess of rebirth, but in all the social relations of the community's daily life. It has been observed that Gauguin based his pictographs on the decorative but indecipherable glyphs of ancient Easter Island, examples of which he could have seen both at the Universal Exposition of 1889 in Paris and at the Catholic Mission in Papeete.[134] He seems to have used this mysterious primitive writing to suggest that the traditional culture of Oceania which gave birth to Tehamana was a source of secret wisdom: knowledge lost to the West despite all our rational analyses of foreign civilizations. In this celebration of the Tahitians' approach to human relationships, Gauguin paid tribute to the girl whom he credited not only with inducting him into the life and beliefs of the natives, but with regenerating and rejuvenating his spirit.

If Gauguin was so enamored of life in Tahiti, why did he decide to return to France? Although his remarks before he set out for the tropics implied that this was to be a permanent removal and that he expected to sing, love, and die there, far from the decadent centers of European civilization, his reconciliation with Mette before his departure and his persistent desire to use his Tahitian experience as a stepping stone to acceptance in the West indicate that he meant from the beginning to leave after two or three years. In *Noa Noa* he claimed merely that family business necessitated his return home, but in actuality he began to search for a means of leaving Tahiti in September of 1892, several months after he began to live with Tehamana. His reasons

must have been multiple. When Mette had first suggested to him that he was wrong to stay so far away from the artistic center of Paris, he had retorted stubbornly: "No, I am right, I've known for a long time what I'm doing and why I'm doing it. My artistic center is in my brain and not elsewhere and I am strong because I am never deflected by others and what I am doing is what is in me."[135] Yet he did miss the intellectual and social life of Europe as well as his family, and the unexpected hardships and disappointments of his life in Tahiti in addition to his unquenchable need for public acclaim and financial success made his return a necessity. After more than a year of subsisting on minimal funds and receiving nothing from home, he heard from Mette that she had finally been able to sell a lot of his old Brittany paintings. Although keeping the proceeds for herself and the children, she informed him that two Danish artists had arranged for him to be invited to participate in a large exhibition of modern art to be held in Copenhagen in the spring of 1893. Believing that the time was now ripe for success, Gauguin wanted to get back to supervise the hanging and experience the sweet triumph of vindicating himself with Mette's family. While he immediately began to plan his departure, however, he decided to make a quick trip to the Marquesas first in order to finish up his Oceanic adventure in a truly primitive environment as yet undefiled by Western contact. In the loving letter in which he responded to Mette's good news, he wrote:

When will I return, you ask. I long to see you all again and also need a little rest, but have to be sensible. A journey like this hasn't been undertaken lightly, like an excursion. It must be complete, so that there will be no need for me to come again. After that my life of roving will be finished. Just have a little more confidence in me, Mette dear, it is for the good of us all.[136]

Unfortunately, finding the cash to purchase his passage home proved impossible, and while he waited for a repatriation order to be sent from France, he had to occupy himself solely with wood carving because he had run out of canvas and paints. In November he was summoned to Papeete to receive, for the first time since his arrival in Tahiti, a small sum of money from the sale in Paris of one of his Breton pictures, and he was also informed by the governor that a request for his repatriation had been received. A recurrence of the heart problems he had experienced the year before led him to cancel his plan to visit the Marquesas, but believing that he would be sailing in two months he spent most of his funds on the art supplies he needed to paint the final Tahitian pictures he had in mind. Due to the malice of the governor his repatriation request was not honored, and during the five months that it took to obtain a new order he not only existed in a state

of poverty, but received the demoralizing news that his friend Morice had bilked him of a substantial sum of money he had received on Gauguin's behalf from a dealer's sale of several more of his paintings. It must have been with a combination of regret and relief that the penniless artist finally set sail for France on 14 June. *Noa Noa* concludes with an account of Tehamana's tearful farewell at the quay and a sentimental Maori song about a native woman weeping for her departed lover, but Gauguin must have realized that he needn't feel guilty about his young mistress. As

scholars have noted, she had either aborted or miscarried their child, and the penultimate section of *Noa Noa* reveals not only that she had other lovers whom she met during the day while Gauguin was working, but also that either her foster or her real mother had been living with them during the last part of his stay.[137] Like all else in life, Gauguin's Tahitian idyll had been as disillusioning as it was fulfilling, but in *Noa Noa* he declared that his two years in Oceania had left him "rejuvenated by twenty years; more of a barbarian too, and yet more educated."[138]

Bitter Interlude and Return to Paradise:

1893–1903

Disillusionment in France: 1893–1895

GAUGUIN ARRIVED AT MARSEILLES ON 30 AUGUST 1893 with only four francs in his pocket, but with sixty-six Tahitian paintings and the high hopes that he was at last going to reap the fruits of his dedication and hardships: the end of his economic deprivation and a triumphant reunion with his family. There was neither money nor a letter waiting for him, however, so he went to a cheap hotel and sent off telegrams for help as well as a letter to Mette. This inauspicious homecoming established the pattern that his two years in France were to follow. He returned to Paris with a loan from Sérusier only to find that the dealers who had handled his work were no longer with their galleries. Although he managed to convince Durand-Ruel to show his Tahitian pictures in November at his own expense, and his long-range financial anxieties were relieved by the news that he would in a few months be receiving an inheritance from the death of his uncle Isidore in Orléans, he was deeply depressed to learn from Mette that the Copenhagen exhibition had resulted in only a handful of sales and that she had already spent the proceeds for her own and the children's needs. Anticipating a great success with the Durand-Ruel sale, he wrote imploring her to come to Paris with their son Pola to see him and discuss the future.[1] Although their reconciliation before he left for Tahiti had prompted him to write that when he returned they would be "married again,"[2] Mette showed no inclination to rush to his side. Lacking the money to make the trip, wrongly assuming that he was already in possession of his uncle's inheritance, and angry at what seemed to her his perpetual selfishness and irrational optimism, she refused indignantly.[3]

His disappointments continued. When he reminded the new director of the Academy of Art that they had promised to buy one of his Tahitian paintings, he was told that his art was so "revolting and unintelligible" that to support it

would cause a scandal.[4] Understandably bitter, forced to borrow more money from friends against the inheritance that would soon arrive, he threw all his energies into preparing for the exhibition at Durand-Ruel, which he felt sure would vindicate him and mark the beginning of success. Within a few minutes of its opening he could tell by people's faces and remarks that he had once again miscalculated, and that despite the enthusiasm of his inner circle, he was still an object of ridicule and an abject commercial failure. It was to his credit that, according to Charles Morice's account, he remained calm and affable, the embodiment of his own self-characterization as an Indian capable of smiling under torture.[5] The mainstream press denigrated his subjects, his drawing, and his color, calling his sumptuous and deeply serious pictures "a farce" and "the delusions of a sick mind, grossly insulting to art and nature."[6] Only eleven paintings sold, and in addition to the disgrace of his unexpected failure, the prospect of continuing poverty meant the end of his expectations of rejoining his family. Mette had made it clear over the nine years of their separation that she would not live with him unless he had a regular income with which to support a respectable way of life. Although Gauguin's first impulse was to return immediately to Tahiti, his friends convinced him to stay and try to win over the public and critics lest he be forgotten forever. Motivated by Morice's enthusiasm and persuasive offer of collaboration, he launched into the writing and illustration of *Noa Noa*, the document he hoped would make his intentions and subjects intelligible to his hostile audience. He painted the walls of his new studio chrome yellow, arranged his Tahitian paintings and Maori artifacts, and when not receiving visitors to show his work, he set to work on his manuscript.

As Gauguin became friends with his downstairs neighbors—a mildly bohemian couple named William and Ida

Molard whose apartment was an open house for musicians, poets, and painters—he entered into a lively social life of drinking, music, charades, serious discussions, and reading aloud from his manuscript. He also developed a quasi-paternal, quasi-sensual relationship with Ida Molard's precocious and provocative twelve-year-old daughter Judith, whose memoirs reveal that she had a passionate crush on the artist but that to her deep disappointment all he ever did was occasionally fondle her "as if caressing a jug or a woodcarving."[7] Although he frequently saw Juliette Huet, the milliner who had given birth to his daughter after he left for Tahiti, she refused to live with him for fear that he would want to keep their child, and after Mette heard reports of his jolly life style, the remnants of their relationship disintegrated into an acrimonious exchange of accusations about money and hard-heartedness. It was for these reasons that when the dealer Ambrose Vollard mentioned to Gauguin that he might like to use as a model a thirteen-year-old half-caste Javanese girl who needed work, the artist took her in, bought her a pet monkey, and kept her on as a substitute for Tehamana (fig. 335). Her name was Annah, and she immediately aroused the jealousies of both Judith Molard and Juliette, who was so outraged to find her at Gauguin's studio that, after a torrent of abuse, she stormed out and never communicated with him again.[8]

Gauguin's writing and the renewed pleasantries of social life left him little time for painting that winter, but he did produce a strong self-portrait and a large, full-length portrait of Annah the Javanese. The self-portrait (fig. 336) was clearly based on a photograph taken by Schuffenecker in 1888 (fig. 337), which shows the artist wearing the rakish costume that Armand Séguin later described as "his astrakhan hat and his huge dark blue overcoat buttoned with a precious buckle, in which he looked to the Parisians like a sumptuous, gigantic Magyar, or like Rembrandt in 1635."[9] Gauguin's painted version, although executed five years later, shows us a man who looks younger, bolder, more deeply tanned, and even more ironically aware: no doubt the legacy of rejuvenation and education that he had brought home from Tahiti.

His portrait of Annah (fig. 338) is particularly interesting for the suggestiveness of its title, which doesn't refer to Annah at all but consists of a Tahitian phrase meaning *The Child-woman Judith is not yet breached* (*Aita tamari vahine Judith te parari*).[10] In conjunction with the Javanese girl's unconventional portrayal, Gauguin's use of a Tahitian title and his reference to the still virginal but sexually aware Judith Molard indicate the nature of his reflections about his relationships with the three adolescents who had aroused his desires and about the cultures that produced them. The only type of feminine nudity the overtly respectable but secretly prurient European public found acceptable in art was that of idealized women disporting themselves in the guise of goddesses or languishing seductively in harems, and even the unconventional Manet's scandalously realistic portrait of the soubrette Olympia depicted her reclining in bed in a traditional manner. Gauguin must have anticipated that the public would be shocked and offended by his bold representation of the undressed and fully developed but far from idealized foreigner, who is seated upright in a chair as if for a formal portrait. Annah, whom Judith described as both vain and supremely self-confident,[11] faces us with an expression of relaxed assurance and the natural dignity of a queen. Although Gauguin knew that her gaudy earrings, stocky proportions, and unabashed display of pubic hair would make her look more naked than nude to the "civilized" Western eye, and that her frank frontal pose unmodified by the tactful concealments of drapery folds would seem immodest and provocative, Annah faces us with the unselfconscious tranquillity of one who feels no need to mask reality. Perhaps it pleased him to portray her as another incarnation of that primitive blend of experience and innocence which had attracted him in Tahitian girls, and he must have pondered ruefully once more on the misfortune that his own civilization either cloaked, denied, or vilified the sexual instinct. He suggested this cultural contrast by placing his exotic model in a stiff European armchair whose inappropriateness serves to emphasize her easy nudity and the tropical suggestiveness of her accoutrements: the orange monkey, the flowered cloth under her feet, and the richly colored pink wall behind her. Gauguin's title, however, reveals that the serenely sensual Annah evoked comparative thoughts of a more personal and specific nature as well. Woven into his feelings for the Javanese girl was obviously the recognition that his neighbor's daughter Judith, although of the same age and apparently the same amorous inclinations as Annah, was as yet an unplucked fruit whom the artificial moral conventions of the West forbade him to enjoy.

Naturally, Gauguin's thoughts were often on Tahiti during this period, and the majority of the works that he produced during 1894 and 1895 have Tahitian subjects of a particularly dreamlike quality. During this first winter in Paris he began executing woodcut illustrations to accompany his *Noa Noa* manuscript, and he copied and illustrated another document of thoughts and reminiscences called the *Notebook for Aline* because it contains some advice to his daughter whom he hadn't seen since 1891. He also began to try, without success, to recover some of the large number of Impressionist paintings that Mette had sold from his collection in order to support the family. Although he could now have gone to Copenhagen to see them, it seems that Mette's bitter intransigence, Gauguin's own pride, and

perhaps also some thought of putting off the trip until his children were out of school caused him postpone this difficult visit. Instead, at the end of April 1894, he left for Brittany with Annah.

No sooner had Gauguin settled at Le Pouldu than he became embroiled in a fierce dispute with his former landlady, Marie Henry, who on the advice of her new husband refused to return all the paintings and sculptures that the artist had left in her keeping when he went to Tahiti. His bad luck continued when a few weeks later, on a visit to the nearby town of Concarneau with three other artists and their girlfriends, their eccentric-looking group became the target of aggressive abuse from local urchins and sailors. A fight ensued during which Gauguin had his right leg broken, an injury which kept him confined to bed for two months on a steady diet of morphine and alcohol to blunt the pain. On 23 August, still in a fragile condition, he made a twenty-five-mile journey to Quimper to be present when their assailants were sentenced. Having lost two months of work and suffering from considerable physical damage and excruciating pain, he was understandably outraged by the local judge's decisions to award him only six hundred francs of the ten thousand he had demanded, and to imprison the man who broke his leg for a mere eight days. This incident marked the point of no return for Gauguin, and shortly afterwards he announced his decision to return to Paris at the end of autumn, sell all his remaining belongings, and depart forever for the South Seas. He hadn't heard from Mette since the beginning of the year and although she had received the news of his condition, her fury over their finances and her disgust at his bohemian escapades made her choose to let pass any lingering possibility of retrieving their marriage by going to his aid. In addition, tired of caring for the invalid Gauguin, Annah had returned without warning to Paris and had looted his apartment of all his possessions except his paintings. When in November Gauguin also lost his lawsuit against Marie Henry for the repossession of his artworks, he left immediately for Paris to start preparing for his escape from a Europe that now more than ever seemed an evil prison. On 18 February, there was an auction of his work at the Hôtel Drouot which sold only nine pictures and netted Gauguin a mere 464 francs, and on the heels of this new disappointment came his unhappy realization that he was suffering from a venereal disease whose treatment would require a further postponement of his departure from France.

Several years later when he was back in Tahiti, Gauguin accounted for his refusal to consider returning to Europe by claiming that "in France, with the disgust that I have for it, my brain would perhaps be sterile; the cold freezes me physically and morally, everything becomes ugly in my eyes."[12] It is no wonder that, with the exception of a few pictures of Breton subjects, most of the work Gauguin managed to produce before leaving for Tahiti at the end of June 1895 consists of nostalgic visions of a world which, for all its flaws, must have seemed even more of a paradise and a refuge than before. A self-portrait from the first winter in Paris (fig. 339) reveals that Tahiti dominated his thoughts as well as the environment of his studio, for he chose to depict his brooding face against the backdrop of a mirror-reversed image of his painting *Manao tupapau* (*The Spirit of the dead is watching*), a work he felt conveyed the essence of primitive life. As if to emphasize the importance and relevance his experiences there still had for him, he represented himself in front of the same exotic cloth that Tehamana lies on in the picture—a tangible link between his former life and his present existence. Most of his other works from this period, however, are full-blown poetic recreations of the mythic world he had begun fabricating in his paintings of 1892 and 1893. Of these, his woodcut illustrations for *Noa Noa* have a particularly powerful and haunting effect. Some of them (fig. 340) are simply translations of earlier Tahitian pictures (fig. 284) into a graphic medium, while others (figs. 341 and 342) are new syntheses of motifs culled from a variety of his Tahitian images. Nearly all, however, utilize a wire-thin edge of light to delineate dark figures against a dark ground: a device which creates a dream-like impression of nocturnal mystery.

Gauguin's paintings of Tahitian subjects from this period also tend to recombine images from his previous pictures in order to suggest salient aspects of a primitive and sacred way of life. One of these, entitled *Nave nave moe* (*Delicious repose*) (fig. 343), deals with the Tahitians' acceptance of sexuality as a sanctified part of existence. The Tahitian title has to do with the langour that follows sensual pleasure, and the painting depicts two girls resting amid an exotic, richly colored landscape. The girl on the right, wearing the white flower behind her ear that indicates her desire for a lover, is awake and dreamily contemplating the ripe fruit she holds ready to eat in her hand. The girl on the left, whose eyes are closed and who is therefore presumably resting after the pleasures of love, is crowned by the halo that in Christian iconography is reserved for saints or for the Virgin Mary, while the huge, lily-like flower in the foreground seems another exoticized reference to the purity and beauty of the mother of Christ. Gauguin appears to be suggesting here that it is not virginity, but rather love and sexuality that are beautiful and holy, an idea which is reinforced by the imagery of his background. Off in the distance of this imaginary landscape we find another of those monumental statues of Hina that Gauguin invented to express the traditional Polynesian reverence for the sexual forces that counteract death, and around her a

group of dancing women pray to the moon goddess for the fertility that ensures the continuity of life.

The intimate, fluid relationship that the Tahitians perceived between the forces of life and death seems to be the subject of still another picture of 1894. Cryptically entitled *Arearea no varua ino* (*Joyousness of the evil spirit*) (fig. 344), it depicts two women relaxing in silent contemplation amid the lacy patterns of fallen flowers and leafy shadows. Arching behind them, Gauguin's familiar snakelike tree separates them from a background scene in which a lifelike idol on the left is balanced by two naked human figures on the right, poised against a backdrop of rocks and green sea. They appear to be male and female, and the gesture of the male suggests an invitation to the woman on the rock, perhaps to swim. Between the human figures and the idol floats an amorphous form like a winged head or flower. Much of this imagery recalls the components of *By the sea* (fig. 319), where going in to bathe seemed to be a metaphor for the ease with which the Tahitians abandoned themselves to life experience. The brooding central woman amplifies this message, for she and her resting companion are reminiscent of the figures in *What, are you jealous?* (fig. 297), whose subject is the complicated emotions to which adult relationships give rise. To round out his imagery and idea Gauguin added the statue and the odd, floating shape beside it, forms which duplicate the figure of Hina and the head of her worshipper that he had created first as a wood carving (fig. 315), had next incorporated into his 1891 painting *Terrifying words* (fig. 314), and then reused in his 1893 painting of Tehamana (fig. 334). This new synthesis of motifs holding such specific meanings for Gauguin can be understood as yet another evocation of the Tahitian propensity to meditate seriously on the related experiences of love, birth, death, and renewal. Perhaps the title "Joyousness of the evil spirit" was another way of expressing the irony and ambiguity of existence, where happiness is so often mingled with suffering and good so intertwined with evil.

Gauguin addressed the same issues in another visionary landscape entitled *Mahana no Atua* (*The Day of the God*) (fig. 345), a work which again depicts a harmonious world whose elements coalesce in a series of richly colored, serpentine patterns. In the foreground, two recumbent children flank a young girl who sits with her feet in the pool before her, gazing pensively at the swirling, dreamlike colors of the water. Behind them looms yet another statue of Hina in the Hindu pose denoting the rhythmic cycle of life, death, and rebirth, but in this version she is surmounted by an arched crescent symbolizing the bodhi tree under which the Buddha achieved enlightenment: a motif Gauguin adapted from one of the Borobodur reliefs (fig. 346).[13] Around this central statue a group of women are

disposed: some carrying offerings, others dancing, one cradled in a lover's arms, one playing a *vivo*. Like his earlier picture *Vintage at Arles*, this painting seems to symbolize the physical and psychological stages of the life cycle. The figures of the children balancing one another on either side of the main figure lie in forward- and rear-facing fetal positions that are suggestive of birth and death, an idea reinforced by Gauguin's use of the curled-up, rear-facing figure overlooked by a *tupapau* in a woodcut for *Noa Noa* which he had entitled *Manao tupapau* (*The Spirit of the dead is watching*). The women in the background carry out both the secular activities and religious worship that maturity entails, while the young girl in the center, awake but not yet a part of the adults' communal world, sits passively dreaming, with her feet just immersed in the stream of life.

During the winter of 1894–1895 Gauguin's perception of himself as a misfit in and victim of European society led to the creation of his most powerful piece of ceramic sculpture (fig. 347). He called it *Oviri*, the Tahitian word for "savage" or "wild" and a reference to a mythological deity named Oviri-moe-aihere: the "savage who sleeps in the forest" and presides over death and mourning.[14] At the end of *Noa Noa* Gauguin had transcribed a verse from a melancholy Tahitian song entitled *Oviri* about a man who loves two women who both weep for him; its chorus, which he did not include, asks: "What are the thoughts in his heart? Does he dream of wild music, of dancing on the beach? What are the thoughts in his savage, restless heart?"[15] These associations suggest that the sculpture of Oviri was meant to express that primitive part of Gauguin's nature with which he identified so strongly: that savage sensibility which in its ability to penetrate the ruthless facts of reality and symbolize them in a single dramatic image differs from the artificial respectability of the West. The sculpture represents a powerful female being with the staring eye sockets of a mummified Marquesan chief[16] and the body of a Buddhist fertility figure from the Borobodur reliefs.[17] Under her feet lies a crushed wolf in a pool of blood, and in her arms is its cub which she presses to her side. Another source for this terrifying figure must have been the stone sculptures of female deities which were produced in the Austral Islands and the Marquesas and had spread from there to the rest of Polynesia (fig. 348). Its face also resembles the faces of Marquesan tiki carvings that were associated with funerary rituals and divination (fig. 311). Interestingly, in 1892 Gauguin had painted a more human version of Oviri (fig. 349) in a first rendition of the picture entitled *Ea haere ia oe?* (*Where are you going?*) (fig. 304). Here, in place of the ripe fruit held by the figure in the second painting, the solemn woman clutches the limp body of a whelp or puppy.

Gauguin referred to his statue as "La Tueuse," the Killer,[18] and he incorporated a woodcut version of it into

his *Noa Noa* manuscript. The fact that he associated this savage figure, part murderer and part nurturer, with his own fate is evident not only from the personal implications of the Oviri song he included at the end of his manuscript, but from a self-portrait plaque which he executed this same winter (fig. 350). Here, the name "Oviri" is inscribed directly over his head, in between his Pego signature and a large, conspicuous blossom which, in keeping with his earlier use of this motif, must symbolize his own receptivity to sex and love. In 1895 Gauguin sent a copy of his woodcut version of Oviri to his friend Stéphane Mallarmé, inscribed with the cryptic words "this strange figure and cruel enigma." The cruel enigma must be the mysterious paradox of life to which Gauguin had long been sensitive: the brutal fact that every development of creativity, every experience of change and growth, as well as of birth or renewal, is connected with some aspect of death and destruction. This is the same idea that underlies all the metaphorical events in *Noa Noa* by which Gauguin claimed to have annihilated some aspect of his conventional European self in order to refashion himself as a primitive. It is significant that back in 1889 he had written to Theo van Gogh regarding the storm of controversy over his works in the Volpini exhibition that "Degas and others have well understood. There is a wolf in the sheepfold."[19] Years later, in a letter of 1899 to Fontainas, Gauguin also mentioned that at the opening of his disastrous 1893 exhibition at Durand-Ruel's, Degas had answered a baffled young man's request to explain Gauguin's work to him by reciting a fable of La Fontaine's and concluding: "'You see, Gauguin is the hungry wolf without a collar.'"[20] It would seem that Gauguin had this characterization in mind when he placed a bleeding wolf under Oviri's foot and its offspring in her arm. A savage cousin of the dog, the collarless wolf here is the embodiment of Gauguin's primitive self.

Another inscription which he wrote years later on a drawing of Oviri reveals that he indeed associated the figure of "the Killer" with rebirth as much as with death: "And the monster, embracing its creation, filled her generous womb with seed and fathered Séraphitus-Séraphita." We recall that Séraphitus-Séraphita was the androgynous protagonist of one of Gauguin's favorite novels by Balzac, a character who reconciled within a single metamorphic body all the antithetical qualities associated with male and female identity. In its union of reason and intuition, manly strength and womanly tenderness, this supernatural being was described as the pivot of the world from which life in all its complexity is generated. When Gauguin identified Oviri as the progenitor of this character, he revealed that for him this monster-deity symbolized the inexplicable, androgynous life force which drives the universe and which he felt had led him to his present state: it was the source of that creative urge for self-actualization which had seized him in its powerful grip and left so much tragic destruction in its wake. *Oviri* is the expression of Gauguin's conviction that life was killing him in exchange for his pursuit of creativity, crushing him (and by extension his family) underfoot as he gave birth to the art which was the offspring of his spiritual self. In both its savage theme and its deliberate stylistic crudity it pays tribute to that elemental part of himself which was more acceptable in Tahiti than in Europe, and which found comfort in the unvarnished depiction of hard and complex truths. The significance *Oviri* had for Gauguin was evident in the wish he expressed to his friend Monfreid in 1900 to have this sculpture mark his grave.[21] Like Gauguin's other ambitions for recognition and success, even this desire was not fulfilled until long after his death. It was only in 1973 that a bronze cast of his original ceramic figure was finally placed over his grave on the Marquesan island of Hivaoa.

Joy and Suffering in Paradise: Tahiti, 1895–1901

Two months after taking ship once more from Marseilles, making brief stops in Australia and Auckland, New Zealand, where he sketched the Maori collections of the ethnographic museum, Gauguin arrived back in Papeete at the beginning of September 1895. He was immediately struck by the extent to which Europeanization had spread in the port capital during the two years of his absence. Newly installed electric street lights of a strident yellow color destroyed the mystery of the Tahitian night; a hideous and very noisy steam-driven merry-go-round now occupied the park outside the vacant royal palace; bicycles had proliferated and tennis had been introduced.[22] In disgust, Gauguin at once resolved to go to a more primitive

place, writing to William Molard with his usual optimism that he would soon "be in La Dominique, a delightful little island in the Marquesas, where living costs practically nothing and where I'll have no Europeans. With my small capital and a well-equipped studio I shall live there like a lord."[23] But although he spent a few days sailing to neighboring islands, he decided not to leave Tahiti after all. Perhaps reflection reminded him that at the age of forty-eight, suffering from a weak heart, a bad case of eczema, chronic pain from his damaged right leg, and potential trouble from his syphilitic condition, it would be prudent to remain near a hospital. In November he therefore moved to the rural district of Punaauia just three miles

from Papeete, and in early December, after the natives had helped him build a house, he sent for Tehamana in the hopes of reestablishing their old relationship. She came to join him immediately despite being married now to a Tahitian boy, but frightened by his physical condition, and particularly by the running sores of eczema that covered his body, she returned to her husband after only a week.[24]

Gauguin found a willing substitute living nearby, a fourteen-year-old girl named Pau'ura, but since by all accounts she was "stupid, lazy, and slovenly,"[25] his life with her must have lacked the sense of enchantment and delight that he claimed had marked his initial experience with Tehamana. She moved in with him in January, and soon after, he painted a sumptuous portrait of her (fig. 351) which gives no intimation of her drawbacks. He depicted her reclining on the grass in a pose that duplicated his 1889 wood carving of a woman with a fan (fig. 262): a pose whose appeal for Gauguin, we recall, lay in its universality—its recurrence in images as culturally disparate as the Buddhist Borobodur reliefs, a Renaissance nymph by Cranach, and Manet's *Olympia* (figs. 263–65). In *Noa Noa* he had recounted an incident in which, during his first trip, a Tahitian woman had seen his photograph of Manet's painting and asked if it was Gauguin's wife. "Yes," he lied to her, but to his readers he added sardonically: "Me, the lover of Olympia!"[26] Perhaps it was an ironic notion that he was now fulfilling this role that motivated Gauguin to again utilize Olympia's pose, but he aggrandized the equally plebian Pau'ura by calling his picture *Te Arii vahine* (*The Royal woman*) and by repeating his earlier device of a palm-leaf fan poised like a halo behind her head.[27] When he wrote about this painting to Monfreid, Gauguin indicated that it had a greater symbolic significance than his earlier carved rendition of the same motif. He described it as depicting "a naked queen, resting on a green carpet, a servant cutting fruits, two old men, close to a huge tree, disputing over the tree of science; in the background, the shore. . . . The trees are in blossom, the dog is on guard, the two doves at the right are cooing."[28]

The motifs of the nude woman, the fruit picker, and the central "tree of science" entwined with a large snake create a clear reference to the Garden of Eden. In it, Gauguin's second Tahitian Eve reclines with the unselfconscious grace of a Venus on a lush carpet of grass strewn with blossoms. Wearing the white flower behind her ear to signify her readiness for love, a slight, enigmatic smile hovering on her lips, she is the incarnation of serene natural beauty, mysterious and compelling. In harmony with the earth and sea, the plants and animals, his primitive goddess of love enjoys the fruits that nature provides as freely and unquestioningly as do the browsing doves (a traditional attribute of Venus) near her feet. At one with her world,

she is oblivious of the old men pacing behind the "tree of science" which forms the boundary of her domain. It has been noted that Gauguin appropriated the figures of these old men from a sketch by Delacroix for his painting *The Death of Seneca*, where they represented the Roman soldiers who brought Nero's decree of death to the philosopher and watched its execution.[29] Here, wrapped in long, hooded dark robes like those of medieval monks, these gloomy harbingers of death discourse seriously under the "tree of science," presumably therefore disputing about the nature of reality and of knowledge, about empirical proofs and rational concepts. Blind to the beauties and delights nature has spread around them, they pursue their shadowy way on the periphery of life, substituting academic argument for active participation. They are as stooped and severe as the native girl is lovely and relaxed, and their knowledge is analytical and sterile while hers is intuitive and fertile.

Sniffing the earth directly in between these representatives of deadly Western rationalism in the background and vital, instinctual primitivism in the foreground, the black dog "on guard" probably symbolizes the artist himself, a domesticated version of the "hungry wolf without a collar" once again loitering near the native women. The dog's position here, central in the canvas but still peripheral to the idyllic scene of native life, seems to convey Gauguin's sense of his own psychological situation. He was still patrolling the borders between the two worlds, wanting to feel truly at home in this faulty paradise but never able to think and react with the natural ease and naïveté of the Tahitians, never able to rid himself completely of his despised Western skepticism and disillusionment, his intellectual habits and ambitions, his guilts and his doubts about the meaning of existence. Yet his description of the dog as "on guard" suggests that he perceived himself as a defensive intermediary between the natives and the deadly impact of the West: a role he assumed often in his later newspaper articles and attacks on officialdom. In assessing the idyllic and mythic vision of Tahiti that Gauguin presents us in pictures like these, it is worthwhile noting that his letters often reveal a much more prosaic account of his experiences. In January of 1897 he wrote to Armand Séguin with crude complacency regarding his living arrangements:

Just to sit here at the open door, smoking a cigarette and drinking a glass of absinth, is an unmixed pleasure which I have every day. And then I have a fifteen-year-old wife who cooks my simple everyday fare and gets down on her back for me whenever I want, all for the modest reward of a frock, worth ten francs, a month. . . . I want no other life, only this.[30]

A month later, in February, Gauguin's broken ankle

began suppurating so badly that he was unable to paint and had to again lie in bed, drugging himself against the pain. His correspondence from this period reveals that in addition to his physical sufferings, his money was already gone and none was coming in from the friends and dealers back in France who had charge of selling his work and pursuing any project that could bring him financial support. By April, in deep depression, often hungry and unable to buy even the medications he needed, he wrote to Charles Morice that he was "on the verge of suicide."[31] By July he had deteriorated enough to enter the hospital at Papeete, and although he was released a week later in better condition, he was unable to pay his bill.

All these trials are expressed in a self-portrait from this period entitled *Near Golgotha* (fig. 352). This reference to the site of the crucifixion reveals that Gauguin was once again likening his situation to that of Christ, but when we compare this image with his 1889 self-portrait as *Christ in the Garden of Olives* (fig. 250), we find that the earlier figure's stylized look of passive resignation has been replaced by a more mature and revealing expression of hardened suffering. His eyes, heavy and dulled with pain and fatigue, are now fixed unwaveringly on reality and convey a sense of profound awareness. In contrast to the drooping depression of his earlier posture, his erect carriage and the set of his mouth here suggest the determination to endure. Behind him on either side loom the dim figures of a cowled monk and a tribal Indian—symbols of those dual aspects of his nature that he had described to Mette years before. Embodiments of his Christian European and Peruvian or Incan roots just as were the Yellow Christ and the self-portrait tobacco jar, both of these figures signified for him the ability to endure suffering with silent dignity. In his journal *Before and After*, begun the following year, he wrote: "You climb your calvary laughing, legs shaking under the weight of the cross:—having arrived, you grit your teeth, and then, smiling again, you avenge yourself—you spend yourself again."[32] Almost immediately after comparing his lot to Christ's, he added: "With the Indian under torture, the pride of knowing how to smile in the face of grief greatly relieves the suffering."[33] Gauguin's reading of Romantic literature must have reinforced his conviction that there is moral and spiritual virtue in continuing to struggle against adversity. Perhaps in painting this picture he also had in mind the protagonist of Carlyle's *Sartor Resartus*, another rebellious seeker after meaning and self-fulfillment whom Carlyle described as a "solitary savage" exiled in a universe like a "vast, gloomy, solitary Golgotha."[34]

Gauguin's determination to make the best of things after he got out of the hospital was sorely tested, for every plan he pursued to find buyers or patrons in France failed,

and his pride was crushed by the continual need to beg for money and assistance from friends. He was finally reduced to taking a position as a drawing-teacher to the daughters of a successful local lawyer named Goupil. But his health had temporarily improved, and he soon turned again to transforming the ordinary scenes around him into symbols of an eternal way of life. As on his first trip to Tahiti, he accomplished this by borrowing the postures and aesthetics of ancient sacred art, aided as usual by the extensive collection of photographs and prints he kept as a source of motifs. Whether his models were Egyptian tomb painting, as in his two renditions of a man with a canoe (fig. 353), or the Buddhist sculpture from Borobodur—as in the painting *Eiaha ohipa (Don't work)* (fig. 354), or ancient Greek temple friezes—as in his depiction of fruit pickers in *Nave nave mahana (Delightful day)* (fig. 355),[35] these pictures convey the sense of timelessness and serenity for which Gauguin yearned. His colors are particularly rich and intense, their saturated tones orchestrated into sensuous, minor-key harmonies of related and contrasting hues. The golden glow that fills these canvases makes the peaceful figures in their enchanted settings seem even more dreamlike and mysterious.

In December of 1896 Pau'ura gave birth to a baby who died several days later, and two paintings which Gauguin produced at this time portray scenes of childbirth with symbolic overtones. Both contain pictorial references to the nativity of Christ in a manger with domestic animals, and both depict the baby in the arms of a strangely rigid and expressionless figure who adds a disturbing note of menace to the pictures. In *Te tamari no atua (The Child of God)* (fig. 356), the halos of both mother and baby reinforce the title's suggestion that all maternity is holy and that all children are the gift of God, regardless of the parents' race, religion, or marital status. In *Bébé* (fig. 357) this implication of sanctity derives from the blaze of light surrounding the bed in the background—a suggestive radiance paralleled in *The Child of God* by the chrome-yellow bed linen that he set in vivid contrast to the dark, funereal blues and dulled purples of the rest of the canvas. This golden coverlet with its sprig of fragile flowers reminds us of the blossom-sprinkled yellow background in Gauguin's 1888 *Self-portrait called "Les Misérables"* (fig. 226), which he had described as signifying the room of a chaste young girl. Perhaps his reutilization of a motif he associated with innocence to now depict the bed on which lovemaking and childbirth have occurred was meant to imply that for the Tahitians, sexual activity was not perceived as sinful or corrupting. Since his first arrival in Tahiti Gauguin had admired the natives' natural acceptance of sex and procreation, and both *Bébé* and *The Child of God* communicate the same moral idea about the Tahitian reverence for

maternity as did his 1891 painting *We greet you Mary* (fig. 293). Not only do all three pictures liken the Tahitian mother and child to the holy figures of Mary and Jesus, but all also contain references to death which suggest the universal applicability of the Christian story even in a South Seas paradise. In *We greet you Mary,* this intimation of mortality took the form of an angel in the background bearing the palm frond that prepared Mary for the crucifixion, and in *Bébé* we find a similar Tahitian angel whose presence can be construed both as blessing the birth and heralding the death of yet another child of God. In the paintings of 1896, however, there is an even darker symbol of the baby's impending fate, for in both pictures the newborn infant is held by a seated figure whose somber profiled face and strangely hoodlike black hair are reminiscent of Gauguin's earlier representation of the *tupapau* next to the girl's bed in *The Spirit of the dead is watching* (fig. 310).

In February of 1897, despite continual illness, Gauguin painted Pau'ura lying on a bed in another symbolically meaningful picture (fig. 358). Entitled in English on the canvas *Nevermore O Taiti,* it depicts the pensive girl in a shadowy room overlooked by a dark bird and two conversing women in the background. Gauguin wrote to Monfreid that his "simple nude" was meant to suggest "a certain barbaric luxury of the past," and that "the whole is drowned in colors that are deliberately somber and sad." He continued: "As a title, *Nevermore*; not exactly the raven of Edgar Poe, but the bird of the devil who is on watch."[36] Gauguin's reference is to Poe's poem *The Raven,* which had been translated into French by Mallarmé in 1875 and had been read aloud at Gauguin's farewell banquet in 1891 before his first departure for Tahiti.[37] In Poe's verses the diabolical black bird visits the poet like a harbinger of death, interposing its fateful refrain of "nevermore" into his thoughts of his beloved.

Despite Gauguin's disclaimer that this is "not exactly the raven of Edgar Poe," the meaning of the poem provides a clear intimation of the message Gauguin wanted to convey in his painting. His voluptuous native wife lies here on a bed decorated with the little flowers that he associated with the childish purity of young girls, and his statement that she suggests "the barbaric luxury of the past" reveals that for him she epitomized the resplendent primitive sensuality and spirituality of the Tahiti of former times, the powerful natural beauty and unselfconsciousness of a culture not yet destroyed by European influence. But her chamber is gloomy and dark, and her melancholy expression and sideways-rolled eyes indicate that the presences behind her have already threatened her peace of mind. The chaste missionary dresses of the two women in the rear contrast sharply with her nudity, implying that the defilement of Tahiti's natural values has already begun, while the

"bird of the devil," the agent of the evil and decadent West, watches over her like the spirit of death and sounds its gloomy warning that the traditional ways will never return. *Nevermore O Taiti* communicates Gauguin's sad conviction that the death knell had already rung for this primitive world—a world he had been too late to experience in its savage and pristine power.

We find the same kind of bird, which scholars have observed is very similar to birds in the Borobodur reliefs, juxtaposed with a beautiful native woman in another picture of 1897. With his mind always on the Tahiti of the past, Gauguin once again began painting mythic characters he had learned about in 1892 when he read Moerenhout's *Voyages to the islands of the great ocean*. At that time he had claimed that the myth of Vairumati seemed particularly meaningful to him, and we recall that in 1892 he painted two pictures (figs. 320 and 321) of this mortal woman whose voluntary liaison with the son of the creator god produced the caste of warrior-priests charged with maintaining the ancient traditions of Polynesian life. For Gauguin, Vairumati was a crucial symbol of the origins of Tahitian culture, and the legends of the Arioi society's sexual and sacrificial rituals which were encompassed by her myth expressed the natives' belief that both sex and death are laws of existence decreed by the gods. Gauguin perceived Vairumati not as the victim of male domination, but as a sacred consort, a woman raised to the level of deity by her decision to participate in the gods' design, to give herself up freely to love and procreation.

In his 1897 version of this legendary figure (fig. 359), Vairumati appears as a natural woman rather than a hieratically posed goddess. Her gently smiling face bears witness to her contentment with her role as lover and mother, the vehicle of all that the Tahitians felt was most life enhancing, and she relaxes gracefully against a throne-like bed carved with lotus designs which form a nimbus or halo behind her head to signify the principle of renewal that is inseparable from her procreative role. Beside her sits a large bird which is very similar to the raven-like agent of the devil in *Nevermore,* but now it is white and clutches a lizard in its claw. In many Oriental traditions the color white is associated with death, and in Maori mythology the white bird is a symbol of death, the vehicle by which the soul of the deceased is borne into the spirit world.[38] Gauguin has stressed this role by representing the bird as the actual agent of the lizard's death—a force of nature pursuing its necessary ends by preying on another living thing. In the rear, two women from the Borobodur reliefs sit in meditational poses, one lifting her hand in the *mudra* meaning "fear not." The juxtaposition of the death-dealing bird, the life-giving woman, and the reassuring sacred gesture seems to convey the message that although destruction and death sit

ever alongside beauty and vitality, fear should never deter us from our pursuit of meaningful life experience.

In February or early March Gauguin produced one of the most haunting and enigmatic paintings of this period. Entitled *Te Rerioa (The Dream)* (fig. 360), it reveals his continuing preoccupation with the interrelated themes of life and death. At the center sit two meditating women, the foremost of whom seems to be modeled after a figure of the Buddha from one of the Borobodur carvings (fig. 346). This particular relief represents the Buddha sitting in the lotus position under the bodhi tree at the moment of his enlightenment, and Gauguin's application of his pose here suggests that this scene also has to do with the acquisition of spiritual wisdom. At the woman's side a baby sleeps in a cradle over which implike figures swarm, symbols perhaps of all the potential evils that surround us and menace us from birth, both in our sleeping dreams and in the dream that is our waking life. It is possible that in contriving this motif Gauguin was remembering a picture he had painted back in 1881 of one his own young children sleeping in a cradle-like bed (fig. 361). Entitled *The Little dreamer*, it also depicts fanciful biomorphic shapes on the wall like materializations of the child's dreams, while at the head of the bed dangles a doll dressed in the red suit of a jester—an image which in the 1897 picture has metamorphosed into the red-clad little demon climbing up the foot of a cradle modeled after Marquesan wood carvings (fig. 362). Immediately above the sleeping baby, who personifies childhood's innocent lack of awareness, lies the parallel form of a white cat—an embodiment of the same kind of unconscious animal contentment. While the figures in the room imply a contrast between the limited awareness of animals or infants and the full consciousness of human maturity, the images on the walls suggest the nature of the adults' reverie: they deal with the life experiences that contribute to enlightenment. On the left, above a dado of animal and plant forms, we find an embracing man and woman: a motif Gauguin had already used in a print entitled *Te faruru (Making love)* (fig. 363) which he had incorporated into his manuscript of *Noa-Noa*. Unlike the original version, however, the man in the mural looks over his shoulder at the figure who watches the couple from the right. This closely hooded being with a masklike face resembles the personification of death Gauguin had used so often before, but her body here has metamorphosed into a great lotuslike flower. By this transformation Gauguin integrated his symbol of death with a symbol of regenerative fertility, creating a visual suggestion of the unity of life which is reinforced by the images on the rear wall. Here, a figure resembling many of Gauguin's statues of Hina is again depicted with arms lifted in the gesture signifying the ongoing continuity of life, death, and regeneration, a prin-

ciple underscored by the huge, lotuslike flower growing beside her. Beneath it is a pair of enormous copulating marsh rats, a common animal in Tahiti which the Polynesians perceived as a symbol of death because its bite was usually fatal. Gauguin's depiction of the rats in the act of procreation is yet another example of the ways in which he tried to express his conviction that life and death are inseparable, that all are bound together in one great metamorphic whole. This is the spiritual wisdom on which these women meditate. *The Dream* is not only a metaphor for our subjective experience of an ever shifting and changing reality. It also suggests the Hindu and Buddhist concept of the dream of creation: the law of the universe that moves us irrevocably through the stages of the life cycle and alternates birth with mortality in a never ending continuum.

Gauguin's preoccupation with themes of death and regeneration during these months is particularly poignant because in April he received a curt note from his wife informing him that his beloved daughter Aline had died in January at the age of twenty from pneumonia contracted after attending her first ball. Perhaps it was this blow that precipitated such a violent outbreak of his eczema that he was unable to paint during May and June. By July his health had deteriorated even further: he wrote to Monfreid that he was once again confined to bed and had "lost all hope."[39] Throughout the remainder of the summer months he suffered not only from the eczema, but from his wounded ankle, an infected eye, and the syphilitic condition whose sores were mistakenly assumed by both the natives and the colonials to be a sign of leprosy.[40] Lonely, destitute, and grieving, in August he sent Mette such a bitter and angry letter about the abrupt way in which she had broken the news of Aline's death to him that she never wrote to him again. As Gauguin tried to cope with the disintegration of his body and his life, his mind was moving ceaselessly on metaphysical questions and he began to commit his thoughts about religion to the two garbled but impassioned essays he entitled "The Catholic Church and Modern Times" and "The Modern Spirit and Catholicism." He must have been temporarily heartened to hear from France that Charles Morice had finally finished the definitive collaborative version of the *Noa Noa* manuscript and had sent it to *La Revue Blanche* for publication, but when in October he underwent a series of heart attacks, he wrote to Morice in despair that he would probably not live to see it come out. It was printed only a few days later, coincident with his receipt of a crucial sum of money from Monfreid's mistress that enabled him to turn back once again from a decision to commit suicide.

After another heart attack early in December of 1897, despairing of his health and his financial situation and once

again contemplating suicide, Gauguin began to paint the picture which he later claimed was meant to be his last and greatest testament, a summation of his philosophy of life.[41] Having no canvas, he painted it on rough jute sacking tacked to a frame. At the end of the month it was close to completion, and when, on 30 December, the mail boat brought the first installment of *Noa Noa* from Morice but not the money he had been promised, he went up into the mountains and took a large dose of arsenic. In his zeal to succeed in killing himself he took so much poison that he vomited it up and lived, and after a terrible day and night recovering alone on the mountain, he returned to his hut the next morning emotionally prepared to drink to the dregs whatever life still had in store for him.

Gauguin called his masterpiece *Where do we come from? What are we? Where are we going?* (fig. 364) and its title alone reveals his awareness that his own musings about origins and destinies paralleled the central questions of many works of sacred and secular literature. These queries are the fundamental subject of all religions, and they surface repeatedly in the theosophical writings with which Gauguin was familiar. In Schuré's *The Great Initiates*, for example, the early Christian mystic Valentinian Theodotus is quoted as asking: "Who am I and where am I? Where did I come from and why am I come from there? Where am I going?"[42] Gauguin's own essay "The Modern Spirit and Catholicism" opens with a passage that defines the subject of his painting in the same terms. He wrote:

Confronting this ever-posed problem: Where do we come from? What are we? Where are we going? What is our ideal, natural, rational destiny? And what are the conditions of realization, or the law, the regimen by which it can be accomplished in the individual and humanitarian sense? Problem which in these modern times, the human spirit all the same needs to resolve so as to see clearly on its path, to walk with a sure step towards the future.[43]

Unraveling the layers of meaning embedded in this picture requires consideration of two kinds of evidence: Gauguin's somewhat cryptic explanations of it to two friends, and the way in which its figural motifs relate to his own previous imagery. He wrote the following description to Daniel de Monfreid:

At the bottom right, a sleeping baby, then three crouching women. Two figures dressed in purple confide their thoughts; a squatting figure purposely enlarged without regard for perspective, lifts its arms in the air and regards with astonishment these two people who dare to think about their destiny. A figure in their midst plucks a fruit. Two cats near a child. A white goat. The idol, its two arms raised mysteriously and rhythmically seems to indicate the beyond. The crouching figure seems to listen to the idol; then

finally an old woman close to death seems to accept, to be resigned to what she is thinking about and what terminates the inscription: at her feet a strange white bird holding a lizard in its claw, represents the uselessness of vain words. All of this transpires on the bank of a river under the trees. In the background, the sea, then the mountains of the neighboring island. . . . If they told the students at the Academy of Fine Arts competing for the Prix de Rome: "The picture that you have to represent is Where do we come from, what are we, where are we going," *what would they make? I have completed a philosophical work on this theme comparable to the Gospel: I believe that it is good. . . .*[44]

Gauguin's conclusion that his painting is comparable to the Gospel makes it clear that he conceived of it as a religious parable, and his description of its imagery defines the nature of his metaphor. He perceived human destiny as a progression from unconscious infancy through mature awareness to the accepting resignation of old age. Under the dappling shadows of the lush foliage, figures at various stages of the life cycle range across the foreground of the canvas interspersed with a series of symbolically relevant domestic animals. It is significant that Gauguin described the personae of his drama from right to left, beginning with the baby and ending with the old woman close to death. As we follow this order across the canvas we find many characters from Gauguin's repertoire of deeply personal symbolic forms, and by considering their individual and collective meanings in relation to his descriptions of the picture, the full significance of his philosophical message emerges.

Although Gauguin never mentioned it at all, the first occupant of the stage far right is the black dog who appeared earlier in the year at the center of *The Royal woman* (fig. 351): the dog who seems to represent Gauguin himself. It is surely no coincidence that Gauguin chose to place his signature directly over the dog, or that the dog is the only occupant of the scene who isn't fully situated within the picture. As it lies quietly observing from the sidelines, half in this world but half outside it, it seems a perfect expression of the artist's awareness of his own ambiguous relationship to the primitive existence he was extolling. Close by, beside the sleeping baby personifying the unconscious innocence of infancy, sit two of Gauguin's contemplative women, sisters not only of the women in *The Dream*, but of all those pensive female figures by which he suggested the enigma of human thought and our universal need to contemplate the mysteries of life. Next to them a central male figure plucks the fruit from the tree with natural grace and ease, an embodiment of the serene acceptance with which all Tahitians approached life experience. In this garden of Eden there are no prohibitions: men and women alike are free to taste what life offers, and

even children are allowed to help themselves with the same unselfconscious freedom as the cats playing nearby.

Next to the young girl just taking her first bite of life's fruits, we find the familiar figure of Vairumati from earlier in the year, symbol of woman's sacred roles as lover and mother. Reclining gracefully within this fertile setting, she conveys the same sense of tranquil and contented domesticity as the goat beside her. In between Vairumati and the white bird that accompanied her in his earlier version, however, Gauguin has interposed another familiar character from his repertoire: an old woman huddled into the position of the Peruvian mummy which since 1889 he had used as a symbol of withdrawal from the world of active life. Gauguin described her here as accepting, as resigning herself to what she is thinking about and to what terminates the inscription—that is, the question "Where are we going?" Turned in on herself, shutting her ears to the sounds of life around her, she prepares herself for the final destination of death—an event Gauguin has suggested by the "strange white bird" that terminates his picture just as it terminates the life of the lizard gripped in its claw. Gauguin claimed that the bird symbolized "the uselessness of vain words." His meaning is clear: death seizes us all in the end; it "concludes" us despite our prayers or our theories about the meaning of life.

Behind these figures looms the mysterious statue which presides over the scene and makes what Gauguin described as a "rhythmic" gesture that "seems to indicate the beyond." In a letter to André Fontainas, Gauguin stated that in his dream, the idol was intimately united with the entirety of nature; that, reigning over our primitive mind, she consoles us for our sufferings over all that is vague and incomprehensible as we consider the mystery of our origin and our future.[45] She is another of his many imaginary incarnations of Hina, posed to signify the ongoing equilibrium of life and death. The "beyond" she indicates, which Gauguin claimed was so consoling to some primal part of our minds, is the all-encompassing ebb and flow of the universe that continues its eternal cycle regardless of our fears or vain protests. For Gauguin, the "beyond" also implied the entire realm of spiritual possibilities which lies outside our physical experience or rational understanding—realities which in Gauguin's view were so accessible to the inhabitants of primitive culture but so closed to intellectual Westerners.

It was this very difference between the primitive and the modern approaches to existence that Gauguin addressed through the remaining figures of his masterwork: the last actors in this philosophical drama. They are the "two figures dressed in purple" whom Gauguin described as confiding their thoughts to each other, and the "purposefully enlarged" crouching figure who watches them

with an arm raised in the position of sighting something from afar or perhaps warding something off. Gauguin borrowed the solemnly discoursing figures from his painting *The Royal woman* of the previous year, where we recall they were disputing under the "tree of science" as symbols of the deadly Western tendency to pursue rational arguments about issues that are fundamentally spiritual. He incorporated them into *Where do we come from?* in order to set up the same contrast between the analytical and the intuitive ways of life, linking them with the rear-facing woman whom he claimed "regards with astonishment these two people who dare to think about their destiny." Gauguin gave a special emphasis to this enigmatic figure by making it, in his own words, "disproportionately large without regard for perspective." When we trace his other uses of this figure and realize what significance she had for him as a symbolic motif, we can grasp his philosophic intention even more fully. In 1894, when he had recopied his *Noa Noa* manuscript with Morice's poems interspersed among the sections of his own narrative, he drew the figure of the rear-facing woman with uplifted arm (fig. 365) below two verses which praise the simple happiness and spiritual harmony of the timeless primitive life of the past, and compare it with the evils of modern Western existence. Morice's highly romantic poem exclaims:

O new beauty of the ideal, vital Past!
O on this shore of the infinite, walking without pain,
Simple, to live the ancient, happy human life!
O free, without care for tomorrow and yesterday,
To abandon oneself! To abandon oneself, like the water,
 like the air!
To mirror the world in oneself! To radiate into things!
To have for soul the heroic soul of the roses!

Ah, Source of the Past which sings, I hear you,
Mysterious source, divine water of time,
And now that over the plain and over my mind
The accursed Tree no longer sheds its infamous shadow
Of desires, of regrets, of remorse,—of the West,
I come to you, the spirit stilled, the heart ardent,
Already rich in your gifts O Mother, Nature,
To offer you proudly the soul that you made pure
And free of all deceits: give me
Asylum in the serene garden of the New Past,
In the land where I have chosen my destiny,
Where I have lived, where this real soul was born,
Where in truth and in voluptuousness,
All is beauty—all is goodness; all is light.[46]

Morice's verses epitomize Gauguin's feelings about Tahiti—an idealized Tahiti, the primitive paradise of an

earlier age which remained the focus of his dreams. In its celebration of serenity and harmony, frank simplicity and sensuality, the poem underscores all Gauguin's longings to effect his own spiritual salvation by adopting the Tahitians' approach to life. The figure with the lifted arm which he drew under these stanzas was for him such a compelling symbol of the primitive spirit confronting Western civilization that he incorporated it also into the journal he began in 1897, *Before and After* (fig. 366). Here, this embodiment of naïve primitive wisdom sits over the words "Ia Orana," the usual Tahitian salutation, and, in final proof of the identity of all those canines in his work, addresses the little dog passing by with the additional greeting "Bonjour M Gauguin."

When Gauguin juxtaposed this figure with the disputants in *Where do we come from?*, he created an even more specific allusion to Morice's poem. These talkers symbolize that Western need to analyze, theorize, and find rational explanations for life which Gauguin found so dispiriting; the antithesis of the silent, contemplative natives, they are so lost in words that they pass through this enchanted glade heedless of its beauty, its intrinsic meaning, or its consoling power. The tree they walk behind is not the one from which the central figure plucks fruits, but one which rises immediately beside the native with the lifted arm. In Morice's poem, the "accursed tree" with its "infamous shadow of desires, of regrets, of remorse" was offered as the cause of the West's spiritual crisis. This tree was not the Tree of Life or of the knowledge of good and evil that dominated Eden, but the Tree of Science that overshadows the West, the symbol of all the destructive results which were believed to have accrued from our overemphasis on logic and empiricism and materialism. The previous August, writing to Molard about his emotions on learning of his daughter Aline's death, Gauguin related how in his anguish he raged against fate, accusing God, if he existed, of injustice and wickedness, and arguing that since virtue, work, courage, and intelligence were of no use in preventing such a cruel loss, "only crime is logical and reasonable." It was just this sort of futile and self-destructive reasoning in response to the fundamental issue of existence that the melancholy disputants in *Where do we come from?* symbolize, and Gauguin admitted his longing to move beyond it to the instinctual resignation of the primitive when he concluded to Molard that he could only continue to fight if he had "great tranquillity."[47]

In 1901, four years after completing this painting, Gauguin sent Morice an explanation of it which revealed his conscious awareness of the relationship between his own imagery and his friend's poem. In his usual fragmented and cryptic way, he wrote:

In this great picture: Where are we going?
Close by the death of an old woman.
A strange stupid bird concludes.
What are we?
Daily existence.
The instinctual man asks what all this is meant to express.
Where do we come from?
Source.
Child.
The communal life.
The bird concludes the poem in a comparison of the inferior being versus the intelligent being in this great whole which is the problem announced by the title.
Behind a tree, two sinister figures, enveloped in sad-colored clothes, place near the tree of science their note of grief caused by this very science, in comparison with the simple beings in virgin nature which could be a paradise of human conception, giving themselves up to the joy of living.[48]

Rendered into coherent English, this passage summarizes the meaning of Gauguin's testament and clarifies its relationship to Morice's verses: we go toward old age and the conclusion of death; we are no more than the sum of our own daily existence; we come from the mysterious source of all being, from childhood, and from the nature of our communal life. The poem of our days that finishes with the strange, incomprehensible event of death bears within it an intrinsic comparison between intelligent and inferior ways of living. The path taken by the analytical West is the sad, sinister way which results from trying to account rationally for things that are not susceptible to explanation or definition and from shutting out meaningful intuitive, imaginative, and emotional experience. The alternative is the natural, primitive way which enables one to live acceptingly, fully, and serenely, without remorse or despair over the dark aspects of existence that none of us can avoid. This is the spiritual way, the poetic way.

Gauguin came down from the mountain and lived for five more years, but his remaining time was dominated by the pattern of illness, pain, poverty, frustration, and disillusionment that he had been suffering for so long. He was prevented from painting much during the last years of his life by his health problems and his need to support himself, first by taking on a bureaucratic post in the civil service, and later by writing articles for one local paper and publishing another. Despite all the obstacles, however, he continued to produce hauntingly beautiful pictures to the end. The few works he managed to do in 1898 still portray his Tahitian world as a mysterious, enchanted paradise, although there are occasional elements in these idyllic landscapes that remind us of the inevitability of suffering and death. The female idol in *Rave te hiti ramu (The Monster-*

glutton seizes) (fig. 367) is no longer the benevolent and reassuring Hina, but a version of his frightening figure *Oviri* (fig. 347). Symbol of the powerful, impersonal force which binds creation to destruction, its presence here in the lovely but untamed landscape reveals Gauguin's awareness not only of the proximity of death, but of all the ongoing ravages that continued to afflict him in the South Seas.

For the most part, however, Gauguin seems to have preferred devoting his little available time to the creation of consoling visions which satisfied his craving for simple happiness in a paradise of beauty and peace. One of these, *The White horse* (fig. 368), was actually commissioned by a pharmacist who had requested a "comprehensible and recognizable picture" and rejected this one contemptuously because the horse was tinged with green shadows.[49] Another visionary painting that never found a buyer was *Faa Iheihe* (fig. 369), which means "to beautify, adorn, embellish, or glorify."[50] Isolated against its glowing golden ground, the inhabitants of this exquisite world are poised like sacred figures in an ancient frieze amid exotic flowering shrubs modeled after those in the Borobodur reliefs. Mingling with the fruit pickers and the naked man and woman who seem to be the Adam and Eve of this Eden, two more hieratic figures make the Buddhist gesture "fear not." Gauguin described in his journal a picture he wanted to paint which corresponds closely to the imagery of *Faa Iheihe*. Characterizing its principal figure as "a woman being transformed into a statue, remaining alive but becoming an idol," he claimed that he was seeking an effect that was simultaneously "grave like a religious evocation, melancholy and [yet] gay like the children."[51] Although death is not conspicuous here, the left-hand figure clad in white is suggestive of it. In the lushly colored world of Tahiti white garments were usually associated with death and the spirit world, and the woman's solemn averting of her face and body has a ritual look about it. Moreover, the group at the right of a horse and rider accompanied by a dog was possibly meant as more than a genre detail. It has been observed that as a motif, it relates strongly to the group in Albrecht Dürer's famous sixteenth-century engraving *Knight, Death, and the Devil* (fig. 370), a print Gauguin admired so much that he pasted a copy inside the cover of *Before and After*. No intimations of evil or mortality impinge on the natives, however; they pursue their simple activities with the slow serenity of those who feel sure of eternity. We find the familiar black dog with white feet standing firmly in the foreground now, his position perhaps indicative of Gauguin's determination to share fully at last in a world whose inhabitants enjoy the pleasures of living without guilt and accept death stoically when it appears on the scene.

It is part of Gauguin's tragedy that there was always such disparity between his ideals and his reality. In addition to the burdens of his physical problems and the discouragement of having to endure a tedious and demoralizing job in town at the Public Works Department, Gauguin was now suffering from increased isolation as well. His employment in the civil service lost him his previous friendships with both the settlers who hated the colonial government and the officials who had tolerated and interacted with him as an artist, but snubbed him when he was reduced to the position of a minor bureaucrat in a very class-dominated society. Worse, Pau'ura had become bored in town while Gauguin was working at the office all day, and had gone back to her family in the country where she continued to take advantage of their relationship by rifling the possessions he had left in his house there. Bitter, quarrelsome, drinking heavily, and finally back on morphine for the pain in his ankle, by December of 1898 Gauguin was as destitute and ill as he had been the previous year when he tried to kill himself, and he wrote to Monfreid that he had lost all his "moral reasons for living."[52] Yet a month later he received enough money from his friend (part of which was from the sale of *Nevermore*) to enable him to resign his job with the Public Works Department and return to the freedom of life in the house he had built in the country. This event and the fact that Pau'ura, who rejoined him as soon as he went back to Punaauia, was pregnant again with his child, had a regenerative effect on him. He wrote: "It is a happy event for me, because the child perhaps will lead me back to life, which at present I find so unbearable."[53] When in April of 1899 Pau'ura gave birth to a boy, Gauguin named him Émile: the same name he had given to his first child with Mette; the name he also associated with Jean-Jacques Rousseau's novel *Émile*, which espoused free love and allowing children to grow up in a state of natural and healthy freedom.

Although Gauguin was unable to paint during much of 1899, the pictures he did produce continue the effect of gold-ground religious friezes that he had initiated with *Faa Iheihe*. Works like *Rupe rupe (Luxuriance)* (fig. 371) and *Te Avae no Maria (The Month of Mary)* (fig. 372) repeat its moving and enigmatic combination of the serious white-clad woman in the ritual pose with the exotic flowers and fruits of a radiant paradise. The birth of his child also engendered a series of idyllic pictures of women holding up the bounties of nature, including two variations on the theme of maternity (figs. 373 and 374). In their portrayal of women bearing flowers and baskets of ripe fruits to the new mother as she nurses her baby against an abstract background of flowing colors, these canvases create the impression of altarpieces celebrating the beauty of nature and of tender maternal love. An inconspicuous detail in

one version, however, reveals that Gauguin's sense of reality surfaced even in the beatitude of images like these. It is surely no accident that a black dog with white feet stands in the background here, its mouth open and its teeth bared over some amorphous creature it seems to be crushing under its paw.

Gauguin's continual need to deal with the subject of death was the impetus for a pair of even more explicitly symbolic pictures on this theme. *The Great Buddha* (fig. 375) depicts two contemplative women, one of whom wears the inviting white flower, sitting in front of a forbiddingly dark statue that Gauguin based on a Maori ancestor effigy from a gateway he had seen in the Auckland museum.[54] On this composite deity's stomach are carved the figures of a man and woman locked in sexual embrace, and at the women's feet a female dog lies nursing her pups. In the far distance of the background a scene of the Last Supper is being enacted, complete with haloed Christ and the betrayer Judas, while through the rear doorway a new crescent moon illuminates the night sky. From foreground to background, the culturally eclectic imagery of this picture suggests that the theme of the women's meditations is the wisdom taught by both Buddhism and Christianity about life's universal patterns: that existence consists of experiences of birth, maternal care, sexual love, suffering, spiritual growth, self-sacrifice, and death, which in its turn is followed by the promise of renewal implicit in the waxing moon. A related canvas called *The Last Supper* (w580) employs similar imagery. In its foreground an embracing couple sits beside a central supportive column decorated with a carving of Hina and Fatu engaged in their dialogue about death and rebirth, while in the rear a haloed Christ presides over his sacrificial meal.

Improved sales and contract arrangements in Paris gave Gauguin more income in 1900, but he was ill for much of the year and when he felt well, he devoted most of his time to writing vitriolic articles for an antiestablishment local paper aptly called *Les Guêpes* (*The Wasps*). Between bouts in the hospital at the beginning of 1901, he began planning his long-desired move to the Marquesas—his last bid to find the undefiled, traditional life he felt he needed to revive the dying fires of his inspiration. There if anywhere, he hoped, he might succeed in liberating himself from the vestiges of his European personality and finally enter fully into the harmonious spiritual world of primitive society. During the months before he departed Tahiti in September, he painted a handful of pictures which suggest his state

of mind prior to this important move. His still-lifes with sunflowers (figs. 376 and 377) convey his anticipation that the change would be revitalizing for him. He had planted the homely European sunflowers in his Tahitian garden, but he also owned one of Vincent's paintings of them and was well aware that for his dead friend these flowers which continually turn their faces toward the sun were symbols of health and gratitude. They must have seemed to Gauguin a metaphor for the reverent and positive approach to life which he was always hoping to acquire from the Polynesians and believed that his move to the Marquesas implied. He suggests this meaning in one of the pictures by juxtaposing a native's enigmatically smiling head with the bouquet and crowning it with the mysterious eye-like flower used by his friend Redon to signify the innate impulse of living things to grow and to understand the world. In the other version, the wall behind the vase is decorated with Puvis de Chavannes' drawing of Hope: the young girl holding a flower of renewal.

Despite his hopes for regeneration, Gauguin also recognized that this would be his last journey. In a painting he called *The Flight* or *The Ford* (fig. 378), we see, riding on a white horse across the center of the canvas, the tightly hooded, tiki-faced figure who represents the spirit of the dead in so many of his earlier paintings. Followed closely by a male rider and his dog, she is about to cross the ford at the left of the picture, while in the background a canoe bearing a standing figure looking out over the water is being pushed away from the shore. Scholars have observed that in both Greek and Hindu mythology the fording of a stream or river is the path by which one enters the kingdom of the dead,[55] and it has been suggested that the *tupapau* on its white steed is the equivalent of St. John's apocalyptic vision of death on a pale horse.[56] It has also been noted that the group of the male rider and dog was, like that in *Faa Iheihe*, modeled after Dürer's figures in *The Knight, Death, and the Devil*,[57] a work meant to represent the Christian soldier stoically traversing the rough path of life in the service of God, accompanied always by the forces of evil and mortality.[58] In a drawing which approximates Dürer's motif even more closely (fig. 379), Gauguin suggested these associations with greater specificity by replacing the knight with a *tupapau*. The imagery of *The Ford* suggests that whatever revitalizing effects he expected his removal to the remote outpost would achieve, he was as aware as ever that death was always just a step ahead, and that it would be from the Marquesas that he would cross the final river.

The Final Flight: Marquesas, 1901–1903

Gauguin moved to Atuona on the Marquesan island of Hivaoa in September of 1901. Here, with the help of a native named Tioka, he built his last house and decorated it profusely with wood carvings. He called it the "Maison de Jouir," or "House of Pleasure," a title he carved into its monumental doorframe, along with those words of advice that had held so much meaning for him over the years: "Be mysterious" and "Be loving, you will be happy." Shortly after its completion he persuaded a local chief to remove his fourteen-year-old daughter from Catholic school to become his *vahine*. Given his physical condition, this arrangement could hardly have been pleasant for the girl, Vaeoho Marie Rose, who left him a month before giving birth to their daughter the following September. During his last year and a half of life in the Marquesas, Gauguin continued to be deflected from making art by chronic problems with his health and daily affairs, and by his protracted quarrels and lawsuits with the colonial representatives of Western civilization on both his own and on the natives' behalf. But the powerful beauty of the mountainous landscape, the new faces and customs he encountered, and the respect and friendship of the natives had the desired effect of stimulating his will to live and his artistic imagination. Before his departure from Papeete he had written to Monfreid:

My creative powers were beginning to flag here, and moreover the art public was getting too familiar with Tahiti. People are so stupid that when they have seen these pictures with their new and terrible features they will find my Tahitian paintings comprehensible and charming. My Brittany canvases became rose water because of Tahiti; Tahiti will become eau de cologne because of the Marquesas.[59]

Some of his new work was fairly straightforward: there are vivid, Degas-like pictures of riders on the beach, some local genre subjects in a Cézannesque style, and a few exquisite still-lifes. But among these late paintings are several large canvases whose imagery is hauntingly enigmatic and seems to incorporate many references to impending death. One is a new version of *The Fall* (fig. 380), in which Eve no longer covers herself protectively with a cloth and her earlier expression and gesture of dismay at the terrors of life (fig. 316) have been replaced by a serene face and the reassuring sign "fear not." Adam turns sadly away from her with bowed shoulders, as if leaving the Garden in response to the command of the angel of the expulsion who hovers behind the foliage. Conspicuously flanking the figures in the foreground are the white bird of death and the familiar dog who is probably Gauguin himself. A more cryptic

painting is *The Call* (fig. 381), a mysterious summons in which a figure draped in funereal white beckons to something offstage while guiding or escorting another woman in some purposeful way. Gauguin's previous use of the white-clad female to suggest a ritual connected with death, the other woman's covered head and enigmatically clutched white cloth, and the unusual motif of the rear figure with its back turned away from the action of the foreground all contribute to the impression that a deeply significant ceremony is taking place, that the spirits of the dead are being invoked or that one of these women has been summoned. Without any further understanding, the imagery suggests the existence of fundamental mysteries and the universal human need for spiritual contact, ritual, and magic. A painting of a long-haired man in a red cape (fig. 382)[60] produces a similar effect. It has been suggested that this unusual figure was a native former shaman named Haapuani who is known to have befriended Gauguin in Hivaoa.[61] Certainly the artist's passionate interest in traditional religion makes it likely that he would have used such a friend as a model, but whatever the figure's identity, Gauguin made him sexually ambiguous by giving him a woman's flowing hair style and white flowers behind his ear. Eyes fixed pensively on the spectator's, the formally posed androgyne displays a small green sprig like a talisman or an attribute of power, while in the background the two women from *The Call* wait behind a tree, one gazing off into the distance and the other peering secretively at the enigmatic figure as if spying on activities from which they have been excluded, seeking some insight or power they don't possess. And how can we interpret the little vignette in the foreground of the dog licking or nuzzling the wing of a bird? It has been observed that the motif relates to a watercolor of a bird frolicking with two dogs which Gauguin humorously titled "Love one another," and the suggestion has been made that the artist was using the symbol of their unnatural relationship to force us to consider our prejudices about the "deviant" inclinations in human sexuality suggested by the man's ambiguous sexual identity.[62] But given Gauguin's propensity to use the dog as a symbol of himself, we might more simply perceive the brilliantly colored tropical bird as a symbol of the exotic native "sorcerer," and view their odd conjunction as a metaphor for the unlikely friendship which had sprung up between Gauguin and one of the island's more unconventional inhabitants.

Gauguin's ceaseless desire to penetrate the secret of the natives' tranquillity and spiritual wisdom emerged in another picture which seems to relate to these. Called *Barbaric tales* (fig. 383), it depicts Gauguin's now deceased

friend Meyer de Haan, the artist whose mentor he had been in Brittany and whose interests and desire for experience and knowledge so paralleled Gauguin's own. A duplicate of the tormented portrait Gauguin had painted of him in 1889 (fig. 268), de Haan crouches here behind two serene women, one of whom is a red-haired native named Tohotua, wife of the "shaman" Haapuani.[63] Gauguin painted a more formal portrait of her (fig. 384) wearing the same white garment that clothes the figure in *The Call* and her counterpart in the picture of the man in the red cloak, a circumstance which suggests that the shaman's wife shared her husband's ritual role and presumptive spiritual powers. Here, Tohotua and her companion sit in *virasana* and *padmasana*, yoga postures associated with deep meditation which Gauguin had again adopted from one of the Borobodur reliefs, and the exotic flowers surrounding them like an aureole seem a palpable expression of the beauty, the mystery, and the fragile impermanence of life. The title *Barbaric tales* conjures up all the power of primitive legends and myths—the encoded wisdom of ancient peoples handed down by oral tradition through the ages. Gauguin's imagery implies his continuing belief that primitive women, immersed in the symbolic stories and holistic worldviews of a deeply religious culture, possessed an instinctive comprehension of reality and a profound sense of harmony with creation. In contrast, the civilized Western male, even one as familiar as de Haan was with the esoteric texts and philosophies of many religions, is forever barred from their enviable state of consciousness by his rationalist mentality and cultural heritage. The satanic-looking de Haan, a human counterpart of the "bird of the devil" that watches over the native girl in *Nevermore* (fig. 358), seems to symbolize not only the evil and psychological torment brought about by the European approach to life, but perhaps also the ultimate futility of Gauguin's own effort to refashion himself as a primitive. Disguised in a woman's dress of the type introduced by missionaries to conceal the unselfconscious natives' nudity, de Haan crouches in the rear with a look of tortured perplexity, as if by eavesdropping on the women's secrets he could become one of them. It was the great bitterness of Gauguin's last years that, despite all his efforts, he too remained forever shut out from the paradise of experiencing life in an unconflicted and tranquil way.

Suffering from debilitating sores and unbearable pain that he dosed with alcohol and morphine, Gauguin produced two last pictures before his death which are filled with intimations of the approaching event. *The Invocation* (fig. 385) depicts a gaunt-looking woman reaching up toward the sky in the pose and gesture of the fruit picker from *Where do we come from?* (fig. 364), but there is now no fruit to pluck and her hands seem raised instead in supplica-

tion. On the right are the figures from *The Call*, the white-clad female now ushering her companion out of the scene in answer to the invisible summons, while at the left two more women wearing white loincloths and posed like the disciples of the Buddha on the Borobodur reliefs make the reassuring gesture "fear not." On the mountainside above them a white cross marks the Catholic cemetery Gauguin could see from his house, a reminder of the Christian presence which interfered so infuriatingly in native affairs. The effect of this juxtaposition of imagery is again ambiguous, for while Gauguin seems to have invoked the combined powers of Christian, Buddhist, and shamanistic religions to help him face the personal end he knew was near, the cross on the mountain also suggests that it is the death of native culture and religion which is about to occur.

A similar spirit of prophetic insight marks another of Gauguin's final pictures: *Women and white horse* (fig. 386). Based on a motif he had already executed in several media under the sardonic title *Change of residence* (fig. 387), it depicts a nude female reclining on a white horse at the center of the lush Marquesan landscape. Accompanied by two women in white who turn their heads and incline their bodies away from her in the manner that suggests a ritual leave-taking, this Eve seems about to set off on her final journey: the ultimate exile from Eden to the land of the dead.[64] On the mountain above, we again find a white cross, its presence suggesting not only the Western power responsible for rupturing the harmony of paradise, but also the road Christ followed from Calvary to the site of his crucifixion. These combined evocations of Eve and Christ, both of whom set their need for spiritual self-fulfillment above the risk of banishment, suffering, and death, reveal that to the very end Gauguin identified himself with sacred mythic figures who sacrificed themselves in the pursuit of truth and freedom. He died, presumably from heart failure, on 8 May 1903, at the age of fifty-four.

Ironically, despite his violent antagonism to the Catholic Church and his bitter quarrels with the local bishop, the authorities buried him in the same Catholic cemetery that figured in his last paintings. It was not until seventy years later that a bronze cast of his Oviri sculpture was placed on his grave as he had desired. In a letter to Morice written shortly before his death, Gauguin declared:

I am on the ground, but not yet conquered. Is the Indian who smiles under torture vanquished? Decidedly the savage is better than we are. You were mistaken when you said one day that I was wrong to say that I am a savage. It was nevertheless true: I am a savage. And civilized people feel it: because in my works there is nothing that surprises, that baffles, if it is not this "savagery despite myself." This is why it is inimitable. The work of a man is the explanation of this man.[65]

Notes

Notes

CHAPTER I
The Symbolist Revolt Against Modern Life

1. See for example Albert Aurier, "Les Peintres Symbolistes," *Oeuvres posthumes* (Paris: Mercure de France, 1893), pp. 305–6; André Mellerio, *Le Mouvement idéaliste en peinture* (Paris: H. Floury, 1896), p. 13; and Maurice Denis, "Notes sur la peinture religieuse" (1896), "L'Influence de Paul Gauguin," (1903), "Le Soleil (1906), and "De Gauguin de de Van Gogh au classicisme" (1909), *Théories 1890–1910. Du Symbolisme et de Gauguin vers un nouvel ordre classique* (Paris: L. Rouart et J. Watelin, 1920), pp. 42–43, 166–71, 218, 262–75, hereafter referred to as *Théories.*

2. Michel Floorisoone, *Eugène Carrière et le symbolisme*, with notes by Jean Leymarie (Paris: Éditions des Musées Nationaux, 1949), p. 16. Hereafter referred to as *Eugène Carrière.*

3. *The Complete Letters of Vincent van Gogh*, 3 vols., trans. J. van Gogh-Bonger and C. de Dood (Greenwich, Conn.: New York Graphic Society, 1958), 3:433, no. w4. Hereafter referred to as *Complete Letters.*

4. Ibid., 3:426, no. W1.

5. Ibid., 2:491, no. 451.

6. Paul Gauguin, *Noa Noa*, introduction by Jean Loize (Paris: André Balland, 1966), p. 28. Hereafter referred to as *Noa Noa*/L.

7. *Lettres de Gauguin à sa femme et à ses amis*, ed. Maurice Malingue (Paris: Éditions Bernard Grasset, 1946), p. 260. Hereafter referred to as *Lettres*/Malingue.

8. Ibid., p. 195.

9. Paul Gauguin, *Oviri. Écrits d'un sauvage*, ed. Daniel Guérin (Paris: Gallimard, 1974), p. 67. Hereafter referred to as *Oviri.*

10. *Complete Letters*, 1:511, no. 252.

11. Ibid., 3:55, no. 542.

12. Ibid., 2:127, no. 319.

13. Paul Gauguin, *Avant et après* (Paris: G. Crès, 1923), p. 71.

14. *Complete Letters*, 2:149. no. 326.

15. Ibid., 1:283, no. 164.

16. Ibid., 2:185, no. 336.

17. Ibid., 1:288, no. 164.

18. Quoted by Louis Piérard, "Van Gogh au pays noir," in *Van Gogh, raconté par lui-même et par ses amis*, preface by Pierre Courthion (Geneva: Pierre Cailler, 1947), p. 105. Hereafter referred to as *Van Gogh, raconté.*

19. *Avant et après*, p.10.

20. Ibid., p. 101.

21. Ibid., pp. 95–98. See also the section entitled "Diverses choses" at the back of Gauguin's final manuscript of *Noa Noa*, Cabinet des dessins R F 7259, Louvre, Paris, pp. 309–10. Hereafter referred to as *Noa Noa* II.

22. Ibid., p. 100.

23. "Diverses choses," *Noa Noa* II, pp. 308–9.

24. "Diverses choses," *Oviri*, p. 211.

25. Ibid., p. 213.

26. *Avant et après*, pp. 52–53.

27. *Complete Letters*, 3:483, no. B5[5].

28. Ernest Renan, *The Future of Science: Ideas of 1848* (London: Chapman & Hall Ltd., 1891), p. 90.

29. Jean–Jacques Rousseau, *Reveries of a Solitary Walker*, trans. Peter France (New York: Penguin Books, 1979), p. 59.

30. Renan, *Future of Science*, p. 46.

31. Helena Petrovna Blavatsky, *The Key to Theosophy* (London: Theosophical Publishing Society, 1890), p. 5.

32. Ibid., p. 3.

33. André Fontainas, *Mes souvenirs du symbolisme* (Paris: La Nouvelle Revue Critique, 1928), p. 111.

34. *Complete Letters*, 1:513, no. 253.

35. Ibid., 3:52, no. 542.

36. Ibid., 3:54–55, no. 542.

37. *Avant et après*, p. 97.

38. Ibid., p. 100.

39. Paul Gauguin, *Cahier pour Aline*, facsimile of the original manuscript, presented by Suzanne Damiron (Paris: Société des amis de la bibliothèque d'art et d'archéologie de l'Université de Paris, 1963), n.p.

40. *Avant et après*, p. 97.

41. *Noa Noa*/L, p. 44.

42. See in particular "Diverses choses," *Oviri*, pp. 182–90.

43. Quoted in Bengt Danielsson, *Gauguin in the South Seas*, trans. Reginald Spink (New York: Doubleday & Co., Inc., 1965), p. 235. Hereafter referred to as *South Seas.*

44. *Complete Letters*, 1:366, no. 197.

45. Ibid., 2:49–50, no. 290.

46. *Letters to an Artist: From Vincent van Gogh to Anton Ridder van Rappard 1881–1885*, trans. Rela van Messel (New York: Viking Press, 1936), p. 166. Hereafter referred to as *Letters to Rappard.*

47. Albert Aurier, "Essai sur une nouvelle méthode du critique," *Oeuvres posthumes*, p. 176.

48. Émile Bernard, "Les Ouvriers et les artistes," *Réflexions d'un témoin de la décadence du beau* (Cairo: M. Roditi & Cie, 1902), p. 49. Hereafter referred to as *Réflexions.*

49. Ibid., p. 52.

50. *Complete Letters*, 1:511, no. 252.

51. Ibid., 2:620, no. 514.

52. Ibid., 3:16, no. 524.

53. *Cahier pour Aline*, n.p.

54. Ibid.

55. *Lettres*/Malingue, p. 187.

56. Ibid., p. 193.

57. Richard Shiff, *Cézanne and the End of Impressionism: A Study of the Theory, Technique, and Critical Evaluation of Modern Art* (Chicago and London: University of Chicago Press, 1984), pp. 3–26.

58. For a thorough analysis of the French Academy's theory and practice, see Albert Boime, *The Academy and French Painting in the Nineteenth Century* (New York: Phaidon, 1971). Hereafter referred to as *Academy.*

59. "Notes sur l'art: L'Exposition Universelle," *Oviri*, p. 48.

60. Ibid.,"Qui trompe-t-on ici?", *Le Moderniste Illustré* (21 September, 1889), p. 56.

61. *Racontars de rapin* (Paris: Falaize, 1951), p. 15. Hereafter referred to as *Racontars*.

62. "Interview de Paul Gauguin," by Eugène Tardieu, *L'Echo de Paris* (13 May, 1895), in *Oviri*, p. 138.

63. *Complete Letters*, 2:431, no. 431.

64. Ibid., 3:15, no. 524.

65. Ibid., 2:471, no. 443.

66. Ibid., 1:160, no. 117.

67. *Letters to Rappard*, p. 144.

68. *Complete Letters*, 1:503, no. 250.

69. Ibid., 2:70, no. 297.

70. Ibid., 2:347–48, no. 393.

71. *Letters to Rappard*, p. 28.

72. Ibid., p. 21.

73. *Complete Letters*, 3:474, no. BI[1].

74. Gustave Kahn, *Symbolistes et décadents* (Paris: Librairie Léon Vanier, 1902), p. 33.

75. Ibid., p. 58.

76. Camille Mauclair, *The Great French Painters and the Evolution of French Painting from 1830 to the Present Day*, trans. P. G. Konody (New York: E. P. Dutton, 1903), pp. 93–94.

77. Quoted in Floorisoone, *Eugène Carrière*, p. 10.

78. "Salon of 1866," quoted in Hendrik Rookmaaker, *Gauguin and 19th Century Art Theory* (Amsterdam: Swets & Zeitlinger, 1972), p. 11.

79. Émile Bernard, "Paul Cézanne," *L'Occident* 32 (July 1904): 27.

80. Maurice Denis, "Préface de IXe exposition des peintres impressionnistes et symbolistes" (1895), *Théories*, p. 26.

81. Ibid.

82. Charles Morice, "Paul Gauguin," *Mercure de France* 48 (December 1893): 292.

83. Charles Baudelaire, "The Salon of 1859," *Art in Paris 1845–1862*, trans. and ed. Jonathon Mayne (New York: Phaidon, 1965), p. 154. Hereafter referred to as *Art in Paris*.

84. *Complete Letters*, 2:374, no. 406.

85. Ibid., 2:427, no. 429.

86. Lettres/Malingue, p. 319.

87. "Salon of 1846," in *Art in Paris*, pp. 58–59.

88. *Letters to Rappard*, p. 107.

89. *Complete Letters*, 1:426–27, no. 221.

90. Ibid., 1:479, no. 241.

91. Ibid., 1:507, no. 251.

92. Ibid., 3:250, no. 626a.

93. *Avant et après*, p. 10.

94. "Diverses choses," *Oviri*, pp. 175–77.

95. "Notes synthétiques" (1886), *Paul Gauguin: Carnet de croquis 1884–1888*, ed. Raymond Cogniat and John Rewald (New York: Hammer Galleries, 1962), p. 60. Hereafter referred to as *Carnet de croquis*.

96. *Complete Letters*, 3:6, no. 520.

97. Ibid., 2:427, no. 429.

98. *Racontars*, p. 73.

99. "Diverses choses," *Oviri*, p. 175.

100. Aurier, "Le Symbolisme en peinture: Paul Gauguin," *Oeuvres posthumes*, pp. 211–12.

101. *Cahier pour Aline*, n.p.

102. *Racontars*, pp. 75–76.

103. Bernard, in *Lettres à Odilon Redon*, ed. Roseline Bacou, preface by Ari Redon (Paris: Librairie José Corti, 1960), p. 205.

104. Aurier, "Le Peintres symbolistes," *Oeuvres posthumes*, p. 301.

105. Friedrich Wilhelm Joseph von Schelling, "System of Transcendental Idealism," in *Philosophies of Art and Beauty: Selected Readings in Aesthetics from Plato to Heidegger*, eds. Albert Hofstadter and Richard Kuhns (Chicago: University of Chicago Press, 1964), p. 370. Hereafter referred to as Hoftstadter.

106. Ibid., p. 374.

107. Fontainas, p. 40.

108. Rookmaaker, p. 92.

109. Renan, p. 46.

110. "Enquête sur la séparation des Beaux–arts et de l'État," *Théories*, p. 180.

111. *Avant et après*, p. 181.

112. Ibid., p. 16.

113. "Les Écoles," *Réflexions*, p. 35.

114. *Complete Letters*, 1:196, no. 133.

115. Ibid., 3:131, no. 574.

116. *Racontars*, p. 44.

117. *Complete Letters*, 2:605, no. 506.

118. Ibid., 3:25, no. 531.

119. Ibid., 3:39, no. 538.

120. Ibid., 3:46, no. 540.

121. *Lettres*/Malingue, p. 59

122. For discussions of this aspect of traditional societies, see William James, *The Varieties of Religious Experience* (New York: Macmillan Publishing Co., Inc., 1961) p. 108; Lucien Lévy-Bruhl, *L'Expérience mystique et les symboles chez les primitifs* (Paris: Félix Alcan, 1938), pp. 12–35; Ernst Cassirer, *An Essay on Man: An Introduction to a Philosophy of Human Culture* (New Haven: Yale University Press, 1944), pp. 79–86; Herbert Read, *Art and Society* (New York: Schocken Books, 1966), pp. 33, 45–46, 108.

123. *Complete Letters*, 2:620, no. 514.

124. *Lettres de Gauguin à Daniel de Monfreid*, ed. Mme Joly-Ségalen, preface by Victor Ségalen (Paris: Georges Falaize, 1950), p. 192. Hereafter referred to a *Lettres à Monfreid*.

125. The Journal of Eugène Delacroix, ed. André Joubin, trans. Walter Pach (New York: Viking Press, 1972), p. 585.

126. *Complete Letters*, 3:187, no. 597.

127. "De Gauguin, de Whistler et de l'exces des théories," *Théories*, p. 200.

128. "Les Peintres symbolistes," *Oeuvres posthumes*, p. 304.

129. "Définition du néo-traditionnisme," *Théories*, p. 12.

130. Incorporated into *Lettres*/Malingue, p. 145.

131. *Cahier pour Aline*, n.p.

132. "De Gauguin et de van Gogh au classicisme," *Théories*, p. 263.

133. "Les Primitifs et la Renaissance," *Réflexions*, p. 16.

134. Maurice Denis, *Journal*, 3 vols. (Paris: La Colombe, Éditions du Vieux Colombier, 1957), 1:64.

135. "Le Symbolisme en peinture: Paul Gauguin," *Oeuvres posthumes*, pp. 215–16.

CHAPTER II
The Symbolist Requirements of Art

1. "Philosophy of Fine Art," in *Readings in Philosophy of Art and Aesthetics*, ed. Milton Nahm (Englewood Cliffs, N.J.: Prentice-Hall, 1975), p. 456. Hereafter referred to as Nahm.

2. *Letters to Rappard*, pp. 89–90.

3. *Complete Letters*, 1:89.

4. Ibid., 1:196–97, no. 133.

5. Ibid., p. 198.

6. Ibid., 1:541, no. 266.

7. Ibid., 1:198, no. 133.

8. Ibid., 1:495, no. 248.

9. Ibid., 1:437, no. 225.

10. Ibid., 3:478, no. B3[3].

11. *Avant et après*, p. 198.

12. *Cahier pour Aline*, n.p.

13. Ibid., "Notes sur Edgar Allan Poe."

14. "Diverses choses," *Oviri*, p. 159.

15. *Lettres*/Malingue, p. 45.

16. "Diverses choses," *Oviri*, p. 168.

17. *Lettres*/Malingue, p. 284.

18. Ibid., p. 319.

19. *Cahier pour Aline*, n.p.

20. *Avant et après*, p. 188.

21. "L'Église catholique et les temps modernes," *Oviri*, p. 198.

22. Ibid., "L'Esprit moderne et le catholicisme," *Oviri*, p. 207.

23. "Diverses choses," *Noa Noa* II, p. 272.

24. *Lettres*/Malingue, p. 166.

25. *Complete Letters*, 1:84, no. 82a.

26. Ibid., 1:88; Sermon of January 1877.

27. Ibid., 1:288, no. 164.

28. Ibid., 1:274, no. 161.

29. Ibid., 1:198, no. 133.

30. Ibid., 1:271, no. 160.

31. Ibid., 1:287, no. 164.

32. Ibid., 2:401, no. 418.

33. Ibid., 1:196, no. 133.

34. Ibid., 1:87, 91.

35. Ibid., 1:90–91.

36. Ibid., 2:362, no. 400.

37. Ibid., 1:477, no. 240.

38. *Letters to Rappard*, pp. 58–59.

39. *Complete Letters*, 2:620, no. 514.

40. Ibid., 2:492, no. 451.

41. Ibid., 1:195, no. 133.

42. Quoted by Gauguin, *Avant et après*, p. 11.

43. *Complete Letters*, 3:506, no. B13[8].

44. Ibid., 1:495, no. 248.

45. Ibid.

46. Ibid., 3:332, no. R38.

47. "De Richard Wagner," *Cahier pour Aline*, n.p.

48. Ibid.

49. "Diverses choses," *Oviri*, pp. 182–87, 213–16.

50. Ibid., p. 187.

51. *Avant et après*, p. 185.

52. *Lettres*/Malingue, p. 64.

53. *Avant et après*, p. 188.

54. Ibid., p. 189.

55. Arsène Alexandre, *Paul Gauguin, sa vie et le sens de son oeuvre* (Paris: Bernheim-Jeune, 1930), p. 31.

56. *Lettres*/Malingue, p. 124.

57. *Noa Noa*/L, p. 24.

58. *Lettres*/Malingue, pp. 229–30

59. "Diverses choses," *Oviri*, pp. 168–69.

60. *Avant et après*, p. 55.

61. "L'Église catholique et les temps modernes," *Oviri*, pp. 198–99.

62. "Diverses chose," *Noa Noa* II, pp. 272–73.

63. *Lettres à Monfreid*, p. 183.

64. *Lettres*/Malingue, p. 301.

65. "Diverses choses," *Oviri*, p. 163.

66. *Racontars*, pp. 22–23.

67. *Lettres*/Malingue, p. 288.

68. Ibid., p. 166.

69. *Cahier pour Aline*, n.p.

70. *Avant et après*, p. 17.

71. *Lettres*/Malingue, p. 288.

72. Ibid., p. 47.

73. *Lettres à Monfreid*, p. 184.

74. Ibid., p. 188.

75. *Complete Letters*, 3:503, no. B12[10].

76. *Letters to Rappard*, p. 107.

77. *Complete Letters*, 3:257, no. 626a.

78. Ibid., 3:58, no. 543.

79. Ibid., 3:134, no. 576.

80. For a full discussion of these ideas see James, *The Varieties of Religious Experience*.

81. "Salon of 1859," *Art in Paris*, p. 156.

82. *Complete Letters*, 3:478, no. B3[3].

83. "Notes sur Edgar Allan Poe," *Cahier pour Aline*, n.p.

84. Odilon Redon, *À soi-même. Journal 1867–1915* (Paris: Librairie José Corti, 1961), p. 92.

85. Charles Morice, *La Littérature de tout à l'heure* (Paris: Perrin et Cie, 1889), p. 33.

86. Bernard, "Le Rêve et l'art," *Réflexions*, p. 90.

87. Ibid., p. 92.

88. Fontainas, p. 40.

89. Bernard, "Le Rêve et l'art," *Réflexions*, p. 90.

90. Gustave Kahn, "Réponse des Symbolistes," quoted in Sven Loevgren, *The Genesis of Modernism* (Stockholm: Almquist & Wiskell, 1959), p. 83.

91. "The Enneads," in Nahm, pp. 219–21.

92. "The Republic," in Hofstadter, pp. 24–25.

93. "Politics," in Nahm, p. 142.

94. "Critique of Judgment," in Hofstadter, pp. 291, 313.

95. "System of Transcendental Idealism," in Hofstadter, pp. 366, 368–70.

96. "Philosophy of Fine Art," in Nahm, p. 456.

97. "The World as Will and Idea," in Hofstadter, p. 481.

98. Thomas Carlyle, *Sartor Resartus*, ed. Charles Frederick Harrold (New York: Odyssey Press, 1937), pp. 256–58.

99. See H. R. Graetz, *The Symbolic Language of Vincent van Gogh* (New York: McGraw–Hill, 1963), p. 291.

100. The Compact Edition of *The Oxford English Dictionary* (Oxford University Press, 1971), 2:3206, sec. 362.

101. *Sartor Resartus*, pp. 219–20.

102. Charles Baudelaire, "Correspondances," *Les Fleurs du mal*, 2d ed., ed. Jacques Crepet and Georges Blin (Paris: Librairie José Corti, 1942), p. 9.

103. "Salon of 1859," *Art in Paris*, p. 162.

104. "Exposition Universelle 1855," *Art in Paris*, p. 143.

105. Charles Baudelaire, "The Life and Work of Eugène Delacroix," *The Painter of Modern Life*, trans. and ed. Jonathon Mayne (New York: Phaidon, 1965), pp. 43–44. Hereafter referred to as *Modern Life*.

106. "The Painter of Modern Life," *Modern Life*, pp. 3, 12.

107. "Exposition Universelle 1855," *Art in Paris*, p. 125.

108. "Salon of 1859," *Art in Paris*, p. 171.

109. From J. Huret, *Enquête sur l'évolution littéraire* (Paris: 1891), quoted in Loevgren, p. 105.

110. See Helena Petrovna Blavatsky, *Isis Unveiled*, 2 vols. (New York: J. W. Bouton, 1877), 1:xi, xiii, xxi, 17–19, 25–6, 155–59, 276–80, 433, 435–36; 2: Chapter IX; also Edouard Schuré, *The Great Initiates*, 2 vols., trans. Fred Rothwell (Philadelphia: David M'Kay Co., 1925), 1:x, xiv, 170, 181.

111. "La Réaction nationaliste," *Théories*, p. 190.

112. See Anna Balakian, *The Symbolist Movement* (New York: Random House, 1967), p. 156.

113. "Le Symbolisme en peinture: Paul Gauguin," *Oeurves posthumes*, pp. 210, 214; ibid., "Les Peintres symbolistes," pp. 299–301.

114. Ibid., pp. 206, 215–16, 299.

115. Ibid., "Les Peintres symbolistes," p. 302–03.

116. Ibid., "Le Symbolisme en peinture: Paul Gauguin," p. 213.

117. Ibid., p. 217.

118. Ibid., p. 216; "Les Peintres symbolistes, p. 296.

119. "De Gauguin et de van Gogh au classicisme," *Théories*, pp. 268, 276.

120. Ibid., "L'Esthétique de Beuron," p. 185.

121. Ibid., "De Gauguin et de van Gogh au classicisme," p. 267.

122. Ibid., "Notes sur la peinture religieuse," p. 34.

123. "Les Écoles," Notes, *Réflexions*, p. 40.

124. Ibid., "Le Passion de l'art," Notes, p. 192.

125. Introduction to Odilon Redon's letters in *Lettres à Emile Bernard* (Brussels: Éditions de la Nouvelle Revue Belgique, 1942), p. 135.

126. "Vincent van Gogh," *Mercure de France* 40 (April 1893): 26.

127. Ibid., p. 327.

128. "Puvis de Chavannes," *Réflexions*, p. 276.

129. *Lettres à Bernard*, pp. 79–80.

130. "Ce que c'est que l'art mystique," *Réflexions*, p. 130.

131. *Complete Letters*, 3:288–89, no. 645.

132. Ibid., 1:495, no. 248.

133. Ibid., 3:491, no. B6[6].

134. Ibid., 2:605, no. 506.

135. Ibid., 2:94, no. 306.

136. Ibid.

137. Ibid., 2:50, no. 290.

138. Ibid.

139. Ibid., 1:519, no. 256.

140. Ibid., 1:37, no. 39a, and 2:317, no. 381.

141. Ibid., 2:364–66, no. 401; 2:413, no. 424; 2:423–25, no. 428.

142. Ibid., 3:153, no. 584a.

143. Ibid., 3:228, no. 613.

144. "Salon of 1846," *Art in Paris*, p. 50.

145. *Complete Letters*, 2:513, no. 459a.

146. Ibid., 2:104, no. 309.

147. Ibid., 2:431, no. 431.

148. Ibid., 2:420, no. 427.

149. Ibid., 2:297, no. 371.

150. Ibid., 2:299, no. 372.

151. Ibid., 2:349, no. 394.

152. Ibid., 3:496, no. B8[11].

153. Ibid., 1:482–83, no. 242.

154. Ibid., 1:360, no. 195.

155. Ibid., 3:25, no. 531.

156. Ibid., p. 26.

157. Ibid., 3:524, no. B21[21].

158. *Van Gogh, raconté*, p. 132.

159. *Complete Letters*, 1:507, no. 251; 1:523, no. 259.

160. Ibid., 2:185, no. 336.

161. Ibid., 3:20, no. 527.

162. Ibid., 2:206, no. 339a; 3:494, no. B7[7].

163. Ibid., 3:180, no. 594.

164. Ibid., 2:589–90, no. 499.

165. Ibid., 3:490, no. B6[6].

166. *Lettres à Redon*, p. 194.

167. Ibid., see also "De Richard Wagner," *Cahier pour Aline*, n.p.

168. *Avant et après*, p. 59.

169. Ibid., p. 101.

170. *Lettres*/Malingue, p. 166.

171. "L'Esprit moderne et le catholicisme," *Oviri*, p. 207.

172. *Avant et après*, p. 186.

173. Ibid., p. 187.

174. "Notes synthétiques," *Carnet de croquis*, p. 64.

175. *Lettres*/Malingue, p. 135.

176. "Diverse choses," *Oviri*, p. 179.

177. "De Richard Wagner," *Cahier pour Aline*, n.p.

178. "Diverses choses," *Oviri*, p. 159.

179. "Diverses choses," *Noa Noa* II, p. 272.

180. *Lettres*/Malingue, p. 289.

181. *Paul Gauguin: 45 Lettres à Vincent, Théo, et Jo van Gogh*, ed. Douglas Cooper, (Gravenhage, 1983), p. 221, no. 31. Hereafter referred to as *45 Lettres*.

182. Ibid., p. 306.

183. Inge Jonsson, *Emanuel Swedenborg*, trans. Catherine Djurklou (New York: Twayne Publishers, 1971), p. 114.

184. Honoré de Balzac, *Séraphita*, in *Balzac's Works*, (Boston: Dana Estes & Co., n.d.), vol. 2, pp. 57, 58, 102.

185. *Lettres*/Malingue, pp. 45, 47.

186. Ibid., p. 237.

187. Ibid., p. 136.

188. "Diverses choses," *Oviri*, p. 168.

189. Ibid., p. 170.

190. Ibid., "L'Église catholique et les temps modernes," pp. 199–200; "L'Esprit moderne et le catholicisme," pp. 206–07.

191. *Lettres*/Malingue, p. 293.

192. Quoted in Charles Chassé, *Gauguin et le groupe de Pont-Aven* (Paris: H. Floury, 1921), p. 58. Hereafter referred to as *Pont-Aven*.

193. "Interview de Paul Gauguin," *Oviri*, p. 140.

194. *Lettres*/Malingue, p. 150.

195. *Avant et après*, pp. 35–36.

196. Charles Morice, *Paul Gauguin* (Paris: H. Floury, 1920), pp. 26–27.

197. "The Painter of Modern Life," *Modern Life*, p. 15.

198. *Journal*, p. 329.

199. Ibid., pp. 375–76.

200. Ibid., pp. 298, 306, 334.

201. "Définition du néo-traditionnisme," *Théories*, p. 23.

202. Ibid., p. 24; "Notes sur la peinture religieuse," p. 34; "De la gaucherie des primitifs," pp. 173–75.

203. Ibid., p. 178; "Aristide Maillol," p. 242.

204. *Complete Letters*, 2:77, no. 299.

205. Ibid., 2:401, no. 418.

206. Ibid.

207. Ibid., 2:382, no. 408.

208. Ibid., 2:572, no. 490

209. Ibid., 1:448, no. 228.

210. Ibid., 3:492, no. B7[7].

211. Ibid., 2:457, no. 439.

212. Ibid., 2:433, no. 431.

213. Ibid.

214. *Letters to Rappard*, p. 146.

215. *Lettres*/Malingue, p. 134.

216. *Avant et après*, p. 35.

217. Ibid., p. 36

218. "Diverses choses," *Oviri*, pp. 176–77.

219. Ibid., "Interview de Paul Gauguin," pp. 138–39.

220. Ibid., "Diverses choses," p. 163.

221. Ibid., "Interview de Paul Gauguin," p. 138.

222. *Lettres*/Malingue, p. 302.

223. "Définition du néo-traditionnisme," *Théories*, p. 23.

224. "De Gauguin et de van Gogh au classicisme," *Théories*, p. 277.

225. Ibid., p. 271.

226. Ibid., "Notes sur la peinture religieuse," p. 34.

227. "Metaphysics," in Nahm, p. 36.

228. "Notes sur la peinture religieuse," *Théories*, p. 33.

229. Ibid., "Les Arts à Rome ou la méthode classique," p. 47.

230. Ibid., "De Gauguin et de van Gogh au classicisme," p. 268.

231. "Le Symbolisme en peinture: Paul Gauguin," *Oeuvres posthumes*, p. 217.

232. Paul Sérusier, *A. B. C. de la peinture, suivies d'une correspondance inédite*, reprinted from 1899 manuscript (Paris: 1950), p. 43.

233. "De Gauguin et de van Gogh au classicisme, *Théories*, p. 276.

234. Ibid., "Notes sur la peinture religieuse," p. 36.

235. Ibid., "Définition du néo-traditionnisme," p. 1.

236. Ibid., "Le Salon de la Société des artistes français," p. 79.

237. Hippolytus, "Philosophumena," in Nahm, p. 36.

238. Ibid., Aristotle, "Metaphysics."

239. Plato, "The Laws," in Nahm, p. 107.

240. "The Republic," in Hofstadter, p. 28.

241. "Politics," in Nahm, p. 142.

242. Thomas Carlyle, *On Heroes, Hero-Worship and the Heroic in History*, ed. Carly Niemeyer (Lincoln and London: University of Nebraska Press, 1966), pp. 83–84.

243. Lewis Thomas, "The Music of *This* Sphere," *The Lives of a Cell: Notes of a Biology Watcher* (New York: Bantam Books, 1975), p. 22.

244. Ibid., pp. 27–28.

245. Intermission broadcast of the Metropolitan Opera, 23 October, 1980.

246. Ernest Renan, *Dialogues et fragments philosophiques*, 3rd ed. (Paris: Calmann-Lévy, 1885), p. 26. Hereafter referred to as *Dialogues*.

247. Blavatsky, *Isis Unveiled*, 1:275, 506.

248. "Salon of 1845," *Art in Paris*, p. 6.

249. Ibid., "Salon of 1846," pp. 48–50.

250. David Sutter, "Les Phénomènes de la vision," quoted in William Innes Homer, *Seurat and the Science of Painting* (Cambridge, Mass.: The MIT Press, 1964), p. 44.

251. Henry, quoted in José Argüelles, *Charles Henry and the Formation of a Psychophysical Aesthetic* (Chicago: University of Chicago Press, 1972), pp. 7, 10.

252. *Complete Letters*, 2:297, no. 371.

253. Ibid., 2:427, no. 429.

254. Ibid., 2:448, no. 435c.

255. Ibid., p. 447.

256. Ibid., 3:54–55, no. 542.

257. *Cahier pour Aline*, n.p.

258. "Notes synthétiques," *Carnet de croquis*, p. 63.

259. Ibid., pp. 61–62.

260. "Interview de Paul Gauguin," *Oviri*, p. 138.

261. Ibid., p. 27.

262. *Racontars*, pp. 49–50.

263. *Lettres à Monfreid*, p. 183.

264. "Diverses choses," *Oviri*, pp. 178, 179.

265. *Lettres*/Malingue, p. 288.

266. Ibid., pp. 287–88.

267. "Notes synthétiques," *Carnet de croquis*, p. 62.

268. *Noa Noa/L*, pp. 22–23.

269. "Notes synthétiques," *Carnet de croquis*, p. 61.

270. *Lettres à Monfreid*, p. 44.

271. *Cahier pour Aline*, n.p.

272. "Notes synthétiques," *Carnet de croquis*, pp. 57–58.

273. "Diverses choses," *Oviri*, p. 179.

274. *La Littérature de tout à l'heure*, p. 65.

275. André Barre, *Le Symbolisme* (Paris: Jouve et cie, 1911), p. 18.

276. "The Laws," in Hofstadter, pp. 121–22.

277. "The Enneads," in Nahm, p. 226.

278. "The Moralists," in Hofstadter, pp. 248–49.

279. Ibid., p. 259.

280. Jonsson, pp. 138–39.

281. "Critique of Aesthetic Judgment," in Hofstadter, pp. 291, 294–96, 310, 312–13.

282. Ibid., "The World as Will and Idea," p. 453.

283. Ibid., p. 481.

284. Ibid., p. 483.

285. *Sartor Resartus*, pp. 56–57.

286. Ibid., p. 225.

287. *The Future of Science*, pp. 299–302.

288. *Dialogues*, pp. 96–97.

289. Ibid., pp. 99–101, 103.

290. John Rewald, "Extraits du Journal inédit de Paul Signac I, 1894–1895," *Gazette des Beaux-Arts* 36 (July–September, 1939): 104.

291. Gustave Geffroy, "Puvis de Chavannes," *La Vie artistique*, vols. 1–4 (Paris: E. Dentu, 1892–1895), 4:102.

292. Geffroy, "Indépendants," *La Vie artistique*, vols. 5–8 (Paris: H. Floury, 1897–1903), 5:21.

293. Geffroy, "Salon de 1894 au Champs-de-Mars: Le Miroir sociale," *La Vie artistique*, 4:100.

294. Ibid., "Conditions historiques nouvelles," 4:320–21.

295. "Les Ouvriers et les artistes," Notes, *Réflexions*, p. 56.

296. Ibid., "L'Éducation," Notes, p. 202; "Paul Cézanne," p. 30.

297. Ibid., "Le Passion de l'art," Notes, p. 189.

298. *Letters to Rappard*, p. 218.

299. *Complete Letters*, 2:363, no. 400.

300. *Van Gogh, raconté*, p. 132.

301. *Complete Letters*, 3:39, no. 538.

302. Ibid., 1:145, no. 110.

303. Ibid., 2:220, no. 343.

304. "De Richard Wagner," *Cahier pour Aline*, n.p.

305. "Notes synthétiques," *Carnet de croquis*, pp. 59–60.

306. "Diverses choses," *Oviri*, p. 180.

307. Ibid., p. 181.

308. *Lettres*/Malingue, p. 147.

309. *Lettres à Monfreid*, p. 31.

310. *Lettres*/Malingue, p. 159.

311. *Cahier pour Aline*, n.p.

312. *Lettres*/Malingue, p. 219.

313. Ibid., p. 220.

314. *Lettres à Monfreid*, p. 188.

315. *Complete Letters*, 3:256, no. 626a.

316. *Lettres*/Malingue, p. 223.

317. Ibid., p. 234.

318. *Avant et après*, pp. 53–54.

319. Ibid., p. 188.

CHAPTER III
Out of Darkness

1. Most biographical material can be found in Johanna van Gogh-Bonger's memoirs in the preliminary section of *The Complete Letters of Vincent van Gogh*, as well as in the letters themselves. Two comprehensive recent treatments of Vincent's life and work are Jan Hulsker's *The Complete Van Gogh* (New York: Harry N. Abrams, 1980), and Ingo Walther and Rainer Metzger's *Vincent van Gogh, The Complete Paintings*, 2 vols. (Cologne: Benedikt Taschen, 1990). Hereafter referred to as Walther/Metzger.

2. *Complete Letters*, 1:xxiv.

3. See Louis van Tilborgh and Evert van Uitert's essay "A Ten-Year Career: The Oeuvre of Vincent van Gogh," in *Vincent van Gogh*, 2 vols. (Amsterdam: Rijksmuseum Vincent van Gogh and Rijksmuseum Kröller-Müller, 1990), 1:15–24.

4. *Complete Letters*, 1:520, no. 257.

5. Ibid., 2:290, no. 367.

6. Ibid., 2:414, no. 425.

7. Ibid., 1:360, no. 195.

8. Ibid., 1:326, no. 181.

9. Ibid., 1:165, no. 121.

10. Ibid., 1:274, no. 161.

11. Ibid., 1:271, no. 160.

12. Ibid., 1:284, no. 164.

13. Ibid., p. 285.

14. Ibid.

15. Ibid., 2:232, no. 346.

16. Ibid., 2:178, no. 334.

17. Ibid., 2:250, no. 350.

18. Ibid., 2:175, no. 333.

19. Ibid., 1:196, no. 133; 1:496, no. 248; 1:498, no. 249.

20. Ibid., 1:482, no. 242; 1:512–13, no. 253; 2:399–400, no. 418.

21. Ibid., 1:204, no. 136.

22. Ibid., 2:231, no. 346.

23. Ibid., 2:234, no. 347.

24. Letter to Rappard, p. 17.

25. *Complete Letters*, 2:239, no. 347.

26. *Sartor Resartus*, p. 30.

27. *The Letters of Gustave Flaubert*, 2 vols., trans. and ed. Francis Steegmuller (Cambridge: Harvard University Press, 1982), 1:36.

28. *Complete Letters*, 2:367, no. 402.

29. Ibid., 2:370–71, no. 404.

30. See Meyer Shapiro, *Vincent van Gogh* (New York: Harry N. Abrams, 1950), p. 40.

31. See Graetz, p. 42, and Mark Roskill, *Van Gogh, Gauguin, and the Impressionist Circle* (Greenwich, Conn.: New York Graphic Society, 1970), p. 7. Hereafter referred to as *Impressionist Circle*.

32. See Jean Leymarie, *Van Gogh* (Paris and New York: P. Tisné, 1951), p. 26; Carl Nordenfalk, *The Life and Work of Van Gogh* (New York: Philosophical Library, 1953), pp. 141–42; Bogomila Welsh-Ovcharov, *Vincent Van Gogh: His Paris Period 1886-1888* (Utrecht and The Hague: Editions Victorine, 1976), pp. 141–42; Hulsker, p. 206; Walther/Metzger, p. 154.

33. *Complete Letters*, 2:227–28, no. 345.

34. Ibid., 1:268, no. 159.
35. Ibid., 2:231, no. 345a.
36. Ibid., 1:283, no. 164.
37. Ibid., 3:426, no. w1.
38. Ibid., 1:274, no. 161.
39. Ibid., 3:235, no. 615.
40. *Sartor Resartus*, p. 172.
41. *Complete Letters*, 1:145, no. 110.
42. Ibid., 3:428, w1.
43. Ibid., 2:515, no. 459a.
44. Ibid., 2:513, no. 459a.
45. Ibid., 2:471, no. 443.
46. Marc Edo Tralbaut, *Vincent van Gogh* (New York: Viking Press, Studio Books, 1969), p. 199.
47. Hulsker, p. 244.
48. Frank Elgar, *Van Gogh: A Study of His Life and Work*, trans. James Cleugh (New York: Frederick A. Praeger, 1958), p. 44.
49. *45 Lettres*, p. 16; Walther/Metzger, p. 238.
50. *Complete Letters*, 2:453, no. 437 and 611, no. 510.
51. Ibid., 3:427, no. w1.

52. Ibid., 3:202, no. 604, and 425, no. w1.
53. Ibid., p. 425.
54. Ibid., 2:523, no. 462.
55. Ibid., 2:524, no. 462a.
56. Walther/Metzger, p. 294.
57. *Complete Letters*, 3:428, no. w1.
58. Ibid., 3:468, no. w20.
59. Ibid., 3:427, no. w1.
60. Ibid., 2:521, no. 462.
61. Ibid., 2:338, no. 388a.
62. *The Unconscious Humorists*, in *Balzac's Works: The Human Comedy* (New York: Century Co., 1904), vol. 5, p. 342.
63. *Letters of Flaubert*, 1:161.
64. *Complete Letters*, 2:203, no. 339.
65. Ibid., p. 204.
66. Ibid., 2:205, no. 339a.
67. Ibid., 2:390, no. 413.
68. Ibid., 2:203, no. 339.
69. Ibid., 2:205, no. 339a.
70. Ibid., 2:234, no. 347.

CHAPTER IV
Salvation in the South

1. *Complete Letters*, 2:525, no. 463.
2. Ibid., 3:526, no. B22.
3. Ibid., 3:443, no. w7.
4. Ibid., 2:589, no. 500.
5. Ibid., p. 590.
6. Ibid., 3:514, no. B17[14].
7. Ibid., 3:60, no. 544.
8. Ibid., 1:541, no. 266.
9. Ibid., 3:59, no. 543.
10. Ibid., 2:538, no. 473.
11. Ibid.
12. Ibid., 2:541, no. 474.
13. Ibid., 3:478, no. B3[3].
14. Ibid., 3:477, no. B2[2].
15. Ibid., 3:490, no. B6[6].
16. Ibid., 2:590, no. 500.
17. Ibid., 3:485, no. B5[5].
18. Ibid., 2:564, no. 487.
19. Ibid., 3:288–89, no. 645.
20. Ibid., 3:55, no. 542.
21. Ibid., 3:501, no. B10[18].
22. Ibid., 3:58, no. 543.
23. *Letters to Rappard*, p. 17.
24. Ibid., p. 128.
25. *Complete Letters*, 2:203, no. 339.
26. Ibid., 3:490, no. B6[6].
27. *Letters to Rappard*, p. 21.
28. *Complete Letters*, 2:406, no. 419b.
29. *Letters to Rappard*, p. 166.
30. *Complete Letters*, 3:485–86, no. B6[6].
31. Ibid., 2:581, no. 496.

32. Ibid., 2:585, no. 498.
33. Ibid., 3:503, no. B11[13].
34. Ibid., 2:591, no. 501.
35. Ibid., 3:29, no. 533.
36. Ibid., 2:597, no. 503.
37. Ibid., 3:492, no. B7[7].
38. Ibid., 3:456, no. w13.
39. Ibid., 1:125, no. 101.
40. Ibid., 1:142, no. 110.
41. *Sartor Resartus*, p. 174.
42. Ibid., p. 225.
43. *Complete Letters*, 3:499, no. B9[12].
44. Ibid., 2:590, no. 500.
45. Ibid., 2:606, no. 507.
46. Ibid., p. 607.
47. Ibid., 2:617, no. 513.
48. Ibid., 3:425, no. w1.
49. Ibid.
50. Ibid., 1:271, no. 160.
51. Ibid., 3:25, no. 531.
52. Ibid., 3:430, no. w3.
53. Ibid., 2:591, no. 501.
54. Ibid., 3:499, no. B9[12].
55. Ibid., 3:494, no. B7[7].
56. Ibid., 3:498, no. B8[11].
57. Ibid., 3:509, no. B14[9].
58. Ibid., pp. 509–10.
59. Ibid., 3:497, no. B8[11].
60. Ibid., 2: 623, no. 516.
61. Ibid., 3:510, no. B14[9].
62. Ibid.

63. Ibid., 3:6, no. 520.

64. Ibid.

65. Ibid., pp. 6–7.

66. Ibid., 3:444, no. w7.

67. *Sartor Resartus*, p. 227.

68. *Complete Letters*, 3:7, no. 520.

69. Ibid., 3:128, no. 573.

70. Ibid., 3:19, no. 526.

71. Ibid., 3:511, no. B15[19].

72. Ibid., 3:20, no. 527.

73. Ibid., 3:28, no. 533.

74. Ibid., 3:28–29, no. 533.

75. Ibid., 3:31, no. 534.

76. Ibid., 3:512, no. B16[16].

77. Ibid., 3:31, no. 534.

78. Ibid., 3:7, no. 520.

79. Ibid., 3:478, no. B3[3].

80. Ibid., 2:605, no. 506.

81. Ibid., 2:615, no. 511.

82. Ibid., 3:496, no. B8[11].

83. See Albert Boime, "Vincent Van Gogh's *Starry Night*: A History of Matter and a Matter of History," *Arts Magazine* 59 (December 1984): pp. 86–103.

84. Ibid., pp. 92–93.

85. *Complete Letters*, 3:37, no. 537.

86. Ibid., 3:56, no. 543.

87. Ibid.

88. Ibid., p. 57.

89. Ibid., p. 59.

90. Ibid., 3:433, no. w4.

91. Ibid., 3:26, no. 531.

92. Ibid., 3:66, no. 545.

93. Ibid., 3:24, no. 531.

94. Ibid., p. 25.

95. Ibid., p. 26.

96. Ibid., 3:6, no. 520.

97. Ibid., 3:43, no. 539.

98. Ibid., 3:37, no. 537.

99. Ibid., 3:42, no. 539.

100. Ibid., 3:47, no. 541.

101. Ibid., p. 48.

102. Ibid., 3:65, no. 544a.

103. Ibid., 3:43, no. 539.

104. Ibid.

105. Ibid., 3:158, no. 587.

106. Ibid., 3:65, no. 544a.

107. Ibid., 3:78, no. 552.

108. Ibid., 1:87 and 90, sermon of 1877; also 1:122, no. 99.

109. Ibid., 1:87 and 90; also 1:38, no. 41.

110. Ibid., 3:43, no. 539.

111. Ibid., 3:497, no. B8[11].

112. Ibid., 3:159, no. 588.

113. Ibid., 3:444, no. w7.

114. Ibid., 3:67, no. 545.

115. Ibid., 3:64, no. 544a.

116. Roskill, *Impressionist Circle*, p. 55.

117. *Complete Letters*, 3:46, no. 540.

118. Ziva Amishai-Maisels, *Gauguin's Religious Themes* (New York and London: Garland Publishing, 1985), p. 73.

119. *Complete Letters*, 3:65, no. 544a.

120. Ibid., 3:46, no. 540, regarding S. Bing, "Programme," *Le Japon Artistique* 1 (1888).

121. Ibid., 3:516, no. B18[15].

122. Ibid., 3:60, no. 544.

123. Ibid., 3:432, no. w4.

124. Ibid., 3:31, no. 534.

125. Ibid., 3:86, no. 554.

126. Ibid., 3:527, no. B22.

127. Ibid.

128. Argüelles, p. 117.

129. Ibid., p. 123.

130. *Complete Letters*, 3:431, no. w3.

131. Ibid., 3:460–61, no. w15.

132. Ibid., 2:172, no. 333.

133. Ibid., 3:99, no. 558b.

134. Ibid., 3:33, no. 535.

135. Ibid., 3:92, no. 556.

136. *Avant et après*, p. 12.

137. *Complete Letters*, 3:101, no. 560.

138. Ibid., 3:522, no. B21[21].

139. Ibid., 3:105, no. 562.

140. Ibid., 3, 101, no. 560.

141. Ibid., 3:103, no. 561.

142. Ibid., 3:106–7, no. 563.

143. Ibid., p. 108.

144. Ibid., 3:28, no. 533.

145. Ibid., 3:109, no. 564.

146. Ibid., 3:122, no. 571.

147. Ibid., 3:110, no. 565.

148. Ibid., 3:122, no. 571.

149. Ibid., 3:167–68, no. 590b.

150. Ibid., 3:110, no. 565.

151. *45 Lettres*, p. 85, no. 11.

152. *Avant et après*, p. 10.

153. Ibid., pp. 12–13.

154. Ibid., p. 14.

155. *Complete Letters*, 1:xlvi.

156. Ibid., 3:111, on the back of letter no. 566.

157. Ibid., 2:606, no. 507.

158. Ibid., 3:431, no. w4.

159. Ibid., 3:144, no. 581.

160. Ibid., 3:452, no. w11.

161. Ibid., 3:114, no. 569.

162. Ibid., 3:124, no. 571a.

163. Ibid., 3:110, no. 566.

164. Ibid.

165. Ibid., 3:112, no. 568.

166. Ibid., 3:168, no. 590b.

167. Ibid., pp. 167–68.

168. Ibid., 3:129, no. 574.

169. Ibid., 3:123–24, no. 571a.

170. This was pointed out by Mark Roskill, *Van Gogh, Gauguin,*

and *French Painting of the 1880s: A Catalogue Raisonné of Key Works* (Ann Arbor, Mich.: University Microfilms, 1970), p. 85.

171. *Complete Letters*, 3:129, no. 574.
172. Ibid., 3:128, no. 573.
173. Ibid., 3:146, no. 582.
174. Ibid., 3:128, no. 573.
175. Ibid., p. 127; also 3:146, no. 582.
176. Ibid., 3:127, no. 573.
177. Ibid., 3:132, no. 574.
178. Ibid., p. 129.
179. Ibid., 3:133, no. 576.
180. Ibid., 3:129, no. 574.
181. Ibid., 3:171, no. 592.
182. Ibid., 3:211, no. 605.
183. Aurier, "Les Isolés – Van Gogh," *Oeuvres posthumes*, p. 263.
184. *Complete Letters*, 3:129, no. 574.
185. Ibid., 3:148, no. 583.
186. Ibid., 3:125, no. 572.
187. Ibid., 3:133, no. 575.
188. Ibid., 1:xlvii.
189. Ibid., 3:116, no. 570.
190. Ibid., 3:167, no. 590b.
191. Ibid., 3:140, no. 579.
192. Ibid., 3:135, no. 576

193. Ibid., 3:140, no. 579.
194. Ibid., p. 141.
195. Ibid., M. Salles' assessment in Jo van Gogh-Bonger's memoir, 1:xlvii; Signac's in letter to Theo, 3:145, no. 581a.
196. Ibid., 3:154, no. 585.
197. Ibid., 3:138, no. 578.
198. Ibid., 3:139, no. 579.
199. Ibid., 1:xlviii.
200. Ibid., 3:141, no. 580.
201. Ibid., p. 142.
202. Ibid., 3:143, no. 581.
203. Ibid., p. 144.
204. Ibid.
205. Ibid., 3:43, no. 539.
206. Ibid., 3:146–47, no. 582
207. Ibid., 3:150–52, no. 583b.
208. Ibid., 3:155, no. 585.
209. Ibid., p. 154.
210. Ibid., 3:161, no. 589.
211. Ibid., 3:157, no. 586.
212. Ibid., 3:157, no. 587, and 161, no. 589.
213. Ibid., p. 162.
214. Ibid., 3:166, no. 590.
215. Ibid., 3:180, no. 595.

CHAPTER V
"Through a looking glass, by a dark reason"

1. *Complete Letters*, 3:170, no. 591.
2. Ibid., 3:174, no. 592.
3. Ibid.
4. Ibid., 3:179, no. 594.
5. Ibid., 3:195, no. 601.
6. Ibid., 3:179, no. 594.
7. Ibid., p. 180.
8. Ibid., 3:175, no. 592.
9. Ibid., 3:182, no. 595.
10. Ibid., 3:217, no. 607.
11. Blavatsky, *Isis Unveiled*, 1:511.
12. Graetz, p. 213.
13. Ibid., pp. 198–200.
14. Symposium "Van Gogh at Arles," The Metropolitan Museum of Art, 16 November, 1984.
15. *Sartor Resartus*, pp. 65–66.
16. Ibid., p. 77.
17. *Complete Letters*, 3:2, no. 518 and 3:109, no. 564.
18. *Sartor Resartus*, pp. 148–49.
19. Ibid., p. 151.
20. *Complete Letters*, 3:185, no. 596.
21. Ibid., 3:253, no. 625.
22. Ibid., 3:185, no. 596.
23. Ibid., 3:257–58, no. 626a.
24. Ibid., 3:188, no. 597.
25. Ibid., 3:202, no. 604.
26. Ibid.

27. Ibid., 3:189, no. 597.
28. Ibid., 3:218, no. 607.
29. Ibid., 3:191, no. 599.
30. Ibid., p. 192.
31. Ibid., 3:195, no. 601.
32. Ibid., 3:216, no. 607.
33. Ibid., 3:202, no. 604.
34. Ibid., 3:196, no. 602.
35. Ibid., 3:204, no. 604.
36. Ibid.
37. Ibid., 3:212, no. 605.
38. Ibid., 3:457, no. W14.
39. Ibid., 3:210, no. 605.
40. Ibid., 3:216, no. 607.
41. Ibid., 3:205, no. 604.
42. Ibid., 3:212, no. 605.
43. Ibid., 3:201, no. 603.
44. Ibid., 3:222, no. 610.
45. Ibid.
46. Ibid., 3:226, no. 612.
47. Ibid.
48. Ibid., 3:521, no. B20[20].
49. Ibid., 3:227, no. 613.
50. Ibid., 3:521, no. B21[21].
51. Ibid., 3:229, no. 614.
52. Ibid.
53. Ibid., 3:233, no. 615.

54. Ibid., 3:227, no. 613.
55. Ibid., 3:232, no. 614.
56. Ibid., 3:524, no. B21[21].
57. Ibid.
58. Ibid., 3:237, no. 617.
59. Ibid., 3:239, no. 618.
60. Ibid, 3:524, no. B21[21].
61. Ibid., p. 525.
62. Ibid., 3:225, no. 611.
63. Ibid., 3:244, no. 622.
64. Ibid., 3:262, no. 629.
65. Ibid., 1:191, no. 132.
66. Ibid., 1:193, no. 133.
67. Ibid., p. 197.
68. Ibid., p. 198.
69. Ibid., p. 199.
70. Ibid., 3:240, no. 619.
71. Ibid., 3:245, no. 622a.
72. Ibid., p. 246.
73. Ibid., 3:285–86, no. 643.
74. Ibid., 3:468, no. W20.
75. Ibid., 3:258, no. 627.
76. Ibid., 3:467, no. W20.
77. Ibid., 3:260, no. 628.
78. Ibid., 3:262, no. 629.
79. Ibid., 3:260, no. 628.
80. Ibid.
81. Ibid., 3:261, no. 629.
82. Ibid.
83. Ibid., 3:262, no. 629a.
84. Ibid., pp. 262–63.
85. Ibid., 1:495, no. 248.
86. Ibid., 3:466, no. W19.
87. Ibid., 3:468, no. W20.
88. Ibid., 3:263, no. 630.
89. Ibid., p. 264.
90. Ibid., 3:267, no. 631.
91. Ibid., 3:496–97, no. B8[11].
92. Ibid., 3:269, no. 632.
93. Ibid., 3:263, no. 630.
94. Ibid., no. 633.
95. Ibid., 3:287, no. 643.
96. Ibid., 3:273, no. 635.
97. Ibid., 1:L.
98. Ibid., 3:268, no. 631.

99. Ibid., 3:273, no. 635.
100. Ibid., 3:274, no. 636.
101. Ibid., 3:275, no. 637.
102. Ibid., 3:274, no. 636.
103. Ibid., 3:470, no. W22.
104. Ibid., 3:282, no. 641a.
105. Ibid., 3:273, no. 635.
106. Ibid., 3:279, no. 639.
107. Ibid., 3:469–70, no. W22.
108. Ibid., 3:287, no. 643.
109. Jules Huret, "Paul Gauguin devant ses tableaux," *L'Écho de Paris* (23 February 1891), in *Oviri*, p. 69.
110. *Complete Letters*, 3:203, no. 604.
111. Ibid., 3:269, no. 632.
112. Ibid., 3:276–77, no. 638.
113. Ibid., 3:470, no. W22.
114. Ibid., 3:472, no. W23.
115. Ibid., 3:279, no. 639.
116. Ibid., 3:281, no. 640a.
117. Ibid., 3:203, no. 604.
118. Ibid., pp. 204–5.
119. Ibid., 3:472, no. W23.
120. Ibid., 3:574–75, no. T39.
121. Ibid., 3:292–93, no. 646.
122. Ibid., 3:293, no. 647.
123. Ibid., 3:294–95, no. 648.
124. Ibid., p. 295, no. 649.
125. Meyer Shapiro, "On a Painting of Van Gogh: *Crows in the Wheatfield*" (1946), in *Van Gogh in Perspective*, ed. Bogomila Welsh-Ovcharov (Englewood Cliffs, New Jersey: Prentice-Hall, 1974), pp. 160–63.
126. *Complete Letters*, 3:189, no. 597.
127. Ibid., 1:495, no. 248.
128. Ibid., 1:163, no. 120.
129. Ibid., 1:492, no. 247.
130. Ibid., 1:495, no. 248.
131. Ibid., 3:177, no. 593.
132. Ibid., 3:204, no. 604.
133. Ibid., 3:297, no. 651.
134. Ibid., 3:296, no. 650.
135. Ibid., 3:297, no. 651.
136. Ibid., 3:298, no. 652.
137. Ibid., 2:605, no. 506.
138. *Lettres*/Malingue, p. 201.

CHAPTER VI
Decadence and Disillusionment in the West

1. The biographical details in this chapter have been culled from a great variety of sources. Much of this information has been summarized in the chronologies, essays, and entries of the exhibition catalogue *The Art of Paul Gauguin* by Richard Bretell, Françoise Cachin, Claire Frèches-Thory, and Charles Stuckey (Washington, D. C.: The National Gallery of Art and The Art Institute of Chicago, 1988).

2. *Avant et après*, p. 194.

3. Ursula F. Marks-Vandenbroucke, "Gauguin, ses origines et sa formation artistique," *Gazette des Beaux-Arts*, 47 (January–April 1956): 34.

4. A question of dating this box has been treated by Charles Stuckey, *The Art of Paul Gauguin*, p. 30.

5. It has been pointed out that the dancers derive from Degas'

1874 *Rehearsal for a Ballet on Stage* and the male head from Degas' 1868 *Musicians in the Orchestra*, both then in the Jeu de Paume, Paris. See Amishai-Maisels, *Gauguin's Religious Themes*, pp. 59–60, f.n. 7.

6. *Correspondance de Paul Gauguin 1873–1888*, ed. Victor Merlhès (Paris: Fondation Singer-Polignac, 1984), 1:172. Hereafter referred to as *Correspondance*.

7. For a discussion of Gauguin's early ceramics and their influences see Christopher Gray, *The Sculpture and Ceramics of Paul Gauguin* (Baltimore: The Johns Hopkins Press, 1963), pp. 12–24.

8. *Lettres*/Malingue, p. 97.

9. Ibid., p. 100.

10. Ibid., p. 133.

11. Wayne Andersen, *Gauguin's Paradise Lost* (New York: The Viking Press, 1971), pp. 53, 281. Hereafter referred to as *Paradise*.

12. *Complete Letters*, 2:578, no. 493.

13. Ibid., pp. 578–9, no. 494a.

14. *Lettres*/Malingue, pp. 140–41.

15. Ibid., p. 220.

16. "Notes sur l'art: Exposition universelle," *Le Moderniste illustré* (July 4 and 11, 1889) in *Oviri*, p. 50.

17. "Diverses choses," *Oviri*, p. 158.

18. Ibid., p. 181.

19. *Lettres*/Malingue, p. 126.

20. *Complete Letters*, 3:66, no. 545.

21. See Matthew Herban, "The Origin of Paul Gauguin's Vision after the Sermon: Jacob Wrestling with the Angel." *Art Bulletin* 59 (September 1977): 417–20.

22. *45 Lettres*, pp. 229–31, no. 32.

23. Ibid.

24. See Bogomila Welsh-Ovcharov, *Vincent van Gogh and the Birth of Cloisonism* (Toronto: Art Gallery of Ontario, 1981), pp. 180–81. Hereafter referred to as *Cloisonism*.

25. *Avant et après*, p. 1.

26. Andersen, *Paradise*, p. 88.

27. *Correspondance*, p. 306. The original scholarly association of this figure with death was made by Henri Dorra, "Gauguin's Dramatic Arles Themes," *Art Journal* 38 (fall 1978): 12. Hereafter referred to as "Arles."

28. *Correspondance*, p. 306.

29. *Complete Letters*, 3:108, no. 564.

30. *Correspondance*, p. 109.

31. *Lettres*/Malingue, pp. 154–55.

32. *Avant et après*, pp. 10–11.

33. Henri Dorra, "The First Eves in Gauguin's Eden," *Gazette des Beaux-Arts* 41 (March 1953): 192. Hereafter referred to as "Eves."

34. Wayne Andersen, "Gauguin and a Peruvian Mummy," *Burlington Magazine* 109 (April 1967): 238.

35. See Anita Brookner, *The Genius of the Future* (New York: Phaidon, 1971), ch. 2.

36. Gray, pp. 43–44. See also Andersen, *Paradise*, p. 87.

37. Pola Gauguin, *My Father Paul Gauguin*, trans. Arthur G. Chater (New York: Alfred A. Knopf, 1937), pp. 48, 57, 65, 84–85, 88, 184, 232.

38. Amishai-Maisels (*Religious Themes*, p. 79) has pointed out the similarity between this image and the head of Christ from Beauvais Cathedral which was on view at the Trocadéro in 1889.

39. Merete Bodelsen, *Gauguin's Ceramics: A Study in the Development of His Art* (London: Faber & Faber, Ltd., 1964), p. 216; Roskill, *Impressionist Circle*, p. 197.

40. See Charles Chassé, *Le Mouvement symboliste dans l'art du XIXe siècle* (Paris: Librairie Floury, 1947), p. 116. Hereafter referred to as *Mouvement*.

41. "Paul Gauguin devant ses tableaux," in *Oviri*, p. 69.

42. *45 Lettres*, p. 283, no. 37.

43. Gauguin scrawled fragmented notes about this picture on a calling card that he gave to Aurier in 1890 or 1891; see appendix in *Lettres*/Malingue, p. 323.

44. See Welsh-Ovcharov's analysis of this picture in *Cloisonism*, p. 218.

45. Charles Chassé, *Gauguin et son temps* (Paris: La Bibliothèque des Arts, 1955), p. 52. Hereafter referred to as *Temps*.

46. *45 Lettres*, p. 165, no. 22.

47. Written on the calling card to Aurier; see appendix in *Lettres*/Malingue, p. 323.

48. *45 Lettres*, pp. 221–23, no. 31.

49. *Lettres*/Malingue, p. 220.

50. *Complete Letters*, 3:109, no. 564.

51. Quoted in Alexandre, p. 94.

52. *Sartor Resartus*, p. 77.

53. Dorra, "Arles," p. 15.

54. *Complete Letters*, 1:66, no. 74.

55. See Barbara Landy, "Paul Gauguin: Symbols and Themes in the Pre-Tahitian Works." Master's thesis, Columbia University, 1968, pp. 64–66; also Dorra, "Arles," p. 15.

56. The Trémalo Chapel source of the Christ figure was first identified by Fernand Dauchot, "Le Christ jaune de Gauguin," *Gazette des Beaux-Arts*, 44 (July–August 1954): 66–68; the background was identified by Ronald Pickvance in his entries for the exhibition catalogue *Gauguin and the Pont-Aven Group* (London: Tate Gallery and Arts Council, 1966), no. 26.

57. *Avant et après*, pp. 32–33.

58. *Lettres*/Malingue, p. 180.

59. Ibid., p. 194.

60. Amishai-Maisels (*Religious Themes*, p. 36) noted that Theo van Gogh immediately identified the derivation from Japanese prints; Merlhès pointed out in *Correspondance* I: 491, n. 3 that a similar device was used in the 1888 copy of Pierre Loti's novel *Madame Chrysanthème* which both Gauguin and Van Gogh read.

61. Frèches-Thory in *The Art of Paul Gauguin*, p. 159.

62. Chassé, *Pont-Aven*, p. 24.

63. He mentioned this rejection to Schuffenecker: *Lettres*/Malinge, p. 140, and to Vincent van Gogh: *45 Lettres*, p. 227, no. 32.

64. *45 Lettres*, p. 273, no. 36.

65. *Lettres*/Malingue, p. 157, no. 81.

66. Chassé, *Pont-Aven*, p. 48.

67. Lydia Aran, *The Art of Nepal* (Kathmandu: Sahayogi Prakashan, 1978), p. 224.

68. Vojtech Jirat-Wasiutynski, *Paul Gauguin in the Context of Symbolism* (New York: Garland Publishing, 1978), p. 258.

69. Gray, p. 192.

70. Brettel in *The Art of Paul Gauguin*, p. 399.

71. Schuré, 1:51.

72. Ibid., p. 46.
73. *Lettres*/Malingue, p.167.
74. *45 Lettres*, pp. 159–61, no. 22.
75. Ibid., p. 163.
76. Jirat-Wasiutynski, p.178.
77. Andersen, *Paradise*, p.112.
78. *Lettres*/Malingue, p. 323.
79. Ibid., p.194.
80. Ibid., p.172.
81. Amishai-Maisels (*Religious Themes*, p. 164) cites two sources for this image of "the inner voice" that were seen by Gauguin: a portal figure from St. Trophème in Arles and the figure of Titus in Rembrandt's *St. Matthew* in the Louvre.
82. Andersen, *Paradise*, pp. 109, 114.
83. Amishai-Maisels, *Religious Themes*, p.130.
84. Jirat-Wasiutynski (p.181) also takes this view of the title's irony.
85. Chassé, *Pont-Aven*, p.112.
86. M. Mothéré, eventual husband of Marie Henry, quoted by Chassé, *Pont-Aven*, p. 33.
87. Morice, *Paul Gauguin*, p. 29.
88. Amishai-Maisels, *Religious Themes*, pp.133–39.
89. *Lettres*/Malingue, p.159.
90. *Avant et après*, p.186.
91. Ibid.
92. Octave Mirbeau in *L'Echo de Paris* (16 February 1891), quoted by John Rewald, *Gauguin* (Paris: Hyperion Press, 1938), p. 19.

93. *45 Lettres*, p. 171, no. 22.
94. Thomas Buser, "Gauguin's Religion," *Art Journal* 27 (summer 1968): 377.
95. Schuré, 1:xxiv.
96. See Andersen, *Paradise*, pp.101–3.
97. *Lettres*/Malingue, p. 187.
98. *45 Lettres*, pp. 315–17, no. 41.
99. *Lettres*/Malingue, pp. 198–99.
100. *45 Lettres*, pp. 167–69, no. 22.
101. Ibid., p. 185, no. 25.
102. Andersen, *Paradise*, p. 120.
103. Aran, p. 212.
104. *Avant et après*, p. 138.
105. See Dorra, "Eves," pp. 195, 197–98.
106. Aran, p. 213.
107. See Chassé, *Temps*, pp. 87–88.
108. See Andersen, *Paradise*, pp. 98–100.
109. Ibid., pp. 101–3.
110. Chassé, *Temps*, p. 88.
111. René Huyghe, "Gauguin, créateur de la peinture moderne," preface to the catalogue for *Gauguin: Exposition du Centaire* (centenary exhibition at the Orangerie des Tuilleries) (Paris: Editions des Musées Nationaux, 1949), pp. 95–96.
112. *Lettres*/Malingue, p. 213.
113. Quoted in *Gauguin, a Retrospective*, ed. Marla Prather and Charles Stuckey (New York: Park Lane, 1989), p. 135.

CHAPTER VII
Death and Rebirth in the Garden

1. *Lettres*/Malingue, p. 153.
2. Ibid., p. 193.
3. *Oviri*, pp. 67–68.
4. *Lettres à* Redon, p. 194.
5. Jules Huret, "Paul Gauguin devant ses tableaux," in *Oviri*, pp. 69–70.
6. *Avant et après*, p. 60.
7. *Lettres*/Malingue, pp. 195–96.
8. Ibid., p. 184.
9. *Lettres à Redon*, p. 194.
10. *45 Lettres*, p. 221, no. 31.
11. *Lettres*/Malingue, p. 249.
12. *Noa Noa*/L, p. 28.
13. Ibid., p. 26.
14. Ibid., p. 45.
15. *Noa Noa*, ed. Nicholas Wadley, trans. Jonathon Griffin (London: Phaidon, 1985), p. 43. Hereafter referred to as *Noa Noa*/W.
16. Ibid., p. 47.
17. Sérusier, p. 60.
18. Most of the biographical details of this period of Gauguin's life are summarized in Danielsson's *Gauguin in the South Seas*.
19. *Noa Noa*/L, pp. 19–20.
20. All translations of Tahitian words here are based on the explanations of Bengt Danielsson, "Gauguin's Tahitian titles," *Burlington Magazine* 109 (April 1967): 228–33. Hereafter referred to as "Titles."

21. *Noa Noa*/L, p. 25.
22. *Lettres à* Redon, p. 194.
23. Bernard Dorival, "Sources of the Art of Gauguin from Java, Egypt, and Ancient Greece," *Burlington Magazine* 93 (April 1951): 118–122. Hereafter referred to as "Sources".
24. *Noa Noa* II, pp. 38–39.
25. William M. Kane, "Gauguin's *Le Cheval blanc*: Sources and Syncretic Meanings," *Burlington Magazine* 108 (July 1966): 356.
26. *Noa Noa* II, pp. 79–80, and *Avant et après*, pp. 51–52.
27. In *Avant et après*, p. 185, Gauguin refers to the ceaseless union of Séraphitus-Séraphita, the androgynous protagonist of Balzac's novel *Séraphita*, as the pivotal force of the world.
28. *Noa Noa*/L, p. 27.
29. Ibid., p. 29
30. Jehanne H. Teilhet, "The Influence of Polynesian Culture and Art on the Works of Paul Gauguin: 1891–1903," Ph.D. dissertation, University of California, Los Angeles, 1975, p. 161. Hereafter referred to as "Influence".
31. *Noa Noa*/L, p. 29.
32. Ibid.
33. Dorival, "Sources," p. 121.
34. Danielsson, *South Seas*, p. 77.
35. *Avant et après*, p. 117.
36. *Noa Noa*/L, p. 20.
37. *Avant et après*, p. 190.

38. See Richard S. Field, *Paul Gauguin: The Paintings of the First Voyage to Tahiti* (New York: Garland Publishing, 1977), pp. 64–65. Hereafter referred to as *First Voyage*.

39. Charles Morice, Preface to *Exposition Paul Gauguin* (Paris: Galéries Durand-Ruel, 1893), p. 15.

40. *Noa Noa*/L, p. 24.

41. *Noa Noa* II, p. 32.

42. *Reveries*, p. 35.

43. *Sartor Resartus*, p. 219.

44. Pierre Loti [Julien Viaud], *The Marriage of Loti*, trans. Wright and Eleanor Frierson (Honolulu: University Press of Hawaii, 1976), pp. 36–37, 67, 69.

45. *Lettres*/Malingue, pp. 227, 229–30.

46. Field, *First Voyage*, pp. 149–50. Dorival noted ("Sources," p. 121) that this monument was part of Gauguin's collection of "documents."

47. Loti, p. 30.

48. *Lettres*/Malingue, p. 218.

49. Ibid., p. 263.

50. Ibid., p. 236.

51. Field, *First Voyage*, p. 133.

52. *Noa Noa*/L, p. 21.

53. Aran, p. 215.

54. John House in *Post-Impressionism: Cross-currents in European Painting* (London: Royal Academy of Art, 1979), p. 78.

55. *Noa Noa*/L, p. 19.

56. Ibid., p. 25.

57. Ibid., p. 27.

58. Ibid., pp. 33–35.

59. Ibid., p. 34.

60. Ibid., p. 35.

61. Danielsson, *South Seas*, p. 119.

62. Charles Stuckey, in a private conversation, has maintained that Tehamana was entirely a figment of Gauguin's imagination, since there is no documentary evidence of her existence outside the blatantly fictionalized *Noa Noa*, and the pictures which he associates with her could have represented an anonymous model. While it seems more likely that there was a real Tehamana, it is clear that Gauguin's accounts of their relationship were colored by his reading of Loti and by his paramount desire to create a spiritualized explanation of his Tahitian experiences and art.

63. *Noa Noa* II, pp. 104–5.

64. *Lettres à Monfreid*, p. 25.

65. *Noa Noa*/L, p. 36.

66. *Noa Noa* II, p. 107.

67. Amishai-Maisels, *Religious Themes*, p. 185.

68. Charles Stuckey in *The Art of Paul Gauguin*, p. 270.

69. Achille Delaroche, "D'un point de vue esthétique: À propos du peintre Paul Gauguin," *L'Ermitage* 5 (January 1894): 37.

70. Aran, p. 215.

71. *Noa Noa* II, pp. 105–6.

72. Ibid., p. 105.

73. *Lettres*/Malingue, p. 263.

74. "Diverses choses," *Oviri*, pp. 169–70.

75. *Noa Noa*/L, p. 36, *Noa Noa* II, p. 152.

76. René Huyghe, introduction to Gauguin's *Ancien culte mahorie*, facsimile of original MS in the Musée du Louvre, Cabinet des dessins (Paris: Pierre Berès, 1951), pp. 25–26.

77. Loti, p. 157.

78. *Lettres*/Malingue, pp. 237–38.

79. Charles Stuckey identifies these as hotu flowers rather than fungus in *The Art of Paul Gauguin*, p. 281.

80. *Noa Noa*/L, pp. 30–31; "Notes éparses," in Robert Rey, *Gauguin*, trans. F. C. de Sumichrast (London: Bodley Head, 1924), p. 38.

81. *Cahier pour Aline* (Danielsson has disputed this meaning in *South Seas*, p. 122.)

82. Ibid.

83. *Noa Noa* II, p. 15

84. See Field, *First Voyage*, pp. 74–75.

85. Gray, p. 226.

86. Quoted by Huyghe in *Ancien culte mahorie*, p. 9.

87. Amishai-Maisels, *Religious Themes*, p. 374.

88. Field, *First Voyage*, p. 124.

89. Teilhet, "Influence" pp. 179–80.

90. Ibid.

91. Jirat-Wasiutynski, p. 204.

92. *Noa Noa* II, p. 152.

93. Ibid., pp. 159–63.

94. Samuel J. Wagstaff in *Gauguin: Paintings, Drawings, Prints, Sculpture*, 2nd rev. ed. (Chicago: The Art Institute of Chicago and The Metropolitan Museum of Art, 1959), no. 67.

95. *Noa Noa* II, pp. 36–39.

96. Ibid., p. 160; also *Ancien culte mahorie*, p. 22.

97. *Ancien culte mahorie*, pp. 32–33.

98. *Lettres*/Malingue, p. 236.

99. Terrence Barrow, *The Art of Tahiti* (London: Thames and Hudson, 1979), p.16.

100. Teilhet, "Influence," p. 157.

101. *Noa Noa*/L, p. 32.

102. *Noa Noa* II, p. 99.

103. Danielsson, *South Seas*, p. 134.

104. *Noa Noa* II, p. 99.

105. Ibid., pp. 40–41.

106. Aran, p. 212.

107. Gray, p. 81; Teilhet, "Influence," p. 208.

108. Andersen, *Paradise*, p. 186.

109. *Noa Noa*/L, pp. 28–31.

110. Danielsson, *South Seas*, p. 90.

111. *Noa Noa*/L, pp. 30–31.

112. Ibid., p. 31.

113. *Noa Noa* II, pp. 87–88.

114. Richard Field, "Plagiaire ou créateur?," *Paul Gauguin. Collection Génies et réalités*, pp. 165–66. See also Danielsson, *South Seas*, pp. 134–35.

115. *Noa Noa*/L, p. 31.

116. *Noa Noa* II, pp. 138–42.

117. Ibid., p. 89.

118. *Noa Noa*/L, p. 31. In "Titles," p. 231, Danielsson notes that Gauguin's use of the name Tefatou was an error and referred to Fatu.

119. *Noa Noa* II, p. 88.

120. Ibid., pp. 88–89, and *Ancien culte mahorie*, p. 11.

121. Ibid., pp. 149–50.

122. Ibid., p. 151.

123. Wagstaff, no. 52; Field, *First Voyage*, p. 179.

124. Amishai-Maisels, *Religious Themes*, pp. 373–74.

125. Georges Wildenstein and Raymond Cogniat, *Gauguin*. Catalogue (Paris: Editions Les Beaux-Arts, 1964), p. 181.

126. *Ancien culte mahorie*, pp. 43–45; *Noa Noa* II, pp. 163–67.

127. Field, *First Voyage*, p. 130.

128. Jirat-Wasiutynski, p. 288, notes that Gauguin drew the same "life and death" figures as an illustration for Hina and Fatu's dialogue in the text of *Noa Noa*.

129. Danielsson, "Titles," p. 231.

130. *Noa Noa* II, pp. 102–3.

131. *Avant et après*, pp. 189–90.

132. Teilhet, "Influence," pp. 211–14.

133. Danielsson, *South Seas*, p. 135.

134. Ibid.

135. *Lettres*/Malingue, p. 221.

136. Ibid., p. 225.

137. *Noa Noa* II, pp. 199–200; these facts were pointed out by Danielsson, *South Seas*, p. 129.

138. *Noa Noa*/L, p. 45; *Noa Noa* II, p. 203.

CHAPTER VIII
Bitter Interlude and Return to Paradise

1. *Lettres*/Malingue, p. 247.

2. Ibid., p. 214.

3. Ibid., pp. 326–28 (Mette's letter to Schuffenecker).

4. Danielsson, *South Seas*, p. 150.

5. Charles Morice, *Paul Gauguin* (Paris: H. Floury, 1920), pp. 31–32.

6. Quoted in Danielsson, *South Seas*, p. 154.

7. Ibid., p. 160.

8. Ibid., pp. 161–66.

9. Armand Séguin, "Paul Gauguin" I, *L'Occident* 16 (March 1903): 160.

10. Danielsson, "Titles," p. 230, no. 2.

11. Danielsson, *South Seas*, pp. 165–66.

12. *Lettres*/Malingue, p. 284.

13. Teilhet, "Influence," pp. 242–44.

14. Gray, p. 64, f.n. 7.

15. Danielsson, *South Seas*, pp. 123–24. Danielsson translates the song in its entirety from the Tahitian original, claiming that Gauguin's translation into French was full of errors.

16. Gray, p. 65.

17. Frèches-Thory in *The Art of Paul Gauguin*, p. 371.

18. 1897 letter to Ambroise Vollard, quoted by John Rewald, "The Genius and the Dealer," *Art News* 58, no. 3 (May 1959): 62.

19. *45 Lettres*, p. 151, no. 22.

20. *Lettres*/Malingue, p. 289.

21. *Lettres à Monfreid*, p. 168.

22. *Lettres*/Malingue, p. 270.

23. Ibid., p. 271.

24. Danielsson, *South Seas*, p. 195.

25. Ibid., p. 196.

26. *Noa Noa*/L, p. 24.

27. It has been pointed out by Amishai-Maisels (*Religious Themes*, p. 216) that the red fan here is the same attribute of a great beauty that Gauguin put into the hand of Tehamana in his portrait *The Many Parents of Tehemana* (fig. 334).

28. *Lettres à Monfreid*, pp. 40–41.

29. Amishai-Maisels, *Religious Themes*, p. 217.

30. Quoted in Danielsson, *South Seas*, p. 204.

31. *Lettres*/Malingue, p. 274, no. 162.

32. *Avant et après*, p. 188.

33. Ibid., p. 189.

34. *Sartor Resartus*, p. 164.

35. Dorival, "Sources," p. 120.

36. *Lettres à Monfreid*, p. 65.

37. Rewald, *Post-Impressionism*, pp. 485–86.

38. Mircea Eliade, *From Primitives to Zen. A Thematic Sourcebook of the History of Religions* (New York: Harper & Row, 1967), pp. 369–70.

39. *Lettres à Monfreid*, p. 76.

40. Danielsson, *South Seas*, pp. 205–06.

41. *Lettres à Monfreid*, p. 90.

42. See René Huyghe, *La Relève du réel* (Paris: Flammarion, 1974), p. 353.

43. "L'Esprit moderne et le catholicisme," *Oviri*, p. 202.

44. *Lettres à Monfreid*, pp. 91–92.

45. *Lettres*/Malingue, pp. 288–89.

46. *Noa Noa* II, pp. 91–92.

47. *Lettres*/Malingue, p. 277.

48. Ibid., pp. 301–2.

49. Danielsson, *South Seas*, p. 222.

50. Ibid., p. 223

51. "Le Tableau que je veux faire," *Oviri*, pp. 165–66.

52. *Lettres à Monfreid*, p. 112.

53. Quoted in Danielsson, *South Seas*, p. 224.

54. Field, "Plagiaire," p. 148; Teilhet, "Influence," p. 322.

55. Teilhet, "Influence," p. 327.

56. Kane, p. 361.

57. Ibid.; see also Teilhet, "Influence," pp. 326–27.

58. *The Complete Engravings, Etchings, and Drypoints of Albrecht Dürer*, ed. Walter L. Strauss (New York: Dover Publications, 1972), p. 150.

59. *Lettres à Monfreid*, p. 175.

60. Called *The Enchanter* or *The Sorcerer of Hivaoa* in the past, although Gauguin seems not to have given it a title.

61. Danielsson, *South Seas*, p. 257; Teilhet, "Influence," p. 356

62. Richard Bretell in *The Art of Paul Gauguin*, p. 484.

63. Danielsson, *South Seas*, p. 257.

64. See Kane, p. 362.

65. *Lettres*/Malingue, pp. 318–19.

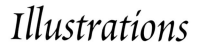

Illustrations

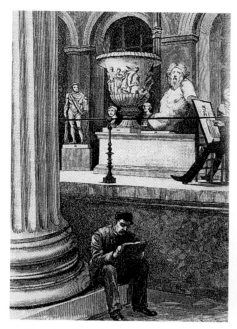

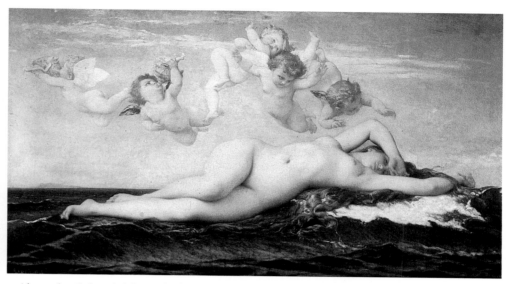

1. *Drawing from the antique*: engraving in Alexis Lemaistre's *L'École des Beaux-arts dessiné et racontée par un élève* (Paris, 1889).

3. Alexandre Cabanel, *The Birth of Venus,* 1863, oil on canvas. Musée d'Orsay, Paris.

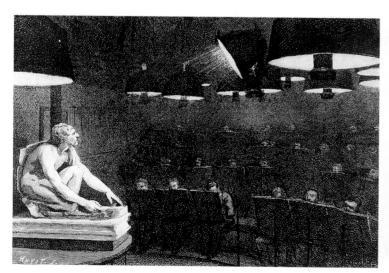

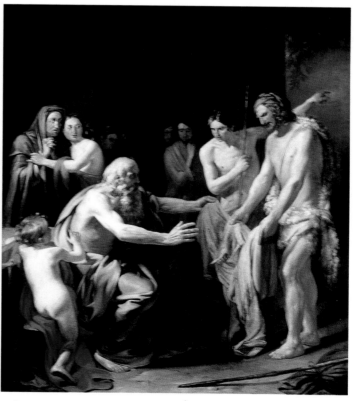

2. *The drawing lesson*; engraving in Alexis Lemaistre's *L'École des Beaux-arts dessiné et racontée par un élève* (Paris, 1889).

4. Jean-Jacques Forty, *Jacob recognizing the robe of Joseph,* 1791, oil on canvas. The Minneapolis Institute of Arts.

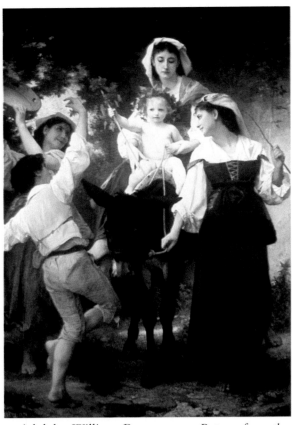

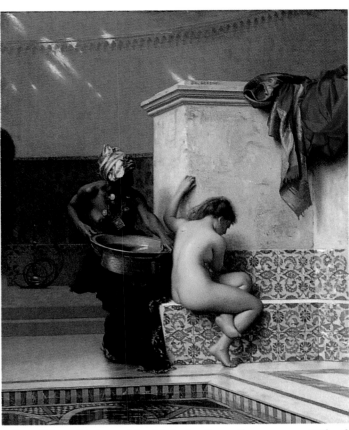

5. Adolphe-William Bouguereau, *Return from the harvest*, 1878, oil on canvas. Cummer Museum of Art & Gardens, Jacksonville, Florida.

6. Jean-Léon Gérôme, *Moorish bath*, 1870, oil on canvas. Gift of Robert Jordan from the Collection of Eben D. Jordan. Courtesy Museum of Fine Arts, Boston.

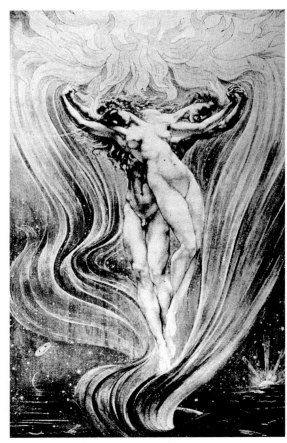

7. Armand Point, *The Chimera*, 1897, oil on canvas. Location unknown.

8. Jean Delville, *Love of Souls*, 1900, oil on canvas. Musée Communal, Ixelles, Belgium.

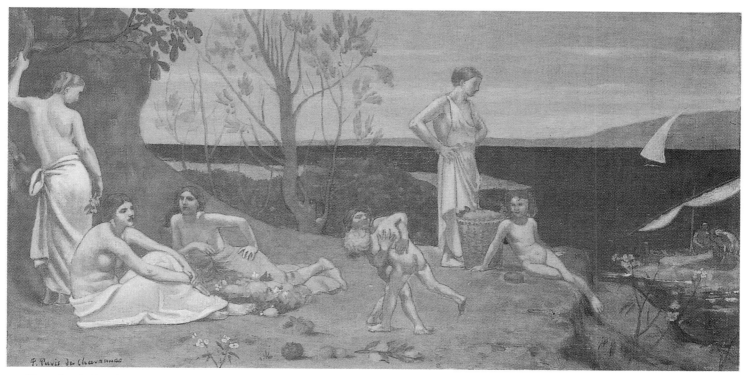

21. Pierre Puvis de Chavannes, *Pleasant land,* 1882, oil on canvas. Yale University Art Gallery, New Haven, Connecticut, The Mary Gertrude Abbey Fund.

22. Georges Pierre Seurat, *Port-en-Bessin,* 1888, oil on canvas. The Minneapolis Institute of Arts, The William Hood Dunwoody Fund.

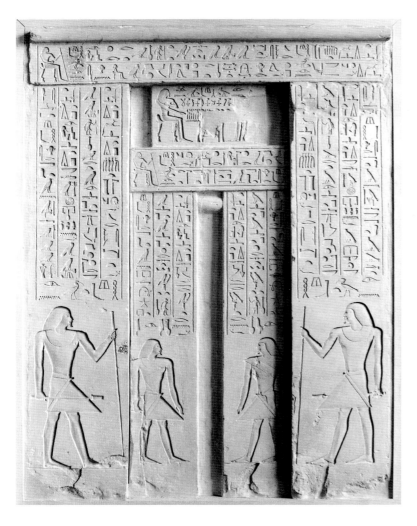

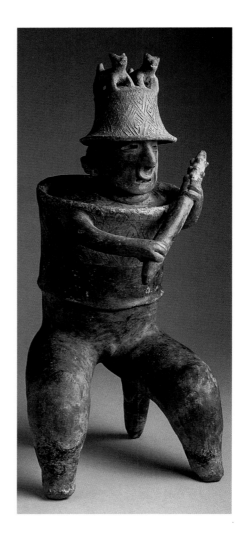

ABOVE 23. False door, tomb of Iry-en-Akhaet, Egypt, 6th dynasty, 2345–2181 BC, limestone. The Minneapolis Institute of Arts, Lilian Z. Turnblad Fund.

ABOVE RIGHT 24. Standing warrior, Jalisco, Mexico, ca. 750, polychromed ceramic. The Minneapolis Institute of Arts.

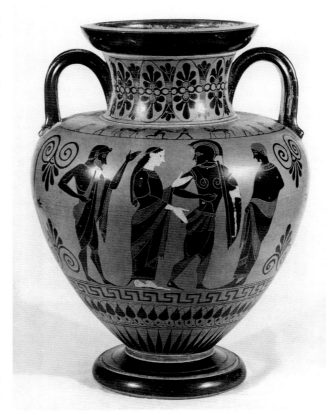

RIGHT 25. Black-figure amphora, attributed to Antimenes Painter, Greece, 520–500 BC, ceramic. The Minneapolis Institute of Arts, The John R. Van Derlip Fund.

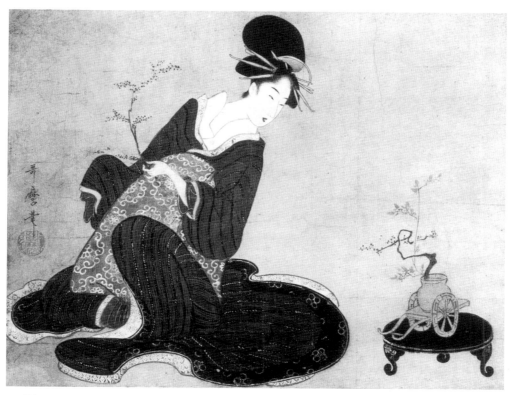

26. Kitagawa Utamora, *Woman making a flower arrangement,* ca. 1802, ink and watercolor on paper. The Minneapolis Institute of Arts, Collection Mr. and Mrs. Richard P. Gale.

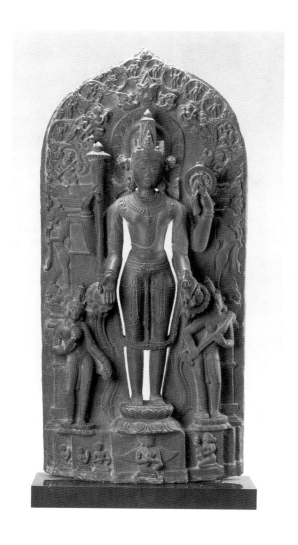

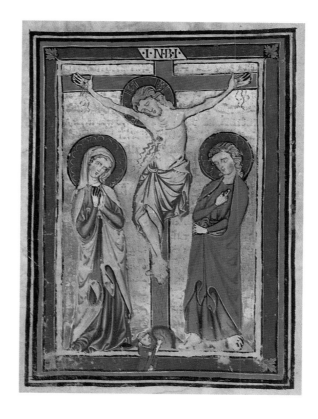

LEFT 27. Stele of Vishnu, Bengal, India, Pala dynasty, 11th century, chlorite (gray-stone). The Minneapolis Institute of Arts, The John R. Van Derlip Fund.

ABOVE 28. *Crucifixion,* Dominican missal, southern Germany (Regensburg), 13th century, tempera on parchment. The Minneapolis Institute of Arts.

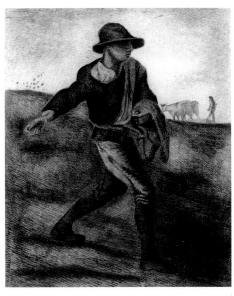
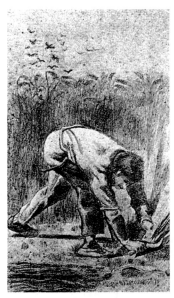
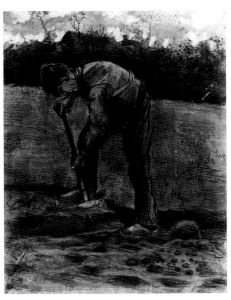

LEFT 29. Vincent van Gogh, *The Sower* (after Millet), April 1881, pen, washed and heightened with green and white on gray paper, 48 × 36.5 cm. (18⅞ × 14⅝″). H1. Van Gogh Museum (Vincent van Gogh Foundation), Amsterdam.
CENTER 30. Vincent van Gogh, *The Mower* (after Millet), April 1881, pencil washed with sepia, 55.5 × 30.5 cm. (22 × 12¼″). H2. Location unknown.
RIGHT 31. Vincent van Gogh, *Man digging*, October 1881, black and colored chalk, watercolor, 62.5 × 47 cm. (24¾ × 18½″). H54. Van Gogh Museum (Vincent van Gogh Foundation), Amsterdam.

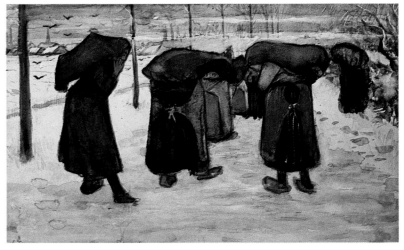

32. Vincent van Gogh, *Women miners*, October 1882, watercolor, 32 × 50 cm. (12⅝ × 19⅝″). H253. Kröller–Müller Museum, Otterlo, Netherlands.

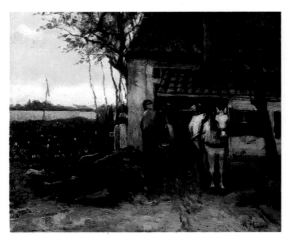
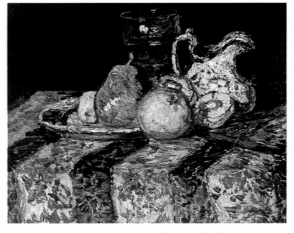

LEFT 33. Anton Mauve, Dutch, *The Woodchopper's cart,* ca. 1870s–80s, oil on panel. Tweed Museum of Art, Duluth, Minnesota.
RIGHT 34. Adolphe Monticelli, *Still-life with fruit and white pitcher,* ca. 1878–80, oil on canvas. Musée d'Orsay, Paris.

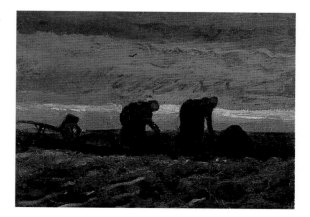

35. Vincent van Gogh, *Two peasants in a peat field*, October 1883, oil on canvas, 27 × 35.5 (10⅝ × 14⅛″). H409. Van Gogh Museum (Vincent van Gogh Foundation), Amsterdam.

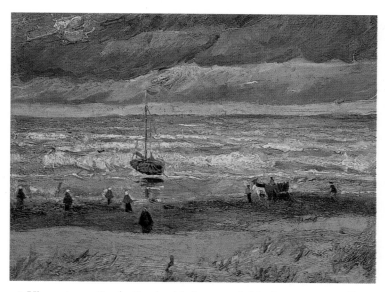

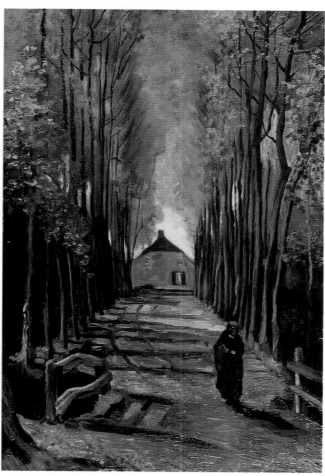

36. Vincent van Gogh, *Beach with figures and ship*, August 1882, oil on canvas, 34.5 × 51 cm. (13¾ × 20⅛″). H187. Van Gogh Museum (Vincent van Gogh Foundation), Amsterdam.

38. Vincent van Gogh, *Avenue of poplars in autumn*, October–November 1884, oil on canvas, 99 × 66 cm. (39 × 26″). H522. Van Gogh Museum (Vincent van Gogh Foundation), Amsterdam.

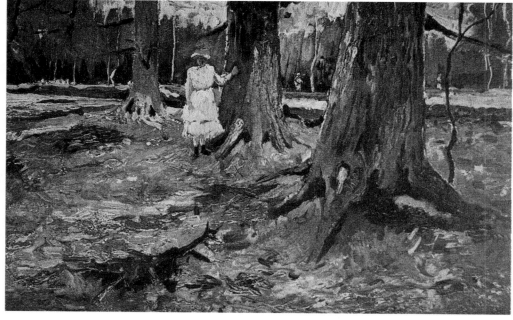

37. Vincent van Gogh, *Girl in white in a wood,* August 1882, oil on canvas, 39 × 59 cm. (15⅜ × 23¼″). H182. Kröller-Müller Museum, Otterlo, Netherlands.

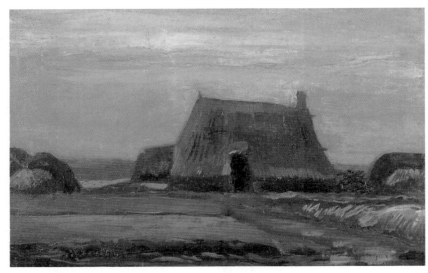

39. Vincent van Gogh, *Farmhouses with peat stacks*, October–November 1883, oil on canvas on cardboard, 37.5 × 55.5 cm. (15 × 22″). H421. Van Gogh Museum (Vincent van Gogh Foundation), Amsterdam.

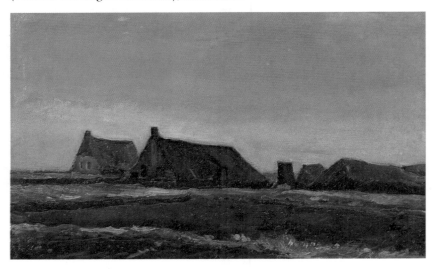

40. Vincent van Gogh, *Farmhouses*, September 1883, oil on canvas on cardboard, 36 × 55.5 cm. (14⅛ × 22″). H395. Van Gogh Museum (Vincent van Gogh Foundation), Amsterdam.

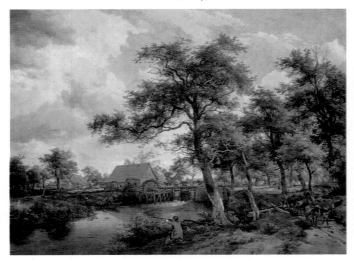

41. Meindert Hobbema, Dutch, *Wooded landscape with watermill*, mid 17th century, oil on canvas. The Minneapolis Institute of Arts, The William H. Dunwoody Fund.

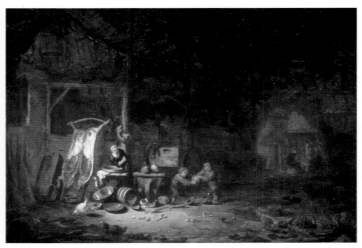

42. Egbert van der Poel, Dutch, *Interior of a barn*, 1644, oil on canvas. The Minneapolis Institute of Arts, The John R. Van Derlip Fund.

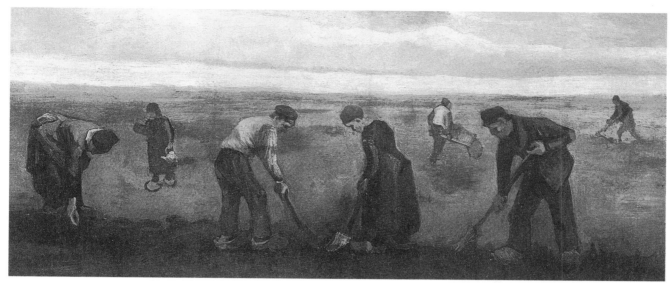

43. Vincent van Gogh, *Farmers planting potatoes,* September 1884, 66 × 149 cm. (26 × 58⅛″). H513. Kröller-Müller Museum, Otterlo, Netherlands.

44. Labors of the Months (June, July, August), 1220–30, relief on west façade of Amiens Cathedral, France.

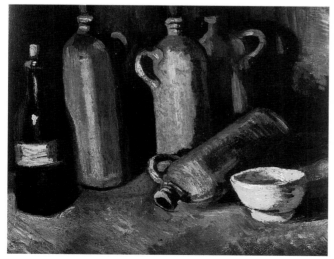

45. Vincent van Gogh, *Still-life with stone bottles, flask and white cup,* November 1884, oil on canvas, 33 × 41 cm. (13 × 16⅛″). H529. Kröller-Müller Museum, Otterlo, Netherlands.

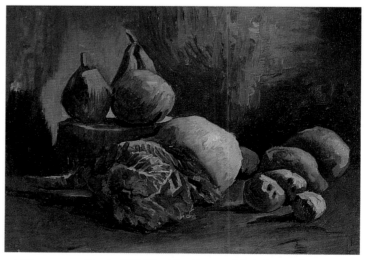

46. Vincent van Gogh, *Still-life with cabbage and fruit*, September 1885, oil on canvas, 32.5 × 45 cm. (13 × 16⅞″). H928. Van Gogh Museum (Vincent van Gogh Foundation), Amsterdam.

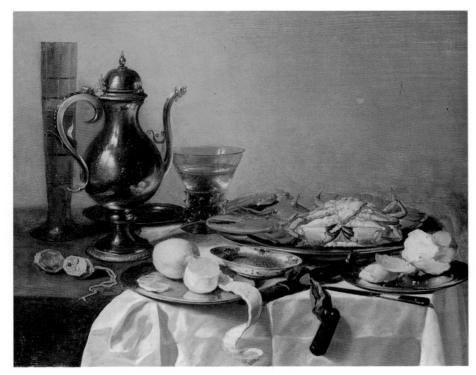

47. Pieter Claesz, Dutch, *Still-life,* 1643, oil on canvas. The Minneapolis Institute of Arts, The Eldridge C. Cooke Fund.

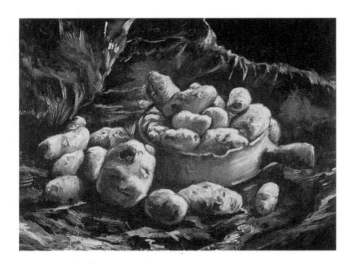

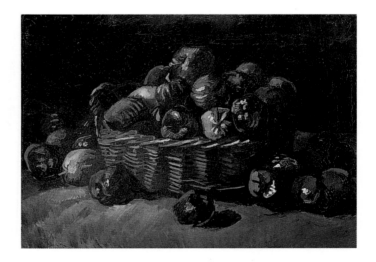

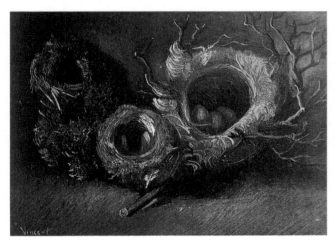

ABOVE LEFT 48. Vincent van Gogh, *Still-life with earthen bowl and potatoes,* September 1885, oil on canvas, 44.5 × 57 cm. (17¾ × 22½"). H932. Private Collection, Museum Boijmans Van Beuningen, Rotterdam.

ABOVE RIGHT 49. Vincent van Gogh, *Still-life with basket of apples,* September 1885, oil on canvas, 43 × 59 cm. (16⅞ × 23¼"). H930. Van Gogh Museum (Vincent van Gogh Foundation), Amsterdam.

LEFT 50. Vincent van Gogh, *Still-life with three birds' nests,* October 1885, oil on canvas, 33 × 42 cm. (13 × 16½"). H938. Kröller-Müller Museum, Otterlo, Netherlands.

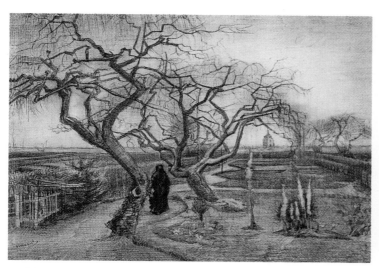

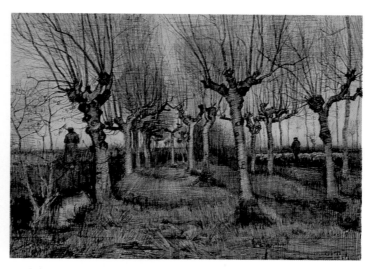

51. Vincent van Gogh, *Parsonage garden*, March 1884, pencil, pen and ink on paper, 39 × 53 cm. (15⅜ × 20⅞″). H466. Van Gogh Museum (Vincent van Gogh Foundation), Amsterdam.

52. Vincent van Gogh, *Pollard birches*, March 1884, pencil, pen and ink, heightened with white, 39.5 × 54.5 cm. (15¾ × 21⅝″). H469. Van Gogh Museum (Vincent van Gogh Foundation), Amsterdam.

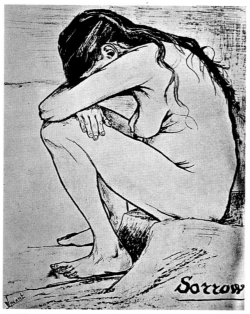

53. Vincent van Gogh, *"Sorrow,"* November 1882, lithograph, 38.5 × 29 cm. (15⅜ × 11⅜″). H259.

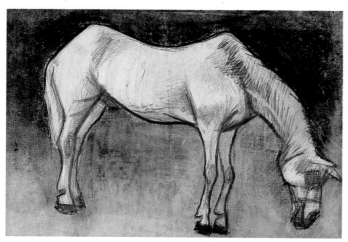

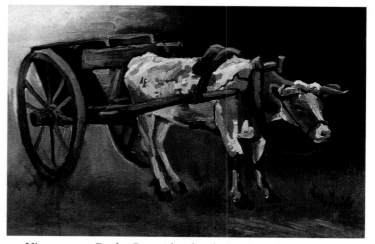

54. Vincent van Gogh, *Horse at the garbage dump,* June–July 1883, pencil, black chalk, washed, 42 × 59 cm. (16½ × 23¼″). H368. Van Gogh Museum (Vincent van Gogh Foundation), Amsterdam.

55. Vincent van Gogh, *Cart with red and white ox,* June–July 1884, oil on canvas, 57 × 82.5 cm. (22½ × 32⅝″). H504. Kröller–Müller Museum, Otterlo, Netherlands.

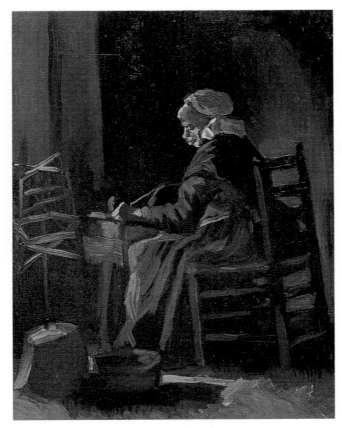

56. Vincent van Gogh, *Woman at spinning wheel*, March 1885, oil on canvas on cardboard, 41 × 32.5 cm. (16⅛ × 13″). H698. Van Gogh Museum (Vincent van Gogh Foundation), Amsterdam.

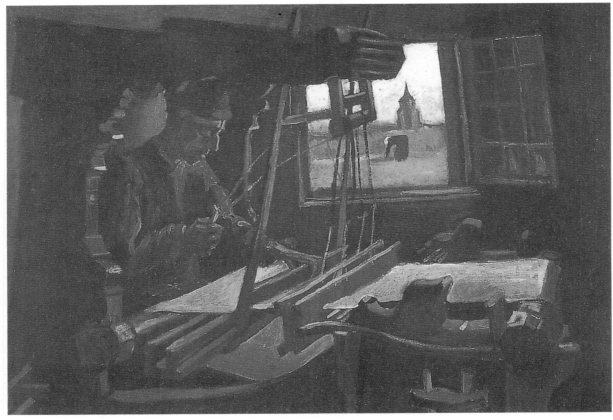

57. Vincent van Gogh, *Weaver near open window*, June–July 1884, oil on canvas, 68.5 × 93 cm. (27⅛ × 36⅝″). H500. Bayerischen Staatsgemäldesammlungen, Munich.

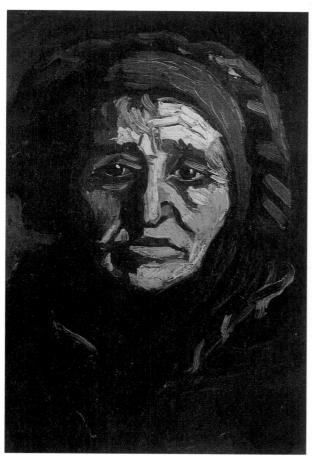

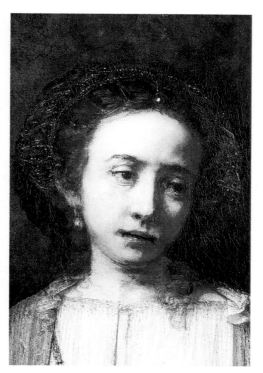

59. Rembrandt van Rijn, Dutch, *Lucretia* (detail), 1666, oil on canvas. The Minneapolis Institute of Arts, The William Hood Dunwoody Fund.

58. Vincent van Gogh, *Head of a peasant woman*, February 1885, oil on canvas, 37.5 × 28 cm. (15 × 11"). H648. Kröller-Müller Museum, Otterlo, Netherlands.

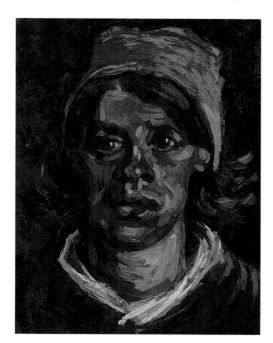

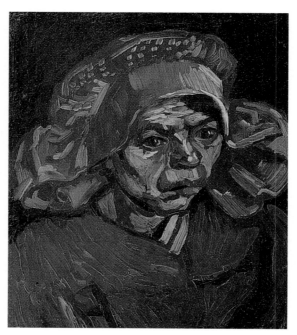

60. Vincent van Gogh, *Head of a peasant woman*, March 1885, oil on canvas, 42.5 × 29.5 cm. (16⅞ × 11¾"). H722. Van Gogh Museum (Vincent van Gogh Foundation), Amsterdam.

61. Vincent van Gogh, *Peasant head,* May 1885, oil on canvas, 42.5 × 35.5 cm. (16⅞ × 14⅛"). H782. Van Gogh Museum (Vincent van Gogh Foundation), Amsterdam.

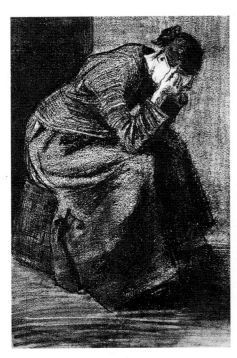

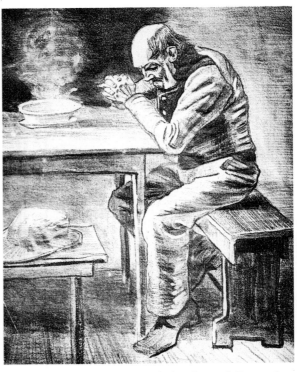

62. Vincent van Gogh, *Old man with head in hands* (*At Eternity's Gate*), November 1882, lithograph, 55.5 × 36.5 cm. (22 × 14⅝″). H268.

64. Vincent van Gogh, *Prayer before the meal,* December 1882, pencil, black chalk, ink heightened with white, 60 × 50 (23⅝ × 19⅝″). H281. Private European collection, Courtesy Christies.

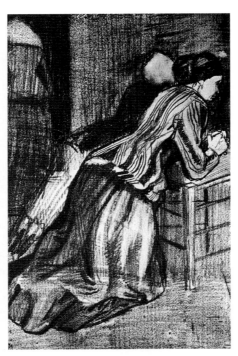

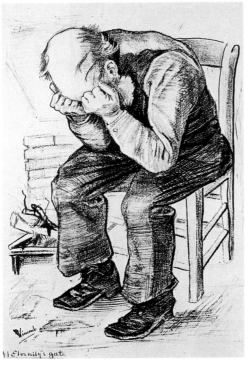

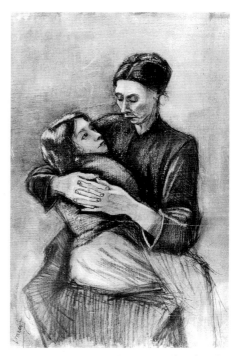

63. Vincent van Gogh, *Woman with head in hands*, February–March 1883, black chalk, washed and heightened with white, 47.5 × 29.5 cm. (18⅞ × 11¾″). H326. Kröller-Müller Museum, Otterlo, Netherlands.

65. Vincent van Gogh, *Two women kneeling,* March–April 1883, pencil, black chalk, 60 × 50 cm. (23⅝ × 19⅝″). H348. Kröller-Müller Museum, Otterlo, Netherlands.

66. Vincent van Gogh, *Sien with girl on her lap,* April, 1883, charcoal, pencil, heightened with white and brown, 53.5 × 35 cm. (21¼ × 13¾″). H356. Van Gogh Museum (Vincent van Gogh Foundation), Amsterdam.

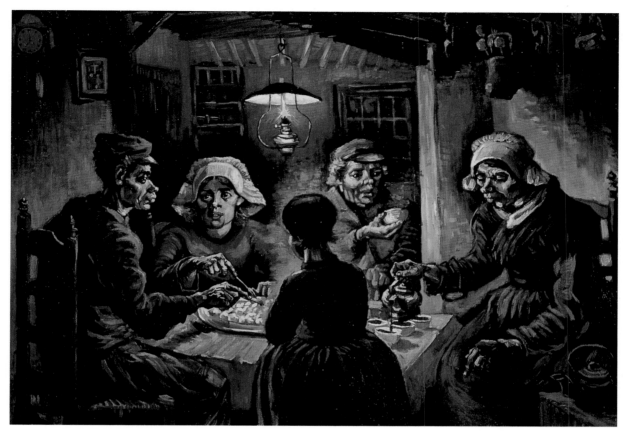

67. Vincent van Gogh, *The Potato eaters*, April 1885, oil on canvas, 82 × 114 cm. (32¼ × 44⅞″). H764. Van Gogh Museum (Vincent van Gogh Foundation), Amsterdam.

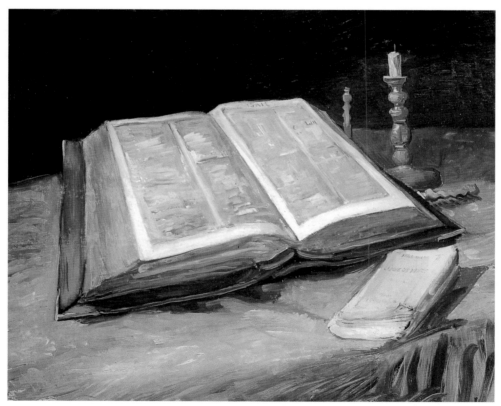

68. Vincent van Gogh, *Still-life with Bible, candlestick, and "La Joie de vivre"*, October–November 1885, oil on canvas, 65 × 78 cm. (25⅝ × 30¾″). H946. Van Gogh Museum (Vincent van Gogh Foundation), Amsterdam.

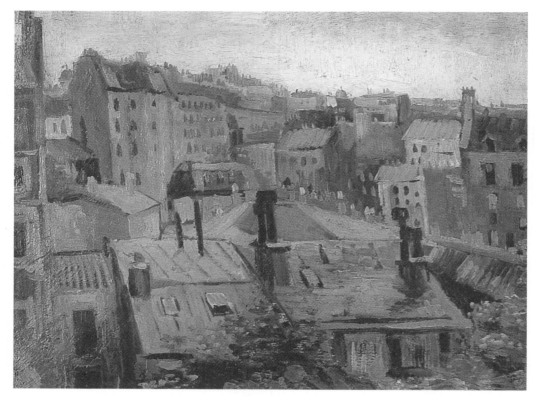

69. Vincent van Gogh, *View of roofs and houses,* spring 1886, oil and pasteboard on multiplex, 30 × 41 cm. (11¾ × 16⅛″). H1099. Van Gogh Museum (Vincent van Gogh Foundation), Amsterdam.

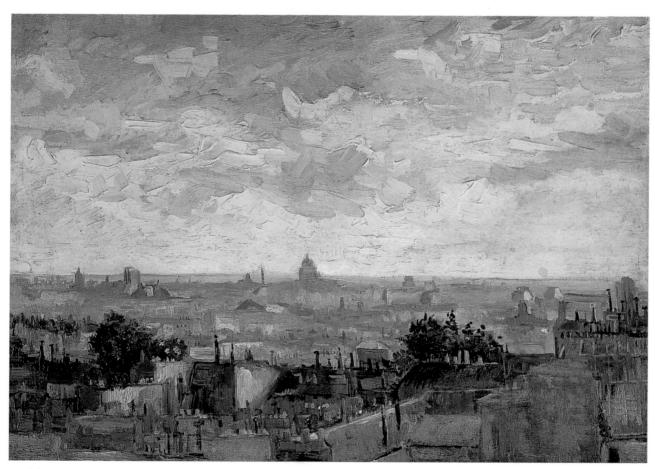

70. Vincent van Gogh, *The roofs of Paris,* spring 1886, oil on canvas, 54 × 72 cm. (21¼ × 28⅜″). H1101. Van Gogh Museum (Vincent van Gogh Foundation), Amsterdam.

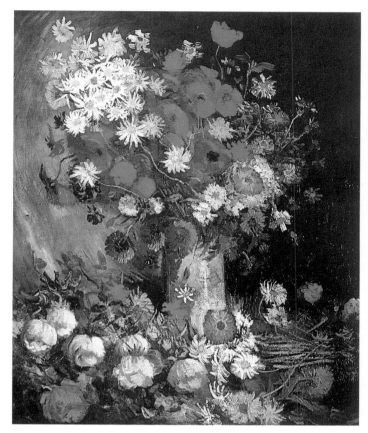

71. Vincent van Gogh, *Vase with mixed flowers*, summer 1886, oil on canvas, 99 × 79 cm. (39 × 31⅛″). H1103. Kröller-Müller Museum, Otterlo, Netherlands.

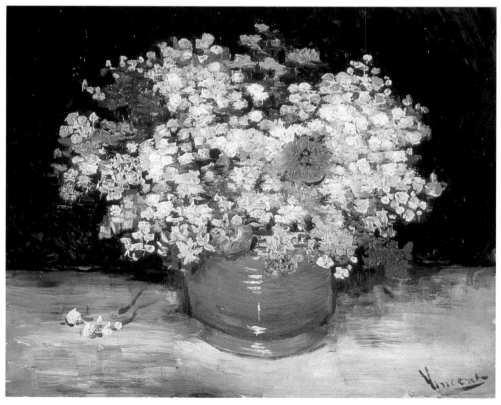

72. Vincent van Gogh, *Vase with zinnias and other flowers*, summer 1886, oil on canvas, 49.5 × 61 cm. (19⅝ × 24″). H1142. National Gallery of Canada, Ottawa.

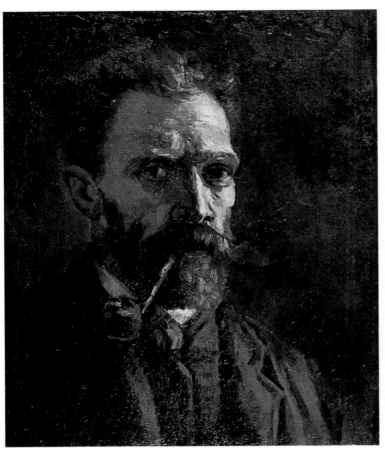

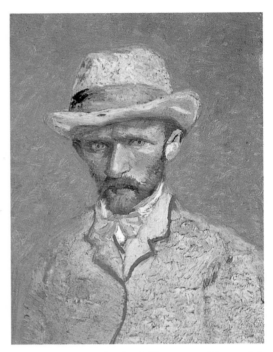

74. Vincent van Gogh, *Self-portrait with gray felt hat,* March–April, 1887, oil on cardboard, 19 × 14 cm. (7½ × 5½"). H1210. Van Gogh Museum (Vincent van Gogh Foundation), Amsterdam.

73. Vincent van Gogh, *Self-portrait with pipe,* spring 1886, oil on canvas, 46 × 38 cm. (18⅛ × 15"). H1194. Van Gogh Museum (Vincent van Gogh Foundation), Amsterdam.

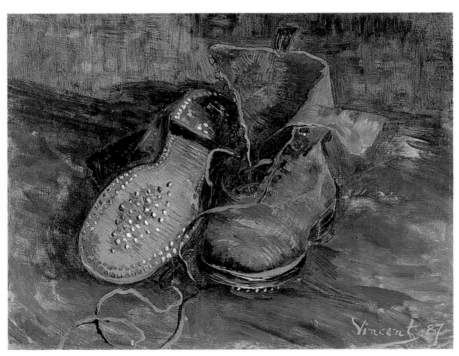

75. Vincent van Gogh, *A pair of boots,* spring 1887, oil on canvas, 34 × 41.5 cm. (13⅜ × 16½"). H1236. The Baltimore Museum of Art: The Cone Collection, formed by Dr. Claribel Cone and Miss Etta Cone of Baltimore, Maryland, BMA 1950.302.

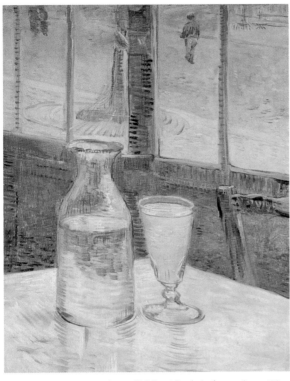

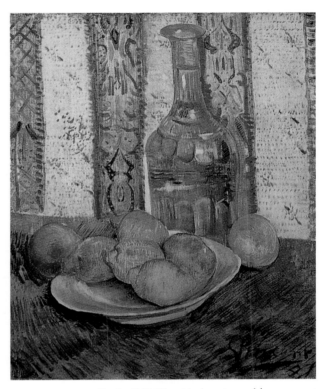

76. Vincent van Gogh, *Still-life with absinthe,* spring 1887, oil on canvas, 46.5 × 33 cm. (18½ × 13″). H1238. Van Gogh Museum (Vincent van Gogh Foundation), Amsterdam.

77. Vincent van Gogh, *Still-life with decanter and lemons on a plate,* April–June 1887, oil on canvas, 46 × 38 cm. (18⅛ × 15″). H1239. Van Gogh Museum (Vincent van Gogh Foundation), Amsterdam.

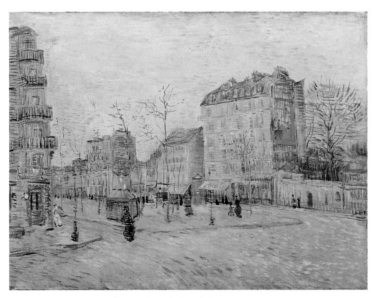

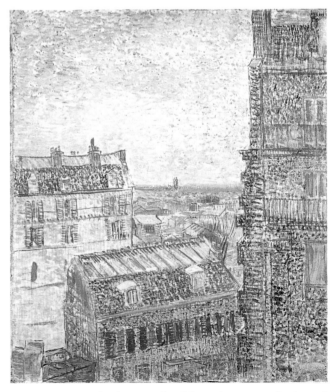

78. Vincent van Gogh, *Boulevard de Clichy,* February–March 1887, oil on canvas, 46.5 × 55 cm. (18½ × 21⅝″). H1219. Van Gogh Museum (Vincent van Gogh Foundation), Amsterdam.

79. Vincent van Gogh, *View from Vincent's room, rue Lepic,* spring 1887, oil on canvas, 46 × 38 cm. (18⅛ × 15″). H1242. Van Gogh Museum (Vincent Van Gogh Foundation), Amsterdam.

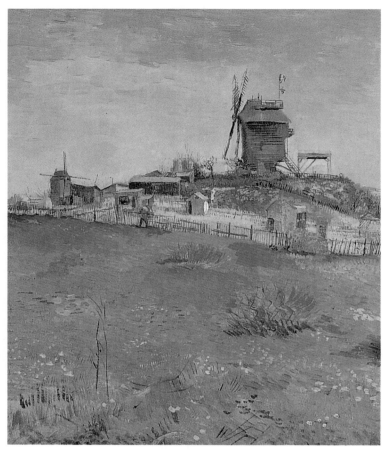

80. Vincent van Gogh, *Moulin du Blute-Fin, Montmartre,* March 1887, oil on canvas, 46 × 38 cm. (18⅛ × 15″). H1221. Carnegie Museum of Art, Pittsburgh; Acquired through the generosity of the Sarah Mellon Scaife family, 67.16.

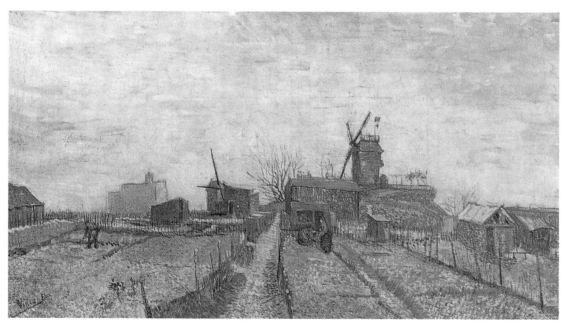

81. Vincent van Gogh, *Vegetable gardens in Montmartre,* spring 1887, oil on canvas, 43 × 80 cm. (16⅞ × 31½″). H1244. Van Gogh Museum (Vincent van Gogh Foundation), Amsterdam.

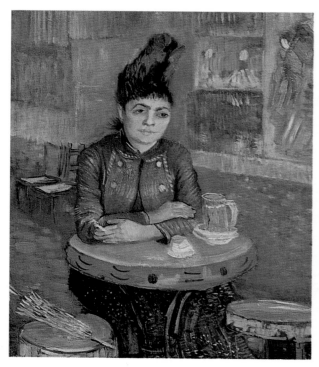

82. Vincent van Gogh, *Mme Agostina Segatori in the Café du Tambourin*, March 1887, oil on canvas, 55.5 × 46.5 cm. (22 × 18½″). H1208. Van Gogh Museum (Vincent van Gogh Foundation), Amsterdam.

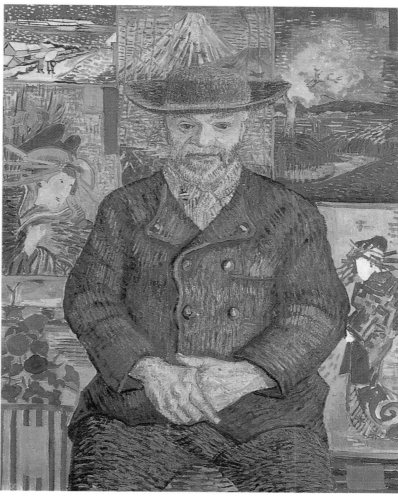

83. Vincent van Gogh, *Père Tanguy*, winter 1887, oil on canvas, 92 × 75 cm. (36¼ × 29½″). H1351. Musée Rodin, Paris.

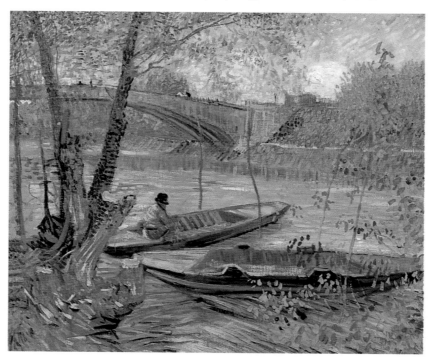

84. Vincent van Gogh, *Fishing in spring*, April–June, 1887, oil on canvas, 50.5 × 60 cm. (19½ × 23⅜″). H1270. The Art Institute of Chicago, Gift of Charles Deering McCormick, Brooks McCormick and Roger McCormick, 1965.1169.

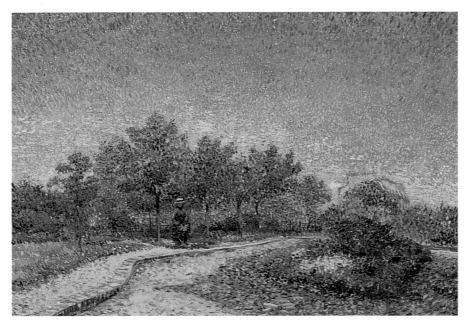

85. Vincent van Gogh, *Corner in Voyer d'Argenson Park at Asnières*, May–June, 1887, oil on canvas, 59 × 81 cm. (23¼ × 31⅞"). H1259. Yale University Art Gallery, New Haven, Connecticut, Gift of Henry R. Ouce, B.A.1920.

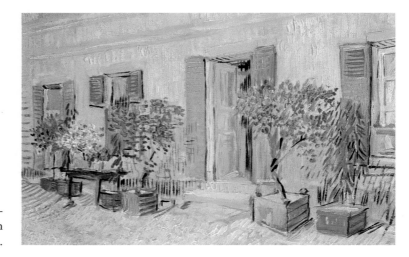

86. Vincent van Gogh, *Exterior of restaurant at Asnières*, July–September, 1887, oil on canvas, 19 × 26.5 cm. (7½ × 10⅝"). H1311. Van Gogh Museum (Vincent van Gogh Foundation), Amsterdam.

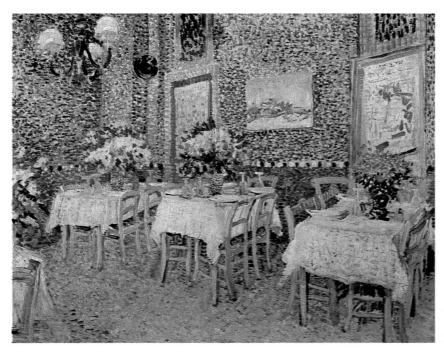

87. Vincent van Gogh, *Interior of restaurant,* June–July, 1887, oil on canvas, 45.5 × 56.5 cm. (18⅛ × 22½"). H1256. Kröller-Müller Museum, Otterlo, Netherlands.

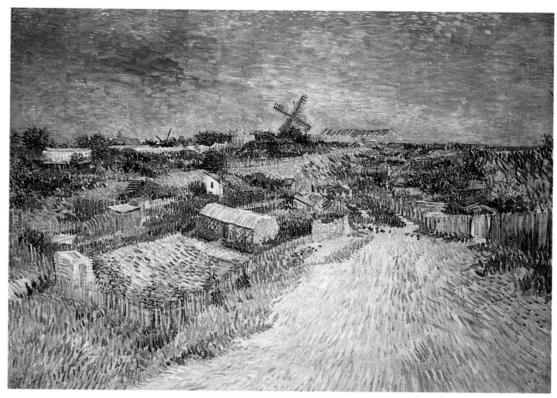

88. Vincent van Gogh, *Vegetable gardens in Montmartre*, June–July, 1887, oil on canvas, 96 × 120 cm. (37¾ × 47¼″). H1245. Stedelijk Museum, Amsterdam.

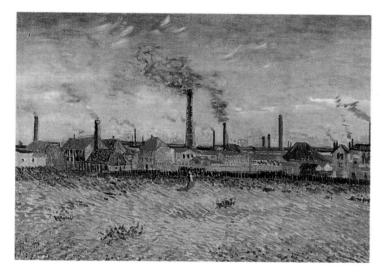

89. Vincent van Gogh, *The Hüth factories at Clichy,* summer 1887, oil on canvas, 54 × 72 cm. (21¼ × 28⅜″). H1287. The St. Louis Art Museum, Gift of Mrs. Mark C. Steinberg.

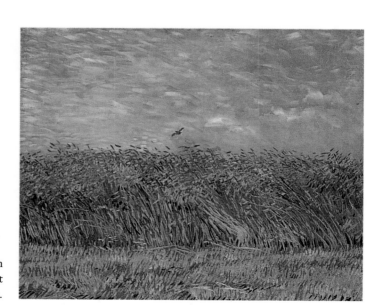

90. Vincent van Gogh, *Wheat field with lark*, May–June, 1887, oil on canvas, 54 × 64.5 cm. (21¼ × 25⅝″). H1274. Van Gogh Museum (Vincent van Gogh Foundation), Amsterdam.

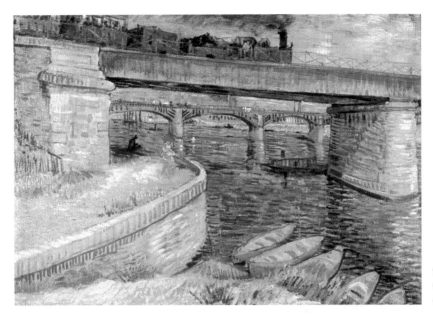

91. Vincent van Gogh, *The Bridge at Asnières*, summer, 1887, oil on canvas, 52 × 65 cm. (20½ × 25⅝″). H1327. The Foundation E. G. Bührle Collection, Zurich.

92. Vincent van Gogh, *Path in the woods*, summer, 1887, oil on canvas, 46 × 38.5 cm. (18⅛ × 15⅜″). H1315. Van Gogh Museum (Vincent van Gogh Foundation), Amsterdam.

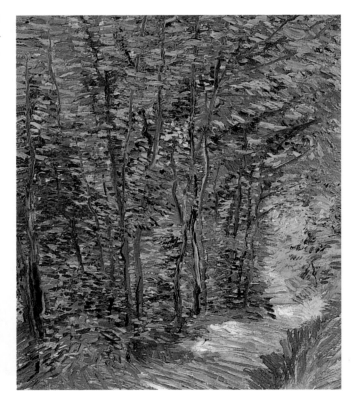

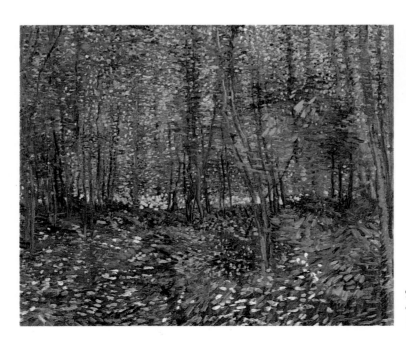

93. Vincent van Gogh, *Trees and undergrowth*, summer, 1887, oil on canvas, 46 × 55.5 cm. (18⅛ × 22″). H1312. Van Gogh Museum (Vincent van Gogh Foundation), Amsterdam.

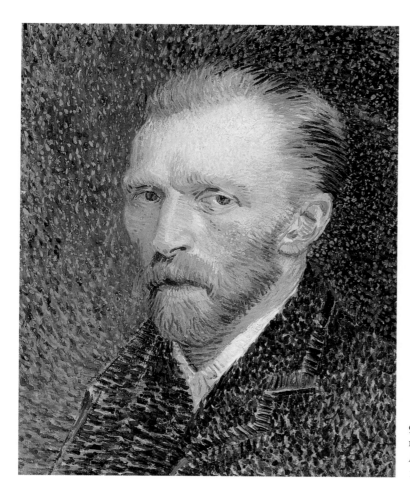

94. Vincent van Gogh, *Self-portrait*, spring 1887, oil on artist's board mounted on cradled panel, 42 × 34 cm. (16½ × 13⅜″). H1249. The Art Institute of Chicago, Joseph Winterbotham Collection, 1954.326.

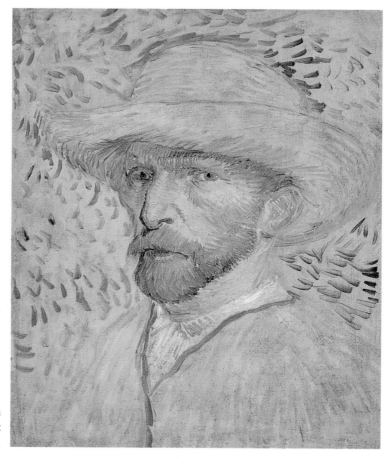

95. Vincent van Gogh, *Self-portrait with straw hat*, summer 1887, oil on canvas, 41 × 33 cm. (16⅛ × 13″). H1310. Van Gogh Museum (Vincent van Gogh Foundation), Amsterdam.

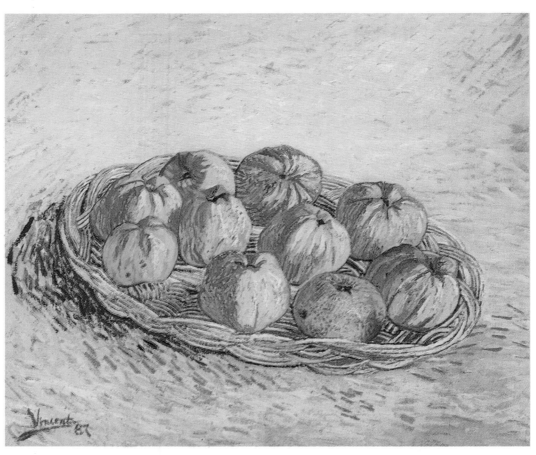

96. Vincent van Gogh, *Still-life: basket of apples,* autumn 1887, oil on canvas, 46 × 55 cm. (18⅛ × 21⅝″). H1341. The St. Louis Art Museum, Gift of Sydney M. Shoenberg, Sr.

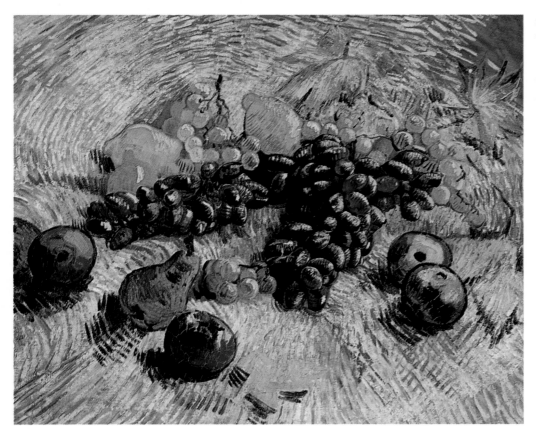

97. Vincent van Gogh, *Still-life with apples, pears, lemons and grapes,* autumn 1887, oil on canvas, 46.5 × 55.2 cm. (18⅜ × 21⅝″). H1337. The Art Institute of Chicago, Gift of Kate L. Brewster, 1949. 215.

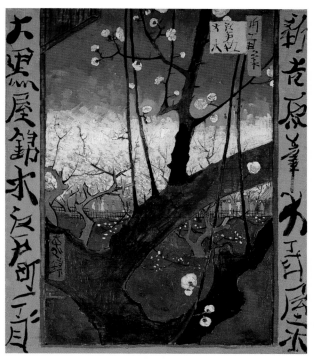

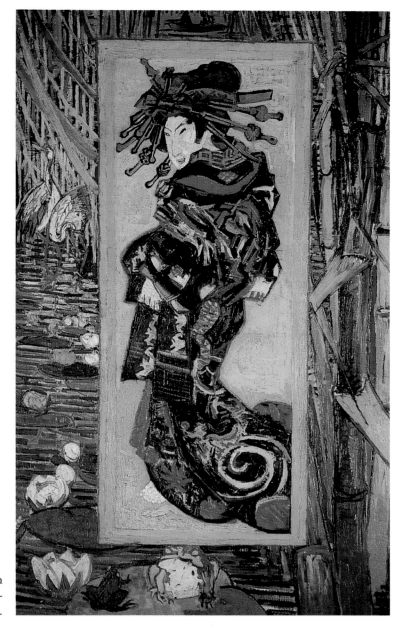

98. Vincent van Gogh, *Flowering plum tree (after Hiroshige)*, autumn 1887, oil on canvas, 55 × 46 cm. (21⅝ × 18⅛″). H1296. Van Gogh Museum (Vincent van Gogh Foundation), Amsterdam. (See Hiroshige, fig. 229.)

99. Vincent van Gogh, *Oiran (after Kesaï Yeisen)*, autumn 1887, oil on canvas, 105 × 61 cm. (41⅜ × 24″). H1298. Van Gogh Museum (Vincent van Gogh Foundation), Amsterdam.

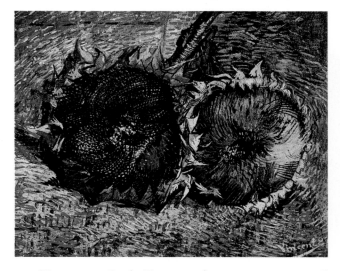

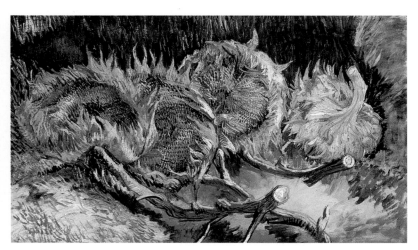

100. Vincent van Gogh, *Two cut sunflowers*, autumn 1887, oil on canvas, 50 × 60 cm. (19⅝ × 23⅝″). H1331. Kunstmuseum, Bern, Switzerland.

101. Vincent van Gogh, *Four cut sunflowers*, autumn 1887, oil on canvas, 60 × 100cm. (23⅝ × 39⅜″). H1330. Kröller-Müller Museum, Otterlo, Netherlands.

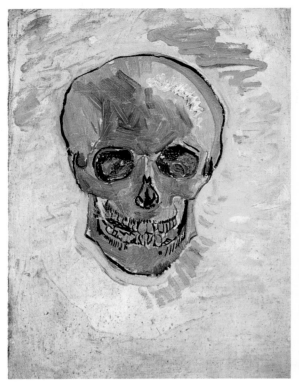

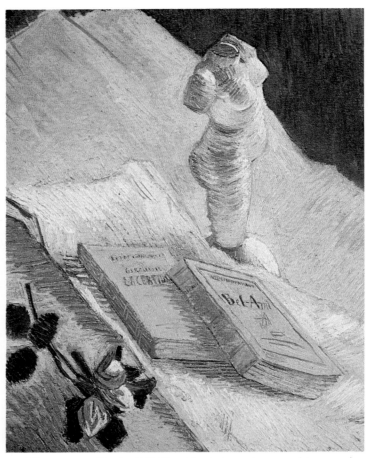

102. Vincent van Gogh, *Skull*, winter 1887, oil on canvas, 41.5 × 31.5 cm. (16½ × 12⅝″). H1347. Van Gogh Museum (Vincent van Gogh Foundation), Amsterdam.

103. Vincent van Gogh, *Still-life with plaster cast, rose and two novels*, winter 1887–1888, oil on canvas, 55 × 46.5 cm. (21⅝ × 18½″). H1349. Kröller-Müller Museum, Otterlo, Netherlands.

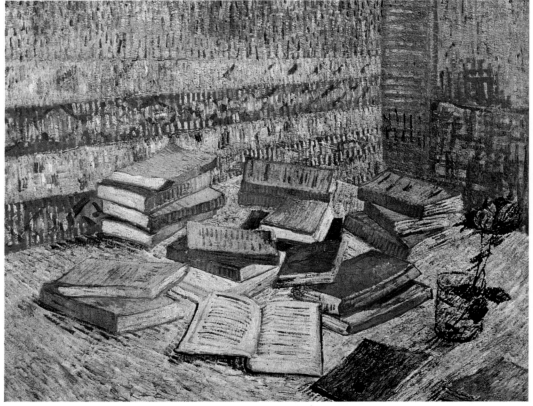

104. Vincent van Gogh, *Still-life with French novels and rose*, December 1887, oil on canvas, 73 × 93 cm. (28¾ × 36⅝″). H1332. Private Collection, Courtesy Richard L. Feigen and Co.

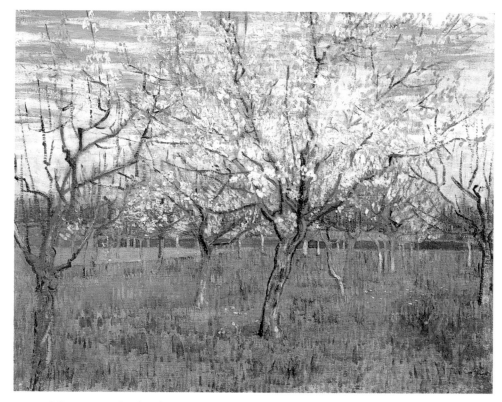

105. Vincent van Gogh, *Blossoming apricot trees,* March, 1888, oil on canvas, 65.5 × 80.5 cm. (26 × 31⅞″). H1380. Van Gogh Museum (Vincent van Gogh Foundation), Amsterdam.

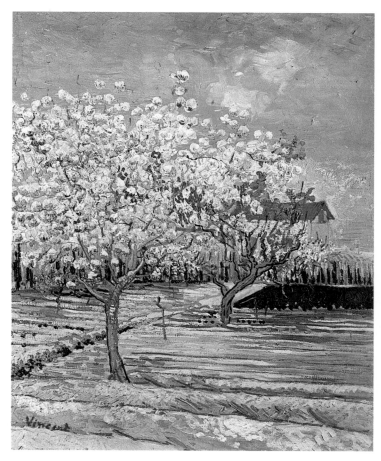

106. Vincent van Gogh, *Orchard in blossom,* April, 1888, oil on canvas, 72 × 58 cm. (28⅜ × 22⅞″). H1399. Harmon Fine Arts, Ltd.

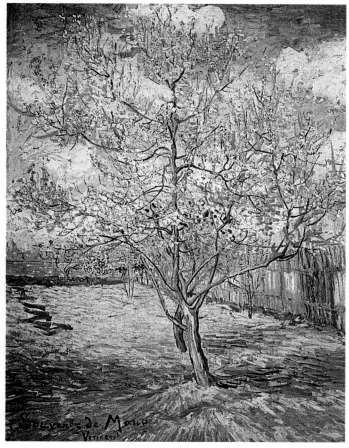

107. Vincent van Gogh, *Pink peach trees. Souvenir de Mauve,* March, 1888, oil on canvas, 73 × 59.5 cm. (28¾ × 23⅝″). H1379. Kröller-Müller Museum, Otterlo, Netherlands.

108. Vincent van Gogh, *Bridge of Langlois*, March 1888, oil on canvas, 54 × 65 cm. (21¼ × 25⅝"). H1368. Kröller-Müller Museum, Otterlo, Netherlands.

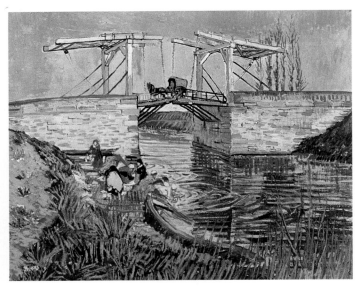

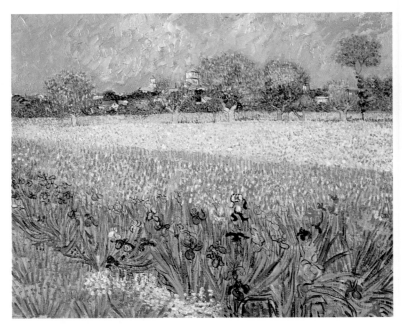

109. Vincent van Gogh, *View of Arles with irises*, April–May 1888, oil on canvas, 54 × 65 cm. (21¼ × 25⅝"). H1416. Van Gogh Museum (Vincent van Gogh Foundation), Amsterdam.

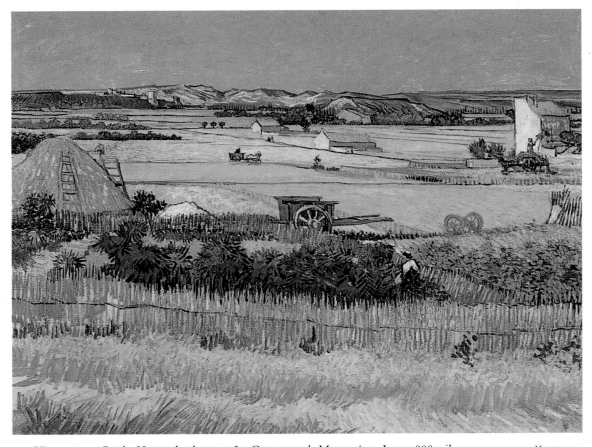

110. Vincent van Gogh, *Harvest landscape at La Crau, towards Montmajeur*, June 1888, oil on canvas, 72.5 × 92 cm. (28¾ × 36¼"). H1440. Van Gogh Museum (Vincent van Gogh Foundation), Amsterdam.

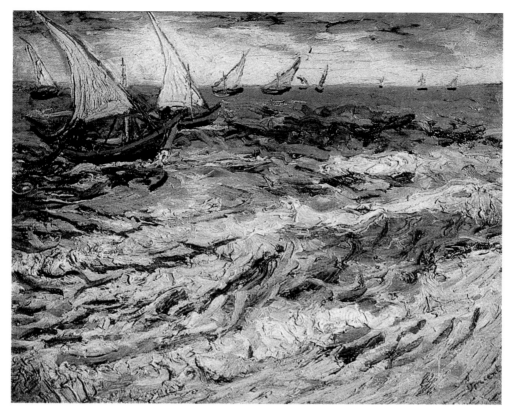

111. Vincent van Gogh, *Fishing boats on the sea at Saintes-Maries-de-la-mer*, June 1888, oil on canvas, 44 × 52 cm. (17⅜ × 20⅞″). H1453. Pushkin State Museum of Fine Arts, Moscow.

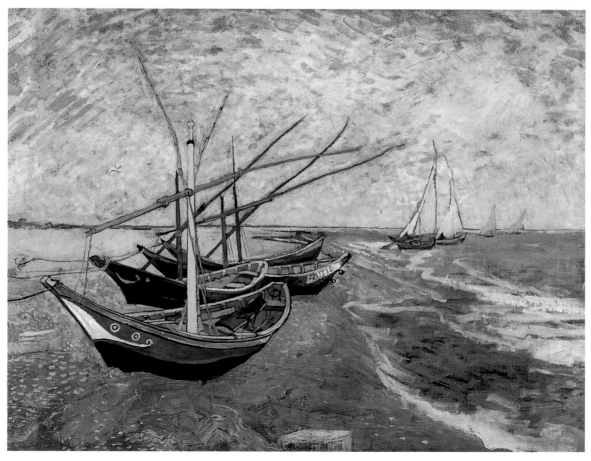

112. Vincent van Gogh, *Fishing boats on the beach at Saintes-Maries-de-la-mer*, June 1888, oil on canvas, 64.5 × 81 cm. (25⅝ × 31⅞″). H1460. Van Gogh Museum (Vincent van Gogh Foundation), Amsterdam.

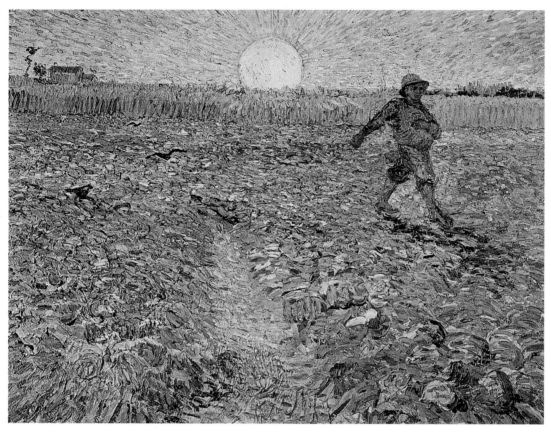

113. Vincent van Gogh, *The Sower*, June 1888, oil on canvas, 64 × 80 cm. (25¼ × 31⅞″). H1470. Kröller-Müller Museum, Otterlo, Netherlands.

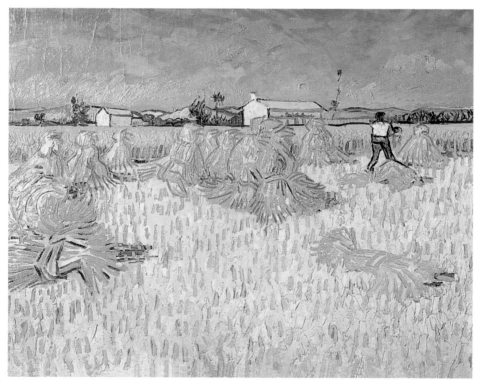

114. Vincent van Gogh, *Harvest in Provence*, June 1888, oil on canvas, 50 × 60 cm. (19⅝ × 23⅝″). H1481. The Israel Museum, Jerusalem.

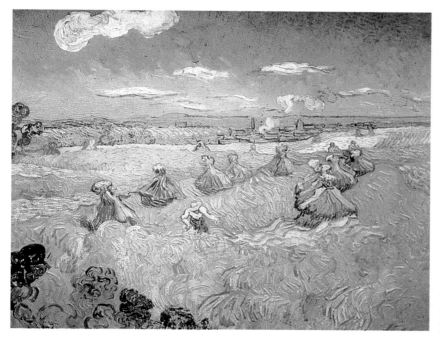

115. Vincent van Gogh, *Wheat fields with reaper*, June 1888, oil on canvas, 73 × 93 cm. (28¾ × 36⅝″). H1479. The Toledo Museum of Art, Toledo, Ohio; Purchased with funds from the Libbey Endowment, Gift of Edward Drummond Libbey.

116. Vincent van Gogh, *Sunset: wheat fields near Arles*, June 1888, oil on canvas, 74 × 91 cm. (29⅛ × 35⅞″). H1473. Künstmuseum Winterthur, Switzerland.

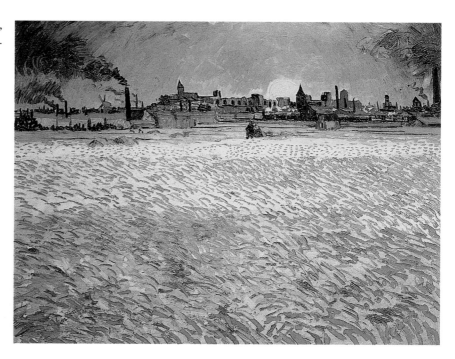

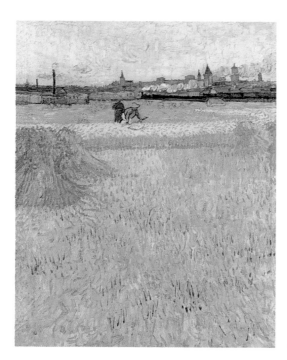

117. Vincent van Gogh, *Arles: view from the wheat fields*, June 1888, oil on canvas, 73 × 54 cm. (28¾ × 21¼″). H1477. Musée Rodin, Paris.

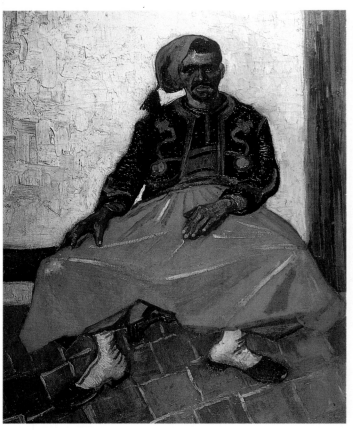

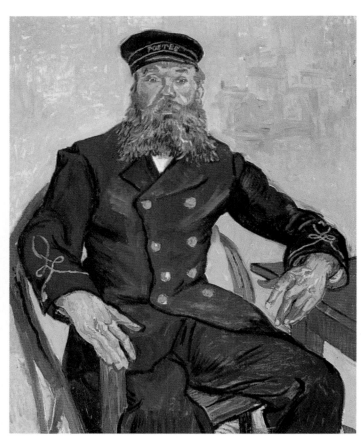

118. Vincent van Gogh, *Seated Zouave,* June–July 1888, oil on canvas, 81 × 65 cm. (31⅞ × 25⅝"). H1488. Private Collection, Argentina.

119. Vincent van Gogh, *Postman Joseph Roulin,* July–August 1888, oil on canvas, 81 × 65 cm. (31⅞ × 25⅝"). H1522. Gift of Robert Treat Paine II, Courtesy of Museum of Fine Arts, Boston.

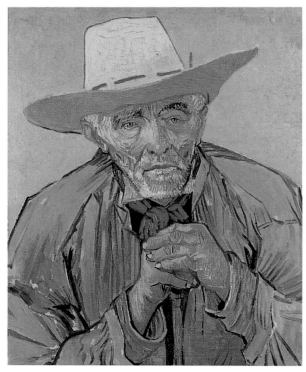

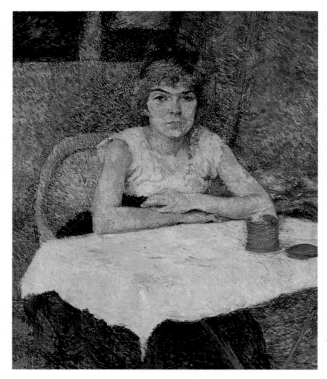

120. Vincent van Gogh, *Portrait of Patience Escalier,* August 1888, oil on canvas, 69 × 56 cm. (27⅛ × 22"). H1563. Private Collection.

121. Henri de Toulouse-Lautrec, *Young woman at a table, "Rice powder",* 1887, oil on canvas, Van Gogh Museum (Vincent van Gogh Foundation), Amsterdam.

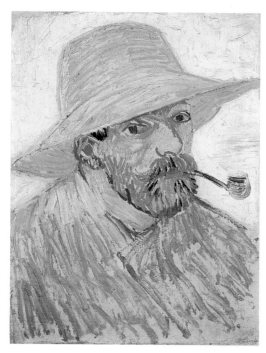

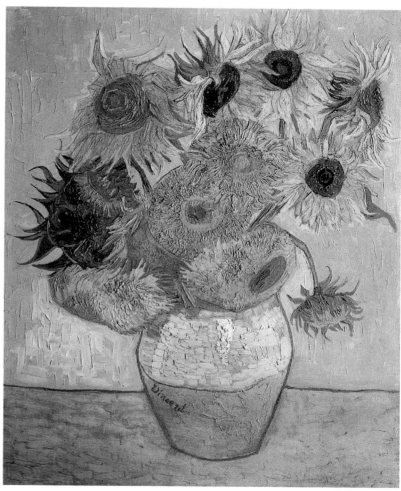

122. Vincent van Gogh, *Self-portrait with straw hat and pipe*, August 1888, oil on canvas on pasteboard, 42 × 31 cm. (16½ × 12¼″). H1565. Van Gogh Museum (Vincent van Gogh Foundation), Amsterdam.

123. Vincent van Gogh, *Vase with sunflowers,* August 1888, oil on canvas, 91 × 72 cm. (35⅞ × 28⅜″). H1561. Bayerischen Staatsgemäldesammlungen, Munich.

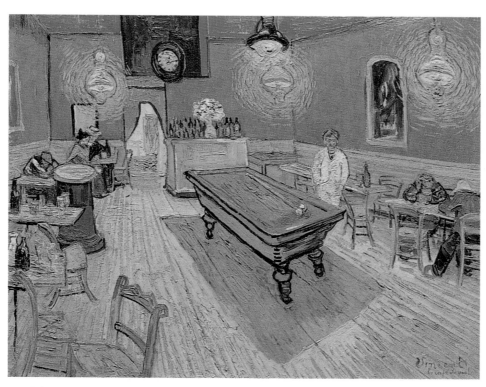

124. Vincent van Gogh, *The Night café,* September 1888, oil on canvas, 70 × 89 cm. (27⅝ × 35″). H1575. Yale University Art Gallery, New Haven, Connecticut, Bequest of Stephen Carlton Clark, B.A. 1903.

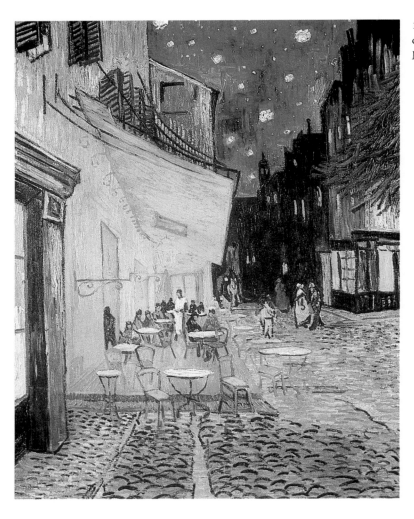

125. Vincent van Gogh, *Café terrace at night*, September 1888, oil on canvas, 81 × 65.5 cm. (31⅞ × 26″). H1580. Kröller-Müller Museum, Otterlo, Netherlands.

127. Vincent van Gogh, *Portrait of Eugène Boch*, August 1888, oil on canvas, 60 × 45 cm. (23⅝ × 17¾″). H1574. Musée d'Orsay, Paris.

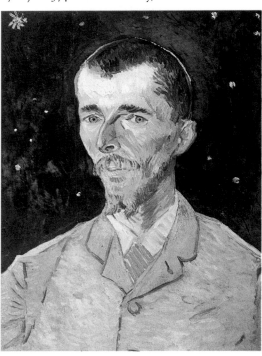

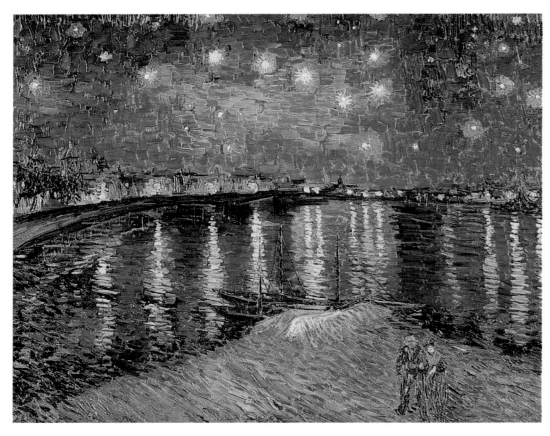

126. Vincent van Gogh, *Starry night over the Rhone*, September 1888, oil on canvas, 72.5 × 92 cm. (28¾ × 36¼″). H1592. Musée d'Orsay, Paris.

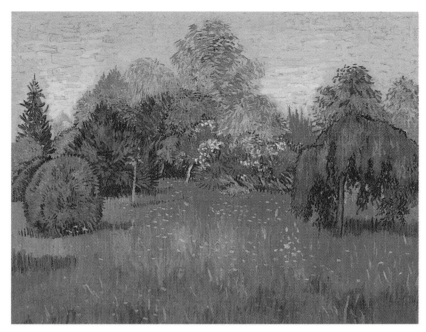

128. Vincent van Gogh, *The Garden of the Poets*, September 1888, oil on canvas, 73 × 92 cm. (28¾ × 36¼″). H1578. The Art Institute of Chicago, Mr. and Mrs. Lewis Larned Coburn Memorial Collection, 1933. 433.

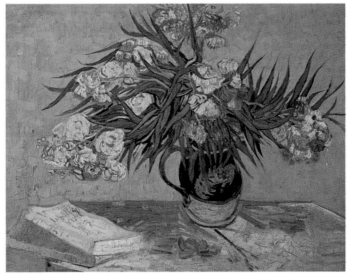

129. Vincent van Gogh, *Vase with oleanders and books,* August 1888, oil on canvas, 60 × 73 cm. (23⅝ × 28¾″). H1566. The Metropolitan Museum of Art, New York, Gift of Mr. and Mrs. John L. Loeb, 1962, 62.24.

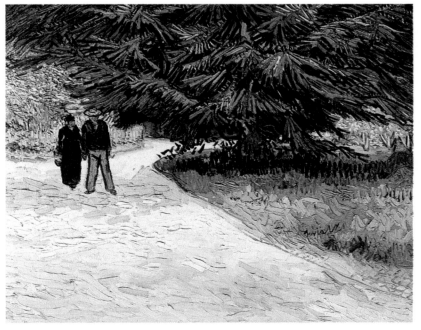

130. Vincent van Gogh, *Public park with couple and blue fir tree: The Poets' Garden III,* October 1888, oil on canvas, 73 × 92 cm. (28¾ × 36¼″). H1601. Private Collection.

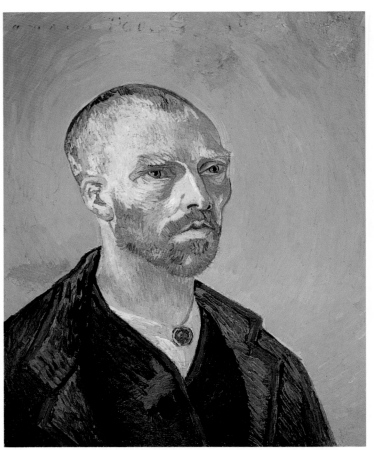

131. Vincent van Gogh, *Self-portrait as bonze, dedicated to Paul Gauguin,* September 1888, oil on canvas, 62 × 52 cm. (24⅜ × 20½"). H1581. Courtesy of the Fogg Art Museum, Harvard University Art Museums, Cambridge, Bequest of the Collection of Maurice Wertheim, Class of 1906.

133. Vincent van Gogh, *The Sower,* November 1888, oil on canvas, 32 × 40 cm. (12⅝ × 15¾"). H1629. Van Gogh Museum (Vincent van Gogh Foundation), Amsterdam.

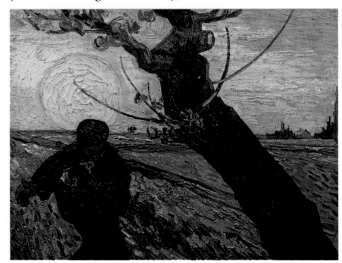

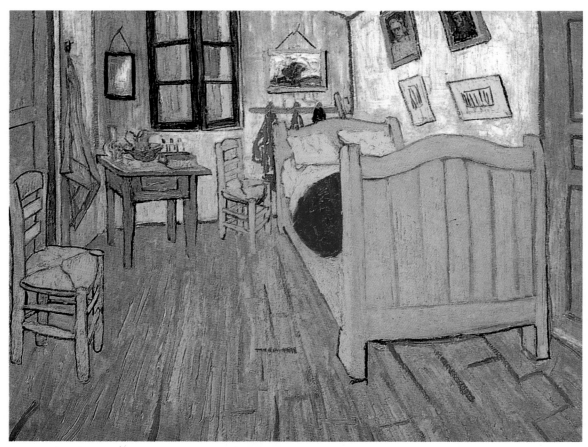

132. Vincent van Gogh, *Vincent's bedroom at Arles,* October 1888, oil on canvas, 72 × 90 cm. (28⅜ × 35⅜"). H1608. Van Gogh Museum (Vincent van Gogh Foundation), Amsterdam.

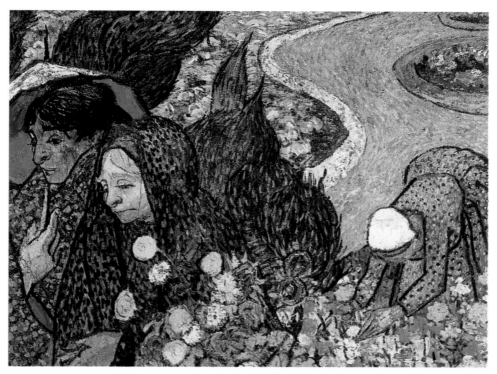

134. Vincent van Gogh, *Memory of the garden at Etten*, November 1888, oil on canvas, 73.5 × 92.5 cm. (29⅛ × 36⅝″). H1630. The State Hermitage Museum, St. Petersburg.

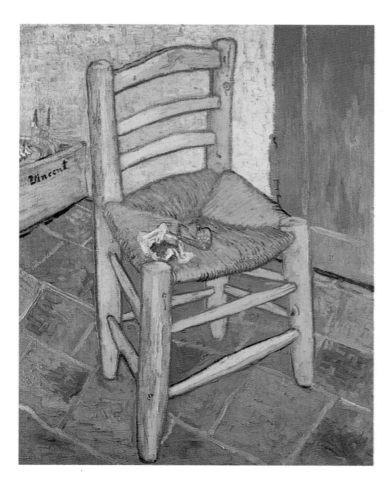

135. Vincent van Gogh, *Van Gogh's chair*, December 1888, oil on canvas, 93 × 73.5 cm. (36⅝ × 29⅛″). H1635. The National Gallery, London.

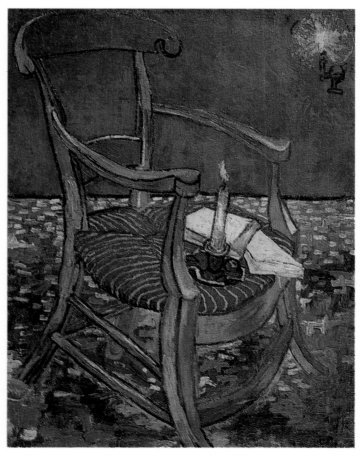

136. Vincent van Gogh, *Gauguin's armchair*, December 1888, oil on canvas, 90.5 × 72 cm. (35⅞ × 28⅜″). H1636. Van Gogh Museum (Vincent van Gogh Foundation), Amsterdam.

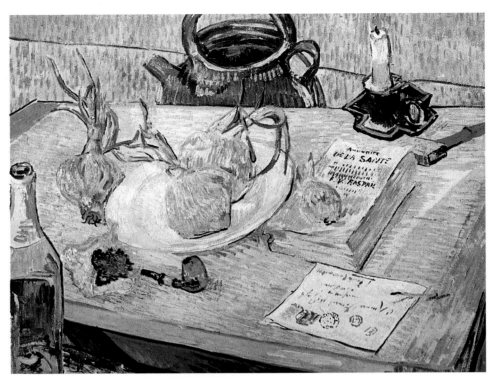

137. Vincent van Gogh, *Still-life on the drawing board*, January 1889, oil on canvas, 50 × 64 cm. (19⅝ × 25¼″). H1656. Kröller–Müller Museum, Otterlo, Netherlands.

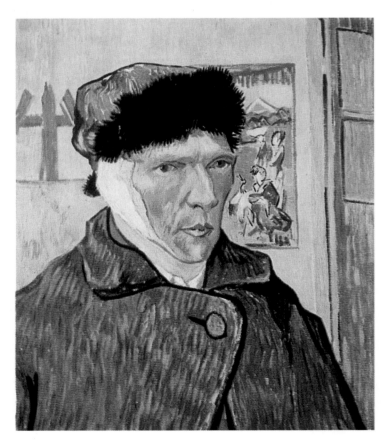

138. Vincent van Gogh, *Self-portrait with bandaged ear and easel*, January 1889, oil on canvas, 60 × 49 cm. (25⅝ × 19¼″). H1657. Courtauld Institute Galleries, London.

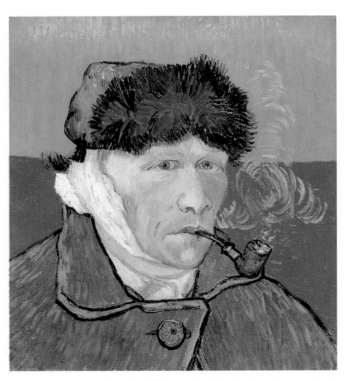

139. Vincent van Gogh, *Self-portrait with bandaged ear and pipe*, January 1889, oil on canvas, 51 × 45 cm. (20⅛ × 17¾″). H1658. Private Collection.

141. Vincent van Gogh, *Portrait of Dr. Félix Rey*, January 1889, oil on canvas, 64 × 53 cm. (25¼ × 20⅞″). H1659. Pushkin State Museum of Fine Arts, Moscow.

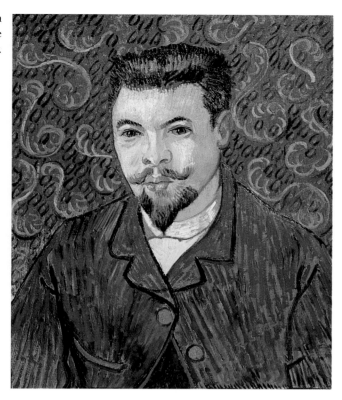

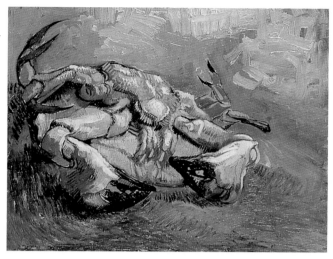

140. Vincent van Gogh, *Crab on its back*, January 1889, oil on canvas, 38 × 45.5 cm. (15 × 18⅛″). H1663. Van Gogh Museum (Vincent van Gogh Foundation), Amsterdam.

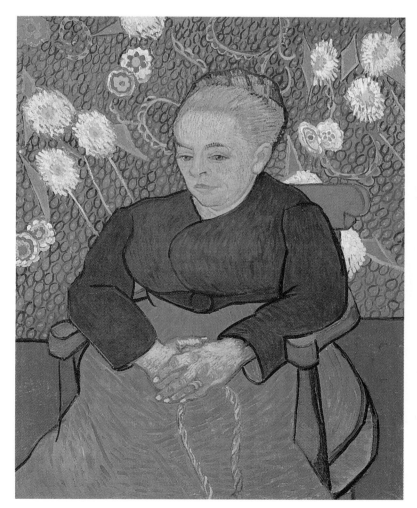

142. Vincent van Gogh, *Lullaby: Madame Augustine Roulin rocking a cradle (la Berceuse)*, January–April 1889, oil on canvas, 92.7 × 72.8 cm. (36⅝ × 28¾″). H1671. Bequest of John T. Spaulding, Courtesy Museum of Fine Arts, Boston.

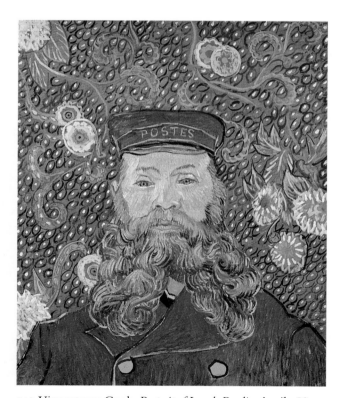

143. Vincent van Gogh, *Portrait of Joseph Roulin,* April 1889, oil on canvas, 64 × 54.5 cm. (25¼ × 21⅝″). H1675. The Museum of Modern Art, New York. Gift of Mr. and Mrs. William A. M. Burden, Mr. and Mrs. Paul Rosenberg, Nelson A. Rockefeller, Mr. and Mrs. Armand Bartos, Sidney and Harriet Janis, Mr. and Mrs. Werner E. Josten, and Loula D. Lasker Bequest (by exchange). Photograph © 1996 The Museum of Modern Art.

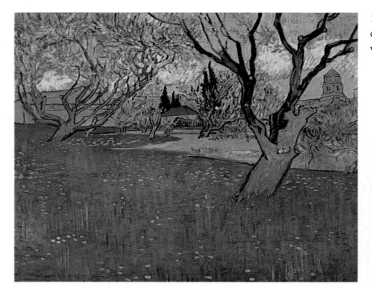

144. Vincent van Gogh, *View of Arles with trees in blossom,* April 1889, oil on canvas, 50.5 × 65 cm. (20⅛ × 25⅝″). H1683. Van Gogh Museum (Vincent van Gogh Foundation), Amsterdam.

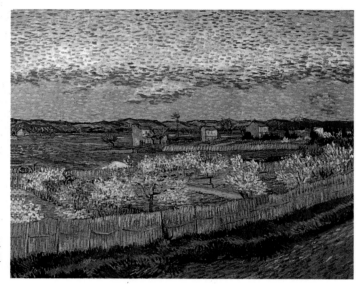

145. Vincent van Gogh, *La Crau with peach trees in blossom,* April 1889, oil on canvas, 65.5 × 81.5 cm. (26 × 32¼″). H1681. Courtauld Institute Galleries, London.

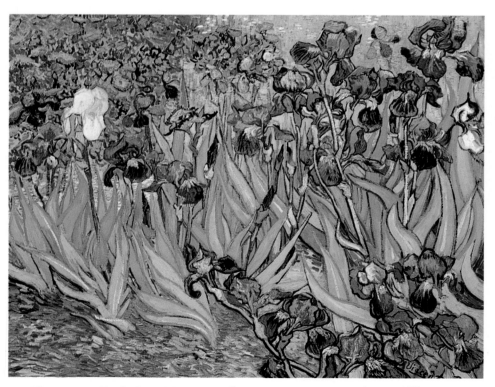

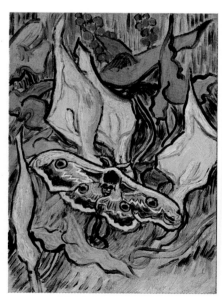

147. Vincent van Gogh, *Death's-head moth,* May 1889, oil on canvas, 33 × 24 cm. (13 × 9½″). H1702. Van Gogh Museum (Vincent van Gogh Foundation), Amsterdam.

146. Vincent van Gogh, *Irises,* May 1889, oil on canvas, 71 × 93 cm. (28 × 36⅝″). H1691. The J. Paul Getty Museum, Los Angeles.

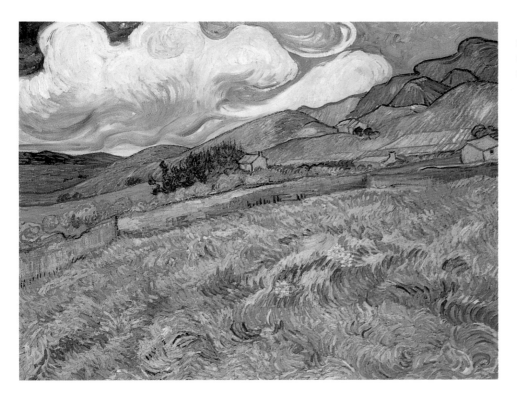

148. Vincent van Gogh, *Field with ruined wheat*, June 1889, oil on canvas, 70.5 × 88.5 cm. (28 × 35″). H1723. Ny Carlsberg Glyptotek, Copenhagen, Denmark.

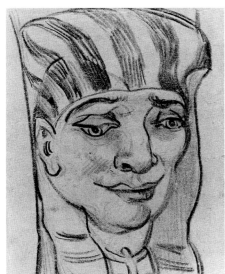

149. Vincent van Gogh, *Head of Egyptian king*, June 1889, blue and black chalk, 31 × 23.5 cm. (12¼ × 9½″). H1737. Van Gogh Museum (Vincent van Gogh Foundation), Amsterdam.

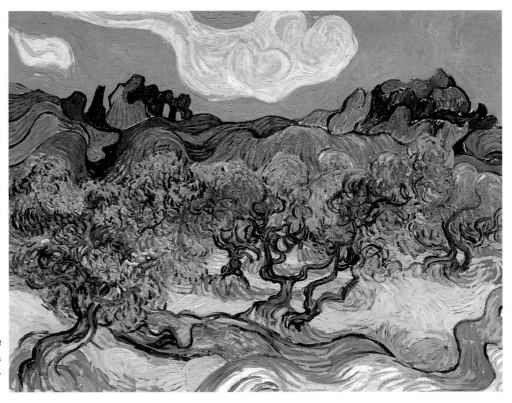

150. Vincent van Gogh, *Olive trees with Alpilles*, June 1889, oil on canvas, 72.5 × 92 cm. (28¾ × 36¼″). H1740. From the Collection of Mrs. John Hay Whitney, New York.

151. Vincent van Gogh, *Olive orchard*, June 1889, oil on canvas, 73 × 93 cm. (28¾ × 36⅝″). H1759. The Nelson-Atkins Museum of Fine Art, Kansas City, Missouri (Purchase: Nelson Trust).

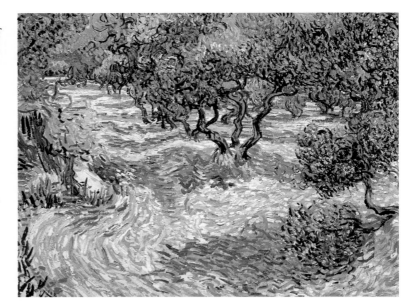

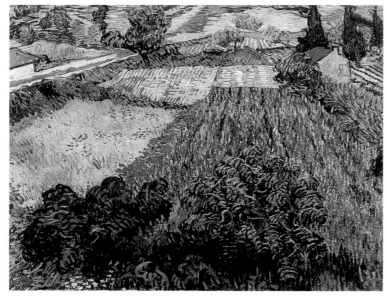

152. Vincent van Gogh, *Field with poppies*, June 1889, oil on canvas, 71 × 91 cm. (28 × 35⅞″). H1751. Kunsthalle Bremen, Germany.

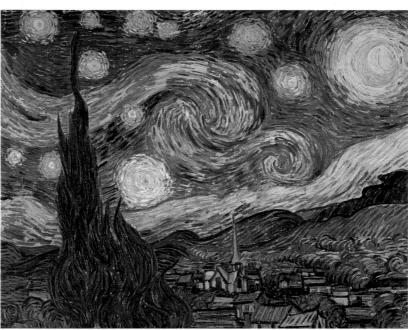

153. Vincent van Gogh, *The Starry night*, June 1889, oil on canvas, 73 × 92 cm. (28¾ × 36¼″). H1731. The Museum of Modern Art, New York. Acquired through the Lillie A. P. Bliss Bequest. Photograph © 1995 The Museum of Modern Art, New York.

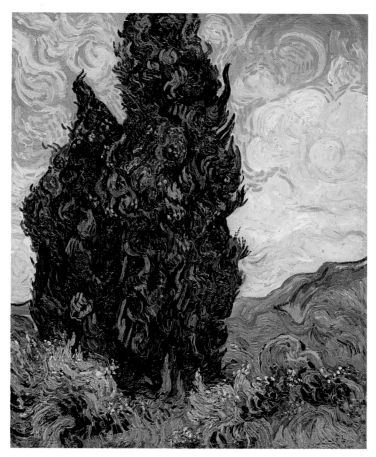

154. Vincent van Gogh, *Cypresses*, June 1889, oil on canvas, 95 × 73 cm. (37⅜ × 28¾″). H1746. The Metropolitan Museum of Art, New York, Rogers Fund, 1949, 49.30. Photograph by Malcolm Varon.

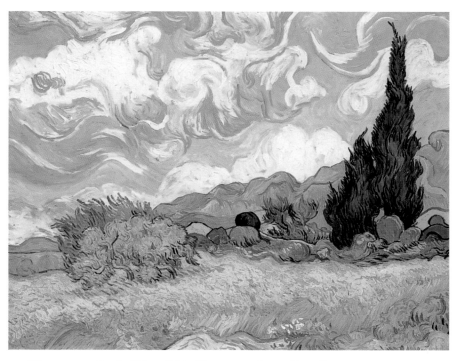

155. Vincent van Gogh, *Wheat field with cypresses*, June 1889, oil on canvas, 72.5 × 91.5 cm. (28¾ × 36¼″). H1755. The National Gallery, London.

156. Vincent van Gogh, *Wheat field with reaper and sun*, June 1889, oil on canvas, 72 × 92 cm. (28⅜ × 36¼″). H1753. Kröller-Müller Museum, Otterlo, Netherlands.

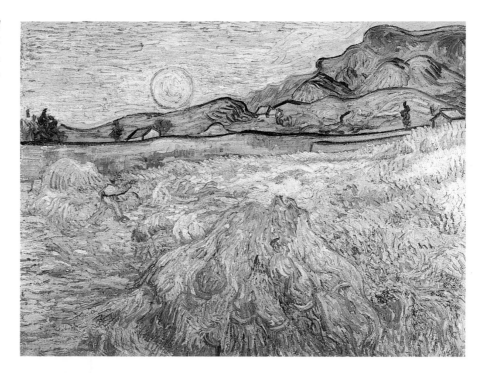

157. Vincent van Gogh, *Mountains at Saint-Rémy*, July 1889, oil on canvas, 73 × 93 cm. (28¾ × 36⅝″). H1766. Solomon R. Guggenheim Museum, New York, Justin K. Thannhauser Collection, 1978. Photo by David Heald © The Solomon R. Guggenheim Foundation, New York, FN78.2514 T24.

158. Vincent van Gogh, *Entrance to a quarry,* mid. July 1889, oil on canvas, 60 × 72.5 cm. (23⅝ × 28¾″). H1802. Van Gogh Museum (Vincent van Gogh Foundation), Amsterdam.

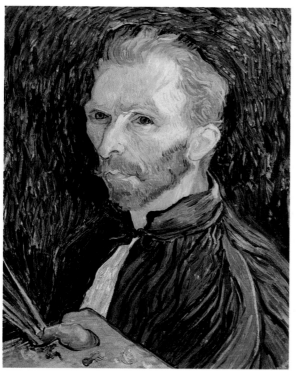

159. Vincent van Gogh, *Self-portrait*, late August 1889, oil on canvas, 57 × 43.5 cm. (22½ × 17⅜″). H1770. From the Collection of Mrs. John Hay Whitney, New York.

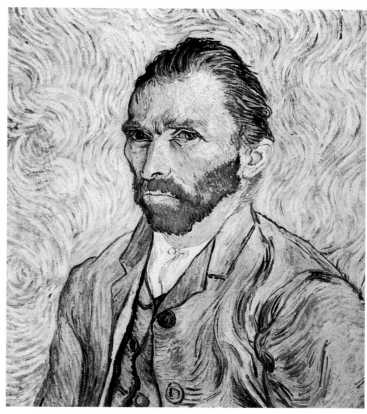

160. Vincent van Gogh, *Self-portrait*, September 1889, oil on canvas, 65 × 54 cm. (25⅝ × 21¼″). H1772. Musée d'Orsay, Paris.

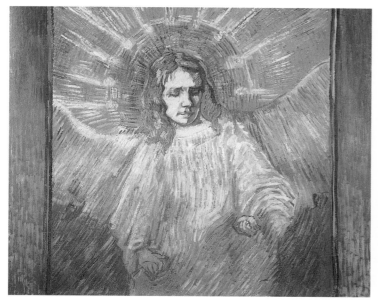

161. Vincent van Gogh, *Angel (after Rembrandt)*, September 1889, oil on canvas, 54 × 64 cm. (21¼ × 25¼″). H1778. Location unknown.

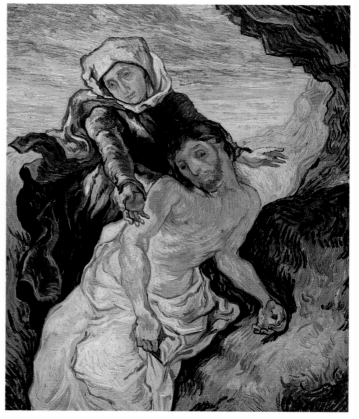

162. Vincent van Gogh, *Pietà (after Delacroix)*, September 1889, oil on canvas, 73 × 60.5 cm. (28¾ × 24″). H1775. Van Gogh Museum (Vincent van Gogh Foundation), Amsterdam.

LEFT 163. Vincent van Gogh, *The Sheaf-binder (after Millet)*, September 1889, oil on canvas, 44 × 32.5 cm. (17⅜ × 13″). H1785. Van Gogh Museum (Vincent van Gogh Foundation), Amsterdam.

RIGHT 164. Vincent van Gogh, *The Sheep-shearers (after Millet)*, September 1889, oil on canvas, 43 × 29 cm. (16⅞ × 11⅜″). H1787. Van Gogh Museum (Vincent van Gogh Foundation), Amsterdam.

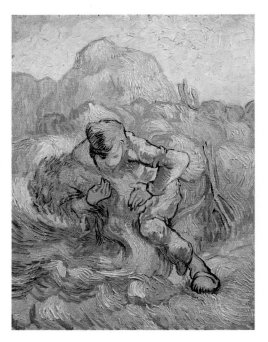 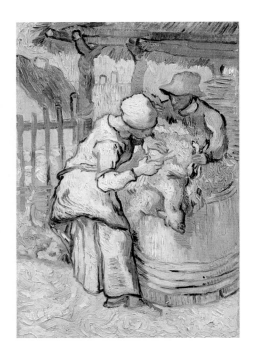

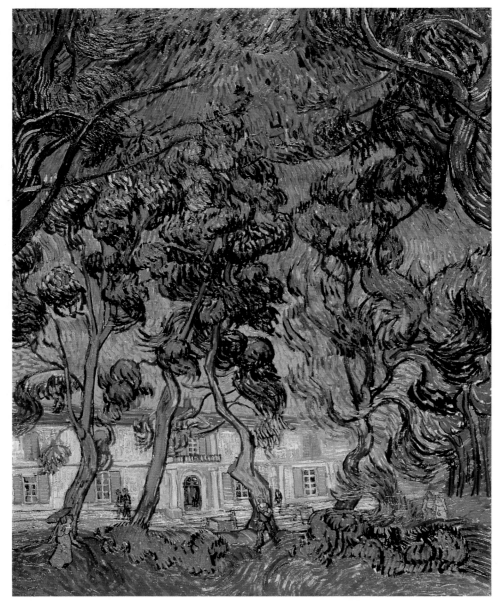

165. Vincent van Gogh, *Garden of Saint-Paul Hospital at St. Rémy*, October 1889, oil on canvas, 90.2 × 71.1 cm. (35½ × 28″). H1799. The Armand Hammer Collection, UCLA at the Armand Hammer Museum of Art and Cultural Center, Los Angeles.

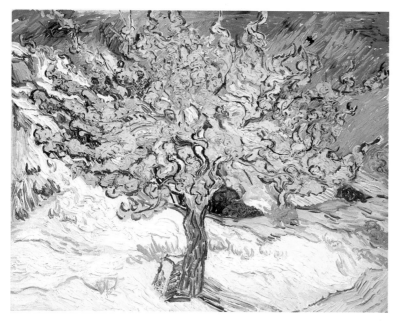

166. Vincent van Gogh, *Mulberry tree*, October 1889, oil on canvas, 54 × 65 cm. (21¼ × 25⅝″). H1796. Norton Simon Art Foundation, Pasadena, California, Gift of Mr. Norton Simon, 1976.

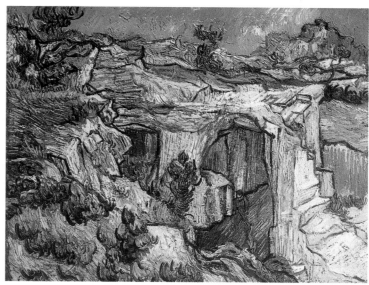

167. Vincent van Gogh, *Entrance to a quarry*, October 1889, oil on canvas, 52 × 64 cm. (20½ × 25¼″). H1767. Private Collection.

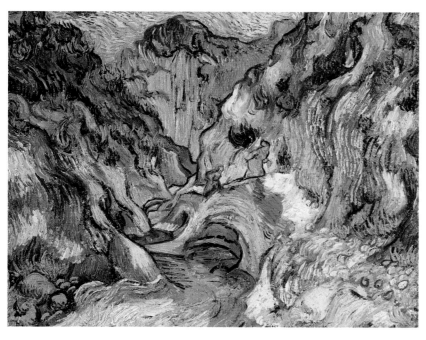

168. Vincent van Gogh, *Les Peiroulets ravine*, October 1889, oil on canvas, 73 × 92 cm. (28¾ × 36¼″). H1804. Bequest of Keith McLeod, Courtesy Museum of Fine Arts, Boston.

169. Vincent van Gogh, *The Family at night (after Millet)*, October 1889, oil on canvas, 73 × 92 cm. (28¾ × 36¼"). H1834. Van Gogh Museum (Vincent van Gogh Foundation), Amsterdam.

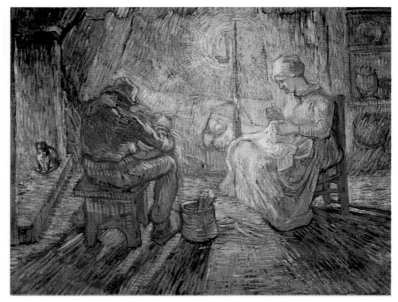

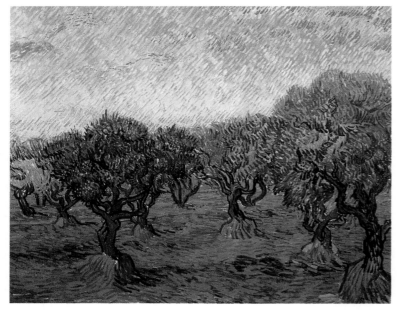

170. Vincent van Gogh, *Olive grove with orange sky,* November 1889, oil on canvas, 74 × 93 cm. (29⅛ × 36⅝"). H1854. Göteborgs Konstmuseum.

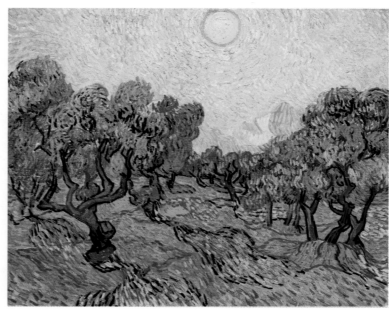

171. Vincent van Gogh, *Olive trees with yellow sky and sun,* November 1889, oil on canvas, 74 × 93 cm. (29⅛ × 36⅝"). H1856. The Minneapolis Institute of Arts, The William Hood Dunwoody Fund.

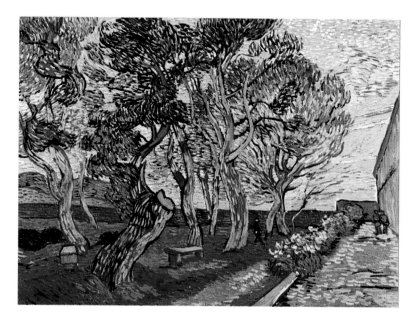

172. Vincent van Gogh, *The Garden of Saint-Paul Hospital in autumn*, December 1889, oil on canvas, 71.5 × 90.5 cm. (28⅜ × 35⅞"). H1850. Van Gogh Museum (Vincent van Gogh Foundation), Amsterdam.

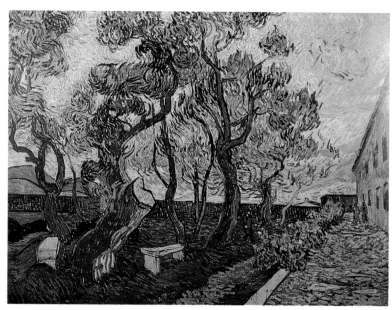

173. Vincent van Gogh, *The Garden of Saint-Paul Hospital*, December 1889, oil on canvas, 73.5 × 92 cm. (29⅛ × 36¼"). H1849. Museum Folkwang, Essen, Germany.

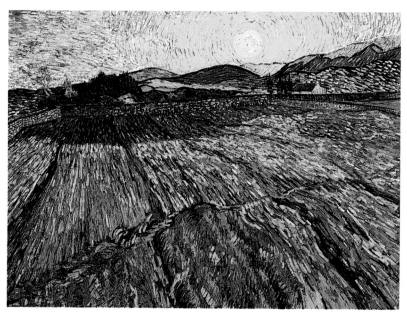

174. Vincent van Gogh, *Enclosed wheat field with rising sun*, December 1889, oil on canvas, 71 × 90.5 cm. (28 × 35⅞"). H1862. Private Collection.

175. Vincent van Gogh, *First steps (after Millet)*, January 1890, oil on canvas, 73 × 92 cm. (28¾ × 36¼″). H1883. The Metropolitan Museum of Art, New York, Gift of George N. and Helen M. Richard, 1964, 64.165.2

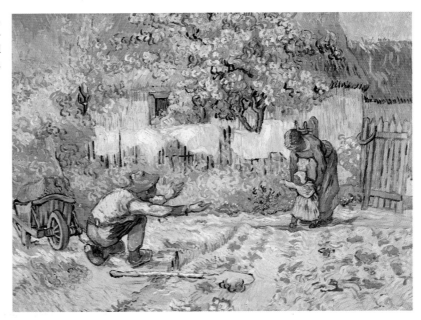

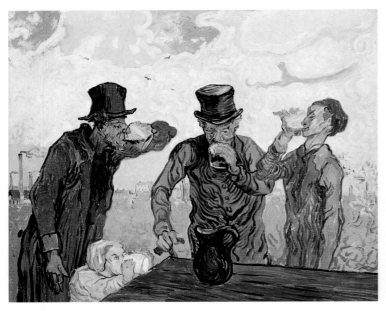

176. Vincent van Gogh, *The Drinkers (after Daumier)*, February 1890, oil on canvas, 59.4 × 73.4 cm. (23⅜ × 28⅝″). H1884. The Art Institute of Chicago, Joseph Winterbotham Collection, 1953.178.

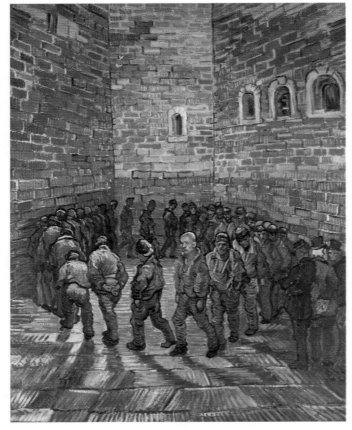

177. Vincent van Gogh, *Prisoners' round (after Doré)*, February 1890, oil on canvas, 80 × 64 cm. (31½ × 25¼″). H1885. Pushkin State Museum of Fine Arts, Moscow.

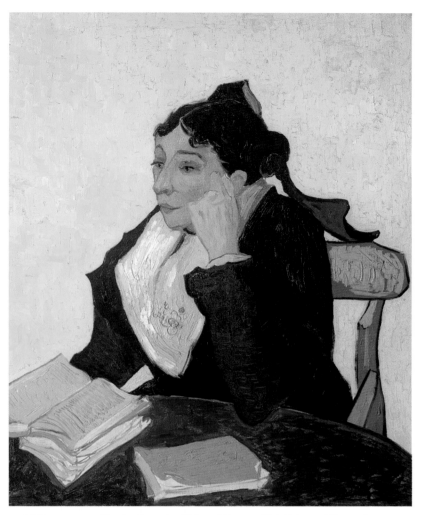

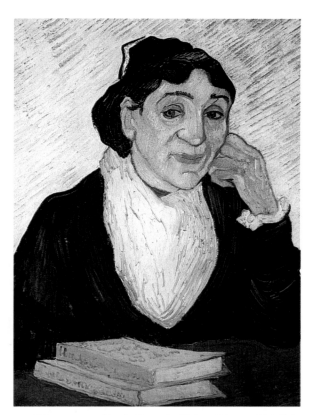

179. Vincent van Gogh, *Portrait of Mme Ginoux: L'Arlésienne*, February 1890, oil on canvas, 65 × 49 cm. (25⅝ × 19¼″). H1893. Kröller-Müller Museum, Otterlo, Netherlands.

178. Vincent van Gogh, *Portrait of Mme Ginoux: L'Arlésienne*, November 1888, oil on canvas, 90 × 72 cm. (35⅜ × 28⅜″). H1624. The Metropolitan Museum of Art, New York, Bequest of Sam A. Lewisohn, 1951, 51.112.3.

180. Paul Gauguin, *L'Arlésienne, Mme Ginoux*, November 1888, colored chalks and charcoal with white chalk on woven paper. Fine Arts Museums of San Francisco, Achenbach Foundation for Graphic Arts, Memorial gift from Dr. Edward and Tullah Hanley, Bradford, Pennsylvania, 69.30.78.

181. Vincent van Gogh, *Portrait of Mme Ginoux: L'Arlésienne*, February 1890, oil on canvas, 65 × 54 cm. (25⅝ × 21¼″). H1894. Museu de Arte de São Paolo Assis Chateaubriand, Brazil.

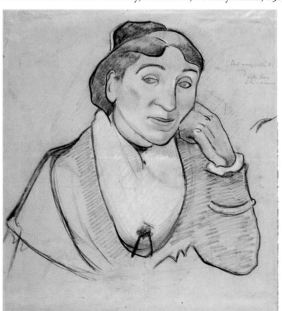

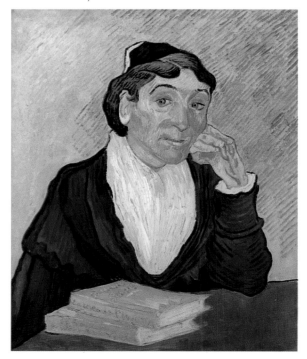

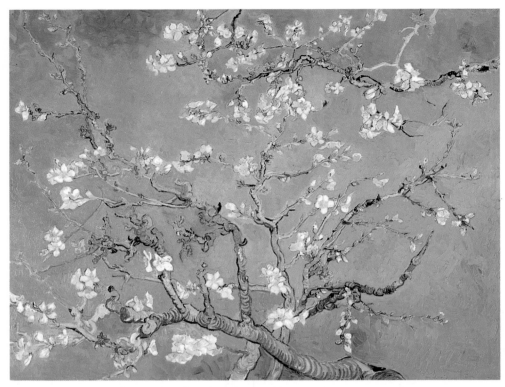

182. Vincent van Gogh, *Branches of an almond tree in blossom*, February 1890, oil on canvas, 73 × 92 cm. (28¾ × 36¼″). H1891. Van Gogh Museum (Vincent van Gogh Foundation), Amsterdam.

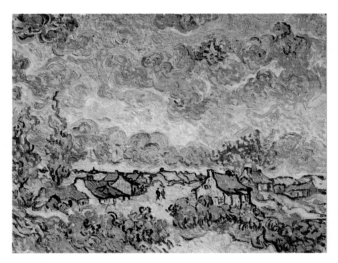

183. Vincent van Gogh, *"Reminiscence of the North"*, March–April 1890, oil on canvas on panel, 29 × 36.5 cm. (11⅜ × 14⅝″). H1921. Van Gogh Museum (Vincent van Gogh Foundation), Amsterdam.

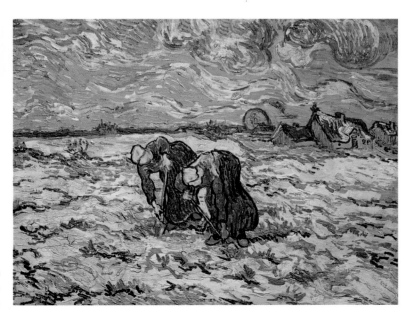

184. Vincent van Gogh, *Peasant women digging in snowy field*, March–April 1890, oil on canvas, 50 × 64 cm. (19⅝ × 25¼″). H1923. The Foundation E. G. Bührle Collection, Zurich.

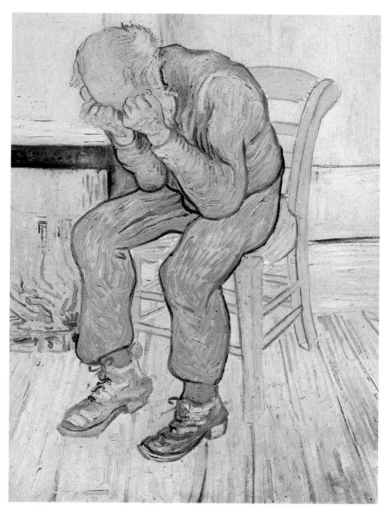

185. Vincent van Gogh, *Old man in sorrow (On the Threshold of Eternity)*, April–May 1890, oil on canvas, 81 × 65 cm. (31⅞ × 25⅝″). H1967. Kröller-Müller Museum, Otterlo, Netherlands.

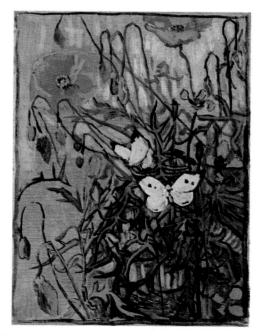

186. Vincent van Gogh, *Butterflies and poppies*, April–May 1890, oil on canvas, 33.5 × 24.5 cm. (13⅜ × 9⅞″). H2013. Van Gogh Museum (Vincent van Gogh Foundation), Amsterdam.

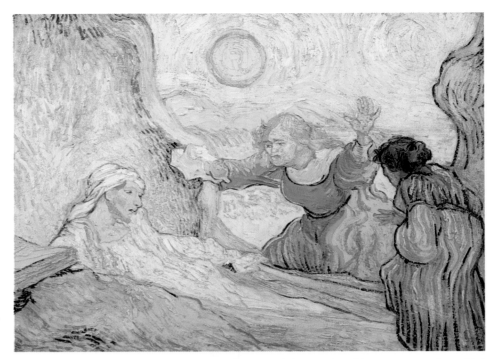

187. Vincent van Gogh, *The Resurrection of Lazarus (after Rembrandt)*, May 1890, oil on thick paper lined with canvas, 48.5 × 63 cm. (19¼ × 24¾″). H1972. Van Gogh Museum (Vincent van Gogh Foundation), Amsterdam.

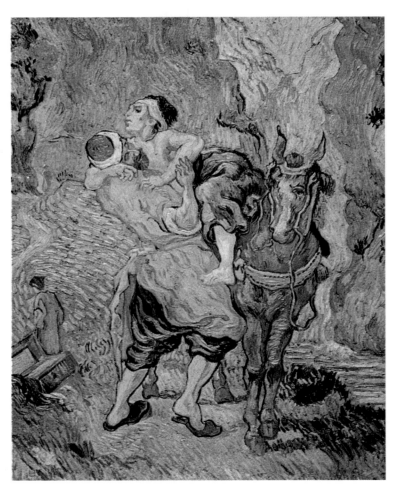

188. Vincent van Gogh, *The Good Samaritan (after Delacroix)*, May 1890, oil on canvas, 73 × 60 cm. (28¾ × 23⅝″). H1974. Kröller-Müller Museum, Otterlo, Netherlands.

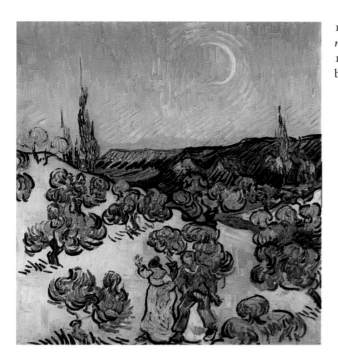

189. Vincent van Gogh, *Landscape with couple and crescent moon,* May 1890, oil on canvas, 49.5 × 45.5 cm. (19⅝ × 18⅛″). H1981. Museu de Arte de São Paolo Assis Chateaubriand, Brazil.

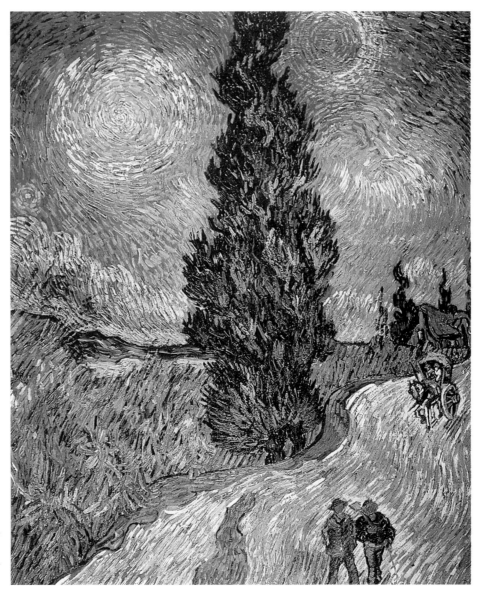

190. Vincent van Gogh, *Road with cypress and star,* May 1890, oil on canvas, 92 × 73 cm. (36¼ × 28¾″). H1982. Kröller-Müller Museum, Otterlo, Netherlands.

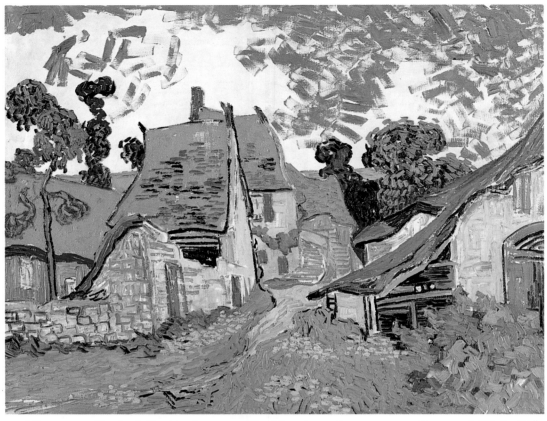

191. Vincent van Gogh, *A Street in Auvers-sur-Oise*, May 1890, oil on canvas, 73 × 92 cm. (28¾ × 36¼″). H2001. Museum of Finnish Art Ateneum/The Antell Collection, Helsinki.

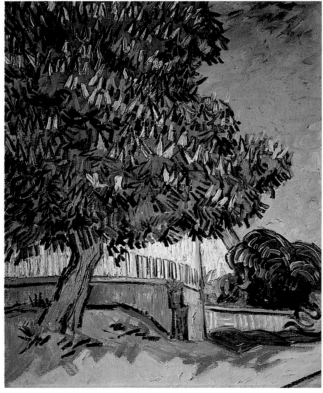

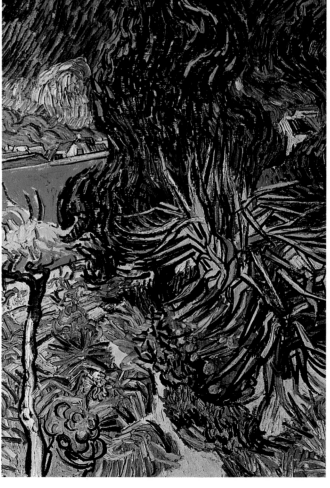

192. Vincent van Gogh, *Chestnut tree in blossom*, May 1890, oil on canvas, 63 × 50.5 cm. (24¾ × 20⅛″). H1991. Kröller–Müller Museum, Otterlo, Netherlands.

193. Vincent van Gogh, *Dr. Gachet's garden*, May 1890, oil on canvas, 73 × 51.5cm. (28¾ × 20½″). H1999. Musée d'Orsay, Paris.

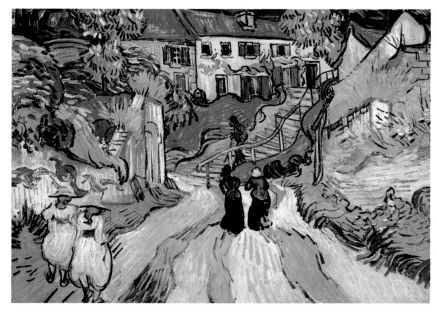

194. Vincent van Gogh, *Village street with steps*, May 1890, oil on canvas, 51 × 71 cm. (20⅛ × 28″). H2111. The Saint Louis Art Museum, Purchase.

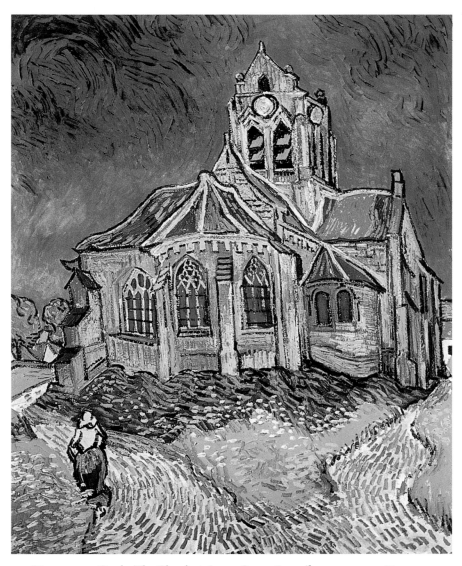

195. Vincent van Gogh, *The Church at Auvers*, June 1890, oil on canvas, 94 × 74 cm. (37 × 29⅛″). H2006. Musée d'Orsay, Paris.

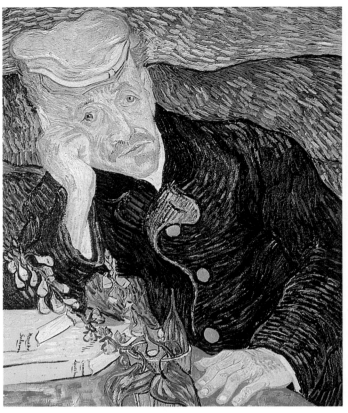

196. Vincent van Gogh, *Portrait of Dr. Gachet*, June 1890, oil on canvas, 66 × 57 cm. (26 × 22½″). H2007. Private Collection, Japan.

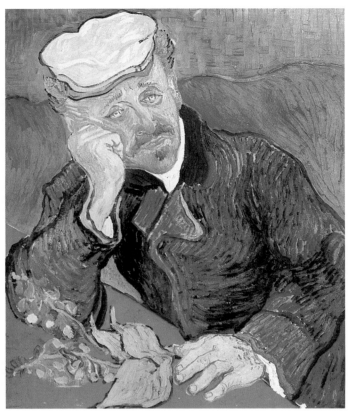

198. Vincent van Gogh, *Portrait of Dr. Gachet*, June 1890, oil on canvas, 68 × 57cm. (26¾ × 22½″). H2014. Musée d'Orsay, Paris.

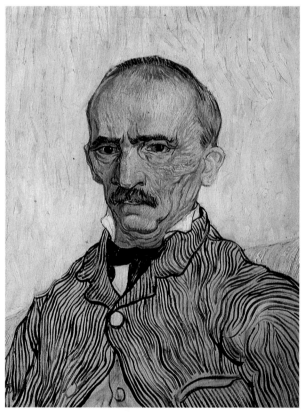

197. Vincent van Gogh, *Portrait of Trabuc, attendant at Saint-Paul's hospital*, September 1889, oil on canvas, 61 × 46 cm. (24× 18⅛″). H1774. Kunstmuseum Solothurn, Dübi–Müller Foundation, Solothurn, Switzerland.

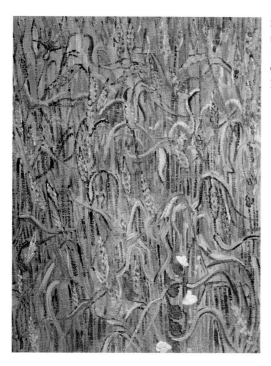

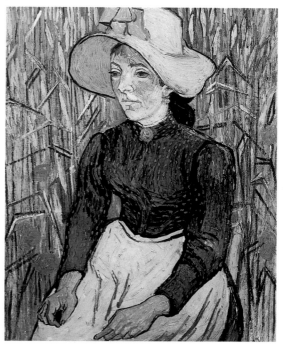

LEFT 199. Vincent van Gogh, *Ears of wheat,* June 1890, oil on canvas, 64.5 × 47 cm. (25⅝ × 18½″). H2034. Van Gogh Museum (Vincent van Gogh Foundation), Amsterdam.

RIGHT 202. Vincent van Gogh, *Peasant girl in the wheat,* June 1890, oil on canvas, 92 × 73 cm. (36¼ × 28¾″). H2053. Location unknown.

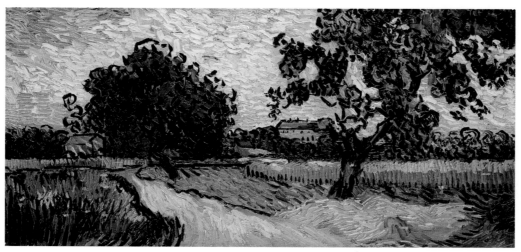

200. Vincent van Gogh, *Landscape with the Chateau of Auvers at sunset,* June 1890, oil on canvas, 50 × 100 cm. (19⅝ × 39⅜″). H2040. Van Gogh Museum (Vincent van Gogh Foundation), Amsterdam.

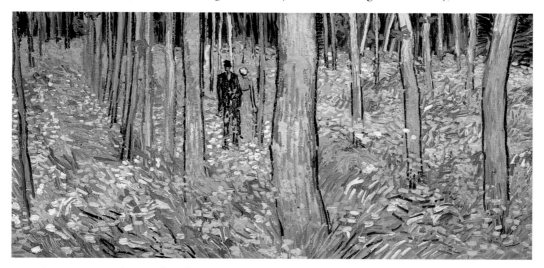

201. Vincent van Gogh, *Couple walking in the trees,* June 1890, oil on canvas, 50 × 100 cm. (19⅝ × 39⅜″). H2041. Cincinnati Art Museum, Bequest of Mary E. Johnston, 1967.1430.

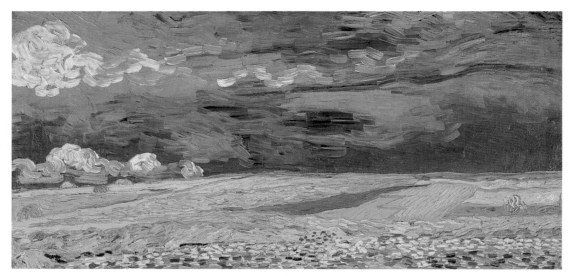

203. Vincent van Gogh, *Wheat field under stormy sky*, July 1890, oil on canvas, 50 × 100 cm. (19⅝ × 39⅜″).
H2097. Van Gogh Museum (Vincent van Gogh Foundation), Amsterdam.

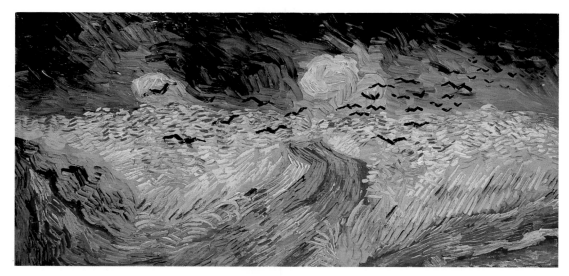

204. Vincent van Gogh, *Crows over the wheat field*, July 1890, oil on canvas, 50.5 × 100.5 (20⅛ × 39¾″).
H2117. Van Gogh Museum (Vincent van Gogh Foundation), Amsterdam.

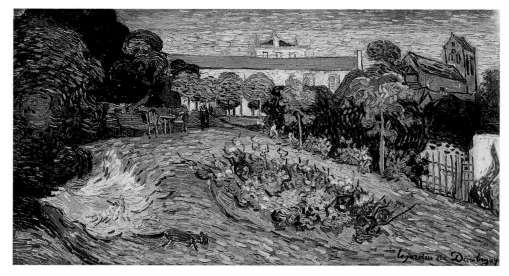

205. Vincent van Gogh, *Daubigny's garden*, July 1890, oil on canvas, 56 × 101.5 cm. (22 × 40⅛″).
H2105. Museum für Gegenwartskunst, Basel, Switzerland.

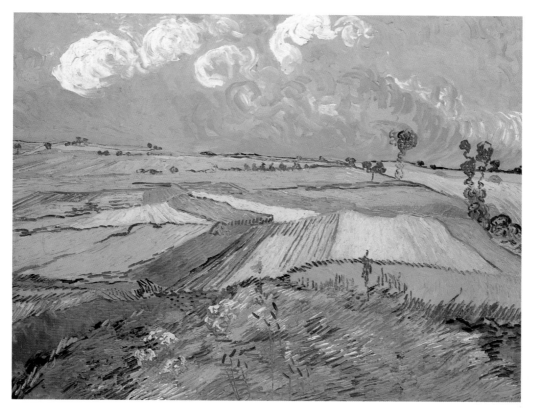

206. Vincent van Gogh, *Wheat fields (Plain of Auvers),* July 1890, oil on canvas, 73 × 92 cm. (28¾ × 36¼″). H2102. Carnegie Museum of Art, Pittsburgh. Acquired through the generosity of the Sarah Mellon Scaife family, 68.18.

207. Dr. Paul Ferdinand Gachet, *Vincent van Gogh on his deathbed,* 29 July 1890, charcoal, Musée d'Orsay, Paris.

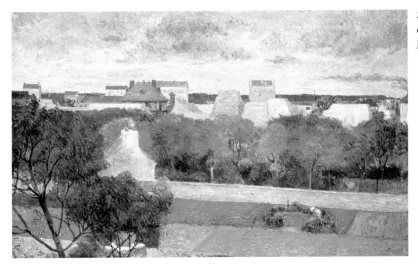

208. Paul Gauguin, *The Market gardens of Vaugirard*, 1879, oil on canvas, 65 × 100 cm. (25⅞ × 39⅜"). w36. Smith College Museum of Art, Northampton, Massachusetts.

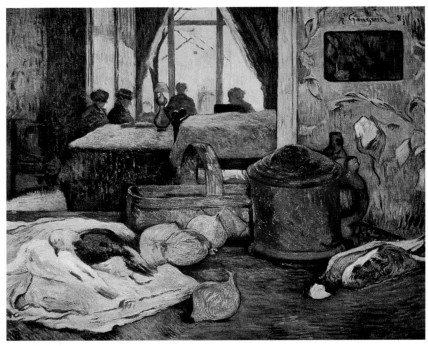

209. Paul Gauguin, *Interior of Gauguin's home in Paris, rue Carcel*, 1881, oil on canvas, 130 × 162 cm. (50¾ × 63⅛"). w50. Nasjonalgalleriet, Oslo.

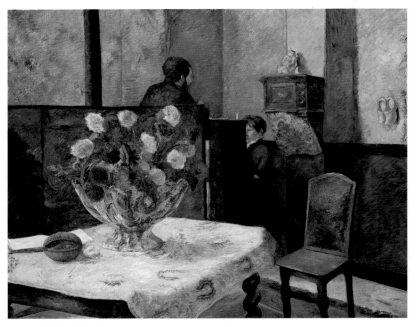

210. Paul Gauguin, *Still-life in an interior*, 1885, oil on canvas, 60 × 74 cm. (23½ × 29"). w176. Private Collection.

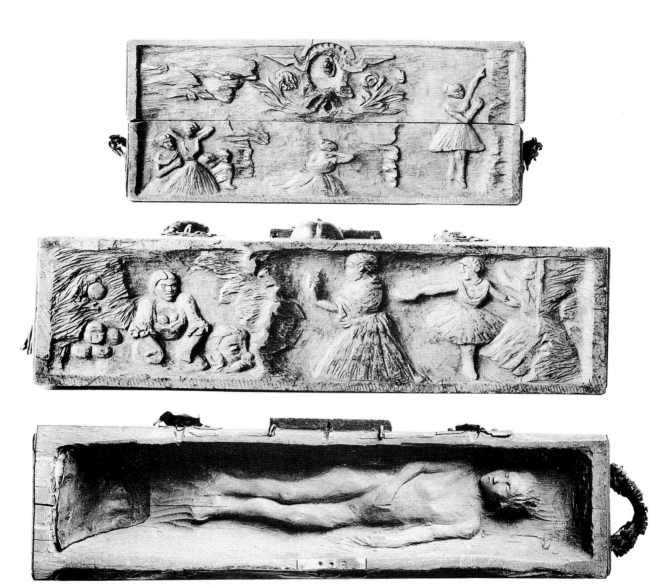

211. Paul Gauguin, *Box with carved reliefs of dancers*, 1884, pear wood, leather and iron, 21 × 13 × 51 cm. (8¼ × 5 × 19⅞″). G8. Private Collection.

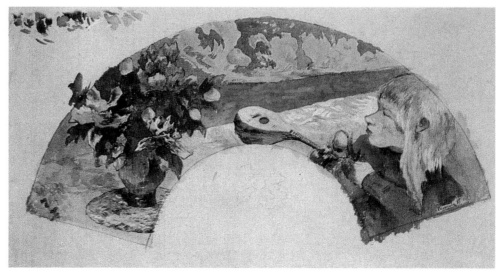

212. Paul Gauguin, *Fan with Clovis, mandolin, and still-life*, 1885, gouache on fabric, 32.5 × 56.3 cm. (12 13/16 × 22 3/16″). W180. Collection Dr. Ivo Pitanguy, Rio.

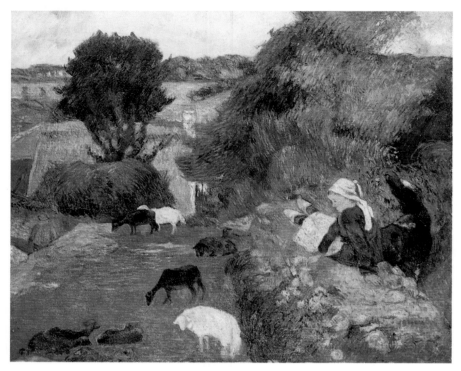

213. Paul Gauguin, *The Breton shepherdess*, 1886, oil on canvas, 60.4 × 73.3 cm. (23¾ × 28⅞"). w203. Tyne and Wear Museums, Newcastle-upon-Tyne, England.

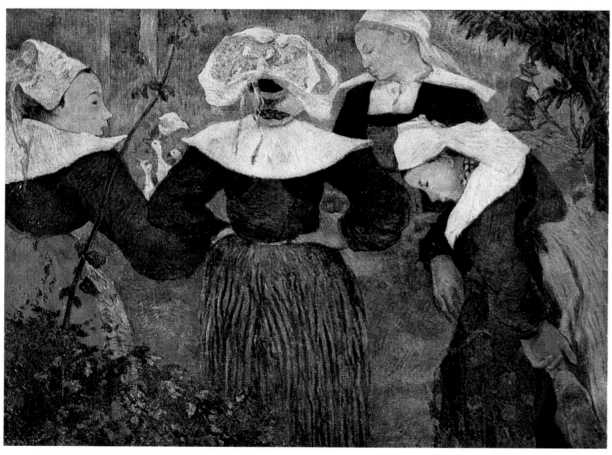

214. Paul Gauguin, *Four Breton women*, 1886, oil on canvas, 72 × 91 cm. (28¾ × 35¾"). w201. Bayerischen Staats-gemäldesammlungen, Munich.

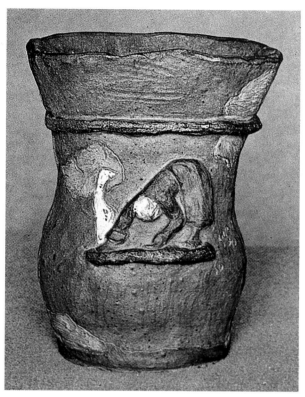

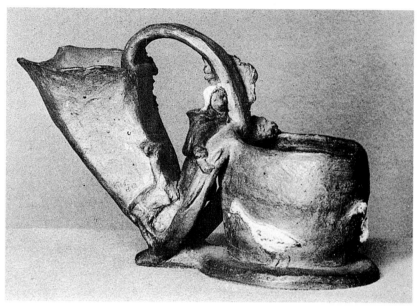

215. Paul Gauguin, *Pot with Breton woman and tree*, 1886, dark brown unglazed stoneware, 13 cms. (8¼"). G38. Musée d'Orsay, Paris.

216. Paul Gauguin, *Pot with Breton woman, sheep and geese*, 1886, brown stoneware, 13.5 cm. (8½"). G28. Musée d'Orsay, Paris.

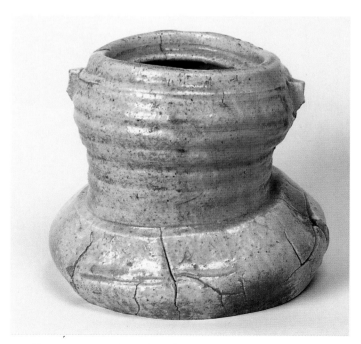

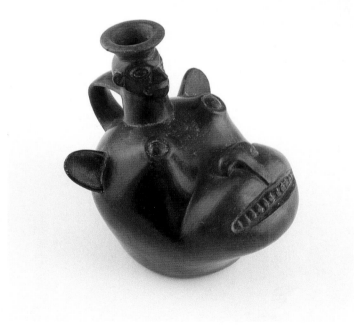

217. Japanese water jar, Mizuashi, Iga ware, Momoyama period, 16th century, ceramic. Collection Mary Griggs Burke, New York. Photography by Sheldan Comfert Collins.

218. Jar with animal-head body, Peru, Chimu culture, 1000–1470, black ceramic. The Minneapolis Institute of Arts.

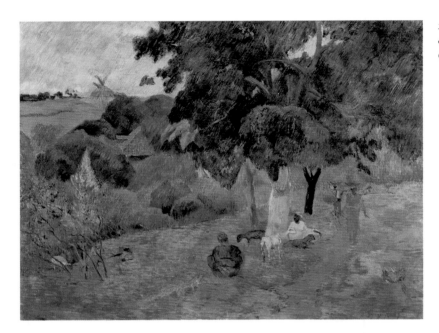

219. Paul Gauguin, *Goings and comings: Martinique*, 1887, oil on canvas, 77 × 92 cm. (30¾ × 36¼″). No 'w' number. Carmen Thyssen-Bornemisza Collection.

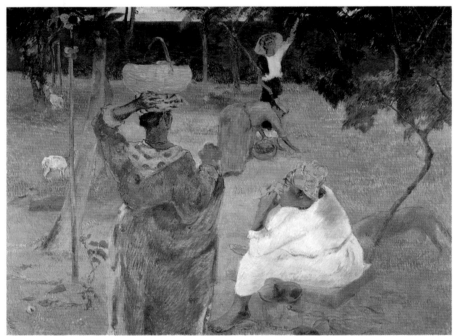

220. Paul Gauguin, *In the mangoes*, 1887, oil on canvas, 89 × 116 cm. (35 × 41¾″). w224. Van Gogh Museum (Vincent van Gogh Foundation), Amsterdam.

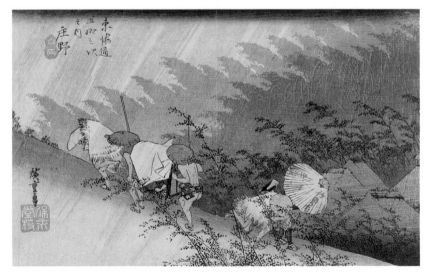

221. Utagawa Hiroshige, *Shono in driving rain*, no. 46 in *53 Stations of the Tokaido Road*, 1833–34, woodcut, Minneapolis Institute of Arts.

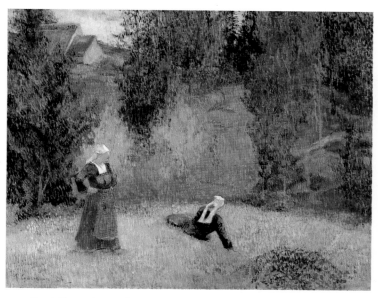

222. Paul Gauguin, *Early sowers in Brittany*, 1888, oil on canvas, 70 × 92 cm. (27½ × 36¼"). w249. Private Collection.

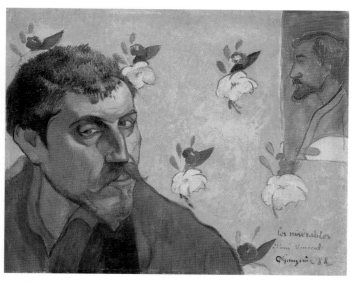

226. Paul Gauguin, *Self-portrait called "Les Misérables"*, summer 1888, oil on anvas, 45 × 55 cm. (17¾ × 21⅝"). w239. Van Gogh Museum (Vincent van Gogh Foundation), Amsterdam.

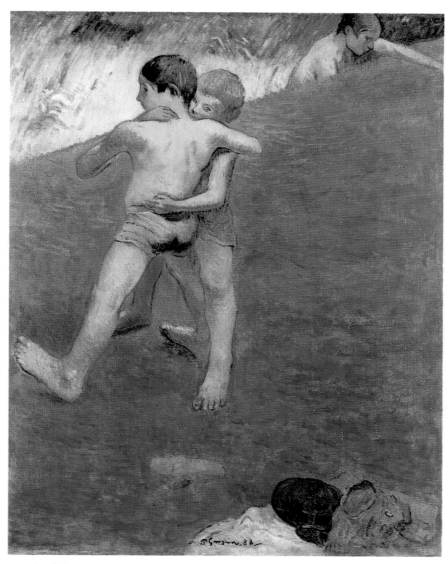

223. Paul Gauguin, *Young Bretons wrestling*, July 1888, oil on canvas, 93 × 73 cm. (36⅝ × 28¾"). w273. Josefowitz Collection.

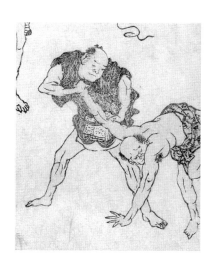

224. Hokusai, *Wrestlers*, Mangwa album no. 6, 1817, woodcut, The British Museum, London.

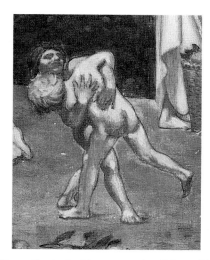

225. Pierre Puvis de Chavannes, detail from *Pleasant land*, 1882, Yale University Art Gallery, New Haven, Connecticut, The Mary Gertrude Abbey Fund.

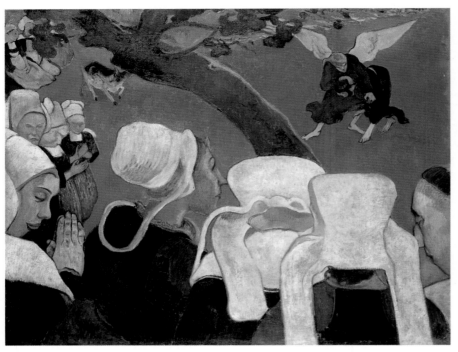

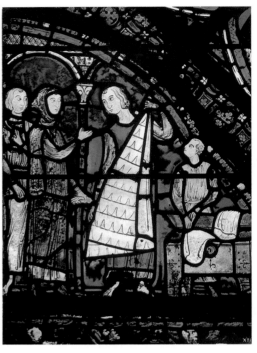

227. Paul Gauguin, *The Vision after the sermon (Jacob wrestling the angel)*, summer 1888, oil on canvas, 73 × 92 cm. (28¾ × 36¼″). W245. National Gallery of Scotland, Edinburgh.

228. *History of St. James the Greater*, Notre Dame de Chartres, stained glass lancet window, north side of apse ambulatory, 13th century, France.

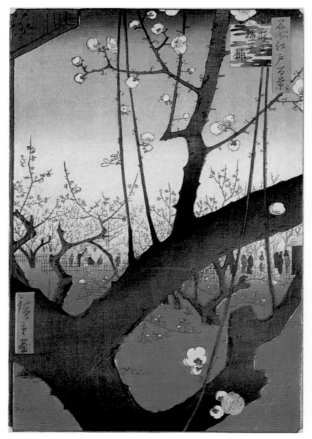

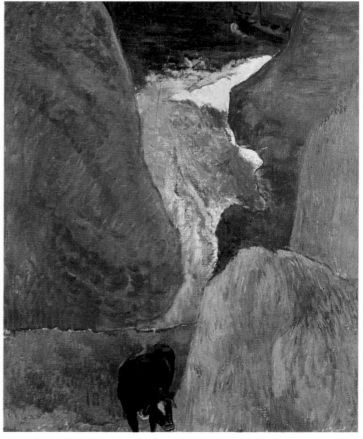

229. Utagawa Hiroshige, *Plum tree teahouse at Kameido*, 1857, woodcut. Van Gogh Museum (Vincent van Gogh Foundation), Amsterdam.

230. Paul Gauguin, *Above the whirlpool*, 1888, oil on canvas, 73 × 60 cm. (28¾ × 23⅝″). W282. Musée des Arts Decoratifs, Paris.

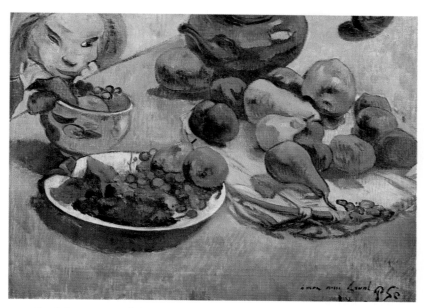

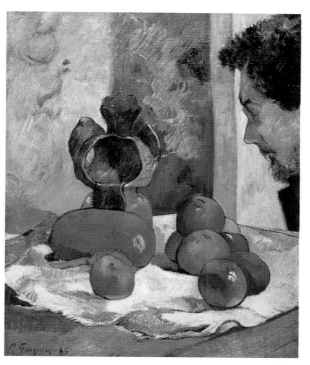

231. Paul Gauguin, *Still-life with fruit*, summer 1888, oil on canvas, 43 × 58 cm. (17 × 22¾"). w288. Pushkin State Museum of Fine Arts, Moscow.

232. Paul Gauguin, *Portrait of Charles Laval*, 1886, oil on canvas, 46 × 38 cm. (18⅛ × 15"). w207. Josefowitz Collection.

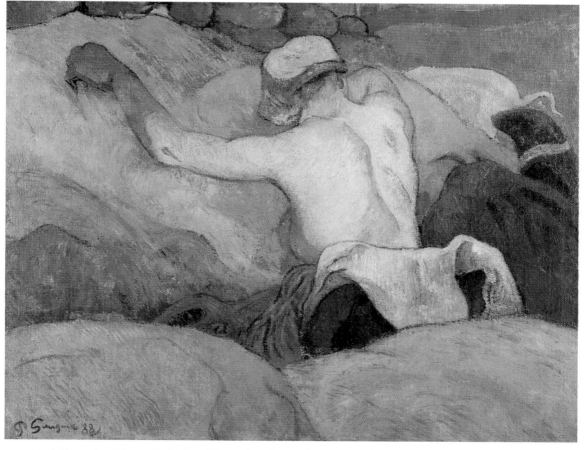

233. Paul Gauguin, *Woman in the hay*, November–December 1888, oil on canvas, 73 × 92 cm. (28¾ × 36¼"). w301. Private Collection.

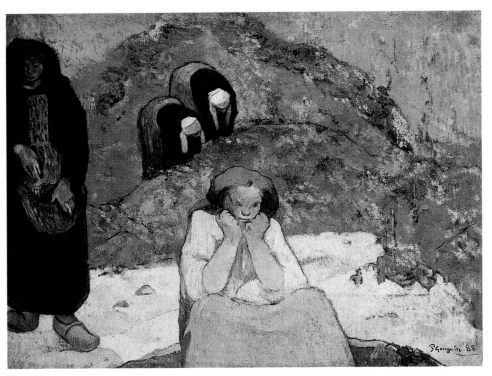

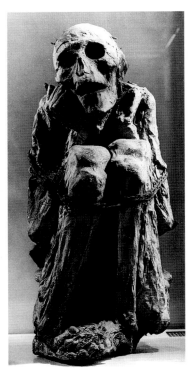

234. Paul Gauguin, *Vintage at Arles: "Human misery"*, November 1888, oil on canvas, 73 × 92 cm. (28¾ × 36¼″). w304. The Ordrupgaard Museum, Copenhagen.

236. Peruvian mummy, 12th–15th century, Musée de l'Homme.

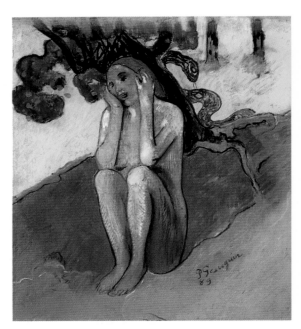

235. Paul Gauguin, *Breton Eve*, spring 1889, watercolor and pastel on paper, 33 × 31 cm. (13⅛ × 12¼″). The Marion Koogler McNay Art Museum, San Antonio, Texas, Bequest of Marion Koogler McNay, 1950.45.

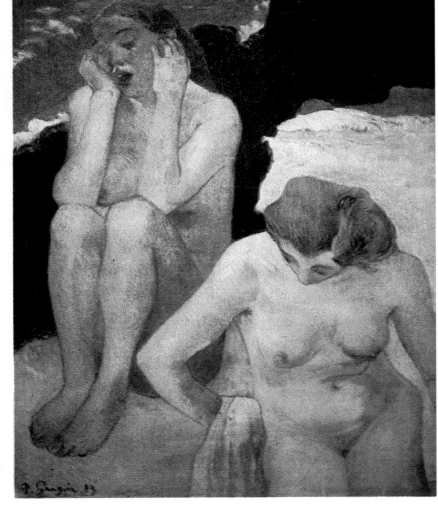

237. Paul Gauguin, *Life and death*, spring 1889, oil on canvas, 92 × 73 cm. (36¼ × 28¾″). w335. Mahmoud Khalil Museum, Cairo. Photo Courtesy National Gallery of Art, Washington, D.C.

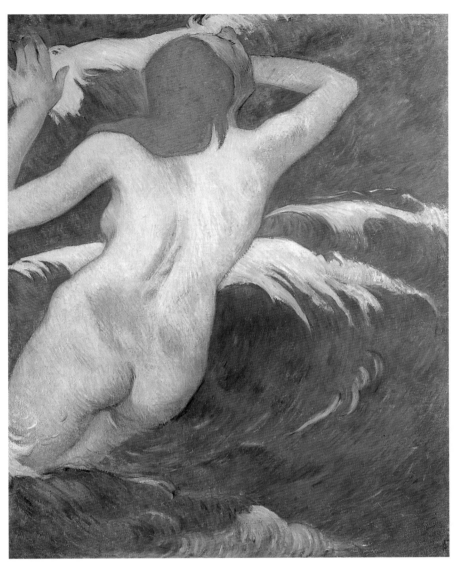

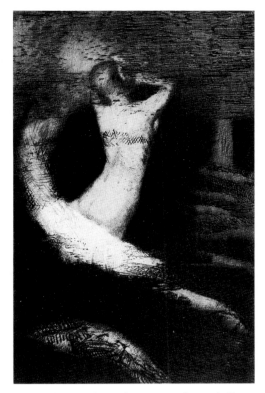

239. Odilon Redon, *The Passage of a Soul*, (frontispiece of Adrien Remacle's novel *La Passante*), 1891, etching, M. 21. The Art Institute of Chicago, Charles Stickney Collection, 1920.1543.

238. Paul Gauguin, *Woman in the waves*, spring 1889, oil on canvas, 92 × 72 cm. (36¼ × 28⅜″). w336. The Cleveland Museum of Art, Gift of Mr. and Mrs. William Powell Jones.

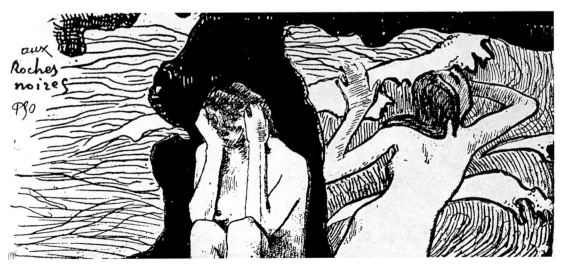

240. Paul Gauguin, *At the Black Rocks*, (frontispiece of the Volpini exhibition catalogue), spring 1889, woodcut. The National Gallery of Art, Washington, D.C., 1952.8.233.

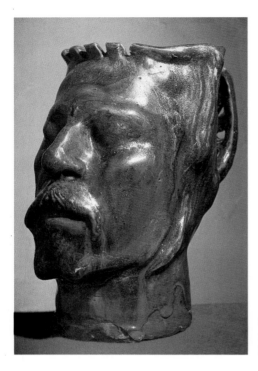

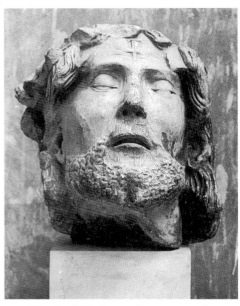

241. Paul Gauguin, *Self-portrait jug*, January (?) 1889, glazed stoneware, 24 cm. (9½″). G65. Museum of Decorative Arts, Copenhagen.

242. Head of Christ, 15th century, plaster cast from Beauvais Cathedral, France. Musée des Monuments Français, Paris.

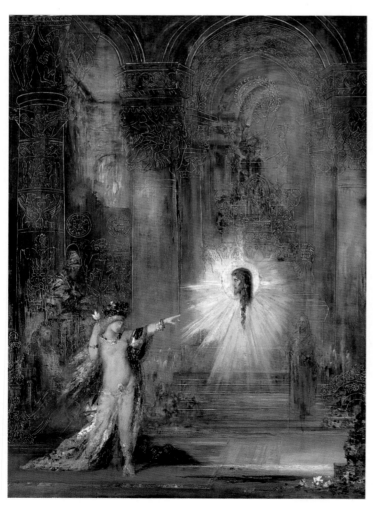

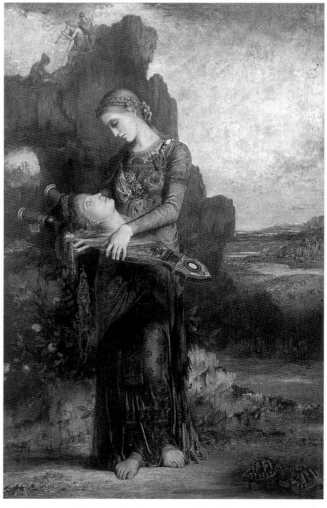

243. Gustave Moreau, *The Apparition*, ca. 1876, oil on canavas. Musée Gustave Moreau, Paris.

244. Gustave Moreau, *Orpheus*, ca. 1865, oil on canvas. Musée d'Orsay, Paris.

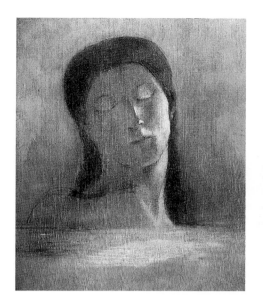

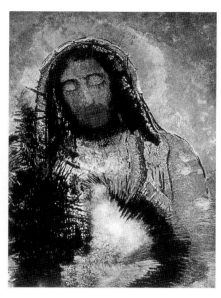

LEFT 245. Odilon Redon, *Closed Eyes*, 1890, pastel on cardboard. Musée d'Orsay, Paris.

RIGHT 246. Odilon Redon, *Sacred Heart*, 1895, pastel on cardboard. Kröller-Müller Museum, Otterlo, Netherlands.

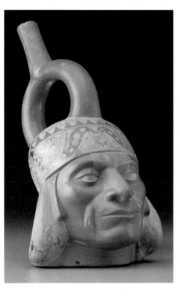

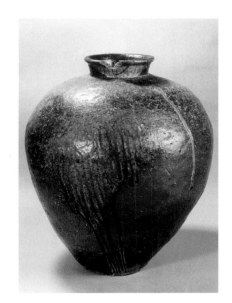

LEFT 247. South America, Moche Culture, Stirrup-head vessel, 100 BC–500 AD, ceramic. The Art Institute of Chicago, Buckingham Fund, 1955.2341.

RIGHT 248. Japanese water jar, Shigaraki, 15th century, ceramic, Private Collection.

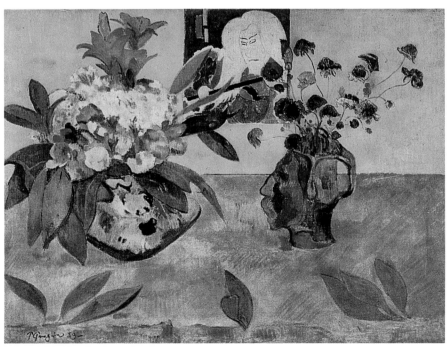

249. Paul Gauguin, *Still-life with self-portrait jug and Japanese print*, winter–spring 1889, oil on canvas, 73 × 92 cm. (28¾ × 36¼″). W375. Private Collection.

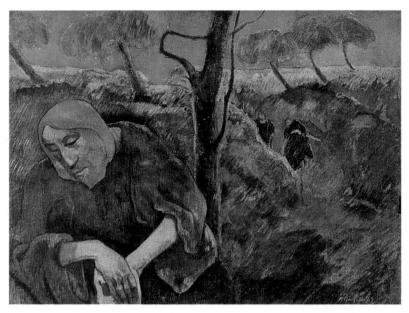

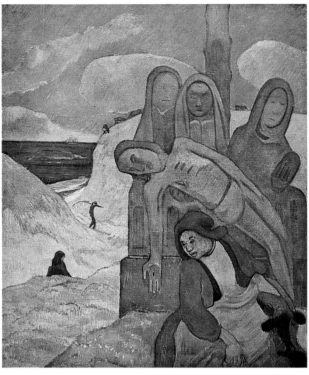

250. Paul Gauguin, *Christ in the Garden of Olives*, or *The Agony in the Garden*, autumn 1889, oil on canvas, 73 × 92 cm. (28¾ × 36¼″). w326. Norton Museum of Art, West Palm Beach, Florida.

251. Paul Gauguin, *Breton Calvary: The Green Christ*, autumn 1889, oil on canvas, 92 × 73 cm. (36¼ × 28¾″). w328. Musées royaux des Beaux-Arts de Belgique, Brussels.

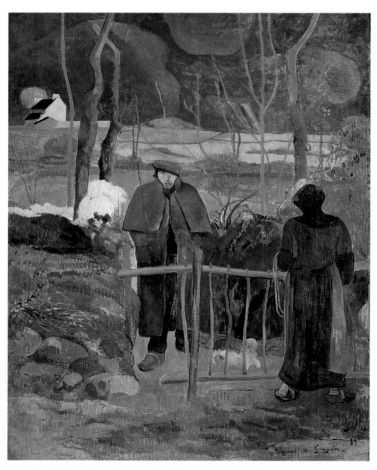

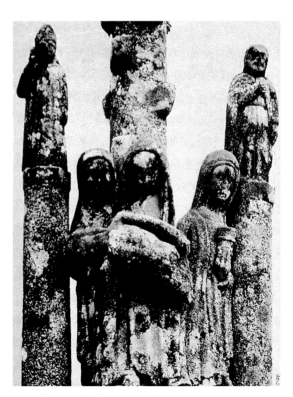

253. Paul Gauguin, *Bonjour M Gauguin*, 1889, oil on canvas, 113 × 92 cm. (44 × 36¼″). w322. Nàrodni Gallery, Prague.

252. Breton Calvary at Nizon near Pont-Aven, France, sandstone.

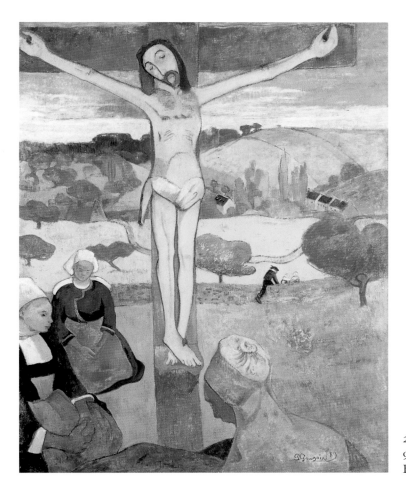

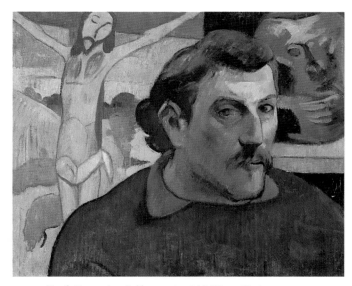

255. Paul Gauguin, *Self-portrait with Yellow Christ*, autumn 1889, oil on canvas, 38 × 46 cm. (14⅞ × 18″). w324. Musée d'Orsay, Paris.

254. Paul Gauguin, *The Yellow Christ*, September 1889, oil on canvas, 92 × 73 cm. (36¼ × 28¾″). w327. Albright-Knox Art Gallery, Buffalo, New York, General Purchase Funds, 1946.

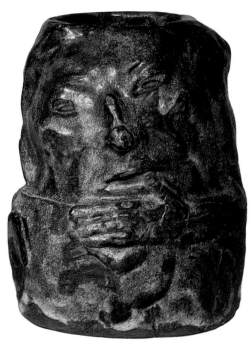

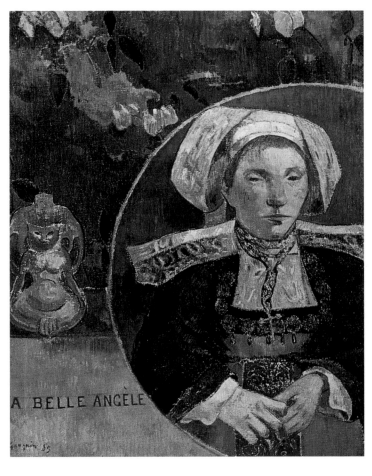

256. Paul Gauguin, *Self-portrait tobacco jar*, 1889, glazed stoneware, 28 cm. (11″). G66. Musée d'Orsay, Paris.

257. Paul Gauguin, *La Belle Angèle (Portrait of Mme Satre)*, August 1889, oil on canvas, 92 × 73 cm. (36¼ × 28¾″). w315. Musée d'Orsay, Paris.

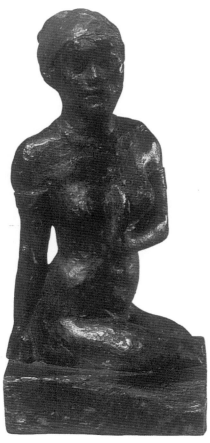

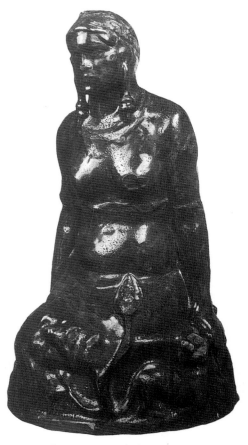

LEFT 258. Paul Gauguin, *Martiniquan woman*, summer–autumn 1889, painted wax, 20 cm. (7⅞″). G61. The Henry and Rose Pearlman Foundation, New York.

259. Paul Gauguin, *Black woman*, summer–autumn 1889, glazed stoneware, 50 cm. (19⅝″). G91. Location unknown.

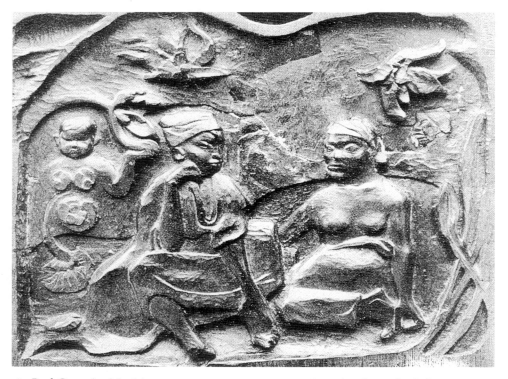

260. Paul Gauguin, *Martiniquan women*, summer–autumn 1889, painted wood relief, 78 × 95 cm. (30⅝ × 37¼″). G73. Location unknown.

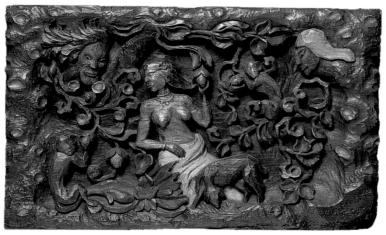

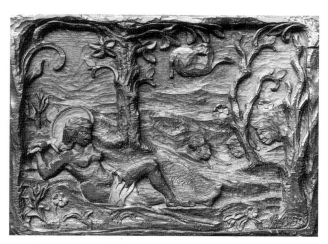

261. Paul Gauguin, *Martinique*, summer–autumn 1889, painted oak relief, 35 × 45 cm. (13¾ × 17¾"). G60. Ny Carlsberg Glyptothek, Copenhagen, Denmark.

262. Paul Gauguin, *Reclining woman with a fan*, summer–autumn 1889, painted oak relief, 35 × 45 cm. (13¾ × 18"). G74. Ny Carlsberg Glyptothek, Copenhagen.

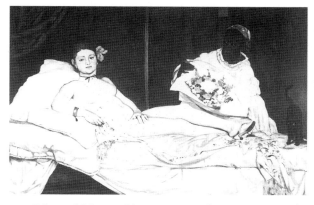

263. Edouard Manet, *Olympia*, 1863, oil on canvas. Musée d'Orsay, Paris.

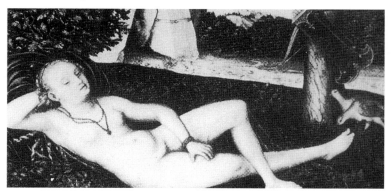

264. Lucas Cranach the Younger, *Diana Reclining* (detail), ca. 1537, oil on canvas. Musée des Beaux-arts et d'Archéologie, Besançon, France.

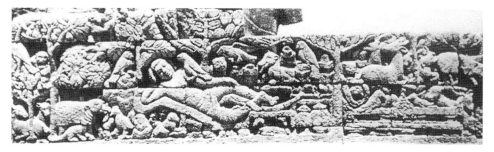

265. *Reclining monk*, scene from the Awadenas and the Jatakas, frieze on Borobodur Temple, 8th century, Java.

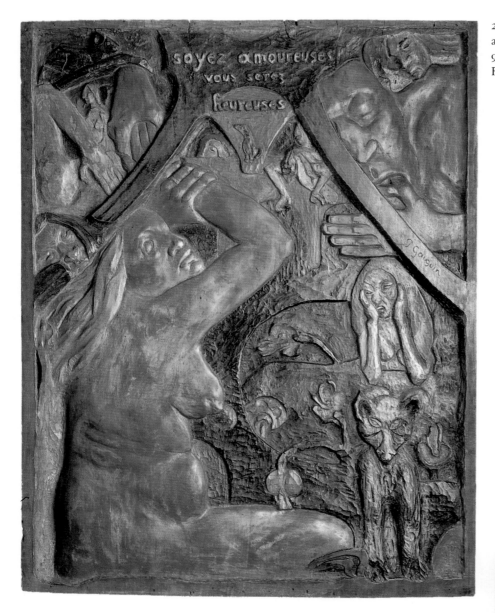

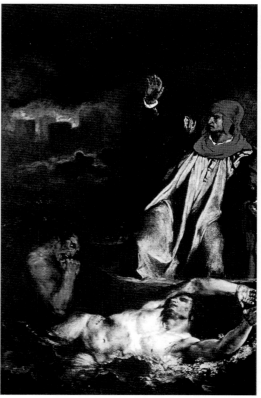

266. Paul Gauguin, *Be loving, you will be happy*, autumn 1889, painted linden wood relief, 119 × 96.5 cm. (47 × 38″). G76. Arthur Tracy Cabot Fund, Courtesy Museum of Fine Arts, Boston.

267. Eugène Delacroix, *The Barque of Dante* (detail), 1822, oil on canvas. Musée du Louvre, Paris.

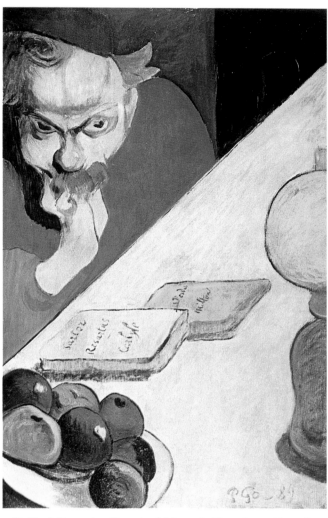

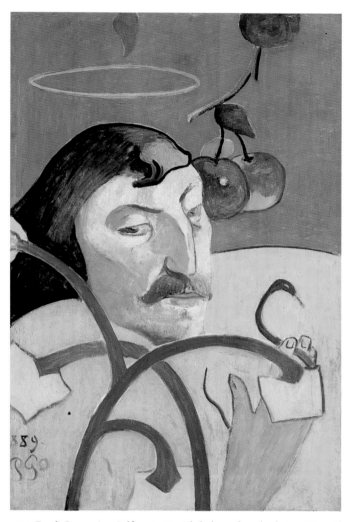

268. Paul Gauguin, *Portrait of Meyer de Haan*, late 1889, oil on wood, 80 × 52 cm. (31⅜ × 20⅜″). w317. Private Collection.

269. Paul Gauguin, *Self-portrait with halo and snake*, late 1889, oil on wood, 79.2 × 51.3 cm. (31½ × 20½″). w323. National Gallery of Art, Washington, D.C., Chester Dale Collection.

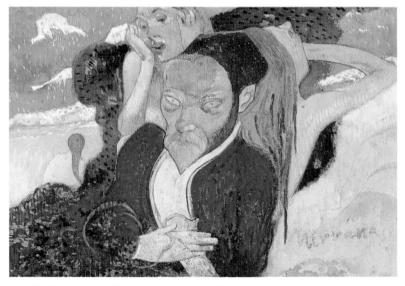

270. Paul Gauguin, *"Nirvana": Portrait of Meyer de Haan*, early 1890, essence on silk, 20 × 29 cm. (7⅞ × 11⅜″). w320. Wadsworth Atheneum, Hartford. Ct., The Ella Gallup Sumner and Mary Catlin Sumner Collection Fund.

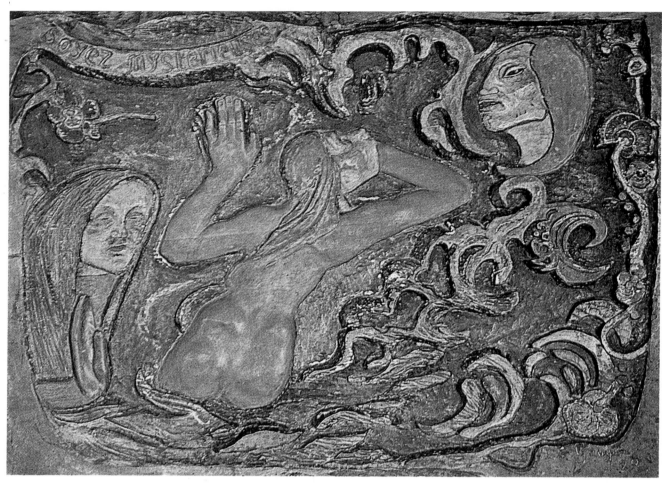

271. Paul Gauguin, *Be mysterious*, late summer 1890, painted lime wood relief, 73 × 95 cm. (29 × 37¼″). G87. Musée d'Orsay, Paris.

272. Japanese woodcut (*Le Japon Artistique*, April 1889).

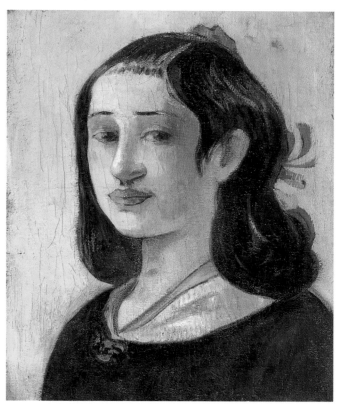

273. Paul Gauguin, *Portrait of Aline Gauguin*, 1890, oil on canvas, 41 × 33 cm. (16⅛ × 13″). w385. Staatsgalerie Stuttgart, Germany.

274. Photograph of Aline Gauguin. Private Collection. Photo courtesy Musée d'Orsay Service de Documentation.

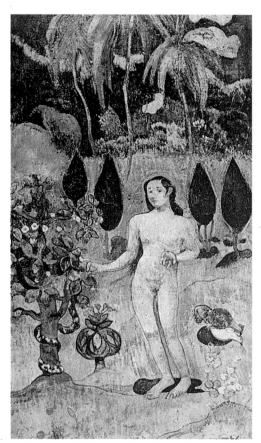

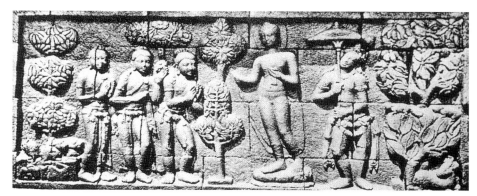

276. *The Tathagata meets an Ajivaka monk on the Benares road*, frieze on Borobodur Temple, 8th century, Java. Photo Courtesy of the Institut Kern, Leiden.

275. Paul Gauguin, *Exotic Eve*, 1890, gouache on millboard transferred to fabric, 43 × 25 cm. (16⅞ × 9⅞″). w389. Private Collection.

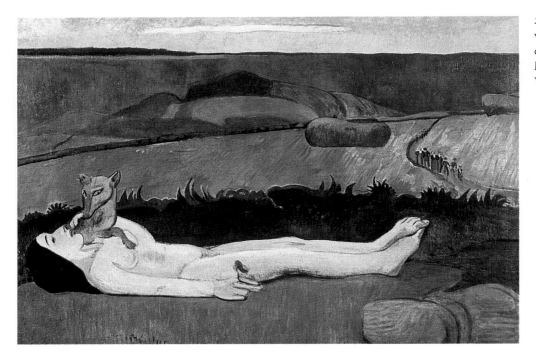

277. Paul Gauguin, *The Loss of virginity*, winter 1890–1891, oil on canvas, 90 × 130 cm. (35½ × 51¼"). w412. The Chrysler Museum, Norfolk, Virginia, Gift of Walter P. Chrysler, Jr., 75.510.

278. Émile Bernard, *Madeleine in the woods*, 1888, oil on canvas. Musée d'Orsay, Paris.

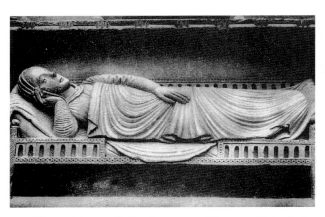

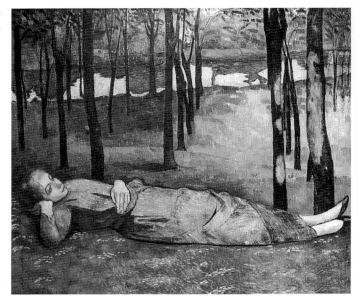

279. Virgin Mary, relief sculpture on Chartres Cathedral, France, 13th century.

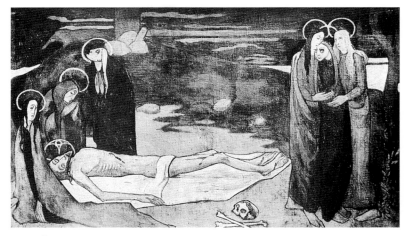

280. Émile Bernard, *The Deposition of Christ*, 1890, oil on canvas. Private Collection.

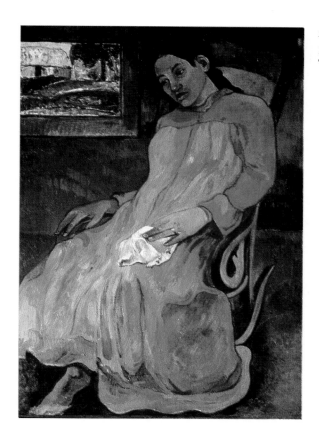

281. Paul Gauguin, *Faaturuma* (*Melancholy*), 1891, oil on canvas, 73 × 92 cm. (28¾ × 36¼″). w424. Nelson–Atkins Museum of Art, Kansas City, Missouri (Purchase: Nelson Trust).

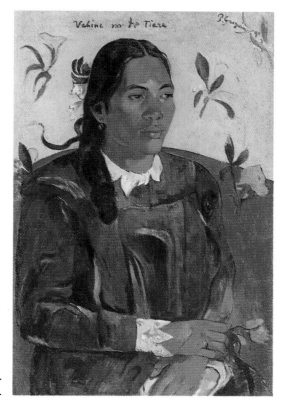

282. Paul Gauguin, *Vahine no te tiare* (*Woman with a flower*), 1891, oil oncanvas, 70 × 46 cm. (27⅝ × 18⅛″). w420. Ny Carlsberg Glyptothek, Copenhagen, Denmark.

283. Paul Gauguin, *Te fare hymenee* (*The House of song*), 1892, oil on canvas, 50 × 90 cm. (19⅝ × 35⅝″). w477. Private Collection.

284. Paul Gauguin, *Upaupa* (*Dance of joy*), 1891, oil on canvas, 73 × 92 cm. (28¾ × 36¼″). w433. The Israel Museum, Jerusalem.

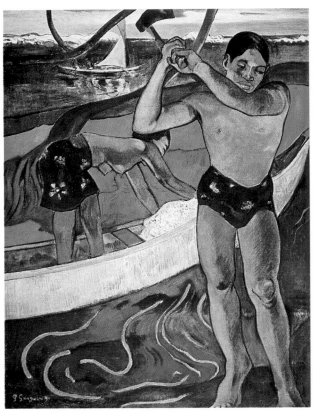

285. Paul Gauguin, *The Man with the axe*, 1891, oil on canvas, 92 × 70 cm. (36¼ × 27⅝"). w430. Galerie Beyeler, Basel, Switzerland.

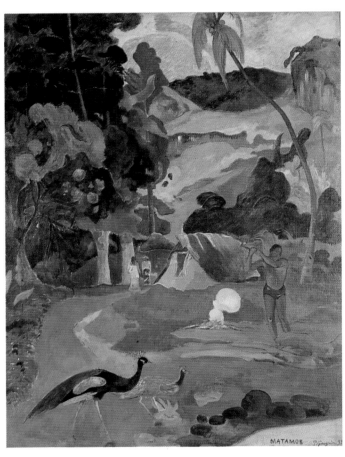

287. Paul Gauguin, *Matamoe (Sleeping)*, early 1892, oil on canvas, 115 × 86 cm. (45¼ × 34"). w484. Pushkin State Museum of Fine Arts, Moscow.

286. Standing figure, west frieze of the Parthenon, Athens, Greece, 447–33 BC.

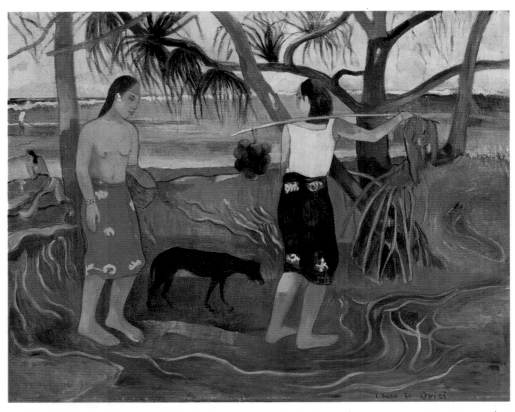

288. Paul Gauguin, *I raro te oviri* (*Under the pandanus palms*), 1891, oil on canvas, 73.6 × 96.2 cm. (29 × 37⅞"). w432. The Minneapolis Institute of Arts, The William Hood Dunwoody Fund.

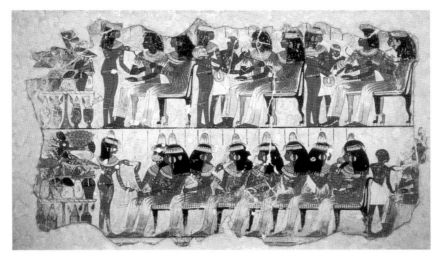

289. *A banquet scene,* fresco from the Tomb of Nebamun, Thebes, Egypt, 18th dynasty, ca. 1400 BC, The British Museum, London.

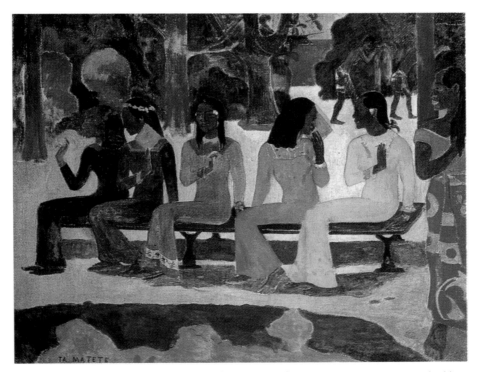

290. Paul Gauguin, *Ta Matete* (*The Market*), 1892, oil on canvas, 73 × 91.5 cm. (28¾ × 36″). W476. Oeffentliche Kunstsammlung, Basel, Kunstmuseum, Gift of Dr. H. C. Robert von Hirsch, 1941.

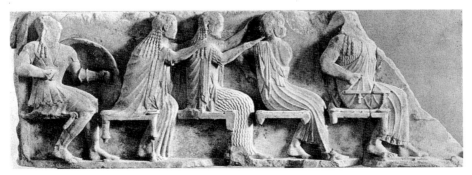

291. Seated deities, frieze from the Treasury of the Siphnians, Delphi, Greece, ca. 6th century BC

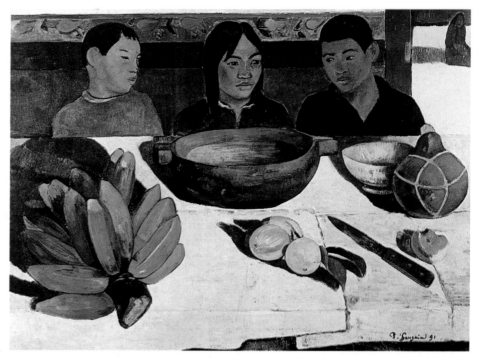

292. Paul Gauguin, *The Meal*, 1891, oil on paper mounted on canvas, 73 × 92 cm. (28¾ × 36¼″). w427. Musée d'Orsay, Paris.

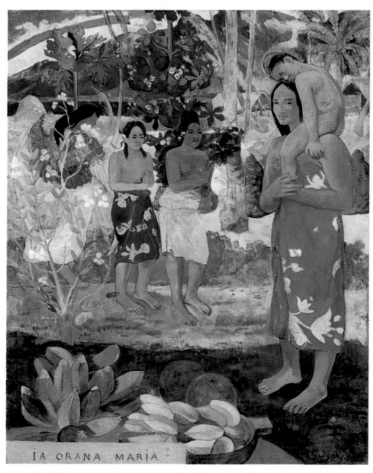

293. Paul Gauguin, *Ia Orana Maria* (*We greet you, Mary*), 1891, 113.7 × 87.7 cm. (44¾ × 34½″). w428. The Metropolitan Museum of Art, New York, Bequest of Sam A. Lewisohn, 1951, 51.112.2.

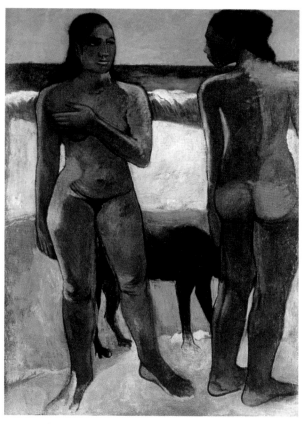

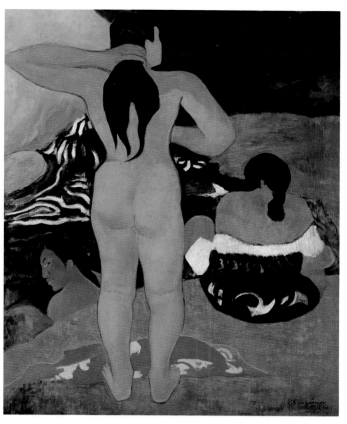

294. Paul Gauguin, *Two Tahitians on the seashore*, 1891 or 92, oil on canvas, 91 × 65 cm. (35¾ × 25½"). w456. Honolulu Academy of Arts, Gift of Mrs. Charles M. Cooke, 1933.

295. Paul Gauguin, *Tahitians on the seashore*, 1891 or 92, 110 × 89 cm. (43½ × 35⅛"). w462. The Metropolitan Museum of Art, New York, Robert Lehman Collection, 1975. 1975.1.179.

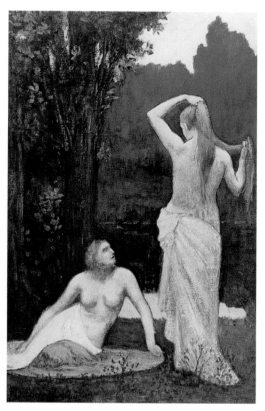

296. Pierre Puvis de Chavannes, *Bathers*, 1890, oil on canvas. Art Gallery of Ontario, Toronto. Purchase, Peter Larkin Endowment, 1974.

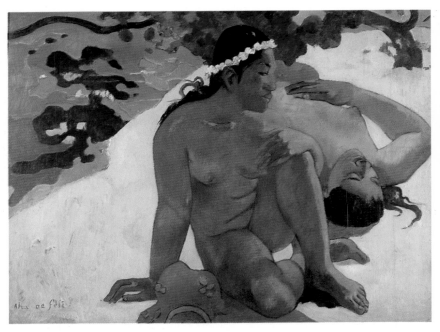

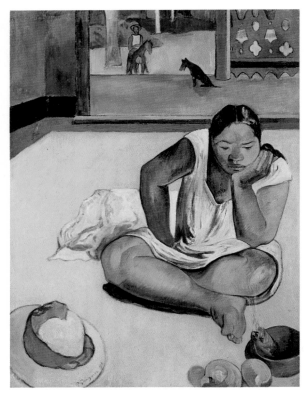

297. Paul Gauguin, *Aha oe feii?* (*What, are you jealous?*), 1892, oil on canvas, 66 × 89 cm. (25⅞ × 35⅛″). w461. Pushkin State Museum of Fine Arts, Moscow.

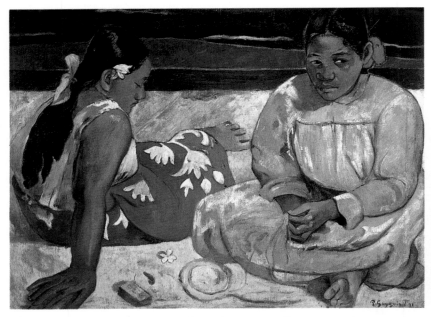

298. Paul Gauguin, *Two women on the seashore*, 1891, oil on canvas, 69 × 91.5 cm. (27⅛ × 36″). w434. Musée d'Orsay, Paris.

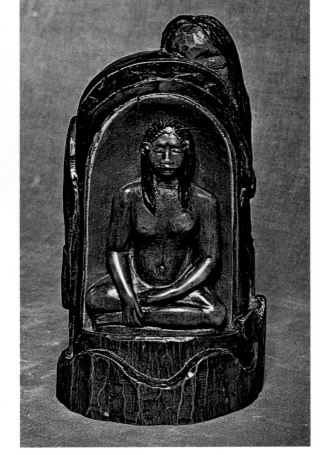

TOP RIGHT 299. Paul Gauguin, *Te Faaturuma* (*The Brooding woman* or *The Silence*), 1891, oil on canvas, 91.2 × 68.7 cm. (35⅞ × 27″). w440. Worcester Arts Museum, Worcester, Massachusetts.

RIGHT 300. Paul Gauguin, *Idol with a pearl*, 1891/92, stained and gilded tamanu wood with inlaid pearl, 25 × 12 cm. (9¾ × 4⅝″). G94. Musée d'Orsay, Paris.

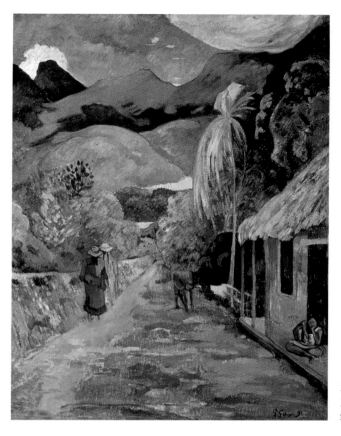

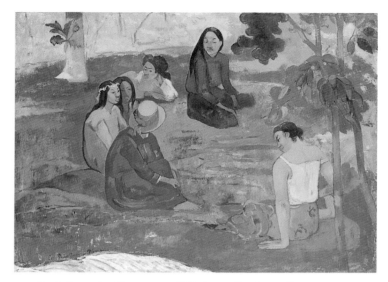

302. Paul Gauguin, *Parau parau* (*Words words*), 1891, oil on canvas, 71 × 92.5 cm. (28 × 36½″). w435. The State Hermitage Museum, St. Petersburg.

301. Paul Gauguin, *Street in Tahiti*, 1891, oil on canvas, 115.5 × 88.5 cm. (45 × 34¾″). w441. The Toledo Museum of Art, Toledo, Ohio; Purchased with funds from the Libbey Endowment, Gift of Edward Drummond Libbey.

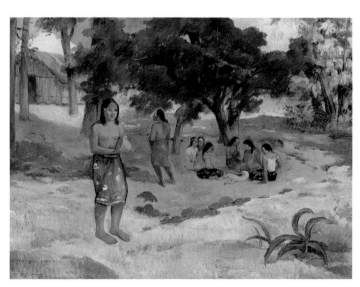

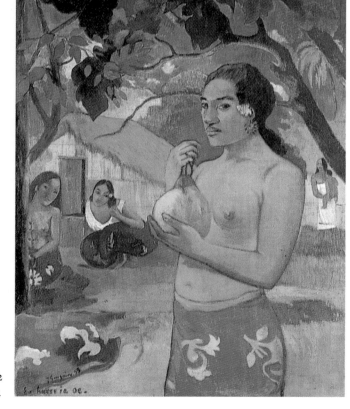

303. Paul Gauguin, *Parau parau* (*Words words*), 1892, oil on canvas, 56 × 76 cm. (21⅞ × 29⅞″). w472. Yale University Art Gallery, New Haven, Connecticut, John Hay Whitney, B.A. 1926, Honorary M.A. 1956, Collection.

304. Paul Gauguin, *Ea haere ia oe?* (*Where are you going?*), 1893, oil on canvas, 92 × 73 cm. (36¼ × 28¾″). w501. The State Hermitage Museum, St. Petersburg.

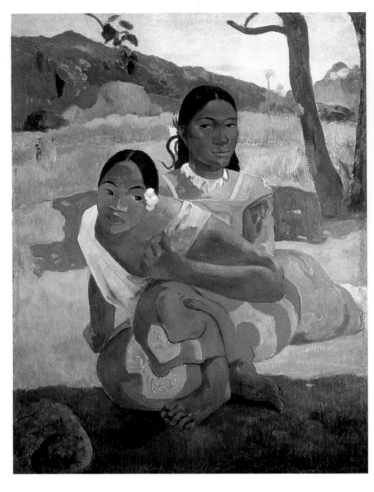

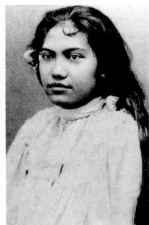

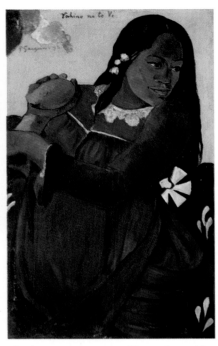

ABOVE LEFT 306. Photograph of Tehemana, ca. 1894. Photo from *Noa Noa par Gauguin*, Jean Loize edit. (Paris 1966).

ABOVE RIGHT 307. Paul Gauguin, *Vahine no te vi* (*Woman with a mango*), 1892, oil on canvas, 70 × 45 cm. (27⅝ × 17¾"). W449. The Baltimore Museum of Art: The Cone Collection, formed by Dr. Claribel Cone and Miss Etta Cone of Baltimore, Maryland, BMA 1950.213.

TOP LEFT 305. Paul Gauguin, *Nafea faa ipoipo* (*When will you marry?*), 1892, oil on canvas, 105 × 77.5 cm. (41¼ × 30½"). W454. Oeffentliche Kunstsammlung Basel, Kunstmuseum; permanent loan from the Rudolf Staechelin Family Foundation.

BOTTOM LEFT 308. Paul Gauguin, *Te nave nave fenua* (*The Land of sensuous pleasure*), 1892, oil on canvas, 91 × 72 cm. (35⅞ × 28⅜"). W455. Ohara Museum of Art, Kurashiki, Japan.

BELOW 309. Odilon Redon, "There was perhaps a first vision attempted in the flower," #2 of *The Origins*, 1883, lithograph. M46. The Art Institute of Chicago, Charles Stickney Collection, 1920.1579.

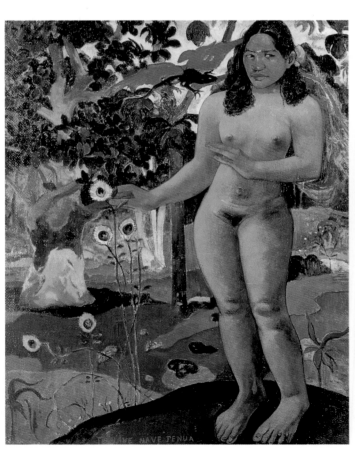

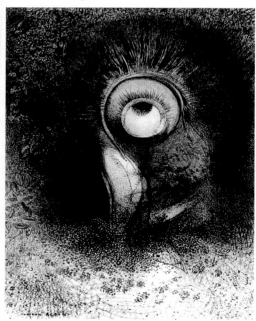

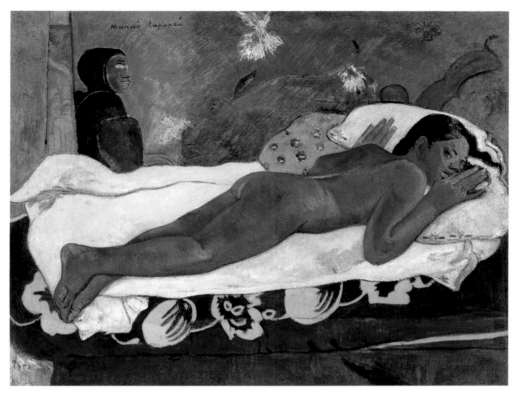

310. Paul Gauguin, *Manao tupapau* (*The Spirit of the dead is watching*), 1892, oil on canvas, 72.5 × 92.5 cm. (28½ × 36⅜″). W457. Albright-Knox Art Gallery, Buffalo, New York, A. Conger Goodyear Collection, 1965.

RIGHT 312. Paul Gauguin, *Idol with a shell*, 1893, ironwood with mother-of-pearl and bone, 27 × 14 cm. (10⅝ × 5½″). G99. Musée d'Orsay, Paris.

BELOW 311. Tiki (detail), stone, Marquesas islands. Musée de l'Homme, Paris.

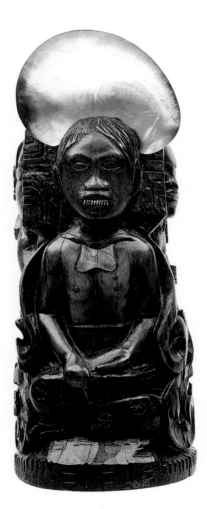

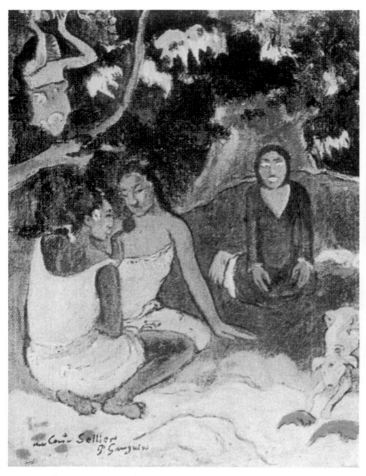

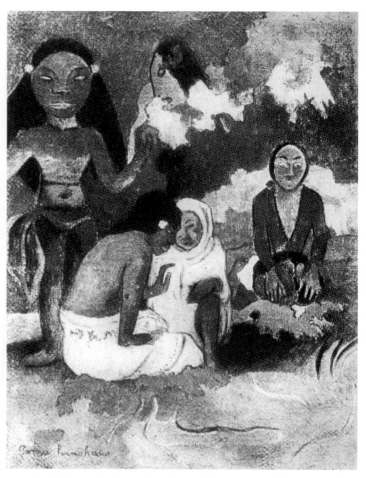

313. Paul Gauguin, *Barbaric tales*, 1892, oil on canvas, 39 × 28 cm. (15½ × 11″). W459. Private Collection.

314. Paul Gauguin, *Parau hanohano* (*Terrifying words*), 1892, oil on canvas. W460. Private Collection.

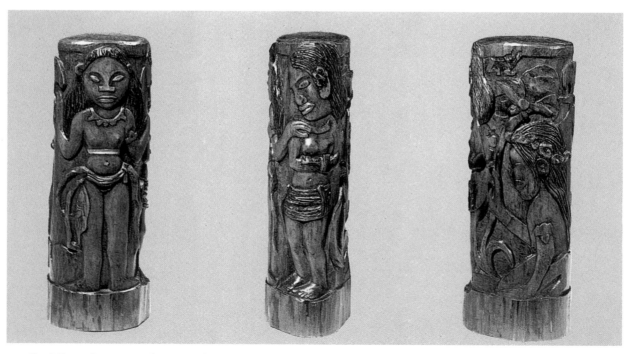

315. Paul Gauguin, *Hina and two attendants*, 1892, carved tamanu wood cylinder, 37 × 13.4 × 10.8 cm. (14½ × 5¼ × 4¼″). G95. Hirshhorn Museum and Scluputure Garden, Smithsonian Institution, Washington D.C.; Museum purchase with funds provided under the Smithsonian Institution Collections Acquisitions Program, 1981.

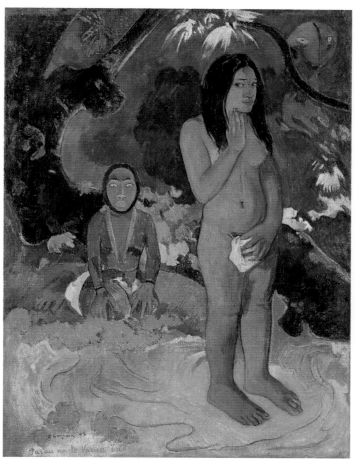

317. *Eve*, doorjamb sculpture from the 17th-century church at Gui-miliau in Brittany, France.

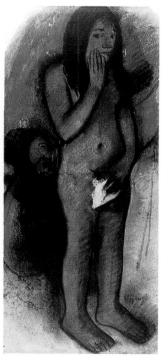

318. Paul Gauguin, *Parau na te varua ino* (*Talk about the evil spirit*), 1892, pastel, 77 × 35.5 cm. (30¼ × 14″). Oeffentliche Kunstsammlung, Basel, Kup-ferstichkabinett.

316. Paul Gauguin, *Parau na te varua ino* (*Talk about the evil spirit*), 1892, oil on canvas, 91.5 × 70 cm. (36⅛ × 27″). w458. National Gallery of Art, Washington, D.C., Gift of the W. Averell Harriman Foundation in memory of Marie N. Harriman.

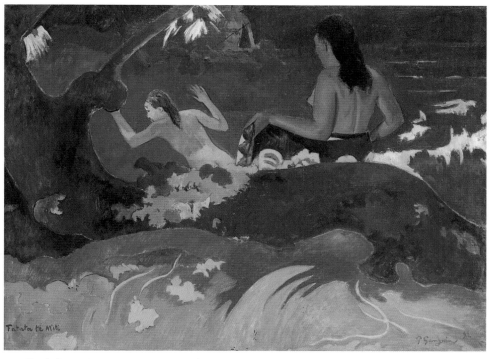

319. Paul Gauguin, *Fatata te miti* (*By the sea*), 1892, oil on canvas, 68.5 × 91.5 cm. (27¼ × 36″). w463. National Gallery of Art, Washington D.C., Chester Dale Collection.

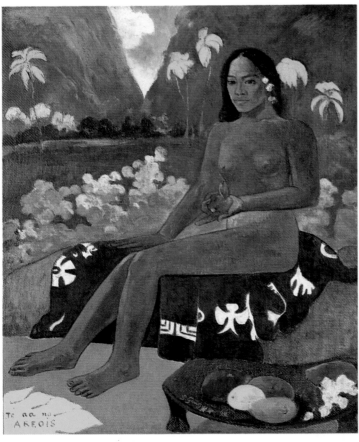

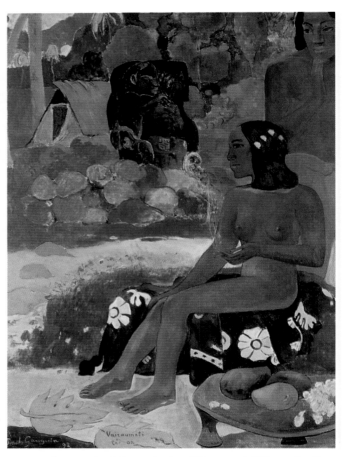

320. Paul Gauguin, *Te aa no areois* (*The Seed of the Areois*), 1892, oil on canvas, 92 × 73 cm. (36¼ × 28¾"). w451. The Museum of Modern Art, New York, The William S. Paley Collection. Photo © 1997, The Museum of Modern Art, New York.

321. Paul Gauguin, *Vairumati tei oa* (*Her name is Vairumati*), 1892, oil on canvas, 91 × 68 cm. (35⅞ × 27"). w450. Pushkin State Museum of Fine Arts, Moscow.

322. Pierre Puvis de Chavannes, *Hope*, 1872, black chalk on paper. The Walters Art Gallery, Baltimore.

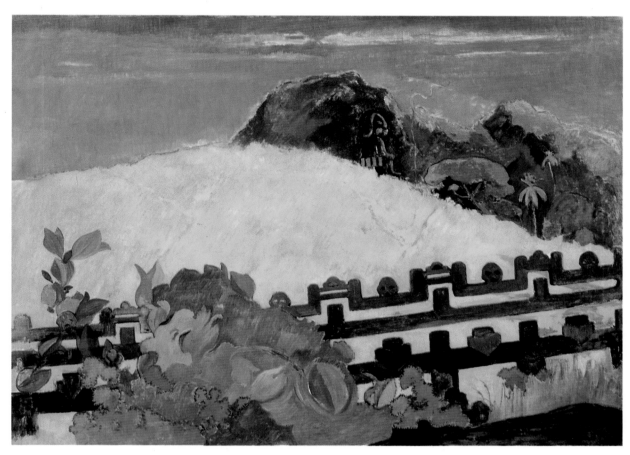

323. Paul Gauguin, *Parahi te marae* (*There is the temple*), 1892, oil on canvas, 68 × 91 cm. (27 × 35⅞″). w483. The Philadelphia Museum of Art. Gift of Mr. and Mrs. Rodolphe Meyer de Schauensee.

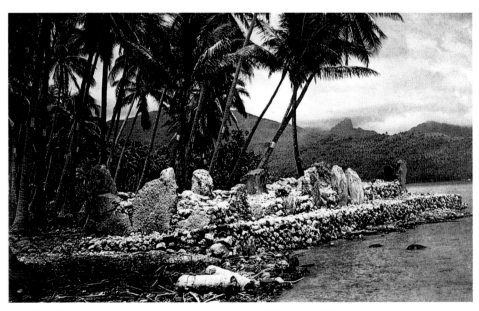

324. The Taputapuatea *marae* at Opoa on Ra'iatea. Photo Axel Poignant.

325. Top of a Marquesan oar, carved wood. The British Museum, London.

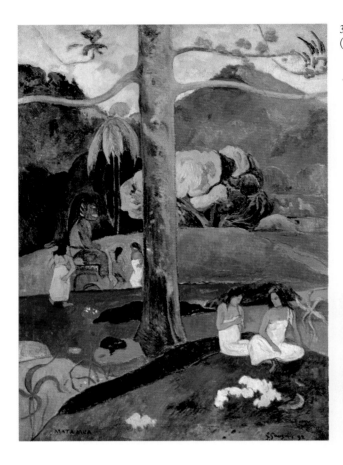

326. Paul Gauguin, *Matamua (In former times)*, 1892, oil on canvas, 93 × 72 cm. (36⅝ × 28⅜″). W467. Carmen Thyssen–Bornemisza Collection.

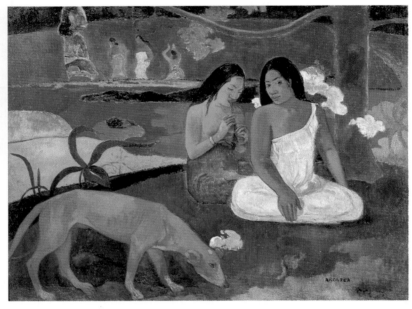

327. Paul Gauguin, *Arearea (Joyousness)*, 1892, oil on canvas, 75 × 94 cm. (29½″ × 37″). W468. Musée d'Orsay, Paris.

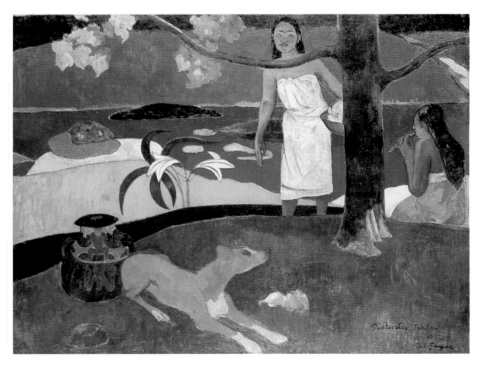

328. Paul Gauguin, *Tahitian pastorale,* end of December 1892, oil on canvas, 86 ×113 cm. (34 × 44½″). W470. The State Hermitage Museum, St. Petersburg.

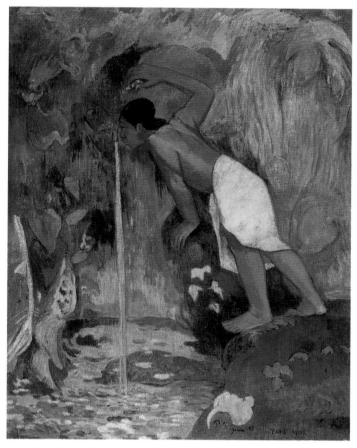

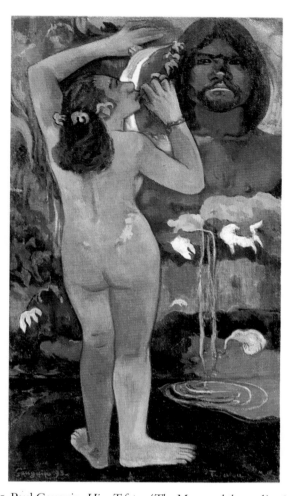

329. Paul Gauguin, *Pape moe* (*Mysterious water*), 1893, oil on canvas, 99 × 75 cm. (39 × 29½″). w498. Private Collection, Switzerland.

330. Paul Gauguin, *Hina Tefatou* (*The Moon and the earth*), 1893, oil on canvas, 114.3 × 62.2 cm. (45 × 24½″). w499. The Museum of Modern Art, New York, Lillie P. Bliss Collection. Photograph © 1996 The Museum of Modern Art, New York.

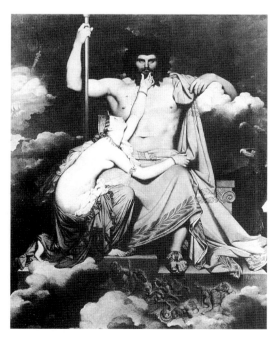

331. Vegetation in the South Seas. Photo by Charles Spitz, *Autour du monde*, ca. 1889, pl. 241.

332. Jean-Auguste-Dominique Ingres, *Jupiter and Thetis*, 1811, oil on canvas. Musée Granet, Aix-en-Provence, France.

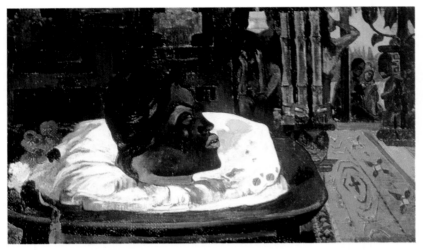

333. Paul Gauguin, *Arii matamoe* (*The Sleeping King* or *The Royal end*), 1892, oil on canvas, 45× 75 cm. (17¾ × 29½″). W453. Private Collection.

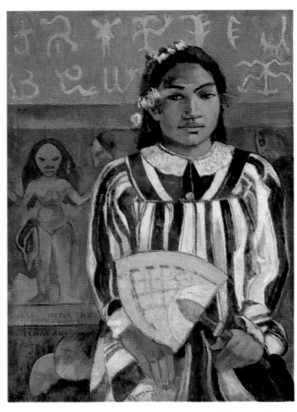

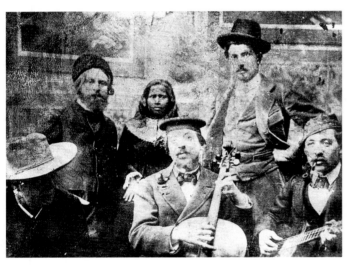

335. Gauguin's studio at 6 rue Vercingétorix, with Annah the Javanese in the back row between Paul Sérusier (left) and Georges Lacombe, 1894. Musée Gauguin, Papeari, Tahiti.

334. Paul Gauguin, *Merahi metua no Tehamana* (*The Many parents of Tehamana*), 1893, oil on canvas, 76.3 × 54.3 cm. (30 × 21¼″). W497. The Art Institute of Chicago, Gift of Mr. and Mrs. Charles Deering McCormick, 1980.613.

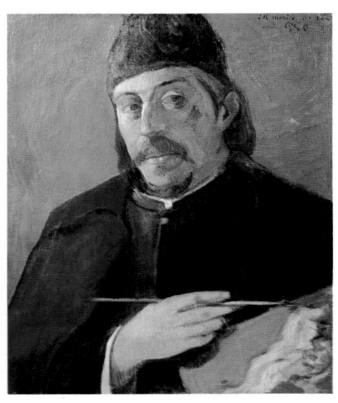

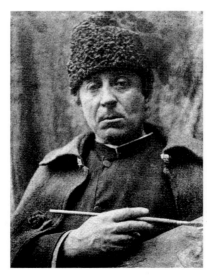

337. Photograph of Gauguin with palette, c. 1888. Musée d'Orsay, Paris.

336. Paul Gauguin, *Self-portrait with palette*, c. 1894, oil on canvas, 92 × 73 cm. (36¼ × 28¾″). W410. Private Collection.

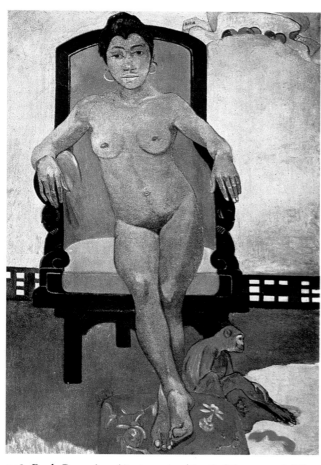

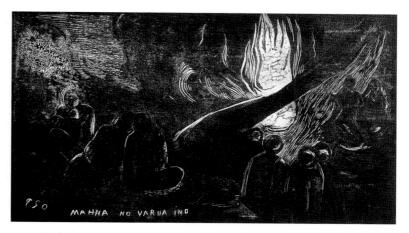

340. Paul Gauguin, *Mahna no varua ino* (*Day of the evil spirit*), 1894–95, woodcut, 20.2 × 35.6 cm. (8 × 14″). GU34. The Art Institute of Chicago, Clarence Buckingham Collection, 1948.263 recto.

338. Paul Gauguin, *Aita tamari vahine Judith te parari* (*The Child-woman Judith is not yet breached*), late 1893–94, oil on canvas, 116 × 81 cm. (45¾ × 31⅞″). w508. Private Collection.

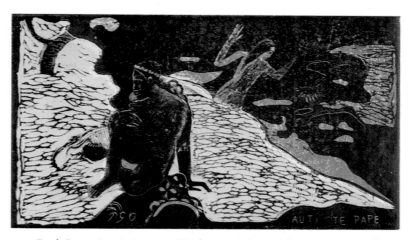

341. Paul Gauguin, *Auti te pape* (*Fresh water is in motion*), 1894–95, woodcut, 20.2 × 35.4 cm. (8 × 14″). GU35. The Art Institute of Chicago, Albert Roullier Memorial Collection, 1926.198.

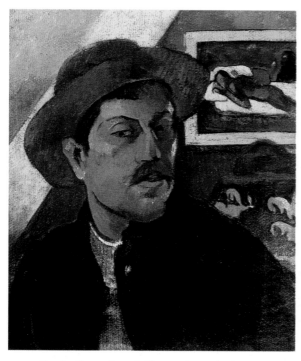

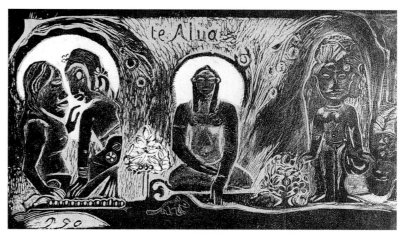

339. Paul Gauguin, *Self-portrait with hat*, winter 1893–94, oil on canvas, 46 × 38 cm. (18⅛ × 15″). w506. Musée d'Orsay, Paris.

342. Paul Gauguin, *Te Atua* (*The Gods*), 1894–95, woodcut, 20.2 × 35.6 cm. (8 × 14″). GU31. The Art Institute of Chicago, Joseph Brooks Fair Collection, 1946.286.

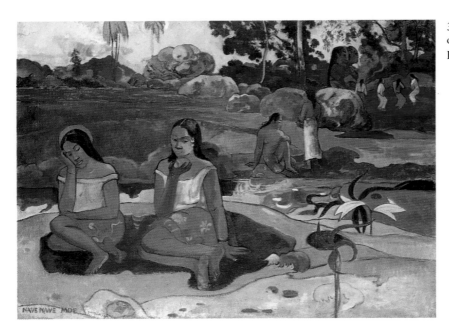

343. Paul Gauguin, *Nave nave moe* (*Delicious repose*), 1894, oil on canvas, 73 × 98 cm. (28¾ × 38½″). W512. The State Hermitage Museum, St. Petersburg.

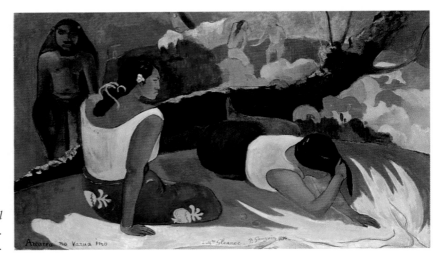

344. Paul Gauguin, *Arearea no varua ino* (*Joyousness of the evil spirit*), 1894, oil on canvas, 60 × 98 cm. (23⅜ × 38½″). W514. Ny Carlsberg Glyptotek, Copenhagen, Denmark.

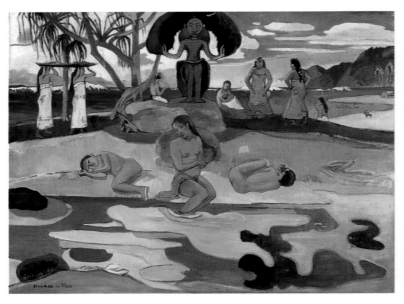

345. Paul Gauguin, *Mahana no atua* (*Day of the God*), 1894, oil on canvas, 68.3 × 91.5 cm. (25⅝ × 35⅝″). W513. The Art Institute of Chicago, Helen Birch Bartlett Memorial Collection, 1926.198.

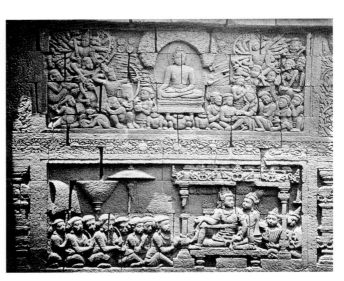

346. *The Assault of Mara*, frieze on the Temple of Borobodur, 8th century, Java. Photo courtesy Rÿksmuseum voor Volkenkunde, Leiden.

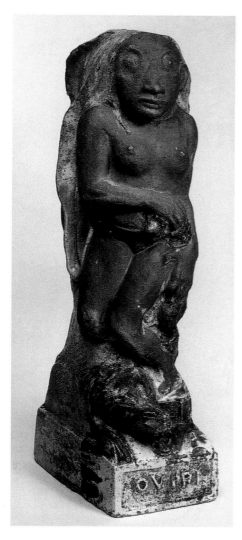

347. Paul Gauguin, *Oviri* (*Savage*), late 1894, glazed stoneware, 74 cm. (29″). G113. Musée d'Orsay, Paris.

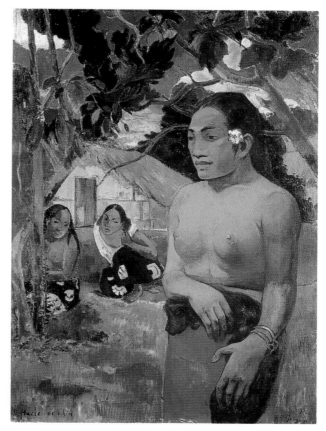

349. Paul Gauguin, *Ea haere oe i hia?* (*Where are you going?*), 1892, oil on canvas, 96 × 69 cm. (37⅝ × 27¼″). W478. Staatsgalerie, Stuttgart.

348. Female deity from Ra'ivavae, Marquesas, stone. Musée Gauguin, Papeari, Tahiti.

350. Paul Gauguin, *Self-portrait, Oviri*, 1894–95, bronze, 36 × 34 cm. (14¼ × 13⅜″). G109. Museum Folkwang, Essen, Germany.

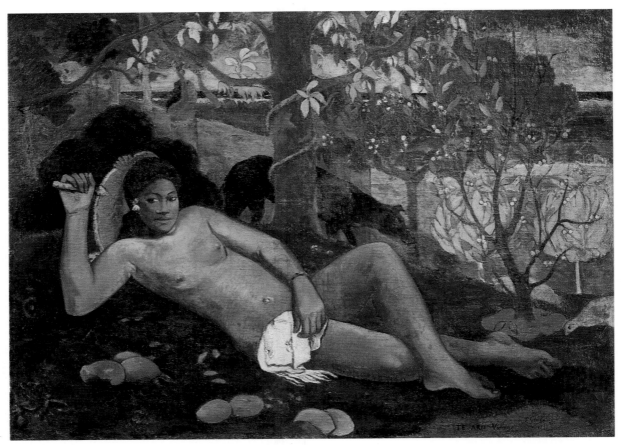

351. Paul Gauguin, *Te Arii vahine* (*The Royal woman*), 1896, oil on canvas, 97 × 130 cm. (38 × 51″). W542. Pushkin State Museum of Fine Arts, Moscow.

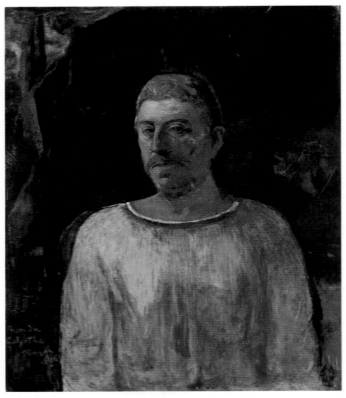

352. Paul Gauguin, *Self-portrait. Near Golgotha*, 1896, oil on canvas, 76 × 64 cm. (30 × 25¼″). W534. Museu de Arte de São Paolo Assis Chateaubriand, Brazil.

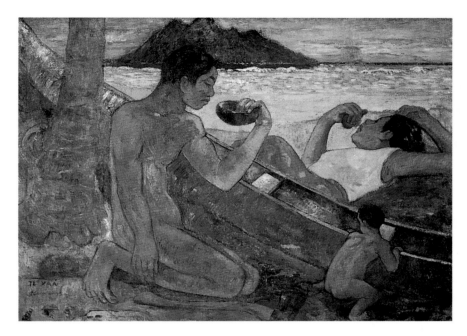

353. Paul Gauguin, *Te Vaa* (*The Canoe*), oil on canvas, 1896, 96 × 130 cm. (37⅝ × 51″). W544. The State Hermitage Museum, St. Petersburg.

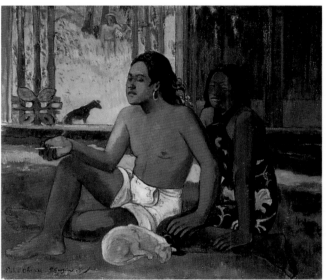

354. Paul Gauguin, *Eiaha ohipa* (*Don't work*), 1896, oil on canvas, 65 × 75 cm. (25⅜ × 29½″). W538. Pushkin State Museum of Fine Arts, Moscow.

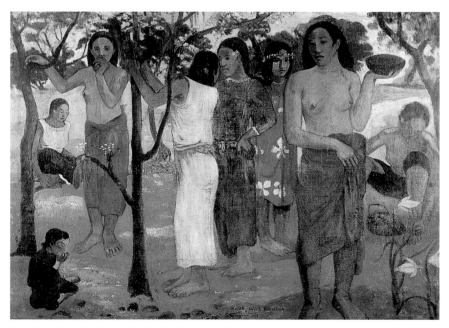

355. Paul Gauguin, *Nave nave mahana* (*Delightful day*), 1896, oil on canvas, 94 × 130 cm. (37 × 51″). W548. Musée des Beaux-Arts de Lyon, France.

356. Paul Gauguin, *Te Tamari no atua* (*The Child of God*), 1896, oil on canvas, 96 × 128 cm. (37½ × 50″). w541. Bayrischen Staatsgemäldesammlungen, Munich.

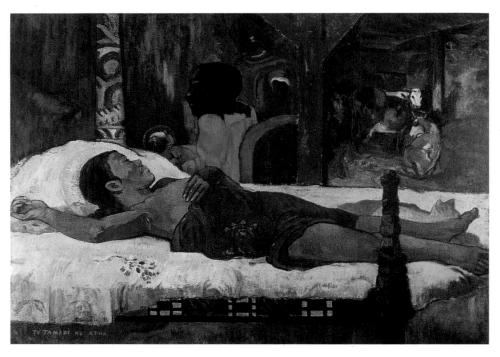

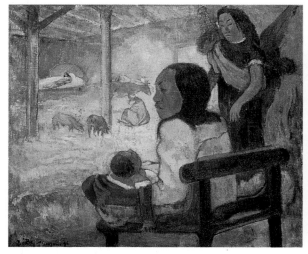

357. Paul Gauguin, *Bébé* (*Baby*), 1896, oil on canvas, 66 × 75 cm. (26 × 29½″). w540. The State Hermitage Museum, St. Petersburg.

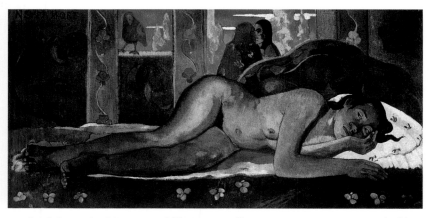

358. Paul Gauguin, *Nevermore O Taiti*, 1897, oil on canvas, 60.5 × 116 cm. (23⅞ × 45⅝″). w558. Courtauld Institute Galleries, London.

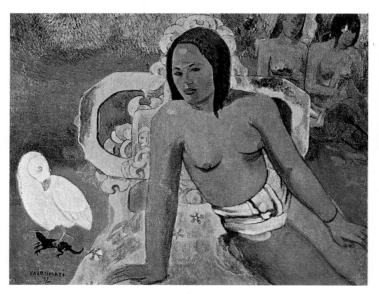

359. Paul Gauguin, *Vairumati*, 1897, oil on canvas, 73 × 94 cm. (28¾ × 37″). w559. Musée d'Orsay, Paris.

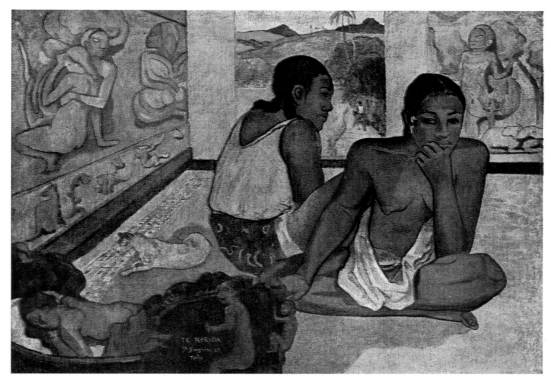

360. Paul Gauguin, *Tè Rerioa* (*The Dream*), 1897, oil on canvas, 95 × 132 cm. (37½ × 52″). W557. Courtauld Institute Galleries, London.

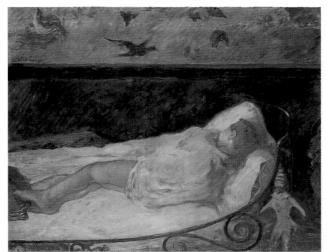

361. Paul Gauguin, *The Little dreamer*, 1881, oil on canvas, 54 × 73 cm. (21⅛ × 28¾″). W52. The Ordrupgaard Museum, Copenhagen.

363. Paul Gauguin, *Tè Faruru* (*Here we make love*), 1893–94, woodcut printed from endgrain boxwood in ocher and black on japan paper stained prior to printing with various hand-applied and transferred watercolors and waxy media, 35.6 × 20.3 cm. (14 × 8″). GU22. The Art Institute of Chicago, Clarence Buckingham Collection, 1950.158.

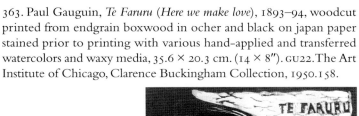

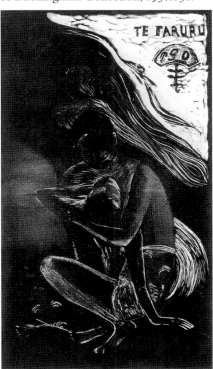

362. Marquesan kumete, wood, (AIM 117). Auckland Art Gallery, New Zealand.

364. Paul Gauguin, *Where do we come from? What are we? Where are we going?*, 1897, oil on canvas, 139 × 375 cm. (55 × 147⅝")
w561. Tompkins Collection, Courtesy Museum of Fine Arts, Boston.

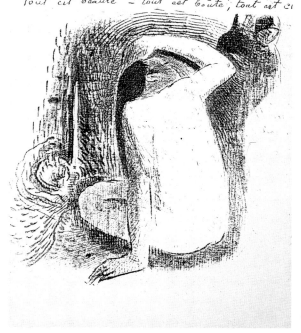

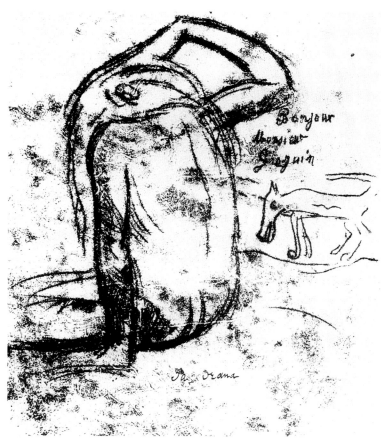

365. Paul Gauguin, *The Source*, 1894–95, pen and ink drawing on p. 92 of Gauguin's final *Noa Noa* manuscript (R.F. 7259), Cabinet des dessins, Louvre, Paris.

366. Paul Gauguin, *Bonjour Monsieur Gauguin*, 1897, pen and ink drawing on p. 167 of Gauguin's manuscript *Avant et après*. Facsimile, vol. 2 (Copenhagen: Skripta, 1953).

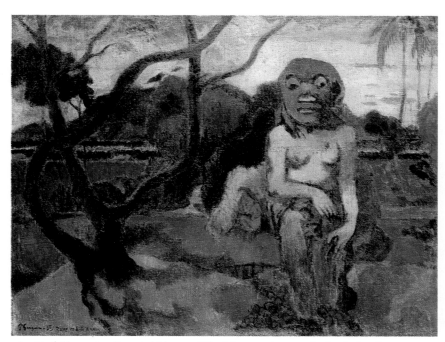

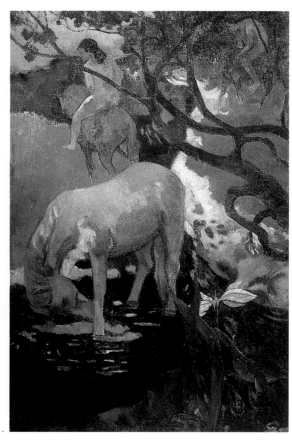

367. Paul Gauguin, *Rave te hiti ramu (The Monster-glutton seizes)*, 1898, oil on canvas, 73 × 91 cm. (28¾ × 36″). W570. The State Hermitage Museum, St. Petersburg.

368. Paul Gauguin, *The White horse*, 1898, oil on canvas, 140 × 91 cm. (55⅛ × 35⅞″). W571. Musée d'Orsay, Paris.

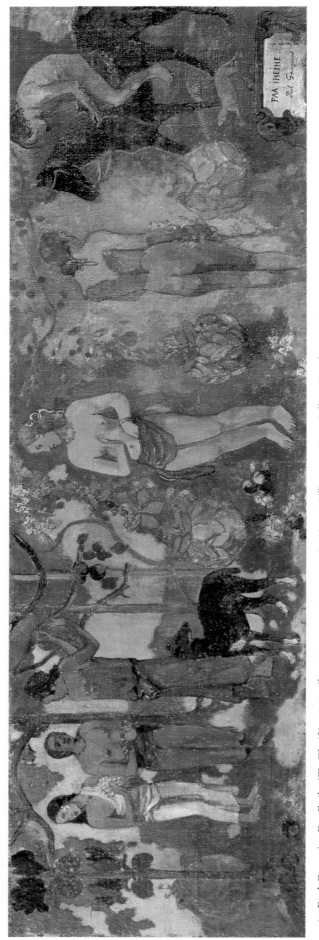

369. Paul Gauguin, *Faa Iheihe (To Glorify)*, 1898, oil on canvas, 54 × 169 cm. (21⅛ × 66¾"). W569. Tate Gallery, London. Photo Art Resource, New York.

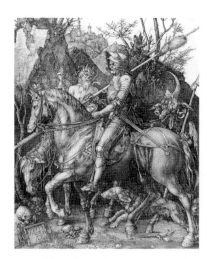

370. Albrecht Dürer, German, *The Knight, Death, and the Devil,* 1513, engraving. The Art Institute of Chicago, Clarence Buckingham Collection, 1938.1449.

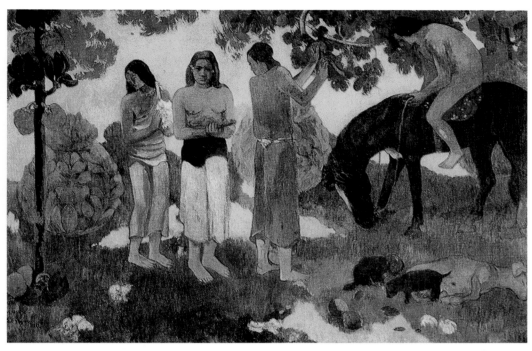

371. Paul Gauguin, *Rupe rupe (Luxuriance),* 1899, oil on canvas, 128 × 190 cm. (50½ × 74¾"). W 585. Pushkin State Museum of Fine Arts, Moscow.

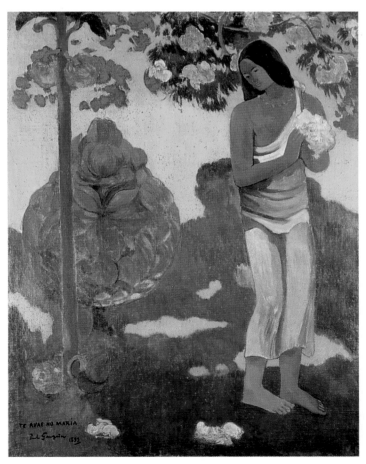

372. Paul Gauguin, *Te Avae no Maria (The Month of Mary),* 1899, oil on canvas, 97 × 72 cm. (38¼ × 28⅜"). W 586. The State Hermitage Museum, St. Petersburg.

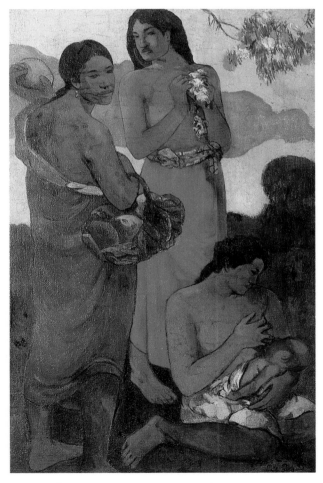

373. Paul Gauguin, *Maternity,* 1899, oil on canvas, 93 × 60 cm. (36½ × 23⅜"). W 582. Private Collection.

374. Paul Gauguin, *Maternity*, 1899, oil on canvas, 95.5 × 73.5 cm. (37¼ × 28⅝″). W581. The State Hermitage Museum, St. Petersburg.

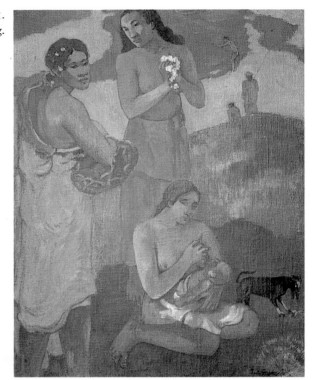

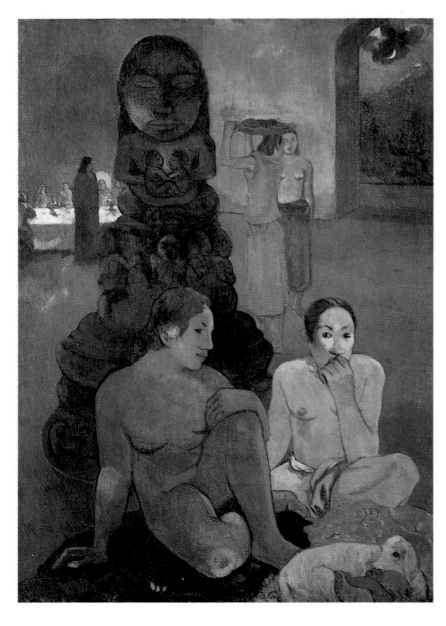

375. Paul Gauguin, *The Great Buddha*, 1899, oil on canvas, 134 × 95 cm. (52⅞ × 37¼″). W579. Pushkin State Museum of Fine Arts, Moscow.

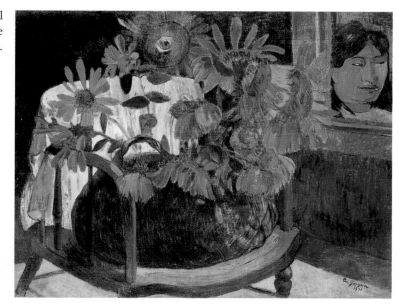

376. Paul Gauguin, *Still-life with sunflowers on an armchair*, 1901, oil on canvas, 73 × 91 cm. (28¾ × 35⅞"). w603. The State Hermitage Museum, St. Petersburg.

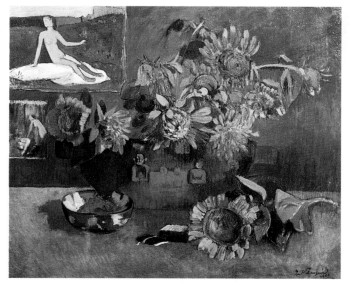

377. Paul Gauguin, *Still-life with sunflowers and Puvis' "Hope,"* 1901, oil on canvas, 65 × 77 cm. (25⅜ × 30¼"). w604. Private Collection.

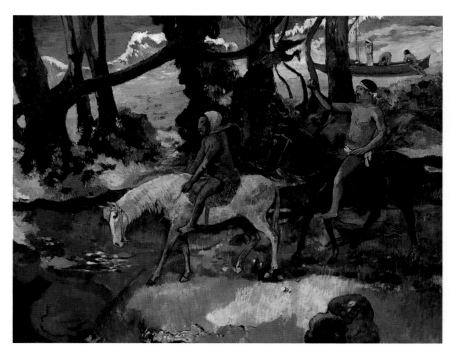

378. Paul Gauguin, *The Flight*, or *The Ford*, 1901, oil on canvas, 76 × 95 cm. (30 × 37½"). w597. Pushkin State Museum of Fine Arts, Moscow.

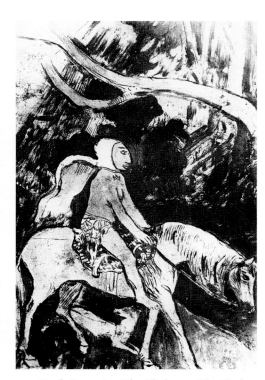

379. Paul Gauguin, *The Flight,* or *The Ford*, c. 1900, watercolor. Location unknown.

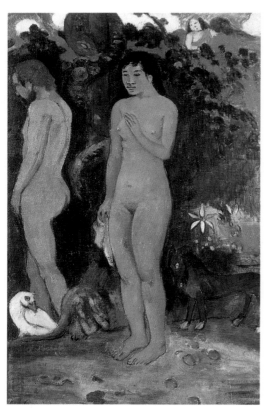

380. Paul Gauguin, *The Fall* or *Adam and Eve*, 1902, oil on canvas, 59 × 38 cm. (23 × 15¼″). w628. The Ordupgaard Museum, Copenhagen.

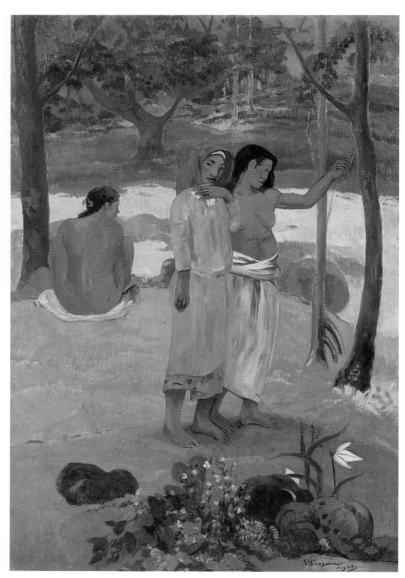

381. Paul Gauguin, *The Call*, 1902, oil on canvas, 130 × 90 cm. (51¼ × 35½″). w612. The Cleveland Museum of Art, Gift of the Hanna Fund, 1943.392.

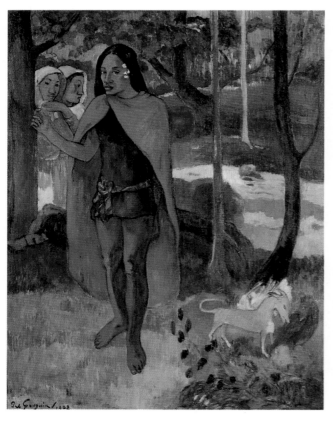

382. Paul Gauguin, *Marquesan in a red cape* (*The Magician of Hivaoa*), 1902, oil on canvas, 92 × 73 cm. (36¼ × 28¾″). w616. Musée d'Art Moderne et d'Art contemporain de la Ville de Liège, Belgium.

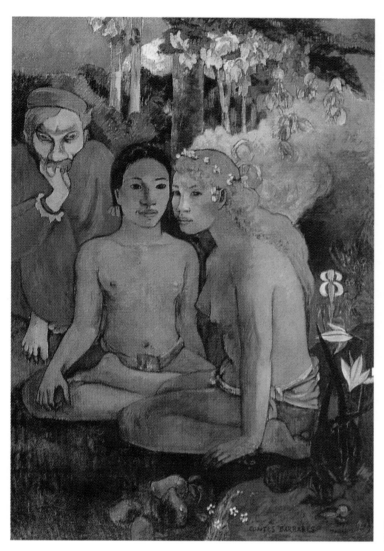

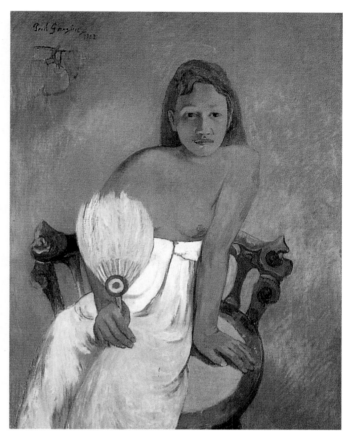

384. Paul Gauguin, *Portrait of Tohotua*, 1902, oil on canvas, 92 × 73 cm. (36¼ × 28¾″). W609. Museum Folkwang, Essen, Germany.

383. Paul Gauguin, *Barbaric tales*, 1902, oil on canvas, 131.5 × 90.5 cm. (51⅞ × 35¾″). W625. Museum Folkwang, Essen, Germany.

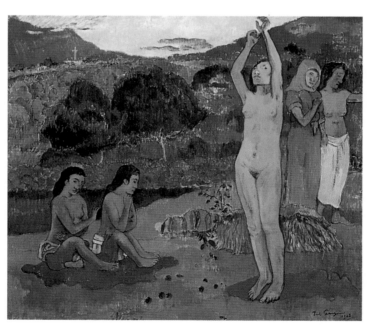

385. Paul Gauguin, *The Invocation*, 1903, oil on canvas, 65.5 × 75.6 cm. (25¾ × 29¾″). W635. National Gallery of Art, Washington, D.C. Gift from the Collection of John and Louise Booth in memory of their daughter, Winkie.

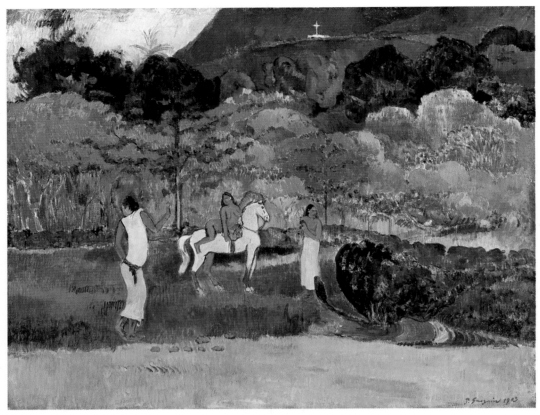

386. Paul Gauguin, *Women and white horse*, 1903, oil on canvas, 72 × 91.5 cm. (28⅞ × 36⅛"). w636. Bequest of John T. Spaulding, Courtesy Museum of Fine Arts, Boston.

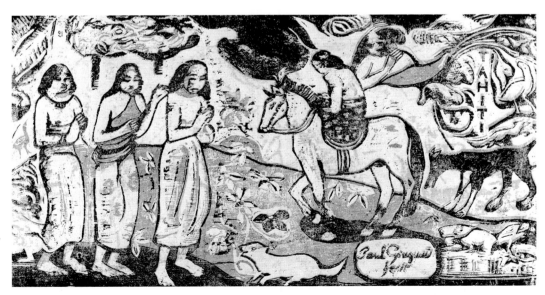

387. Paul Gauguin, *Change of residence*, 1899, woodcut printed in black, pasted down over an impression of a first state printed in ocher, numbered in pen and ink, 21, 1898/99, 16.3 × 30.5 cm. (6⅜ × 12"). GU66. The Art Institute of Chicago, The Albert H. Wolf Memorial Collection, 1939.322.

Bibliography

Abrams, M. H. *The Mirror and the Lamp: Romantic Theory and the Critical Tradition*. New York: W. W. Norton, 1958.

Alexandre, Arsène. *Paul Gauguin, sa vie et le sens de son oeuvre*. Paris: Bernheim-Jeune, 1930.

Amishai-Maisels, Ziva. "Gauguin's 'Philosophical Eve.'" *Burlington Magazine* 115 (June 1973): 373–82.

———. *Gauguin's Religious Themes*. New York and London: Garland Publishing, 1985.

Andersen, Wayne. "Gauguin and a Peruvian Mummy." *Burlington Magazine* 109 (April 1967): 238–42.

———. *Gauguin's Paradise Lost*. New York: Viking Press, 1971.

Antoine, Jules. "Impressionnistes et synthétistes." *Art et Critique* 1 (November 1889): 369–71.

The Art of Paul Gauguin. By Richard Brettell, Françoise Cachin, Claire Frèches-Thory, and Charles Stuckey. Washington, D. C.: The National Gallery of Art and the Art Institute of Chicago, 1988.

Aran, Lydia. *The Art of Nepal*. Kathmandu: Sahayogi Prakashan, 1978.

Argüelles, José. *Charles Henry and the Formation of a Psychophysical Aesthetic*. Chicago: University of Chicago Press, 1972.

Aurier, Albert. *Oeuvres posthumes*. Paris: Mercure de France, 1893.

Balakian, Anna. *The Symbolist Movement*. New York: Random House, 1967.

Balzac, Honoré de. *Seraphita*. Vol. 2, *Balzac's Works*. Boston: Dana Estes & Co.

———. *The Unconscious Humorists*. Vol. 5, *Balzac's Works: The Human Comedy*. New York: Century Co., 1904.

Barre, André. *Le Symbolisme*. Paris: Jouve et Cie, 1911.

Barrow, Terrence. *The Art of Tahiti*. London: Thames and Hudson, 1979.

Baudelaire, Charles. *Art in Paris 1845–1862*. Translated and edited by Jonathon Mayne. New York: Phaidon, 1965.

———. *Les Fleurs du mal*. Text from 2nd edition. Edited by Jacques Crepet and George Blin. Paris: Librairie José Corti.

———. *The Painter of Modern Life*. Translated and edited by Jonathon Mayne. New York: Phaidon, 1965.

Bernard, Émile. "Notes sur l'école dite de 'Pont-Aven.'" *Mercure de France* 168 (December 1903): 675–82.

———. "Paul Cézanne." *L'Occident* 32 (July 1904): 17–30.

———. Puvis de Chavannes." *L'Occident* 25 (December 1903): 273–80.

———. *Réflexions d'un témoin de la décadence du beau*. Cairo: M. Roditi & Cie, 1902.

———. "Vincent van Gogh." *Mercure de France* 40 (April 1893): 324–30.

Blanc, Charles. *Grammaire des arts du dessin*. Paris: Librairie Renouard, H. Laurens, 1880.

Blavatsky, Helena Petrovna. *Isis Unveiled*. 2 vols., New York: J. W. Bouton, 1877.

———. *The Key to Theosophy*. London: Theosophical Publishing Society, 1890.

Bodelsen, Merete. "Gauguin and the Marquesan God." *Gazette des Beaux-Arts* 57 (March 1961): 167–80.

———. *Gauguin's Ceramics: A Study in the Development of His Art*. London: Faber & Faber, 1964.

———. "Gauguin's Cézannes." *Burlington Magazine* 104 (May 1962): 204–11.

———. "Gauguin, the Collector." *Burlington Magazine* 112 (Sept. 1970): 590–615.

———. "Gauguin Studies." *Burlington Magazine* 109 (April 1967): 217–27.

———. "The Wildenstein-Cogniat Catalogue." *Burlington Magazine* 108 (January 1966): 27–38.

Boime, Albert. *The Academy and French Painting in the Nineteenth Century*. New York: Phaidon, 1971.

———. "Vincent van Gogh's *Starry Night*: A History of Matter and a Matter of History." *Arts Magazine* 59 (December 1984): 86–103.

Bois, Jules. *Les Petites religions de Paris*. Paris: Chailley, 1894.

Bronowski, Jacob. "The Imaginative Mind in Science." In *The Visionary Eye*. Boston: M.I.T. Press, 1978.

Brookner, Anita. *The Genius of the Future*. New York: Phaidon, 1971.

Buser, Thomas. "Gauguin's Religion." *Art Journal* 27 (summer 1968): 375–80.

Carlyle, Thomas. *On Heroes, Hero-Worship and the Heroic in History*. Edited by Carly Niemeyer. Lincoln and London: University of Nebraska Press, 1966.

———. *Sartor Resartus*. Edited by Charles Frederick Harrold. New York: Odyssey Press, 1937.

Cassirer, Ernst. *An Essay on Man: An Introduction to a Philosophy of Human Culture*. New Haven: Yale University Press, 1944.

Charlton, D. G. *Secular Religions in France 1815–1870*. London: Oxford University Press, 1963.

Chassé, Charles. *Gauguin et le groupe de Pont-Aven*. Paris: H. Floury, 1921.

———. *Gauguin et son temps*. Paris: La Bibliothèque des Arts, 1955.

———. *Le Mouvement symboliste dans l'art du XIXe siècle*. Paris: Librairie Floury, 1947.

Chetham, Charles. *The Role of Vincent van Gogh's Copies in the Development of his Art*. New York: Garland Publishing, 1976.

Chipp, Herschel B., ed. *Theories of Modern Art*. Berkeley: University of California Press, 1969.

The Complete Engravings, Etchings, and Drypoints of Albrecht Dürer. Edited by Walter L. Strauss. New York: Dover Publications, 1972.

Colin, Paul. *Van Gogh*. Translated by Beatrice Moggridge. London: John Lane, Bodley Head, 1926.

Coquiot, Gustave. *Vincent van Gogh*. Paris: Librairie Ollendorff, 1923.

Cornell, Kenneth. *The Symbolist Movement*. New York: Archon Books, 1970.

Danielsson, Bengt. *Gauguin in the South Seas*. Translated by Reginald Spink. New York: Doubleday & Co., 1965.

———. "Gauguin's Tahitian Titles." *Burlington Magazine* 109 (April 1967): 228–33.

———, and P O'Reilly. *Gauguin, Journaliste à Tahiti et ses articles des "Guêpes."* Paris: Société des océanistes, 1966.

Dauchot, Fernand. "Le Christ jaune de Gauguin." *Gazette des Beaux-Arts* 44 (July–August 1954): 66–68.

———. "Meyer de Haan en Bretagne." *Gazette des Beaux-Arts* 60 (December 1952): 355–58.

Delacroix, Eugène. *The Journal of Eugène Delacroix.* Edited by André Joubin. Translated by Walter Pach. New York: Viking Press, 1972.

Delaroche, Achille. "D'un point de vue esthétique: À propos du peintre Paul Gauguin." *L'Ermitage* 5 (January 1894): 35–39.

Denis, Maurice. "L'Époque du symbolisme." *Gazette des Beaux-Arts* 11 (January–June 1934): 165–79.

———. *Journal.* 3 vols. Paris: La Colombe. Éditions du Vieux Colombier, 1957.

———. *Théories. 1890–1910. Du symbolisme et de Gauguin vers un nouvel ordre classique.* 4th edition. Paris: L. Rouart and J. Watelin, 1920.

Dickens, Charles. *The Christmas Books.* 2 vols. Edited with introduction by Michael Slater. New York: Penguin Books, 1971.

Doiteau, Victor. "Deux 'copains' de Van Gogh, tel qu'ils l'ont vu." *Aesculape* 40 (March 1957): 39–53.

———, and Edgar Leroy. *La Folie de van Gogh.* Paris: Éditions Aesculape, 1928.

Dorival, Bernard. "Le Milieu de Paul Gauguin." In *Paul Gauguin. Collection Génies et réalités,* pp. 54–93.

———. "Sources of the Art of Gauguin from Java, Egypt, and Ancient Greece." *Burlington Magazine* 93 (April 1951): 118–22.

Dorra, Henri. "The First Eves in Gauguin's Eden." *Gazette des Beaux-Arts* 41 (March 1953): 189–202.

———. "Gauguin's Dramatic Arles Themes." *Art Journal* 38 (fall 1978): 12–17.

———. "More on Gauguin's Eves." *Gazette des Beaux-Arts* 69 (February. 1967): 109–11.

Dorsenne, Jean. *La Vie sentimentale de Paul Gauguin.* Paris: L'Artisan du livre, 1927.

Duret, Théodore. *Critique d'avant-garde.* Paris: G. Charpentier et Cie, 1885.

———. *Vincent van Gogh.* Paris: Bernheim-Jeune, 1924.

Durkheim, Émile. *The Elementary Forms of the Religious Life.* Translated by Joseph Swain. New York: Free Press, 1965.

Elgar, Frank. *Van Gogh: A Study of his Life and Work.* Translated by James Cleugh. New York: Frederick A. Praeger, 1958.

Eliade, Mircea. *From Primitives to Zen. A Thematic Sourcebook of the History of Religions.* New York: Harper & Row, 1967.

———. *Images et symboles: essais sur le symbolisme magico-religieux.* Paris: Gallimard, 1952.

Erpel, Fritz. *Van Gogh. The Self-Portraits.* Translated by Doris Edwards. Greenwich: New York Graphic Society, 1968.

Estienne, Charles. *Gauguin.* Translated by James Emmons. Geneva: Skira, 1953.

———. *Van Gogh.* Translated by S. J. C. Harrison. New York: Skira, 1953.

Faille, J. B. de la. *L'Époque française de Van Gogh.* Paris: Bernheim-Jeune, 1927.

———. *Vincent van Gogh.* Translated by Prudence Montagu-Pollack. Paris: Hyperion Press, 1939.

———. *The Works of Vincent van Gogh: His Paintings and Drawings.* Rev. ed. Amsterdam: Meulenhoff International, 1970.

Fels, Florence. *Vincent van Gogh.* Paris: H. Floury, 1928.

Field, Richard. Gauguin's Noa-Noa Suite." *Burlington Magazine* 110 (September 1968): 500–11.

———. *Paul Gauguin: The Paintings of the First Voyage to Tahiti.* New York: Garland Publishing, 1977.

———. "Plagiaire ou créateur?" In *Paul Gauguin. Collection Génies et réalités,* 138–69.

Fierens-Gevaert, H. *Essai sur l'art contemporaine.* Paris: Félix Alcan, 1897.

Flaubert, Gustave. *The Letters of Gustave Flaubert.* 2 vols. Translated and edited by Francis Steegmuller. Cambridge: Harvard University Press, Belknap Press, 1982.

Floorisoone, Michel. *Eugène Carrière et le symbolisme.* Musée de l'Orangerie, December 1949–January 1950. Notes by Jean Leymarie. Paris: Éditions des Musées Nationaux, 1949.

Fontainas, André. "Art moderne – Paul Gauguin." *Mercure de France* 109 (January 1899): 235–38.

———. *Mes souvenirs du symbolisme.* Paris: La Nouvelle Revue Critique, 1928.

Gachet, Paul. "Les Médecins de Théodore et Vincent van Gogh." *Aesculape* 40 (March 1957): 4–37.

Gauguin and the Pont-Aven Group. The Tate Gallery and Arts Council, January–February 1966. Introduction by Denys Sutton; catalogue by Ronald Pickvance. London: Arts Council, 1966.

Gauguin, Exposition du Centaire. Musée de l'Orangerie, July 1949. Preface by René Huyghe; catalogue by Jean Leymarie. Paris: Éditions des Musées nationaux, 1949.

Gauguin: Paintings, Drawings, Prints, Sculpture. 2nd rev. ed. Introduction by Theodore Rousseau Jr. Prints by Harold Joachim and Hugh Edwards. Paintings, drawings and sculpture by Claus Virch and Samuel J. Wagstaff. Chicago: The Art Institute of Chicago and the Metropolitan Museum of Art, 1959.

Gauguin, A Retrospective. Edited by Marla Prather and Charles Stuckey. New York: Park Lane, 1989.

Gauguin, Paul. *Ancien culte mahorie.* Facsimile of original MS in the Musée du Louvre, Cabinet des dessins, no. RF 10.755. Introduction by René Huyghe. Paris: Pierre Berès, 1951.

———. *Avant et après.* Paris: G. Crès et Cie, 1923.

———. *Avant et après.* vol. 2: Facsimile of original MS. Copenhagen: Skripta, 1953.

———. "Armand Séguin." *Mercure de France* 62 (February 1895): 222–24.

———. *Cahier pour Aline.* Facsimile of original MS. Introduction by Suzanne Damiron. Paris: Société des amis de la bibliothèque d'art et d'archéologie de l'Université de Paris, 1963.

———. *Le Carnet de Paul Gauguin.* Edited by René Huyghe. Paris: Quatre Chemins-Éditart, 1952.

———. *Carnet de Tahiti.* Edited by Bernard Dorival. Paris: Quatre Chemins-Éditart, 1954.

———. *Correspondance de Paul Gauguin 1873–1888.* Edited by Victor Merlhès. Paris: Fondation Singer-Polignac, 1984.

————. *Letters to Ambroise Vollard and André Fontainas*. Edited by John Rewald. San Francisco: Grabhorn Press, 1943.

————. *Lettres de Gauguin à Daniel de Monfreid*. Edited by Mme Joly-Ségalen. Preface by Victor Ségalen. Paris: Georges Falaize, 1950.

————. *Lettres de Gauguin à sa femme et à ses amis*. Edited by Maurice Malingue. Paris: Éditions Bernard Grasset, 1946.

————. *Lettres de Paul Gauguin à Émile Bernard 1888–1891*. Geneva: Pierre Cailler, 1954.

————. "Natures mortes." *Essais d'Art Libre* 4 (January 1894): 273–75.

————. *Noa Noa*. Introduction by Jean Loize. Paris: André Balland, 1966. (*Noa Noa/L*)

————. *Noa Noa*. Edited by Nicholas Wadley. Translated by Jonathon Griffin. London: Phaidon, 1985. (*Noa Noa/W*)

————. *Noa-Noa*. Original MS of Gauguin's reworked version with Charles Morice in the Musée du Louvre, Cabinet des dessins, no. RF 7259, Paris. (*Noa Noa/II*)

———— with Charles Morice. "Noa Noa." *La Revue Blanche* 14 (15 October 1897): 81–103.

————. "Notes synthétiques." In *Paul Gauguin: Carnet de croquis 1884–1888*. Edited by Raymond Cogniat and John Rewald. New York: Hammer Galleries, 1962.

————. *Paul Gauguin: 45 Lettres à Vincent, Théo, and Jo van Gogh*. Edited by Douglas Cooper. Gravenhage: 1983.

————. *Oviri. Écrits d'un sauvage*. Selected and introduced by Daniel Guérin. Paris: Gallimard, 1974.

————. "Qui trompe-t-on ici?" *Le Moderniste Illustré* (September 21, 1889): 56.

————. *Racontars de rapin*. Paris: Falaize, 1951.

Gauguin, Pola. *My Father Paul Gauguin*. Translated by Arthur G. Chater. New York: Alfred A. Knopf, 1937.

Geffroy, Gustave. *La Vie artistique*. Vols. 1–4. Paris: E. Dentu, 1892–1895.

————. *La Vie artistique*. Vols. 5–8. Paris: H. Floury, 1897–1903.

Goldwater, Robert. *Paul Gauguin*. New York: Harry N. Abrams, 1928.

————. "Symbolic Form: Symbolic Content." *Problems of the Nineteenth and Twentieth Centuries, Studies in Western Art: Acts of the 20th International Congress of the History of Art*. Vol. 4. Princeton: Princeton University Press, 1963.

————. *Symbolism*. New York: Harper & Row, 1979.

Goncourt, Edmond de. *Germinie Lacerteux*. New York: Grove Press, 1955.

Graff, Louis. "Pictorial Tragedy." *The Kenyon Review* 9 (winter 1947): 96–109.

Graetz, H. R. *The Symbolic Language of Vincent van Gogh*. New York: McGraw Hill, 1963.

Gray, Christopher. *The Sculpture and Ceramics of Paul Gauguin*. Baltimore: Johns Hopkins Press, 1963.

Guérin, Marcel. *L'Oeuvre gravé de Gauguin*. 2 vols. Paris: H. Floury, 1927.

Hammacher, A. M. *Genius and Disaster. The Ten Creative Years of Vincent van Gogh*. New York: Harry N. Abrams, 1968.

Harries, Karsten. *The Meaning of Modern Art. A Philosophical Interpretation*. Evanston, Ill.: Northwestern University Press, 1968.

Hemmings, F. W. J. *Culture and Society in France 1848–1898*. New York: Charles Scribner & Sons, 1971.

Herban, Matthew. "The Origin of Paul Gauguin's *Vision after the Sermon: Jacob Wrestling with the Angel*." *Art Bulletin* 59 (September 1977): 215–20.

Herbert, Eugenia. *The Artist and Social Reform. France and Belgium 1885–1898*. New Haven: Yale University Press, 1961.

Herbert, Robert. *Barbizon Revisited*. Boston: Museum of Fine Arts, 1962.

————. *Neo-Impressionism*. New York: The Solomon R. Guggenheim Foundation, 1968.

Hofstadter, Albert, and Richard Kuhns, eds. *Philosophies of Art and Beauty. Selected Readings in Aesthetics from Plato to Heidegger*. Chicago: University of Chicago Press, 1964.

Homer, William Innes. *Seurat and the Science of Painting*. Cambridge: M. I. T. Press, 1964.

Hugo, Victor. *Les Misérables*. Translated by Charles E. Wilbour. New York: Modern Library, Random House, n.d.

Hulsker, Jan. *The Complete Van Gogh*. New York: Harry N. Abrams, 1980.

Humber, Agnes. *Les Nabis et leurs époque*. Paris: Caillier, 1954.

Huyghe, René. "La Clef de Noa-Noa." In introduction to Paul Gauguin's *Ancien culte mahorie*. Paris: Pierre Berès, 1951.

————. *Gauguin*. Translated by Helen C. Slonim. New York: Crown Publishers, 1978.

————. "Initiateur des temps nouveau." In *Paul Gauguin. Collection Génies et réalités*, 236–83.

————. *La Relève de l'imaginaire*. Paris: Flammarion, 1976.

————. *La Relève du réel*. Paris: Flammarion, 1974.

James, William. *The Varieties of Religious Experience*. New York: Macmillan Publishing Co., 1961.

Jaworska, Wladyslawa. *Gauguin and the Pont-Aven School*. Translated by Patrick Evans. Greenwich, Conn: New York Graphic Society Ltd., 1972.

Jirat-Wasiutynski, Vojtech. *Paul Gauguin in the Context of Symbolism*. New York: Garland Publishing, 1978.

Johnson, Ron. "Vincent van Gogh and the Vernacular: The Poet's Garden." *Arts Magazine* 53 (February 1979): 98–104.

Jonsson, Inge. *Emanuel Swedenborg*. Translated by Catherine Djurklou. New York: Twayne Publishers, 1971.

Jullian, Philippe. *The Symbolists*. Translated by MaryAnne Stevens. New York: Phaidon, 1973.

Kahn, Gustave. "Paul Gauguin." *L'Art et les Artistes* 12 (November 1925): 37–64.

————. *Symbolistes et décadents*. Paris: Librairie Léon Vanier, 1902.

Kane, William M. "Gauguin's *Le Cheval blanc*: Sources and Syncretic Meanings." *Burlington Magazine* 108 (July 1966): 352–62.

Landy, Barbara. "The Meaning of Gauguin's 'Oviri' Ceramic." *Burlington Magazine* 109 (April 1967): 242–46.

————. "Paul Gauguin: Symbols and Themes in the Pre-Tahitian Works." Master's thesis, Columbia University, 1968.

Lehmann, A. G. *The Symbolist Aesthetic in France*. Oxford: Basil Blackwell, 1950.

Lethève, Jacques. *Impressionnistes et symbolistes devant la presse*. Paris: Armand Colin, 1959.

Lettres à Émile Bernard. Brussels: Éditions de la Nouvelle Revue Belgique, 1942.

Lettres à Odilon Redon. Edited by Roseline Bacou. Paris: Librairie José Corti, 1960.

Lévy-Bruhl, Lucien. *L'Expérience mystique et les symboles chez les primitifs*. Paris: Félix Alcan, 1938.

Leymarie, Jean. *Paul Gauguin: Watercolors, Pastels, and Drawings in Color*. Translated by Robert Allen. London: Faber & Faber, 1961.

————. *Van Gogh*. Paris and New York: Tisné, 1951.

Loevgren, Sven. *The Genesis of Modernism*. Stockholm: Almquist & Wiskell, 1959.

Loti, Pierre [Julien Viaud]. *The Marriage of Loti*. Translated by Wright and Eleanor Frierson. Honolulu: University Press of Hawaii, 1976.

Malingue, Maurice. *Gauguin, le peintre et son oeuvre*. Introduction by Pola Gauguin. Paris: Les Presses de la Cité, 1948.

————. "L'Homme qui a réinventé la peinture." In *Paul Gauguin. Collection Génies et réalités*, 108–37.

Marks-Vandenbroucke, Ursula F. "Gauguin, ses origines et sa formation artistique." *Gazette des Beaux-Arts* 47 (January–April 1956): 9–61.

Mauclair, Camille. T*he Great French Painters and the Evolution of French Painting from 1830 to the Present Day*. Translated by P. G. Konody. New York: E. P. Dutton, 1903.

Maupassant, Guy de. *Bel-Ami*. Translated by Douglas Parmée. New York: Penguin Books, 1975.

Meier-Graefe, Julius. *Vincent van Gogh*. Translated by John Holroyd-Reece. New York: Blue Ribbon Books, 1933.

Mellerio, André. *Le Mouvement idéaliste en peinture*. Paris: H. Floury, 1896.

Milton, John. *Paradise Lost and Paradise Regained*. Edited by Christopher Ricks. New York: New American Library, A Signet Classic, 1968.

Mittelstädt, Kuno. *Paul Gauguin: Self-Portraits*. Translated by E. G. Hull. Oxford: Cassirer, 1968.

Moerenhout, Jacques A. *Voyages aux îles du grand océan*. Paris: Bertrand, 1837.

Moffett, Charles. *Van Gogh as Critic and Self-Critic*. New York: The Metropolitan Museum of Art, 1973.

Morice, Charles. *La Littérature de tout à l'heure*. Paris: Perrin et Cie, 1889.

————. "Paul Gauguin." *Mercure de France* 48 (December 1893): 289–300.

————. "Paul Gauguin." *Mercure de France* 166 (October 1903): 100–35.

————. *Paul Gauguin*. Paris: H. Floury, 1920.

————. Preface to *Exposition Paul Gauguin*. Paris: Galéries Durand-Ruel, 1893.

————. "Quelques opinions sur Paul Gauguin." *Mercure de France* 167 (November 1903): 413–33.

Mornand, Pierre. *Émile Bernard et ses amis*. Geneva: Pierre Cailler, 1957.

Nagera, Humberto. *Vincent van Gogh: A Psychological Study*. Foreword by Anna Freud. New York: International Universities Press, 1967.

Nahm, Milton, ed. *Readings in Philosophy of Art and Aesthetics*. Englewood Cliffs, New Jersey: Prentice-Hall, 1975.

Neumayer, Alfred. *The Search for Meaning in Modern Art*. Englewood Cliffs, New Jersey: Prentice-Hall, 1964.

Nochlin, Linda. *Impressionism and Post Impressionism 1874–1904*. Englewood Cliffs, New Jersey: Prentice-Hall, 1966.

————. *Realism*. Baltimore: Penguin Books, 1971.

————. *Realism and Tradition in Art 1848–1900*. Englewood Cliffs, New Jersey: Prentice-Hall, 1966.

Nordenfalk, Carl. *The Life and Work of Van Gogh*. New York: Philosophical Library, 1953.

————. "Van Gogh and Literature." *Journal of the Warburg and Courtauld Institutes* 10 (1947): 132–47.

Nourissier, François. "Sa place dans le melée symboliste." In *Paul Gauguin. Collection Génies et réalités*, 94–107.

Oeuvres écrites de Gauguin et van Gogh. Paris: Institut de Néerlandais, 1975.

Paul Gauguin. Collection Génies et réalités. Paris: Hachette, 1961.

Peckham, Morse, ed. *Romanticism. The Culture of the Nineteenth Century*. New York: George Braziller, 1965.

Perruchot, Henri. *La Vie de Gauguin*. Paris: Hachette, 1961.

————. *La Vie de Van Gogh*. Paris: Hachette, 1955.

Pickvance, Ronald. *The Drawings of Gauguin*. London: Hamlyn Publishing Group, Ltd., 1970.

————. *English Influences on Vincent van Gogh*. University Art Gallery, Nottingham, 1974. London: Arts Council of Great Britain, 1974.

————. *Van Gogh in Arles*. New York: The Metropolitan Museum of Art, 1984.

————. *Van Gogh in Saint-Rémy and Auvers*. New York: The Metropolitan Museum of Art, 1986.

Post-Impressionism. Cross-Currents in European Painting. "France" by John House and Mary Anne Stevens. London: Royal Academy of Arts, 1979.

Pottier, E. "Grèce et Japon." *Gazette des Beaux-Arts* 4 (August 1890): 105–32.

Puig, René. *Paul Gauguin, Daniel de Monfreid et leurs amis*. Paris: Éditions de "la Tramontane," 1958.

Quesne-Van Gogh, Elizabeth du. *Personal Recollections of Vincent van Gogh*. Translated by Katherine S. Dreier. Boston: Houghton Mifflin Co., 1913.

Radhakrishnan, S. *Eastern Religions and Western Thought*. Oxford: Clarendon Press, 1939.

Read, Herbert. *Art and Society*. New York: Schocken Books, 1966.

————. *Icon and Idea*. New York: Schocken Books, 1965.

————. "Gauguin. Return to Symbolism," *Art News Annual* 25 (1956): 125–58.

————. *The Philosophy of Modern Art*. New York: Meridian, 1957.

Redon, Odilon. *A soi-même. Journal 1867–1915*. Paris: Librairie José Corti, 1961.

Renan, Ernest. *Dialogues et fragments philosophiques*. 3rd ed. Paris: Calmann-Lévy, 1885.

————. *The Future of Science. Ideas of 1848*. London: Chapman & Hall, Ltd., 1891.

————. *Studies of Religious History*. London: William Heinemann, 1893.

Rewald, John. "The Artist and his Land." In *Van Gogh*, 23–30. New York: The Art Foundation, 1953.

———. "Extraits du Journal inédit de Paul Signac I, 1894–1895." *Gazette des Beaux-Arts* 36 (July–September 1939): 97–128.

———. *Gauguin*. Edited by André Gloeckner. Paris: Hyperion Press, 1938.

———. *Gauguin*. New York: Harry N. Abrams, 1954.

———. *Gauguin Drawings*. New York: Thomas Yoseloff, 1958.

———. "The Genius and the Dealer." *Art News* 58, no. 3 (May 1959).

———. *Georges Seurat*. New York: Wittenborn & Co., 1946.

———. *The History of Impressionism*. New York: The Museum of Modern Art, 1961.

———. *Post-Impressionism. From Van Gogh to Gauguin*. 3rd rev. ed. New York: The Museum of Modern Art, 1978.

———. *Vincent van Gogh*. Paris: Revue d'Art. n.d.

Rey, Robert. *Gauguin*. Translated by F. C. Sumichrast. London: Bodley Head, 1924.

———. *La Renaissance du sentiment classique dans la peinture française à la fin du XIXe siècle*. Paris: Éditions G. van Oest, 1931.

Roger-Marx, Claude. "Gauguin et la naïveté en art." *Revue de Paris* (October 1960): 122–30.

Rookmaaker, Hendrik Roelof. *Gauguin and 19th Century Art Theory*. Amsterdam: Swets & Zeitlinger, 1972.

Roskill, Mark. *Van Gogh, Gauguin and French Painting of the 1880s: A Catalogue Raisonné of Key Works*. Ann Arbor, Mich.: University Microfilms, 1970.

———. *Van Gogh, Gauguin, and the Impressionist Circle*. Greenwich: New York Graphic Society., 1970.

Rotonchamp, Jean de. *Paul Gauguin*. Paris: G. Crès et Cie, 1925.

Rousseau, Jean-Jacques. *Discours sur les sciences et les arts; Discours sur l'origine et les fondements de l'inégalité parmi les hommes*. Edited by Roger D. Masters. New York: St. Martin's Press, 1964.

———. *Émile*. Translated by Barbara Foxley. New York: E. P. Dutton & Co., 1933.

———. *Reveries of a Solitary Walker*. Translated by Peter France. New York: Penguin Books, 1979.

Rowland, Benjamin. *The Art and Architecture of India*. Pelican History of Art. 3rd rev. ed. Baltimore: Penguin Books, 1967.

The Sacred and Profane in Symbolist Art. Toronto: Art Gallery of Toronto, 1969.

Scherjon, W., and Joseph de Gruyter. *Vincent van Gogh's Great Period*. Amsterdam: "De Spiegel" Ltd., 1937.

Schneeberger, Pierre-Francis. *Gauguin à Tahiti*. Paris: Bibliothèque des Arts SPADEM, 1961.

Schopenhauer, Arthur. *The Philosophy of Schopenhauer*. Edited by Irwin Edman. New York: E. P. Dutton & Co., 1933.

Schuré, Edouard. *The Great Initiates*. 2 vols. Translated by Red Rothwell. Philadelphia: David M'Kay Co., 1925.

Ségalen, Victor. "Gauguin dans son dernier décor." *Mercure de France* 174 (June 1904): 679–85.

Séguin, Armand. "Paul Gauguin." I, II, III. *L'Occident* 16 (March 1903): 158–67; 17 (April 1903): 230–39; 18 (May 1903): 298–304.

Sérusier, Paul. *A. B. C. de la peinture, suivies d'une correspondance inédite*. Reprinted from the 1899 MS. Paris: n.p., 1950.

Seznec, Jean. "Literary Inspiration in van Gogh." *Magazine of Arts* 43 (December 1950): 282–88, 306–07.

Shapiro, Meyer. "On a Painting of Van Gogh: *Crows in the Wheatfield*." In *Van Gogh in Perspective*, edited by Bogomila Welsh-Ovcharov. Englewood Cliffs, New Jersey: Prentice-Hall, 1974.

———. *Vincent van Gogh*. New York: Harry N. Abrams, 1950.

Shiff, Richard. *Cézanne and the End of Impressionism: A Study of The Theory, Technique, and Critical Evaluation of Modern Art*. Chicago and London: University of Chicago Press, 1984.

Signac, Paul. *D'Eugène Delacroix au néo-impressionnisme*. Edited by Françoise Cachin. Paris: Hermann, 1964.

Sloan, Thomas. "Paul Gauguin's *D'Où venons-nous? Que sommes-nous? Où allons-nous?*: A Symbolist Philosophical Leitmotif." *Arts Magazine* 53 (January 1979): 104–09.

Sloane, Joseph. *French Painting Between the Past and Present: Artists, Critics, and Traditions from 1848 to 1870*. Princeton: Princeton University Press, 1973.

Les Sources d'inspiration de Vincent van Gogh. Introduction by Dr. V. W. van Gogh. Paris: Institut Néerlandais, 1972.

Le Sourire. Facsimile of complete collection. Introduction and notes by L. J. Bouge. Paris: G. P. Maisonneuve, 1952.

Stowe, Harriet Beecher. *Uncle Tom's Cabin*. New York: Bantam Books, 1981.

Stromberg, Roland N., ed. *Realism, Naturalism, and Symbolism: Modes of Thought and Expression in Europe 1848–1914*. New York: Walker, 1968.

Sutton, Denys. "*La Perte du Pucelage* by Paul Gauguin." *Burlington Magazine* 91 (April 1949): 103–5.

Taine, Hippolyte. *Lectures on Art*. 2 vols. Translated by John Durand. New York: Henry Holt and Company, 1875.

Teilhet, Jehanne H. "The Influence of Polynesian Culture and Art on the Works of Paul Gauguin: 1891–1903." Ph.D. dissertation, University of California, Los Angeles, 1975.

———. "*Te Tamari No Atua*: An Interpretation of Paul Gauguin's Tahitian Symbolism." *Arts Magazine* 53 (January 1979): 110–11.

Thomas, Lewis. *The Lives of a Cell. Notes of a Biology Watcher*. New York: Bantam Books, 1975.

Tolstoy, Count Leo N. *What is Art?* Translated by Aylmer Maude. New York: Thomas Y. Crowell, 1899.

Thirion, Yvonne. "L'Influence de l'estampe japonais dans l'oeuvre de Gauguin." *Gazette des Beaux-Arts* 47 (January–April 1956): 95–114.

Tralbaut, Marc Edo. *Vincent van Gogh*. New York: Viking Press, Studio Books, 1969.

Uitert, Evert van. *Van Gogh Drawings*. Translated by Elizabeth Willems-Treeman. Woodstock, New York: Overlook Press, 1978.

Van Gogh, Vincent. *The Complete Letters of Vincent van Gogh*. 3 vols. Translated by J. van Gogh-Bonger and C. de Dood. Greenwich: New York Graphic Society, 1958.

———. *Letters to an Artist. From Vincent van Gogh to Anton Ridder van Rappard 1881–1885*. Translated by Rela van Messel. Introduction by Walter Pach. New York: Viking Press, 1936.

Van Gogh in Perspective. Edited by Bogomila Welsh-Ovcharov. Englewood Cliffs, New Jersey: Prentice-Hall, 1974.

Van Gogh, raconté par lui-même et par ses amis. Vol. 2. Preface by Pierre Courthion. Geneva: Pierre Cailler, 1947.

Vincent van Gogh. 2 vols. Amsterdam: Rijksmuseum Vincent van Gogh and Rijksmuseum Kröller-Müller, 1990.

Venturi, Lionello. *Impressionists and Symbolists.* Translated by Francis Steegmuller. New York: Charles Scribner's Sons, 1950.

Wadley, Nicholas. *The Drawings of Van Gogh.* London: Hamlyn Publishing Group, 1969.

Walther, Ingo, and Rainer Metzger. *Vincent van Gogh, The Complete Paintings.* 2 vols. Cologne: Benedikt Taschen, 1990.

Wattenmaker, Richard J. *Puvis de Chavannes and the Modern Tradition.* Toronto: Art Gallery of Ontario, 1975.

Welsh-Ovcharov, Bogomila. *Vincent van Gogh and the Birth of Cloisonism.* Toronto: Art Gallery of Ontario, 1981.

———. *Vincent van Gogh: His Paris Period 1886–1888.* Utrecht and The Hague: Éditions Victorine, 1976.

Wildenstein, Georges, and Raymond Cogniat. *Gauguin: Catalogue.* Paris: Édition Les Beaux-Arts, 1964.

Zink, Mary Lynn. "Gauguin's Poèmes Barbares and the Tahitian Chant of Creation." *Art Journal* 38 (fall 1978): 18–21.

Zola, Émile. *Germinal.* Translated and introduced by Havelock Ellis. New York: E. P. Dutton & Co., Everyman's Library, 1933.

———. *La Joie de vivre.* Paris: Charpentier, 1907.

———. *The Masterpiece [L'Oeuvre].* Translated by Thomas Walton. Ann Arbor, Mich.: University of Michigan Press, 1968.

Index

Subheadings follow the thematic organization of the text and the chronological order of Van Gogh's and Gauguin's work.